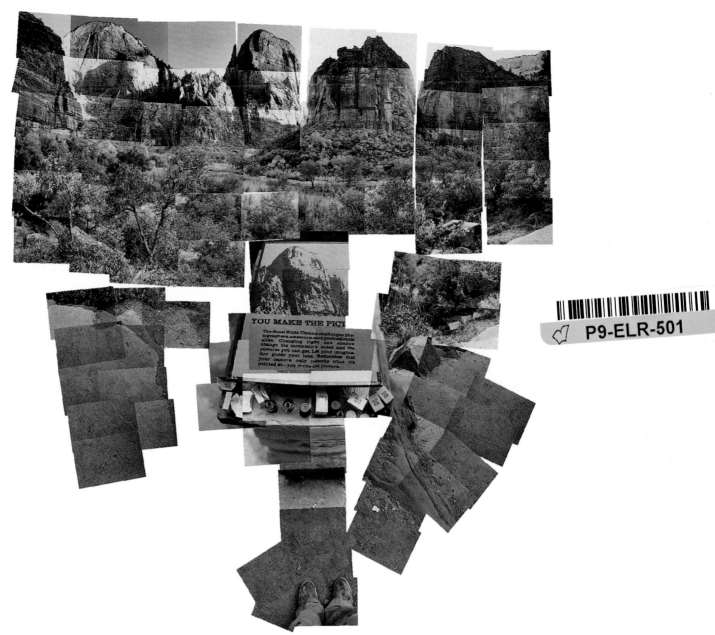

YOU MAKE THE PICT

The Great White Throne challenges pho-
tographers, amateurs and professionals
alike. Changing light and shadow
change the mountain's mood and the
pictures you can get. Let your imagina-
tion guide your lens. Remember that
your camera only records what it's
pointed at—you make the picture.

Barbara London and John Upton
PHOTOGRAPHY
FIFTH EDITION

HarperCollinsCollegePublishers

Acquisitions Editor: Daniel F. Pipp
Developmental Editor: Robin Jacobson
Project Editor: Thomas R. Farrell
Design Supervisor: Paul Agresti
Cover Design: Paul Agresti
Production Administrator: Valerie A. Sawyer
Compositor, Printer, and Binder: Arcata Graphics/Kingsport
Cover Printer: Coral Graphics Services, Inc.

Thanks for permission to use material from *Breaking Bounds: The Dance Photography of Lois Greenfield* by William A. Ewing. © 1992 Thames and Hudson, Ltd., London

Cover photo: Ken Kay. Digital manipulation by Paul Agresti.

Title page photo: David Hockney, *You Make the Picture, Zion Canyon, Utah, October 1982*, photographic collage, 52½ × 48¼″, © David Hockney.

For permission to use copyrighted material, grateful acknowledgment is made to the copyright holders on pp. 416–417, which are hereby made part of this copyright page.

Photography, Fifth Edition
Copyright © 1994 by HarperCollins College Publishers

Library of Congress Cataloging-in-Publication Data

London, Barbara, (date)–
 Photography / Barbara London, John Upton. — 5th ed.
 p. cm.
 Includes bibliographical references and index.
 ISBN 0-673-52223-7
 1. Photography. I. Upton, John, (date)– . II. Title.
TR145.L66 1994
770—dc20 93–2366
 Cip

94 95 96 9 8 7 6 5 4 3 2

Contents

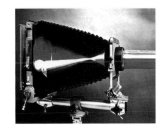
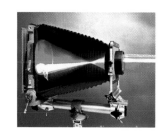

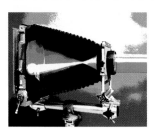

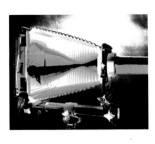 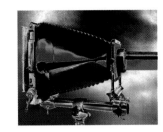 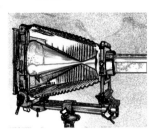 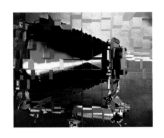

Preface

Photography will sell its one millionth copy sometime during this edition. Many people who have used this book are now professional photographers or photography instructors, or are continuing to pursue their personal interest in photography. Whatever *your* interest is in photography, this book is designed to teach the skills that you will need in order to use the medium confidently and effectively.

The emphasis of this fifth edition continues to be in two major areas—technique and visual awareness. The technical material helps you learn how to control the photographic process, or as Ansel Adams put it, to "understand the way that the lens 'sees' and the film 'sees.'"

• Basic black-and-white photography is covered completely in Chapters 1–8: camera, lens, film, exposure, developing, printing, and mounting.

• Chapters 9–14 cover special techniques (such as close-up photography), color photography, lighting, digital imaging, view camera use, and a specialized method of exposure and development—the Zone System.

• What Went Wrong? sections in various chapters describe potential technical problems, their causes, and ways to prevent them. See, for example, Troubleshooting Camera and Lens Problems, page 63.

Equally important, this book can help *you* see by showing you the choices that other photographers have made and that you can make when you raise a camera to your eye. Photographs themselves provide a vital teaching force, and throughout the book you will find many illustrations by the best photographers showing how they have put to use various technical concepts.

• See, for example, the two photographs illustrating perspective on pages 60–61, or how one photographer uses simple portrait lighting set-ups on pages 254–255.

• Photographer at Work spreads throughout the book feature interviews with photographers who have each developed a successful career in everything from dance photography (*pages 32–33*) to advertising photography (*pages 240–241*).

• Chapter 15, Seeing Photographs (*pages 335–361*), deals with composition, tonality, sharpness, and other visual elements that will help you make better pictures yourself, and that will help you see other people's photographs with a more sophisticated eye.

• Chapter 16 surveys the history of photography (*pages 363–405*), so that you can place today's photography—and your own—in a historical context.

This book makes the information you will need as accessible and as easy to use as possible.

• Each two facing pages completes a single idea, skill, or technique.

• Key topics appear in the text as boldface type, making it easy to pick out the main concepts.

• Topics are explained using words, drawings, charts—but especially pictures, hundreds of them, the best of many different styles. The inside front cover lists a sample of the types of photographs in the book and the pages where you can find them.

New to this addition are several features that instructors and students have requested.

• If you are brand new to photography, see Chapter 1, Getting Started (*pages 1–7*). It will walk you through the first steps of selecting and loading film, focusing sharply, adjusting the exposure, and making your first pictures.

• A major new chapter on digital imaging (*pages 275–297*) has been added. In one sense, digital imaging is just another tool, but it is an immensely powerful one that is changing photography and that will empower those who know how to use it.

• A technical update has, of course, been made throughout.

This fifth edition of *Photography* has been a collaborative effort. Instructors, students, photographers, manufacturers, editors, gallery people, and many others participated in it. They fielded queries, made suggestions, responded to material, and were unfailingly generous with their time, energy, and creative thinking. Special thanks go to the instructors who reviewed the previous edition of *Photography* before work on this one was started. They brought a particularly useful point of view, contributing many ideas on not only what to teach, but how to teach it:

Andrée L. Abecassis, *De Anza College*
Charles Altschul, *Center for Creative Imaging*
Al Assid, *Collin County Community College*
James G. Babcock, *California State University at Chico*
Robert K. Baylor, *Harrisburg Area Community College*
Val Brinkerhoff, *Western Wyoming College*
G. Lloyd Carr, *Gordon College*
Neil Chapman, *California State University at Long Beach*
John Chastain, *Nashville State Technical College*
Alma Davenport de la Ronde, *University of Massachusetts*
Steve Dzerigian, *Fresno City College*
Susan Felter, *Santa Clara University*
Harris Fogel, *Chaffey Community College*
Deirdre Garvey, *Santa Monica College*
Bill Gillette, *Iowa State University*
Maureen Gobel, *Southeast Community College*
Anna C. Hansen, *University of New Mexico*
Wendy Jacobs, *University of Maryland*
Richard Johnson, *Delaware County Community College*
Robert Johnson, *College of DuPage*

Manuel Kennedy, *Central Piedmont Community College*
Ellen Land-Weber, *Humboldt State University*
Gerald Lang, *Pennsylvania State University*
Wayne R. Lazorik, *University of New Mexico*
John Leahey, *Point Park College*
Howard LeVant, *Rochester Institute of Technology*
David Litschel, *Brooks Institute*
John D. Mercer, *Phoenix College*
Patrick Mitten, *Milwaukee Area Technical College*
Gypsy Ray, *Cabrillo College*
Nancy Roberts, *Art Institute of Boston*
Jack Sal, *Moore College of Art and Design*
M. K. Simqu, *Ringling School of Art and Design*
Curtis Stahr, *Des Moines Area Community College*
David Sutherland, *Syracuse University*
Elizabeth Turk, *Atlanta College of Art*
G. Pasha Turley, *Southwestern College*
Ruth Wallen, *Southwestern College*

Robert Ward, *Bridgewater State College*
Roy White, *Rhode Island School of Design*
Wendel A. White, *Stockton State College*
David Wing, *Grossmont College*
Henry Witkowski, *Southwestern College*
Dixon Wolf, *University of New Mexico*

Without editorial and production assistance, a book of this size and complexity would be impossible to complete. Peggy Ann Jones, Kenn Rabin, and Rick Steadry contributed much to the book editorially. Digital imaging had its own line of consultants, including Joe Ciaglia, Dr. Bob Davis (and his students), Kurt Foss, Alexis Gerard, Stephen Johnson (who also edited and printed the illustrations on pages 282–285), Tommy Morgeson, Jeff Parker, Barbara Robertson, Elmo Sapwater, and Sueki Woodward. John Sexton reviewed the Zone System chapter and clarified a number of points there.

At HarperCollins, support was given at every stage by Susan Driscoll, Laurie Likoff, Dan Pipp, Betty Slack, Peter Glovin, Kewal Sharma, Teresa Delgado, Bonnie Biller, Thomas Farrell, and Valerie Sawyer. Special thanks to Paul Agresti for his creative thinking and tireless efforts.

Thanks also to Robin Jacobson—as usual—above and beyond; to Ken Kobre and Betsy Brill, who know how to make book; to Terry Gallagher for an inspiration on meeting deadlines; to Katherine Doyle, Edward Stanton, and Sean Upton for help with the thousand-and-one things. And to Nyanko-chan and Bea Tamale: what would one do without them?

This is a book that students keep and refer to long after they have finished the basic photo course for which they purchased it. Some of the people who contributed to this new edition used the book themselves when they were studying photography, and still have their original, now dog-eared, copy. As you work with the book, you may have suggestions on how to improve it. They will be sincerely welcomed.

Dedicated to everyone who is part of this one-millionth-copy new edition.

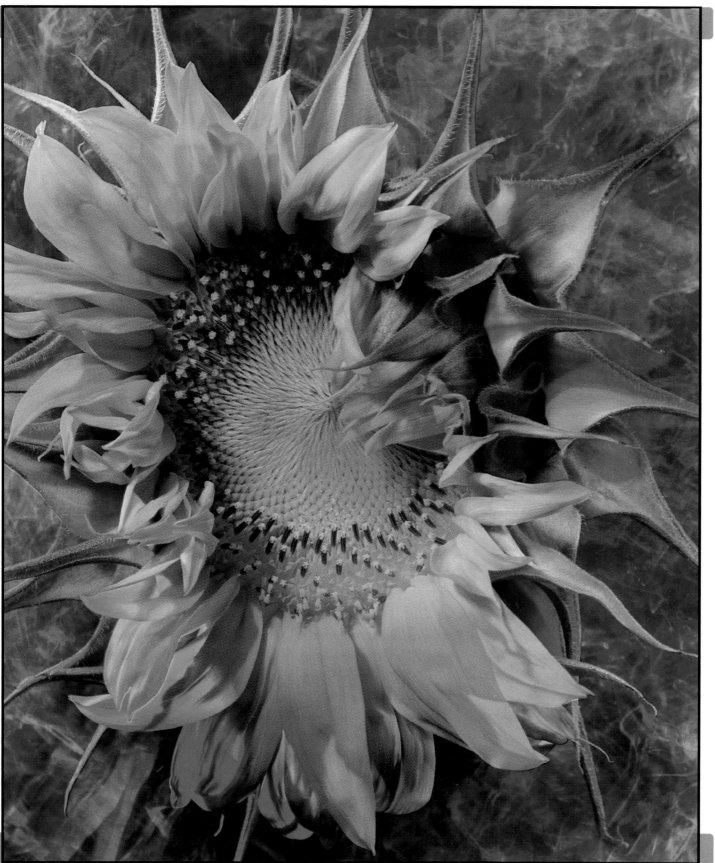

There are as many ways to photograph a sunflower—or a landscape or a person or anything else—as there are photographers. Left, the flower glows with intense and not quite realistic hues. William Lesch wanted to avoid the fixed feeling of stationary lights. He used a single light that he moved across the subject, simultaneously moving colored filters across the light. He also moved the background during the exposure. Lesch says he seeks to record the "flow of nature and reality," and to do so he uses moving lights, moving subjects, multiple exposures, and other means of going beyond static exposures.

Opposite, the flower is reduced to a halo of leaves created by a single light behind the flower. Paul Caponigro became absorbed with photographing sunflowers after being given one by a friend. "Sunflower resounded in me," he said. "I worked and lived with the sunflower by day, and at night it followed me into my sleep. . . . Inwardly, silently, I was asking to see that aspect of the sunflower which the physical eye could not."

WILLIAM LESCH: *Sunflower*

Getting Started 1

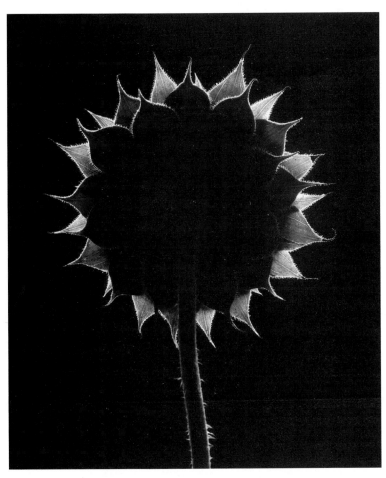

PAUL CAPONIGRO: *Sunflower, Winthrop, Massachusetts,* 1965

If you are just getting started in photography, this chapter will walk you through the first steps of selecting and loading film, focusing an image sharply, adjusting the camera settings so your photographs won't be too light or too dark, and making your first exposures. You can go directly to Chapter 2 if you prefer more detailed coverage right away.

The steps in this chapter are a basic checklist. Cameras vary in design, so to find out exactly what button to push, it helps to read your instruction book or to ask someone who is familiar with your camera. Most of the steps apply to the camera you are likely to be using: a 35mm single-lens reflex. (You'll find more about different types of cameras beginning on page 9. See also the More About . . . references in this chapter. They will guide you to more information about various topics.)

Cameras have become increasingly automatic in recent years, with automatic exposure and automatic focus found on more and more models. But manual operation is a common alternative and not necessarily a second choice. Many photographers prefer to make their own exposure and focusing decisions, and under some conditions, manual operation is a necessity. If you are using this book in a photography class, your instructor may prefer that you operate the camera manually for your first exposures, because it's a good way to learn the basics of photographic controls. Where appropriate on the following pages, both manual and automatic operation are shown.

Once you have gotten the basics down, how do you get better? What's the best way to improve? Many of the photographers whose work appears in this book were asked that question. The advice they offered was surprisingly consistent. "Photograph more and more." "Take more pictures." "Shoot, shoot, shoot." "Persevere." "Just keep after it; you can't help but improve if you do." If this sounds like obvious advice—no secrets or inside information—it seems to be obvious advice that works. These photographers volunteered such comments often and with feeling. They knew how they had improved their skills, and they knew what you should do to get better, too.

Have fun.

CAMERA AND FILM

A camera's main functions are to help you **view** the scene so you can select what you want to photograph, **focus** to get the scene sharp where you want it to be, and **expose** the film so the picture is not too light or too dark.

The **viewfinder** shows the picture that the lens focuses on the film.

The **lens** rotates forward and back to bring objects at different distances into sharp focus.

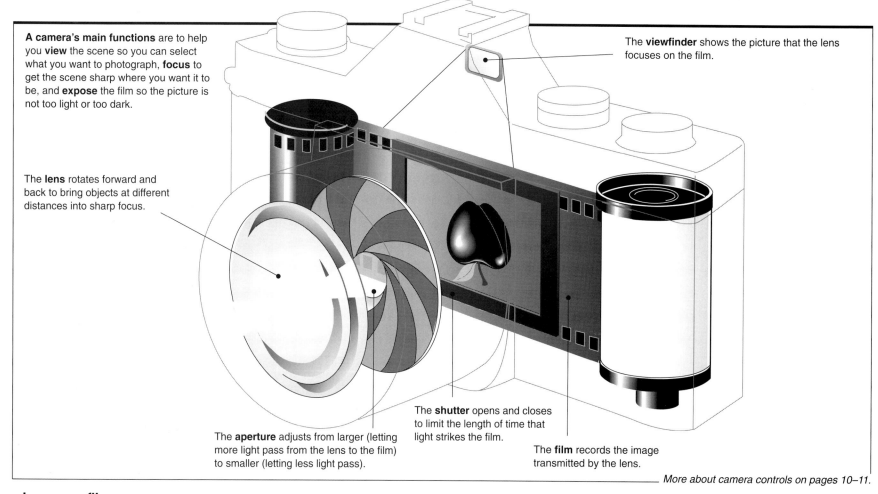

The **shutter** opens and closes to limit the length of time that light strikes the film.

The **aperture** adjusts from larger (letting more light pass from the lens to the film) to smaller (letting less light pass).

The **film** records the image transmitted by the lens.

More about camera controls on pages 10–11.

choose a film

If you want prints, select a negative film, either color or black and white. The film is developed to a negative image, then printed onto paper to make a positive image.

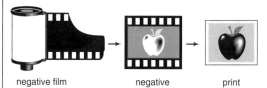

negative film negative print

If you want slides or transparencies, select a reversal film, one that produces a positive image directly on the film that is in the camera. Most reversal films are for color images.

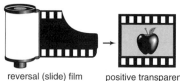

reversal (slide) film positive transparency

Film speed (ISO 100, 200, and so on) describes a film's sensitivity to light. The higher the number, the more sensitive ("faster") the film, and the less light it needs for a correct exposure (one that is not too light or too dark). For your first exposures, choose a film with a speed of 100 to 200 for shooting outdoors in sunny conditions. In dimmer light, use film with a speed of 400 or higher.

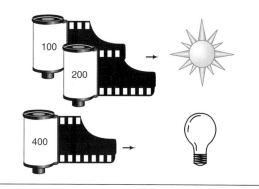

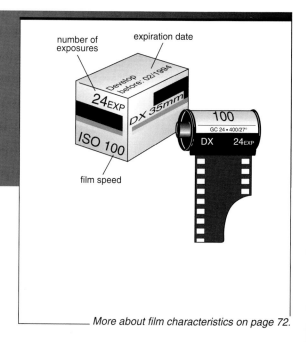

number of exposures

expiration date

film speed

More about film characteristics on page 72.

LOADING FILM INTO THE CAMERA

open the camera

Make sure there is no film in the camera before you open it. Check that the film frame counter shows empty or that your camera's film rewind knob (if it has one) rotates freely. If there is film in the camera, rewind it (see page 6).

Keep film out of direct sunlight. Load film into the camera in subdued light, or at least shield the camera from direct sunlight with your body as you load the film.

A camera that loads film manually will have a rewind knob on the top. This type of camera usually opens when you pull up on the rewind knob.

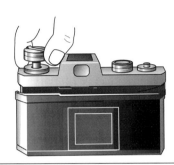

A camera that loads film automatically probably will have a release lever, not a rewind knob, to open the camera. Turn on the camera's main power switch. Open the camera by sliding the release lever to its open position.

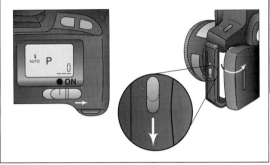

insert and thread film

Check for dust or small chips of film inside the camera. Clean, if needed, with a soft brush. Avoid touching the shutter mechanism at the center of the camera.

Insert the film cassette. A 35mm single-lens reflex camera usually loads the film in the left side of the camera with the extended part of the cassette toward the bottom. The film should lie flat as it comes out of the cassette; if needed, rotate the cassette slightly to the right.

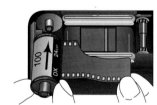

Manual loading. Push down the rewind knob. Pull out the tapered end of the film until you can insert it into the slot of the take-up spool on the other side of the camera. Alternately press the shutter release button and rotate the film advance lever until the teeth that advance the film securely engage the sprocket holes at the top and bottom of the film, and any slack in the film is reeled up by the take-up spool.

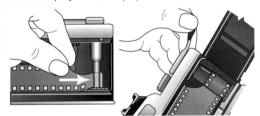

Automatic loading. Pull out the tapered end of the film until it reaches the other side of the camera. Usually a red mark or other indicator shows where the end of the film should be. The film won't advance correctly if the end of the film is in the wrong position.

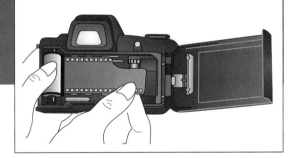

advance film to the first frame

Close the camera back. You'll need to advance the film past the exposed film leader to an unexposed frame.

Manual film advance. With the camera back closed, alternately press the shutter release button and rotate the film advance lever. Repeat two times.

If the film is advancing correctly, the film rewind knob will rotate counterclockwise as you move the film advance lever. If it does not, open the camera and check the loading. Don't rely on the film frame counter; it may advance even though the film does not move.

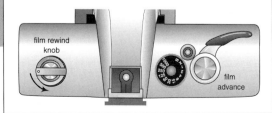

Automatic film advance. Depending on your camera, you may simply need to close the camera back to have the film advance to the first frame. Some cameras require you to also depress the shutter button.

If the film has correctly advanced, the film frame counter will display the number 1. If it does not, open the camera back and check the loading.

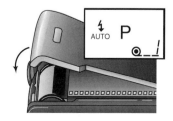

FOCUSING AND SETTING THE EXPOSURE

set the film speed

Film speed is a measure of a film's sensitivity to light. The higher the film speed number (the film's ISO number), the less light the film needs for a good exposure. The camera should be set to the speed of the film you are using. Film speed is marked on the film box and on the film cassette.

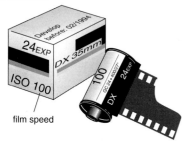

film speed

Manually setting the film speed. On some cameras you must set the film speed manually. Turn the film speed dial (marked ISO or sometimes ASA) to the speed of your film. Here it is set to a film speed of 100.

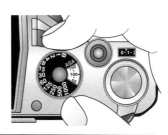

Automatically setting the film speed. On some cameras the film speed is set by the camera as it loads the film. The film must be DX coded, marked with a kind of bar code that is read by a sensor in the camera. DX-coded films have "DX" printed on the cassette and box.

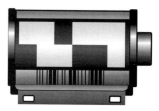

More about film speed on pages 73–77.

focus

Focus on the most important part of your scene to make sure it will be sharp in the photograph. Practice focusing on objects at different distances as you look through the viewfinder so that you become familiar with the way the camera focuses.

Manual focusing. As you look through the viewfinder, rotate the focusing ring at the front of the lens. The viewfinder of a single-lens reflex camera has a ground-glass screen that displays a sharp image of the parts of the scene that are in focus. Some cameras also have a microprism, a small ring at the center of the viewfinder in which an object appears coarsely dotted until it is focused. With split-image focusing, part of an object appears offset when it is out of focus.

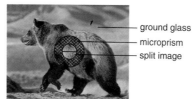

— ground glass
— microprism
— split image

Automatic focusing. Usually this is done by centering the focusing brackets (visible in the middle of the viewfinder) on your subject as you depress the shutter release part way. The camera rotates the lens for you to bring the bracketed object into focus. Don't push the shutter release all the way down until you are ready to make an exposure.

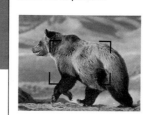

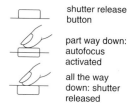

shutter release button

part way down: autofocus activated

all the way down: shutter released

More about focus on pages 50–57. See page 56 for when and how to override automatic focus.

setting the exposure

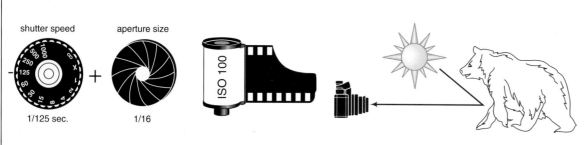

shutter speed

aperture size

1/125 sec.

1/16

To get a correctly exposed picture, one that is not too light (overexposed) or too dark (underexposed), you—or the camera—set the shutter speed and the aperture depending on the sensitivity of the film (its speed) and on how light or dark your subject is. The aperture size determines how bright the light is that passes through the lens; the shutter speed determines the length of time that the light strikes the film.

More about shutter speed and aperture on pages 12–21, and about exposure and metering on pages 92–105.

exposure readout

Exposure readout about the shutter speed and aperture appears in the viewfinder of many cameras that have a built-in exposure meter. Some cameras show the actual settings: here, $^{1}/_{250}$ sec shutter speed, f/16 aperture.

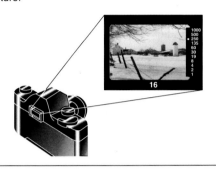

A data panel appears on the top of some cameras, displaying shutter speed and aperture settings (here, $^{1}/_{250}$ sec shutter speed, f/16 aperture), as well as other information.

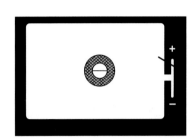

This needle-centering display doesn't show the actual shutter speed and aperture settings, but it does show when the exposure is correct. You change the shutter speed and/or aperture until the needle centers between + (overexposure) and – (underexposure).

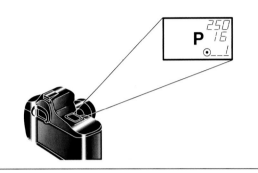

manually setting the exposure

ISO 100 FILM				
OUTDOOR EXPOSURE GUIDE FOR AVERAGE SUBJECTS				
Shutter Speed 1/250 Second	Shutter Speed 1/125			
Bright or Hazy Sun on Light Sand or Snow	Bright or Hazy Sun (Distinct Shadows)	Weak, Hazy Sun (Soft Shadows)	Cloudy Bright (No Shadows)	Open Shade † or Heavy Overcast
f/16	*f*/11*	*f*/8	*f*/5.6	*f*/4

*f/5.6 for backlighted close-up subjects.
†Subject shaded from sun but lighted by a large area of sky.

With manual exposure, you set both the shutter speed and aperture yourself. How do you know which settings to use? At the simplest level you can use a chart like the one at left. Decide what kind of light is on the scene, and set the shutter speed and aperture accordingly.

The chart is based on what is sometimes called the Sunny 16 rule: on a sunny day, set the camera to the shutter speed that is closest to the film speed number, and set the aperture to f/16. If the film speed is 100, set the shutter speed to $^{1}/_{125}$ sec and the aperture to f/16. The chart shows an equivalent exposure—a faster shutter speed at a wider aperture, $^{1}/_{250}$ sec at f/11.

You can use a camera's built-in meter for manual exposure. Point the camera at the most important part of the scene and activate the meter. The viewfinder will show whether the exposure is correct. If it isn't, change the shutter speed and/or aperture until it is.

To prevent blur caused by the camera moving during the exposure (if the camera is not on a tripod), use a shutter speed of at least $^{1}/_{60}$ sec. A shutter speed of $^{1}/_{125}$ sec is safer.

exposure OK	overexposure	underexposure

automatically setting the exposure

With automatic exposure, the camera sets the shutter speed or aperture or both for you.

With programmed automatic exposure, each time you press the shutter release button, the camera automatically meters the light, then sets both shutter speed and aperture.

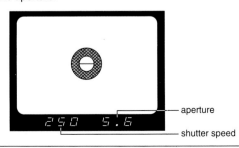

aperture

shutter speed

With aperture-priority automatic exposure, you set the aperture (the f-stop) and the camera sets the shutter speed. Check the shutter speed: to keep the picture sharp if you are hand holding the camera (it is not on a tripod), the shutter speed should be $^{1}/_{60}$ sec or faster. If it is not, set the aperture to a larger opening (a smaller f-number).

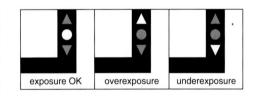

With shutter-priority automatic exposure, you set the shutter speed and the camera sets the aperture. To keep the picture sharp if you are hand holding the camera (it is not on a tripod), select a shutter speed of $^{1}/_{60}$ sec or faster.

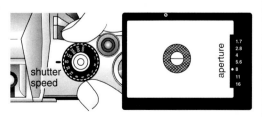

More about when and how to override automatic exposure on page 95.

EXPOSING THE FILM

hold the camera steady

For horizontal photographs, keep your arms against your body to steady the camera. Use your right hand to hold the camera, your right forefinger to press the shutter release. Your left hand can be used to focus or make other camera adjustments.

For vertical photographs, support the camera in either your right or left hand. Keep that elbow against your body to steady the camera.

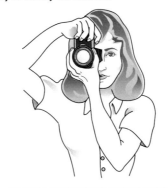

A tripod steadies the camera for you and lets you use slow shutter speeds, such as for night scenes or other situations when the light is dim.

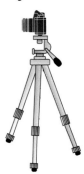

More about keeping the camera steady on pages 30–31.

expose the film

Make an exposure. Recheck the focus and composition just before exposure. When you are ready to take a picture, stabilize your camera and yourself and **gently** press the shutter release all the way down.

Make some more exposures. You might want to try several different exposures of the same scene, perhaps from different angles. See opposite page for some ideas.

You'll learn faster about exposure settings and other technical matters if you keep a record of your exposures. For example, write down the frame number, subject, f-stop and shutter speed settings, direction or quality of light, and any other relevant information. This way you won't forget what you did by the time you develop and print the film.

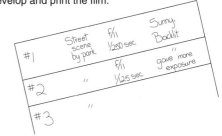

at the end of the roll, rewind the film

After your last exposure on the roll, rewind the film back into the cassette before opening the camera. Store film away from light and heat until it is developed.

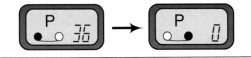

Manual rewind. You'll know that the roll of film is completely exposed when the film advance lever will not turn. The film frame counter will also show the number of exposures you have taken. Activate the rewind button or catch at the bottom of the camera. Lift the handle of the rewind crank and turn it clockwise until tension on the crank releases.

Automatic rewind. Your camera may automatically rewind the film after you make your last exposure. Or it may signal the end of a roll, then rewind when you press a film rewind button.

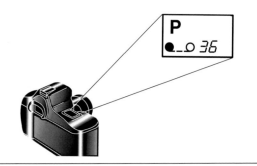

WHAT WILL YOU PHOTOGRAPH?

Where do you start? One place to start is by looking around through the viewfinder. A subject often looks different isolated in a viewfinder than it does when you see it surrounded by other objects. What interests you about this scene? What is it that you want to make into a photograph?

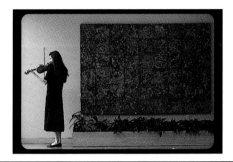

Get closer (usually). Often people photograph from too far away. What part of the scene attracted you? Do you want to see your friend from head to toe, or are you interested in the expression on his face? Do you want the whole wall of a building, or was it the graffiti on it that caught your attention?

More about selecting a subject on pages 336–337.

Look at the edges. How does the frame of the photograph (the top, bottom, and sides of the image area) intersect the subject? Does the top edge cut into the subject's head? Is the subject down at the bottom of the frame, with a lot of empty space above it? See what you've got and see if you might want something a little different.

Look at the background (and the foreground). How does your subject relate to its surroundings? Is there a telephone pole growing out of someone's head? Are you interested just in that old prairie church, or would it say about it more to have it in the background and include those three bales of hay in the foreground? Take a look.

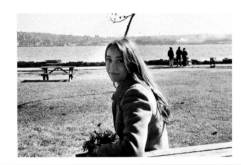

More about the image frame and backgrounds on pages 338–341 and 352–353.

Check the lighting. If this is your first roll, you are most likely to get a good exposure if you photograph a more or less evenly lit scene, not one where the subject is against a very light background, like a bright sky.

More about lighting on pages 243–273.

But why not experiment, too? Include a bright sky or bright light in the picture (just don't stare directly at the sun through the viewfinder). Try a different angle. Instead of always shooting from normal eye-level height, try kneeling and looking up at your subject or getting up high and looking down at them. See what happens.

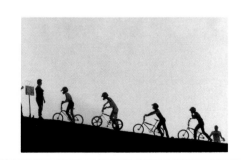

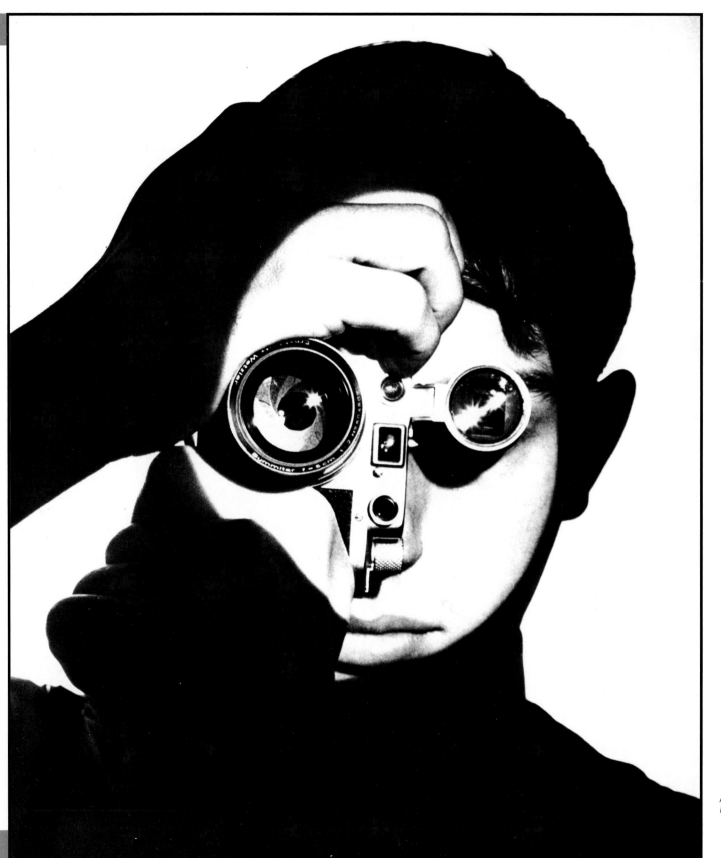

ANDREAS FEININGER:
Photojournalist, 1955

Why do you need to know how a camera works? Much of modern camera design is based on one of the earliest camera slogans—"You press the button, we do the rest." Automatic-exposure cameras set the shutter speed or aperture for you. Automatic-focus cameras adjust the lens focus. Automatic features such as these are increasingly built into the most popular of cameras—those that use 35mm film. However, no matter what technological improvements are claimed to make a camera "foolproof" or "easy to use," there are still choices to make at the moment a picture is taken. If you don't make the choices, the camera does, based on what the manufacturer calculates will produce the best results for an average scene. But the results may not be what you want. Do you want to freeze the motion of a speeding car or let it race by in a blur? Bring the whole forest into sharp focus or isolate a single flower? Only you can make these decisions, and the more pictures you take, the more you will want to decide deliberately rather than leave it all to the camera.

One of the great technical experts of photography, Andreas Feininger has written many books on the subject. Opposite, he completely merges photographer and camera. Notice how the dark shadows isolate and emphasize the important part of the picture. "Making a good photograph requires genuine interest in the subject," he said. "Without it, making a photograph sinks to the level of boring routine."

Automatic features can be useful, but if you are learning photography, many instructors recommend using manual operation at first because it will speed your understanding of f-stops, shutter speeds, and other basic camera controls. If you do have a camera with automatic features, this book tells not just what those features do, but even more important, when and how to override an automatic mechanism and make the basic choices for yourself. The time you spend learning what camera equipment can do and how to control its effects will be more than repaid whether you make a snapshot, a portrait, a commercial illustration, a news photograph, a personal statement about the world, or any other kind of photograph.

BASIC CAMERA CONTROLS

Even though cameras can differ considerably in design, their basic controls are designed to help you perform very much the same actions every time you take a picture. You'll need to see the scene you are photographing, decide how much of it you want to include, focus it sharply—where you want it to be sharp—and use the shutter speed and aperture (the size of the lens opening) to expose the film to the correct amount of light.

As the camera's settings change, the picture changes also. What will this scene look like at a faster shutter speed or a slower one? How do you make sure the background will be sharp . . . or out of focus, if you want it that way? Once you understand how the basic camera controls operate and what your choices are, you'll be better able to get the results you want, rather than simply pressing the button and hoping for the best.

One of the most popular types of cameras is shown here, the 35mm single-lens reflex: a model with manually adjusted controls (above) and a model with automatic features (below). Other basic camera designs are described later in this chapter.

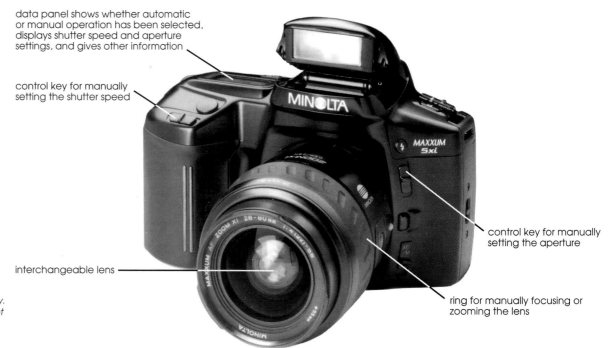

shutter-speed selector

Manually adjusted controls on this 35mm single-lens reflex camera let you set the shutter speed (the length of time the shutter remains open), select the lens aperture (the size of the lens opening), focus on a particular part of the scene, and change from one lens to another.

aperture ring
focusing ring

interchangeable lens

data panel shows whether automatic or manual operation has been selected, displays shutter speed and aperture settings, and gives other information

control key for manually setting the shutter speed

control key for manually setting the aperture

On automatic cameras, control keys often replace adjustable knobs or rings This model automatically adjusts the focus, shutter speed, aperture, and lens focal length and fires a built-in flash when necessary. You can override the automatic features if you want to adjust the camera's settings yourself.

interchangeable lens

ring for manually focusing or zooming the lens

viewfinder image

The focusing control adjusts the lens so that a given part of the scene is as sharp as possible. In the camera's viewfinder you see the scene that will be recorded on the film and that part of the scene that is focused most sharply. More about focus is on pages 50–51 and 56–57. Many viewfinders also display exposure information, here the shutter speed and aperture. See pages 12–13 and 16–17 for details on how the shutter speed and aperture affect exposure.

slower shutter speed

faster shutter speed

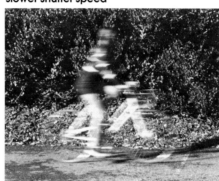
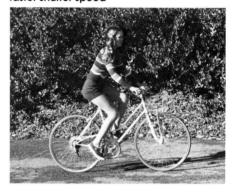

The shutter-speed selector controls the length of time that the shutter remains open. The shorter that time is, the less likely a moving object will appear blurred. See pages 14–15 for more about shutter speed, motion, and blur.

larger aperture opening

smaller aperture opening

The aperture selector adjusts the size of the lens opening, the diaphragm. The smaller the aperture opening, the greater the depth of field (the more of the scene from near to far that will be sharp). More about aperture and depth of field is on pages 18–19 and 50–53.

short-focal-length lens

long-focal-length lens

Interchangeable lenses let you select the lens focal length, which controls the size of objects in the picture and the extent of the scene recorded on the film. See pages 40–41 for information about lens focal length.

THE SHUTTER AS A CONTROLLER OF LIGHT

To expose film correctly, so that your picture is neither too light nor too dark, you need to control the amount of light that reaches the film. Two controls do this: the shutter, described here, and the aperture *(pages 16–17)*.

The **shutter** controls the amount of light by the length of time it remains open. Each shutter setting is half (or double) the time of the next one and is marked as the denominator (bottom part) of the fraction of a second that the shutter remains open: 1 ($^1/_1$ or one second), 2 ($^1/_2$ second), 4 ($^1/_4$ second), and so on through 8, 15, 30, 60, 125, 250, 500, and on some cameras up to 12,000. You may find a different sequence on older equipment: 1, 2, 5, 10, 25, 50, 100, 200. B or bulb setting keeps the shutter open as long as the release button is held down. T or time setting opens the shutter with one press of the release, closes it with another. Electronically controlled shutters can also operate at any speed, for example, $^1/_{38}$ second. These stepless speeds are set by the camera in automatic exposure operation; you usually can't dial them in yourself.

A leaf or between-the-lens shutter is generally located in the lens itself (a). It consists of a number of small overlapping metal blades. When the shutter release is pushed, the blades open up and then shut again in a given amount of time. In the examples at right, the blades are just beginning to swing open at (1) and very little light is hitting the film. At (2), with the shutter open farther, the blades are almost completely withdrawn, and at (3) light pours in. Then the blades begin to close again, admitting less and less light (4, 5). The total amount of light admitted during this cycle produces the fully exposed photograph (6).

Leaf Shutter

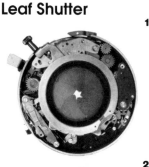

1

2

3

4

5

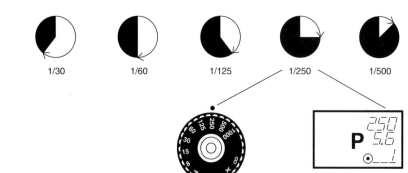

1/15 1/30 1/60 1/125 1/250 1/500

Shutter speeds are shown on a camera's shutter-speed dial or in the readout that appears on a data panel or in the viewfinder. Here the shutter is set to $^1/_{250}$ sec.

Focal-Plane Shutter

There are two principal types of shutters: the leaf shutter *(opposite)* and the focal-plane shutter *(this page)*. A **focal-plane shutter** is built into the camera body itself—just in front of the film, or focal, plane—while a leaf shutter is usually located between the lens elements. Interchangeable lenses for a camera with a focal-plane shutter can be less expensive, since a shutter mechanism does not have to be built into each lens. One drawback to the focal-plane shutter on some cameras is that it cannot be used with electronic flash at very fast shutter speeds. The maximum speed with flash with a 35mm camera may be as slow as $1/60$ second, up to $1/300$ second with some models. At faster shutter speeds the slit in the focal-plane shutter does not completely uncover the film at any one time; before the first part of the shutter is fully open, the second part starts to close *(right)*. Also, since the slit exposes one end of the film frame before the other, objects moving rapidly parallel to the shutter may be distorted; this is rare, but it can happen.

A **leaf shutter** is quieter than a focal-plane shutter and can be used with flash at any shutter speed. But since the leaf shutter has to open, stop, and then reverse direction to close again, most have top speeds of $1/500$ second. The focal-plane shutter has a simpler mechanism that moves in one direction and permits speeds of up to $1/12,000$ second.

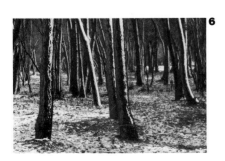

6

1

2

3

4

5

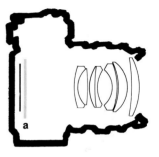

a

The focal-plane shutter *(a)* is located directly in front of the film. The shutter consists of two overlapping curtains that form an adjustable slit or window. When the shutter is released, the window moves across the film, exposing the film as it moves. The series at left shows how the film is exposed at fast shutter speeds. The slit is narrow and exposes only part of the film at any one time. Picture *(6)*, below, shows the effect of the entire exposure, with all sections of the film having received the proper amount of light. At slow shutter speeds, one edge of the slit travels across the film until the film is completely uncovered; then the other edge of the slit travels in the same direction, re-covering the film. The shutter shown here moves from side to side across the length of the film. The Copal Square type of focal-plane shutter moves from top to bottom across the film.

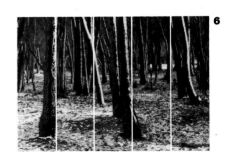

6

The Shutter: continued

THE SHUTTER AS A CONTROLLER OF MOTION

 1/30 second

 1/500 second

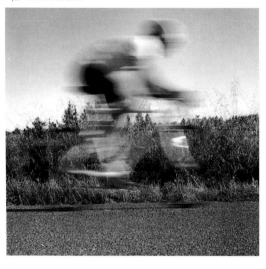

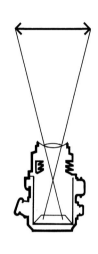

The diagrams and photographs this page and opposite show how the direction of a moving object affects the amount of blur that will result. When an object is traveling parallel to the plane of the film (this page considerable movement is likely to be recorded on the film and the object blurred, unless the shutter speed is fast.

If the object is moving directly toward or away from the camera (opposite, top left there is no sideways movement recorded on the film and so a minimum of blur, even at a relatively slow shutter speed.

When the camera is panned or moved in the same direction as the object (opposite right), the object will be sharp and the background blurred.

A blurred image can occur when an object moves in front of a camera that is not moving, because the image projected onto the film by the lens will move. If the object moves swiftly or if the shutter is open for a relatively long time, this moving image will **blur** and be indistinct. But if the shutter speed is increased, the blur can be reduced or eliminated. You can control this effect and even use it to advantage. A fast shutter speed can freeze a moving object, showing its position at any given instant, whether it be a bird in flight or a football player jumping for a pass. A slow shutter speed can be used deliberately to increase the blurring and accentuate the feeling of motion.

Photographer Penny Wolin illustrated above the effects of varying shutter speed and camera movement. In the picture at far left the bicycle moved enough during the relatively long $1/30$-second exposure to leave a broad blur on the film. In the next photograph at a shutter speed of $1/500$ second the bicycle is much sharper. A mov-

ing subject may vary in speed and thus affect the shutter speed needed to stop motion. For example, at the peak of a movement that reverses (such as the peak of a jump just before descent), motion slows, and even a relatively slow shutter speed will record the action sharply.

The amount of blurring in a photograph, however, is not determined simply by how fast the object itself moves. What matters is how far an image actually travels across the film during the exposure. In the third photograph, with the rider moving directly toward the camera, the bicycle remains in virtually the same position on the film. Thus, there is far less blurring even at $1/30$ second. A slow-moving object close to the camera, such as a bicycle 10 feet away, will cross more of the film and appear to blur more than a fast-moving object far away, such as a jet in flight. A telephoto lens magnifies objects and makes them appear closer to the camera; it will blur a moving subject more than

a normal lens used at the same distance.

The photograph opposite right shows the effect of **panning.** The camera was moved in the same direction the bicycle was moving. Since the camera moved at about the same speed as the bicycle, the rider appears sharp while the motionless background appears blurred. Successful panning takes both practice and luck. Variables such as the exact speed and direction of the moving object make it difficult to predict exactly how fast to pan. Decide where you want the object to be at the moment of exposure, start moving the camera a few moments before the object reaches that point, and follow your motion through as you would with a golf or tennis stroke. The longer the focal length of the lens, the less you will need to pan the camera; with a telephoto lens, a very small amount of lens movement creates a great deal of movement of the picture image. *(Focal length is explained on page 40.)*

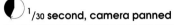

¹/₃₀ second

¹/₃₀ second, camera panned

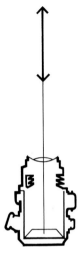

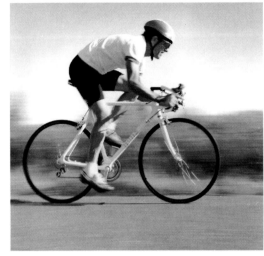

Photographer Daniel Hall, age 9 at the time he took this picture, said of his subject, "It took him a long time, 'cause he kept messing up." Hall was part of photojournalist Jim Hubbard's Shooting Back project, a program that Hubbard started in order to teach photography to homeless children. Hubbard and volunteer professional photographers regularly visit homeless shelters to work with the young residents and give them a chance to look through the viewfinder at their world and "shoot back."

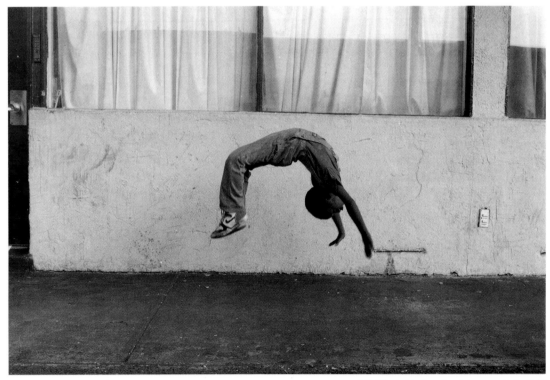

DANIEL HALL: *Flip, Washington, D.C.*, 1989

THE APERTURE AS A CONTROLLER OF LIGHT

Changing the size of the **aperture,** the lens opening through which light enters the camera, can change the exposure, the amount of light that reaches the film. The shutter speed controls the length of time that light strikes the film; the aperture controls the brightness of the light.

The aperture works like the pupil of an eye; it can be enlarged or contracted to admit more light or less. In a camera this is done with a **diaphragm,** a ring of thin, overlapping metal leaves located inside the lens. The leaves are movable: they can be swung out of the way so that most of the light reaching the surface of the lens passes through. They can be closed so that the aperture becomes very small and allows little light to pass *(see opposite).*

The size of an aperture is indicated by its **f-number** or **f-stop.** On early cameras the aperture was adjusted by individual metal stop plates that had holes of different diameters. The term "stop" is still used to refer to the aperture size,

and a lens is said to be "stopped down" when the size of the aperture is decreased.

The standardized series of numbers commonly used on the f-stop scale runs as follows: f/1.4, f/2, f/2.8, f/4, f/5.6, f/8, f/11, f/16, f/22, f/32, f/45, f/64. The largest of these, f/1.4, admits the most light. Each f-stop after that admits half the light of the previous one. A lens that is set at f/4 admits half as much light as one set at f/2.8 and only a quarter as much as one set at f/2. (Notice that f-stops have the same half or double relationship that shutter-speed settings do.) The change in light over the full range of f-stops is large; a lens whose aperture is stopped down to f/64 admits less than $\frac{1}{2000}$ of the light that comes through a lens set at f/1.4.

No lens is built to use the whole range of apertures. A general-purpose lens for a 35mm camera, for example, might run from f/1.4 to f/22. A camera lens designed for a large view camera might stop down to f/64 but open up only to

f/5.6. The widest possible aperture at which a particular lens design will function well may not be a full stop from a standard setting. So a lens's f-stops may begin with a setting such as f/1.8, f/4.5, or f/7.7, then proceed in the standard sequence.

Lenses are often described as **fast** or **slow.** These terms refer to how wide the maximum aperture is. A lens that opens to f/1.4 opens wider and is said to be faster than one that opens only to f/2.

The term **stop** is used to refer to a change in exposure, whether the aperture or the shutter speed is changed. To give one stop more exposure means to double the amount of light reaching the film (either by opening up to the next larger aperture setting or by doubling the exposure time). To give one stop less exposure means to cut the light reaching the film in half (stopping down to the next smaller aperture setting or halving the exposure time). More about f-stops is explained on pages 18–21.

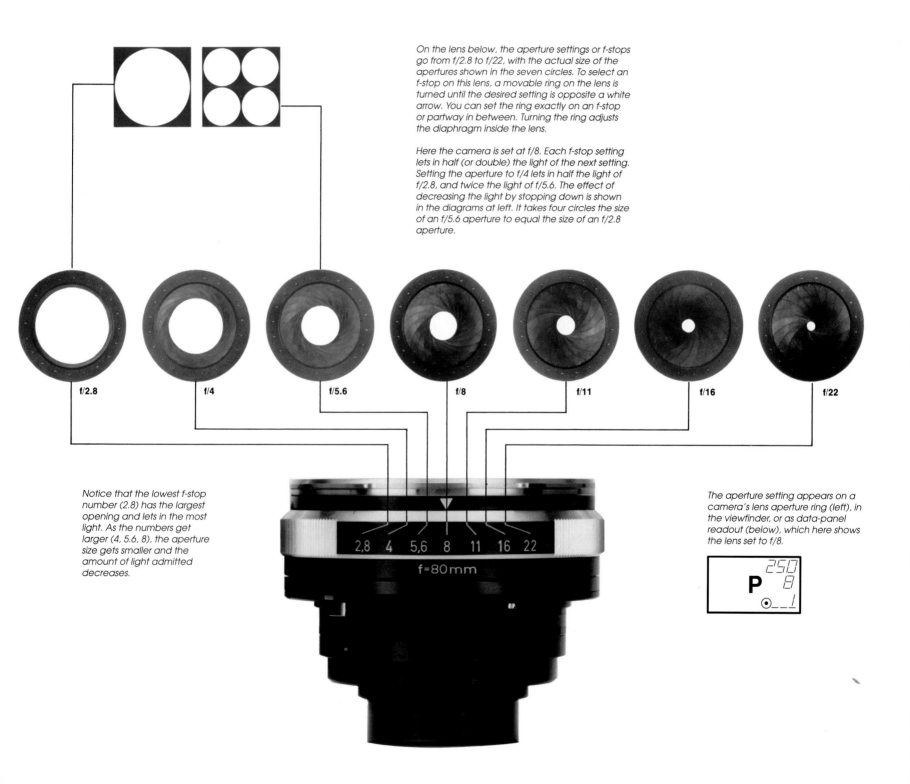

On the lens below, the aperture settings or f-stops go from f/2.8 to f/22, with the actual size of the apertures shown in the seven circles. To select an f-stop on this lens, a movable ring on the lens is turned until the desired setting is opposite a white arrow. You can set the ring exactly on an f-stop or partway in between. Turning the ring adjusts the diaphragm inside the lens.

Here the camera is set at f/8. Each f-stop setting lets in half (or double) the light of the next setting. Setting the aperture to f/4 lets in half the light of f/2.8, and twice the light of f/5.6. The effect of decreasing the light by stopping down is shown in the diagrams at left. It takes four circles the size of an f/5.6 aperture to equal the size of an f/2.8 aperture.

f/2.8 f/4 f/5.6 f/8 f/11 f/16 f/22

Notice that the lowest f-stop number (2.8) has the largest opening and lets in the most light. As the numbers get larger (4, 5.6, 8), the aperture size gets smaller and the amount of light admitted decreases.

2,8 4 5,6 8 11 16 22

f=80mm

The aperture setting appears on a camera's lens aperture ring (left), in the viewfinder, or as data-panel readout (below), which here shows the lens set to f/8.

The Aperture: continued

THE APERTURE AS A CONTROLLER OF DEPTH OF FIELD

shallow depth of field
aperture setting: f/2

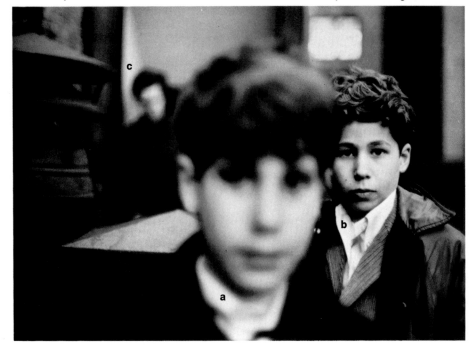

A change in aperture size affects the sharpness of the image as well as the amount of light entering the camera. As the aperture is stopped down and gets smaller, more of the background and foreground in a given scene becomes sharp. The area of acceptable sharpness in a picture is known as the **depth of field.** *(See also pages 50–55.)*

The two large photographs shown on these pages were taken under identical conditions but with different aperture settings. In the photograph above, the diaphragm was opened to its widest aperture, f/2, and the lens was focused on the boy (b) about seven feet away *(see side view of photographer Duane Michals and his subjects, above right)*. The resulting photograph shows a shallow depth of field; only the middle boy (b) is sharp, while both the boy in front (a) and the

man behind (c) appear out of focus. Using a small aperture, f/16, gives a different picture *(opposite page)*. The lens is still focused on the middle boy but the depth of field is now great enough to yield sharp images of the other figures as well.

With a view camera or a single-lens reflex, checking depth of field is relatively simple. A view camera views directly through the lens. As the lens is stopped down, the increasing sharpness is visible on the ground-glass viewing screen. A single-lens reflex camera also views through the lens. Most models automatically show the scene through the widest aperture, and so with the least depth of field. But some also provide a **depth-of-field preview button** that stops down the lens so you can see the depth of field at the

Depth of field is the area from near to far in a scene that is acceptably sharp in a photograph. As the aperture changes, the depth of field does too. If your lens has a depth-of-field scale, you can use it to estimate the extent of the depth of field. On this lens, the bottom ring shows the aperture (f-stop) to which the lens is set. The top ring shows the distance on which the lens is focused. The paired numbers on the middle ring show the nearest and farthest distances the depth of field covers when the lens is set at various f-stops.

Here, the lens is focused on the middle boy (see side view of scene above), who is at a distance of 7 feet. The lens is set to its widest aperture, f/2. The depth of field extends from more than 6 ft to less than 8 ft; only objects within that distance will be acceptably sharp. If depth of field is shallow, as it is here, a lens can be sharply focused on one point and still not produce a picture that is sharp enough overall.

aperture setting: f/16 **increased depth of field**

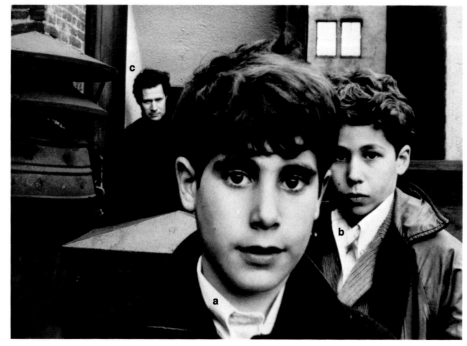

depth of field: 8 feet

When the lens is stopped down to its smallest aperture, f/16, the depth of field increases. Almost the entire scene—everything between about 5 ft and 13 ft—is now sharp at the same focusing distance of 7 ft.

A reminder: The bigger the f-stop number, the smaller the lens opening (you can see this illustrated on page 17). Thus f/16 is a smaller aperture than f/2.

aperture to which you have set the camera. However, in very dim light or at a very small aperture, the image may be too dark to be seen clearly once the lens is stopped down.

Examining depth of field is somewhat more difficult with a twin-lens reflex camera or a camera with a simple viewfinder window. A twin-lens reflex shows the scene only at the widest aperture of the viewing lens. There is no way to stop it down to check depth of field at other apertures. Through a simple viewfinder, objects at all distances appear equally sharp.

A **depth-of-field scale** is a way to predict depth of field in place of or in addition to visually checking through the lens. This scale often appears printed on the lens as paired numbers that bracket the distances of the nearest

and farthest points of the depth of field. As the lens is focused and the f-stop set, the scale shows approximately what part of the picture will be in focus and what part will not. On the lenses at left, the bottom row of numbers shows the f-stops. The top row shows the distance from the lens to the object on which it is sharply focused. The middle row shows the nearest and farthest distances within which objects will be sharp at various apertures. (This lens shows the distances only in feet; many lenses also show them in meters.) The farthest distance on the lens appears as the symbol ∞. This **infinity** mark stands for all distances at that given point or farther from the lens. When the camera is focused on infinity or when infinity is within the depth of field, all objects at that distance or farther will be in sharp focus.

USING SHUTTER AND APERTURE TOGETHER

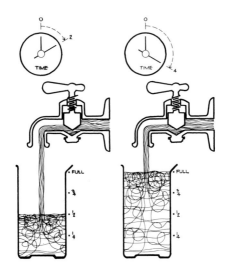

The quantity of light that reaches a piece of film inside a camera depends on a combination of aperture size (f-stop) and length of exposure (shutter speed). In the same way, the amount of water that flows from a faucet depends on how wide the valve is open and how long the water flows. If a 2-sec flow from a wide-open faucet fills a glass, then the same glass will be filled in 4 sec from a half-open faucet. If the correct exposure for a scene is $1/30$ second at f/8, you get the same total amount of exposure with twice the length of time (next slower shutter speed) and half the amount of light (next smaller aperture)—$1/15$ sec at f/11.

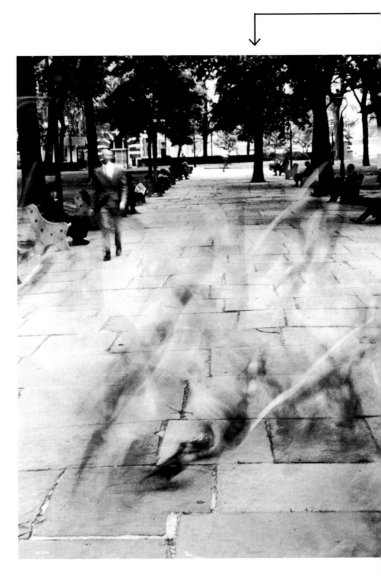

A small aperture (f/16) produces great depth of field; in this scene even distant trees are sharp. But to admit enough light, a slow shutter speed ($1/8$ sec) was needed; it was too slow to show moving pigeons sharply. It also meant that a tripod had to be used to hold the camera steady.

Both shutter speed and aperture affect the amount of light that enters the camera. To get a correctly exposed negative (one that is neither too light nor too dark), you have to find a **combination of shutter speed and aperture** that will let in the right amount of light for a particular scene and film. (Chapter 5, Exposure, tells in detail how to do this.) But shutter speed and aperture also affect sharpness, and in this respect they act quite differently: shutter speed affects the sharpness of moving objects; aperture affects the depth of field, the sharpness from near to far.

Once you know any single combination of shutter speed and aperture that will let in the right amount of light, you can change one setting as long as you change the other—in the opposite way. Since each aperture setting lets in twice as much light as the next smaller size, and each shutter speed lets in half as much light as the next slower speed, you can use a larger aperture if you use a faster shutter speed, or you can use a smaller aperture if you use a slower shutter speed. The same amount of light will

be let in by an f/22 aperture at a 1-second shutter speed, f/16 at $1/2$ second, f/11 at $1/4$ second, and so on.

The effects of such combinations are shown in the three photographs at right. In each, the lens was focused on the same point, and shutter and aperture settings were balanced to admit the same total amount of light into the camera. But the three equivalent exposures resulted in three very different photographs.

In the first picture, a small aperture produced considerable depth of field that rendered background details sharply; but the shutter speed needed to compensate for this tiny aperture had to be so slow that the rapidly moving flock of pigeons appears only as indistinct ghosts. In the center photograph, the aperture was wider and the shutter speed faster; the background is less sharp but the pigeons are visible, though still blurred. At far right, a still larger aperture and faster shutter speed sacrificed almost all background detail, but the birds are now very clear, with only a few wing tips still blurred.

Each combination here of f-stop and shutter speed produces the equivalent exposure (lets in the same amount of light) but produces differences in depth of field and motion.

f/16	f/11	f/8	f/5.6	f/4	f/2.8	f/2

Smaller aperture:
Less light reaches film
More depth of field

Larger aperture:
More light reaches film
Less depth of field

Slower shutter speed:
More light reaches film
More chance of motion blur

Faster shutter speed:
Less light reaches film
Less chance of motion blur

1/8	1/15	1/30	1/60	1/125	1/250	1/500

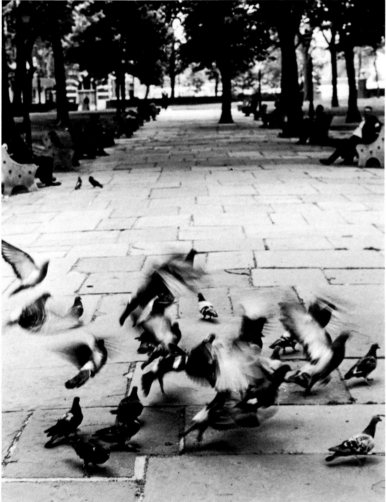

A medium aperture (f/4) and shutter speed (¹/₁₂₅ sec) sacrifice some background detail to produce recognizable images of the birds. But the exposure is still too long to freeze the motion of the birds' wings.

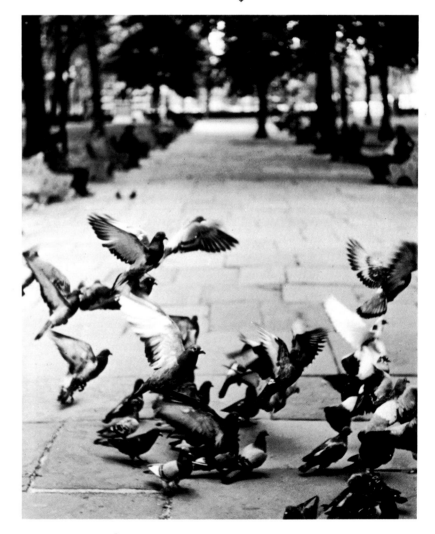

A fast shutter speed (¹/₅₀₀ sec) stops the motion of the pigeons so completely that the flapping wings are frozen. But the wide aperture (f/2) needed gives so little depth of field that the background is now out of focus.

THE MAJOR TYPES OF CAMERAS
View Camera

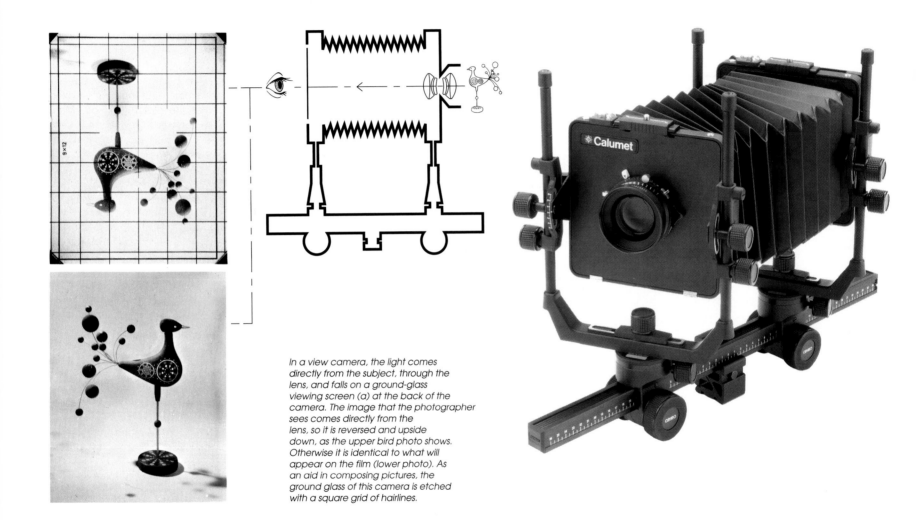

In a view camera, the light comes directly from the subject, through the lens, and falls on a ground-glass viewing screen (a) at the back of the camera. The image that the photographer sees comes directly from the lens, so it is reversed and upside down, as the upper bird photo shows. Otherwise it is identical to what will appear on the film (lower photo). As an aid in composing pictures, the ground glass of this camera is etched with a square grid of hairlines.

One of the oldest basic designs for a camera—direct, through-the-lens viewing and a large image on a translucent viewing screen—is still in use today. A **view camera** is built somewhat like an accordion, with a lens at the front, a **ground-glass** viewing screen at the back, and a flexible **bellows** in between. You focus by moving the lens, the back, or the entire camera forward or back until you see a sharp image on the ground glass.

Advantages of the view camera: The image on the ground glass is projected by the picture-taking lens, so what you see is exactly what will be on the negative; there can be no parallax error (as in a rangefinder camera, *opposite*). The ground glass is large, and you can examine it with a magnifying glass to check sharpness in all parts of the picture. The film size is also large (4 × 5, 5 × 7, or 8 × 10 inches or larger), which produces sharp detail. The camera parts are adjustable, and you can change the position of lens and film relative to each other so that you can correct problems of focus or distortion. Each picture is exposed on a separate piece of film, so you can give negatives individual development.

Disadvantages: The most serious are the bulk and weight of the camera and the necessity of using a tripod. Second, the image projected on the ground glass is not very bright, and to see it clearly you must put a **focusing cloth** over both your head and the back of the camera. Finally, the image appears reversed and upside down on the viewing screen. You get used to this, but it is disconcerting at first.

Rangefinder/Viewfinder Cameras

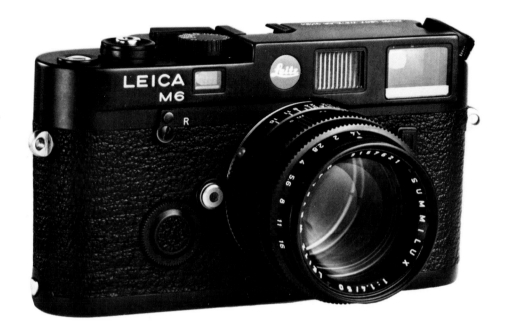

In a **viewfinder camera** the scene to be photographed is viewed through a small window (the **viewfinder**) equipped with a simple lens system that shows an almost—but not quite—exact view of what the picture will be. Many inexpensive **point-and-shoot cameras** have a viewfinder plus automatic focus.

A **rangefinder camera,** like the one shown here, has a viewfinder, plus a **coupled rangefinder** *(page 27)* that lets you focus the camera manually instead of only relying on automatic focus. Most rangefinder and viewfinder cameras use 35mm film; a few use other film sizes.

Advantages of the rangefinder or viewfinder camera: The camera is compact, lightweight, and fast handling. Compared to a single-lens reflex camera, it has few parts that move during an exposure, so it tends to be quieter and less subject to vibration during operation. A high-quality rangefinder camera has a bright viewfinder image, which makes it easy to focus quickly, particularly at low light levels where other viewing systems may be dim.

Disadvantages: Because the viewfinder is in a different position than the lens that exposes the negative, the camera suffers from an inherent defect called **parallax** *(left)* that prevents you from seeing exactly what the lens sees. The closer the subject to the camera, the more evident the parallax. A high-quality camera like the one shown here automatically corrects for parallax except when the subject is within a few feet of the camera. Because complete correction is difficult at close range, sighting through the viewfinder is awkward for carefully composed close-up work. Even when the edges of the picture are fully corrected for parallax, the alignment of objects within the picture will always be seen from slightly different angles by the viewfinder and the lens that exposes the film.

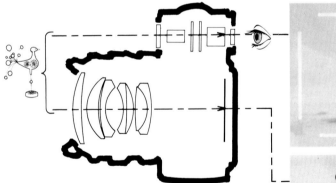

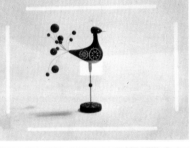

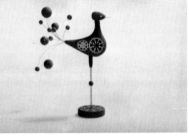

parallax

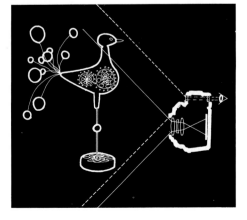

In a rangefinder or viewfinder camera the image goes from the lens to the film but through a separate viewfinder to the eye (diagram, above left). The difference between these two viewpoints creates parallax. When the viewfinder shows the whole bird (broken lines in diagram, bottom left), the lens may not (solid lines); here, the bird's head will be out of the picture. Better models correct for parallax (photos above), except for subjects that are very near.

FOCUSING SYSTEMS

Ground–Glass Viewing Screen

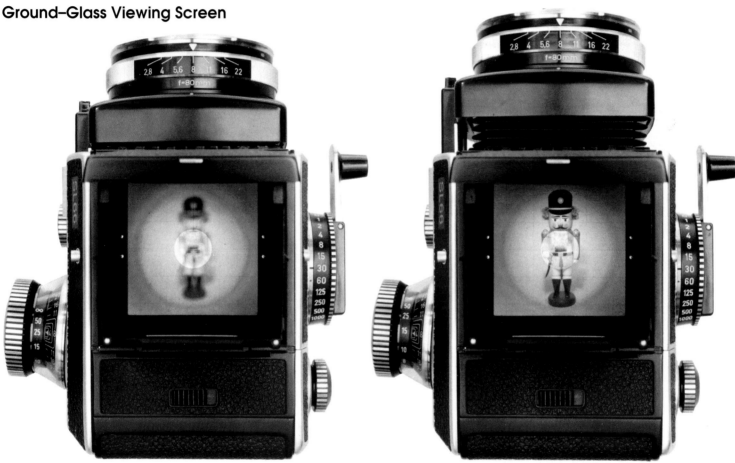

In this reflex camera a mirror reflects the image from the lens upward onto a ground-glass screen. Since the ground glass at the top and the film at the back of the camera are the same distance from the lens, the image that falls on the screen will be sharp only when the lens is also focusing the image sharply on the film plane.

At left, the focusing knob on the left side of the camera is incorrectly set at 25 ft, producing an unclear image of a toy soldier 15 ft away. But when the knob is set for 15 ft (right), the image is more sharply defined.

All cameras with adjustable focus have some means of showing you when you have focused a subject sharply. A **ground-glass viewing screen** is found on single-lens reflex, twin-lens reflex, and view cameras. Light from the camera lens hits a pane of glass that is etched, or ground, to be translucent. This ground glass creates a surface on which a viewer, looking at it from the other side, can see an image *(above)* and focus it. The image on a ground glass is not as bright as that in a viewfinder; in dim light you may not be able to see readily whether the image is sharp.

A **coupled rangefinder** *(opposite)* may be easier to use in dim light because you only have to line up a double image, or two parts of a split image. The focusing mechanism of the lens is coupled with the rangefinder so that they focus at the same time.

Don't confuse the function of a rangefinder with that of a viewfinder. The viewfinder shows the view the camera will take. The rangefinder (usually built into the viewfinder) finds the range or distance of an object and shows when it is sharply focused.

A **microprism** focusing aid may ac-company a ground-glass or split image, especially on a single-lens reflex camera. A central spot or collar around the split image shimmers or appears broken when the subject is unfocused.

With **automatic focus,** you don't turn a focusing knob or ring to adjust the lens yourself. Instead, the camera focuses the lens sharply, usually on whatever object is at the center of the viewfinder image. A focus confirmation symbol may appear in the viewfinder when focus is set. Some cameras also beep to let you know when focus is found.

Coupled Rangefinder

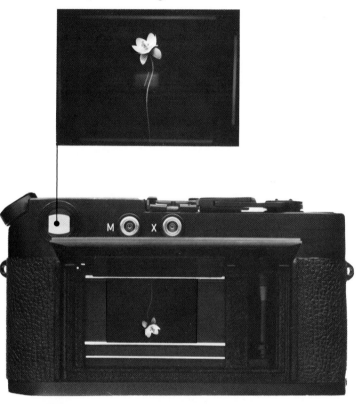

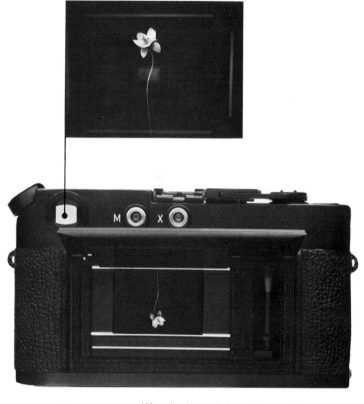

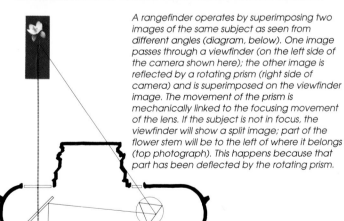

A rangefinder operates by superimposing two images of the same subject as seen from different angles (diagram, below). One image passes through a viewfinder (on the left side of the camera shown here); the other image is reflected by a rotating prism (right side of camera) and is superimposed on the viewfinder image. The movement of the prism is mechanically linked to the focusing movement of the lens. If the subject is not in focus, the viewfinder will show a split image; part of the flower stem will be to the left of where it belongs (top photograph). This happens because that part has been deflected by the rotating prism.

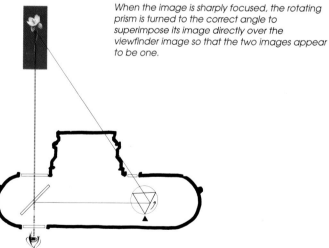

When the image is sharply focused, the rotating prism is turned to the correct angle to superimpose its image directly over the viewfinder image so that the two images appear to be one.

CHOOSING A CAMERA

Choosing a camera will be easier if you first decide what kind of pictures you want to take—then think about which basic camera design best fits your needs. If your picture taking consists of occasional snapshots of family, friends, or sightseeing views, then an inexpensive, nonadjustable, point-and-shoot camera will be satisfactory.

If you are a photography student, a serious amateur, or just someone who would like to learn more about photography, you will want an adjustable camera. A camera may have automatic features, but at a minimum it should also give you the option of selecting the focusing distance and either the shutter speed or aperture, preferably both.

Once you have decided on a basic design and are ready to buy, shop around to compare prices, accessories, and service. Make sure you like the way the camera fits in your hands. With the more automatic models, see if it is convenient to override the automatic features. If you wear glasses, make sure you can see the entire image. You may be able to find a good used camera at a considerable saving, but look over used equipment carefully: avoid cameras with dents, scratched lenses, rattles, or gouged screw heads that could indicate a home repair job. If a dealer is reputable, you will be able to exchange a camera, new or used, if your first roll of film is unsatisfactory. Examine that first roll carefully for scratches, soft focus, or other signs of trouble.

Point-and-shoot cameras, also called compact cameras, dominate the low-priced end of the market. Most use 35mm film and are "auto everything": they read the speed of the film you put in the camera, advance it to the first frame, focus, calculate exposure, trigger a built-in flash if you need it, advance the film after each exposure, and rewind at the end of the roll. Many are nonadjustable and can only be operated automatically. Some offer limited options for adjusting the focus or exposure. They are small, inexpensive, and easy to use, but they are easy to outgrow as soon as you begin to be more seriously interested in photography.

A **35mm rangefinder camera** with adjustable controls gives you more flexibility than a simple point-and-shoot model. You focus and set the exposure yourself, or with some models have the option to do so automatically. A high-quality 35mm rangefinder camera, such as the Leica, has long been a favorite of experienced photographers who want to work inconspicuously and quickly. They value the camera's dependability and its fast and precise focusing.

Because the viewing system is separate from the lens that exposes the film, you do not see exactly what the lens sees, especially at close focusing distances. This type of camera is not your best choice if you want to make extreme close-ups or align objects within the picture precisely.

A **35mm single-lens reflex (SLR) camera** is the most popular type when a buyer moves beyond snapshot level. SLRs offer the greatest variety of interchangeable lenses, plus features such as through-the-lens metering. Automatic exposure, focus, flash, and film winding are standard on many models. Since these cameras show you the scene directly through the lens, you see an exact view of what will appear on the film, an advantage with close-ups, microphotography, or other work where you want to see in advance exactly how the image will look.

The 35mm film format produces a rather small negative, $1 \times 1^1/_2$ inches (24 \times 36 mm). You can make high-quality enlargements from 35mm negatives, but

you need carefully exposed and processed negatives to do so. Many types of film, both black-and-white and color, are available in 35mm. This film format also has the advantage of being relatively inexpensive.

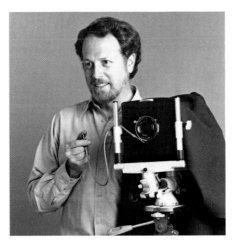

Medium-format single-lens reflex cameras are popular with photographers who want a negative larger than 35mm plus the versatility of a single-lens reflex—fashion or advertising photographers, for example. Not only are lenses interchangeable, but sometimes the camera's back is as well; you can expose part of a roll of black-and-white film, remove the back, and replace it with another loaded with color film. These cameras are bigger, heavier, and noisier than a 35mm single-lens reflex—and the price is higher, too. Most cameras make a $2^{1}/_{4}$ -inch-square (6×6 cm) negative; some models have a rectangular format, such as $2^{1}/_{4} \times 2^{3}/_{4}$ inches (6×7 cm) or $2^{1}/_{4} \times 1^{5}/_{8}$ inches (6×4.5 cm).

Medium-format rangefinder cameras combine a large ($2^{1}/_{4}$-inch) film with compact rangefinder design. They are lightweight, with interchangeable lenses, a quiet shutter, and a bright, easy-to-focus viewfinder. They are popular with professionals and others who want a camera that is easy to use in the field, but that delivers a high quality negative larger than 35mm.

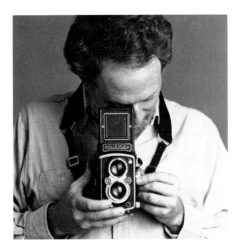

Twin-lens reflex (TLR) cameras also deliver a negative larger than 35mm, usually $2^{1}/_{4}$ inches square. Lenses are not interchangeable (except for the Mamiya), although supplementary lenses are available—for example, for close-ups. TLRs are quiet, reliable, and somewhat less expensive than other types of medium-format cameras. They are good for portraits or other fairly conventional photographic situations, but don't expect the speed of a rangefinder or the flexibility of a single-lens reflex. Once very popular, now only a few models are made.

View cameras give the utmost in control over the image. You can adjust the plane of sharpest focus within the image, as well as the apparent shape and perspective of objects within the scene (see pages 299–314). The large-size negatives (4×5 inches and larger) make prints of maximum sharpness and minimum grain. Heavy, bulky, and slow to operate, the view camera is still the camera of choice for architectural photography, studio work, or any use where the photographer's first aim is carefully controlled, technically superior pictures.

Special-purpose cameras fill a variety of needs. **Instant cameras** produce a print within a few seconds, if not instantly. Polaroid makes films for its own cameras, as well as for view cameras and for 35mm cameras. **Underwater cameras** are mostly for use underwater, but also in situations where a camera is likely to get extremely wet. Some cameras are water resistant, rather than usable underwater. **Panoramic cameras** rotate the lens from side to side. Their long, narrow format can add interest to, for example, a landscape. **Stereo cameras** take two pictures at the same time through two side-by-side lenses. The result, a stereograph (page 371), gives the illusion of three dimensions when seen in a stereo viewer. **Electronic still photography** is a recent technical innovation. See Chapter 12, Digital Imaging, beginning on page 275.

PHOTOGRAPHER AT WORK: DANCE PHOTOGRAPHY

"The root of my interest is movement," says Lois Greenfield, "or rather how movement can be interpreted photographically. And dance provides a perfect opportunity for this. You might say that dance is my landscape."

In Greenfield's landscape, dancers dispense with gravity as they walk on air, hang in space, and intersect the image frame and each other in improbable movement. No tricks are involved: no wires holding up the dancers, no unusual point of view making it look as if the dancers are in the air when they are not, no composite of dancers stripped in from different shots. "They're just straightforward snapshots," she says disarmingly. These are snapshots, however, that require an intense collaboration between dancer and photographer.

Greenfield approaches her work differently from conventional dance photographers, who often have the choreographer arrange a pose for them or who simply capture the peak moment of a movement. She says of her earlier work, "People would look at one of my pictures of Baryshnikov in a spectacular leap ten feet off the ground and say, 'What a great photograph!' But I knew that it wasn't; it was merely a great dance moment competently captured." Her dissatisfaction with merely recording dance choreography led her to explore other ways of working with dancers. She quotes a Duane Michals comment she heard at a lecture as part of her inspiration: "I want to create something that would not have existed without me."

She began collaborating with dancers David Parsons and Daniel Ezralow, encouraging them to see how their bodies moved, independent of the choreography

they had been trained to perform. That left the dancers free to soar, leap, lunge, and fall, and Greenfield free to explore her personal vision. Each of them had an active career: Greenfield photographed for newspapers, magazines, and commercial clients; Parsons and Ezralow were prominent dancers with Paul Taylor Dance Company. But when they got together, Greenfield says, something new happened. It felt, "as if we were toys which came to life when the toymaker went to sleep. At night the toys played!" (One of those photographs of Parsons appears on page 262.)

Recording motion sharply is vital to Greenfield's stop-action photography. She uses a Broncolor Pulso A2 electronic flash because she can adjust it to a very short flash duration. She had been working with a 35mm single-lens reflex camera, but eventually switched to a medium-format $2^1/_4$-inch-square single-lens reflex. The medium-format camera synchronized with flash at $^1/_{500}$ second, faster than her 35mm, which meant that she was less likely to have problems with blurred motion. When she switched cameras, she discovered a bonus: the square format gave equal emphasis to all sides of the image, compared to the bottom-heavy 35mm, which could seem to pull the image—and the dancers—down.

Greenfield's dancers are sharply photographed but not simply frozen in time. Questions about the past and future enter the pictures, too. "Because of the seeming impossibility of what my dancers are doing, you can't help asking yourself, 'Where are they coming from? Where are they going?' Or even, 'How is he going to land without breaking his neck?' "

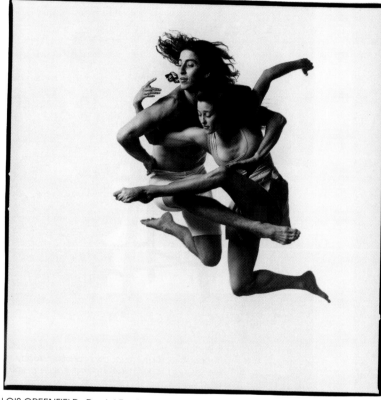

LOIS GREENFIELD: *Daniel Ezralow and Ashley Roland,* 1988

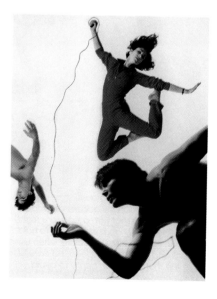

Lois Greenfield thinks of the dancers she photographs as her collaborators, not just as performers who are demonstrating choreographed moments from a particular dance. Above, Daniel Ezralow described himself as "a piece of clay which he would throw up in the air to make a different shape each time."

LOIS GREENFIELD: *Self Portrait with Daniel Ezralow and David Parsons,* 1983

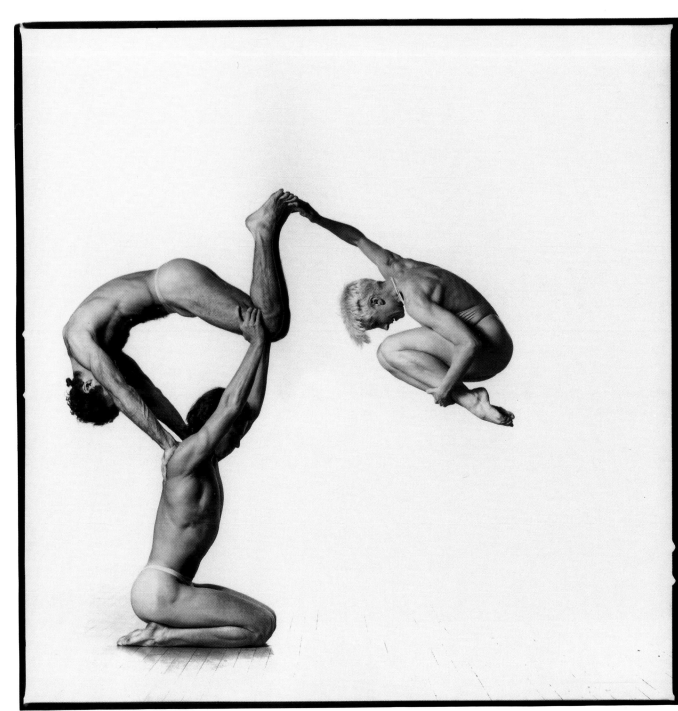

The Pilobolus Dance Theater asked Lois Greenfield to create new publicity images. Instead of pictures of specific dances, they wanted photographs that conveyed their acrobatic style of gesture and balance. Greenfield had Jude Woodcock jump so that she would seem to be hanging from the other dancers. "I was trying for effects that would disorient the viewer, trying to make things look impossible by providing contradictory information, or clues as to what is up or down, on or off balance."

LOIS GREENFIELD: *Adam Battelstein, Kent Lindemer, and Jude Woodcock,* 1991

ANDRÉ KERTÉSZ; *On Martinique*, 1972

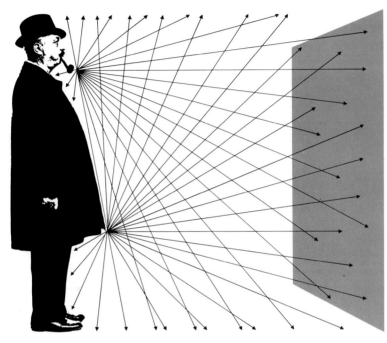

Uncontrolled light rays, shown reflected from two points—the subject's pipe and the bottom of his coat—travel in straight lines in almost all directions toward a sheet of film placed in front of the subject. Rays from the pipe strike the film all over its surface, and so do rays from the coat; they never form an image of pipe or coat at any place on the film. The result is not a picture but totally exposed film.

◄ On the island of Martinique, an anonymous figure looks out over an anonymous ocean. Glass, sky, ocean, and railing divide the scene in a geometry of angles and gray shapes that the eye takes pleasure in comparing and measuring. The print is relatively grainy, echoing the granularity of the glass. The scene is quite understandable—we have all seen figures or shapes behind translucent glass— but the picture invites other associations. Landscapes by the surrealist painter René Magritte come to mind, and one can imagine that just out of sight a giant rock is floating across the sky.

Light must be controlled if our eyes or our cameras are to form images of objects. You can't simply place a square of sensitized film in front of a man and hope that an image of him will appear on the film. The rays reflecting off the man would hit the film in a random jumble, resulting not in a picture but in a uniform exposure over the entire surface of the film. For simplicity's sake, the drawing at left shows only a few rays coming from only two points on the man, his pipe and his coat tip, but their random distribution over the entire film makes it clear that they are not going to produce a useful image. What is needed is some sort of light-control device in front of the film that will select and aim the rays, putting the pipe rays where they belong and the coat rays where *they* belong, resulting in a clear picture.

All photographic lenses do the same basic job: they collect light rays coming from a scene in front of the camera and project them as images onto a piece of film at the back. This chapter explains how this happens and how you can use lens focal length (which controls the magnification of a scene), lens focus (which controls the sharpest part of an image), lens aperture, and subject distance to make the kinds of pictures you want.

WHY LENSES ARE NEEDED
A Pinhole to Form an Image

Although all the light rays reflected from an object cannot produce an image on a flat surface, a selection of rays can. Suppose there is a barrier with a small hole in it, like that in the drawing below. All but a few rays from each point are deflected by the barrier. Those few rays that do get through, traveling in straight lines from object to film, can make an image.

For example, the few rays from the man's pipe that geÏt through the hole all fall on a certain spot near the bottom of the film. Only that one spot on the film registers an image of a pipe. Similarly, rays from the coat, the shoes, the ear, the hat brim—from every point on the man—travel to other specific points on the film. Together they form a complete image, but one that is inverted. Everything that was at the top of the man appears at the bottom of his image on the film and everything at the bottom appears at the top. Similarly, left becomes right and right becomes left.

The image-making ability of the pinhole was first put to use—long before the invention of photography—as part of the **camera obscura,** a darkened room whose only light source is a small hole in one wall. Light rays coming through the hole form on the opposite wall an image of the scene outside. The camera obscura is, in fact, a room-size primitive camera. Shrink the room down to shoebox size, reduce the hole to $\frac{1}{50}$ inch (0.5 mm) in diameter, place a piece of film at the end opposite the hole, and it will make a recognizable picture; the photograph opposite was made with such a camera.

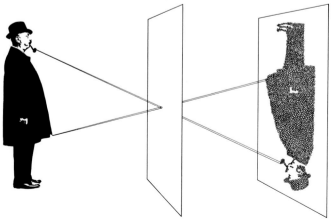

To take this picture of a fence and barn in California, photographer Ansel Adams replaced the lens of an ordinary camera with a thin metal disk pierced by a pinhole $\frac{1}{50}$ inch in diameter. The film was exposed for 6 sec. The way the pinhole produced an image is illustrated in the diagram at left. Only a few rays of light from each point on the subject can get through the tiny opening, and these strike the film in such tight clusters that blurring is reduced to a minimum. The result is a soft but acceptably clear photograph. See pages 200–201 for how to make your own pinhole camera and for an illustration by a contempory photographer who uses one.

For a second photograph of the same scene, Adams increased the size of the opening to $^1/_8$ inch, which meant reducing the exposure time to $^1/_5$ sec. The result is an extremely out-of-focus picture. As shown in the diagram at right, the larger hole permits a greater number of rays from each point on the subject to enter the camera. These rays spread before reaching the film and are recorded as large circles. Because of their size, these circles tend to run into one another, creating an unclear image.

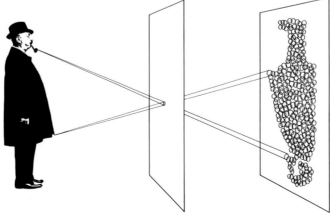

The trouble with this **pinhole camera** is its tiny opening, which admits so little light that very long exposures are needed to register an image on the film. If the hole is enlarged appreciably, the picture it makes becomes much less sharp, like the photograph on this page. Why this happens is explained in the two drawings.

The image in the drawing on the opposite page is actually composed of a great many tiny circles known as **circles of confusion.** This is because the hole, small though it is, actually admits a cluster of light rays. Coming at slightly different angles, these rays continue through the hole in slightly different directions. They fan out, and when they hit the film they cover a small circular area on it. If the hole in the barrier is made larger *(drawing below)*, a larger cluster of light rays will get through to the film and cover a wider circle. The larger the circles are, the more they will overlap their neighbors and the less clear the picture will be.

To get sharp pictures, the circles of confusion should be as small as possible. But the only way to achieve that with a pinhole camera is to use a very small opening, which admits little light and requires long exposure times. To admit more light and to make a sharper picture, a different method of image formation is needed. That is what a lens provides.

Why Lenses Are Needed: continued

A Lens to Form an Image

Four centuries ago a Venetian noble-man named Daniello Barbaro found a new and better way to convert light rays into images in the camera obscura of his day. He enlarged the opening of his room-size camera obscura and fitted into it a convex **lens** taken from the spectacles of a farsighted man. To his delight, the lens projected images superior to those previously supplied by the simple pinhole opening.

Several hundred years later, with the advent of photography, this discovery proved even more significant. For not only can a camera with a lens provide sharper images than a pinhole camera, but it admits enough light to take a picture in a fraction of a second.

Most modern photographic lenses are based on the convex lens, the type used by Barbaro. Thicker in the middle than at the edges, the convex lens can collect a large number of light rays from a single point on an object and refract, or bend, them toward each other so that they converge at a single point *(diagram, right)*. This point of convergence, the **focal point,** falls on a surface called the **focal plane.** In a camera, a strip of film is stretched across the focal plane, which is now the **film plane.** The film records an image formed by light rays from an infinite number of tiny circles of confusion.

How does a lens **refract** (bend) light to form an image? When light rays pass from one transparent medium, such as air, into a different transparent medium, such as water or glass, the rays may be bent, or refracted. Look at the shape of a spoon half submerged in a glass of water and you will see a common example of refraction: rays of light reflected by the spoon are bent by the water and glass so that part of the spoon appears displaced.

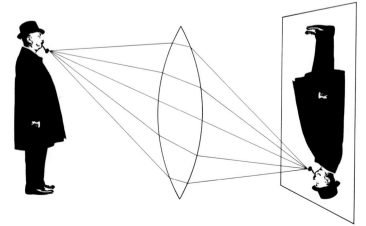

Photographed this time through a convex lens, Ansel Adams's barn scene is as good as—or better than—the one on page 36 taken with a pinhole camera. Its exposure time, instead of being 6 sec, was only $^1/_{100}$ sec. This is because the lens is much bigger than a pinhole and thus admits far more light. The diagram at right shows how the lens handles all this light by collecting many rays reflected from a single point and redirecting them to a corresponding single point on the film or focal plane.

For refraction to take place, light must strike the new medium at an angle. If it is perpendicular to the surface when it enters and leaves the medium *(diagram, 1)*, the rays pass straight through. But if it enters or leaves at an oblique angle *(2)*, the rays will be bent to a predictable degree. The farther from the perpendicular they strike, the more they will be bent.

When light strikes a transparent medium with a curved surface, such as a lens, the rays will be bent at a number of angles depending on the angle at which each ray enters and leaves the lens surface. They will be spread apart by concave surfaces *(3)* and directed toward each other by convex surfaces *(4)*. Rays coming from a single point on an object and passing through a convex lens (the simplest form of camera lens) will cross each other—and be focused—at the focal point.

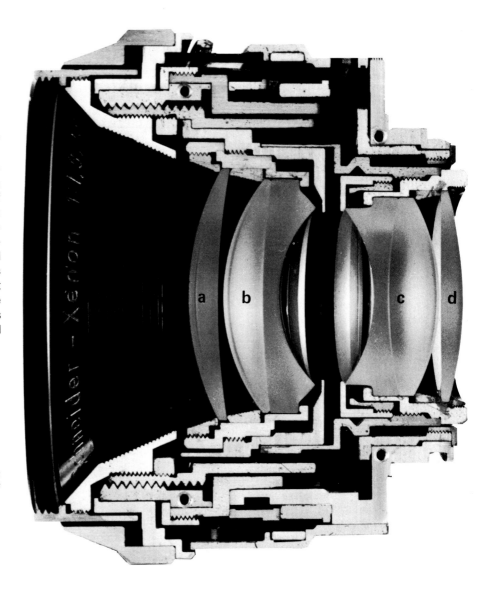

A modern compound lens, as this cutaway view shows, is usually a single convex lens sliced in two with some other lens elements placed in between to correct the aberrations or focusing defects that in any single lens affect the sharpness and sometimes the shape of the image. The front half of the convex lens (a) has a 2-piece element of special color-correcting glass (b) behind it. Farther back are another color correcting element (c) and finally the back half of the convex lens (d). The use of optical glass manufactured with certain chemicals, such as fluoride, also improves lens performance.

How refraction works is shown in the diagram (right) of beams of light passing through four glass blocks. The beams, entering from the left, strike the first block head on and are therefore not refracted. But the next block has been placed at an angle, so that the rays are refracted, resuming their former direction on the other side. The concave surfaces of the third block spread the beams apart, but the last block—a convex lens like the basic light gathering lenses used in cameras—draws the rays back together so that they cross each other at the focal point.

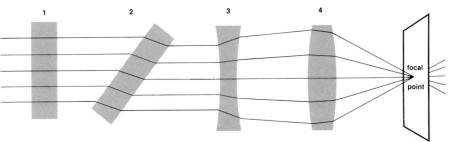

TYPES OF LENSES
Lens Focal Length

Since most cameras can be used with interchangeable lenses, a photographer can choose which lens to buy or use. The most important way lenses differ is in their **focal length.** Focal length is the distance between the lens (technically, from its rear nodal point) and the focal plane when the lens is focused on infinity (a far distance from which light reaches the lens in approximately parallel rays). A lens is often described in terms of its focal length (a 50mm lens, a 12-inch lens) or its relative focal length (short, normal, or long).

Focal length controls **magnification** (the size of the image formed by the lens) and **angle of view** (the amount of the scene shown on a given size of film). The effect of focal length on magnification is diagrammed at right.

A long-focal-length lens forms a larger image of an object than a short-focal-length lens. Consequently, the long lens must include on a given size of film less of the scene in which the object appears. If you make a circle with your thumb and forefinger and hold it close to your eye, you will see most of the scene in front of you. If you move your hand farther from your eye, the circle will be filled by a smaller part of the scene: you have decreased the angle of view seen through your fingers. In the same way, the longer the focal length, the smaller the angle of view seen by the lens.

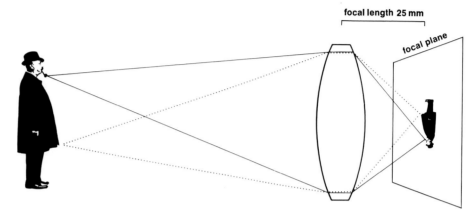

A lens of short focal length bends light sharply. The rays of light focus close behind the lens and form a small image of the subject.

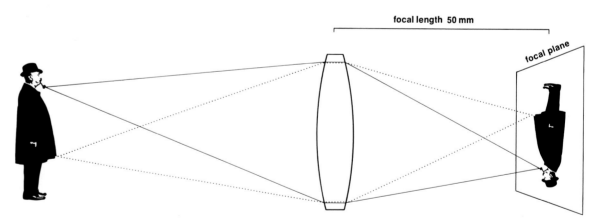

The longer the focal length, the less the lens bends the light rays, the farther behind the lens the image is focused, and the more the image is magnified.

The size of the image increases in proportion to the focal length; if the subject remains at the same distance from the lens, the image formed by a 25mm lens will be half as big as that from a 50mm lens.

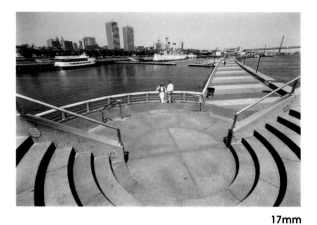

17mm

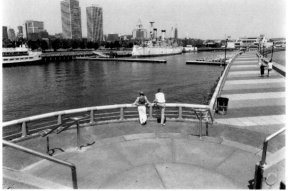

28mm

50mm

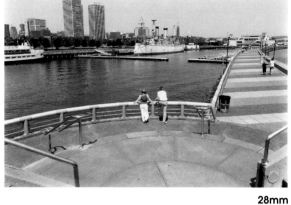

85mm

135mm

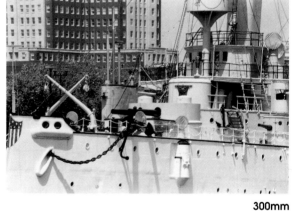

300mm

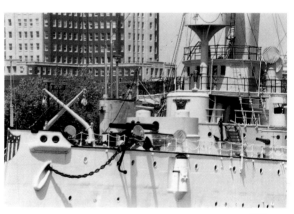

500mm

1000mm

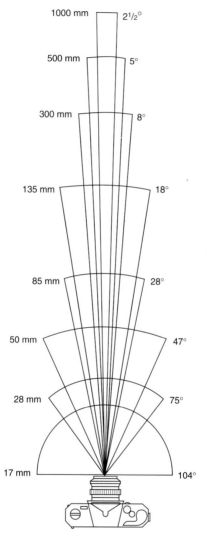

The diagram above shows the angle of view of some of the lenses that can be used with a 35mm camera. The examples at left show the effect of increasing focal length while keeping the same lens-to-subject distance: a decrease in the angle of view and an increase in magnification. Since the photographer has not changed position, the sizes of objects within the scene remain the same in relation to each other.

Types of Lenses: continued

The Normal Lens

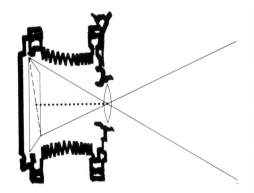

If the focal length of a lens (dotted line) is about the same as the diagonal measurement of the film (broken line), the lens is considered to be of normal (or standard) focal length for that film size. It collects light rays from an angle of view of about 50°—the same as the human eye—and projects them onto the film within the same angle. A normal-focal-length lens for a 4 × 5 camera is 150 mm. An 80mm lens is normal for a camera using 2¹/₄ × 2¹/₄-inch film; a 50mm lens is normal for a 35mm camera.

Bruce Davidson used a 50mm lens on his 35mm camera for the picture at right, part of a photo essay on a Brooklyn teenage gang, the Jokers.

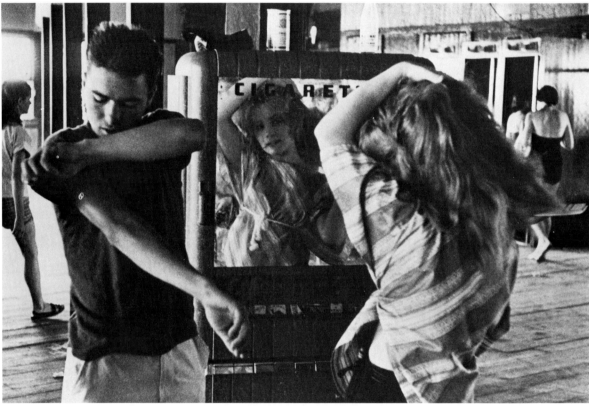

BRUCE DAVIDSON: *The Brooklyn Gang,* 1959

You can create significantly different effects simply by switching to a lens of a different focal length *(see page 41),* but one of the greatest of modern photographers almost never changed lenses. Henri Cartier-Bresson, who once described the camera as "an extension of my eye," usually did his work with a **normal-focal-length lens,** also called a standard-focal-length lens—one that approximates the impression human vision gives. In his picture opposite, the angle of view is about the same as what the eye can see clearly from one position, and the relative size of near and far objects seems normal.

But a lens that is a normal focal length for one camera can be a long focal length for another camera. Film size determines what will be a "normal" focal length. The larger the size of the film format, the longer the focal length of a normal lens for that format. A camera using 35mm film takes a 50mm lens as a normal focal length; a camera using 4 × 5-inch film requires a 150mm lens. Usage varies somewhat: for example, lenses from about 40mm to 58mm are also referred to as normal focal lengths for a 35mm camera.

A lens of normal focal length has certain advantages over lenses of longer or shorter focal length. Most normal lenses are faster, that is, they open to a wider maximum aperture, and so can be used with faster shutter speeds or in dimmer light than lenses that do not open as wide. They often are less expensive, more compact, and of lighter weight.

Though a 50mm lens is called normal for a 35mm camera, that doesn't necessarily mean it is the one you will usually want to use on your camera. Some photographers habitually use a shorter focal length because they want a wide angle of view most of the time; others prefer a longer focal length that narrows the angle of view to the central objects in a scene. If you have a 35mm camera, a 50mm lens is a good focal length to start with, but the lens that turns out to be "normal" for you will be a matter of personal preference.

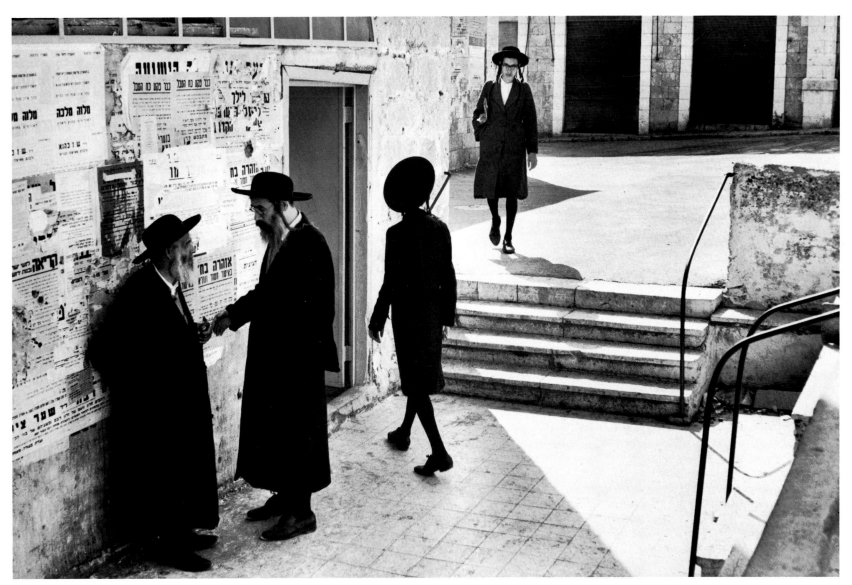

HENRI CARTIER-BRESSON: *Jerusalem, 1967*

This photograph of Hasidic Jews in Jerusalem shows Henri Cartier-Bresson's characteristic use of a normal-focal-length lens. The photographer was at a medium distance, so all four figures appear to be of normal size and perspective relative to each other. There is no distortion of perspective as there might have been had a short lens been used up close or a long lens been used from far away. Most of the scene is sharp because at a medium distance a normal-focal-length lens provides considerable depth of field.

Types of Lenses: continued
The Long Lens

long lens, moderate distance

short lens, up close

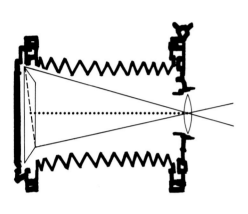

A lens is considered long for a camera if its focal length (dotted line) is appreciably greater than the diagonal of the film format (broken line). It then collects light over an angle that is narrower than that covered by human vision, producing an enlarged view of a restricted area. For a 35mm camera, a popular and useful long focal length is 105 mm; for a camera using $2^1/_4 \times 2^1/_4$ film the comparable focal length is 150 mm; and for a 4 × 5 view camera, about 300 mm.

A moderately long lens (such as an 85mm or 105mm lens on a 35mm camera) used at least 6 ft from the subject (above left) makes a better portrait than a shorter lens used close to the subject (above right). Compare the sizes of nose and chin in the pictures. Photographing a person at too close a lens-to-subject distance makes features nearest the camera appear too large and gives an unnatural-looking dimension to the head.

A **long-focal-length lens** provides an enlarged image of an object. Its angle of view is narrower and its magnification greater than that of a normal lens. Long lenses are excellent for situations where you cannot or do not want to get close to the subject, as in the picture opposite, where the photographer seems to be in the middle of the action even though he is standing on the sidelines. Long lenses make it possible to photograph birds and animals from a distance. They are excellent for portraiture; most people get self-conscious when a camera is too close to them and their expressions become artificial. A long lens also avoids the kind of distortion that occurs when shorter lenses used close to a subject exaggerate the size of whatever is nearest the camera—in a portrait, usually the nose *(above)*.

There are also subtler qualities that can be exploited when you use a long lens. Because a long lens has less depth of field, objects in the foreground or background can be photographed out of focus so that the sharply focused subject stands out clearly and powerfully. Also, a long lens can be used to create an unusual perspective in which objects seem to be closer together than they really are *(see opposite and page 60)*.

Long lenses have some disadvantages, and the longer the lens the more noticeable the disadvantages become. Compared to a lens of normal focal length, they are somewhat heavier, bulkier, and usually more expensive. Because of their shallow depth of field, they must be focused accurately. They usually do not open to a very wide aperture; a maximum

aperture of f/4 is typical for a 200mm lens. And they are difficult to use for hand-held shots since they magnify lens movements as well as subject size. The shutter speed for a medium-long lens, such as a 105mm lens on a 35mm camera, should be at least $^1/_{125}$ second if the camera is hand-held; otherwise camera movement may cause blurring. A tripod or some other support is even better.

Photographers commonly call any long lens a **telephoto,** or tele, although not all long lenses are actually of telephoto design. A true telephoto has an effective focal length that is greater than the distance from lens to film plane. A **tele-extender** or teleconverter contains an optical element that increases the effective focal length of a lens. It attaches between the lens and the camera.

WALTER IOOSS, JR.: *Giants' Defense*, 1963

This photograph of the New York Giants' defense line stopping Number 33 also shows two characteristics of the long lens. Although the photographer was standing on the sidelines, a 400mm lens on his 35mm camera includes only a 6° angle of view, magnifying the image to fill the frame with action. The long lens also seems to compress the space, making the players appear to be in even more of a crunch than they actually are.

Types of Lenses: continued
The Short Lens

In the diagram above, the focal length of the lens (dotted line) is about $^2/_3$ of the film diagonal (broken line). This makes it a wide-angle lens; it produces a viewing angle of 75°, or about 50 percent more than the eye could see clearly if focused on the same subject. The focal length of a commonly used wide-angle lens for a 35mm camera is 28 mm; for a camera using $2^1/_4 \times 2^1/_4$ film it is 55mm, and for a 4 × 5 view camera, 90mm.

The exaggerated size of the model's hand, her rapidly receding arm, and her unnaturally undersized body were all created by photographing an average-size model with the camera close to her outstretched fingertips. This kind of apparent distortion is a result of the short distance from lens to subject and is easy to achieve—intentionally or otherwise—with a wide-angle lens, which can be focused very close to a subject.

A **short-focal-length lens** shows more of a scene than a normal lens used from the same position. This is of special importance if you are physically prevented (as by the walls of a room) from moving back as much as necessary to take the picture with a normal lens. The short lens (commonly called a **wide-angle lens** or sometimes a wide-field lens) increases the angle of view and thus reduces the size of the image compared to the image formed by a normal lens.

Wide-angle lenses also have considerable depth of field. A 24mm lens focused on an object 7 feet away and stopped down to f/8 will show everything from 4 feet to infinity in sharp focus. News photographers or others who work in fast-moving situations often use a moderately wide lens, such as a 35mm lens on a 35mm camera, as their normal lens. They don't have to pause to refocus for every

shot because so much of a scene is sharp with this type of lens. At the same time it does not display too much **distortion,** which is the wide-angle lens's other main characteristic.

Pictures taken with a wide-angle lens can show both real and apparent distortions. Genuine aberrations of the lens itself, such as curvilinear distortion, are inherent in extremely curved or wide elements made of thick pieces of glass, which are frequently used in wide-angle lenses. While most aberrations can be corrected in a lens of a moderate angle of view and speed, the wider or faster the lens, the more difficult and/or expensive that correction becomes.

A wide-angle lens can also show an apparent distortion of perspective, but this is actually caused by the photographer, not the lens. An object that is close to a lens (or your eye) appears larger than an ob-

ject of the same size that is farther away. Since a wide-angle lens can be focused very close to an object, it is easy to get this kind of exaggerated size relationship *(photograph, above).* The cure is to learn to see what the camera sees and either minimize the distortion, or use it intentionally. More about how to control perspective and apparent distortion is on pages 58–61.

A lens of very short focal length requires some design changes for use in a single-lens reflex camera, because the lens is so close to the film plane that it gets in the way of the mirror used for viewing. A retrofocus (reversed-telephoto) lens solves this problem with a design that is the reverse of that of a telephoto lens. The result is a lens of very short focal length that can be used relatively far from the film plane and out of the way of the viewing mirror.

With a 75mm on his 4 × 5 view camera (a wide-angle lens for that format), David Muench positioned his camera relatively close to the furrows of sand in the foreground. The result was to increase the apparent size of the furrows nearest the camera and to create an impression of great distance from the foreground to the background. See page 61 for a similar effect with a different subject.

This "c
body
head
in an
Althou
sacrifi
edge
the ce
mear
its ow

DAVID MUENCH: *Sand Dunes, Monument Valley, Arizona, 1985*

Focus and Depth of Field: continued

Controlling Depth of Field

There are several ways to control the depth of field, the distance between the nearest and farthest points in a scene that appear sharp in a photograph. If you want to increase the depth of field so that more of a scene is sharp, setting the lens to a small aperture is almost always the first choice. This is the case even though you have to use a correspondingly slower shutter speed to maintain the same exposure, which can be a problem if you are photographing moving objects. You can also increase the depth of field by changing to a shorter focal length lens or stepping back from the subject, but that will change the picture in other ways as well *(opposite)*. To decrease the depth of field and make less of the scene sharp, use a wider aperture or a longer lens, or move closer to the subject.

Why does a lens of longer focal length produce less depth of field than a shorter lens used at the same f-stop? The answer relates to the diameter of the aperture opening. The **relative aperture** (the same f-stop setting for lenses of different focal lengths) is a larger actual opening on a longer lens than it is on a shorter lens. For example, f/8 on a 50mm lens is an aperture of larger diameter than f/8 on a 28mm lens. The diagram below shows why this is so. Since at the same f-stop setting, the aperture diameter of the longer lens is larger than that of the shorter lens, the circles of confusion for the longer lens will also be larger and the image will have less depth of field.

The smaller the aperture, the greater the depth of field. *Here the photographer focused on the mooring buoy. Near right: with a wide aperture, f/2, the depth of field was relatively shallow; only objects that were about the same distance from the lens as the mooring buoy are sharp; other objects that were nearer or farther are out of focus. Far right: only the aperture was changed, to a much smaller one—f/16. Much more of the scene is now sharp. Changing the aperture is usually the easiest way to change the depth of field.*

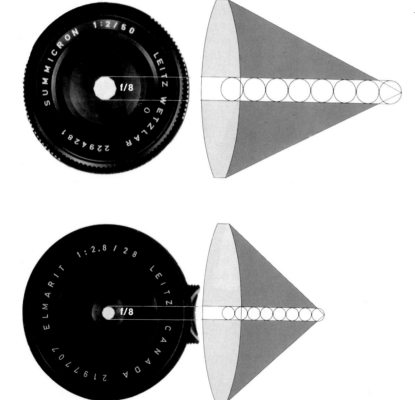

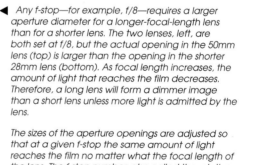

◄ *Any f-stop—for example, f/8—requires a larger aperture diameter for a longer-focal-length lens than for a shorter lens. The two lenses, left, are both set at f/8, but the actual opening in the 50mm lens (top) is larger than the opening in the shorter 28mm lens (bottom). As focal length increases, the amount of light that reaches the film decreases. Therefore, a long lens will form a dimmer image than a short lens unless more light is admitted by the lens.*

The sizes of the aperture openings are adjusted so that at a given f-stop the same amount of light reaches the film no matter what the focal length of the lens. The f-stop number, also called the relative aperture, equals the focal length of the lens divided by the aperture diameter:

$$\text{f-stop} = \frac{\text{lens focal length}}{\text{aperture diameter}}$$

If the focal length of the lens is 50mm, at f/8 the actual diameter of the aperture will be 6.25mm:

$$f/8 = \frac{50}{6.25}$$

For a 28mm lens, at f/8 the actual diameter of the aperture will be only 3.5mm.

$$f/8 = \frac{28}{3.5}$$

The diagrams, by actually lining up eight aperture-size circles and fitting them into the focal length of each lens, show the larger aperture diameter for the longer focal length.

The shorter the focal length of the lens, the greater the depth of field. *Near right: with a 200mm lens, only two gravestones are sharp. Far right: with a 35mm lens set to the same aperture and focused on the same point as the previous shot, a bigger section of the cemetery is now sharp. Notice that changing the focal length changes the angle of view (the amount of the scene shown) and the magnification of objects in the scene. The kind of picture has changed as well as the sharpness of it.*

The greater the distance from the subject, the greater the depth of field. *Near right: with the lens focused on the horse about 5 ft away, only a narrow band from near to far in the scene is sharp. Far right: stepping back to 15 ft from the horse and refocusing on it made much more of the scene sharp. Stepping back has an effect similar to changing to a shorter focal length lens: more of the scene is shown.*

less depth of field

more depth of field

same focal length and distance

wider aperture

smaller aperture

same aperture and distance

200mm lens

35mm lens

longer
focal length

shorter
focal length

longer focal length

shorter focal length

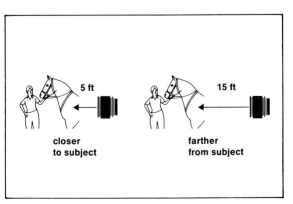

same focal length and aperture

5 ft

15 ft

closer
to subject

farther
from subject

closer to subject

farther from subject

Focus and Depth of Field: continued

More About Controlling Depth of Field

How much of a scene should be sharp? You won't always want everything to be sharp. A distracting background is much less conspicuous if it is soft and out of focus instead of crisply detailed. But something that obviously should be sharp but isn't can be equally distracting. Pages 52–53 present basic techniques for controlling depth of field, the extent of a scene near to far that will be sharp. Two other techniques are shown here. For these techniques you need a lens with a depth-of-field scale (the scale is described in detail on page 19). A zoom lens may not have one; a fixed-focal-length lens often will. You also need a camera that can be focused manually, not one that only works automatically.

When you want to be able to shoot rapidly without refocusing, **zone focusing** lets you set the depth of field in advance of shooting. This is useful if you

can predict approximately where, but not exactly when, action will take place. It is also useful if you want to be relatively inconspicuous and don't want to spend time with your camera to your eye focusing (for example, when photographing strangers on the street). To zone focus, use the depth-of-field scale on your lens to find the f-stop and distance setting you will need to use in order to get adequate depth of field. Everything photographed within the near and far limits of that depth of field will be acceptably sharp; the precise distance at which something happens will not be important because the general area will be sharp *(see explanation, below)*.

Sometimes you will want maximum depth of field, with everything sharp from the foreground to the far distance. When a scene extends into the dis-

tance, you may find that you rather automatically focus on a far part of the scene. In photographic terms, you have focused on **infinity,** which, depending on the lens, extends from about 40 feet or so to as far as the eye can see. (Infinity is marked ∞ on the lens distance scale.)

But for maximum depth of field in a scene that extends to a far distance, don't focus on infinity. Instead, turn the focusing ring so that the infinity mark falls just within the farthest limits of the depth of field for the f-stop you are using. You are now focused on a distance that is closer to the lens than infinity (the **hyperfocal distance**). Everything from the infinity distance and farther will still be sharp, but more of the foreground will be in focus *(see opposite)*.

ELLIOTT ERWITT: *Sunday in Hungary, 1964*

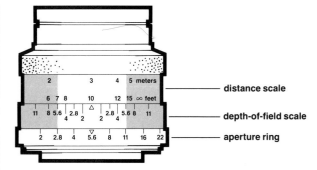

distance scale

depth-of-field scale

aperture ring

Zone focusing is a way of using a lens's depth-of-field scale so you can be ready to shoot without focusing before every shot. Suppose the nearest point you want sharp is 7 ft away and the farthest is 15 ft away. Turn the focusing ring until those distances on the distance scale fall opposite a matched pair of f-stops on the depth-of-field scale. If you set your lens aperture to that f-stop, objects between the two distances will be in focus. Here, the two distances fall opposite a pair of f/5.6's. With this lens set to f/5.6 or a smaller aperture (f/8 or f/11), everything between 7 ft and 15 ft will be sharp. No further focusing need be done as long as the action stays between these distances.

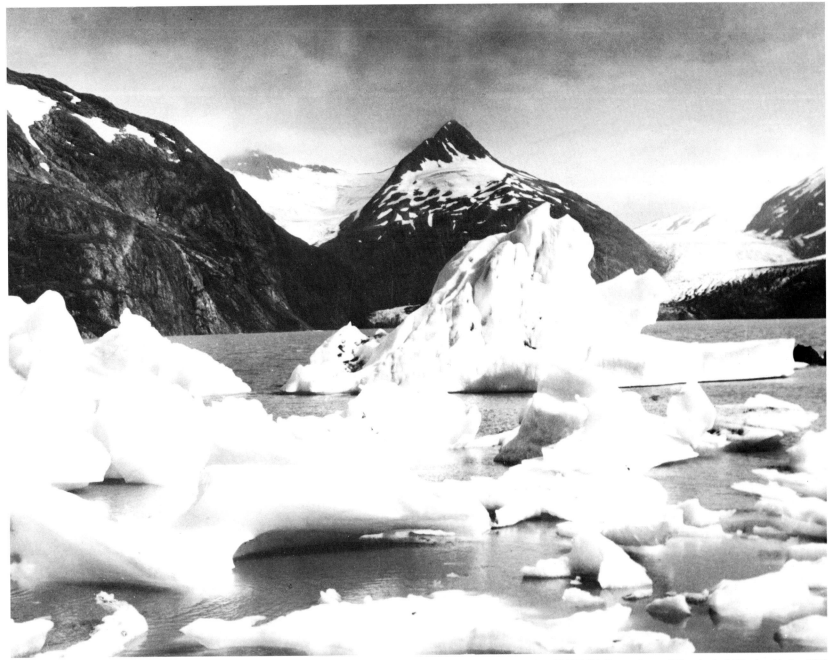

PHOTOGRAPHER UNKNOWN: *Upper Area of Mendenhall Glacier, Alaska, 1968*

For maximum depth of field in a scene that extends to the far distance—infinity, in photographic terms (marked ∞ on the lens distance scale)—don't focus on the infinity mark, as has been done with the lens at left. With this lens, if the aperture is f/8 and the lens is focused on infinity, everything from 20 ft to infinity will be sharp.

Instead, set the distance scale so that the infinity mark lines up opposite your f-stop on the depth of-field scale (lens, right). Now, with the lens still set to f/8, everything from 10 ft to infinity will be sharp.

Focus and Depth of Field: continued

Automatic Focus

Automatic-focus cameras generally focus on the center of a scene. This can make the main subject (or subjects) out of focus if it is off to one side and at a different distance from whatever is at the center. Here, small brackets at the center of the viewfinder indicate the focused area.

More and more cameras are coming equipped with **automatic focus.** In the most common design, you push down the shutter-release button and the camera adjusts the lens to focus sharply on whatever object is at the center of the image. This type of automatic focus generally works well in straightforward, simple scenes where the subject is at the center of the frame. Some focusing systems feature more elaborate electronics, such as predicting where the subject is likely to be next or even focusing in the direction that your eye is looking. Some autofocus cameras, when used with specially designed flash units, can focus in total darkness; the flash sends out a beam of infrared light that lets the camera focus the subject even when you can't see it.

No automatic system functions well in every situation. Just as with automatic exposure, there will be times when you should override the automatic focusing mechanism or use the camera in its manual mode. If you have a camera with an autofocus option, don't let it do all the focusing for you. Don't buy a camera that cannot be focused manually unless you will use it only for simple snapshooting.

The problems that you encounter with automatic focus depend on the system used in your camera. Some cameras, like the Polaroid Spectra, focus by sending out a burst of high-frequency sound. Sensors then count the time until an echo of the sound reflected by the subject returns to the camera; the longer the time, the farther away the subject. However, the sound will bounce back from a pane of glass if one is between you and your subject. So, for example, if you are on the street and want to photograph a holiday display inside a shop window, the camera will focus on the window pane and not on Santa, unless you focus manually.

An autofocus 35mm single-lens reflex camera has different problems. It uses photocells to analyze the contrast or other characteristics of the image formed by the lens and may not work well if a subject has, for example, very low contrast or is in very dim light. Also, most systems focus on an area at the center of the viewfinder image (marked by the small brackets in the middle of the photos at right) on the assumption that most subjects are more or less centrally located. But not all subjects are, and for those you need to override the automatic focusing system as shown at right.

In some cases, the time required for focusing can create difficulties. An automatic-focus camera can take as long as two seconds between the first pressure on the shutter-release button and the actual beginning of the exposure. If the subject is moving so fast that you can't keep it within the focusing brackets for the time that the lens needs to adjust itself, the lens may "hunt" back and forth, unable to focus or maybe focusing on some part of the background. The shutter button may not operate at all until focus is set, or the camera may fire away, even if the lens is completely unfocused.

The point of all these cautions is not to say that you should never use automatic focus, but only that you should evaluate each situation. Override the automatic focus system when it is better to do so, rather than assuming that simply because you are set for automatic focus, the right part of the picture is going to be sharp. If you have enough depth of field and you set your lens manually, you can get a sharp photograph even if you haven't focused specifically on any particular object; pages 54–55 tell how.

To correct this in autofocus mode, first focus by placing the autofocus brackets on the main subject; this can be done with many cameras by holding down the shutter button partway. Lock the focus by keeping partial pressure on the shutter release.

Then reframe your picture while keeping partial pressure on the shutter release. Push the shutter button all the way down to make the exposure. You can get the same results—a sharply focused main subject—by simply focusing the camera manually.

Using Focus and Depth of Field

HENRY HORENSTEIN: *Jockey's Excuse, Keeneland,* 1985

Having this jockey who has just lost a race appear sharp, in contrast to the horse's disappointed trainer and owners who are out of focus, underscores the gulf between them. Horenstein had been looking for several days for a photograph to illustrate the excuses that jockeys make when they lose a race. He positioned himself in the passageway that the jockeys used after a race and waited for something to happen. When it did, he knew he had a good picture. He remembers putting an X on the film cassette to remind himself to treat this roll of film with extra care.

PERSPECTIVE

It is vital to learn to see things the way the camera sees them, since the camera image can appear surprisingly different from reality. A long lens used far from the subject gives a so-called **telephoto effect**—on page 51, for example, the line of soldiers seems compressed, with the soldiers in impossibly close formation. A short lens used close to the subject produces what is known as **wide-angle distortion**—on page 46, it apparently stretches a human form to unnatural proportions. See also the photographs on pages 60 and 61.

Those photographs seem to show distortions in **perspective**—in the relative size and depth of objects within the image. Actually, perspective is controlled not by lens focal length but by the lens-to-subject distance. How perspective changes when lens-to-subject distance changes is shown at right.

David Arky often photographs studio still lifes for advertising and corporate clients. He took the three pictures in the top row from the same distance but with lenses of different focal lengths. The shortest lens produced the widest view of the scene; the longest lens gave the narrowest view, simply an enlargement of part of the original picture. Eggs, bird, and cage all increased in size the same amount as lens focal length increased.

He took the three pictures in the bottom row with the same lens but from different distances. The closer he came, the bigger the foreground objects (eggs and nest) appear relative to the background one (cage). The nest is smaller than the cage in the first picture, bigger than the cage in the last picture. The brain judges depth in a photographed scene mostly by comparing the size of objects, so the depth seems to increase as the camera moves closer. Compare the illusion of depth in the two pictures at far right.

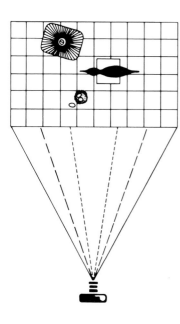

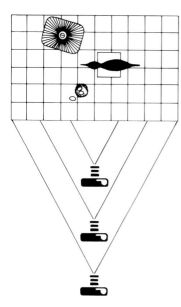

Top row: three views of the same still life, each shot from relatively far away, show how lenses of different focal lengths change the size of all the objects in a scene but not the size of one object compared to another. The first picture was taken with a short-, the next with a medium-, and the third with a long-focal-length lens.

short-focal-length lens, far from subject

short-focal-length lens, far from subject

Bottom row: changes in a lens's distance from a scene change the relative size of near and far objects. As the lens came closer to the scene, foreground objects enlarged more than background ones to give three different perspectives.

medium-focal-length lens, far from subject

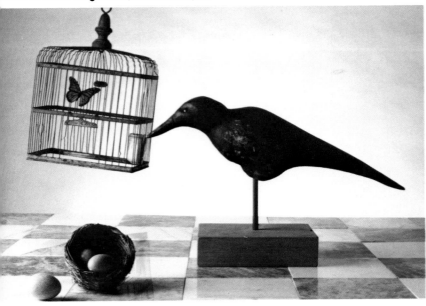

long-focal-length lens, far from subject

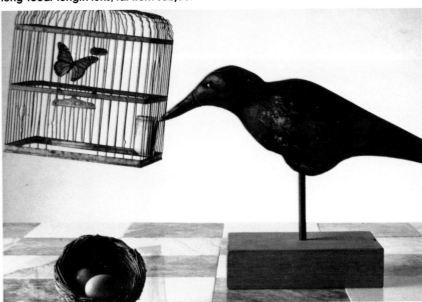

short-focal-length lens, medium distance from subject

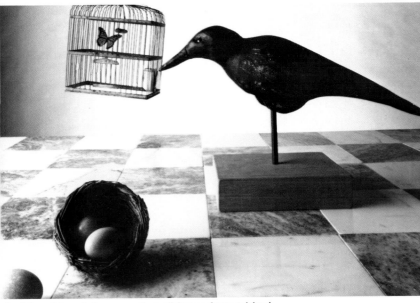

short-focal-length lens, close to subject

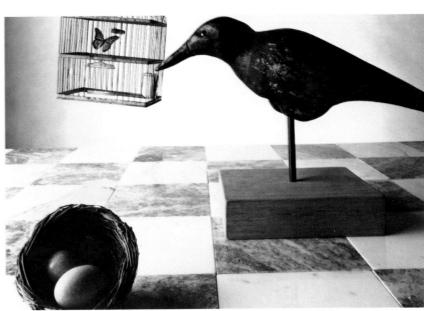

Perspective: continued

Using Perspective

ANDREAS FEININGER: *Fifth Avenue, New York*, 1950

You can exaggerate the perspective, the impression of depth in a photograph, to add impact to an image or to communicate an idea visually. What is known as telephoto effect seems to compress the objects in a scene into a crowded mass. It occurs when a long-focal-length lens is used far from a subject. Left, Andreas Feininger made many photographs of New York that conveyed its beehive crowding and intense activity. The super-telephoto lens he used for these pictures was so long that he had to add a two-legged extension to his tripod to support the lens.

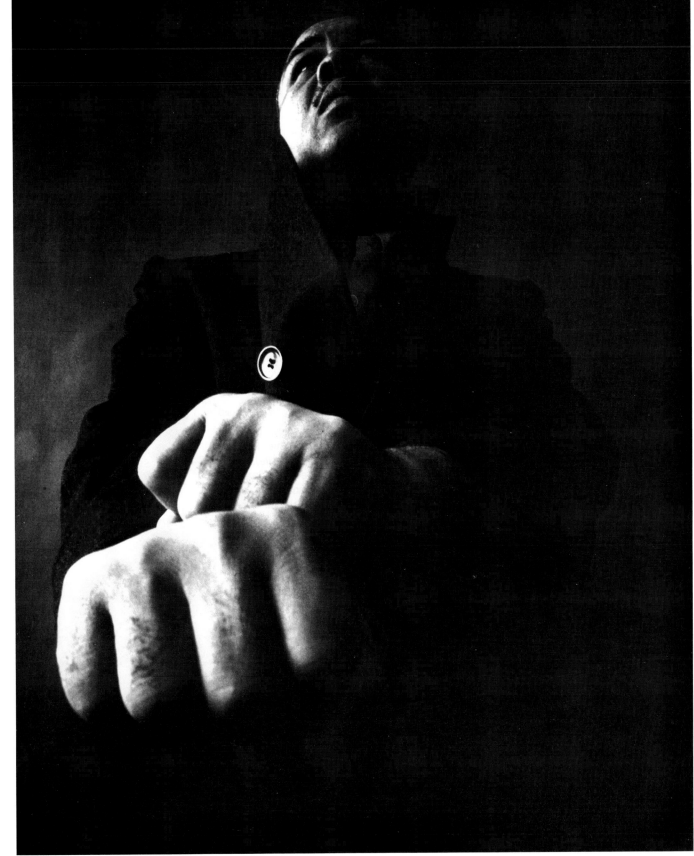

A short-focal-length lens used up close increases the apparent size of the part of the subject that is closest to the camera, producing what is called wide-angle distortion. Like telephoto effect (shown opposite), this is caused by the distance of the lens to the subject, not by the lens itself. Right, the fists that brought the world heavyweight championship to Joe Louis are emphasized in this brooding portrait taken after the fighter had lost his title and fallen on hard times.

ART KANE: *Joe Louis,* 1964

CHOOSING LENSES

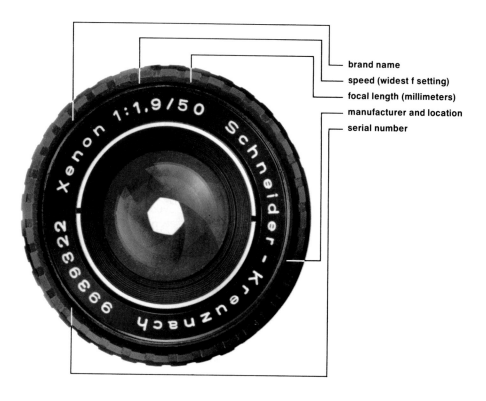

- brand name
- speed (widest f setting)
- focal length (millimeters)
- manufacturer and location
- serial number

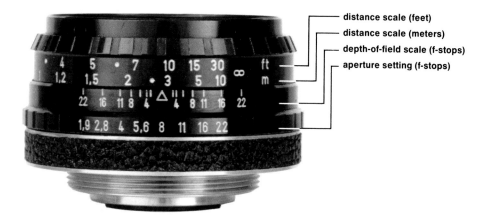

- distance scale (feet)
- distance scale (meters)
- depth-of-field scale (f-stops)
- aperture setting (f-stops)

Learn to read the information about a lens that is marked on it. On its front (top photograph) are its brand (Xenon), its speed (maximum aperture of f/1.9), its focal length (50 mm), its maker's name and location (Schneider, Kreuznach, Germany), and its serial number (9939322). Distance, depth of field, and aperture scales are marked on the side of the lens.

Since buying a lens can involve a considerable investment of money, it pays to invest a little time in deciding exactly what lenses you need.

The "speed" of a lens affects its price. Lenses made by reputable manufacturers can be assumed to be reasonably good. And yet two lenses of the same focal length, perhaps even made by the same company, may vary widely in price. This price difference probably reflects a difference in the speed of the lens. One will be faster—it will have a wider maximum aperture and admit more light than the other. The faster and more expensive lens can be used over a wider range of lighting conditions than the slower one but otherwise may perform no better. It may, in fact, perform less well at its widest aperture because of increased optical aberrations.

Following are some guidelines for **buying camera lenses.**

1) If you are getting a camera with interchangeable lenses, start with a normal lens or a zoom lens with a moderate-focal-length range. (This is the type that ordinarily comes with the camera anyway.) Don't buy more lenses until you feel a strong need to take the different kinds of pictures that other focal lengths can provide.

2) Get your lenses one at a time and think ahead to the assortment you may someday need. Begin by buying lenses in increments of more or less two times the focal length; for example, a good combination for a 35mm camera is a 50mm normal lens for general use, a 28mm wide-angle lens for close-in work, and a 105mm long lens for portraits and for magnifying more distant subjects. Be wary of ultra-wide-angle (24mm or below) and extra-long (above 200mm) lenses. They may be considerably more expensive than the less extreme types and are so specialized that their usefulness is limited.

CARING FOR YOUR CAMERA AND LENS

3) Don't spend money on extra-fast lenses unless you have unusual requirements. A couple of extra f-stops may cost you an extra couple of hundred dollars. With modern high-speed film, a lens that can open to f/2.8 is adequate in all but the dimmest light.

4) Consider a secondhand lens. Many reputable dealers take used lenses in trade, and they may be bargains. But look for signs of hard use, such as a dented barrel, a scratched lens surface, or a slight rattling that may indicate loose parts, and be sure to check the diaphragm to see that it opens smoothly to each f-stop over the entire range of settings.

5) Test your lens. The only sure way is to take pictures with it in your own camera at various f-stops, so insist on a trial period or a return guarantee. If you plan to buy several lenses eventually, a good investment is a standardized test chart that can give an accurate reading of a lens's sharpness.

6) A lens shade is a very desirable accessory to attach to the front of the lens to prevent flare *(see page 62)*. Buy one that is matched to the focal length of the lens; too wide a shade is inefficient, and too narrow a shade will cut into the image area *(see vignetting, page 63)*.

Cameras and lenses are rugged, considering what precision instruments they are. Commonsense care and a little simple maintenance will help keep them running smoothly and performing well.

Protect from dust and dirt. *The best way to keep equipment clean is not to get it dirty in the first place. Cases and bags protect cameras and lenses from bangs and scratches as well as keep them clean. A UV or skylight filter on the lens helps protect it during use. Keep a cap on the lens when it is not in use, and if you take a lens off a camera, protect both front and back lens surfaces either by placing the lens in a separate lens container or by capping both ends. Sand is a particular menace; clean the camera well after using it on the beach.*

Protect from moisture. *Most modern cameras are packed with electronic components that can corrode and malfunction if exposed to excessive humidity or moisture, especially salt water. On a boat or at the beach, keep equipment inside a case when it is not in use. If you use it where salt spray will get on it, wrap it in a plastic bag so just the lens pokes out.*

Protect from temperature extremes. *Excessive heat is the worst enemy. It can cause parts to warp, lubricating oil inside the camera to get where it shouldn't be, and film to deteriorate. Avoid storage in places where heat builds up: in the sun, inside an auto trunk or glove compartment on a hot summer day, or near a radiator in winter.*

Excessive cold is less likely to cause damage but can make batteries sluggish. If you photograph outdoors on a very cold day, keep your camera warm inside your coat until you are ready to use it. Moisture can condense on a camera, just as it does on eyeglasses, if metal or glass that has gotten cold outdoors meets warm, humid air when it comes indoors. Keep a cold camera wrapped up until it comes to room temperature.

Protect during storage. *If you won't be using the camera for a while, release the shutter, make sure the meter is off, and store in a clean, dry place. If humidity is high, ventilation should be good to prevent a buildup of moisture on electronic components. Cock and release the shutter once in a while; it can become balky if not used for long periods of time. For long-term storage, remove batteries to prevent possible damage from corrosion.*

Batteries *provide the power for a camera's metering system, readout data, automatic functions, and sometimes the shutter. Check the battery strength regularly (see manufacturer's instructions).*

How to clean a lens. *Gently. Blow or gently brush any dust particles from the lens surface. Be especially careful with granular dirt, like sand, which can scratch the lens surface badly. To clean grease or water spots from the lens, wad a clean piece of camera lens tissue into a loose ball and moisten it with a drop or two of lens cleaner solution. Don't put drops of solution directly on the lens. They can seep along the edges of the lens to the inside. Wipe the lens gently with a circular motion. Dry it by wiping gently with another clean piece of wadded lens tissue. Don't use any products designed for cleaning eyeglasses.*

How to clean a camera. *If you are cleaning the lens or changing film, also check inside the camera for dust that can settle on the film and cause specks on the final image. Blow or gently dust along the film path, particularly around the winding mechanisms, but with a single-lens reflex be careful not to damage the shutter curtain in the body of the camera or the film pressure plate on its back. The shutter curtain is particularly delicate, and it is best not to touch it at all unless absolutely necessary.*

Professional care *is recommended for all but basic maintenance. Never lubricate any part of the camera yourself or disassemble anything for which the manufacturer's manual does not give instructions. Cameras are more difficult to put back together than they are to take apart.*

	film size used by camera			
	35mm	**2 ¼ × 2 ¼ inch**	**2 ¼ × 2 ¾ inch**	**4 × 5 inch**
short focal length	35mm or shorter	55mm or shorter	75mm or shorter	90mm or shorter
normal focal length	50mm	75mm, 80mm	100mm	150mm (6 inches)
long focal length	85mm or longer	120mm or longer	150mm or longer	250mm (10 inches) or longer

The chart at left gives some typical focal lengths for cameras using various sizes of film. Focal lengths are sometimes stated in inches, sometimes in millimeters. There are approximately 25mm to an inch.

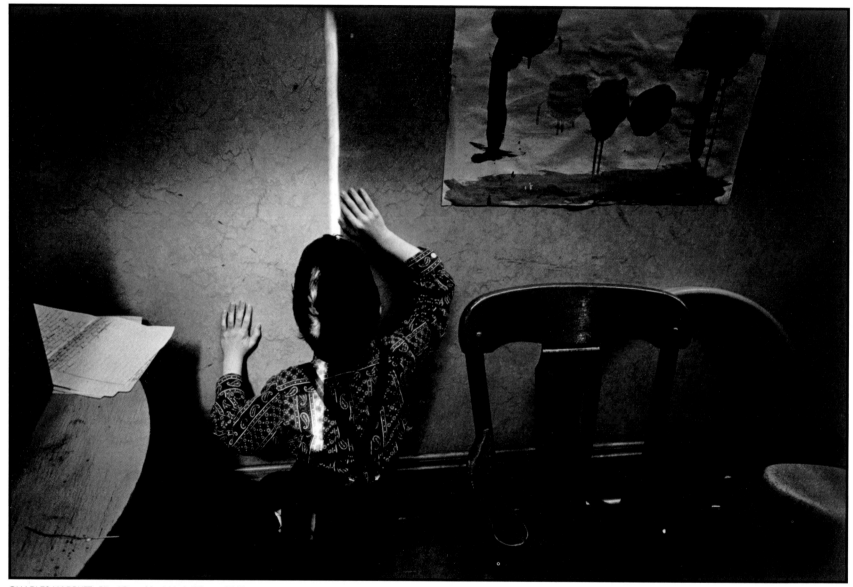

CHARLES HARBUTT: *Blind Boy, New York City,* c. 1960

The spectrum contains heat as well as light, and you can feel the sun even if you can't see it. Charles Harbutt's photograph is an interesting picture even without the title. But the words add a poignant meaning that greatly strengthens the photograph; without the words there is no clue that the child can't see.

This picture is one of a series Harbutt made of children at The Lighthouse in New York City, an institution for the blind. Harbutt had noticed that every day the boy used his hands to feel for the warmth created by the rays of sunlight that threaded the narrow space between two buildings each afternoon at about the same time.

400 nanometers

gamma rays

x-rays

ultraviolet

visible spectrum

infrared

heat

radar

television
and radio waves

violet

blue

500 nanometers

green

yellow

600 nanometers

red

700 nanometers

wave length

The light that we see and that we use to form an image on film is only a small part of a tremendous range of energy called the **electromagnetic spectrum** *(diagram, left)*, which also includes X-rays, heat, radar, and television and radio waves. This energy can be described as waves that spread from a source in the same way that ripples spread when a stone is dropped in a pond of water. The waves can be measured; the distance from crest to crest (wavelength) ranges from 0.000000001 millimeter for some gamma rays to six miles for some radio waves.

The human eye is sensitive to a very small group of waves near the middle of the spectrum whose wavelengths range from about 400 nanometers (billionths of a meter) to 700 nanometers. When waves in this **visible spectrum** strike the retina of the eye, the brain senses light; each wavelength or combination of wavelengths produces the sensation of a different color, and a mixture of all the wavelengths produces colorless or "white" light. For most purposes, films are manufactured to be sensitive to about the same range of wavelengths that the eye sees.

MAKING AN IMAGE IN SILVER

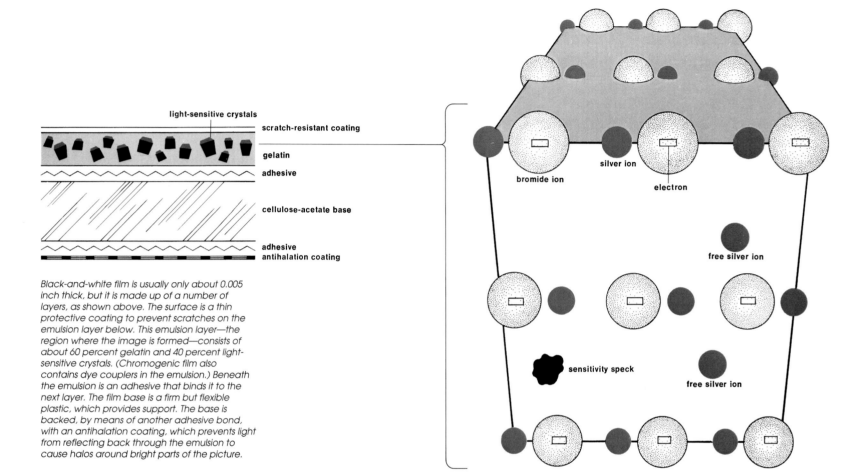

light-sensitive crystals

scratch-resistant coating

gelatin

adhesive

cellulose-acetate base

adhesive
antihalation coating

Black-and-white film is usually only about 0.005 inch thick, but it is made up of a number of layers, as shown above. The surface is a thin protective coating to prevent scratches on the emulsion layer below. This emulsion layer—the region where the image is formed—consists of about 60 percent gelatin and 40 percent light-sensitive crystals. (Chromogenic film also contains dye couplers in the emulsion.) Beneath the emulsion is an adhesive that binds it to the next layer. The film base is a firm but flexible plastic, which provides support. The base is backed, by means of another adhesive bond, with an antihalation coating, which prevents light from reflecting back through the emulsion to cause halos around bright parts of the picture.

bromide ion

silver ion

electron

free silver ion

sensitivity speck

free silver ion

The process that creates a picture on a piece of film involves a reaction between light and the **silver halide crystals** spread through the gelatin of the **emulsion layer.** Each crystal is a compound of silver plus a halogen such as bromine, iodine, or chlorine, held together in a cubical arrangement by electrical attraction. If a crystal were a perfect structure lacking any irregularities, it would not react to light. However, a number of electrically charged silver ions are also in the structure and move about when light strikes the emulsion, eventually forming an image. The crystal also contains impurities, such as molecules of silver sulfide, that play a role in the trapping of light energy.

As shown in the diagrams opposite, an impurity—called a sensitivity speck—and the free-moving silver ions build a small collection of uncharged atoms of silver metal when the crystal is struck by light.

This bit of metallic silver, too small to be visible even under a microscope, is the beginning of a latent image. Developing chemicals use the latent image specks to build up **density,** an accumulation of enough metallic silver to create a visible image.

A **chromogenic film** is somewhat different from the conventional silver halide film described above. A chromogenic emulsion contains dye couplers as well as silver halides. During development, the presence of silver that has been exposed to light leads to a proportional buildup of dyes. The original silver is then bleached out, leaving the dyes to form the visible image. Most color materials use chromogenic development to produce the final color image, as does one type of black-and-white film, which produces black dye instead of colors.

A silver bromide crystal (above) has a cubic structure somewhat like a jungle gym, in which silver (small balls) and bromine (large balls) are held in place by electrical attraction. Both are in the form of ions—atoms possessing electrical charge. Each bromide ion has an extra electron (small box)—that is, one more electron than an uncharged bromine atom, giving it a negative charge; each silver ion has one electron less than an uncharged silver atom and is positively charged. The irregularly shaped object in the crystal represents a "sensitivity speck." In actuality, each crystal possesses many such specks, or imperfections, which are essential to the image-forming process (diagrammed at right).

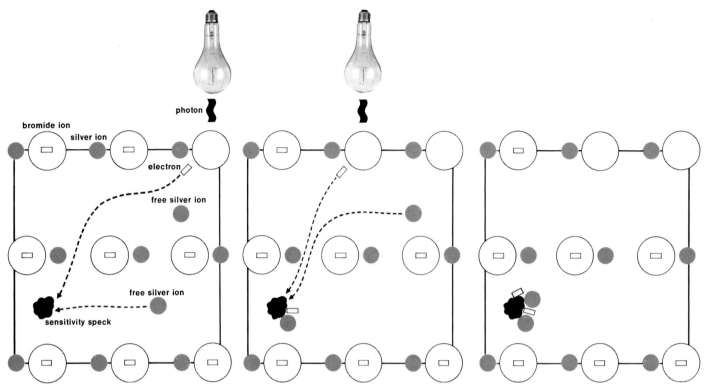

When a photon of light strikes a silver bromide crystal, image formation begins. The photon gives its energy to a bromide ion's extra electron, lifting it to a higher energy level. Then the negatively charged electron can roam the structure of the crystal until it reaches a sensitivity speck. There its electrical attraction pulls a positively charged free silver ion to it.

As additional photons of light strike other bromide ions in the crystal and release electrons, more silver migrates to the sensitivity speck. The electrons join up with the silver ions, balancing their electrical charges and making them atoms of silver metal. However, if the crystal were examined through a microscope at this stage, no change would be seen.

The presence of several metallic silver atoms at a sensitivity speck constitutes a latent image—an invisible chemical site that will serve as the starting point for the conversion of the whole crystal to silver during development. The developer enormously magnifies the slight chemical change caused by light energy and creates the visible photographic image.

MINOR WHITE: *Negative Print of Feet, San Francisco,* 1947

◄ A conventional black-and-white negative is formed when millions of exposed crystals are converted to silver metal by the developer. The result is a record of the camera's view in which the film areas struck by the most light are darkened by metallic silver, while the areas struck by no light remain transparent after processing, since they contain no silver. The intermediate areas have varying amounts of silver, creating shades of gray.

When this very ordinary scene was printed as a negative image, the feet became not quite real. They seem to float above the surface of the floor, as if the subject is stepping off into space. The skin tones resemble an X-ray, so that one looks not just at the feet but into them. The diagonal lines of the floorboards add a visual tension to the picture, repeating at an angle the rectangular shape of the print format.

CHARACTERISTIC CURVES: HOW FILMS RESPOND TO LIGHT

The more light that reaches film, the denser with silver (or dyes), and so the darker, the developed negative will be. The pictures opposite were all taken at the same aperture and shutter speed. As more and more light bulbs shine on the head of Buddha, the negatives *(bottom row)* become darker. The negatives are the opposite of their positive prints *(top row)*; the darkest parts of the negative are the lightest in the print.

The response of a particular film to light can be diagrammed as its **characteristic curve,** which shows to what degree silver density increases as the amount of light reaching the film increases. The graph on the next page represents the characteristic curve for the film used in taking those pictures.

The curve shows graphically something you can also see if you look closely at the pictures—the density of the negatives did not increase in exact proportion to the amount of light reaching the film. Although the light was doubled for each exposure, the negative densities increased slowly for the first few exposures (the **toe** of the curve), increased more rapidly for the middle exposures (the **straight-line** portion), then leveled off again for the last exposures (the **shoulder**).

Here the characteristic curve plots seven different pictures. But imagine the seven pictures as all part of the same scene, each representing an object of a different tone ranging from a dark, shadow area *(Buddha at left)* to a brilliant, highlight area *(Buddha at right)*. If you take a picture of such a scene, the film will record different densities depending on the lightness or darkness of the various objects *and* on the portion of the characteristic curve in which they fall.

In the straight-line portion of the curve, an increase in light will cause a proportionate increase in density, but in the toe

and shoulder portions an increase in light will cause a much smaller increase in density. This means that in the straight-line portion, tones that were different in the original scene will look that way in the final print. The tonal separation will be good for these areas and the print will seem to represent the scene accurately.

When film is **underexposed,** it receives too little light. The tones move toward the toe of the curve, where only small increases in silver density occur. With considerable underexposure, shadow areas and midtones are thin, tonal separation is poor, and detail is lost. Only light areas of the original scene are on the straight-line portion and show good tonal separation and detail. Tones are reversed in the positive print, so a print will tend to be too dark.

When film is considerably **overexposed,** it receives too much light. The tones move too much toward the shoulder of the curve. Midtones and bright values are too dense with silver; they "block up" without tonal separation, and details again are lost. Only the shadow values show tonal separation and detail. A print will tend to be too light.

Exposure is not the only process that affects the density of a negative. The developer used and the development time, temperature, and agitation also affect density, especially for bright areas in the original scene. The Zone System is one method used by some photographers for controlling densities in a negative by making adjustments in exposure and development *(pages 321–333)*. Some adjustments can also be made to an image during printing, but a very thin or very dense negative will never make a print with the richness and clarity of a print made from a properly exposed negative with good tonal separation.

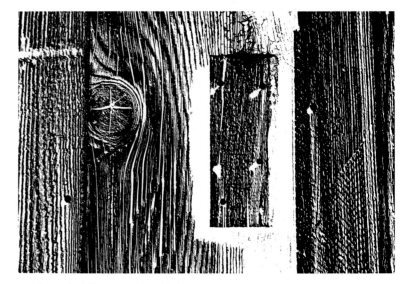

characteristic curve for a high-contrast film

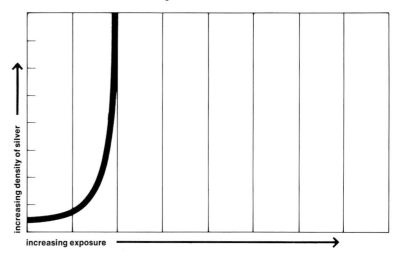

Different films have different characteristic curves. The negative above, made with high-contrast film, consists of two tones, maximum black and maximum white. High-contrast film has a curve that rises almost straight up. Silver density increases rapidly in the negative so that tones above a certain light level are recorded as very dense areas; they will appear in a print as white. Tones below a certain light level are recorded mostly as clear areas in the negative; they will appear in a print as black. Compare this to the curve for the normal-contrast film at right, in which density increases gradually and many midtones are produced.

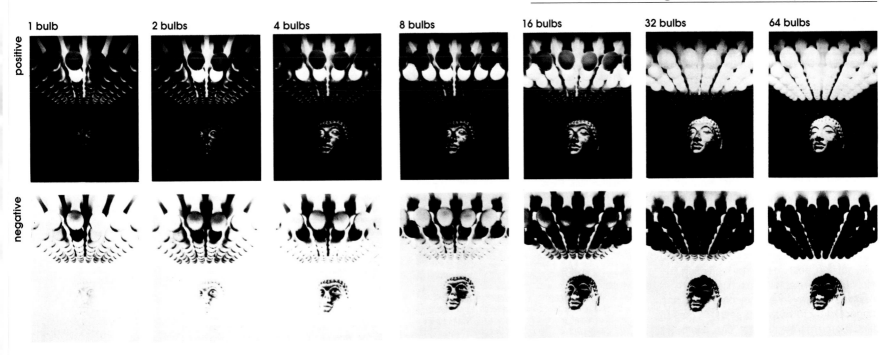

positive

negative

1 bulb 2 bulbs 4 bulbs 8 bulbs 16 bulbs 32 bulbs 64 bulbs

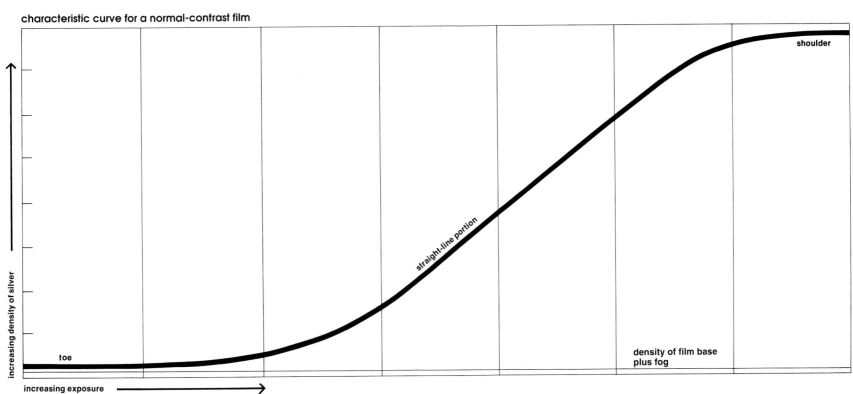

characteristic curve for a normal-contrast film

shoulder

straight-line portion

increasing density of silver

toe

density of film base plus fog

increasing exposure ⟶

The characteristic curve of a film shows how much density is produced in a negative by increases in exposure, as well as by development time, temperature, and agitation. Even without exposure, some density is always present due to film base plus fog, the slight density caused by the base material of the film plus the fog caused by development.

The toe shows the first response of the film to light. Density increases gradually with each increase in exposure. At the straight-line portion of the curve, density increases an equal amount for each exposure increase. At the shoulder, density increases less with each exposure increase than at the straight-line portion.

Choosing a Film: continued

When Speed Is Essential—Fast Films

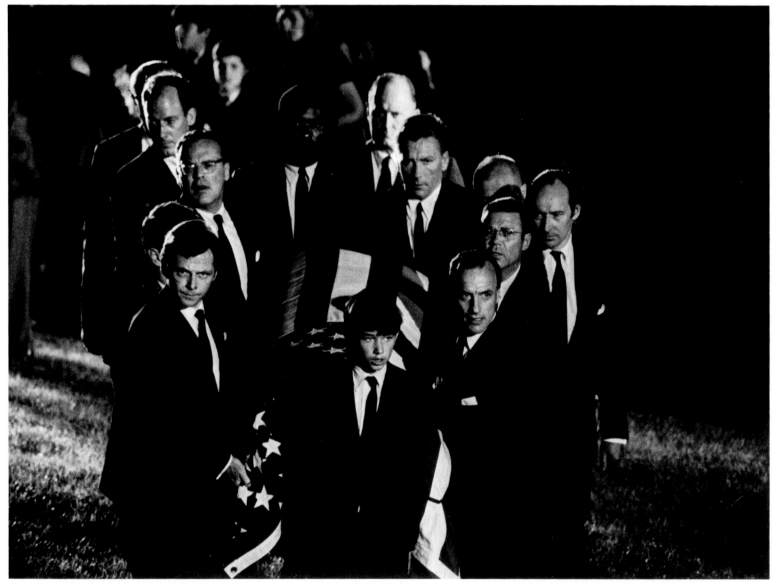

ROBERT LEBECK: *Funeral of Robert Kennedy*, 1968

A **fast film,** about ISO 400 or higher, is an asset when photographing in dim light. Because a fast film needs less light to produce a printable image, it makes photography easier indoors, at night, or in other low-light situations (such as for the picture above). If you "push" a fast film, you can increase even more the speed at which you shoot it. Expose the film as though the film speed is higher than the one designated by the manufacturer, and then give the film in-creased development *(see pages 128–129).*

Even when light is not dim, a fast film is useful for stopping motion. Since it re-quires less light than a slower film, you can use a faster shutter speed, which will

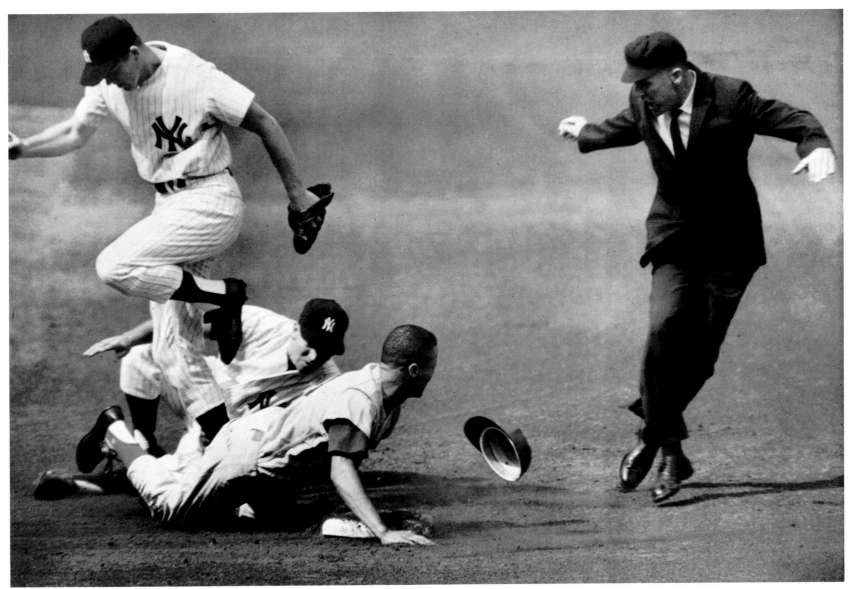

JAMES DRAKE: *World Series,* 1963

record a moving subject more sharply than a slow shutter speed will. In the photograph above, the photographer used a fast film. Even though he was using a long lens, which has a relatively small maximum aperture, he was able to shoot at a fast enough shutter speed to stop umpire, ballplayers, and hat in midplay.

Fast films are getting faster. The film speed of Kodak's T-Max P3200 film, for example, starts at 800. Its speed can readily be pushed to 3200, up to 25,000 if you are adventuresome. A fast film may show increased grain and loss of image detail, especially if you push the film, but the advantages of fast film often outweigh its disadvantages.

HOW BLACK-AND-WHITE FILM SEES COLOR

Different types of black-and-white film react differently to colors in a scene *(see illustrations at right)*. Colors are produced by specific wavelengths of light, and silver halide crystals (the light-sensitive part of photographic emulsion) do not respond equally to all wavelengths.

The first photographic emulsions responded only to the shorter wavelengths of light, from ultraviolet through blue-green. In 1873, **orthochromatic film** was introduced. It had a dye added to the emulsion that extended the response to green and yellow wavelengths. In a way that is still not completely understood, the dye absorbs these slightly longer wavelengths and transfers their energy to the silver halide crystals.

Panchromatic film was a further improvement, and it is now used for almost all ordinary photography. Dyes enable the film to record all colors seen by the human eye, although the film's response is still not exactly like that of the eye. Panchromatic film is still slightly more sensitive to short wavelengths (bluish colors) than to long wavelengths (reddish colors). Sometimes in a print, a blue sky may appear too light or red apples may have almost the same tone as green leaves. This final imbalance can be corrected with filters *(pages 84–87)* if desired.

Special dyes have also been devised to make films respond to invisible infrared wavelengths in addition to all the visible colors, with unusual and often beautiful results *(far right and following pages)*.

orthochromatic film

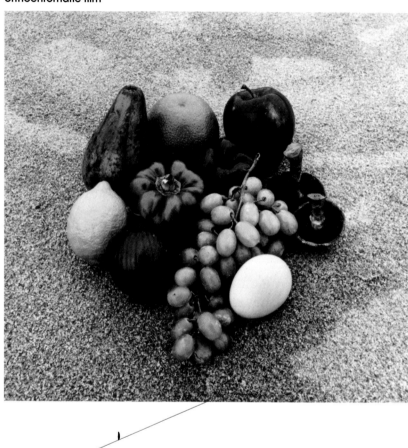

In a photograph made on orthochromatic film, some of the fruits and vegetables above come out looking darker than they would to the human eye because the film responds only to shorter wavelengths—toward the violet end of the spectrum (above)—and is insensitive to reddish colors. The orange, red pepper, and apple (upper right) and the red onion (lower left) all appear unnaturally dark.

panchromatic film

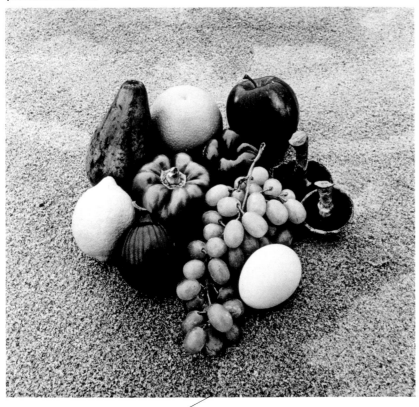

When panchromatic film is used, the tones of reddish objects are more natural in appearance because the film records almost all colors, red through violet and into the ultraviolet (above), that are seen by the eye. The egg looks even whiter than it does in the orthochromatic picture because it has added the light energy of the longer wavelengths to its blend of reflected colors.

infrared film

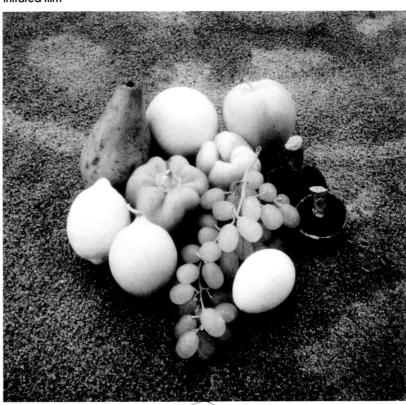

Infrared film records visible colors as well as some longer wavelengths that are not visible. Although most natural objects strongly reflect infrared rays, there is no consistent relationship between the color of an object and the amount of infrared rays that are reflected. In the picture above, only the avocado (upper left) and the mushrooms do not reflect infrared strongly; thus they appear darker than the other objects.

How Black-and-White Film Sees Color: continued

Infrared Film: Seeing Beyond the Visible

Infrared film can produce unusual black-and-white photographs. In a landscape, blue sky will appear very dark, with green foliage unexpectedly light *(see opposite)*. In a portrait, skin tones will have a luminous, almost unearthly, glow. Infrared color film produces interesting color variations but not always with such visually appealing results as black-and-white infrared film.

Infrared films are sensitive to visible light and also to invisible infrared wavelengths that are just slightly longer than the visible waves of red light. These "near-red" waves often create unusual photographic effects because they are not absorbed or reflected in the same amounts as visible light. Objects that appear lightest to the eye may not reflect the most infrared radiation, so infrared images may have unexpected, even surreal, tonal relationships. When a deep-red filter on the lens is used to block most visible wavelengths, so that the photograph is taken principally with infrared waves, these effects become particularly evident.

Leaves, grass, and skin in an infrared photograph will be white because they reflect infrared very strongly. Water particles in clouds also reflect infrared, making clouds very light. But blue sky becomes very dark, because its blue light is mostly blocked by the deep red filter. The film has a grainy look that softens surface detail and can give an overall texture. Details are also softened by halation, a diffuse, halolike glow that surrounds very light objects, especially with overexposure.

Sometimes photographers use infrared film and a red filter for long-distance views on hazy days. Haze is caused by the scattering of visible light by very small particles of water and smoke in the air—an action that does not affect infrared radiation. Instead of being scattered by these particles, infrared waves reflected off the scenery can pass right through them as if they did not exist; a hazy scene photographed with infrared film thus looks perfectly clear.

Using Infrared Film

Storage. *Exposure to heat will fog infrared film with unwanted exposure. Buy infrared film only if it has been refrigerated by the dealer, and keep it under refrigeration yourself as much as possible. Let the film come to room temperature before opening the package.*

Handling. *Even slight exposure to infrared radiation will fog the film, so load and unload the camera in total darkness, either in a darkroom or in a changing bag (a light-tight cloth sack into which you put your hands, the camera, and the film). The slot through which 35mm film leaves its cassette does not block infrared radiation, so only open the film's original sealed container to take out the cassette in total darkness. Put exposed film back in the container before you bring it into the light.*

Focusing. *A lens focuses infrared wavelengths slightly differently than it focuses visible light; so if you focus sharply on the visible image, the infrared image will be slightly out of focus. With black-and-white film, focus as usual, then rotate the lens barrel very slightly forward as if you were focusing on an object just a little closer. Many lenses have a red indexing mark on the lens barrel to show the adjustment needed. Make this correction if depth of field is very shallow, for example, if you are using a long-focal-length lens at a wide aperture or if you are focusing on a point very close to the lens. But the difference is so slight that you don't need to adjust for it otherwise; the depth of field will be adequate to keep the image sharp, even if the critical focusing point is slightly off. No adjustment is necessary with color infrared film.*

Filtration. *See manufacturer's instructions. Kodak recommends a #25 red filter for general use with black-and-white infrared film. This increases the infrared effect by absorbing the blue light to which the film is also sensitive. Kodak recommends a #12 deep yellow filter for general use with color infrared film.*

Exposure. *Infrared wavelengths are not accurately measured by ordinary light meters, whether built into the camera or hand-held. You can try setting a film speed of 50 with black-and-white film or 100 with color film, metering the scene, then bracketing. If your meter is built into the camera, meter without a filter over the lens. Kodak recommends the following manually set trial exposures for average, front-lit subjects in daylight:*

Kodak High-Speed Infrared black-and-white film used with #25 filter: distant scenes—1/125 sec at f/11; nearby scenes—1/30 sec at f/11.

Kodak Ektachrome Infrared color film used with #12 filter: 1/125 sec at f/16.

Flash exposures. *You can use infrared film with flash simply by putting a red filter on the lens and using your flash in the usual way. Or you can cover the flash head with a #87 filter, which passes only infrared radiation. You can also buy a special infrared flash unit that emits mostly infrared light. Make a series of trial exposures to determine the best starting exposure with your unit.*

Bracketing. *Consider any infrared exposure as an estimate that should be bracketed. Start with four additional exposures: $1/2$ stop more exposure, 1 stop more, $1/2$ stop less, and 1 stop less. Even greater bracketing can be useful: all of the above exposures plus $1^1/2$ and 2 stops more exposures, $1^1/2$ and 2 stops less. Once you have some experience with the film, you may be able to reduce the amount of bracketing.*

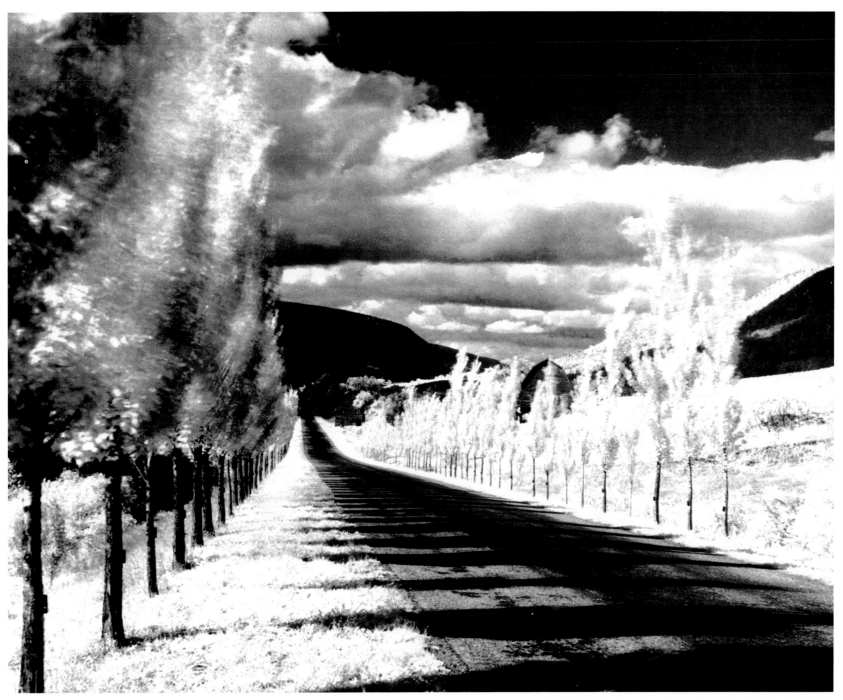

MINOR WHITE: *Road and Poplar Trees, Upstate New York,* 1955

Minor White often saw the sublime in the ordinary, and here infrared film with its altered tonalities aids in the expression of a landscape that becomes a dreamscape. The perspective of the converging lines of road and trees funnels the eye down the road to the dark mountains beyond. The repeated shadows of the trees reinforce the depth in the scene as the distance between them apparently diminishes. There is no sure way to make a landscape like this happen out of a road lined with trees, no matter what film you use. The landscape itself has to cooperate. White often put forth his basic rule of composition: let the subject generate its own composition.

INSTANT-PRINT FILM

In the ordinary photographic process, film is exposed, later developed to produce a negative, and then, even later, printed to make a positive. **Instant-print film,** however, gives you a visible image almost at once. The Polaroid film diagrammed at right has both a negative emulsion and positive paper in one package. After the picture is exposed, the negative and positive are tightly sandwiched together by being pulled between two metal rollers. The image is transferred from the negative to the positive by chemicals at the center of the sandwich.

Polaroid makes instant materials in many formats. In addition to pack film, individual sheets of 4 × 5-inch or 8 × 10-inch film can be used (with a special film holder) in a view camera. Polaroid instant 35mm transparency film can be exposed in any 35mm camera and then, using a special processor, be completely processed in about three minutes to make color or black-and-white slides. *(See pages 238–239 for more about instant color films.)*

Instant film is often used by professional photographers to make a quick check of a setup. An exposure can be made and evaluated on the spot to avoid a mistake when the picture is taken with standard film. Many photographers also use Polaroid film as an end product.

Polaroid makes black-and-white and color film for use with view cameras. A packet containing a sheet of film is loaded into a film holder that is inserted in the camera like an ordinary view camera film holder.

processing chemicals

After the film is exposed, the packet is pulled out of the holder between rollers that break a pod of processing chemicals within the packet. The chemicals spread evenly within the packet to develop and fix the picture.

ALAN ROSS: *Onion,* 1976

◄ *Instant-print materials can produce extraordinarily beautiful images. Polaroid Polapan 400 4 × 5 film has a very smooth gradation of tones. An original Polapan 400 print can have a subtle luminosity that is almost impossible to achieve with conventional black-and-white materials.*

JOE WRINN: *Their First Polaroid, China,* 1979

The special pleasure of instant photography: a group of Chinese soldiers sees for the first time a Polaroid picture developing its image. The Polaroid photograph is of the soldiers themselves, taken by a Western tourist just a few moments before. This scene has a naturalness and ease that is not always easy to get when the photographer is obviously a foreigner. The soldiers have forgotten the photographer and become engrossed in the instant magic of the instant picture—objects taking shape, colors brightening and getting richer while they watch.

USING FILTERS

Attach a filter to the front of a lens, and you change the light that reaches the film. The name—*filter*—describes what most filters do: they remove some of the wavelengths of light reflected from a scene and so change the way that the scene looks in a photograph.

Colored filters let you control the relative lightness and darkness of tones in a black-and-white photograph. They absorb light of certain colors and thus make objects of those colors appear as darker tones of gray. The more light the filter absorbs, the less light reaches the film, and the darker those colors will appear to be. It is easier to predict the effect of a colored filter if you think of it as subtracting (and darkening) colors, not adding them. For example, if you look through a red filter, it seems to tint the entire scene red. But the filter isn't adding red; it is removing blue and green. As a result, blue and green objects will appear darker.

A colored filter absorbs its **complementary color,** the color or colors opposite it on a color wheel *(see color wheel illustrated on page 230)*; a yellow filter absorbs blue, a green filter absorbs red and blue, and so on. A colored filter can appear to lighten objects of its own color, but this is because it makes other colors darker, and by comparison, objects that are the color of the filter seem lighter.

Contrast filters are colored filters that change the relative brightness of colors that would otherwise be too similar in tone in black and white. In color, red apples contrast strongly against a background of green leaves, but in black and white the apples and leaves can be almost the same gray tone. A green filter, which absorbs red, darkens the apples so that they look more natural *(see illustrations, right)*.

Correction filters are colored filters designed to correct the response of film so that it shows the same relative brightnesses that the human eye perceives. For example, film is more sensitive to blue and ultraviolet wavelengths than the eye is. A blue sky photographed without a filter can look too light in a black-and-white photograph, almost as light as clouds that appeared at the scene to be much lighter. A yellow filter, which absorbs blue, darkens the blue part of the sky so that clouds stand out *(see opposite page)*.

Neutral-density filters absorb a quantity of all wavelengths of light. They reduce the overall amount of light that reaches the film while leaving the color balance unchanged; they can be used with either black-and-white or color film. Their purpose is to increase the exposure needed for a scene, so that you can use a slower shutter speed (to blur motion) or a larger aperture (to decrease depth of field).

A **polarizing filter** can be used with either black-and-white or color film to remove reflections, darken skies, and intensify colors *(see page 86)*.

In addition to filters that absorb light, **lens attachments** produce special effects. A cross-screen attachment causes streamers of light to radiate from bright lights such as light bulbs. A soft-focus attachment softens details and makes them slightly hazy.

Filters are made of gelatin or of glass in various sizes to fit different lens diameters. **Gelatin filters** are taped to the front of the lens or placed in a filter holder. They come in many colors and may cost less than glass but can be damaged relatively easily. Handle them by the edges only. **Glass filters** screw or clamp onto the front of the lens. They are convenient to use and sturdier than gelatin but are often more expensive. You will need to increase the exposure for a filtered scene; page 87 tells how to do this.

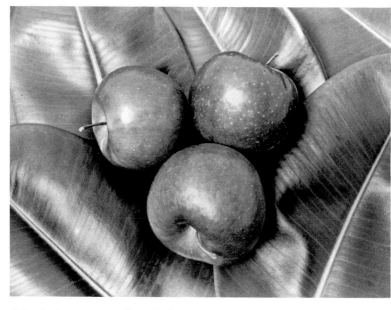

Colors that appear very different to the eye can be confusingly similar in tone in black and white, such as the red apples on the green leaves, above. A colored filter can correct this by absorbing certain colors and making those colors darker in a black-and-white print.

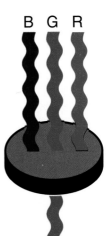

A green filter *#58, used to take the picture below, absorbs much red light, making the red apples darker than the leaves, a natural-looking appearance.*

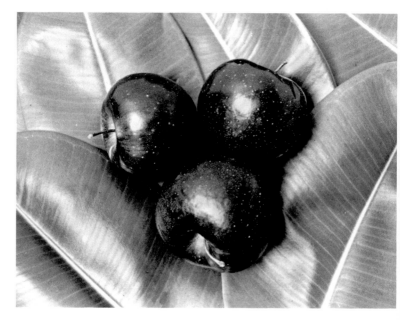

One of the most common uses for a filter in black-and-white photography is to darken a blue sky. Colored filters work for this purpose only when the sky is actually blue. They do not darken the sky on an overcast or hazy day.

Without any filter, the sky in this photograph appears very light, with clouds barely visible. Black-and-white film is very sensitive to blue and ultraviolet light; this often causes skies to appear too light in a black-and-white photograph.

A yellow filter #8 absorbs some of the sky's blue light, making the sky in the picture at right appear somewhat darker than it does above.

A red filter #25 absorbs nearly all blue as well as green light, making the sky in the picture at right much darker than it normally appears and also darkening foliage. Shadows, too, appear darker than in the unfiltered view, because they are illuminated largely by blue light from the sky that the red filter blocks.

Using Filters: continued

A Polarizing Filter to Reduce Reflections

Reflections from a shiny surface can be a distracting element in a photograph. With a **polarizing filter,** you can remove or reduce reflections from water, glass *(top photo)*, or any smooth surface except metal. This is possible because light waves ordinarily vibrate in all directions perpendicular to their direction of travel. But light reflected from nonmetallic smooth surfaces has been polarized—the light waves vibrate in only one plane.

A polarizing filter contains submicroscopic crystals lined up like parallel slats. Light waves that are parallel to the crystals pass between them; waves vibrating at other angles are blocked by the crystals *(center diagram)*. Since the polarized light is all at the same angle, the filter can be turned so as to block it.

To use a polarizing filter, look through it and rotate it until the unwanted reflection is reduced as desired *(bottom photo)*. Then place the filter in the same position over the lens. (You see through the lens with a single-lens reflex or view camera, so the filter can be adjusted while it is in place over the lens.) Because of the partial blockage of light by the filter, the exposure must be increased by 1⅓ stops.

Tiny particles of dust and water in the atmosphere also reflect light and can make a distant scene look hazy. A polarizing filter will decrease such reflections, darken the sky, and make a distant scene look more distinct and more vividly colored. It is the only filter that will darken the sky in a color picture without changing the color balance.

The photograph at top was taken without any filter. The reflection in the window was removed in the picture below by adjusting a polarizing filter (or polarizer) over the lens. The drawing shows how the polarizer works. It is adjusted to pass only those light waves (black) oriented parallel to its picketlike aligned crystals and to screen out all other light waves (gray) angled across the pickets.

reducing reflections from shiny surfaces

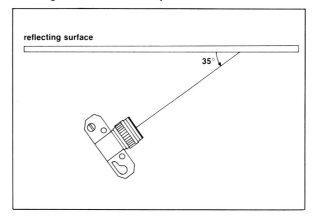

reducing reflections from atmosphere

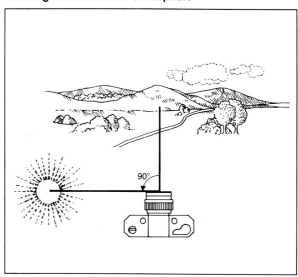

▲
A polarizing filter used to block reflections from a shiny surface like glass or water is most efficient at an angle of about 35° to the reflecting surface (top diagram). Directly in front of the surface, the filter has little or no effect. A polarizing filter can be used to darken a blue sky and to reduce haze by blocking light reflected from particles in the atmosphere. In this case, the filter works best when you are taking pictures at approximately a right angle to the sun (bottom diagram).

More About Filters

Filters absorb part of the light that passes through them, so you need an **exposure increase** when using a filter or the film will be underexposed. The chart shows the effect of various filters on black-and-white film and the number of stops to increase the exposure with them. For each full stop of exposure increase, change the shutter to the next slower speed or the aperture to the next wider setting. Use the aperture to make fractional changes. With an automatic-exposure camera, do this in manual exposure operation *(see page 95)*.

If you have a camera that meters through the lens, it would be convenient if you could simply meter the scene through the filter and let the camera set the exposure. But some types of meters do not respond to all colors, so you may get an in-

correct reading if you meter through a filter, particularly through a dark filter. A #29 deep-red filter, for example, requires 4 stops additional exposure, but some cameras only produce a $2^{1}/_{2}$-stop increase when they meter through that filter, which will underexpose the film by $1^{1}/_{2}$ stops.

You can meter through a filter if you run a simple test first. Select a scene with a variety of colors and tones. Meter the scene without the filter and note the shutter speed and aperture. Then meter the same scene with the filter over the lens. Compare the number of stops the camera's settings changed with the number of stops that they should have changed according to the chart. Adjust the settings as needed whenever you use that filter.

Some sources list the exposure increase needed for a filter not directly in

stops, but as a **filter factor.** The end result is the same, but the calculation is a little different. The factor tells how many times the exposure should be increased. A factor of 2 means the exposure should be doubled (the same as a 1-stop change); a factor of 4 means the exposure should be increased four times (a 2-stop change), and so on. See bottom of chart.

In the chart, the increase for tungsten light (from light bulbs) is different from the increase for daylight because tungsten is more reddish, while daylight is more bluish. Specific films may vary somewhat from these listings; see film instructions. See page 211 for filters used with color film.

Filters for Black-and-White Film

number or designation	color or name	physical effect	practical use	exposure increase for black-and-white film	
				daylight	tungsten
8	yellow	Absorbs ultraviolet and blue-violet	Darkens blue sky to bring out clouds. Increases contrast by darkening bluish shadows. Reduces bluish haze.	1 stop	$^2/_3$ stop
15	deep yellow	Absorbs ultraviolet, violet, and most blue	Lightens yellow and red subjects such as flowers. Darkens blue water and blue sky to emphasize contrasting objects or clouds. Increases contrast and texture and reduces bluish haze more than #8 filter.	$1^1/_3$ stops	$^2/_3$ stop
25	red	Absorbs ultraviolet, blue-violet, blue, and green	Lightens yellow and red subjects. Darkens blue water and sky considerably. Increases contrast in landscapes. Reduces bluish haze more than #15 filter. Used with infrared film.	3 stops	$2^1/_3$ stops
11	yellowish green	Absorbs ultraviolet, violet, blue, and some red	Lightens foliage, darkens sky. For outdoor portraits, darkens sky without making light skin tones appear too pale. Balances values in tungsten-lit scenes by removing excess red.	2 stops	2 stops
47	blue	Absorbs red, yellow, green, and ultraviolet	Lightens blue subjects. Increases bluish haze.	$2^2/_3$ stops	$3^2/_3$ stops
1A or UV	skylight ultraviolet	Absorbs ultraviolet	Little or no effect on black-and-white scenes. Used by some photographers to protect lens surface from damage.	0	0
ND	neutral density	Absorbs equal quantities of light from all parts of the spectrum	Increases required exposure so camera can be set to wider aperture or slower shutter speed. Comes in densities from 0.1 ($^1/_3$ stop more exposure) to 4 ($13^1/_3$ stops more exposure).	varies with density	
—	polarizing	Absorbs light waves traveling in certain planes relative to the filter	Reduces reflections from nonmetallic surfaces, such as water or glass. Penetrates haze by reducing reflections from atmospheric particles. Darkens sky at some angles.	$1^1/_3$ stops	$1^1/_3$ stops

If filter has a factor of . . .	1	1.2	1.5	2	2.5	3	4	5	6	8	10	12	16	32
Then increase the exposure (in stops) . . .	0	$^1/_3$	$^2/_3$	1	$1^1/_3$	$1^2/_3$	2	$2^1/_3$	$2^2/_3$	3	$3^1/_3$	$3^2/_3$	4	5

If you use two or more filters together, add the number of stops of change (1 stop + 1 stop = 2 stops) or multiply the filter factors (factor of 2 × factor of 2 = factor of 4, equivalent to 2 stops).

PHOTOGRAPHER AT WORK: TWO NATURE PHOTOGRAPHERS

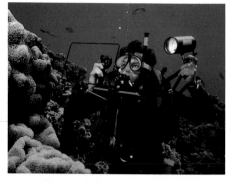

URS MOCKLI: *Jeff Rotman, Red Sea,* 1982

Jeff Rotman

Jeff Rotman was a diver before he became an underwater photographer. People liked the pictures he was taking, and he began promoting story ideas to magazines. His photographic skills are important, but he says his most valuable skill is persuasiveness in dealing with clients. "You have to believe in your work, then go out and sell it. As soon as most editors hear 'fish,' they think it belongs in a wildlife magazine, but many of my pictures can go anywhere."

He goes after assignments on land, too, because he doesn't want to spend all his time in the water. "I don't want to lose my edge. I want to be excited when I go in that water, and if I stay dry for two or three months, I can't wait to get in the water."

"I have been told that I am very aggressive underwater. If I am going to take a picture of a shark, then I go in close, head-on with it. I am not going to shoot from a distance or make it look gentle. I'm going to take its strongest trait and color it up." On land, too, Rotman goes for drama and peak moments. "If I'm doing a story, say at a Bedouin festival where they are going to slaughter a goat, I'm going to shoot the blood spurting out of the goat's throat. I'm not afraid of sensationalism."

Rotman says that before you try to photograph underwater, you should be an excellent diver. "You have to be able to concentrate on the shooting, and to do that you can't worry about your diving." In the photograph of him, Rotman is using a Nikonos III underwater camera fitted with a 28mm lens and a frame that helps position the camera for close-ups. His right hand is adjusting a light meter. His left hand holds an underwater strobe.

JEFF ROTMAN: *Colonial Anemones, Red Sea,* 1990

◄ Rotman photographed these anemones feeding on plankton at night. Night shooting underwater lets Rotman get closer to animals that stay hidden during daylight hours.

▼ This 10-ft sand tiger shark lives in the large ocean tank at the New England Aquarium. It would be very difficult to get a shot like this in open waters—and bring home the film. In the ocean the shark can be dangerous, but in the tank it has become accustomed to divers. The photograph epitomizes what most people have in mind when they think of sharks; Rotman has sold it over and over for use in magazines and books.

JEFF ROTMAN: *Shark!* 1979

JIM ALLAN: *Fred Bruemmer, High Arctic,* 1992

Right: Autumn is one of the best seasons in the far north. "The mosquitoes are gone," says Bruemmer, "so you're not being eaten alive. And the colors of fall are extremely intense." He used the chalky white of a caribou jaw to set off the brilliant red leaves of bearberries. ▶

Bruemmer wondered what would happen if he ▼ *joined some walrus bulls who were lolling in shallow water near a beach. "Easing into the hip-deep water behind a rock, I crept cautiously toward a group about 30 feet away. It took the bulls a while to realize I was there, and that I wasn't a fellow walrus. A few snorted in surprise. Most looked baffled and affronted, like elderly club men whose sanctuary has been invaded."*

FRED BRUEMMER: *Caribou Jaw and Bearberry Leaves in Fall on the Tundra,* 1984

Fred Bruemmer

Fred Bruemmer calls himself "a self-employed anthropologist, biologist, naturalist, photographer, and writer." Typically, he will organize a two- or three-month trip and photograph whatever interests him, for example, sea lions. He will study the animals and their behavior intensively and eventually write an article for a magazine such as *Natural History, Smithsonian,* or *International Wildlife.*

His special interest has been in photographing the Arctic, particularly in creating an awareness of the fragility of the Arctic environment. During his many trips, he has developed an intimate familiarity with the animals and landscape he photographs. For his book *The World of Polar Bears,* he spent nearly ten years photographing polar bears every fall. "I got to know a population of bears to the extent that I could recognize them year after year as individuals. They're no longer just animals. You give them names and get to know them, and it becomes a very personal thing."

As for equipment, he says, "I'm very primitive. I use old Nikon F3's and Kodachrome and don't change either equipment or technique very much. I'm quite happy with them. I use a monopod a lot, because so much of my work is walking, especially in the Arctic. I have a heavy tripod, which I have to use for long lenses, but I always use a monopod to go for the initial walks. I may walk five, six, seven, eight, nine hours, and don't want to carry a 25-pound tripod. The monopod is nice and light."

FRED BRUEMMER: *Walrus Bulls, near Round Island, Alaska,* 1980

SYLVIA PLACHY: *After a Heart Attack,* 1983

RALPH MORSE: *Albert Einstein's Study Shortly After His Death,
Princeton, New Jersey, 1955*

*People shape the space around them, and even
if they are not there, can leave a strong sense of
their presence. These two photographs are
powerful despite the fact—or perhaps
because—the people are gone. See also
Photographing People with a Sense of Place
(pages 166–167).*

To get a rich image with realistic tones, dark but detailed shadows, and bright delicate highlights, you need to expose your film correctly. That is, you need to set the shutter speed and aperture so they let in the right amount of light for a given film and scene. Most negative films have a tolerance, or latitude, for a certain amount of exposure error; they allow for a range of exposures all of which will produce satisfactory negatives. However, the best prints, especially if enlargements are made, are produced from properly exposed negatives. Greatly overexposed negatives (much too much light reached the film) are difficult to print and produce grainy and unsharp prints. Badly underexposed negatives (much too little light reached the film) show no detail in the shadows—something that cannot be remedied when the negative is printed. Color reversal films have very little latitude, especially for overexposure; as little as one stop overexposure makes a distinctly inferior color slide.

Cameras with automatic exposure, especially 35mm cameras, have become common in recent years. Built-in meters measure the intensity of the light; electronic circuitry sets the lens aperture and shutter speed automatically. But personal judgment is still important. Equipment is often programmed for "average" conditions, so you may have to change the recommended settings if you are photographing a backlit scene, a snowy landscape, or other nonaverage situation. This chapter tells when you can rely on automatic exposure and when you need to override it.

One of the best cures for exposure problems is experience. The most expensive meter or camera, complicated exposure strategy, or detailed charts will never replace the sureness you will have when you photograph something for the second—and, even better, the third or fourth—time.

How Exposure Meters Work

In order to consistently expose your film correctly so that it is neither too light nor too dark, you'll need an **exposure meter,** commonly called a light meter. Meters built into cameras are popular because they are convenient, but many photographers still prefer a separate hand-held meter for its flexibility in determining and controlling exposure.

The light-sensitive part of an exposure meter is a photoelectric cell, a device that converts the energy of light into a measurable quantity of electrical energy. A basic meter, like the one opposite, uses that energy to move a needle across a scale. The brighter the light, the farther the needle moves. When you match the number shown on the scale with an arrow on a rotating dial, the meter displays appropriate f-stop and shutter speed combinations for a given film speed. A more electronic model saves you the trouble of lining up the arrow and automatically suggests an f-stop and shutter speed combination on a digital display.

Light meters come in two basic designs: they measure either the light reflected from a subject or the light falling on a subject. Most hand-held meters and all those built into cameras are **reflected-light meters;** they measure **luminance,** the light reflected from (or emitted by) the subject. The meter is pointed at the subject, or at the particular part of the subject the photographer wants to measure at close range, and the reading is made. The light-admitting opening of a hand-held reflected-light meter typically reads the angle of view of a normal-focal-length lens, about 30° to 50°.

In a variation of this type of meter, a spot meter, the angle may be reduced to as little as 0.5° so that readings of very small areas can be made. The side of a building from several blocks away, a person's face at 20 feet, or a dime at 1¹/₂ feet can all be read with a 1° spot meter. Photographers find it convenient to use a spot meter when precise meter readings of key areas are needed. Very accurate exposures can be calculated with a spot meter, but it is important to carefully select the areas that are read. Some meters built into cameras can make a spot reading, although seldom one as narrow as a hand-held spot meter.

Incident-light meters are hand-held. They have a much wider angle of view (about 180°) and measure **illuminance,** the light incident on (falling on) the subject. An incident-light meter is pointed not toward the subject but toward the camera from the position of the subject, so that the meter receives the same light that the subject does.

Some meters, such as the one shown opposite, can make both reflected and incident readings. When the sensing cell is open to direct light, it is a reflected-light meter. When the dome-like diffuser is slid over the sensing cell, it becomes an incident-light meter.

Most meters measure a continuously burning source of light, such as the sun or a tungsten lamp, but **flash meters** measure the output from the brief burst of light from electronic flash. **Color temperature meters** measure the color temperature of light rather than its intensity and are used to calculate the filters needed when a specific color balance is required.

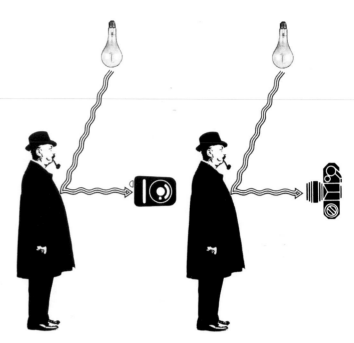

A reflected-light meter can be hand-held (left) or built into a camera (right) and is aimed at a subject to make a reading. It measures the luminance (commonly called the brightness) of a subject—here, the light reflected from the man's coat.

An incident-light meter is faced toward the camera from the position of the subject. It measures the light falling on a subject as seen from the direction of the camera.

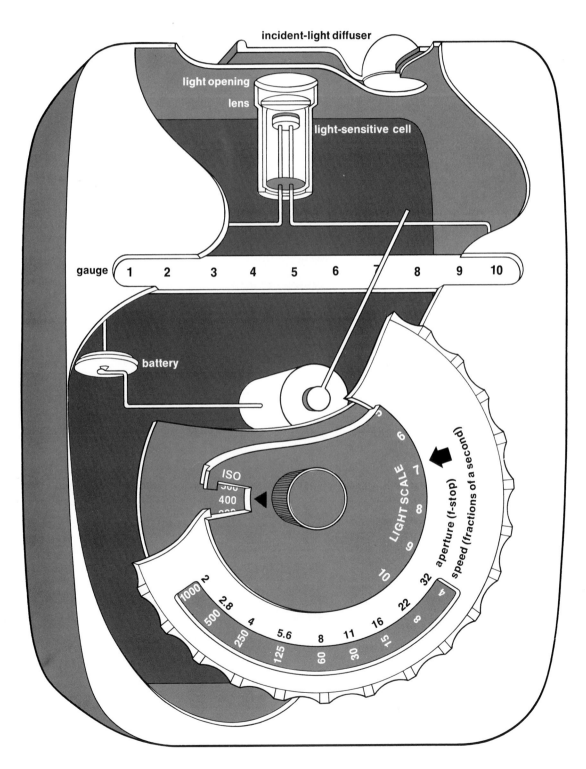

incident-light diffuser

light opening

lens

light-sensitive cell

gauge **1 2 3 4 5 6 7 8 9 10**

battery

ISO
400

LIGHT SCALE

6

7

8

9

10

32

22

16

11

8

5.6

4

2.8

2

1000

500

250

125

60

30

15

8

4

aperture (f-stop)

speed (fractions of a second)

An exposure meter measures the amount of light and then for a given film speed computes shutter speed and f-stop combinations. Meters are calibrated on the assumption that the average of all the tones being read will equal a middle-gray tone. This is true for most scenes—but not all of them. Moreover, the meter doesn't know what it is reading or how light or dark you want the subject to be in the photograph. For these reasons, you sometimes have to override the meter's recommended exposure settings. The following pages contain more about how and when to do this.

Measuring the light. The hand-held meter at left is set to measure reflected light. The domed diffuser, used to make an incident reading, has been slid away from the opening over the light-sensitive cell. To make a reading, the cell is pointed at the subject and the meter activated. How much light strikes the cell determines how much current reaches the needle that moves across the measuring gauge.

The numbers on this gauge are one stop apart: each number indicates a light level twice as high as the preceding number. In this case, the reading is 7—twice the light level at 6, half the level at 8.

Film speed. The speed of the film being used must be set into the meter. Here the center knob is turned until an ISO rating of 400 is shown in the small window near the center of the dial.

Computing the exposure. To convert the light measurement into an exposure setting, the large outer dial of this meter is turned until its arrow points to the number indicated by the gauge needle. This matches apertures (f-stops) with shutter speeds at the bottom of the dials to recommend an exposure for the light intensity measured; f/32 at $^1/_4$ sec, f/22 at $^1/_8$ sec, or any other combination shown would give the same exposure. Here the dial shows the shutter speed in fractions of a second: $^1/_8$ sec is shown on the dial as 8, $^1/_4$ sec is shown as 4, and so on. Many meters provide a direct digital readout of shutter speed and f-stop combinations, light intensity measured in foot-candles, or other data.

Exposure value (EV) scale. Some hand-held meters (and a few cameras) also display an EV scale of equivalent shutter speeds and apertures. EV 1, for example, indicates f/1.4 at 1 sec, and all other combinations of f-stops and shutter speeds that deliver the same amount of light.

Batteries. Many hand-held meters and all meters built into cameras are battery powered. Check batteries regularly (see manufacturer's directions for how to do this). A worn-down or exhausted battery can give an inaccurate reading and eventually will cease functioning altogether.

How Exposure Meters Work: continued

Built-in Meters

Even some professional photographers who used to feel that only hand-held meters were accurate enough, now may also use exposure meters built into cameras. **Built-in meters,** like hand-held, reflected-light meters, measure the light reflected or produced by objects in their view and then calculate an exposure setting. To use a built-in meter, you look through the camera's viewfinder while pointing the meter at the scene or at the part of the scene that you want to meter. The viewfinder shows the area being metered, and most viewfinders also display shutter speed and/or aperture settings. An automatic camera contains circuitry that sets the shutter speed, aperture, or both for you based on the meter reading *(see opposite page)*.

Many built-in meters are **averaging meters** and are **center-weighted:** the meter averages all the light in the scene but weights its average to give more emphasis to the area at the center of the viewfinder than to the surrounding area. This system is based on the assumption—usually, but not always, correct—that the most important part of the subject is in the center of the scene. A center-weighted meter can give an inaccurate reading if the subject is at the side of the frame, for instance, and the surroundings are much lighter or darker than it is.

Some cameras have **multi-segment meters.** They make individual readings from different parts of the viewfinder image, instead of averaging together readings from all parts of the image. These cameras are programmed by the manufacturer to adjust for some potential exposure problems, such as a backlit subject.

A camera may offer several different metering modes, for example, multi-segment metering, center-weighted metering, and spot metering. See the manufacturer's instructions.

Certain scenes can cause a meter to produce the wrong exposure. Most meters are designed to calculate an exposure for scenes including both light and dark areas in a more or less equal balance that averages out to a middle gray tone. If a scene is uniformly light (such as a snow scene), the meter still calculates an exposure as if it were reading middle gray. The result is not enough exposure and a photograph that is too dark. The following pages tell how to identify such scenes and how to set your camera for them.

Meters built into cameras can emphasize different parts of an image when measuring light to calculate exposure settings.

An averaging meter *reads most of the image area and computes an exposure that is the average of all the tones in the scene.*

A center-weighted meter *favors the light level at the center of an image, which is often the most important part to meter.*

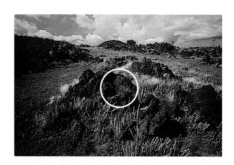

A spot meter *reads only a small part of an image and is useful for exact measurements of individual areas.*

what you see in the camera's viewfinder

what an averaging meter system "sees"

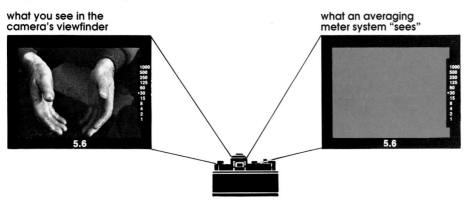

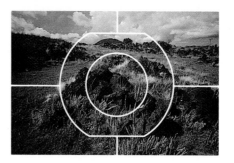

A multi-segment meter *divides the scene into areas that are metered individually and then evaluated against a series of patterns stored in the camera's memory. The resulting exposure is more likely to avoid problems such as underexposure of a subject against a very bright sky.*

In a camera's viewfinder, you can see details of the scene that a built-in meter is reading. Many meters, however, average together light from all parts of a scene and as a result "see" only the overall light level. Even if a meter is programmed to emphasize one or more key areas (such as the central part of a scene), it can't predict every time how you want a scene to look. Sometimes you will want to override the meter's settings.

Automatic Exposure

Overriding Automatic Exposure

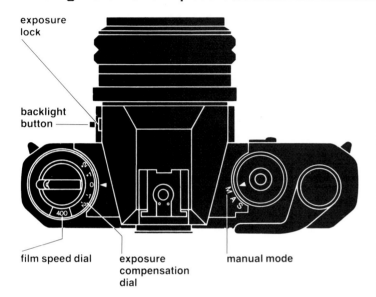

exposure lock

backlight button

film speed dial

exposure compensation dial

manual mode

Automatic exposure works well much of the time, but for some scenes you will want to alter the exposure set by the automatic circuitry. You may want to increase the exposure to lighten one picture or decrease the exposure to darken another. Most cameras have one or more of the following means of allowing you to do so. Camera design and operation vary. For example, some cameras have push-button controls and a data panel to show the settings selected, instead of the dial-operated controls shown here. See the manufacturer's instructions for your model.

Manual mode. *An option on many automatic cameras. You adjust both shutter speed and aperture settings to lighten or darken the picture as you wish.*

Exposure compensation dial. *Moving the dial to +1 or +2 increases the exposure one or two stops and lightens the picture (some dials say ×2 or ×4 for comparable settings). Moving the dial to −1 or −2 (×$\frac{1}{2}$ or ×$\frac{1}{4}$ on some dials) decreases the exposure one or two stops and darkens the picture.*

Backlight button. *May be on the camera if an exposure compensation dial is not. Depressing the button adds a fixed amount of exposure (usually one to one and a half stops) to lighten a picture. It cannot be used to decrease exposure. As its name indicates, it is useful for backlit scenes in which the main subject is against a much lighter background.*

Exposure lock. *The switch temporarily locks in a shutter speed and aperture combination. You move close to meter the most important part of the scene, lock in the settings, then recompose the picture and photograph the entire scene at that exposure.*

Film speed dial. *Resetting the film speed dial causes the camera to give the film less or more exposure than normal. To lighten a picture, decrease the film speed: halving an ISO film speed (for example, from 400 to 200) increases the exposure one stop. To darken a picture, increase the film speed: doubling the film speed (for example, 400 to 800) decreases the exposure one stop.*

Many cameras today come equipped with **automatic exposure.** If your camera is an automatic one, a meter built into the camera measures the average lightness or darkness of the scene in your viewfinder. Electronic circuitry within the camera automatically calculates an exposure that would be correct for an average scene, and then sets shutter speed, aperture, or both, based on the speed of the film you are using. Some cameras are more sophisticated. Their multi-segment meters compare readings from different parts of the scene, then adjust the exposure or warn you of possible problems.

The basic modes of automatic exposure are listed in the box below. Your camera may operate in only one of these modes or in several. See the manufacturer's instructions for details.

For most scenes (those with an average distribution of light and dark tones), automatic exposure works well. There are, however, situations when automatic exposure can underexpose or overexpose your subject because it is giving you an "average" exposure rather than one that is best for a specific scene. A typical example is when a subject is against a much lighter background. Many automatic systems will underexpose such a scene, just as any non-automatic system will if you simply make an overall reading. Unless your camera has a metering system that adjusts for such scenes, you will have to override the automatic exposure mechanism to get the exposure you want. Various means to do this are listed at left. See pages 96–97 for how to meter an average scene, and pages 98–103 for how to identify a nonaverage scene and what to do about it.

Exposure Modes

Aperture-priority automatic. *You select the aperture and the camera adjusts the shutter speed.*	*You set aperture*	*f/5.6*	*f/8*	*f/11*
	Camera adjusts shutter speed	*1/250 sec*	*1/125*	*1/60*
Shutter-priority automatic. *You select shutter speed and the camera adjusts the aperture.*	*You set shutter speed*	*1/250 sec*	*1/125*	*1/60*
	Camera adjusts aperture	*f/5.6*	*f/8*	*f/11*
Programmed (fully) automatic. *The camera adjusts both shutter speed and aperture based on a built-in program. Depending on the program, the camera may select the fastest possible shutter speed, or go to slower shutter speeds rather than opening the lens to the widest aperture.*	*Camera adjusts aperture*	*f/5.6*	*f/8*	*f/11*
	Camera adjusts shutter speed	*1/250 sec*	*1/125*	*1/60*
Manual. *You set both shutter speed and aperture. The camera's built-in meter still can be used to calculate the correct settings.*	*You set aperture*	*f/5.6*	*f/8*	*f/11*
	You set shutter speed	*1/250 sec*	*1/125*	*1/60*

How to Meter: continued

Exposing for Specific Tones

Another method of calculating exposure that can be even more precise than making an overall reading, either from a distance or up close, involves using a reflected-light meter to measure the luminance of one important area, then finding the exposure that will render that area as dark or as light as you want it to be in the final print.

How is it possible to decide in advance what tone an important area will have in the final photograph? It is easy if you know that for any area of uniform tone, a reflected-light meter will recommend an exposure that will render that area as **middle gray** in the print. If you take three meter readings to make three different photographs—first of white lace, then of medium-gray tweed, and finally of black satin—the meter will indicate three different exposures that will record each subject as middle gray *(photographs, this page)*.

However, you can choose how light or dark an area will appear by adjusting the exposures indicated by the meter. If you give more exposure than the meter indicates, the area metered will be lighter than middle gray in the final print. Less exposure will make an area darker than middle gray. For example, if you want the white lace to appear realistically as very light but still show substance and texture, expose two stops more than the meter recommends. (Snow scenes are a typical situation in which you might want to increase the exposure a stop or two because an overall reading can make the scene too dark.) If you want the black satin to appear rich and dark with full texture, expose two stops less than the meter recommends.

One area often metered when calculating exposures for a portrait is **skin tone.** While clothing and background can vary from very light to very dark, most people's skin tones are realistically rendered within only about a three-stop spread. Dark skins seem natural when they are printed as middle gray or slightly darker. Average light-toned skins appear natural one stop lighter than middle gray. Extremely light skins can appear as light at two stops above middle gray. To use a skin tone as the basis for exposure, meter the lighter side of the face (if one side is more brightly lit than the other). For dark skin, use the exposure indicated by the meter; for medium light, give one stop more exposure; for unusually pale, give two stops more.

The other area often metered to determine exposure is the darkest **shadow area** in which it is important to retain a full sense of texture and detail. In the photograph opposite, this is the woman's hair and the shadowed part of the wall to her right. If you want a major shadow area to appear very dark but with objects and details still clearly visible, meter the shadow area and then expose two stops less than the meter indicates.

When you change the exposure indicated by the meter, you must meter specific areas carefully. Changing the exposure affects all the values in the print, not just the one you meter. One area will stay relatively lighter or darker than another—the woman's face *(right)* will always be lighter than her hair or the wall—but all will be either lighter or darker as the scene is given more or less exposure. When shooting negative film, it is worse to underexpose the film than overexpose it. Detail in slightly overexposed highlights can be printed in, but detail that is missing from underexposed shadow areas cannot be added later on. (The opposite is true with color slides; see page 218.) See Chapter 14, Zone System, for a method of controlling tones by adjusting exposure and development.

white lace given exposure suggested by meter

white lace given 2 stops more exposure

gray tweed given exposure suggested by meter

black satin given exposure suggested by meter

black satin given 2 stops less exposure

A reflected-light meter measures the average luminance (the amount of light) from an area, then indicates an exposure that will render that luminance as middle gray in the final print (see photographs above left). If you want a specific area to appear darker or lighter than middle gray, you can measure its luminance and then give less or more exposure than the meter indicates (above right). The gray scale and chart (opposite) show how much to change the meter reading to get a specific tone. The chart is based on material developed by Ansel Adams.

Exposing Black-and-White Film for Specific Tones

Description	Tone
Five stops more exposure than indicated by meter. Maximum white of the paper base. Whites without texture, glaring white surfaces, light sources.	
Four stops more exposure. Near white. Slight tonality, but no visible texture. Snow in flat sunlight.	
Three stops more exposure. Very light gray. Highlights with first sign of texture, bright cement, textured snow, brightest highlights on light skin.	
Two stops more exposure. Light gray. Very light surfaces with full texture and detail, very light skin, sand or snow acutely sidelit.	
One stop more exposure. Medium-light gray. Lit side of average light-toned skin, shadows on snow in a scene with both shaded and sunlit snow.	
Exposure indicated by meter. *Middle gray. The tone that a reflected-light meter assumes it is reading. Neutral gray test card, dark skin, clear north sky.*	
One stop less exposure. Medium-dark gray. Dark stone, average dark foliage, shadows in landscape scenes, shadows on skin in sunlit portrait.	
Two stops less exposure. Dark gray. Shadows with full texture and detail, very dark soil, very dark fabrics with full texture.	
Three stops less exposure. Gray-black. Darkest gray in which some suggestion of texture and detail appears.	
Four stops less exposure. Near black. First step above complete black in the print, slight tonality but no visible texture.	
Five stops less exposure than indicated by meter. Maximum black that paper can produce. Doorway or window opening to unlit building interior.	

Hard-to-Meter Scenes

Exposing Hard-to-Meter Scenes

situation	approximate exposure for ISO 400 film	
stage scene, sports arena, circus event	1/60 sec	f/2.8
brightly lighted downtown street at night, lighted store window	1/60 sec	f/4
city skyline at night	1 sec	f/2.8
skyline just after sunset	1/60 sec	f/5.6
candlelit scene	1/8 sec	f/2.8
campfire scene, burning building at night	1/60 sec	f/4
fireworks against dark sky	1 sec (or keep shutter open for more than one display)	f/16
fireworks on ground	1/60 sec	f/4
television or computer monitor image:		
focal-plane shutter speed must be 1/8 sec or slower to prevent dark raster streaks from appearing in photographs of the screen	1/8 sec	f/11
leaf shutter speed must be 1/30 sec or slower to prevent streak	1/30 sec	f/5.6

If there is light enough to see by, there is probably light enough to make a photograph, but the light level may be so low that you may not be able to get a reading from your exposure meter. Try metering a white surface such as a white paper or handkerchief; then give about two stops more exposure than indicated by the meter.

If metering is not practical, the chart at right *(top)* gives some starting points for exposures with ISO 400 film. Since the intensity of light can vary widely, **bracket your exposures** by making at least three pictures: (1) using the recommended exposure, (2) giving one to two stops more exposure, and (3) giving one to two stops less exposure. One of the exposures should be printable, and the range of exposures will bring out details in different parts of the scene.

If the exposure time is one second or longer, you may find that the film does not respond the same way that it does in ordinary lighting situations. In theory, a long exposure in very dim light should give the same result as a short exposure in very bright light. According to the photographic law of reciprocity, light intensity and exposure time are reciprocal; an increase in one will be balanced by a decrease in the other. But in practice the law does not hold for very long or very short exposures.

Reciprocity effect occurs at exposures of one second or longer (and at exposures shorter than $1/1000$ second); you get a decrease in effective film speed and consequently underexposure. To make up for the decrease in film speed, you must increase the exposure. The exact increase needed varies with different types of film, but the chart at right *(bottom)* gives approximate amounts. Bracketing is a good idea with very long exposures. Make at least two exposures: one as indicated by the chart, plus one more giving at least a stop additional exposure. Some

meters are designed to calculate exposures of several minutes' duration or even longer, but they do not allow for reciprocity effect. The indicated exposure should be increased according to the chart.

Very long exposure times cause an increase in contrast since the prolonged exposure has more effect on highlights than on shadow areas. This is not a problem in most photographs, since contrast can be controlled when the negative is printed. But where contrast is a critical factor, it can also be decreased by decreasing the film development time. The amount varies with the film; exact information is available from the film manufacturer or see the chart below. Kodak's T-Max films require no development change. The reciprocity effect in color film is more complicated since each color layer responds differently, changing the color balance as well as the overall exposure *(see pages 216–217).*

Preventing Reciprocity Effect: Corrections for Long Exposures

	with most black-and-white films					with Kodak T-Max films		
indicated exposure	open up aperture	or	increase exposure time to	also	decrease development time	open up aperture	or	increase exposure time to
1 sec	1 stop more		2 sec		10%	1/3 stop more		no increase
10 sec	2 stops more		50 sec		20%	1/2 stop more		15 sec
100 sec	3 stops more		1200 sec		30%	1 1/2 stops more with T-Max 400; 1 stop more with T-Max 100		300 sec with T-Max 400; 200 sec with T-Max 100

At exposure times of 1 sec or longer, film does not respond exactly as it does at shorter shutter speeds. One unit of light falling on film emulsion for 1 sec has less effect than 10 units of light falling on the same emulsion for 1/10 sec. This reciprocity effect during long exposure times means that exposures must be increased or the film will be underexposed, particularly in shadow areas. To compensate for this, increase the indicated exposure as shown in the chart above. Highlights are less subject to reciprocity effect during long exposures with some films, so to prevent too dense highlights when you increase exposure, decrease development time if shown in the chart.

LISL DENNIS: *Broadway at Night,* 1982

On Broadway at night, Lisl Dennis took a preliminary meter reading off the stone of the statue base because she wanted to make sure that the inscription would show. From that point, she "bracketed like a bandit." The original of this picture was on color transparency film, which has very little tolerance for under- or overexposure, so Dennis bracketed in half-stop increments. Larger increments are satisfactory with black-and-white film. The backward tilt to the statue and the buildings comes from angling a short-focal-length lens upward.

Substitution Readings

What do you do if you can't get close enough to the subject to make a reading and you don't have a spot meter that can make a reading at a distance? The solution is a **substitution reading.** Suppose you are photographing a boat, but water between you and it makes it impossible to walk over to make a reading directly. You can often find an object with a similar tone and in similar light nearby to meter instead.

One object always with you that can be metered is the palm of your hand. Average light-toned skin is about one stop lighter than the middle-gray tone for which meters calibrate an exposure, so if your skin is light, give one stop more exposure than the meter indicates. If the skin of your palm is dark, use the indicated exposure. Even better, calibrate your palm: meter it, then meter a gray card (described below) and see how much the readings differ.

Another useful substitution reading is from a **gray card,** a test card of a standard gray tone. This is a piece of 8 × 10-inch cardboard with a gray side that reflects 18 percent of the light falling on it and a white side that reflects 90 percent of the light. Since light meters are calibrated for a middle-gray tone of about 18 percent reflectance, a reading from a gray card produces an accurate exposure if the card is placed so that it is lit from the same angle as the subject. If the light is very dim, make a reading from the white side of the card; it reflects five times as much light as middle gray, so increase the indicated exposure five times (two and one-third stops).

A gray card is often used to balance the light in a studio setup or when copying an object such as a painting. It is also useful in color photography as a standard against which the color balance of a print can be matched.

For photographing fast-moving situations such as street scenes, metering the palm of your hand makes a quick substitution reading. Hold your palm so that the light on it is about the same as on the people or objects you want to photograph. If your skin is an average light tone, expose one stop more than the meter indicates.

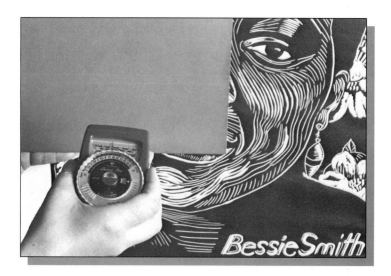

An accurate exposure can be calculated by metering the light reflected from a standard-gray test card. Place the card at the same angle to the light as the front of the subject. Meter the card from the direction that the camera will be when you are shooting. Don't meter at an angle if the camera will be shooting head on. When you meter any object at close range, hold the meter or camera so that it does not cast a shadow on the subject.

WHAT WENT WRONG?

subject too dark against bright background

negative too thin

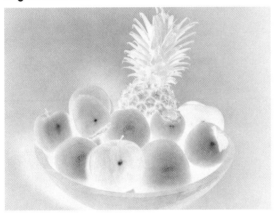

negative too dense

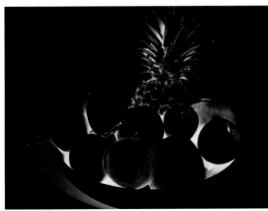

Troubleshooting Exposure Problems

If your negatives didn't come out the way you expected, check below. See also Troubleshooting Camera and Lens Problems (page 63), Negative Problems (page 133), Print Problems (page 163), and Flash Problems (page 272).

When you evaluate exposure, remember that a negative is the reverse of a positive transparency, such as a color slide. An area that is too dense in a negative will be too light in a slide; both are caused by overexposure, too much light reaching the film. An area that is too thin in a negative will be too dark in a slide; the cause is underexposure, not enough light reaching the film.

No picture at all

Image area and film edges are clear in negative (dark in slide). Film frame numbers are visible.

Cause: *The film was not exposed to light. If the entire roll of film is blank, an unexposed roll may have been processed by mistake. If you are sure you took pictures with the film in the camera, it probably did not catch on the film-advance sprockets and so did not advance from frame to frame. If only some frames are blank, the lens cap could have been left on during exposure, the flash failed to fire, the shutter failed to open, or the mirror in a reflex camera failed to move out of the way of the film.*

Prevention: *Check for equipment failure if this is a recurring problem.*

Image area and film edges are clear in negative (dark in slide). Film frame numbers do not show.

Cause: *A film development problem: the film was put into fixer before it was developed.*

Prevention: *If you developed the film yourself, review film processing, page 121.*

Image area and film edges are dark in negative (light in slide).

Cause: *Some or all of the film was accidentally exposed to light, for example, by opening the camera back or by turning on the room lights after the film was on the developing reel but before it was put into a light-tight developing tank.*

Prevention: *Try not to do it again.*

Negative thin-looking; difficult to make a print that is not too dark. Slide too dark.

Cause: *Most likely the film was underexposed: not enough light reached it. Less likely, film did not receive enough development.*

Prevention: *The best prevention for occasional exposure problems is simply to meter scenes more carefully and to make sure you correctly set all camera controls. If your negatives frequently look underexposed, your meter could be inaccurate. If your camera lets you do so, set it to a film speed lower than the rated film speed. For example, with ISO 400 film, set the film speed to half that rating, 200, to get 1 stop more exposure.*

Negative dense-looking; difficult to make a print that is not too light. Slide too light.

Cause: *Most likely the film was overexposed: too much light reached it. Less likely, the film received too much development.*

Prevention: *Metering more carefully will help prevent the problem. But, if your negatives frequently look overexposed, you might have a meter problem. If your camera lets you do so, set it to a film speed higher than the rated film speed. For example, with ISO 400 film, set the camera to double that rating, 800, to get 1 stop less exposure.*

Snow scene (or other very light scene) too dark in slide. Negative thin, difficult to make a light-enough print.

Cause: *The meter computed an exposure for a middle-gray tone, but the scene was actually lighter than middle gray, so it appears too dark.*

Prevention: *When photographing scenes that are very light overall, such as snow scenes or sunlit beach scenes, give 1 or 2 stops more exposure than the meter recommends (see page 106).*

Subject very dark against lighter background in print or slide.

Cause: *Your meter was influenced by the bright background, underexposing the main subject.*

Prevention: *Don't make an overall reading when a subject is against a bright background. Move in close to meter just the subject, then set your shutter speed and aperture accordingly (see page 98).*

Subject very light against darker background in print or slide.

Cause: *Your meter was influenced by the dark background, overexposing the main subject.*

Prevention: *This happens less often than the preceding problem, but can occur if the subject is small and light against a much larger, very dark background. Move in close to meter just the subject (see page 98).*

USING EXPOSURE

Before making an exposure, stop for a moment to visualize how you want the final print or slide to look. Do this especially if you are using a camera in an automatic exposure mode. Using many automatic exposure cameras is like using a hand-held reflected-light meter to make a reading of the overall scene. If the scene has an average tonal range, an overall reading produces a good exposure. But many scenes (like the one on this page) do not have an average range of tones. You can use automatic exposure or make an overall reading when an overall exposure will work well; when it won't, make the metering decisions yourself.

There are other scenes for which you might want an out-of-the-ordinary interpretation, like the silhouette *(opposite)*, which is produced by underexposing part of a scene. Terminology like "underexposed" implies that there is a "correct" exposure. There is—when you want it that way. Don't let anything stop you from experimenting or doing something differently if that is what you want.

ELLEN LAND-WEBER: *Greece, 1990*

If a scene is light overall, the reading recommended by a hand-held reflected-light meter or by a meter built into a camera will probably make the scene too dark. Meters calculate exposures based on the assumption that the tones in a scene average out to middle gray. If a scene has many very light tones (such as a snow scene) or if you want most of the tones in a scene to appear lighter than average in a print, try giving one or two stops extra exposure. Bracket the exposures if you are not sure.

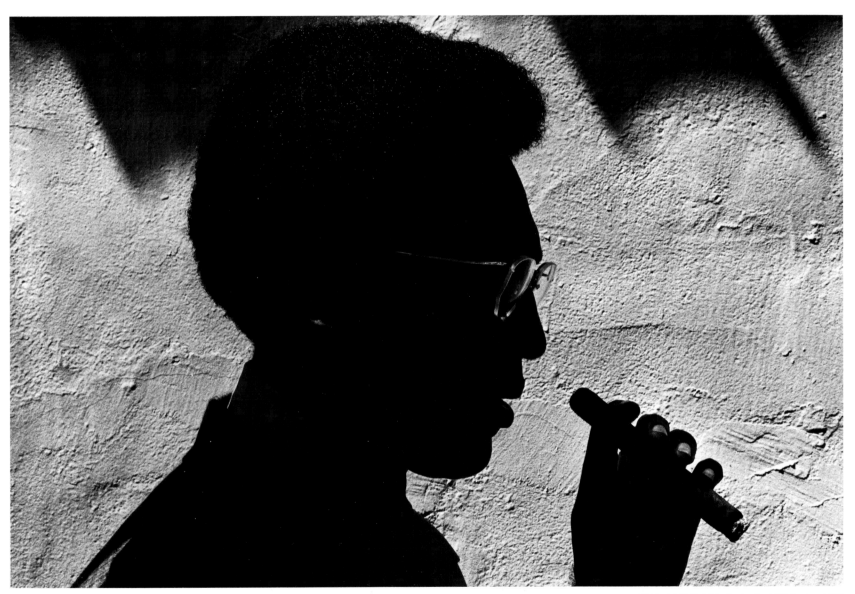

JOHN LOENGARD: *Portrait of Bill Cosby,* 1969

In a silhouette, the subject is underexposed against a much lighter background. In the photograph above, light was shining on the wall, but not on the part of the subject visible from camera position. The wall was actually a glaring white, but exposing it as a middle-gray tone caused the subject to be grossly underexposed.

Four stops more exposure would have produced a normal rendering of the person against an almost white background. This is a deliberate version of the same effect that makes a subject very dark if a very light background such as the sky is included during metering (see page 99).

PAUL CAPONIGRO: *Negative Print*, 1963

Developing the Negative 6

In one sense, the moment the camera shutter exposes the film, the picture has been made. Yet nothing shows on the film; the image is there but it is latent or invisible. Not until it has been developed and printed is the image there to be enjoyed. How enjoyable it will be depends to a great extent on the care you use in darkroom work, for there are many opportunities in developing and printing to control the quality of the final photograph.

This control begins with the development of the negative. The techniques are simple and primarily involve exercising care in following standard processing procedures and in avoiding dust spots, stains, and scratches. Control also includes the ability to adjust the developing process, when necessary, perhaps to "push" the film.

This chapter describes both basic development techniques and somewhat more advanced material to give you greater control over your negatives. The skills needed to develop good negatives are quickly learned and the equipment needed is modest, but the reward is great—an increased ability to make the kind of pictures you want.

◄ *Printing a photograph as a negative image instead of as a positive one often makes the literal recording of a scene less important (as with the spring wildflowers, opposite) and strengthens the graphic elements of line and form. The dark shadow areas in the original scene (or in a positive print) become light so that light seems to come from behind or within the subject. The dark objects in this print (light-toned flowers in the original scene) appear to float on the surface of the print. Compare Minor White's negative print, page 69.*

HOW TO PROCESS ROLL FILM STEP BY STEP

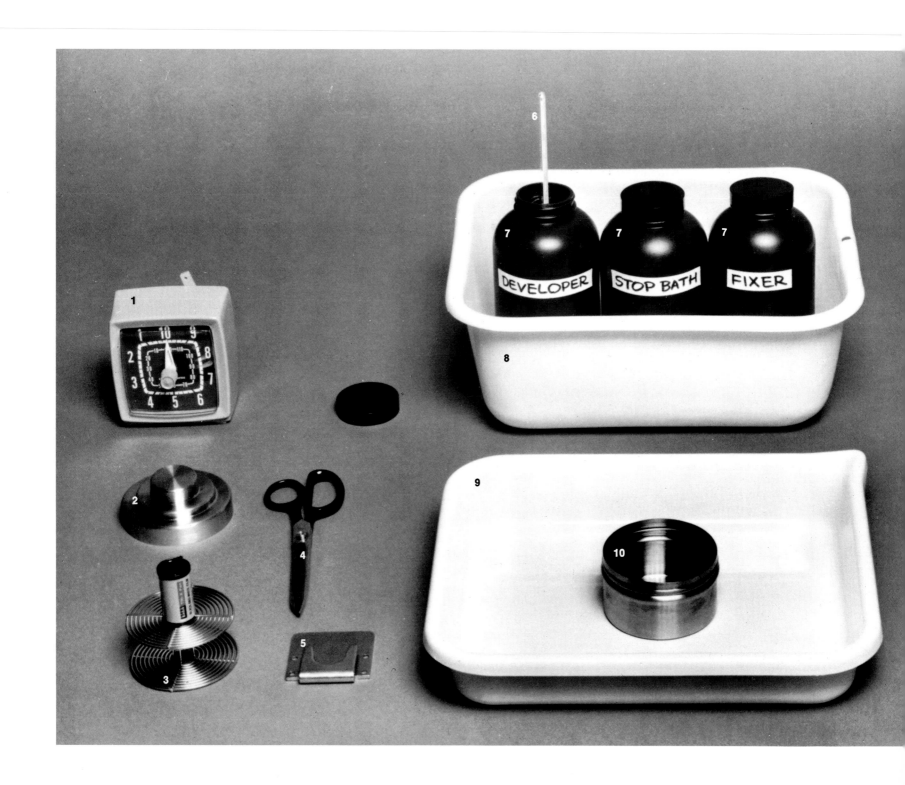

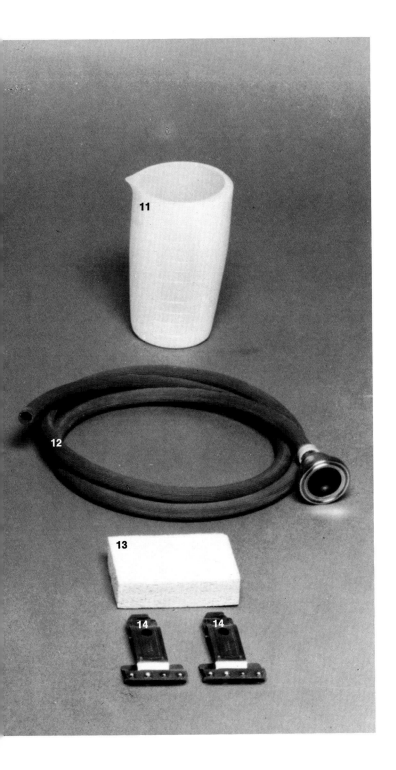

1 | interval timer
2 | developing tank cover and cap
3 | developing reel
4 | scissors
5 | film cassette opener (or bottle cap opener)
6 | thermometer
7 | chemical solutions
8 | temperature control pan for chemical solutions
9 | temperature control tray for developing tank (optional)
10 | developing tank
11 | 1-quart graduate
12 | washing hose
13 | photo sponge
14 | film drying clips (or clothespins)

Orderliness will make development simpler. Developing your first (and all future) rolls of film will be simplified if you arrange your equipment in an orderly and convenient way. The process starts in total darkness and, once begun, moves briskly. **Consistency** also pays off: if you want to avoid too dense, too thin, unevenly developed, or stained negatives, you need to mix solutions accurately, adjust their temperatures within a degree or two, agitate film during development at regular intervals, and watch processing times carefully.

If you are about to develop your first roll of film, practice loading a junked roll of film onto the developing reel. After you get a feeling for how to do this, practice with your eyes closed. Loading the film onto the reel has to be done in total darkness, so practice until the procedure feels comfortable. *(See steps 3 to 8, pages 114–116.)*

Processing chemicals include a developer to change the latent (still invisible) image on your exposed film to a visible one. Pick an easily available, all-purpose developer and become familiar with it before experimenting with other types. You will also need a stop bath (either water or diluted acetic acid) to halt the action of the developer, and a fixer (sometimes called hypo) to dissolve unexposed silver compounds, which will darken in time unless removed. See page 112 for an explanation of how to mix and dilute chemicals and page 121 for a summary of the steps in chemical processing.

Check the recommended **time and temperature** for the film and developer combination you are using *(step 1, page 114)*. The preferred temperature is generally 68° F (20° C), but you may have to use a higher temperature (and a correspondingly shorter development time) if your tap water is warm. Running water is used to wash the film, and the temperatures for all solutions including the wash water should be within about three degrees of the developer temperature. Excessive temperature changes can cause increased graininess and other problems in the film.

How to Process Roll Film Step by Step: continued
Handling Chemicals

Handling Chemicals—A Summary

Record keeping. *After processing film, write down the number of rolls developed on a label attached to the developer bottle—if you are not using a one-shot developer (see below). The instructions that come with developers tell how many rolls can be processed in a given amount of solution and how to alter the procedure if the solution is reused. Each succeeding roll of film requires either extra developing time or, with some developers, addition of a replenisher. Also record the date the developer was first mixed, because even with replenishing most developers deteriorate over time. Check the strength of the fixer regularly with a testing solution made for that purpose.*

Replenishing developers. *Some developers can be used repeatedly before being discarded if you add additional chemicals to them to keep the solution up to full strength. Carefully follow the manufacturer's instructions for replenishment.*

One-shot developers. *These developers are designed to be used once and then thrown away. They simplify use (in that no replenishment is needed), and they can give more consistent results than a developer that is used and saved for a long time before being used again.*

Mixing dry chemicals. *Add dry chemicals to water at the temperature suggested by the manufacturer. Stir gently until dissolved. If some of the chemicals remain undissolved, let the solution stand for a few minutes. Be sure the solution has cooled to the correct temperature before using.*

Stock and working solutions. *Chemicals are often sold or mixed first as concentrated liquids (stock solutions). When the chemical is to be used, it is diluted into a working solution, usually by the addition of water. The dilution of a liquid concentrate may be given on an instruction sheet as a ratio, such as 1:3. The concentrate is always listed first, followed by the diluting liquid. A developer to be diluted 1:3 means 1 part developer and 3 parts water. To fill a 16-oz (500-ml) developing tank with such a dilution, use 4 oz (125 ml) developer and 12 oz (375 ml) water.*

Adjusting temperatures. *To heat up a solution, run hot water over the sides of the container (a metal one will change temperature faster than glass or plastic) or place it in a pan of hot water. Placing a container in a tray of ice water or in a refrigerator will cool down a solution in just a few minutes; cooling by running tap water over the container can take a long time unless the tap water is very cold. Stir the solution gently from time to time; the temperature of the solution near the outside of the container will change faster than at the center.*

Avoid unnecessary oxidation. *Oxygen speeds the exhaustion of most chemicals. Don't use the "cocktail shaker" method of mixing chemicals by vigorously shaking the solution; this adds unwanted oxygen. Store all chemicals in tightly closed containers to prevent their exposure to air. Accordionlike collapsible bottles that leave no room for unwanted air are made. Developers are also affected by light and heat, so store them in dark-colored bottles at temperatures around 70° F (21° C), if possible.*

Contamination—*chemicals where they don't belong—can result in a plague of darkroom ills. Fixer on your fingers transferred to a roll of film being loaded for development can leave a neat tracery of your fingerprints on the film. A residue of the wrong chemical in a tank can affect the next solution that comes into contact with it. Splashes of developer on your clothes will slowly oxidize to a brown stain that is all but impossible to remove. These problems and more can be prevented by taking a few precautions:*

Rinse your hands well when chemicals get on them and dry them on a clean towel; be particularly careful before handling film or paper. It isn't enough just to dip your hands in the water in a temperature control pan or print holding tray; that water may also be contaminated.

Use lint-free paper towels for drying, since cloth ones quickly become loaded with chemicals. If you are conservation minded, use a cloth towel, but wash it frequently.

Rinse tanks, trays, and other equipment well both before and after use. Be particularly careful not to get fixer or stop bath into the developer; they are designed to stop developing action, and that is exactly what they will do. Make sure reels, especially plastic ones, are completely dry before loading film.

Wear old clothes or a lab apron in the darkroom.

Keep work areas clean and dry. Wipe up spilled chemicals and wash the area with water.

Handling Chemicals Safely

Photographic chemicals, dry or in solution, should be handled with care, like all chemicals. The following guidelines are designed to prevent accidents and to minimize injury if accidents occur.

General cautions
1. *Read labels carefully before using a new product.*
2. *Use protective gear such as rubber gloves and a waterproof apron when mixing solutions, plus safety goggles when handling concentrated acids or strong alkalies. Some chemicals, particularly those in developers, can cause allergic skin reactions; wearing rubber gloves and using print tongs can prevent problems.*
3. *If chemicals are accidentally splashed into the eye, immediately flood the eye with running water for at least 15 minutes. Then call a doctor. Keep a hose attached to a cold water tap in the chemical mixing area.*
4. *Keep chemicals out of the mouth. Wash hands before eating. Do not eat in a room where chemicals are used.*
5. *Adequately ventilate areas where chemicals are used.*
6. *Do not smoke where chemicals are used. Some chemicals are flammable or explosive.*
7. *Store chemicals and solutions safely, out of the reach of children. Do not store them in a refrigerator that is used for food.*
8. *Dispose of used chemicals safely. Back before people became conscious of ecological consequences, one simply poured chemicals down the drain. Now, many large users, such as school or professional labs, arrange for a commercial service to handle the disposal of used chemicals. Some community water districts offer a similar service to smaller users. If no other alternative is available in your area, small quantities of most chemicals can generally be discarded down the drain if they are followed by a generous amount of water. Color chemistry can be particularly toxic and should be handled as directed by the manufacturer. Local codes and practices vary. See manufacturer's instructions or ask first.*

Handling acids

Be cautious when using any acid, particularly in a concentrated form, and be prepared to deal with emergencies.

1. *Remember the basic rule when diluting acids: ADD ACID TO WATER, NEVER WATER TO ACID.*
2. *For external contact with a concentrated acid: flush with cold water immediately—do not scrub—until the area is completely clean. Do not use ointments or antiseptic preparations. Cover with a dry, sterile cloth until you can get medical help.*
3. *For eye contact: immediately flood the eye with running water for at least 15 minutes. Then always get medical help.*
4. *For internal contact: do not induce vomiting. Instead, drink a neutralizing agent such as milk or milk of magnesia. Get medical help.*

In order to photograph Bruce Springsteen in concert, Scott Goldsmith had to make both development and exposure choices. Concert lighting is often too dim for an adequately fast shutter speed, so Goldsmith used an ISO 400 film, which he planned to push to a film speed of ISO 800. That is, he would expose the film as if it were one stop more sensitive to light than it actually was, then make up for the resulting underexposure by overdeveloping the film (see pages 128–129 for more about how to push film). This would let him use a shutter speed one stop faster than if he did not push the film.

To meter the scene, Goldsmith did not make an overall reading that averaged all the tones of the scene, because that would have given unpredictable results. The picture could have been too light because of the dark stage areas behind the performers, or the picture could have been too dark because the meter might be overly influenced by the bright lights visible behind them. To prevent both of these problems, he made a spot reading of Springsteen's face and based his exposure on that.

SCOTT GOLDSMITH: *Bruce Springsteen in Concert,* 1984

How to Process Roll Film Step by Step: continued
Preparing Chemicals and Film

1 | set timer, adjust chemical temperatures

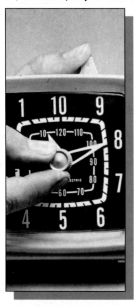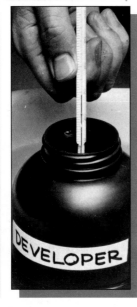

2 | set out materials for loading film

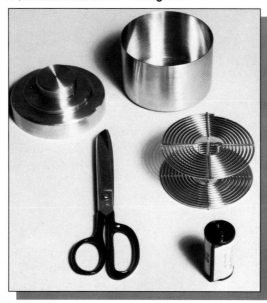

3 | open the film cassette

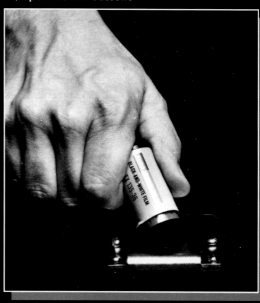

The correct development time depends on the kind of film plus the kind of developer and its temperature. Charts that accompany films and developers list suggested combinations. If a chart lists different times for large tanks and small tanks (sometimes called reel-type tanks), use the small-tank times. Select a time and temperature for your film and developer, and set—but don't start—the interval timer.

Mix the developer, stop bath, and fixer to the working strength recommended by manufacturer. Mix at least enough solution to completely cover the reel (or reels, if you are developing more than one) in the tank; it's better to have too much solution than too little.

Check the temperatures of the developer, stop bath, and fixer (rinse the thermometer between chemicals). Adjust the temperature of the developer exactly; the temperatures of the other solutions should be within about 3 degrees of the developer.

Fill the temperature control pan with water at the developing temperature. Leave the bottles in the pan; the water keeps the chemicals in them at the correct temperature.

Arrange in a dry, clean, light-tight area the materials you will need to load the film onto the developing reel: film cassette, scissors, reel, plus a dry, clean developing tank with—very important—its cover. The film is loaded onto the reel in the dark and has to be put into the tank and covered before you can turn the lights on again. For opening the cassette, also set out an opener like the one shown on page 110 or a bottle cap opener.

Be sure you have a completely dark area in which to load the film. A room is not dark enough if you can see objects in it after staying 5 minutes with all lights out. If you cannot find any completely dark area, a changing bag can be used to reel the film; your hands fit inside the light-tight bag, along with film, opener, scissors, reel, and the empty tank and its cover.

Lock the door and turn out the lights. In the dark, open the roll of film.

To remove film from a standard 35mm cassette, find the spool end protruding from one end of the cassette. Pick up the cassette by this end, then pry off the other end with the cassette opener or a bottle cap opener. Slide the spool out.

With larger sizes of roll film, which are not contained in cassettes, break the paper seal and unwind the paper until you reach the film. Let the film roll up as you continue unwinding the paper; when you reach the other end of the film, gently pull it free of the adhesive strip that holds it to the paper. To open a plastic cartridge used in an instant-loading camera, twist the cartridge apart and remove the spool. Do not unroll film too rapidly or you may generate static electricity—a tiny bit of light, but enough to streak the film.

4 | square off the film end

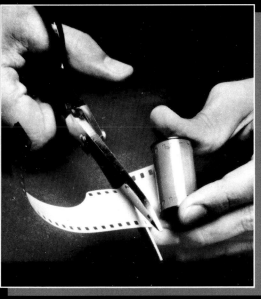

5 | load film on a stainless-steel reel

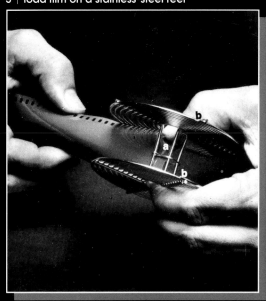

6 | finish loading a stainless-steel reel

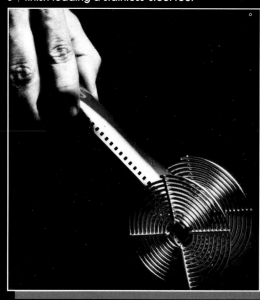

Try to handle the film by the edges only. If you touch the surface, particularly the emulsion side, your skin can leave oil that can cause uneven development or pick up dust.

With the scissors, cut off the half-width strip at the beginning of a roll of 35mm film. Film base is quite tough, so cutting the film is better than trying to tear the end off.

Each side of the stainless-steel reel shown is made of wire in a spiral starting at the core of the reel (a) and running to the outside; the space between the spirals of wire forms a groove that holds the film edge. You have to correctly align the film in one hand and the reel in the other to get the film to slip into the grooves.

Hold the spool of film in either hand so that the film unwinds off the top. Unwind about 3 inches and bow it slightly between thumb and forefinger. Don't squeeze too hard or you may damage the film.

Hold the reel vertically in your other hand and feel for the blunt ends (b) of the spirals at the outside edge of the reel. Rotate the reel until the ends are at the top, then point the ends so they face toward the film.

Now insert the squared-off end of the film into the core of the reel. Some reels have a clip in the core to grip the film end. Rotate the top of the reel away from the film to start the film into the innermost spiral groove.

Other types of reels are available, like the plastic reel shown in step 7, page 116. See step 7 or manufacturer's instructions for loading.

To finish winding film on a stainless-steel reel, rest the reel edgewise on a flat surface. Keep one hand on the reel so it doesn't get away from you. Continue to hold the film spool as before with thumb and forefinger, bowing the film just enough to let it slide onto the reel without catching at the edges. Now unwind a short length of film and push the film so that the reel rolls forward. As it rolls it will draw the film easily into the grooves. (You can, if you prefer, gently rotate the reel with one hand, drawing the film into the spirals.) When all the film is wound on the reel, cut off the spool and the tape that attaches it to the film.

Check that the film has been wound into an open spiral with each coil in a separate groove. (Before loading your first roll of film, use a junked roll to feel about how much a 36-exposure roll of film, or whatever you will be processing, fills up the developing reel when it is correctly loaded.) If, after loading an exposed roll, you find more— or fewer—empty grooves than the length of your film allows for, gently unwind the film from the reel, rolling it up as it comes, then reload. Unless the reel is correctly loaded, sections of film may touch, preventing development at those points.

How to Process Roll Film Step by Step: continued
Getting the Film into the Developer

Alternate procedure
load film on a plastic reel

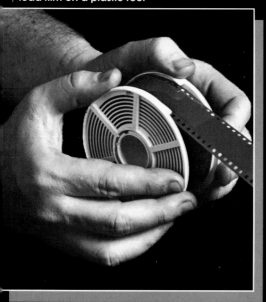

8 | put the reel into the tank and cover it

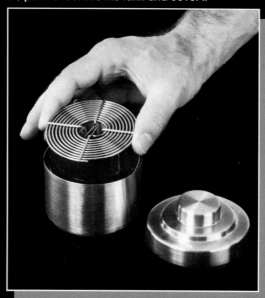

9 | add the developer and start the timer

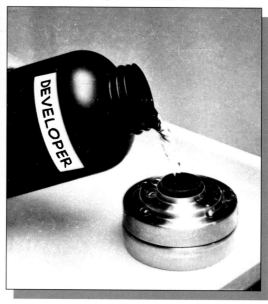

Plastic reels are a popular alternative to stainless-steel reels. They are easier to load, especially for beginners, although not as durable or as easy to clean as stainless reels. Make sure before attempting to load film that the reel is completely dry.

To load 35mm film on this reel, open the cassette and square off the film end (steps 3 and 4, pages 114 and 115.) Cut between the sprocket holes, not through them or the film may not load properly. To test for a proper cut, run your finger along the squared-off end of the film. (Remember, you are doing this in the dark.) If you feel a snag, make another cut close to the end of the film. When the end feels smooth, the cut is correct.

Hold the film in either hand so that the film unwinds off the top. Hold the reel vertically in your other hand with the entry flanges at the top, evenly aligned and pointing toward the film. Insert the end of the film just under the entry flanges at the outermost part of the reel. Push the film forward about half a turn of the reel. Now hold the reel in both hands (as shown above) and turn the two halves of the reel back and forth as far as they will go in opposite directions to draw the film into the reel.

Place the loaded reel in the tank and PUT ON THE TANK COVER. The film is shielded from light when it is inside the tank with cover in place, so you can now turn on the lights or take the tank to the developing area. Keep the cover in place as you add and remove chemicals through the light-tight pouring opening in the tank cover. The tank shown here has a small cap for the pouring opening so chemicals do not spill out during agitation.

Alternate procedure. The reeled film is placed in a tank that is already filled with developer. The advantage is that the developer hits the film all at the same time, which conceivably could produce more uniform development than adding the developer through the small pouring opening; the disadvantage is that, before you can turn the lights on, you have to grope around in the dark to get the film into a liquid-filled tank, the tank covered, and the timer started.

Now actual development can begin, and you have to do two things in rapid succession: (1) pour developer into the small pouring opening in the tank's cover, and (2) start the timer. If you hold the tank at an angle, it may accept the liquid faster.

Time the development period either from the time you begin to pour in the developer to the time you begin to pour in the next chemical (stop bath) or from the time the tank is filled with developer to the time it is filled with stop bath. Either is fine, but be consistent.

If you are working in a cold darkroom, the temperature of the developer in the tank (especially a small metal one, like the one shown here) may drop too much during processing. To prevent this, you can fill a shallow tray with water at the developing temperature and keep the developing tank in it (as shown above) to help maintain the developer at the correct temperature. Don't fill the tray so high that water enters the tank.

10 | agitate

Start agitation as soon as the tank is filled with developer and the timer is started. Put the cap over the pouring opening in the tank cover. Hold the tank so its cover and central cap won't come off.

First, rap the bottom of the tank sharply against the sink or counter several times to dislodge any air bubbles that may have attached themselves to the film.

Then begin the regular agitation pattern to be followed throughout the development time: gently turn the tank upside down, then right side up again 5 times, with each of the 5 inversions taking about 1 sec. Let the tank rest for the remainder of the first 30 sec. After 30 sec, agitate the tank for 5 sec out of every 30 sec of the remaining development time. If you are using a temperature control tray, keep the tank in it between agitation times.

Some tanks cannot be inverted without leakage, so they are agitated by other means. One type has a crank in the lid that agitates the film by turning the reel in the solution. Others have to be used in the dark so the film can be agitated by moving the reel up and down in the developer.

11 | remove cap from the pouring opening

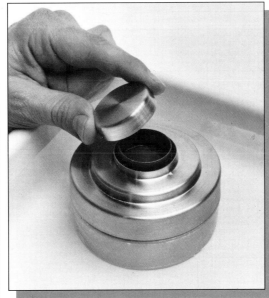

About 15 sec before development is completed, get ready to empty the developer from the tank. Remove the cap from the center pouring opening—BUT DO NOT REMOVE THE TANK COVER ITSELF.

12 | pour out the developer

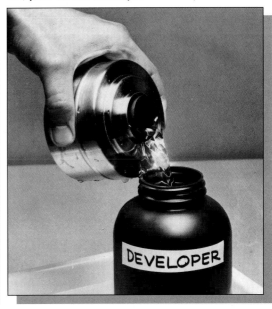

Hold the tank so the cover cannot fall off. A few seconds before the timer signals that development is completed, start pouring the developer from the tank into the developer bottle. If the bottle has a small mouth, or if the tank does not pour out smoothly, use a funnel to speed pouring. As soon as the tank is empty, proceed immediately to the next step, pouring in the stop bath. (One-shot developers are not saved; see page 112.)

How to Process Roll Film Step by Step: continued
Stop-Bath and Fixer Steps

13 | fill the tank with stop bath

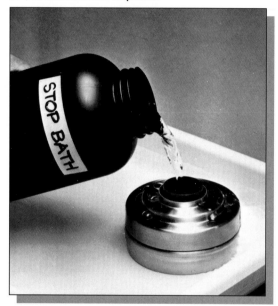

Quickly pour stop bath into the tank through the central pouring opening of the cover. *DO NOT REMOVE THE TANK COVER.* Fill the tank just short of overflowing to make sure the film is entirely covered. On some tanks the light baffle in the opening is arranged so that the tank must be held at a slight angle to speed the filling.

14 | agitate

After replacing the pouring opening cap, agitate the tank gently for about 30 sec.

15 | pour out the stop bath

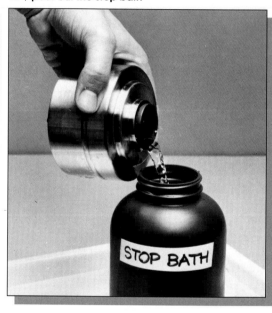

Empty the stop bath from the tank. *DO NOT REMOVE THE TANK COVER.* Some photographers throw out used acetic acid stop bath, since it is inexpensive and easier to store as a concentrated solution. If you are using water instead of acetic acid as a stop bath, simply discard the water.

16 | **fill the tank with fixer**

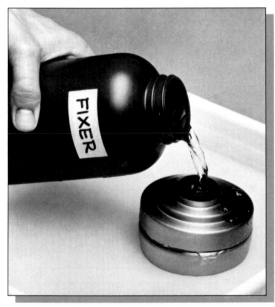

With the tank cover still on, pour fixer through the pouring opening in the cover. Fill just short of overflowing.

17 | **set the timer**

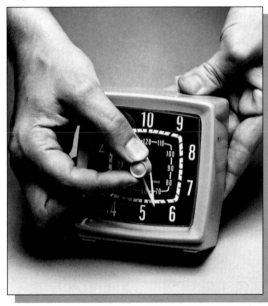

Turn the timer pointer to the fixing time recommended in the chemical manufacturer's instructions. Be sure to use the figures specified for film; most fixing solutions can also be used to process prints, but the dilutions and times required are different.

18 | **agitate**

Agitate the fixer-filled tank continuously for the first 30 sec, then at 1-min intervals during the fixing period. When the timer signals that the period is up, pour the fixer back into its container. The entire cover of the tank may now be removed since the film is no longer sensitive to light.

A general rule is to fix for twice the time it takes to clear the film of its milky appearance. About halfway through the fixing period, you can open the tank to take a quick look at the end of the roll to see if the film no longer looks milky. If the film takes longer than half the recommended time to clear, the fixer is weak and should be discarded. Refix the film in fresh fixer.

How to Process Roll Film Step by Step: continued
Washing, Drying, and Protecting the Film

19 | wash the film

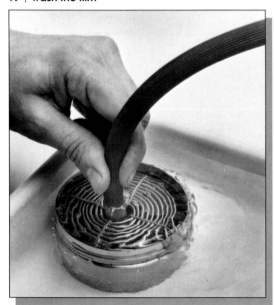

20 | dry the film

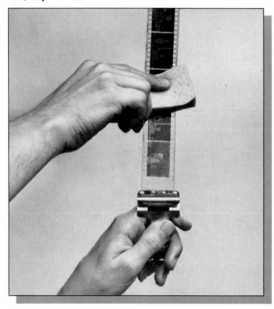

21 | protect the dry negatives

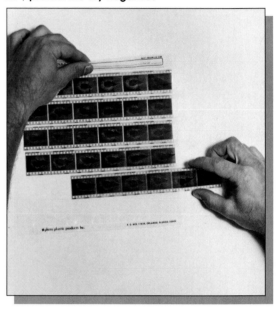

An optional but highly recommended step before washing is to treat the film with a washing aid solution. This greatly reduces washing time and removes more of the fixer (hypo) than water alone can remove. Follow the manufacturer's directions for use.

Adjust faucets to provide running water at the development temperature. Leave the reel in the open tank in the sink and insert the hose from the tap into the core of the reel. Let the water run fast enough to completely change the water in the container every 5 min. If one is available, you can use a specially designed—and more efficient—washing tank. Empty the water and refill several times; fixer is heavier than water and may settle at the bottom of the tank. About 30 min of washing is needed to prevent later deterioration of the image. Much less wash time is needed if a washing aid is used.

After washing, treat the film in a wetting solution, such as Kodak Photo-Flo, to help prevent water spots. Follow the manufacturer's directions for use.

Unwind the film from the reel and hang it up to dry immediately. Unwind gently; the wet emulsion is soft and easily scratched. Resist the temptation to examine the negatives until they are dry; dust quickly accumulates on damp film.

Attach a clip or clothespin to one end of the film and hang it in a dust-free place where the temperature will remain constant during the drying period—1 or 2 hours at average room temperature. A film-drying cabinet is the best place. At home, a good dust-free location is inside a tub or shower enclosure with shower curtain or door closed. Attach a weighted clip to the bottom of the film.

The wetting agent should cause water to sheet off the film so that it dries without spotting. If water spots are a problem, try removing excess water from the surface by very gently drawing a damp, absolutely clean photo sponge, held at a 45° angle, down both sides of the film.

When the film is dry, cut it into appropriate lengths to fit into protective sleeves. Don't cut the film into separate frames; that will make it difficult to handle during printing. Hold film only by its edges to avoid fingerprints and scratches. Careful treatment of negatives now will pay off later when they are printed.

Processing Roll Film—A Summary

	chemicals needed	procedure	
preparation	You will need 3 basic chemical solutions: developer, stop bath, and fixer. Additionally, a washing aid is recommended; a wetting agent is optional. Details below.	Mix the chemical stock solutions needed and dilute to working strength. Carefully follow manufacturer's recommendations for development time and temperature.	Ideally, the developer should be exactly at the recommended temperature, with the other solutions no more than about 3 degrees different. See page 112 for more on mixing and storing chemicals, and especially about handling chemicals safely.
loading film	_____	In total darkness, load film onto developing reel. Put reeled film into empty, dry tank and close with light-tight cover before turning on lights.	_____
development	Use a developer suitable for film. All-purpose developers (such as Kodak D-76, HC-110, or T-Max; Ilford Universal, Ethol UFG, Edwal FG7) work well for most uses. High-energy developers (such as Acufine and Diafine) are useful for push processing (see pages 128–129). Fine-grain developers (such as Kodak Microdol-X, Ilford Ilfotec HC, and Edwal Super-20) produce finer grain but with possible loss in contrast and apparent sharpness; some dilutions cause a loss in film speed. See manufacturer's data.	Fill tank with developer. Begin development by rapping the bottom of the tank on a hard surface to dislodge air bubbles. Agitate by inverting the tank 5 times, with each inversion taking about 1 sec. Repeat the inversion procedure once every 30 sec. Shortly before development time is over, pour out developer through pouring opening of cover. DO NOT REMOVE COVER UNTIL FILM IS FIXED.	_____
stop bath	Some photographers use a plain water rinse for a stop bath; others prefer a dilute solution of acetic acid (about $1\frac{1}{2}$ oz 28% acetic acid per quart of water, or 48 ml per liter). An indicator-type stop bath is available that changes color when it is exhausted, but many photographers simply mix the stop bath fresh each time.	Quickly fill tank through pouring opening with stop bath. Replace cap over pouring opening and agitate for 30 sec. Pour out. DO NOT REMOVE THE ENTIRE COVER YET.	_____
fixing	Use a fixer with hardener. Use a rapid fixer with T-Max films. Fresh fixer will process about 25 rolls of film per quart (or liter) of working solution (fewer rolls with T-Max films). The age of the solution also affects its strength. An inexpensive testing solution is available that indicates when fixer should be discarded.	Fill tank through pouring opening with fixer. Agitate for 30 sec, then at 1-min intervals for the recommended time. Keep the cover on until at least halfway through the fixing time.	The film should have lost its milky appearance about halfway through the fixing time.
washing aid (recommended)	A washing aid (also called hypo neutralizer or clearing agent) promotes more effective washing in less time than washing in water alone. Discard after about 10 rolls of film have been treated per quart (or liter) of working solution (or as directed).	Rinse in running water for 30 sec, then follow manufacturer's data for treatment. With Kodak Hypo Clearing Agent: 2-min immersion with agitation for first 30 sec, then occasional agitation thereafter.	_____
washing	After washing, a wetting agent, such as Kodak Photo-Flo, is an optional treatment that helps prevent water spots, especially in hard-water areas. Mix with distilled water.	Wash 30 min (much less if a washing aid is used; follow manufacturer's data). Then immerse in a wetting agent for 30 sec.	Water should run at least fast enough to completely fill the container several times in 5 min. Dump water several times as well.
drying	_____	Hang to dry in dust-free place with clip on bottom of film to prevent curling.	When dry, cut film into convenient lengths and store in negative envelopes.

HOW TIME AND TEMPERATURE AFFECT DEVELOPMENT

The longer the developer is allowed to act on the film, the greater the number of crystals converted to metallic silver and the darker the negative becomes. The pictures on the opposite page show that the **density** of silver in an image does not increase uniformly. Increasing the development time causes a great deal of change in those parts of the negative that received the most exposure (the bright areas in the original scene). It causes some changes in those areas that received moderate exposure (the midtones), but only a little change in areas that received little exposure (the shadow areas). In any negative, lengthening or shortening development time has a marked effect on **contrast**—the relationship between light and dark tones.

Development time controls contrast and density because of the way that film emulsion is constructed. The crystals of silver bromide that will develop into the negative image lie both on and below the surface of the emulsion. As exposure increases, the number of exposed crystals and their depth in the emulsion also increase. When the developer goes to work, it gets at the surface crystals immediately but needs extra time to soak into the emulsion and develop the crystals below the surface, as illustrated on this page. Thus the total amount of time the developer is allowed to work determines how deeply it penetrates and how densely it develops the exposed crystals, while the original exposure determines how many crystals are available to be developed. See pages 126–127.

The rate of development changes during the process, as is shown in the examples opposite *(left column)*. During the first seconds, before the solution has soaked into the emulsion, activity is very slow; the strongest highlights have barely begun to show up *(top)*. Soon the solution soaks in enough to develop many of the exposed crystals; during this period a doubling of the development time will double the density of the negative *(center)*. Still later, after most of the exposed crystals have been developed, the pace slows down again so that a tripling, or more, of the time adds proportionately less density than it did before *(bottom)*.

Developer temperature also affects the rate of development. Most photographic chemicals and even the wash water take longer to work as their temperatures drop. All solutions work faster at higher temperatures, but at around 80° F (27° C), the gelatin emulsion of the film begins to soften and becomes very easily damaged. The effects of temperature on the rate of development are shown on the opposite page.

Time-and-temperature charts that accompany films and developers show suggested development times at various temperatures—the higher the temperature, the shorter the development time needed *(see chart at right)*. The temperature generally recommended is 68° F (20° C); this temperature combines efficient chemical activity with the least softening of the film emulsion and is a practical temperature to maintain in the average darkroom. A higher temperature can be used when the tap water is very warm, as it can be in many areas during the summer.

A chart may list one set of times for small or reel-type tanks and another for large tanks. A **small tank** holds from one to four reels and is agitated by inverting it (as shown in step 10 on page 117) or by cranking a handle that rotates the reel. A **large tank** is agitated by lifting the reels out of the developer on a central spindle.

developed for 2 minutes
developed for 5 minutes
developed for 15 minutes

Grains of silver, enlarged about 2,500× in this cross section of film emulsion, get denser as development is extended. Grains near the surface (top) form first and grow in size. As developer soaks down, subsurface grains form.

KODAK T-MAX 400 Professional Film

EI (Film Speed)	KODAK Developer	Developing Times (Minutes)—Roll Film									
		Small Tank (Agitation at 30-Second Intervals)					**Large Tank** (Agitation at 1-Minute Intervals)				
		65°F (18°C)	68°F (20°C)	70°F (21°C)	72°F (22°C)	75°F (24°C)	65°F (18°C)	68°F (20°C)	70°F (21°C)	72°F (22°C)	75°F (24°C)
400	T-Max	NR	7	6¹/₂	6¹/₂	**6**	NR	7	6¹/₂	6¹/₂	**6**
400	D-76	9	**8**	7	6¹/₂	5¹/₂	10	**9**	8	7¹/₂	6¹/₂
400	D-76 (1:1)	14¹/₂	**12¹/₂**	11	10	9	—	—	—	—	—
320	HC-110 (Dil B)	6¹/₂	**6**	5¹/₂	5	4¹/₂	8	**7**	6¹/₂	6	5
200	MICRODOL-X	12	**10¹/₂**	9	8¹/₂	7¹/₂	13	**11¹/₂**	10	9	8
320	MICRODOL-X (1:3)	NR	NR	20	18¹/₂	**16**	—	—	—	—	—

Note: The primary development times are in boldface.
NR—Not recommended

A time-and-temperature chart for development is provided by film and developer manufacturers. 68° F (20° C), shown in boldface type, is the recommended temperature for most of the developers listed on this chart. The exceptions are T-Max developer and Microdol-X diluted 1:3, for which the recommended temperature increases to 75° F (24° C). A change in temperature of even a few degrees can cause a significant change in the rate of development and therefore requires a change in the development time. Note that the EI (film speed), shown in the chart's far left column, decreases with some developers.

negative developed for 45 seconds at 68° F

negative developed at 40°F for 6 minutes

negative developed for 6 minutes at 68° F

negative developed at 68°F for 6 minutes

negative developed for 30 minutes at 68° F

negative developed at 100° F for 6 minutes

Development time and temperature need to be monitored carefully because the longer the film is in the developer at a given temperature, the darker the negative image becomes (photos, left). The negative also becomes darker if development takes place at higher temperatures, if development time stays the same (photos, right).

EXPOSURE AND DEVELOPMENT: UNDER, NORMAL, OVER

A correctly exposed and properly developed negative will make your next step—printing—much easier. You are likely to produce a printable negative if you simply follow the manufacturer's standard recommendations for exposure (film speed) and development (time and temperature). But, after you have a grasp of the basic techniques, you may want to adjust your exposure or development. If you are just beginning in photography, you can come back to this material after you have had some experience printing.

To evaluate a negative, you need to look at its density and contrast. **Density** is the amount of silver built up in the negative overall or in a particular part of the negative. **Thin** negatives have low density overall. The thinnest parts of any negative correspond to the darkest areas in the original scene; the film received little light from those parts of the scene and developed little silver density there. **Dense** negatives have a heavy buildup of silver overall. The densest parts of any negative correspond to the lightest areas in the original scene; the film received a large amount of light from those areas and developed a heavy silver density there.

Contrast is the difference in density between the thinner parts of the negative (such as shadow areas) and the denser ones (bright highlights). A **contrasty** or high-contrast negative has a great deal of difference between these areas: the highlights are very dense and the shadows very thin. If you want a normal-looking print from a high-contrast negative, you have to print it on a low-contrast (#1 or lower) paper. A **flat** or low-contrast negative, on the other hand, has highlights that are not very much denser than the shadows. To make a normal print from a low-contrast negative, you must print it on a

high-contrast (#3 or higher) paper. (The relation between negative contrast and printing paper contrast is shown on page 157.)

The amount of exposure and development affects the negative, but in different ways, as expressed in the old photographic rule of thumb: **Expose for the shadows, develop for the highlights.** Changing the development time has little effect on shadow areas, but it has a strong effect on highlight areas. The longer the development at a given temperature, the denser the highlights become; the contrast also increases due to the greater difference between the density of the highlights and that of the shadows. The reverse happens if you decrease development time: the less the difference between highlights and shadows, and the flatter the negative.

Changing the exposure affects both highlight and shadow areas: the greater the exposure, the denser they both will be. But exposure is particularly important to shadow areas because increasing the development time does not significantly increase the density of shadow areas. They must receive adequate exposure if you don't want them to be so dark that they are without detail in the print.

The practical application of these relationships lets you alter exposure or development if you have persistent difficulty printing your negatives. The illustrations opposite show a negative with good density and contrast (center) plus negatives that are thin, dense, flat, and contrasty—and what to do if many of your negatives look that way. You may have to adjust a manufacturer's standard recommendations to suit your own combination of film, camera, darkroom equipment, and so on.

You can also adjust exposure and development for individual scenes. A high-

contrast scene (for example, a sunlit street scene in which you want to see people in both lit and shaded areas) can easily have a nine-stop or greater range between shadows and highlights—too much for details to show in both light and dark areas. In such a situation, you can give enough exposure to maintain details in the shadows, then decrease the development to about three-fourths to two-thirds the normal time to keep highlights from being overly dense. A low-contrast scene (such as one outdoors on a heavily overcast day) may have only a three-stop or less range. If you want more contrast than this, you can decrease the exposure about a stop and increase the development to one and one-half to two times normal. (Kodak T-Max films respond more rapidly to changes in development time than other films do, so smaller time adjustments are needed to produce comparable changes.) If you want to maintain the existing high or low contrast in a scene (for example, if you want to keep the flat gray look of a landscape on a foggy day), use normal exposure and development.

Changing the development for individual scenes is easiest with a view camera, which accepts single sheets of film. With roll film you have to develop the entire roll in the same way. Also, increasing development time with small-format roll film may increase the grain more than you want. Increased grain is seldom a problem with larger-format sheet film.

You can adjust contrast during printing by using a higher- or lower-contrast grade of paper, but also adjusting the contrast of the original negative gives you even more control over the final results. See Chapter 14, Zone System, for more about controlling density and contrast by adjusting exposure and development.

Thin. *Little detail in shadow areas; somewhat low contrast overall; printing times very short. If negatives are often thin, increase exposure by setting camera to a lower film speed. Divide film speed by 2 to increase exposure 1 stop.*

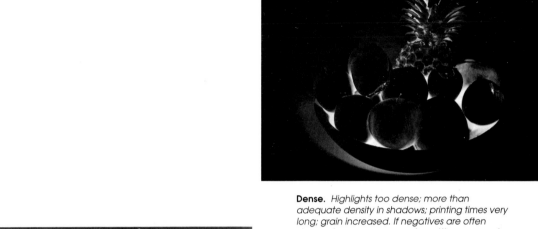

Dense. *Highlights too dense; more than adequate density in shadows; printing times very long; grain increased. If negatives are often dense, decrease exposure by setting camera to a higher film speed. Multiply film speed by 2 to decrease exposure 1 stop.*

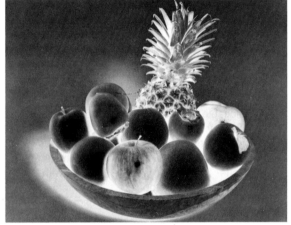

Normal density and contrast. *Good separation of tones in highlights, midtones, and shadows (with a scene of normal contrast). Prints on normal-contrast paper. Normal grain for film.*

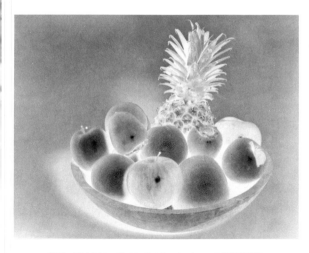

Flat. *Not enough separation between highlights and shadows; needs high-contrast paper for normal print. If negatives are often flat, increase film development; try developing for one and one-half times the normal time.*

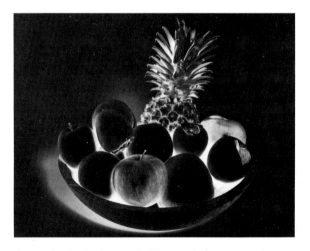

Contrasty. *Too much difference between highlights and shadows; needs low-contrast paper for normal print; grain increased. If negatives are often contrasty, decrease film development; try three-fourths the normal time.*

PHOTOGRAPHER AT WORK: ANOTHER ANGLE ON SPORTS

Don't be surprised if Walter Iooss comes up to you at your next baseball game and offers to trade your seat for his pass to the section reserved for photographers. He does this from time to time because the last place he likes to sit is where all the other photographers are.

Iooss looks for something to make his sports photographs more than simple action shots. Maybe it is the graphic interest of an unusual point of view *(photo, opposite)*. Maybe it is human interest *(this page, top)*. Maybe it is an interesting background against which, if he is lucky, some action will happen or against which he can position a player. He has been willing to gamble a whole game on that, waiting in a particular spot for the action to move to just the place he wants. He often goes to a stadium the day before a game to see where the light is best or what setting might be good. "I really enjoy going to places that photographers have been to time and again—and finding a picture that no one has taken before."

Many sports photographers stay in predictable positions because they know they will get at least something from there: at a basketball game they stay right under the basket or just to one side of it; at a baseball game they keep to the first-base or third-base lines. Iooss prefers to take the chance he will find something even better elsewhere. "I have always been interested in what goes on at a sport's perimeters—the sidelines, a vendor, the fans—not just a guy sliding into third base."

If he is going to be with a team for several days, he likes to move in gradually. He talks to a few players, tells them what he's doing so the word filters around. Professional sports figures are used to photographers, but they still may need to loosen up and relax, especially if you are trying to pose them. "The first roll or two may not be very good until they feel comfortable with you."

Iooss says that you don't have to go to professional games to make great sports pictures. "Go to a kids' football game. It's late in the afternoon, the light is terrific, you have kids crying, screaming, sweating—and their parents doing the same. It's better than professional football." Spring training in baseball is another good time to photograph. It is open to anybody, and you often have opportunities there to be with the players. "Spring training is great because you have more freedom there than at any other sport. Players move between the fields, which means they are moving between the fans. They talk to you, just like players in the old parks where the fans were very close to the players. Baseball years ago was an intimate spectacle, and it still is at spring training."

His advice if you are interested in sports photography: "You have to shoot constantly. If you look at top performers—athletes or photographers—they do what they do all the time. I'm always working, shooting, thinking pictures. If you are really interested in doing well at anything, you have to give yourself to it."

"Sometimes you work and work to make a picture," he says. "At other times, it's just seeing and being ready to shoot during those few moments when everything is just perfect, and you feel, 'This is it.' But I may have been shooting for an hour leading up to that moment. Chance favors you—if you're prepared."

WALTER IOOSS, JR.: *After the Game*, 1980

Human interest (above) and graphic interest (opposite) are both part of what makes sports photography interesting to Walter Iooss, Jr.

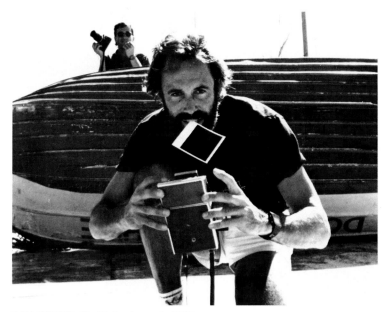

DAN JENKINS, JR.: *Walter Iooss, Jr.,* 1985

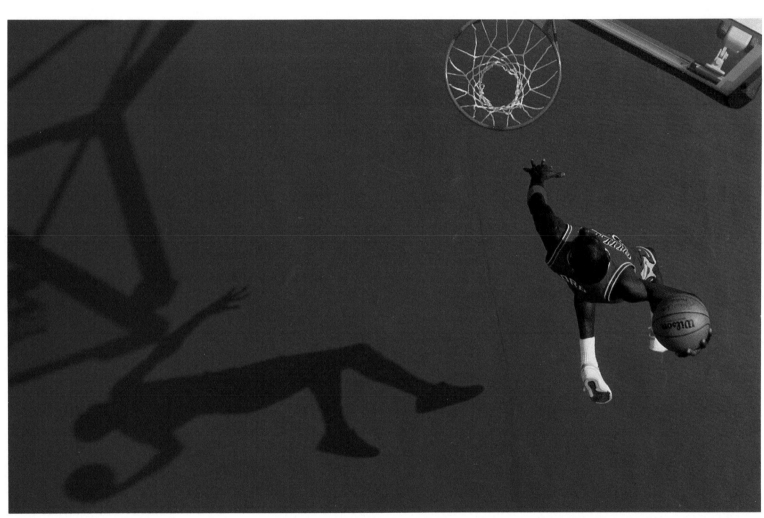

WALTER IOOSS, JR.: *Michael Jordan,* 1987

For another angle on basketball, Iooss had himself hoisted aloft in a cherry picker so he could shoot down on Michael Jordan and his shadow. The effect is agreeably disorienting: the shadow is as important as the man, while the blue of the court could be the blue of the sky.

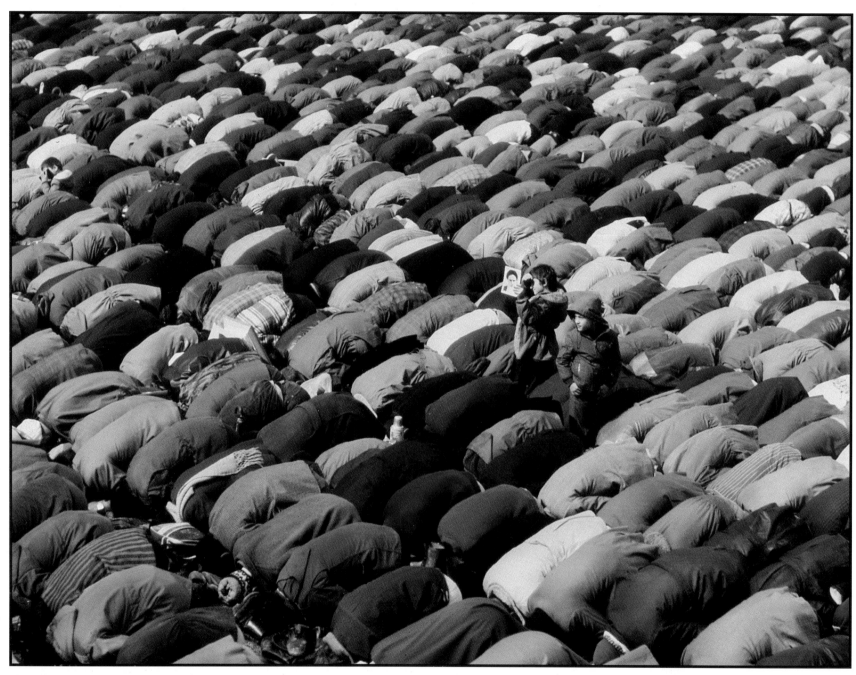

JOHN ISAAC: *Friday Prayers, Teheran, Iran, 1980*

During the 1980 American hostage crisis in Iran, a boy holds up a photograph of the religious and political leader, Ayatollah Khomeini, while men at Teheran University pray. Here, the photographic print is more than just an image of a person; it represents the power of the leader himself.

negative

positive

Printmaking is one of the most pleasurable parts of photography. Unlike film development, which requires rigid control, printmaking lends itself to leisurely creation. Mistakes are inevitable at first, but a wrong choice can be easily corrected by simply making another print.

Like film, printing paper is coated with an emulsion containing light-sensitive silver compounds. Light is passed through the negative and onto the paper. After exposure, the paper is placed in a developer where chemical action converts into visible metallic silver those compounds in the paper's emulsion that have been exposed to light. A stop bath halts the action of the developer; a fixer removes undeveloped and unexposed compounds; finally the print is washed and dried.

The negative is a reversal of the tones in the original scene. Where the scene was bright, the negative contains many dense, dark grains of silver that hold back light from the paper, prevent the formation of silver in the paper's emulsion, and so create a bright area in the print. Where the scene was dark, the negative is thin or even clear, and passes much of the light to the paper, resulting in a dark area in the print. Compare the illustrations at left.

How to Make a Print Step by Step: continued
Processing a Print

1 | **set out trays and tongs**

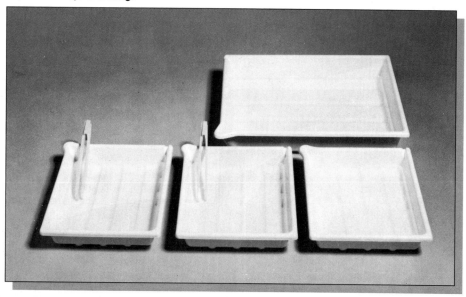

Set out four trays—one each for developer, stop bath, fixer, and water. If you use tongs, use two pairs: one for the developer and one for stop bath and fixer. Do not interchange them. See page 149 for information about chemicals. Until the print is fixed, expose it only to safelight, not ordinary room light (see page 139).

2 | **prepare the solutions**

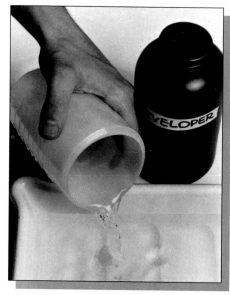

Solution temperatures are not as critical as in film development. Manufacturers often recommend about 68° F (20° C) for the developer, 65° to 75° F (18° to 24° C) for stop bath and fixer.

3 | **begin development**

Darkroom safelights should be on, room lights and enlarger off. Slip the paper smoothly into the developer, emulsion side up, immersing the surface of the print quickly.

4 | **agitate gently**

Rock the tray gently and continuously to agitate the print. Avoid touching the print's surface with the tongs; they can leave marks. Develop for the time recommended for the developer and paper.

5 | **complete development**

If the print develops too rapidly or too slowly, process for the standard time anyway. Then examine the print and change exposure as needed.

6 | drain off developer

Hold the print above the tray for a few seconds so that the developer solution, which contaminates stop bath, can drain away

7 | transfer to the stop bath

The stop bath chemically neutralizes the developer on the print, halting development. Keep developer tongs out of stop bath.

8 | agitate

Keep the print immersed in the stop bath for 30 sec (5–10 sec for RC paper), agitating it gently. Use stop bath–fixer tongs in this solution.

9 | drain off stop bath

Again lift the print so that solution can drain into the stop-bath tray. Don't let stop-bath solution splash into developer.

10 | transfer to the fixer

Slip the print into the fixer and keep it submerged. The same tongs are used for stop bath and fixer, which are compatible solutions.

How to Make a Print Step by Step: continued
Setting Up an Enlargement

Personal judgments *count the most when selecting negatives for enlargement when you have many shots of the same scene. Which had the most pleasing light? Which captured the action most dramatically? Which expressions were the most natural or most revealing? Which is the best picture overall?*

Technical points *should be considered as well. For example, is the negative sharp? With a magnifying glass examine all parts of the contact prints of similar negatives to check for blurring caused by poor focusing or by movement of the camera or subject. If the negative is small—particularly if it is 35mm—even seemingly slight blurring in the contact print will be quite noticeable in an 8 × 10-inch enlargement because the defects will be enlarged as well. Extreme underexposure (shown on the contact as pictures that are very dark) or extreme overexposure (pictures that are very light) will make the negative difficult or even impossible to print successfully. Minor exposure faults, however, can be remedied during enlargement. Use a light-colored grease pencil to mark the contact sheet as a rough guide for cropping.*

1 | **select a negative for printing**

Under bright light, examine the processed contact sheet with a magnifying glass to determine which negative you want to enlarge.

2 | **remove the negative carrier**

Lift up the lamp housing of the enlarger and remove the negative carrier—usually two sheets of metal that hold the negative between them.

3 | **insert the negative**

Place the negative over the window in the carrier and center it. The emulsion side must face down when the carrier is put in the enlarger.

4 | **clean the negative**

Before printing, hold the negative at an angle under the enlarger lens with the lamp on so that the bright light reveals any dust; brush it off. Dust may be easier to see with room lights off.

5 | **replace the negative carrier**

Lift the lamp housing and place the negative carrier in position. Switch off room lights so that you can see the image clearly for focusing.

6 | open the aperture

Open the enlarger's aperture to its largest f-stop to supply maximum light for focusing. The enlarger lamp should be on.

7 | prepare for focusing

Insert a piece of white paper under the masking slides of the easel. Paper shows the focus more clearly than even a white easel surface.

8 | adjust for print size

Adjust the movable masking slides on the easel, first to hold the size of paper being used (in this case, 8 × 10 inches) and later to crop the image.

9 | arrange the picture

Raise or lower the enlarger head to get the desired degree of image enlargement, adjusting the easel as needed to compose the picture.

10 | focus the image

Focus by turning the knob that raises and lowers the lens. Don't shift the enlarger head except to readjust size if this is necessary.

11 | refine the focus

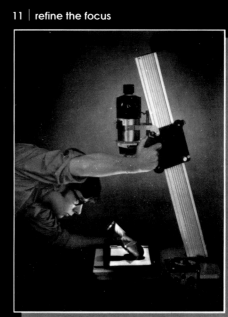

A magnifier helps to make the final adjustments in focus. Some types magnify enough for you to focus on the grain in the negative.

How to Make a Print Step by Step: continued
A Test Print

How much exposure should your print get? A **test print** will give you some choices. The test will show strips of your image, each strip exposed longer than its neighbor to the left. A full-size sheet of printing paper is used here, but a smaller strip of paper placed across an important area is often enough.

Stop down the enlarger lens a few stops from its widest aperture. This gives good lens performance plus enough depth of focus to minimize slight errors in focusing the projected image.

Time, rather than aperture setting, is generally changed when adjusting the exposure during printing. If the negative is badly overexposed or underexposed, however, change the lens aperture to avoid impractically long or short exposure times.

The test print shown here exposes each strip 5 sec longer than its neighbor and produces strips exposed for a total of 5, 10, 15, 20, and 25 sec.

For a test print with a greater range of tones, double the exposure of each strip. For example, exposing the strips for $2^1/2$, $2^1/2$, 5, 10, and 20 sec gives total exposures of $2^1/2$, 5, 10, 20, and 40 sec.

12 | insert paper for a test print

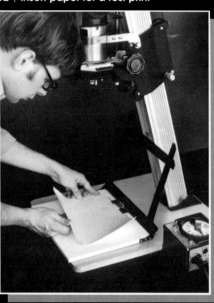

With room lights and enlarger lamp off, slip a fresh piece of medium-contrast printing paper (grade 2 or 3), emulsion side up, into the easel.

13 | first exposure

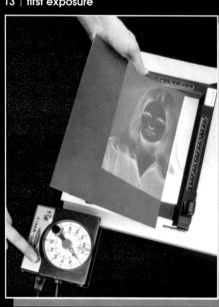

Cover four-fifths of the printing paper with a piece of cardboard. Expose the uncovered section for 5 sec.

14 | second exposure

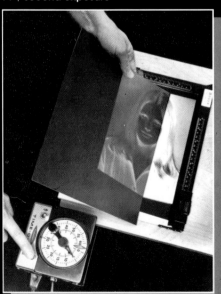

Slide the cardboard to cover only three-fifths of the paper. Expose for another 5 sec.

15 | third, fourth, and fifth exposures

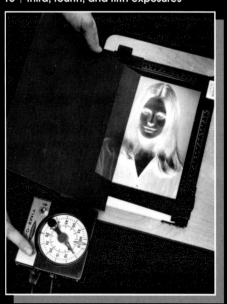

Make 3 more 5-sec exposures in the same manner, first covering two-fifths of the paper, then one-fifth of the paper, and finally exposing the entire sheet.

16 | process the test

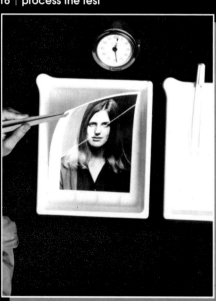

Develop for the recommended time with constant, gentle agitation. Various degrees of darkening—due to the different exposures—are clearly visible.

A Final Print

Evaluate the test print carefully. Before making the final print, examine the test under ordinary room light. Darkroom safelight illumination makes prints seem darker than they actually are. Details on how to judge a test print appear on pages 154–155.

Exposure. *Is one of the exposures about right—not too dark or too light? Or should an entire series of longer or shorter test times be made?*

Contrast. *Is the test print too contrasty, with inky black shadows, harsh white highlights, and little detail showing in either? Or is the print too flat—muddy and gray with dingy highlights and dull shadows? If you change print contrast, the printing time may change, so make another test print for the new contrast grade.*

17 | expose for a final print

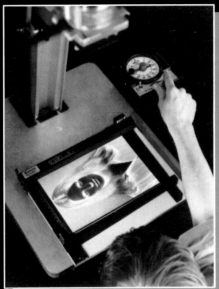

Recheck the focus. Set the timer to the exposure indicated by the test, insert fresh paper in the easel, and press the button for final exposure.

18 | process the print

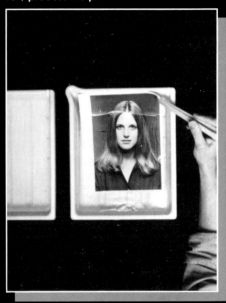

Process the print as shown on pages 146–149. After fixing for a minute or two, you can evaluate the print in room light.

Take time again at this point to evaluate the print under ordinary room light. Don't be discouraged if the print is less than perfect on the first try. Often several trials must be made.

Exposure and contrast. *Could the print be improved by adjusting the exposure or contrast? It is not always possible to tell from a test strip how all areas of the print will look. Skin tones are important if your print is a portrait. Give more exposure if skin tones look pale and washed out. Beginners tend to print skin tones too light, without a feeling of substance and texture.*

Dodging and burning in. *Most prints require some local control of exposure, which you can provide by holding light back (dodging) or adding light (burning in). See next steps and page 160.*

19 | reprint and dodge, if necessary

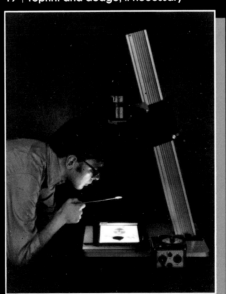

Dodging, or blocking light during part of the exposure, lightens areas that would otherwise print too dark. Often, shadow areas are dodged.

20 | burn in, if necessary

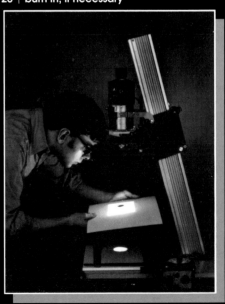

Some areas may need burning in (extra exposure to darken them). A dark cardboard shield with a hole is a useful tool.

EVALUATING DENSITY AND CONTRAST IN A PRINT

Prints are judged for density and contrast. The goal during printing is usually to make a **full-scale print**—one that has a full range of tones (rich blacks, many shades of gray, brilliant whites) and a realistic sense of texture and substance *(opposite page, top)*. You may deliberately depart from this goal at times, but first learning how to make a full-scale print will give you control over your materials so that later you can produce whatever kind of print you want. A test print like the one at near right helps in evaluating a print and deciding how to improve it. Do all your judging under ordinary room light because prints look darker under safelight.

Density refers to the overall darkness or lightness of the print *(opposite, bottom left)*. It is controlled primarily by the amount of exposure given the paper—the greater the exposure, the greater the density of silver produced and the darker the print. Exposure can be adjusted either by opening or closing the enlarger lens aperture or by changing the exposure time.

Contrast is the difference in brightness between light and dark areas within the print *(opposite, bottom right)*. A low-contrast or flat print seems gray and weak, with no real blacks or brilliant whites. A high-contrast or hard print seems harsh and too contrasty: large shadow areas seem too dark and may print as solid black; highlights, very light areas, seem too light and may be completely white; texture and detail are missing in shadows, highlights, or both. The contrast of a print is controlled mainly by the contrast grade of the paper used or, with variable contrast paper, by the printing filter used *(see the following pages)*.

Begin by judging the density. With some experience, you can judge both density and contrast at the same time, but it is easier at first to adjust them in two steps. Examine the test print for an exposure that produced highlights of about the right density, especially in areas where you want a good sense of texture. If all strips in the test seem too light, make another set of strips with more exposure by opening the enlarger aperture two f-stops. If all seem too dark, make a test with less exposure by stopping down two f-stops.

Then check the contrast. When the highlights seem about right in one strip, examine the shadow areas. If they are too dark (if you can see details in the negative image in an area that prints as solid black), your print is too contrasty. Make another test print on a lower-contrast paper. If your shadow areas are too light and look weak and gray, your print does not have enough contrast. Make another test on a higher-contrast paper. If you are printing a portrait, the skin tones are important. Adjust the exposure so that the brightest skin area is about the right density, and then, if necessary, adjust the contrast.

When one of the tests looks about right, expose the full image using the exposure and contrast that you chose. It can be difficult to predict from a single strip in a test exactly how an entire print will look, so judge the density and contrast of the print overall. Examine the print for individual areas you may want to darken or lighten by burning in or dodging *(pages 160–161)*. Prints, especially on matte-finish papers, tend to "dry down," or appear slightly darker and less contrasty when dry. Experience will help you take this into account.

Black and white test patches can help you judge a print. To evaluate the density and contrast of a print, you need standards against which to compare the tones in your print, since the eye can be fooled into accepting a very dark gray as black or a very light gray as white. As much as one full grade of contrast can be involved, enough to make the difference between a flat, dull print and a rich, brilliant one. Two small pieces of printing paper, one developed to the darkest black and the other to the brightest white that the paper can produce, are an aid when you are first learning how to print as well as later when you want to make a particularly fine print.

By placing a black or white patch next to an area, you can accurately judge how light or dark the tone actually is. As a bonus, the black patch indicates developer exhaustion; the developer should be replaced when you are no longer able to produce a black tone in a print as dark as the black patch no matter how much exposure you give the paper. The white patch will help you check for the overall gray tinge caused by safelight fogging.

Make the patches at the beginning of a printing session when developer and fixer are fresh. Cut two 2-inch-square pieces from your printing paper. Use the enlarger as the light source to make the black patch. Set the enlarger head about a foot and a half above the baseboard. The patch should be borderless, so do not use an easel. Expose one patch for 30 seconds at f/5.6; do not expose the other. Develop both patches with constant agitation for the time recommended by the manufacturer or for 2 minutes. Process as usual with stop bath and fixer. Remove promptly from fixer after the recommended time, then store in fresh water. To avoid any possible fogging of the white patch, cut and process the paper in a minimum amount of safelight.

a test print

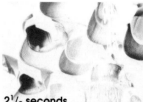

2¹/₂ seconds

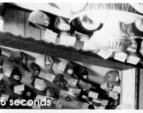

5 seconds

10 seconds

20 seconds

40 seconds

Many photographers make test prints like the one above to help them judge the density (darkness) and contrast of a print. The exposures on this print range from 2¹/₂ to 40 sec. First, the exposure is chosen that renders the highlights (in the lightest area you want to retain detail) at the right density. Then the shadow values are examined: if they appear neither too dark and harsh nor gray and flat, then the contrast of the print is correct.

normal density/normal contrast

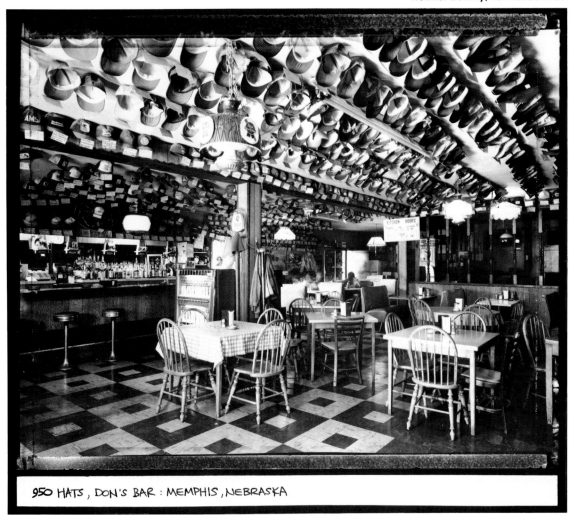

950 HATS, DON'S BAR : MEMPHIS, NEBRASKA

JIM STONE: *Don's Bar,* 1983

A full-scale print of normal density and normal contrast, with texture and detail in the major shadow areas and important highlights, is shown at left. Decreasing the exposure produced a lighter print; increasing the exposure gave a darker version (below left). Printing the same negative on a lower-contrast grade of paper produced a flat print; printing on a higher-contrast grade made a contrasty print (below right).

This photograph was made on Polaroid Type 55 4 × 5 film, which produces both a positive print and a negative. Stone later reprinted the negative in a 5 × 7 glass negative carrier so that the entire edge of the negative shows.

density

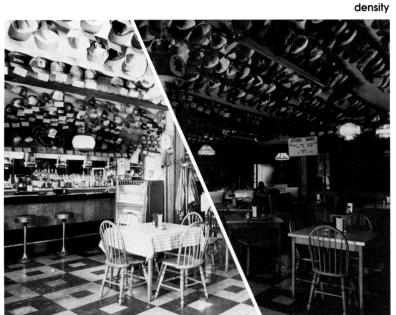

too light **too dark**

contrast

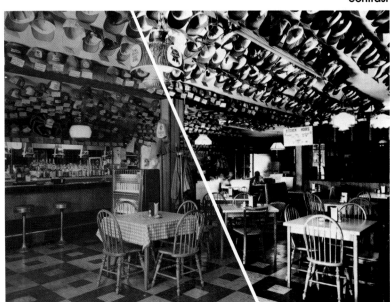

too flat **too contrasty**

Papers That Control Contrast: continued
Variable-Contrast Papers

number 0 filter

number 1 filter

number 2 filter

no filter

You can use a single paper with adjustable contrast instead of a paper that has separate contrast grades. A **variable-contrast** or **selective-contrast paper** is coated with two emulsions. One, sensitive to yellow-green light, yields low contrast; the other, sensitive to blue-violet light, produces high contrast. You change the contrast by inserting appropriately colored filters in the enlarger *(opposite, far right)*. The filter affects the color of the light that reaches the printing paper from the enlarger light source and thus controls contrast. The lower the number of the filter, the less the contrast. If you have a dichroic enlarger head, used for color printing, you can dial in the filtration.

An advantage of variable-contrast paper compared to graded-contrast paper is the convenience and economy of working with only one kind of paper. You can get a range of contrast out of one package of paper and a set of filters instead of having to buy several different packages of paper. The filters come in half steps, so it is easy to produce intermediate contrast grades. You can also change the contrast in different parts of a photograph by printing them with different filters *(shown at right)*.

The three versions at right of a New Hampshire ▶ *mill scene show how variable-contrast paper lets you print different parts of a scene using different degrees of contrast. In the version made with a number 3 enlarger filter (top), the water and sky print almost blank when the building is correctly exposed. The contrast range of the negative is so great that even burning in the sky and water does not produce significant detail. In the version made with a number 1 filter (bottom), the water and sky look good but the mill is too dark and flat and can't be dodged enough to retain detail.*

The final print (opposite page) was made by exposing the mill with the number 3 enlarger filter while shielding the water and sky, then exposing the water and sky with the number 1 filter while shielding the mill. It is tricky to blend the lines where the different areas of contrast meet, but when done successfully a print can have a balance of contrast impossible to achieve with paper of a single contrast grade.

number 3 filter

number 4 filter

number 5 filter

◀ *Variable-contrast paper produces different degrees of contrast by filtering the enlarger light (photos, left). This filter set has eleven filters numbered 0, $^1/_2$, 1, $1^1/_2$, 2, and so on, rising by half steps to number 5. This is not necessarily the same as grades 0 to 5 in a graded-contrast paper since both the filter and the particular brand of paper affect the contrast response. Usually, a number 2 filter is about equal to a grade 2 in a graded-contrast paper. You can also print with no filter in place, which with most variable-contrast papers produces about a grade 2 contrast.*

▼ *Two ways of inserting filters in enlargers are shown below. A filter holder can be attached below the enlarger lens, and a gelatin filter slipped into the holder (top). Some enlargers have a filter drawer (bottom) between the lamp and the negative; an acetate filter is used here. This latter system is preferable. Since the filter is above the lens, it interferes less with the focused image.*

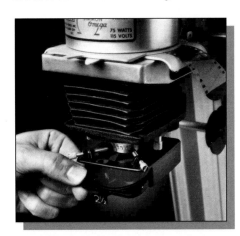

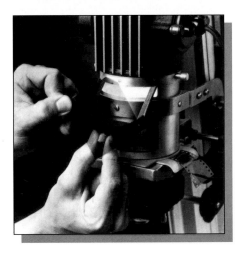

DODGING AND BURNING IN

dodging

burning in

flashing

◄ *Dodging (far left) holds back light during the basic printing exposure to lighten an area. Burning in (center) adds light after the basic exposure to darken an area. Flashing (near left) exposes part of the print to direct light and adds an overall dark tone wherever the light strikes the paper.*

You can give different exposures to different parts of a print by dodging and burning in. Often, the overall density of a print is nearly right, but part of the picture appears too light or too dark—an extremely bright sky or a very dark shadow area, for example.

Dodging lightens an area that prints too dark. That part of the print is simply shadowed during part of the initial exposure time. A dodging tool is useful; the one shown above on the left is a piece of cardboard attached to the end of a wire. Your hand *(opposite page)*, a finger, a piece of cardboard, or any other appropriately shaped object can be used. Dodging works well when you can see detail in shadow areas in the negative image. Dodging of areas that have no detail or dodging for too long merely produces a murky gray tone in the print.

Burning in adds exposure when part of a print is too light. After the entire negative has received an exposure that is correct for most areas, the light is blocked from most of the print while the area that is too light receives extra exposure. A large piece of cardboard with a hole in it

(above center) works well. A piece of cardboard can be cut to an appropriate shape *(opposite page)*, or your hands can be used—cupped or spread so that light reaches the paper only where you want it to.

If you want to darken an area considerably, try **flashing** it—exposing it directly to white light from a small penlight flashlight. Unlike burning in, which darkens the image, flashing fogs the paper: it adds a solid gray or black tone. Tape a cone of paper around the end of the penlight so it can be directed at a small area. Devise some method to see exactly where you are pointing the light. Either do the flashing during the initial exposure or add the flashing afterward with the enlarger light on and an orange or red filter held under the lens. The filter prevents the enlarger light from exposing the paper but lets you see the image during the flashing. With variable-contrast paper, the filter may not block all the light that the paper is sensitive to, so keep the enlarger light on for a minimum of time.

Keep the dodging or burning tool, your hands, or the penlight in constant

motion. Move them back and forth so that the tones of the area you are working on blend into the rest of the image. If you simply hold a dodging tool, for example, over the paper, especially if the tool is close to the paper, an outline of the tool will appear on the print.

Many prints are both dodged and burned. Depending on the print, shadow areas or dark objects may need dodging to keep them from darkening so much that important details are obscured. Sometimes shadows or other areas are burned in to darken them and make distracting details less noticeable. Light areas may need burning in to increase the visible detail. Skies are often burned in, as they were on the opposite page, to make clouds more visible. Even if there are no clouds, skies are sometimes burned in because they may seem distractingly bright. They are usually given slightly more exposure at the top of the sky area than near the horizon. Whatever areas you dodge or burn, blend them into the rest of the print so that the changes are a subtle improvement rather than a noticeable distraction.

3 6 9 12 15 18 seconds

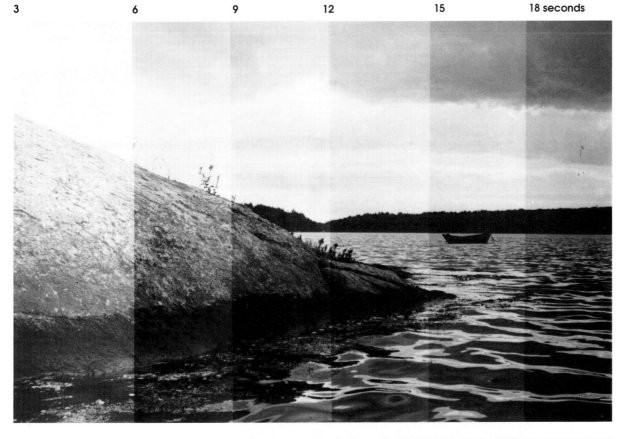

dodging

burning in

This photograph of a Maine inlet was dodged to lighten certain areas and burned in to darken others. The exposures for the test print (top left) ranged from 3 to 18 sec. The dark rock showed the best detail and texture at an exposure of about 6 sec, the water looked best at about 9 sec, and the sky needed about 18 sec of exposure to bring out detail in the clouds. The photographer gave the print a basic exposure of 9 sec, while dodging the rock for 3 sec (top right). Then the sky was burned in for another 9 sec while the rock and water were shielded from light with a shaped cardboard mask (above). In order to blend the tones of the different areas, the photographer's hand and the cardboard mask were kept moving during the exposures.

TONING FOR COLOR AND OTHER EFFECTS

Toning a print, immersing it in chemical toner solutions, can have several effects. **Toning for color** changes the color of the silver image to colors such as sepia (yellowish brown), brown, red, orange, blue, or bluish green (see box right, top). You can selectively tone different areas of a print by coating part of a print with rubber cement or artist's frisket, toning the print, then peeling up the coating. You can coat another area of the print, then tone it with another color, if you wish.

Toning for intensification changes the print color only a little—just enough to remove the very slight color cast present in most prints and to leave a neutral black image. This type of toning increases the density of the dark areas of a print, which also increases the richness and brilliance of the print. Negatives can also be toned for intensification to increase their contrast *(see page 132).*

Most toners help increase the life of a print. The silver in an image can deteriorate in much the same way that a piece of silver jewelry tarnishes. A toner increases the stability of the silver by combining it with a more stable substance, such as selenium. See page opposite.

GEORGE A. TICE: *Grasses with Iris, Saddle River, New Jersey,* 1968

Toning Black-and-White Prints

Paper and development. *Changes during toning depend not only on the toner but on the type of paper, type of developer, development time, and even print exposure time. Sepia toners lighten a print slightly, so start with a slightly dark print. Bluish toners containing ferric ammonium citrate darken a print, so start with a slightly light print. Test the effect of a toner on your particular combination of paper and chemistry.*

Fixing and washing. *Prints will stain if they have not been properly fixed and washed before toning. Two fixing baths are recommended (see page 149). Different toners require different procedures. Following is a general procedure for toning using Kodak Rapid Selenium Toner, which produces chocolate brown tones on warm-tone papers, purplish brown tones on neutral-tone papers, and little or no change on cold-tone papers.*

Toning. *Follow the manufacturer's instructions for diluting the toner, depending on your paper and the effect desired. Set out three clean trays in a well-lighted area. Ideally, light should be similar to that under which the finished print will be viewed. A blue tungsten bulb will show the color under daylight viewing conditions. Place the prints in water in one tray, the diluted toner in the middle tray, and water in the third tray—gently running, if possible.*

Place a print in the toning solution. Agitate constantly until the desired change is visible. As a color comparison, particularly if you want only a slight change, place an untoned print in a tray of water nearby. Changes due to residual chemicals can take place after a print has been removed from the toner, so remove prints from toner just before they reach the tone you want.

Final Wash. *After toning, treat fiber-base prints with fresh washing aid and give a final wash. Do not reuse the washing aid; it may stain other prints. Resin-coated prints need only a 4-min wash after toning.*

Caution. *Use gloves or tongs to handle prints in any toner. Use toners only in a well-ventilated area; fumes released during processing may smell bad or even be toxic if ventilation is inadequate. Read and follow manufacturer's instructions carefully.*

Toning a Print for Intensification

This formula for a selenium toner slightly deepens blacks and produces a rich, neutral black image. The formula incorporates a washing aid, which eliminates its use as a separate step. See also the general toning instructions above.

Dilute 1 part Kodak Rapid Selenium Toner with 10 to 20 parts washing aid (such as Kodak Hypo Clearing Agent) at working strength.

Some papers react more rapidly than others to toning, so adjust the dilution if you get too much—or inadequate—change.

Toning. *Fix prints in a two-step fixing bath (see page 149). You can transfer prints directly from the fixer to the toning solution, but this is not always a workable procedure. Instead, prints can be rinsed thoroughly and held in a tray of water until a batch is ready for toning, or they can be completely washed and dried for later toning. Soak dry prints in water for a few minutes before toning. Keep RC prints wet for as little time as possible.*

Place a print in the toning solution. Agitate until a slight change is visible, usually within 3 to 5 min. Very little change is needed—just enough so the print looks neutral or very slightly purplish in the middle-gray areas when compared to an untoned print. Immediately rinse the print in clean water. Wash for the recommended time.

ARCHIVAL PROCESSING FOR MAXIMUM PERMANENCE

Archival Print Processing

Following is one standard procedure for archival processing. Ilford has developed another method that shortens processing times considerably. Details can be found with Ilfobrom Galerie printing paper.

Paper. *Use a fiber-base paper. RC papers are not recommended for archival processing because of the potential instability of the polyethylene that coats them.*

Exposure and development. *Expose the print with a wide border—at least 1 inch around the edges. Develop for the full length of time in fresh developer at the temperature recommended by the manufacturer.*

Stop bath. *Agitate constantly for 30 sec in fresh stop bath.*

Fixing. *Use 2 baths of fresh fixer. Agitate constantly for 3–5 min in each bath. You can agitate a print in the first bath and store it in gently running water (or in several changes of water) until a number of prints have accumulated. Then all prints can be treated for 4 min in the second bath by constantly shuffling one print at a time from the bottom to the top of the stack.*

Protective toning. *Use the selenium toner formula on page 164, which includes a washing aid. If no change in image tone is desired, mix toner at 1:20 to 1:40 dilution.*

Washing. *Rinse toned prints several times. Wash at 75°–80° F (24°–27° C). Separate the prints frequently if the washer does not. Ideally, the water in the washer should completely change at least once every 5 min. Wash until the prints test acceptably free of hypo (see test procedure below), which will take 30 min to 1 hr or longer, depending on the efficiency of the washer.*

Testing for hypo. *Mix the hypo test solution below or use Kodak's Hypo Test Kit. Cut off a strip from the print's margin and blot dry. With a dropper, place a drop of test solution on the strip and allow to remain for 2 min. Blot off the excess and compare the stain that appears with the comparison patches in Kodak's Black-and-White Darkroom Dataguide, their publication R-20. The stain should be no darker than the recommended comparison patch.*

Kodak Hypo Test Solution HT-2
> *750 ml (25 oz) distilled water*
> *125 ml (4 oz) 28% acetic acid (3 parts glacial acetic acid diluted with 8 parts distilled water)*
> *7.5 gm (1/4 oz) silver nitrate*
> *distilled water to make 1000 ml (32 oz)*
> *Store in a tightly stoppered brown bottle away from strong light. The solution causes dark stains; avoid contact with hands, clothing, or prints.*

Drying and mounting. *Dry on fiberglass drying screens. Leave unmounted or slip print corners into white photo corners (used for snapshot albums) attached to mounting stock, then overmat (see pages 175–177). An archival-quality mounting stock is available in art supply stores; ask for 100% rag, acid-free boards. Separate prints with sheets of 100% rag, acid-free paper.*

How long does a photograph last? Some very early prints, particularly platinum prints that were produced around the turn of the century, have held up perfectly. Platinum paper has a light-sensitive coating that contains no silver and produces an extremely durable and very beautiful image in platinum metal. Other photographs not nearly so old have faded to a brownish yellow, their scenes lost forever.

Conventional prints, which have a silver-based image, have a long life if they are processed in the ordinary way with even moderate care. But today, many museums and individuals are collecting photographs, and, understandably, they want their acquisitions to last for as long as possible.

Archival processing provides maximum permanence for fiber-base silver prints. Resin-coated (RC) paper is not recommended for archival purposes. Archival processing is not very different from the customary method of developing, fixing, and washing. It is basically an extension of the ordinary procedures and involves a few extra steps, some additional expense, and careful attention to the fine details of the work.

Archival processing eliminates residual chemicals, those that washing alone cannot remove entirely. Among the substances that are potentially harmful to a print are the very ones that create the normal black-and-white image: salts of silver, such as silver bromide or silver chloride. During development, the grains of silver salts that have been exposed to light are reduced to black metallic silver, which forms the image; but unexposed grains are not reduced and remain in other parts of the print in the form of a silver compound. If not removed, they will darken when struck by light and will darken the image overall. The chemical used to remove these unexposed grains is fixer, or hypo as it is sometimes called, which converts them into soluble compounds that can be washed away.

Fixer, however, must also be removed. It contains sulfur compounds, which if allowed to remain in a picture will tarnish the metallic silver of the image just as sulfur in the air tarnishes a silver fork. Also, fixer can become attached to silver salts and form complex compounds that are themselves insoluble and difficult to remove. When these silver-fixer complexes decompose, they produce a brown-yellow sulfide compound that may cause discoloration.

Protective toning converts the silver in the image to a more stable compound, such as silver selenide. This protects the image against external contaminants that may be present in air pollution. Selenium toner is used most often. Gold toners used to be recommended for maximum protection but are much more expensive than selenium, and there is now some evidence that they are not as effective as once believed. Experts don't always agree on which is the best method of archival processing. One widely accepted procedure is summarized at left. See the Bibliography for more information.

PHOTOGRAPHING PEOPLE WITH A SENSE OF PLACE

BOB ADELMAN: *Retiree, DuQuoin, Illinois,* 1976

PENNY WOLIN: *Home for the High Holy Days, Wyoming,* 1990

Part of what can make a good portrait is not just the person you are photographing, but something about how they relate to the space around them. An environmental portrait, photographing someone where they work or play or wherever they have established a space of their own, can tell much more about them than a simple head-and-shoulders shot. Props or an environmental setting are not essential to a portrait, but they can help show what a person does or what kind of a person they are. See also Photographing the People in Your Life *(pages 178–179).*

Bob Adelman almost always takes pictures as part of a specific project, in this case a book about some of the programs like Social Security that have provided stability and support to people. He was looking for pictures for the book when he spotted this woman working in her garden. He chatted with her about her garden, and then about how she was getting by. She had strong views about how Social Security enabled her to retire and be self-sufficient. The photograph, by showing something of her daily life, reinforces her statement.

Adelman—intentionally or not—did the first thing you have to do to make a successful portrait: he put his subject at ease. To do this, you have to be relaxed yourself. It helps to be familiar with your equipment, so you are not paying more attention to it than to your subject. Don't skimp on film; taking several photographs to warm up can help your subject get past the novelty of the situation and the nervousness that many people feel when they are photographed.

Penny Wolin was born and raised in Cheyenne, Wyoming, part of a thriving Jewish community there. When she moved to California, she realized people were surprised when they learned that there was a Jewish community in Wyoming. Her project, Fringe of the Diaspora: The Jews of Wyoming, was the result. She photographed and interviewed many Jewish residents, including this man in tallis and yarmulke (prayer shawl and skullcap) standing by a barbed-wire fence. The apparent emptiness of the setting, even though relatively little of it is shown, gives a feeling of the openness and vastness of the Wyoming landscape.

Yousuf Karsh's portraits include presidents, popes, and most of the century's greatest musicians, writers, and artists, including the painter Georgia O'Keeffe (right). This portrait is typical of Karsh's work, conveying very strongly the sitter's public image, that is, what we expect that particular person to look like. Karsh generally photographs people in their own environments but imposes on his portraits his distinctive style: carefully posed and lighted setups, rich black tones, often with face and hands highlighted.

Notice the lighting on your subject. Soft, relatively diffused light is the easiest to handle because it is kind to faces and won't change much, even if you change your position. But stronger lighting, as at right, can add interest and emphasis. Move around your subject, or move them around, to take a look at how the light on them changes. Three simple portrait lighting setups are shown on pages 254–255.

YOUSUF KARSH: *Georgia O'Keeffe*, 1956

MOSHE KATVAN: *Pincushion*

Finishing and Mounting 8

Although much pleasure lies in taking pictures, the real reward lies in displaying and viewing the results. Yet many photographers never seem to finish their images; they have a stack of dog-eared workprints but few pictures they have been willing to carry to completion. Finishing and mounting a photograph is important because it tells viewers the image is worth their attention. And you yourself will see new aspects in your photographs if you take the time to complete them.

Finishing a photograph requires several steps, some of them optional. All prints are eventually dried; the most important precaution is to dry them in a way that does not stain or otherwise damage them. Most prints need some spotting—minor repair of small white or black specks caused by dust.

Mounting a print on a stiff backing protects it from creases and tears and prevents curling of fiber-base papers. Dry mounting, using a special dry-mount tissue, is the most common method; when heated, the tissue attaches the print to the backing in a perfectly smooth bond. An overmat can also be cut to help protect the photograph. Your choice of mounting materials depends on the degree of permanence you want for a print. The gelatin, silver, and paper in a photographic print can be seriously damaged by contact with masking tape and other materials that deteriorate in a relatively short time and generate destructive byproducts in doing so.

The best-quality and longest-lasting materials are the most expensive. Acid-free, archival-quality mounting stock (sometimes called museum board) is free of the potentially damaging acids usually present in paper. It is sold by better art supply stores or companies that specialize in archival-quality photographic materials. Less expensive but still good-quality stock can be found in most art supply stores. It won't last for a hundred years but will make presentable mounting for your print. Avoid long-term contact of prints with ordinary cardboard, brown wrapping paper, brown envelopes, manila folders, and most cheap papers, including glassine. (Archivally minded photographers would say to avoid *all* contact of prints with such materials.) Also avoid attaching to the print pressure-sensitive tapes, such as masking tape or cellophane tape, brown paper tape, rubber cement, animal glues, and spray adhesives.

◄ *Moshe Katvan believes his particular specialty is giving mood and atmosphere to otherwise simple still lifes (opposite). An overhead point of view and a light source at the level of the subject produced this fresh and unusual perspective. Notice that you wouldn't know that the pincushion was shaped like a shoe if the shadow wasn't there, which gives the shadow almost a stronger identity than the pincushion itself.*

DRYING YOUR PRINTS

The goal in **drying prints** is to avoid damaging them and wasting all the effort that has gone into making them up to this point. The most common source of trouble is that familiar enemy, contamination. One improperly washed print still loaded with fixer and placed on a dryer will contaminate every other print that is dried in the same position. And with contamination comes stains—immediately or eventually. If blotters or cloths from heat dryers become tinged with yellow, they have been contaminated with fixer that was not completely washed from prints. Replace blotters and wash the dryer cloths, or they will stain other prints with which they come into contact. Wash fiberglass screening from time to time.

Fiber-base prints can be dried on a rack, in blotters, or on a heat dryer. If the prints curl during drying or afterward, they can be flattened in a minute or two in a heated mounting press. **RC prints** have a plasticlike coating that makes them resistant to water. Since water does not soak into the paper (as it does with fiber-base papers), RC prints dry well if surface water is simply sponged or squeegeed off and the print is placed face up on a clean surface such as a fiberglass screen. Drying can be speeded by blowing the print with a blow dryer set at low heat.

▲ *Blotters may be used for print drying, provided the blotting material is the kind sold expressly for photographic use and has not been contaminated by previous use.*

◄ *This flatbed dryer for fiber-base papers has an electrically heated metal surface and a cloth apron that closes down over the prints to hold them flat. Heat drying is not recommended for RC prints.*

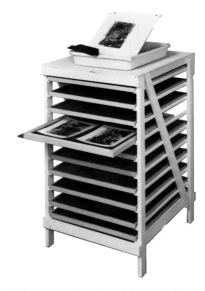

A print is rolled into this rotary dryer by turning the large knob on the side. The cylinder's surface heats electrically while a cloth cover holds the print securely against the metal. It is not recommended for RC prints.

With a screen dryer, the prints are air-dried at room temperature on contamination-resistant fiberglass screens—fiber-base prints face down, RC prints face up. You can make your own racks from wood frames covered with fiberglass screening purchased at a lumberyard or hardware store.

SPOTTING TO REMOVE MINOR FLAWS

spotting with dyes

White specks, lines, or even large spots can be blended into the surrounding tones of the print by spotting with dyes that darken the area. The dyes are used straight from the bottle for the darkest areas, diluted with water for lighter ones.

etching

Small black specks or scratches can be removed by etching the surface of the print with a sharp blade until the darkened silver of the speck is removed. The roughened surface of the print is not objectionable if the speck is small and if you etch gently.

Your prints may have small imperfections that you would like to remove. Even after careful processing, it is almost impossible to produce a print without a few white specks caused by dust on the negative or paper during printing. Black specks or scratches can be very noticeable in a light-toned area. **Spotting** a print improves its overall appearance by removing these distracting marks. Most spotting is done after the print has been completely processed and dried; the exception is local reduction or bleaching, which is done while the print is still wet. Practice is essential with all these techniques; work on some scrap prints before you start on a good print.

White spots are removed by adding dye to the print until the tone of the area being spotted matches the surrounding tone *(top)*. Liquid photographic dyes, such as Spotone, sink into the emulsion and match the surface gloss of unspotted areas. They are usually available in sets of at least three colors—neutral, warm (brown-black), and cool (blue-black)—so that the tones of different papers can be matched. You will need one or more soft, pointed brushes, size 00 or smaller (some people like a brush as small as size five zero, 00000); facial tissue to wipe the brushes; a little water; a small, flat dish to mix the colors; and a scrap print or a few margin trimmings to test them.

Pick up a drop of the neutral black on a brush and place it in the mixing dish. Spread a little on a margin trimming and compare the dye color to the color of the print to be spotted. If necessary, add some of the warmer or cooler dyes to the mixing dish until the spotting color matches the print. Spot first with undiluted

dye in any completely black areas of the print. Dip the brush into the dye, wipe it almost dry, and touch it gently to the print. Several applications with an almost dry brush will give better results than overloading the brush and making a big blob on the print. Spread out the dye in the mixing dish and add a drop of water to part of it to dilute the dye for lighter areas. Since the dyes are permanent once they are applied to the print, it is safer to spot with a light shade of dye—you can always add more. Spot from the center of a speck to the outside so that the dye doesn't overlap tones outside the speck.

Etching can remove a small or thin black mark that obviously doesn't belong where it is, such as a dark scratch in a sky area. Gently stroke the sharp tip of a new mat knife blade or a single-edge razor blade over the black spot *(bottom)*. Use short, light strokes to scrape off just a bit of silver at a time so that the surface of the print is not gouged. Etching generally does not work as well with RC papers as with fiber-base papers.

Local reduction or **bleaching** lightens larger areas. Farmer's Reducer (diluted 1:10) or Spot Off bleaches out larger areas than can be etched and also brightens highlights in a print. Prints are reduced while they are wet. Squeegee or blot off excess water and apply the reducer with a brush (used for this purpose only), a cotton swab, or a toothpick wrapped in cotton. If the print does not lighten enough within a minute or so, rinse, blot dry, and reapply fresh reducer. Refix the print for a few minutes before washing as usual. Do not use reducer in combination with toner.

HOW TO DRY MOUNT

1 | metal ruler
2 | mat knife
3 | tacking iron
4 | dry-mount tissue
5 | print
6 | mount board
7 | mounting press
8 | paper for cover sheet

Bleed Mounting

A bleed-mounted print has no border. After mounting, the print is trimmed to the edges of the image. Page 174 shows how to mount a print with a border around the edges.

1 | dry the materials

Heat the press to about 225° F (107° C) for fiber-base prints, 205° F (96° C) for RC prints, or as instructed with dry-mount tissue. Predry a fiber-base print and its mount board, with cover sheet on top, in the press for 30 sec. Do not predry RC prints.

2 | tack the dry-mount tissue to the print

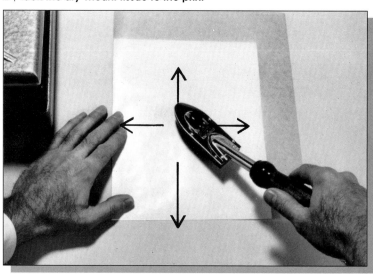

Heat the tacking iron (same temperature as in step 1). With the print face down and mounting tissue on top of it, tack the tissue to the print by moving the tacking iron from the center of the print to the sides. Do not tack at the corners. Trim off the excess mounting tissue.

Dry mounting is a fast method of providing a neat support for a print. Dry mounting uses dry-mount tissue, a thin sheet coated with an adhesive that becomes sticky when heated. The molten adhesive penetrates the fibers of both mounting board and print and forms a tight, perfect bond. To dry mount you will need a tacking iron to attach the tissue to the board and print, and a mounting press to dry the materials and bond the print to the board. The press has a heating plate hinged to a bed plate. In the press, the dry-mount tissue melts and is pressed into the board and print. If you don't have access to a press, you can use cold-mount tissue; it is pressure sensitive and needs no heat for bonding.

All materials should be absolutely clean and dry. Even a small dirt particle trapped between print and board causes an unsightly and permanent lump in the print. The mount board, print, and cover sheet should be bone dry before mounting. A fiber-base print, the mount board, and a cover sheet are placed in a heated press to drive out any residual moisture. An RC print does not have to be heated since it does not absorb atmospheric moisture.

RC prints are more sensitive to heat than fiber-base papers; their resin coating can melt at temperatures higher than 210° F. If you are mounting RC prints, use a dry-mount tissue suitable for RC prints, one that bonds at temperatures lower than 210° F. Notice *(step 1, this page)* that you set the mounting press to a lower temperature for RC paper than for fiber-base paper.

There are various ways to mount a print. The print shown here is bleed mounted—trimmed so that the edges of the image are even with the edges of the mounting board. A common method is to mount the print with a wide border around the edges *(see page 174)*.

3 | tack the dry-mount tissue and print to the board

Place the print and tissue face up on the mount board. Slightly raise one corner of the print only. Tack the tissue to the board with a short stroke of the tacking iron toward the corner. Repeat at the diagonal corner, then the other two. Keep the tissue flat to prevent wrinkles.

4 | mount the print

Put the sandwich of board, tissue, and print (with cover sheet on top) into the press. With RC prints, keep in the press for the least time that will fuse the dry-mount tissue to print and board.

5 | trim the mounted print

Trim the edges of the mounted print with the mat knife, using the ruler as a guide. The blade must be sharp to make a clean cut. Several light slices often work better than only one cut. Press down firmly on the ruler so it does not slip—and be careful not to cut your fingers.

6 | the finished print

The print above is bleed mounted, trimmed to leave no border. Page 174 shows how to mount a print with a margin of mounting board around the edges of the print.

Dry Mounting: continued

Mounting with a Border

To dry mount a print with a border of mounting board around the image, begin by following steps 1 and 2 on page 172; dry the materials in the heated mounting press and tack the dry-mount tissue to the print. Then follow the steps below.

1 │ **trim the print and dry-mount tissue**

Place the print and dry-mount tissue face up. Use the mat knife, with a metal ruler as a guide, to trim off the white print borders, plus the tissue underneath. Cut straight down so that the edges of print and tissue are even. Watch your fingers.

2 │ **position the print on the mount board**

It is convenient to mount your prints on boards of the same size: 8 × 10-inch prints are often mounted on 11 × 14-inch or 14 × 17-inch boards. Position the print so the side margins are even. Then adjust the print top to bottom. Often the bottom margin is slightly larger than the top.

3 │ **tack the dry-mount tissue and print to the board**

Without disturbing the position of the print, slightly raise one corner of the print only. Tack the tissue to the board with a short stroke of the tacking iron toward the corner. Repeat at the diagonal corner, then the remaining two. Keep the tissue flat against the board to prevent wrinkles.

4 │ **the finished print**

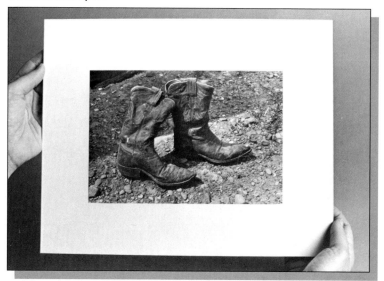

Put the sandwich of board, tissue, and print (with cover sheet on top) into the heated press, as in step 4, page 173. You can test the bonding of the mounted print to the board by slightly flexing it after it has cooled to make sure it has securely adhered.

CUTTING AN OVERMAT

1 | T square
2 | metal ruler
3 | art gum eraser
4 | 2 mount boards
5 | mat cutter
6 | single-edge razor blade
7 | print
8 | pencil

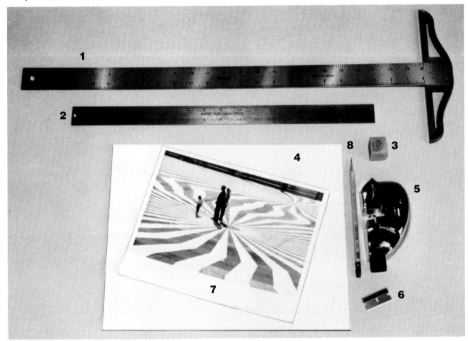

1 | measure the image area

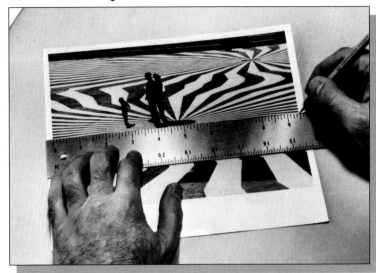

Decide on cropping and measure the resulting image. If the picture is not to be cropped, measure just within the image area so that the print margin will not show. This picture was cropped to $5\,^3/_4$ inches high by $9\,^1/_2$ inches wide. The overmat crops the print; you don't have to cut the print down.

2 | plan the mount dimensions

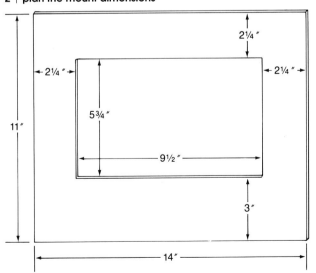

$2\frac{1}{4}''$

$2\frac{1}{4}''$ $2\frac{1}{4}''$

$5\frac{3}{4}''$

$11''$

$9\frac{1}{2}''$

$3''$

$14''$

The print above mounted horizontally on an 11 × 14-inch horizontal board leaves a $2\,^1/_4$-inch border on the top and sides, a 3-inch border on the bottom. The window in the overmat will be cut to the size of the cropped image. Two 11 × 14-inch boards are needed: one for the backing, one for the overmat.

An **overmat** provides a raised border around a print. It consists of a cardboard rectangle with a hole cut in it, placed over a print that has been mounted to a backing board. The raised border protects the surface of the print emulsion, which can be easily scratched by something sliding across it—such as another print. If the print is framed, the overmat prevents the print emulsion from sticking to the glass in the frame. Damage can still occur with a matted print but is less likely. Since the overmat is replaceable, a new one can be cut and mounted without damage to the picture if the original mat becomes soiled. One of the great pleasures of photography is showing your prints to other people—but one of the great irritations is having someone leave a fingerprint on the mounting board of your best print. Pre-

vent problems by handling your own and other people's pictures only by the edges.

It takes practice to cut the inner edges of an overmat with precision. It becomes easier after a few tries, so spend some time practicing with scrap board to get the knack of cutting perfectly clean corners. A mat cutter is a useful aid. A simple, heavy metal device designed to fit into the palm of the hand, it holds a knife blade that can be rotated to cut either a beveled (angled) or a perpendicular edge. Mat cutters, like the other tools and materials shown above, are available at most art or photographic supply stores. They are a worthwhile investment and can make the difference between a ruined board, cut freehand with an unbraced knife, and a perfectly cut mat.

Cutting an Overmat: continued

3 | mark the mat board

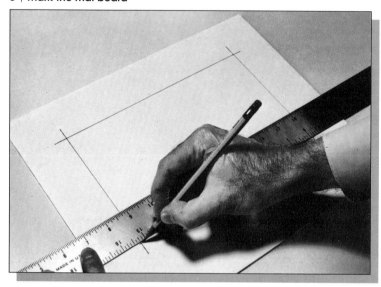

Mark the back of one board for the inner cut, using the dimensions of the image that will be visible. Measure with the ruler, but in drawing the lines use the T square firmly braced to align with the mat edge to be sure the lines are square.

4 | set the cutting blade

Insert the knife blade in the mat cutter, sliding it into the slot on the inner end of the movable bolt. Adjust the blade so that it extends far enough to cut through the board, then tighten, using the threaded knob on the bolt's outer end.

5 | cut the overmat

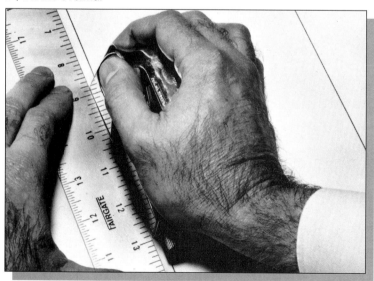

Get a firm grip on the mat cutter and brace it against the ruler. Cut each of the inside edges on a line, stopping short of the corners; finish the corners with the razor blade; do not cut too far, and take care to maintain the angle of the cut.

6 | position and attach the print

Ways of attaching the print to the backing board are shown at right. Slip the print between the backing board and the overmat. Align the print with the inner edge of the overmat. Then remove the overmat and attach the print.

7 | attach the overmat to the backing board

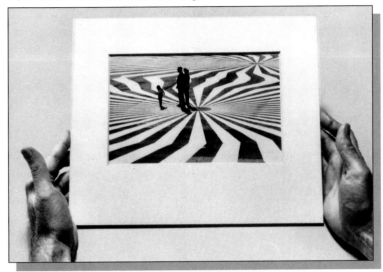

Hinge the overmat to the backing board with a strip of gummed linen tape (diagram below). Framing will hold the boards together without hinging. Handle any mounted print only by the edges. Use a gum eraser to clean the overmat if needed.

an overmatted print

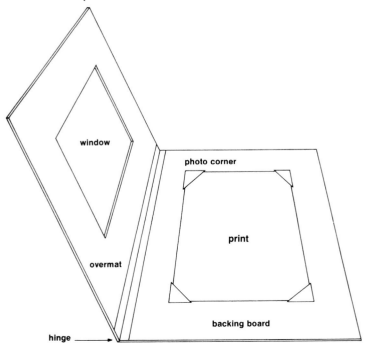

window

photo corner

overmat

print

backing board

hinge

Attaching an Overmatted Print to the Backing Board

Materials. *Ideally, use archival-quality materials such as acid-free paper for the photo corners and gummed linen (Holland) tape or other pH-neutral tape for hinges. Less expensive but good-quality materials can be used when archival permanence is not required. If you value a print, do not hinge it with brown paper tape or pressure-sensitive tapes such as masking tape or cellophane tape. These products deteriorate with age and will damage a print.*

Dry mounting. *Before positioning the print (step 6, opposite), tack a piece of mounting tissue to the back of the print and trim off the excess. After positioning the print, tack the print to the board and then mount. See steps 1–4, pages 172–173.*

Cornering. *Photo corners, like the ones used to mount pictures in snapshot albums, are a convenient means of mounting. The corners are easy to apply and are hidden by the overmat. The print can easily be slipped out of the corners if you need to remove it from the backing. You can buy gummed photo corners or make your own (see below) and attach them to the backing board with a strip of tape.*

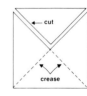 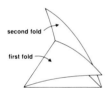

cut

second fold

first fold

crease

Hinging. *Hinging holds the print in place with strips of gummed tape attached to the upper back edge of the print and to the backing board.*

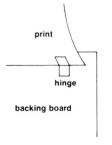 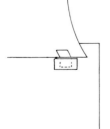

print

hinge

backing board

A folded hinge is hidden when the print is in place.

A folded hinge can be reinforced by a piece of tape.

A pendant hinge is hidden if an overmat is used.

PHOTOGRAPHING THE PEOPLE IN YOUR LIFE

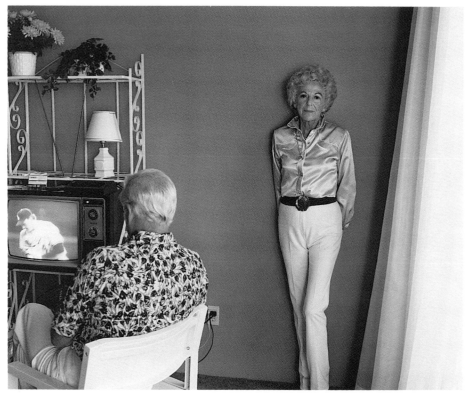

LARRY SULTAN: *My Mother Posing for Me,* 1984

LINDA CONNOR: *My Hand with My Birth Mother's When We Had Our First Meeting,* 1987

What makes a portrait? Hands alone can tell as much about people as a more conventional portrait.

Photographing close to home can be an easy place to start—or a difficult one. Conventional portraits or snapshots are pleasant and fun, but someday you may want to move beyond them to a more personal image, one that reveals more about the person you are photographing or your relationship with them. See also Photographing People with a Sense of Place (pages 166–167).

▲
To step back and see our parents is to see ourselves. It can reveal how we feel about them and about ourselves, as well as something about what we might or might not become. Larry Sultan's book Pictures from Home is a complex portrait that contains old family snapshots, stills from home movies, text from Sultan, and commentary from his parents, in addition to the pictures he made of them.

Sultan wrote, "The house is quiet. They have gone to bed, leaving me alone, and the electric timer has just switched off the living-room lights. . . . I'm restless. I sit at the dining-room table; rummage through the refrigerator. What am I looking for? All day I've been scavenging, poking around in rooms and closets, peering at their things, studying them. I arrange my rolls of exposed film into long rows and count and recount them as if they were loot. There are twenty-eight. . . . My body seems to grow smaller, as if it is finally adjusting itself to the age I feel whenever I'm in their house. It's like I'm releasing the air from an inflatable image and shrinking back down to an essential form. Is this why I've come here? To find myself by photographing them?"

Mihoko Yamagata's extended portrait of her elderly grandmother combines photographs with oral history of her grandmother's life in Japan and how it had changed over the years.

"Before my marriage I had never shopped. The maids took care of such chores. I stayed home most of the time and only went out for lessons to learn flower arrangement and how to play the koto (a stringed instrument). I never went to a post office or bank. I did not know how to make a deposit. But at the beginning of our marriage we did not have a maid. Ojiisama asked me once to go out and buy some dumplings as a snack. I had no concept of how much such a snack might cost. He said fifty sen worth (a small amount of money) would be enough for both of us. I really disliked the idea of having to go shopping on my own to buy food. But over the years, I became accustomed to managing the household. I even began to enjoy reading the financial newspaper daily and dealing in stocks."

Eye contact may or may not be part of a portrait. Having someone look into the camera lens (opposite, left) creates eye contact with the viewer and can help create a sense of intimacy with your subject. But there is another kind of intimacy (right) in a photograph that seems to be capturing a moment when someone is unaware of the camera.

MIHOKO YAMAGATA: *Before My Marriage I Had Never Shopped. . . .* 1986

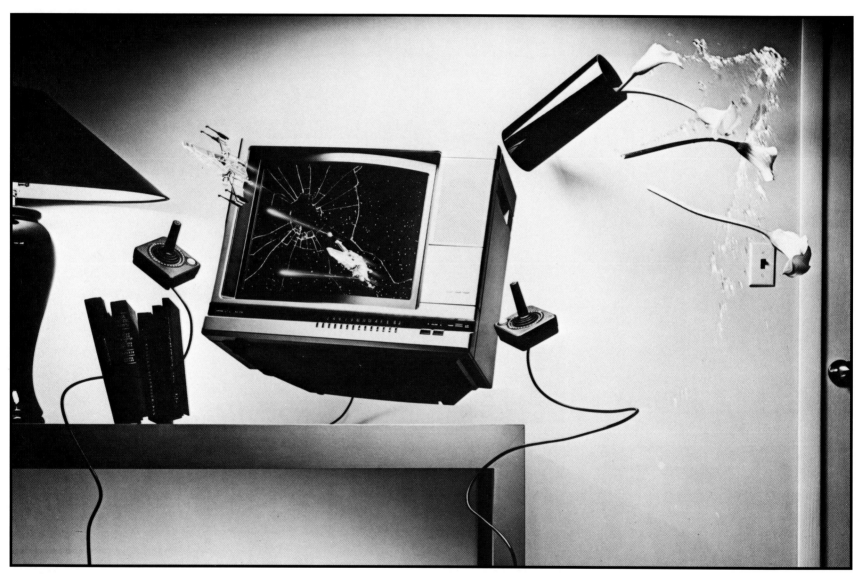

STEVE BRONSTEIN: *Video Wars*, 1982

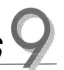

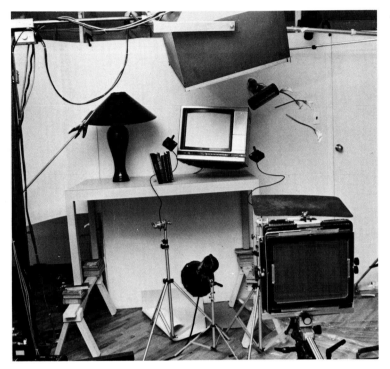

In addition to standard photographic procedures, you can create images using special equipment or techniques. This chapter shows some of the alternative ways of taking photographs or making prints. See also Chapter 12, Digital Imaging *(pages 275–297)*.

Close-up photographs produce effects beyond simple magnification. Close-ups can show objects enlarged for scientific study, but there is also pleasure and magic just in seeing something larger and in greater detail than it is ordinarily seen.

You can also manipulate a photograph and radically change the image formed in the camera (or make a print entirely without a camera) in order to make a print that is more interesting or exciting to you or to express a personal viewpoint that could not be conveyed by conventional methods. Ultimately, the success of a photograph depends not on the technique used but on your taste and judgment in fulfilling its potential—whether through a straight, full-scale black-and-white print or a manipulated image. Probably the main pitfall in manipulating a print is changing it merely for the sake of change instead of making alterations that actually strengthen the image. But you will never know what the possibilities are until you have used different techniques with your own images.

◀ *The ad agency for Mattel Electronics approached photographer Steve Bronstein with an idea they hoped would convey the excitement of home video games—a tongue-in-cheek ad to show that the games were so exciting they would even startle your TV set. The shoot began with getting the set built by a prop expert. The TV (gutted to reduce its weight) and the vase were suspended from the wall behind them. The flowers were hung from monofilament wire, which was later retouched out. Armature wire (which is sturdy but can be shaped) inside the game control cords gave them their wiggle.*

The set was lit from above by a bank of three 2400 watt/second electronic flash units. Other flash units were positioned to highlight the water, the TV screen, and the table lamp, and to add fill light.

The water was the most difficult part. The set builder filled a turkey baster with water, rigged it to the metal wringer of a sponge mop, and then hid the contraption behind the vase. When an assistant behind the set wall pulled a string, it closed the wringer, which squeezed the baster so the water spurted out, mostly into a pail positioned out of the frame. "It was a mess nevertheless," says Bronstein. "The smartest thing we did was to Scotchgard the set beforehand."

THE WORLD IN CLOSE-UP

If you want to make a large image of a small object, you can, at the simplest level, enlarge an ordinary negative. However, this is not always satisfactory because image quality deteriorates in extreme enlargements. A much better picture results from using **close-up techniques** to get a large image on the negative to begin with.

A close-up subject is focused closer than normal to the camera. This is done by fitting a supplementary lens over the front of the regular lens *(opposite)*, by increasing the distance from lens to film with extension tubes or bellows inserted between the lens and the camera back *(page 184)*, or by using a macro lens that is designed for close-up work *(pages 48 and 185)*. Each method can focus a larger-than-normal image on the film *(diagram below)*.

Working close up is somewhat different from working at normal distances. After roughly focusing and composing the image, it is often easier to finish focusing by moving the entire camera or the subject farther away or closer rather than by racking the lens in or out. During shooting, a tripod is almost a necessity because even a slight change in lens-to-subject distance changes the focus. A highly magnified image readily shows the slightest camera movement, so a tripod also helps by keeping the camera steady.

Depth of field decreases as the subject is focused closer to the lens. Depth of field is very shallow at close working distances, so focusing becomes critical. A 50mm lens at a distance of about 12 inches from the subject has a depth of field of one-sixteenth inch when the aperture is set at f/4. At f/11 the depth of field increases—but only to one-half inch.

The depth of field may be distributed differently, too, depending on the lens you are using. In a close-up it may extend about half in front and half behind the plane of focus. At normal working distances it may be more like one-third in front and two-thirds behind the plane of focus.

Some cameras are better than others for close-up work. A single-lens reflex or view camera is good for close-ups, mostly because of its through-the-lens viewing. You can see exactly where the lens is focused and preview depth of field by stopping down the lens, an important ability with shallow depth of field. You can frame the image exactly and see just how the subject relates to the background. Many single-lens reflex cameras have through-the-lens metering, which can solve some close-up metering problems *(see metering on page 186)*.

Twin-lens reflex and rangefinder cameras are less convenient because it is difficult to see the image exactly as the lens does. If you have a twin-lens reflex, you can buy twin supplementary lenses that fit over the camera's viewing and taking lenses; a built-in prism changes the angle of the viewing lens so it sees the same area as the taking lens (although from a slightly higher point of view, which changes the relationship of subject to background). It is also possible to measure the distance from the center of the taking lens to the center of the viewing lens, then raise the tripod head exactly that much; a tripod accessory is available for this.

Rangefinder cameras are even harder to use since the rangefinder mechanism will not focus at very close distances and the viewfinder will not show the exact area being photographed.

In normal photographic situations, the size of the image produced on the film is less than one-tenth of the size of the object being photographed. Close-up images where the subject is closer than normal to the camera can range from about one-tenth to about 50 times life size. Beyond about 10 times life size, however, it is often more practical to take the photograph through a microscope. The term "photomacrograph" (or "macrophotograph") refers to close-ups that are life size or larger. Pictures through a microscope are photomicrographs.

The relative sizes of image and subject are expressed as a ratio with the relative size of the image stated first: a 1:10 ratio means the image is one-tenth the size of the subject. Or the image size can be stated in terms of magnification: a 50× magnification means the image is 50 times the size of the subject. The magnification of an image smaller than life size (actually a reduction) is stated as a decimal: a .10× magnification produces an image one-tenth life size.

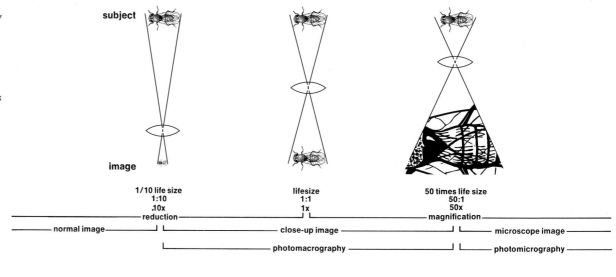

subject

image

1/10 life size	lifesize	50 times life size
1:10	1:1	50:1
.10x	1x	50x
reduction		magnification

normal image ⌐ close-up image ⌐ microscope image

photomacrography ⌐ photomicrography

How to Use Supplementary Lenses

50mm lens alone

How supplementary lenses enlarge. Here, a cluster of petunias as seen by a 35mm camera with a 50mm lens. The lens, set at its closest focusing distance (about 18 inches), produces an image on the film about one-tenth life size. (The pictures here are enlarged slightly above actual film size.)

50mm lens and +1.5 diopter lens

With a +1.5 diopter supplementary lens, camera-to-subject distance is reduced to 15 inches for a larger image, about one-fifth life size.

50mm lens and +4.5 diopter lens

With +4.5 diopters, the distance is 10 inches to the flowers. The image of a blossom enlarges to about one-third life size.

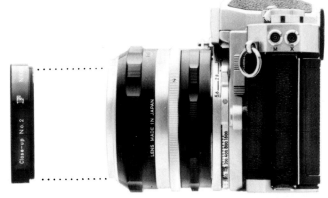

supplementary lens

35mm SLR camera with 50mm lens

Supplementary or **close-up lenses** let you make close-ups with an ordinary camera lens. They are magnifying glasses of varying powers that are attached to the front of the lens. Supplementary lenses enlarge an image in two ways: they add their own power to that of the regular lens, and they change the focusing distance of the regular lens so that it can focus closer than normal.

The power of a supplementary lens is expressed in **diopters,** an optical term used to describe both the focal length and the magnifying power of the lens. Thus a 1-diopter lens (expressed as +1) will focus on a subject 1 meter (100 cm, or 3.28 ft) away. A +2 diopter focuses at half that distance (50 cm) and magnifies twice as much; a +3 diopter focuses at 33 cm and magnifies three times as much, and so on. Lenses of varying diopters can be added to each other to provide greater magnification, as long as the stronger lens is attached to the camera first. Image quality tends to suffer, however, when more than one lens is used.

When a supplementary lens is attached to a camera lens set at infinity, the new focusing distance will be the focal length of the supplementary lens. This is true no matter which camera lens is being used. For example, a +2 diopter lens will always focus on a subject 50 cm (19.7 inches) away with a 50mm lens, an 85mm lens, or any other lens—provided that the regular lens is set at infinity.

Image size, however, depends on the focal length of the camera lens. This happens because the degree of enlargement is determined by the diopter of the supplementary lens plus the magnifying power of the regular lens. Thus a +2 diopter gives a bigger image with an 85mm lens than with a 50mm lens. Also, a supplementary lens gives varying degrees of enlargement depending on the distance setting of the lens. With the lens set for a distance closer than infinity, an object can be brought into focus closer than the regular diopter distance to create an even larger image. Charts provided with supplementary lenses give details.

Supplementary lenses are useful but have some problems. They do not change exposure readings, which is convenient. Also, they are small and inexpensive and can be used with any kind of camera, including those without interchangeable lenses. Because of their design, however, the lenses provide acceptable sharpness only when used with small apertures. They work well with long-focal-length lenses, but not with those of true telephoto design. Their surfaces, not bonded to the regular lens, may cause reflections and other aberrations. And overall sharpness decreases at +5 diopters or stronger.

The World in Close-Up: continued

How to Use Extension Tubes and Bellows

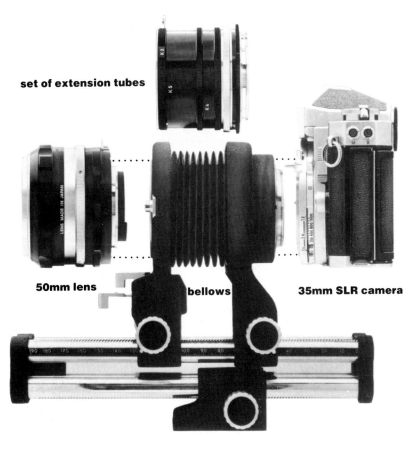

set of extension tubes

50mm lens **bellows** **35mm SLR camera**

Extension tubes and **bellows** are mounted between camera body and lens. They extend the lens farther from the film so the lens can be focused closer to the subject. The closer the lens comes to the subject, the larger its image size on the film. (Similarly, the closer you bring your eye to an object, the larger the object appears.) The main differences between extension tubes and bellows are in the ease with which they produce varying amounts of magnification and in their price.

Tubes are rings of metal. Most are rigid and extend the lens in predetermined, graduated steps depending on the length of each ring and how many of them are used. They are light, easily attached, and relatively inexpensive but not always as useful as bellows because they come in fixed lengths. A more expensive type of tube can be racked in or out like a lens barrel and so extended to variable lengths. A macro-converter is an extension tube with elements that optically im-

prove sharpness when a conventional lens is used at close-up distances.

Bellows have a flexible center and can be expanded to different lengths. They provide continuously variable magnifications over their extendable range. A good-quality bellows is a precision instrument, more expensive but more versatile than an extension tube.

Tubes and bellows maintain better optical quality than supplementary lenses. They provide a wide range of magnifications, including high-quality, larger-than-life-size images. Disadvantages are due to inserting them between lens and camera body. Tubes and bellows can be used only with cameras that have interchangeable lenses. Unless specifically designed for a particular camera, they will interrupt automatic exposure functions if the camera has them, which means that shutter speed and aperture must be adjusted manually.

50mm lens on 35mm SLR camera

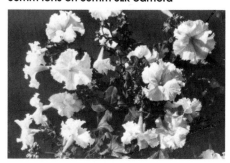

Some different degrees of magnification using extension tubes and bellows are shown in the pictures at left. Here, a view of some petunias taken with a 50mm lens alone. The image on the film is about one-tenth the actual size of the flowers. (The pictures are enlarged slightly more than the film size.)

50mm lens and extension tubes

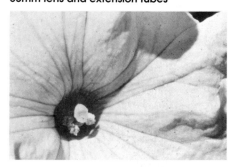

A picture taken with a set of extension tubes inserted between the lens and the camera. This let the lens be focused closer to the flowers, which produced a life-size image of part of a single blossom. Increasing or decreasing the number of rings used in the tube set would produce greater or lesser magnification.

50mm lens reversed and extension tubes

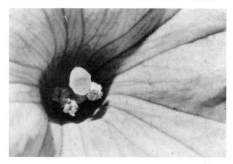

Here the same extension tubes were used as above but with the 50mm lens reversed; the front end of the lens instead of the back was attached (with a reversing ring) to the tubes. At very close distances, many lenses perform better if reversed because of the asymmetrical design of the lens elements. Reversing also provides somewhat more magnification.

50mm lens and fully extended bellows

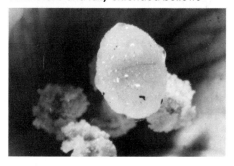

A picture taken with the reversed 50mm lens attached to a fully extended bellows. The lens was able to be focused so close that it showed just the center of a single flower magnified to five times life size.

How to Use Macro Lenses

55mm macro at medium distance

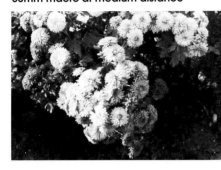

The magnifications produced by moving closer to a subject with a 55mm macro lens are shown at right. Here, the picture was taken from 5 ft away. The resulting image (slightly enlarged here) was about $1/25$ life size.

55mm macro at closest distance, 10 inches

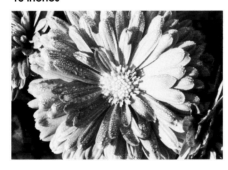

Setting the lens to focus as close as possible and moving the camera about 10 inches from a flower produced an image one-half life size.

55mm macro with extension tube, 8 inches

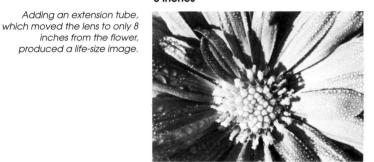

Adding an extension tube, which moved the lens to only 8 inches from the flower, produced a life-size image.

70–150mm macro zoom lens

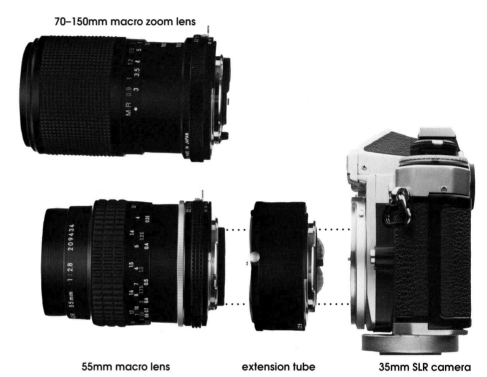

55mm macro lens **extension tube** **35mm SLR camera**

If you want to make close-ups, a **macro lens** is probably the most useful piece of equipment you can own. The lens barrel of a macro is constructed so it can be extended farther than normal, which lets you focus closer than normal to a subject. A 50mm macro lens without any accessories will focus as close as 9 inches and produce a one-half life-size image. The size of the image can be increased even more by inserting extension tubes or bellows between the lens and the camera body.

Macro lenses are optically corrected to prevent the aberrations that reduce sharpness at close focusing distances, so they give close-up images with edge-to-edge sharpness superior to that produced by lenses of conventional design. They also perform well when used for general photography. Macro lenses are available in several fixed focal lengths from 50mm to 200mm and as macro zoom lenses in

focal lengths such as 28–85mm and 70–150mm. Most macro lenses connect directly to the camera body, retaining connections with the camera's meter or any automatic features.

One inconvenience is that a macro lens's widest aperture is relatively small: f/3.5 is a typical maximum aperture for a 50mm macro. Adding an extension tube or bellows also cuts the amount of light reaching the film. This means that in dim light or with slow film, a relatively slow shutter speed must be used.

Macro zoom lenses are popular because they let you produce different degrees of magnification without moving the camera. However, many lenses sold as macro zooms would be more accurately called close-focusing zooms; they are not fully corrected for working up close, and unless tubes or bellows are added, they produce an image only one-third to one-quarter life size.

The World in Close-Up: continued

Close-Up Exposures: Greater than Normal

Two possible exposure problems arise when photographing close up. One is getting an accurate light reading in the first place and the other is adjusting that reading when the lens is extended farther than normal from the film.

The small size of a close-up subject can make metering difficult. The subject is usually so small that you might meter more background than subject and so get an inaccurate reading. A spot meter is one solution; it can read very small objects with accuracy. Or you can make a substitution reading from a gray card *(page 104)*. Another possibility is to use an incident-light meter to read the light falling on the subject.

You need to make an **exposure increase with bellows or extension tubes.** As the distance between lens and film increases, the intensity of the light that falls on the film decreases and the image becomes dimmer. Therefore, to prevent underexposure in close-up photographs, the exposure must be increased. Accessory bellows and extension tubes come with charts for this purpose, or you can calculate the new exposure yourself. Whichever method you use, it's a good idea to bracket your exposures. First make the exposure you think is correct, then make one or two more with increased exposure.

You don't have to do any calculating if your camera has a through-the-lens meter that reads the light that actually reaches the film, as many single-lens reflex cameras do. If the object is magnified enough to fill the viewing screen (or that part of the screen that shows the area being read), the meter will calculate a corrected exposure by itself.

If you are using a hand-held meter, there are several ways to find the exposure increase. One way is to use the dial of the meter, as shown in the diagrams at right. This is easier on a meter with movable dials rather than one with only digital readout.

If you want to do the arithmetic yourself, have the bellows extension (or extension tube length) and the lens focal length in the same units of measure—either inches, centimeters, or millimeters (1 inch = 2.5 cm = 25 mm).

$$\frac{\text{indicated f-stop}}{\text{adjusted f-stop}} = \frac{\text{bellows extension}}{\text{focal length of lens}}$$

Meter the subject and choose an f-stop and shutter-speed combination. If the f-number indicated by the meter is f/16 at $\frac{1}{8}$ sec, the focal length of the lens is 2 inches, and the distance from the lens diaphragm to the film plane measures 10 inches, then:

$$\frac{16}{x} = \frac{10}{2} \qquad 10x = 32 \qquad x = 3.2$$

The new exposure combination is f/3.2 (slightly larger than f/4) at the original shutter speed. Set f/3.2 opposite the speed on the meter dial to read off equivalent combinations.

You can also calculate a bellows extension factor that tells how many times the exposure must be increased.

$$\text{factor} = \frac{\text{bellows extension}^2}{\text{focal length}^2}$$

$$\text{factor} = \frac{10^2}{2^2} = \frac{100}{4} = 25$$

Increase the exposure about 25 times (about $4\frac{1}{2}$ stops).

Very long exposures also require additional exposure. You will need to compensate for reciprocity effect if your final shutter speed is longer than about 1 second *(see page 102)*.

exposure increase for a close-up

For close-ups, you need to increase the exposure because the lens is farther than normal from the film and produces a dimmer-than-normal image. If you have a hand-held meter with rotating dials that line up f-stops and shutter speeds, it's easy to use it to help you calculate the exposure increase. First, measure the bellows extension (or extension tube length), measuring from the rear of the lens to the film.

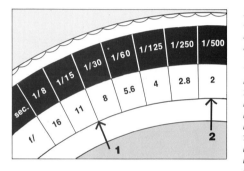

Meter the subject and calculate an exposure as you normally would. Now find two numbers on the f-stop scale on the meter dial to stand for (1) the bellows extension measured above and (2) the focal length of the lens. Have both measurements either in inches or in metric units (1 inch = 2.5 cm = 25 mm). Here the bellows extension was 10 inches (25 cm), and the focal length of the lens was 2 inches (5 cm).

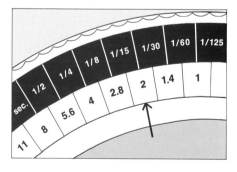

Move the number on the f-stop scale that stands for the focal length to the position occupied by the number that stands for the bellows extension. Read off the new f-stop and shutter-speed combinations. If your meter has digital readout instead of movable dials, you can usually find a way to shift the f-stop setting, although probably not as readily as on a meter with dials.

A kohlrabi is a prosaic vegetable, but in this close-up Ralph Weiss has shown it in an uncommon way. Isolating it against black separates it and causes the viewer to examine its shape in detail. There are no visual clues to its actual size (though the caption will tell you), and it is shown upside down from the way it grows: the photograph presents it as a visual experience rather than as something to eat. It can become a sea creature, with trailing tentacles undulating through dark waters.

RALPH WEISS: *Kohlrabi*, 1966; magnified 0.6×, here enlarged to 3.4×

COPYING TECHNIQUES

Copying an old family portrait, for example, or some other flat object such as a painting or book page requires more than just casually snapping the picture. You will encounter many of the same technical concerns that you do with close-up photography—the need for considerable enlargement if your original is small, the need for camera support, and so on. Plus, you need to align the camera squarely and provide an even, shadowless lighting. The techniques are not difficult but do demand some attention to detail.

The **film** to use depends on whether the copy (the term for the original material to be reproduced) is continuous tone or line copy. Black-and-white **continuous-tone copy** has black, white, and gray tones. Ordinary photographs, pencil drawings, and paintings are examples. Fine-grain, panchromatic film is best for black-and-white reproductions.

Black-and-white **line copy** has no gray tones, only black tones and white ones (*like* Little Red Riding Hood, *opposite*). Ink drawings, charts, and black-and-white reproductions in books are examples. The clean whites and crisp blacks of line copy are most easily reproduced using high-contrast lith film like Kodak Kodalith Ortho. If high-contrast film is not available, use ordinary black-and-white film processed for higher-than-normal contrast: underexpose the film by one stop, develop the film for $1^1/_2$ times the normal development time, then print on contrasty paper.

If you want a color reproduction, select film balanced for your light source. Use tungsten film for ordinary tungsten lights, Type A film for 3400K photolamps (or tungsten film with an 81A filter on the camera lens), daylight film for daylight or flash.

Equipment needed for copying includes a camera, a steady support for it, a means to hold the copy in place, and lighting. A camera with through-the-lens

viewing is best because it lets you accurately position the copy and check for glare and reflections. A 35mm or medium-format single-lens reflex is fine for most work. Use a view camera, which produces a 4 × 5-inch or larger negative, when you want maximum detail. With an SLR, if the copy is small, you will need to use extension tubes, bellows, or a macro lens to enlarge the image enough to fill the film format. A view camera has its bellows built in. It is usually preferable not to use supplementary close-up lenses; they often display aberrations that are more noticeable in copy work than with ordinary close-ups.

A steady support for the camera, either on a tripod or copy stand, provides stability during preparation and exposure. Even a slight amount of camera motion creates unsatisfactory softness in copy work. A cable release to trigger the shutter prevents camera motion at the moment of exposure.

The copy and the camera must be exactly parallel to each other; otherwise your reproduction will be distorted. A **copy stand** *(this page, top)* holds the copy horizontally; once the camera is attached and leveled, it can be moved up and down the central column while the film plane of the camera remains parallel to the copy. Oversize objects can be hung on a wall *(this page, bottom)*. Mount the copy flat against the wall. Move the camera close to the wall and adjust the tripod height so the lens is lined up with the center of the copy, then move the camera straight back from the wall. A view camera often has lines on the ground-glass viewing screen that lets you check the squareness of the image's alignment. Some 35mm cameras let you replace the normal viewing screen with one that has etched lines, or you can use the edges of the finder frame to check the alignment.

Your goal for **lighting** should be even, shadowless light over the entire surface

A copy stand is a convenient way to photograph a small object like a book or small print, which is placed flat on the baseboard. The camera mounts on the central column and can be moved up or down to adjust the framing of the image. Sometimes lights are attached to the sides to provide illumination at an angle to the baseboard.

Wall mounting can be used for a larger item, such as a painting. The object to be copied is hung on the wall. The camera is positioned on a tripod squarely in front of the object. Lights on each side are at a 45° angle to the wall.

Line copy, such as an engraving (above), black-and-white book page, or ink drawing, has only black tones and white tones, no grays. High-contrast lith film produces the best reproduction of it. A continuous-tone original, such as an ordinary black-and-white photograph or a pencil drawing, has a range of gray tones, as well as black and white, and should be copied on fine-grain, general-purpose film.

If the object being copied is behind glass, you may see a reflection of your camera in the image. Eliminate the reflection by shielding the camera behind a large black card or cloth with a hole cut in it for the lens.

of the copy. Although it is possible to use existing daylight if you have a bright area of diffused light to work in, it is usually more practical to set up lights. Position two identical lights, one on each side of the copy at about a 45° angle to it, aimed so the lighting overlaps at the center of the copy. Continuous light sources, such as photofloods, are easier to use than flash to judge the effect of the lighting. Ideally, the lights should be the same age because light output can weaken or change color as a bulb ages.

To check the evenness of the illumination, meter the four corners and the middle of the copy. With black-and-white or color negative film, there should be no more than $1/2$ stop difference in any area, even less with color slides. You can use an incident-light meter (held close to the copy and pointed toward the camera). Or you can use a reflected-light meter (pointed toward the copy). Take reflected-light readings from a gray card *(page 104)* and not from the copy itself so that the tones of the copy do not affect the readings.

You may need to place a piece of glass over your copy to hold it flat. If you do or if the copy itself is shiny, you may have to adjust the position of the lights so that you do not get light reflecting off the copy directly into the lens. A polarizing filter on the camera lens will eliminate most such reflections. In some cases, you may need to use polarizing screens on the lights plus a polarizing filter on the lens. You will also need to check for reflections of the camera itself in the glass. If you see them, hide the camera behind a piece of black card or cloth with a hole cut in it for the lens *(left, bottom)*. Always look through the lens when checking for light

or camera reflections. Even if you are right beside the camera, you may not see them otherwise.

Now that the copy is flat, the camera is square, the lighting is even, and you don't have any reflections of the lights or the camera, you are almost ready to make an **exposure.** Meter the copy using an incident-light meter, or a reflected-light meter and a gray card. Select a medium aperture. Depth of field is very shallow if your focusing distance is close, and a medium aperture provides enough depth of field to allow for slight focusing error. Also, you will get a sharper image at a medium aperture than at the lens's smallest one.

Once you have the basic reading, you will need to increase it if you are using extension tubes or bellows that extend the lens farther than normal from the film *(see page 186)*. You also need to increase the exposure if you are using a polarizing filter ($1\frac{1}{3}$ stops). Is your exposure longer than one second? If so, another increase is needed—for reciprocity effect *(see page 102)*. A reflected-light meter that is built into the camera and reads through the lens has the advantage of directly adjusting for everything but the reciprocity effect. If you are using an automatic camera, be sure that it is set to its manual exposure mode and that you set the f-stop and shutter speed yourself.

Finally, once you have made the exposure, protect yourself by bracketing additional exposures: one stop more and one stop less with black-and-white film, one-half stop more and less with color film. If possible, leave your camera and the copy set up and develop a test exposure so you can reshoot, if needed, with minimum effort.

SPECIAL PRINTING TECHNIQUES
A Photogram: A Cameraless Picture

A **photogram** is a kind of contact print, made by placing objects, instead of just a negative, on a piece of light-sensitive material and exposing it to light. In the 1920s, about 80 years after the first camera photographs were made, photograms and other print manipulations such as solarization became popular with the painter-photographers Man Ray and László Moholy-Nagy, who sought to explore the "pure" actions of light in space.

Any object that comes between the light source and the sensitized material can be used. You can try two-dimensional objects like cut paper, three-dimensional ones, opaque objects that block the light completely, transparent or translucent objects like a pitcher or a plastic bottle that bend the light rays, objects laid on glass and held at different levels above the paper, moving objects, smoke blown over the surface of the paper during the exposure—the possibilities are limitless. All these objects are light modulators—they change the light on its way to the paper. Light can be added to the paper as well as held back: for example, a penlight flashed at the paper or suspended from a string and swung across the surface.

A photogram can be made on a piece of printing paper or on a negative that is then printed. Color photograms can be made by exposing color paper through different color filters or by using translucent, tinted objects to modulate the light.

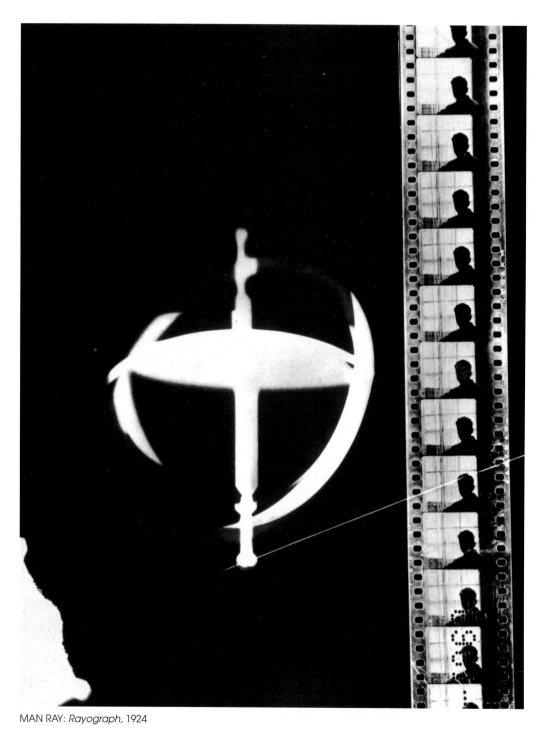

Man Ray arranged string, a toy gyroscope, and the end of a strip of movie film on a piece of photographic paper, then exposed the paper to light. The resulting image is as open to interpretation as you wish to make it. You can see it simply as an assemblage of forms and tones. Or if you see the large black background as a person's head in silhouette (like the silhouetted head in the movie film), then the strip of film might be a dream seen by the internal gyroscope of the brain.

MAN RAY: *Rayograph*, 1924

▲ In a photogram, objects are arranged directly on light-sensitive material. Here a simple photogram is being made by placing a piece of marsh grass on a sheet of high-contrast (grade 5) printing paper. The head of the enlarger is positioned far enough above the baseboard to light the paper completely. After exposure, the paper is developed, fixed, and washed in the usual manner to produce a life-size print of the grass. Experiment with different exposures—longer ones will penetrate some objects more and create a different effect.

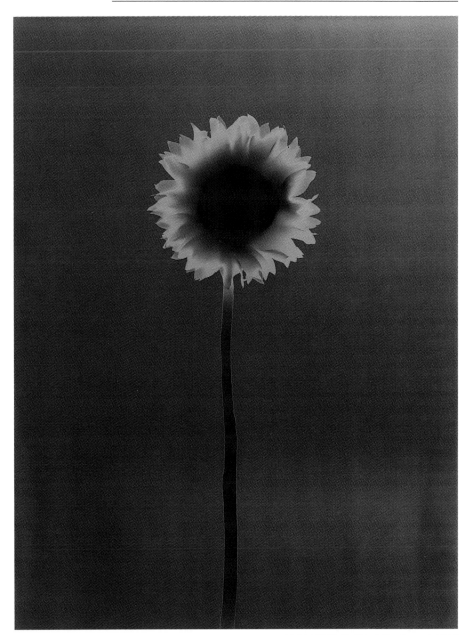

ADAM FUSS: *Untitled (Sunflower)*, 1992

JACK SAL: *No Title*, 1978

◀ You can combine several layers to make a photogram or use just one. Jack Sal sandwiched together a matzo cracker and a piece of very slow printing-out paper that darkens on exposure to sunlight. He put the two in his window for about a month, then fixed the paper like an ordinary print to prevent further darkening. The holes in the cracker appear large because during the day the sun changed position in the sky and shone into the holes from different angles. The effect could be simulated by an ordinary printing paper with a much shorter exposure.

▲
Adam Fuss has made photograms of flowers, water, animals, and other objects placed on printing paper. Here, a single sunflower was placed on reversal color printing paper (ordinarily used to make a positive print from a positive color transparency). The flower seems to radiate light as if backlit or glowing from within. Compare the sunflowers on pages viii and 1.

Special Printing Techniques: continued

A Sabattier Print—Part Positive, Part Negative

A **Sabattier print** is made by reexposing the paper to light during processing. This gives a print both negative and positive qualities and adds halolike Mackie lines between adjacent highlight and shadow areas *(see opposite and page 392)*. The technique is commonly known as **solarization,** although, strictly speaking, solarization (which can look somewhat similar) takes place only when film is massively overexposed. The correct name for the phenomenon shown here is the Sabattier effect.

The unusual appearance of a Sabattier print results from a combination of effects. When the print is reexposed to light during processing, there is little effect on the dark areas of the print because most of the crystals there have already been exposed and reduced to black silver by the developing process. The bright areas, however, still contain many sensitive crystals that can respond to light and development. The bright areas therefore turn gray but usually remain somewhat lighter than the shadows. Between the light and dark areas, by-products remaining from the first development retard further development; these border regions remain light, forming the Mackie lines.

There are several ways to produce a Sabattier print. The simplest way, but the most difficult to control, is simply to turn on a light briefly while the print is in the developer. A procedure that gives much more control is described in the box at right.

Printing from a negative will give a positive image plus negative effects from the second exposure, as in the print opposite. You can also print from a positive color slide, which will give a negative image plus some positive effects. Black-and-white printing paper responds differently to colors in the slide: blue prints as black, yellow prints as white.

Making a Sabattier Print

Basic procedure

Materials needed. *A negative of normal to high contrast. Normal print processing chemicals. High-contrast paper (grade 5 or 6).*

First exposure. *Put negative in enlarger and focus. Expose a test print with a slightly lighter than normal series of text exposures. (Test print, opposite left, received first exposures of 5, 10, 15, and 20 sec.)*

First development. *Develop for the standard time in normal developer.*

Rinse. *Wash in water for 30 sec to remove the surface developer. Do not use an acid stop bath. Remove excess water from the front and back of the print with a squeegee or soft paper towels. Handle gently to avoid scratching the fragile surface of the wet print.*

Second exposure. *Remove the negative from the enlarger. Stop down the aperture about two stops. Reexpose the test print in strips at right angles to the first exposures. (Test print, opposite left, was given second exposures of 5, 10, 15, and 20 sec.)*

Second development. *Develop for the standard time in normal developer.*

Finish processing. *Treat print with stop bath and fixer; wash and dry as usual.*

Final print. *Examine the test print and choose the square that gives the desired effect. Note the combination of exposure times, apertures, and development times. Make a print under these conditions.*

Variations

Set the enlarger slightly out of focus. This will broaden the Mackie lines without making the image noticeably out of focus. The Mackie lines will also be broader with a less contrasty negative.

Develop for less than the standard time. Remove the print quickly from the developer when the desired effect is visible.

Develop in a more dilute developer (if the normal dilution is 1:2, try 1:4, 1:10, or even greater dilutions to produce color shifts).

Develop in two different developers. A cold-tone developer for one development and a warm-tone developer for the other will give color shifts.

Some photographers report better results if the print is aged at this point in a dark place (a photo blotter book works well). Aging times vary from 15 min to a week.

See variations under first development.

Dodging or burning in during the first and/or second exposure will give different results. The Mackie lines can be lightened by bleaching. The reducing formula given by Ansel Adams in his book The Print *is recommended. You can also try local reduction or an overall immersion in Farmer's Reducer (diluted 1:10).*

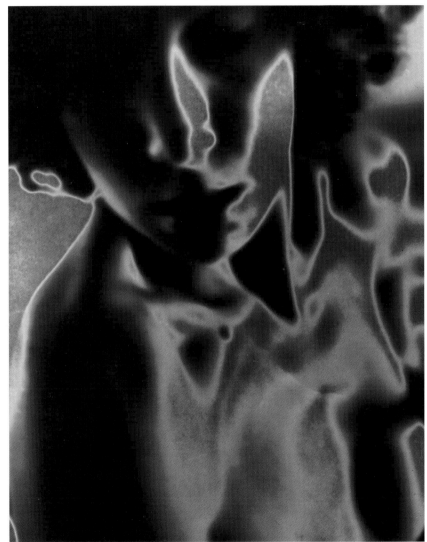

This test for a Sabattier print was given first exposures of 5, 10, 15, and 20 sec (left to right). After a first development, the print was exposed again to light from the enlarger, but without the negative in place. The second exposures were 5, 10, 15, and 20 sec (bottom to top). The test was then developed again, fixed, and washed.

The exposures for the final print were chosen from the test print at left: a first exposure of 20 sec and a second exposure of 5 sec (the bottom right square of the test). The enlarger was deliberately set very slightly out of focus to broaden the very light Mackie lines, and the print was later bleached to lighten them.

TECHNIQUES USING HIGH-CONTRAST FILM

High-contrast materials can change a black-and-white picture in many ways. The pictures on the following pages show methods of using high-contrast materials to change the conventional portrait at right into a high-contrast image, a line print, a posterlike patchwork of grays, and finally a color version.

To start, the original negative is enlarged onto **lith film,** a high-contrast copying film sold under various trade names (such as Kodak Kodalith Ortho) for use in photo-offset printing. One of its properties is that it converts the range of tones in an ordinary image into solid black and pure white. This produces a **dropout,** an image with only black or white areas and no intermediate gray tones. Lith film enables the graphic artist or photographer to change any continuous-tone picture, made on ordinary film, into a pattern of black and white. And by altering the exposure time in the copying process, you can produce images with differing amounts of black—even to the extreme of a practically solid black image pierced only by the brightest highlights.

Because lith film produces black-and-white transparencies, several can be superimposed in printing to achieve a range of effects. Lith film lends itself to various color-printing techniques, including the use of color printing paper. Step-by-step demonstrations of techniques using these materials appear on the following pages. Another way of producing the same results is by using digital imaging programs *(see pages 282–289).*

FRED BURRELL: *Portrait of Ann Ford,* 1971

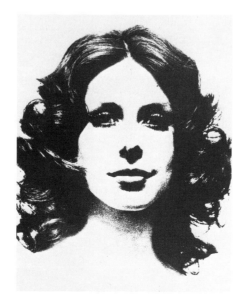

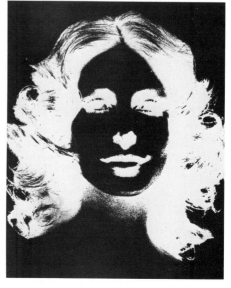

At left, high-contrast positive and high-contrast negative transparencies, made from the ordinary continuous-tone photograph above. High-contrast transparencies like these were used to make the line print and posterizations shown on pages 196–197. They have no middle-gray tones, only black and white. They will be used for contact printing, making final images the same size as the transparencies, and so have been enlarged to 8 × 10 size.

1 | set up enlarger

To start off the printing processes shown on these pages, place the original continuous-tone negative within the enlarger's negative carrier, ready to be inserted in the enlarger for reproduction on high-contrast graphic arts (lith) film such as Kodak Kodalith Ortho Film 2556, Type 3. If the manufacturer describes the film as ortho or orthochromatic, it can be processed under red safelight; you will be able to see what you are doing and how the film is developing. Check the instructions.

2 | expose a positive

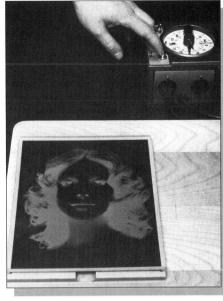

The negative, projected onto the easel on the baseboard, is enlarged to fill an 8 × 10 sheet of film. The first reproduction will be a positive transparency and from that a negative will be contact printed. Try an exposure time of between 10 and 20 sec with the enlarger lens wide open; make a test strip to check the effects of different exposures—slight increases in exposure extend the dark areas.

3 | process

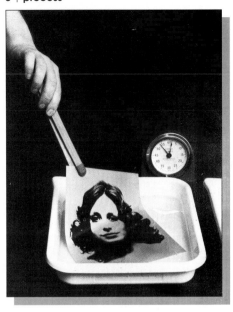

Process like a conventional photographic film but use a developer designed for lith film. Check the instruction sheet for development time—with Kodalith Super RT Developer it is $2\frac{3}{4}$ min at 68° F (20° C) with constant agitation. Agitate in fresh stop-bath solution for about 10 sec. Then agitate in fresh fixer for 4 min. Wash for 10 min in running water at 65°–70° F (18°–21° C), and dry.

4 | make a contact-printed negative

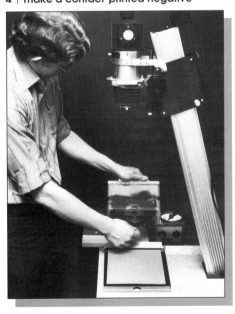

A negative can be produced from a positive transparency by using standard contact printing techniques (pages 144–145). First make sure the enlarger head is raised enough so the light will cover the contact frame. Then (above) clip the positive to the glass cover of a printing frame, emulsion side away from the glass. Insert, emulsion side up, an unexposed sheet of high-contrast copying film.

5 | make a contact-printed positive, if needed

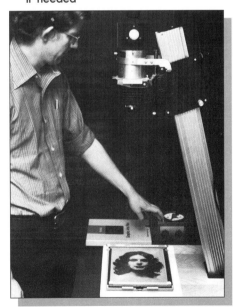

Try an exposure between 5 and 10 sec with the aperture wide open; a test strip will give an exact exposure. You may find in comparing the high-contrast positive to the high-contrast negative that the negative has dropped out more tones than the positive. If so, you can contact the negative onto another sheet of high-contrast film to make a positive that is an exact opposite of the negative: you'll need such a positive if you want to make a line print.

6 | finish the transparencies

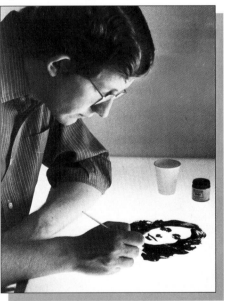

Check for pinholes—clear specks caused by dust on the film or by underexposure. Paint them out with a fine brush dipped in a gooey blocking-out material called opaque. Large areas can also be painted out, if desired. Black specks or large black areas can be removed with a strong solution of Farmer's Reducer, a chemical bleaching agent. A weak solution of Farmer's Reducer removes yellow processing stains.

A Line Print

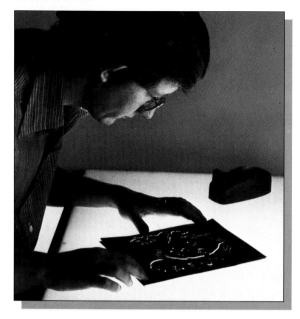 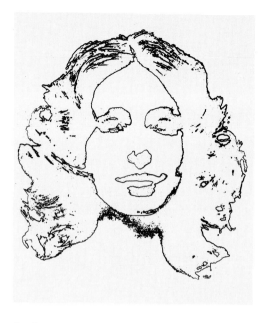

To make a line print—an image composed of dark lines on a white background or white lines on a dark background—place the positive and negative over a light and carefully align them so that the two images overlap exactly. The result, looked at straight on, will be solid black. However, light can pass through the two copies at an angle, along the outlines of the paired images. Tape the copies together.

Put the sandwich into a printing frame with an unexposed sheet of film. A lazy Susan or a turntable rotates the frame so that light can come in from all sides at an angle. The light source shown is a 100-watt frosted bulb placed at a 45° angle 3 ft above a rotating turntable for a 15-sec exposure. You could also rotate the printing frame by hand under an enlarger.

The line print, a thin black outline of the subject on clear film, resembles a pen-and-ink sketch. Adding a thin sheet of acetate or of unexposed, fully processed film between the negative and positive would have made thicker lines. The line picture can be copied directly onto another sheet of high-contrast film to make a clear-line-on-black background transparency. Either image can be printed onto printing paper.

A Posterization

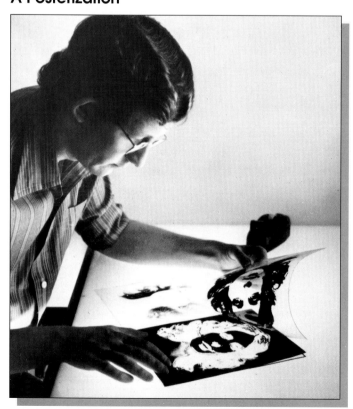

Posterization gives an image with tones that look like the flat shades of poster paints. The images opposite were made from the three high-contrast copies below: two positives plus a negative, each having different dark areas. The three were carefully aligned, then fastened with tape hinges (see left) so that each positive could be laid over or lifted away from the negative. The negative at the bottom of this stack was then taped on two sides to the enlarger baseboard. Printing paper was slipped under the untaped sides, and a piece of glass held all the sheets flat.

The two positive images above were produced on high-contrast film from the same negative (right). The first, which has more dark area than the second, simply received more exposure.

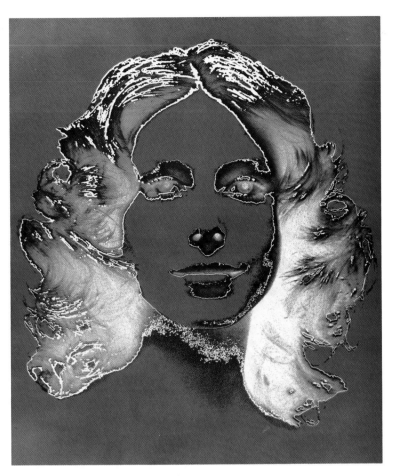

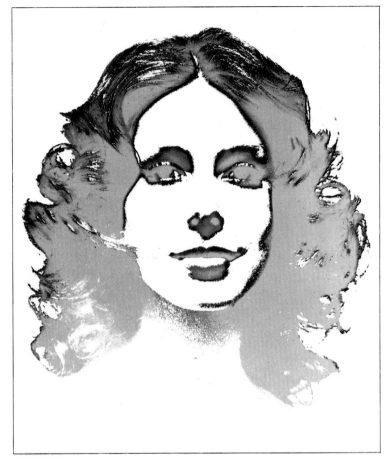

To make the black-and-white posterization above, three exposures were made. The first, for 60 sec, was through all three copies of the sandwich of high-contrast transparencies (opposite, bottom). It gave the black tones of the final print. Then the darker positive was flipped back, and an exposure of 1 sec was made through the lighter positive and the negative to start the dark-gray tone. An exposure of 1 sec through the negative alone produced the light gray and completed the dark gray. The exposures were determined by test strips.

The starting point for the color posterization above was much the same as for the black-and-white posterization shown at left (a high-contrast negative plus two high-contrast positives of unequal dark areas), but a line image (opposite, top right) was also used. Color was produced by using color-printing paper and filtering the light from the enlarger.

For this posterization, the line print and the lighter positive were used for an exposure with a blue filter, to get yellow. The darker positive was added next and three exposures were made, through red, green, and blue filters, for 3, 5, and 6 sec, respectively. The resulting color, mixed with the yellow, gave the russet hue. The final exposure, with the negative copy added, was through a red filter and produced cyan, which gave a slight greenish cast that is most visible in the features of the face.

USING SPECIAL TECHNIQUES

Starry Night III, 1975. Cyanotype with watercolors and applied stars

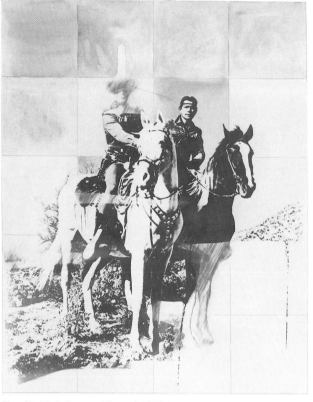

Blue Sky Variation and Erased, 1977. Vandyke print with pencil and watercolors

BETTY HAHN *Taos Sky,* 1979. Lithograph

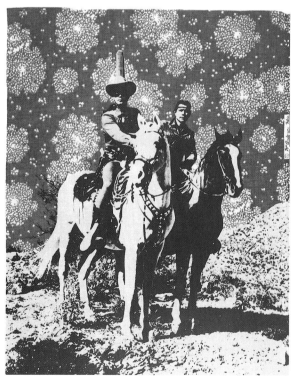

Starry Night Variation #2, 1977. Silkscreen

As a starting point for work that incorporates various printing processes, hand coloring, and other techniques, Betty Hahn used a publicity photograph of those mythic heroes the Lone Ranger and Tonto. The cyanotype and Vandyke processes, photographic printing processes invented in the 19th century, utilize light-sensitive iron salts to form the image. The lithograph and silkscreen are traditional fine-art printmaking processes.

Each print is enjoyable in its own right, but when the versions are placed together, the eye jumps back and forth among them, comparing skies, colors, and other traces of the artist's intervention in the original photograph. A bonus is the cactus growing out of the Lone Ranger's head.

Many alternative processes like cyanotyping or platinum printing (shown opposite) require contact printing. Enlargements cannot be made because the materials respond too slowly to light. If you are working from an existing small-format negative, you will have to make an enlarged negative. For a high-contrast image, you can make a high-contrast negative (as shown on page 194). If you want an enlarged continuous-tone negative, you can enlarge an existing negative onto materials such as Kodak Professional B/W Duplicating Film SO-339. See the Bibliography for publications that give more information about alternative processes.

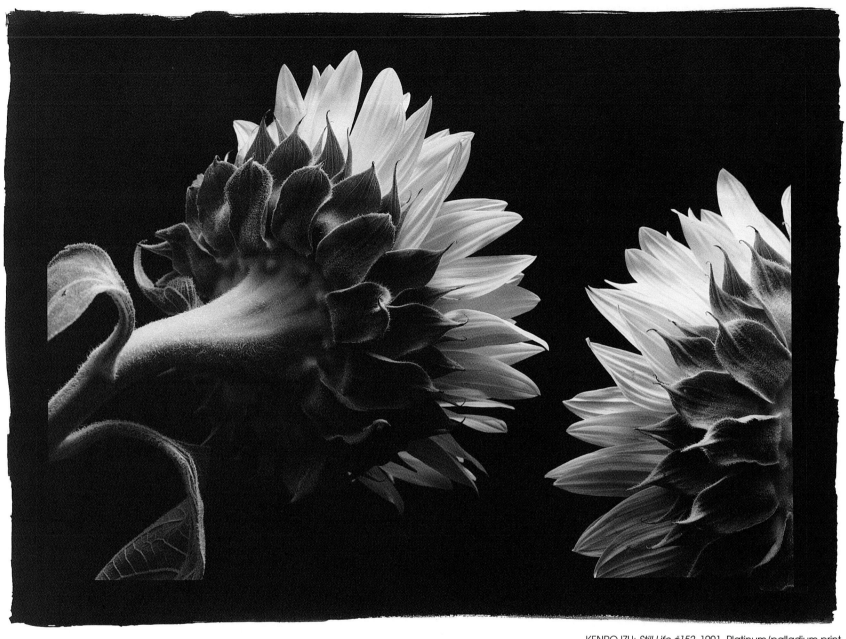

KENRO IZU: *Still Life #152*, 1991. Platinum/palladium print

Platinum (and similar palladium) printing produces very beautiful and stable photographic images. Platinum paper has a light-sensitive coating that yields an image of platinum metal instead of silver. Its subtle gradations of tone give unsurpassed delicacy and depth to a print, and because platinum is chemically stable, the prints are extremely long lasting. Images produced around the turn of the century, when the platinum process was originally popular, still retain their richness and subtle detail. A book reproduction can only hint at the beauty of an original.

Kenro Izu has been working in platinum since he saw a vintage Paul Strand platinum print. "At the time I didn't know it was platinum, but I was overwhelmed by the beauty of what black-and-white photography could be." The main disadvantage of platinum prints is cost; platinum is more expensive than silver. Like cyanotyping and certain other processes, the paper is not very sensitive to light, so enlargements can't be made. Negatives have to be contact printed, which requires either using a large-format camera or making an enlarged negative.

Izu coats his own paper (you can see the edges of the coated area in the print above). He believes enlarged negatives lead to loss of quality, so he photographs using a specially constructed view camera that holds 14×20-inch film cut to that size for his use. If you want to try platinum printing, commercial platinum paper is available (see Specialty Printing Papers, page 143). You can also buy the chemicals and coat your own. See the Bibliography for publications that give the details of platinum printing.

PINHOLE PHOTOGRAPHY

Would you like to make a picture that shows a truly unique view of the world? Use a one-of-a-kind camera? Have your pictures be more or less sharp from one inch to infinity? Make negatives on film or paper? Don't buy another expensive camera or lens—just reach for a handy box and construct a pinhole camera. All you need for pinhole photography is a light-tight container (the camera body), a pinhole aperture (instead of a lens) to let in light, and a light-sensitive material (film or paper).

More about the theory and history of pinhole imaging on pages 36–37 and 364.

Drilling the aperture. *Cut a 1-inch-square piece from an aluminum beverage can, or use a piece of very thin brass. Pierce the metal with a needle. A good choice for the camera diagrammed at right is a size 8 U.S. sewing needle, which has a diameter of 0.57 mm. Keep the needle perpendicular to the metal and gently rotate it to pierce a small hole. To get a better grip on the needle, you can insert it in an X-Acto blade holder. Sand the back of the metal with fine sandpaper until the hole is smooth and round.*

Constructing a pinhole camera. *You can use any existing box with a tight-fitting lid, like an oatmeal box or a squarish gift box with a deep lid. A shoe box can be used but because the lid is shallow, you'll have to tape the box shut every time you use it to make sure it is light tight. You can also construct a box from heavy mounting stock, as shown here. This box is versatile because you can move the two sections farther apart or closer together to adjust the angle of view (see diagrams at bottom). Paint the inside of the box flat black.*

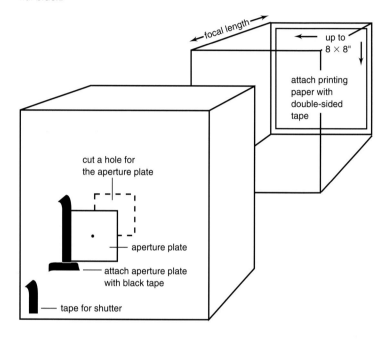

Pinhole Exposures

Exposing a paper negative

Start by working outdoors in midday sun. Paper has a slow "film speed," and the relatively dim light indoors can make the exposure impractically long. A contrast grade 1 or 2 paper gives the best results. You can use a double-weight paper if you want only a negative image. But if you want to contact-print the negative to make a positive, use a single-weight paper so that it will be thin enough to print through.

Load the paper into the camera in complete darkness. Close the camera and, if necessary, seal the closure with black tape. Make sure your "shutter" (a piece of black tape over the pinhole) is in place.

Keep the camera stationary during the exposure. Everything from about 3 inches to infinity will be equally sharp (or equally unsharp, depending on how you look at it), so you can try including objects that are very close as well as far away.

Start with a trial exposure of 1 minute. Peel back the tape covering the pinhole, then replace the tape at the end of the exposure time. Develop the paper and evaluate the exposure. If the negative is too light, try double (or more) the exposure time. If too dark, cut the exposure time to half (or less).

If the entire negative turns black during development, your camera probably has a light leak. To check for leaks, place the loaded camera in the sun for a minute or two without opening the shutter and then develop the negative. If it turns black, check for light leaks to fill or seal with tape, or repaint the inside of the camera with black paint.

Exposing a film negative

Film is much faster than paper, so ideally with film, you should meter the scene. To calculate the exposure, you'll need to determine your f-stop (which is determined by the size of your box) and then your shutter speed, depending on the brightness of the scene and the film speed.

To find your f-stop, divide the diameter of the aperture (the size of your pinhole) into the focal length of the camera (the distance from the pinhole to the film). Don't mix your measurement systems: use either millimeters or inches, not both.

Or, bypass the calculations and simply make a trial exposure. If you are using a film with a speed of ISO 100, try a 4-sec exposure with the camera diagrammed at right.

normal focal length

long focal length

To increase the focal length, *slide the front and back sections farther apart. You may need to use black tape to prevent light leaks.*

short focal length

short focal length

For a wider angle, *shorten the focal length by building up the interior of the box, or curve the paper inside the box.*

◀ *Pinhole photography fulfills Peggy Jones's interest in transforming reality instead of just recording it. Jones often uses paper negatives for both aesthetic and practical reasons. She likes the paper texture that prints through from a paper negative, and paper negatives are more economical than film for larger cameras. For this picture, she placed the camera on the grass. Pinhole photographs characteristically are softly focused overall from immediately in front of the camera to the farthest distance. Notice how the grass close to the lens is about as sharp as the house in the background.*

Instead of having a flat film plane that is parallel to the aperture, this camera was designed with an angled film plane to create distortion. One of the advantages of constructing your own camera is the possibility of design variations to create unique images.

"This camera does have its problems, though," says Jones. Remember the inverse square law? The light must travel an increasingly greater distance to reach the farthest part of the film plane, and in doing so it gets dimmer. The far end of the film plane gets less exposure than the nearer end, so printing the positive requires considerable dodging and burning to balance the exposure overall.

The same site as in the pinhole photograph, far left, but this time taken with a conventional 35mm camera and 50mm lens. The round object is a small well in Spyglass, a housing development in southern California. Compare the shape of the well to that of the well in the pinhole image.

PEGGY ANN JONES: *Spyglass Well, Newport Beach, California,* 1985. Photograph taken with pinhole camera. Silver print with hand-coloring

MICHAEL SKOTT: *Ratatouille, 1987*

KEVIN CLARK; *Fresh Peppers*

A realistic or at least pleasing color balance is important in food photography, where the intention is usually to appeal to the appetite by way of the eye. Stylists are often used in food photography to prepare the food, usually in multiple, so the photographer always has a fresh dish to shoot. Lighting, focus, composition, and items that won't wilt are arranged before the food is ready, using a mock-up of the main dish. An image-perishable dish is the last thing to hit the set. Timing, coordination, and teamwork are critical, because the ideal is to photograph the food as soon as possible after it is done, before it melts, congeals, dries up, bleeds water, or otherwise visually deteriorates.

Left, every crumb was carefully controlled in this complex setting to illustrate a recipe for ratatouille (an eggplant, zucchini, and tomato stew). Above, the backlit colors and shapes are the main attraction.

Color film takes advantage of the fact that any color can be produced by mixing only a few basic or primary colors. Color film is made with three color-sensitive layers, each of which records the wavelengths of light in a different third of the spectrum. When the three layers are combined, they form a full-color image of the original scene.

This sensitivity to color, which makes color photography possible, can sometimes produce unexpected results. The human eye tends to ignore slight shifts in color balance, but film can only record colors at a given moment. Consequently, color photographs may appear to be more reddish or bluish than seems natural, or flesh tones in a photograph can take on an unappealing color cast from nearby objects, such as light reflected from green leaves. The colors were probably there to begin with but are easy to ignore if you don't know what to look for. This chapter deals in depth with how to control color balance both when film is exposed and later during printing.

COLOR: ADDITIVE OR SUBTRACTIVE

There are two ways to create colors in a photograph. One method, called additive, starts with three basic colors and adds them together to produce some other color. The second method, called subtractive, starts with white light (a mixture of all colors in the spectrum) and, by taking away some colors, leaves the one desired.

In **additive** mixing *(right)*, the basic or primary colors are red, green, and blue lights (each providing about one-third of the wavelengths in the total spectrum). Mixed in varying proportions, they can produce all colors—and the sum of all three primaries is white.

In the **subtractive** method *(opposite page)*, the primaries are cyan (a bluish green), magenta (a purplish pink), and yellow, the pigments or dyes that absorb red, green, and blue wavelengths, thus subtracting them from white light. These dye colors are the complementary colors to the three additive primaries of red, green, and blue. Used together the subtractive primaries absorb all colors of light, producing black. But mixed in varying proportions, they can also produce any color in the spectrum.

Whether a particular color is obtained by adding colored lights together or by subtracting some light from the total spectrum, the result looks the same to the eye. The additive process was employed for early color photography. But the subtractive method, while requiring complex chemical techniques, has turned out to be more practical and is the basis of all modern color films.

In the additive method, separate colored lights combine to produce various other colors. The three additive primary colors are green, red, and blue. Green and red light mix to produce yellow; red and blue light mix to produce magenta; green and blue mix to produce cyan. When equal parts of all three of these primary-colored beams of light overlap, the mixture appears white to the eye. A color television produces its color by the additive system. The picture tube is coated inside with green, red, and blue phosphors that can be mixed in various combinations to produce any color, including white.

cyan filter blocks red

magenta filter blocks green

yellow filter blocks blue

White light is a mixture of all wavelengths. In the subtractive process, colors are produced when a dye (as in paint or color photographic materials) absorbs some wavelengths and so passes on only part of the spectrum. Above, the three subtractive primaries—yellow, cyan, and magenta—are seen placed over a source of white light. Where two overlap, they pass red, green, and blue light. Where all three overlap, all wavelengths are blocked. At right, each subtractive primary transmits two-thirds of the spectrum and blocks one-third. Notice that the color often called blue is named cyan.

COLOR PHOTOGRAPHS: THREE IMAGE LAYERS

A color photograph begins as three superimposed black-and-white negatives. Color film consists of three layers of emulsion, each layer basically the same as in black-and-white film but responding to only one-third of the spectrum. The top layer is sensitive to blue light, the middle layer to green light, and the bottom layer to red light. When this film is exposed to light and then developed, the result is a multilayered black-and-white negative.

The developer converts the light-sensitive silver halide compounds in the layers of emulsion to metallic silver. As it does so, the developer oxidizes and combines with **dye couplers** that are either built into the layers of emulsion or added during development. Three dye colors are formed—the subtractive primary colors of yellow, magenta, and cyan—one in each emulsion layer. The blue-sensitive layer of the film forms a yellow image, the green-sensitive layer forms a magenta image, and the red-sensitive layer forms a cyan image. A **bleach** then removes all the silver, and each layer is left with only a color image. This basic process is used in the production of color negatives, positive color transparencies (slides), and color prints *(see illustrations, right)*.

Color film consists of three layers of emulsion, each sensitive to blue, green, or red (as diagrammed above by color dots over a film cross section). During exposure, light of each color of the moth shown above produces an invisible latent image on the emulsion layer or layers sensitive to it. Where the moth is black, no emulsion is exposed; where it is white, all three layers are exposed equally. This results in three superimposed latent images.

During development of the film, each latent image is converted into a metallic silver negative image. Thus, three separate negative images indicate by the density of the silver they contain the amount of each primary color in the moth. The images are shown separately here but are, of course, superimposed on the film.

color negative

color transparency or print

CHOOSING A COLOR FILM

◄ *When exposed color negative film is developed, a colored dye is combined with each black-and-white negative image. The dyes are cyan, magenta, and yellow—the complements of red, green, and blue. The silver images are then bleached out, leaving three layers of superimposed negative dye images (shown separately here). The color negative also has an overall orange color or "mask" (opposite, top) to compensate for color distortions that would otherwise occur in printing.*

◄ *The positive color image of a transparency or slide is created in exposed film by a reversal process. After a first development, the emulsion is either exposed a second time to light or is treated with a chemical that produces the same effect. Silver is deposited by a second development to form black-and-white positive images in the emulsion. Dyes then combine with the metallic silver positive images to form three superimposed positive color images. In each layer the dye produced is the complement of the color of the light that was recorded there—yellow dye is formed in the blue-sensitive layer, magenta in the green-sensitive layer, and cyan in the red-sensitive layer. The black-and-white silver images are then bleached out, leaving the positive color images in each layer (shown separately here).*

To make a positive print from a negative, light is passed through a color negative onto paper containing three emulsion layers like those in film. Developing the paper produces three superimposed positive images of dye plus silver. The silver is then bleached out of the print, leaving the final color image. In reversal printing, light is passed through a positive color transparency onto reversal paper; the result is a positive image.

The look of **color films** is linked to film speed. Slower films appear sharper, have more saturated colors with a fuller range of tones, and have less apparent graininess. Faster films appear less sharp, with less color saturation and more apparent graininess. But even within the same speed range, different films produce different color balances. One film may have an overall warm reddish cast, while another may look slightly cooler and blue-green. It is useful to compare different films by exposing a roll of each to the same subject under identical conditions. This is particularly important with color slides because their tones cannot be manipulated after development as can a color negative when it is printed. Magazines such as *Popular Photography* and *Camera & Darkroom* regularly feature such comparisons. The difference between films can be surprisingly large.

Color Film Characteristics

For characteristics such as format and film speed that are common to all films, see box, page 72.

Negative film. *Produces an image that is the opposite in colors and density of the original scene. It is printed, usually onto paper, to make a positive color print. Color negative film often has "color" in its name (Agfacolor, Vericolor).*

Reversal film. *The film exposed in the camera is processed so that the negative image is reversed back to a positive transparency with the same colors and density of the scene. Positive transparencies can be projected or viewed directly and can also be printed onto reversal paper to make a positive print.*

Color reversal film often has "chrome" in its name (Ektachrome, Fujichrome), and professional photographers often refer to a color transparency, especially a large-format one, as a chrome. A slide is a transparency mounted in a cardboard holder so it can be inserted in a projector for viewing.

Professional films. *The word "professional" in the name of a color film (Kodachrome 64 Professional Film) means that the film is designed for professional photographers, who often have exacting standards, especially for color balance, and who tend to buy film in large quantities, use it up quickly, and process it soon after exposure. Kodak manufactures its professional color films so that they are at optimum color balance when they reach the retailer, where—if the retailer is competent—the film will be refrigerated.*

Kodak makes its nonprofessional color films for a typical "amateur" or "consumer," who would be more likely to accept some variation in color balance, buy one to two rolls at a time, and keep a roll of film in the camera for days, weeks, or longer, making exposures intermittently. Thus Kodak nonprofessional color films do not have to be refrigerated unless room temperatures are high. In fact, they are manufactured to age to their optimum color balance sometime after they reach the retailer and after room-temperature storage.

Color balance. *Daylight films produce the best results when exposed in the relatively bluish light of daylight or electronic flash. Tungsten-balanced films should be used in the relatively reddish light of incandescent bulbs. Type A film is made for the slightly different balance of 3400K tungsten photolamps. More about color balance on pages 208–217.*

Type S/Type L films. *A few films are designed to produce the best results within certain ranges of exposure times, as well as with specific light sources. Type S films (S for "short"), such as Kodak Vericolor III Professional Film, Type S, are balanced for daylight or electronic flash at exposure times of $1/10$ second or shorter. Type L films (L for "long"), such as Vericolor II Professional Film, Type L, are balanced for the warmer light of tungsten 3200K lamps and for exposure times of $1/50$ second to 60 seconds.*

COLOR BALANCE
Matching Film to the Light Source

Color films sometimes record colors that the photographer did not see when the shot was made. Though the picture may look wrong, the film is not at fault. Although a white shirt looks white both outdoors in daylight and indoors in artificial light, light from ordinary tungsten bulbs has a different **color balance**—more red wavelengths and fewer blue wavelengths—than daylight; thus the white shirt reflects more red light indoors than outdoors and has a golden cast. Color film records such subtle differences.

The balance of colors in light is measured as **color temperature** on the Kelvin scale. This scale is commonly used by physicists and serves as a standard comparative measure of wavelengths present in light *(see chart, this page)*.

Different color films are made for different color temperatures. **Daylight films** are balanced for a 5500K light source, and so give good results with the relatively high color temperature of midday light, electronic flash, and blue flashbulbs. **Indoor films** are balanced for incandescent light sources of lower temperatures. Most indoor films are **tungsten balanced**—designed specifically for light of 3200K color temperature, but producing acceptable results in any tungsten light, such as ordinary light bulbs. A few (**Type A**) films have a slightly different balance for use with 3400K photolamps.

Color balance is more important with reversal films than with negative films. With a color reversal film, transparencies (such as slides) are made directly from the film that was in the camera, and they have a distinct color cast if the film was not shot in the light for which it was balanced or if it was not shot with a filter over the lens to balance the light *(see opposite and page 210)*. With a color negative film, color balance can be adjusted when prints are made.

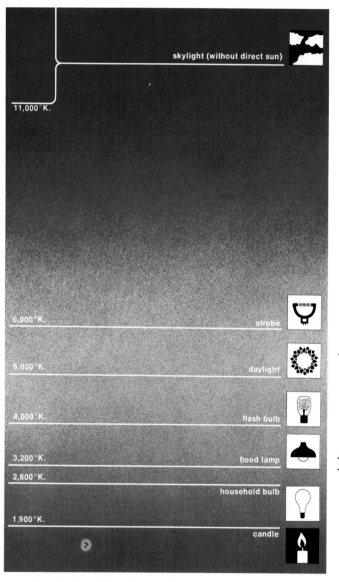

5500K daylight film ◄

3400K Type A film ◄
3200K tungsten film ◄

The chart above shows the approximate color temperatures of "white" light sources. The ordinary description of colors as warm or cool doesn't match their actual color temperature. Red is often called a warm color, but the color temperature of reddish light is low on the scale. Blue is called a cool color, but its color temperature is high on the scale.

The pictures opposite illustrate how different ► types of color film record different colors when exposed to the same light. The top pictures were all taken in daylight (color temperature 5500K). Photographed with daylight film (left), the colors of the bus look normal. When shot with indoor (tungsten) film designed for 3200K (center), the bus takes on a heavy bluish cast. If a corrective 85B filter is used, however, the colors produced by the indoor film improve significantly (right).

The bottom pictures were all taken indoors in 3200K light. The bride looks normal when photographed with indoor film (left), but daylight film in the same light produces a yellowish cast (center). A corrective 80A filter produces a near-normal color rendition with the daylight film (right).

Since the filter blocks part of the light reaching the film, the exposure must be increased (about $2/3$ stop with an 85B filter, $2^{1}/_{3}$ stops with an 80A filter). This can create inconveniently long exposures, so it is more efficient to use the correct type of film.

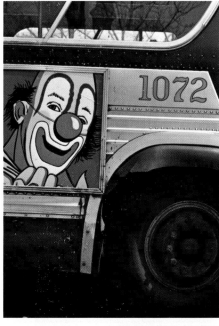

daylight film in daylight

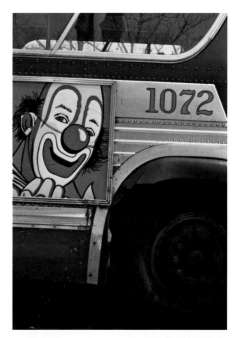

tungsten film in daylight

85B filter

tungsten film in daylight with 85B filter

tungsten film in tungsten light

daylight film in tungsten light

80A filter

daylight film in tungsten light with 80A filter

Color Balance: continued

Filters to Balance Color

color film in fluorescent light

The penny arcade fortune-telling machine (left) was lit mostly with fluorescent lights. The greenish cast in the picture is due to the concentration of green wavelengths in fluorescent lighting. An FL (fluorescent) filter combines magenta and blue and improves the color balance for average scenes. Magenta (which absorbs greens) and blue (which absorbs reds and greens)—alters the light exposing the film so that the color image looks closer to normal (right). It is difficult to give exact filter recommendations for fluorescent light because the color balance varies depending on the type of lamp, the manufacturer, how old the lamp is, and even voltage fluctuations.

color film in fluorescent light with FL filter

What happens if the color balance of light does not match the color balance of your film? Most color films are balanced to match the color temperatures of one of four possible light sources—midday sunlight (or electronic flash) and two types of incandescent lamp. Any other lighting conditions may give an unusual color balance. Sometimes you may want this imbalance. If not, you can use **filters** to correct to a more standard color balance.

It is not unusual to encounter light conditions that do not match the color bal-ance of any film. For example, the light is reddish late in the day because the low-lying sun is filtered by the earth's atmos-phere to a color temperature lower than 5500K. You may want to photograph this scene unfiltered to keep a reddish cast that looks like sunset.

In a picture of a field of snow having sunlit and shadowed areas, the shadows will be illuminated mainly by clear blue skylight of a very high color temperature. Shadowed snow comes out blue when photographed with ordinary daylight film.

A pale "skylight" filter, designed to block some of the blue light, would reduce the bluish cast of the shadows as the film records it. Actually, if you look at a snow-field under such conditions, you can often see the bluish cast in the shadows—but ordinarily the brain adapts what the eye sees to what it expects the snow to look like.

A similar problem occurs when a light source does not emit a smooth distribu-tion of colors across the spectrum but gives off concentrations of one or a few

Filters for Color Film

number or designation	color or name	type of film	physical effect	practical use	increase in stops	factor
1A	skylight	daylight	Absorbs ultraviolet rays.	Eliminates ultraviolet light that eye does not see but that film records as blue. Useful for snow, mountain, marine, and aerial scenes, on rainy or overcast days, in open shade.	–	–
81A	yellow	daylight	Absorbs ultraviolet and blue rays.	Stronger than 1A filter. Reduces excessive blue in similar situations. Use with electronic flash if pictures are consistently too blue.	$1/3$	1.2
		tungsten		Corrects color balance when tungsten film is used with 3400K light sources.	$1/3$	1.2
82A	light blue	daylight	Absorbs red and yellow rays.	Reduces warm color cast of early morning and late afternoon light.	$1/3$	1.2
		Type A		Corrects color balance when Type A film is used with 3200K light source.	$1/3$	1.2
80	blue	daylight	Absorbs red and yellow rays.	Stronger than 82A. Corrects color balance when daylight film is used with tungsten light. Use 80A with 3200K sources and with ordinary tungsten lights. Use 80B with 3400K sources.	2 (80A) $1 2/3$ (80B)	4 3
85	amber	Type A or tungsten	Absorbs blue rays.	Corrects color balance when indoor films are used outdoors. Use 85 filter with Type A film, 85B filter with tungsten film.	$2/3$	1.5
FL	fluorescent	daylight or tungsten	Absorbs blue and green rays.	Approximate correction for excessive blue-green cast of fluorescent lights. FL-D used with daylight film, FL-B with tungsten film.	1	2
CC	color compensating			Used for precise color balancing. Filters come in various densities in each of six colors—red, green, blue, yellow, magenta, cyan (coded R, G, B, Y, M, C). Density indicated by numbers—CC10R, CC20R, etc.	Varies	
	polarizing	any	Absorbs polarized light (light waves traveling in certain planes relative to the filter).	Reduces reflections from nonmetallic surfaces, such as water or glass (see page 86). Penetrates haze by reducing reflections from atmospheric particles. The only filter that darkens a blue sky without affecting color balance overall.	$1 1/3$	2.5
ND	neutral density	any	Absorbs equal quantities of light from all parts of the spectrum.	Increases required exposure so camera can be set to wider aperture or slower shutter speed. Comes in densities from 0.10 ($1/3$ stop more exposure) to 4 ($13 1/3$ stops more exposure).	Varies with density	

colors. Fluorescent lights are examples of this kind of discontinuous spectrum, having, in addition to other colors, large amounts of blues and greens. Although the brain compensates for such uneven distribution, there are no color films that do so. Filtration provides a partial correction (see illustrations, opposite).

It is particularly important to balance the light the way you want it when making color slides, because the film in the camera is the final product that will be pro-

jected for viewing. With color negative film used for color prints, exact balance is not so critical because corrections can be made during the printing process. Printing will be easier, though, with a properly balanced negative.

Some commonly used filters for color films are listed above; more detailed information is supplied by film and filter manufacturers. The color temperature is marked on photographic bulbs. Electronic flash units are more or less balanced for

daylight films, although the light they emit may be somewhat bluish; a light yellow filter helps if flash-lit pictures are often too blue. Color temperature meters are available if it is important to balance the light critically.

The examples opposite and on page 209 show the imbalance that occurs when films are not matched to the light. In each case, you can use a corrective filter to adjust the balance of the light.

Color Balance: continued

Color Casts

Almost every photographer has, at one time or another, found that in a picture a subject has taken on the colors reflected by a nearby strongly colored surface, like a wall or drapery. The eye tends to see almost every scene as if it were illuminated by white light, whereas color film reacts to the true color balance of the light. **Color casts,** or shifts of color, are less noticeable on objects that are strongly colored but are easy to see on more neutral shades, such as skin tones or snow.

A color cast can be a desirable addition, as in the picture on the opposite page, where the bluish light adds an icy coldness to the snow, or on this page, where the photographer added gold tones to the light to enhance the naturally warm colors of the fruit.

But sometimes the color shift can be a problem, as in a portrait shot beneath a tree. People photographed under such seemingly flattering conditions can appear a seasick green because the sunlight that reaches them is filtered and reflected by the green foliage.

Colors can add the impression of heat or cold to a picture. Because they trigger mental associations, golden yellows and reds appear distinctly warm, while blues and yellowish greens seem cool. But the impressions go beyond mere illusions of temperature. Warm colors, especially if they are dark, can make an object seem heavy and dense. Pale, cool colors, on the other hand, give an object a light, less substantial appearance. Warm colors can appear to be farther forward, cool colors farther back. You can use this distance effect to increase the illusion of depth within a picture by placing warm-colored objects against a cool-colored background.

RICHARD STEINBERG: *Fruit,* 1970

The photographer wanted to intensify the reds and yellows in the fruit above. To do so he enclosed the fruit in a specially constructed tunnel (diagram at left) lined with gold foil, which strongly reflected yellow and red wavelengths, to suffuse the entire scene with very warm golden light. Light entering at the far end of the tunnel was bounced down on the fruit from the slanting roof. A second light, positioned directly under the glass table supporting the fruit, illuminated the arrangement from below. He could also have used color-compensating (CC) filters over the lens to shift the color balance.

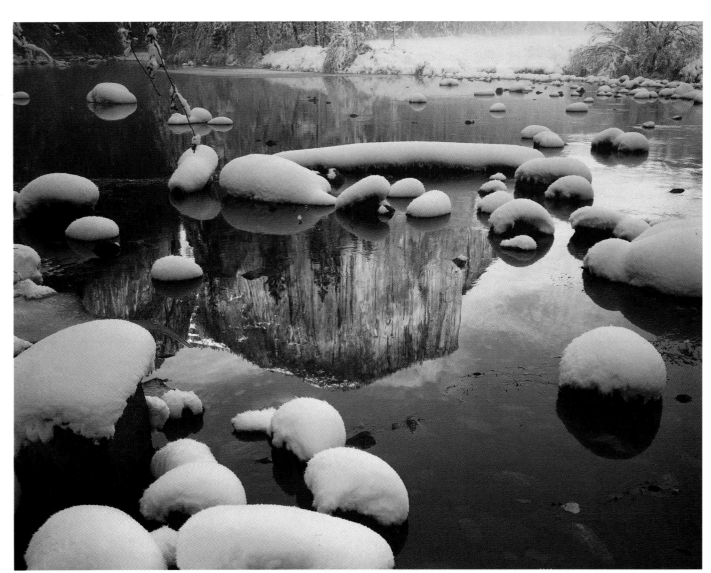

DAVID MUENCH: *Reflection of El Capitan in Merced River,* 1970

Shadowed areas can appear surprisingly blue in a photograph, especially if the subject itself is not strongly colored. In this Yosemite landscape, the rocks and snow are shaded from direct light from the sun and are illuminated only by skylight, light reflected from the blue dome of the sky. Sunlight, direct rays from the sun, is much less blue.

Compare the skylit snow to the sunlit—and less blue—granite outcropping of El Capitan, visible in the reflection in the water. Here, the contrast between the two tones adds interest to the picture, but for less of a bluish cast, a 1A (skylight) or 81A (light yellow) filter could have been used over the lens.

Color Balance: continued

Color Changes Throughout the Day

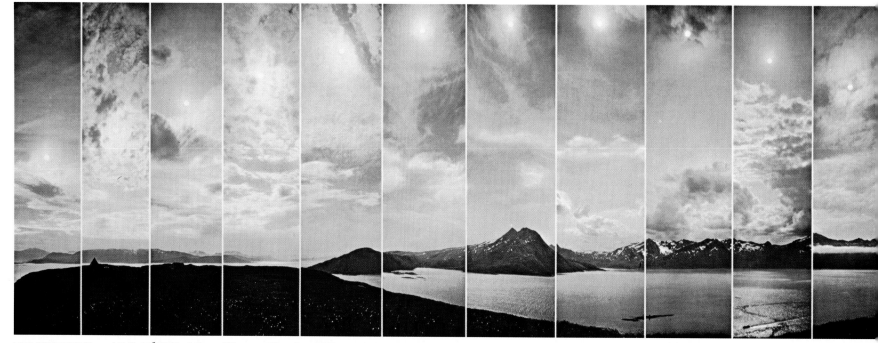

EMIL SCHULTHESS and EMIL SPÜHLER: *A Day of Never-setting Sun,* 1950

Colors in your photographs will vary depending on the time of day that you made them. Photographing very early or late in the day can produce strikingly beautiful pictures simply because the light is not its usual "white" color.

In the earliest hours of the day, before sunrise, the world is essentially black and white. The light has a cool, shadowless quality. Colors are muted. They grow in intensity slowly, gradually differentiating themselves. But right up to the moment of sunrise, they remain pearly and flat.

As soon as the sun rises, the light warms up. Because of the great amount of atmosphere that the low-lying sun must penetrate, the light that gets through is much warmer in color than it will be later in the day—that is, more on the red or or-

ange side because the colder blue hues are filtered out by the air. Shadows, by contrast, may look blue because they lack gold sunlight and also because they reflect blue from the sky.

The higher the sun climbs in the sky, the greater the contrast between colors. At noon, particularly in the summer, this contrast is at its peak. Film for use in daylight is balanced for midday sunlight, so colors appear accurately rendered. Each color stands out in its own true hue. Shadows at noon are more likely to be neutral black.

As the sun goes down, the light begins to warm up again. This occurs so gradually that you must remember to look for it; otherwise the steady increase of red in the low light will do things to your film that

you do not expect. Luckily, these things can be beautiful. If the evening is clear and the sun remains visible right down to the horizon, objects will begin to take on an unearthly glow. Shadows lengthen, so surfaces become strongly textured.

After sunset there is a good deal of light left in the sky, often tinted by sunset colors. This light can be used, with longer and longer exposures, almost up to the point of darkness, and it sometimes produces pinkish or even greenish-violet effects that are delicate and lovely. Just as before sunrise, there are no shadows and the contrast between colors lessens.

Finally, just before night, with the tinted glow gone from the sky, colors disappear, and the world once again becomes black and white.

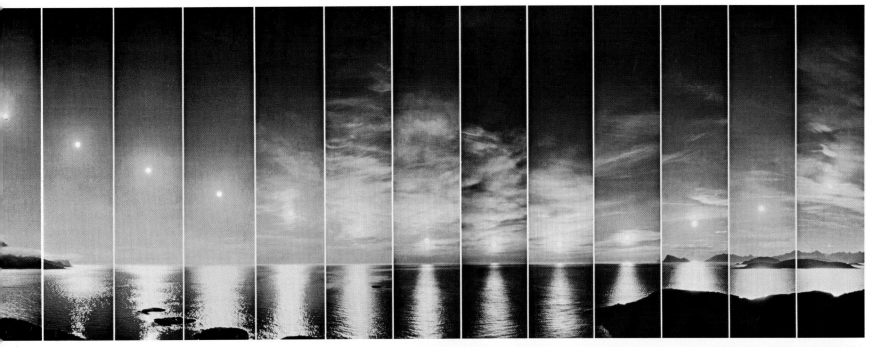

The sun never sinks below the horizon in this time-lapse sequence of photographs taken on a Norwegian island far above the Arctic Circle during the summertime period of the midnight sun. The changing colors of light are clearly visible, however, as the sun rises and sets. Objects seem to be more realistically colored when the sun is high in the sky than when it is close to the horizon; compare the color of the water in the segments on this page with its color in the segments on the opposite page.

Dick Durrance takes advantage of the golden glow of sunset—and boosts it along even further. He often uses graduated filters, which are colored on one edge, clear on the other, with a gradual transition between the two halves. Since the colored part of the filter decreases the exposure as well as affecting color, Durrance uses the filter to balance lighter parts of a scene against darker ones. Here, he used two graduated yellow filters, one to intensify the color of the sky and reduce its brightness against the darker vineyard and one to color and reduce the brightness of the grassy foreground.

DICK DURRANCE II: *Alexander Valley, California,* 1980

DAVID MOORE: *Torchlight Procession of Skiers, Australia, 1966*

Shifted Colors from Reciprocity Effect

PETER deLORY: *Summer,* 1970

The warm purple tint over the snow (left) and the two-toned sky (above) were produced by the reciprocity effect that causes shifts in color balance during exposures that are longer than about 1 sec. Both pictures were shot in the dim light of dusk and given lengthy exposures. David Moore exposed his film for the full five minutes it took the skiers to run the trail (the zigzag thread of light that bisects his picture).

At dusk, at dawn, sometimes indoors, the light may be so dim that exposure times become very long, even with the lens aperture wide open. Very long exposures with color film produce the same **reciprocity effect** that takes place with black-and-white films *(page 102)*—the exposure must be increased even more or the film will be underexposed. Various types of color film react differently to long exposures; check the manufacturer's instructions for recommended exposure increases. Very long exposures are not recommended at all for some color films. In general, however, increase the exposure about one stop for a 1-second exposure, two stops for a 10-second exposure, three stops for a 100-second exposure.

Bracket the exposures by making a shot at the calculated exposure plus another at one-half stop more and a third at one stop more. When exposures are very long, underexposure is more likely to be a problem than overexposure.

Reciprocity effect with color films is even more complicated than with black-and-white films. Since color films contain three separate emulsion layers, each layer may be affected differently, and the varied speed losses will change the color balance of the film. The result is color shifts like those shown here. Often the shifts are pleasing, but if you want a more accurate color rendition, use the color filters listed in the film's instruction sheet.

EXPOSURE LATITUDE:
HOW MUCH CAN EXPOSURES VARY?

You will get the best results with any film if you expose it correctly, but accurate exposure is particularly important with color reversal film because the film in the camera becomes the final transparency or slide. Film that is reversed to make a transparency has very little **exposure latitude;** that is, it tolerates very little under- or overexposure. With as little as one-half stop underexposure, colors in a slide begin to look dark and murky; there is even less tolerance for overexposure before colors begin to look pale and washed out.

Color negative film has more exposure latitude, and a picture can be lightened or darkened when the negatives are printed. You will have a printable negative even with about one stop underexposure or one to two stops overexposure, although best results come from a correctly exposed negative.

In contrasty lighting, such as the sunlit scene at right, color film is not able to record color and details accurately in both very light highlights and very dark shadows because the range of tones in the scene is greater than the usable exposure range of the film. If the lightest areas are correctly exposed, the shadows will be too dark. If shadows look good, highlights will be too light. Try exposing for the most important part of the scene, then bracket additional exposures.

It is easier to get good exposures with color if lighting is flat, with relatively little difference between the lightest and darkest areas *(see opposite page)*. With such a scene it is less likely that areas will be much too light or much too dark. Sometimes you can use a reflector or a flash unit to add fill light to even out the contrast in a scene *(see pages 252–253 and 270–271).*

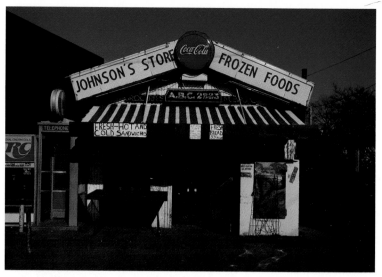

When exposing color transparency film, even a small change in exposure makes a large change in the lightness or darkness of the picture. With about 1 1/2 stops underexposure, shadows are black, and middle tones, such as the awning's stripes, are unnaturally dark. Highlight details, such as the signs on the awning, show clearly.

underexposure

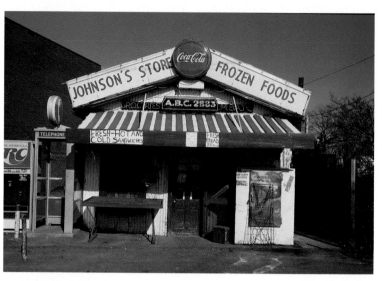

Normal exposure for the overall scene produced bright colors, with details visible in sunlit areas as well as in shadows, except for the darkest areas by the fence and under the awning.

correct exposure

With about 1 stop overexposure in a transparency, colors are noticeably washed out and too light. The shadow areas, however, now show clearly.

overexposure

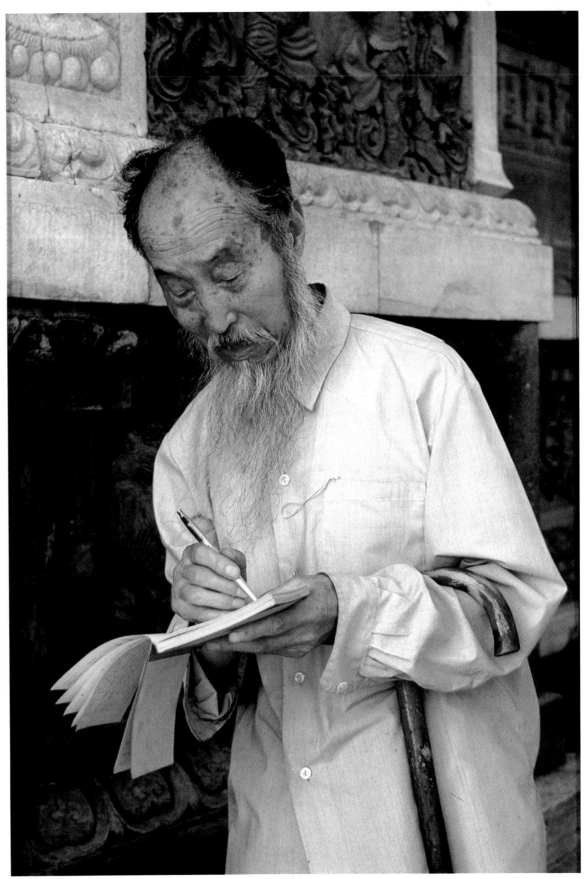

Shooting in soft, diffused light is a bit simpler than working in contrasty light, because the range of tones from light to dark is not so extreme. Diffused light is also kind to the human face, creating soft shadows that are often more complimentary than the hard-edged, dark ones of direct light.

EVE ARNOLD: *Traditional Doctor, China*, 1979

PROCESSING YOUR OWN COLOR

Processing color materials is similar to processing black-and-white materials except that any change in the processing has a greater effect on the final product. Color materials are more sensitive to changes in processing times, temperatures, and other variables; color balance and density shift significantly with even slight variations in processing.

Photographers are more likely to use a commercial lab for **developing color film** than they will for black-and-white film. Many feel that a commercial lab with sophisticated equipment for processing control produces more consistent results than they could in their own darkrooms. In addition, some films, such as Kodak Kodachrome, have a complicated processing procedure that is designed for automated commercial equipment.

Nonetheless, some photographers prefer to do their own color film processing. Doing your own film processing may be less expensive than lab work. It may be faster than a lab if you are in a hurry to get your film developed. You may be able to maintain better quality control if your local lab is not geared for high quality. Some popular and readily available color negative films that you can develop are Agfacolor, Fujicolor, Kodak Vericolor, Ektapress Gold, and Gold Plus films. Among the reversal (slide) films that you can process yourself are Agfachrome, Fujichrome, and Kodak Ektachrome. See the film manufacturer's instructions for the processing chemicals and procedures to use.

The real advantage is in doing your own **color printing** from color negatives or transparencies. Although making color prints is somewhat more exacting than making black-and-white prints, it is not a difficult process to learn and you have the advantage of full control over the final image. Only the most expensive professional printing labs will give you color prints made to your specifications. A much less expensive alternative—and one that produces a print exactly to your taste—is to make your own.

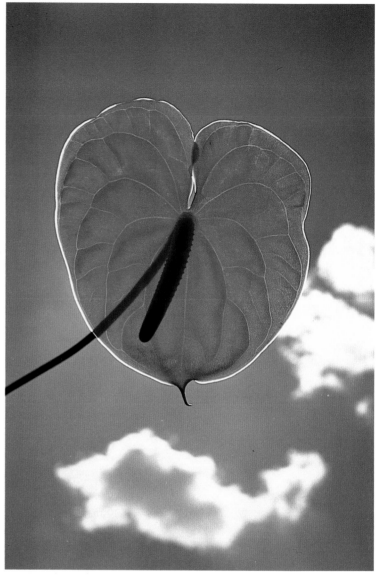

HAROLD FEINSTEIN: *Anthurium,* 1981

Any subject—above and opposite, flowers—can be photographed in an infinite variety of ways. Above, Harold Feinstein boldly isolated one flower against the sky. He held the flower in one hand and a 35mm camera in the other, then moved around to get the best lighting and pattern of clouds. Opposite, Michael Geiger's seemingly casual arrangement was carefully set up. Geiger uses an 8 × 10 view camera because its large viewing screen makes it easier to see and control the complex arrangements that are his specialty. Notice how Feinstein wholly enclosed his flower within the frame of the picture format, while the center of Geiger's picture is almost empty, with the action taking place at the edges.

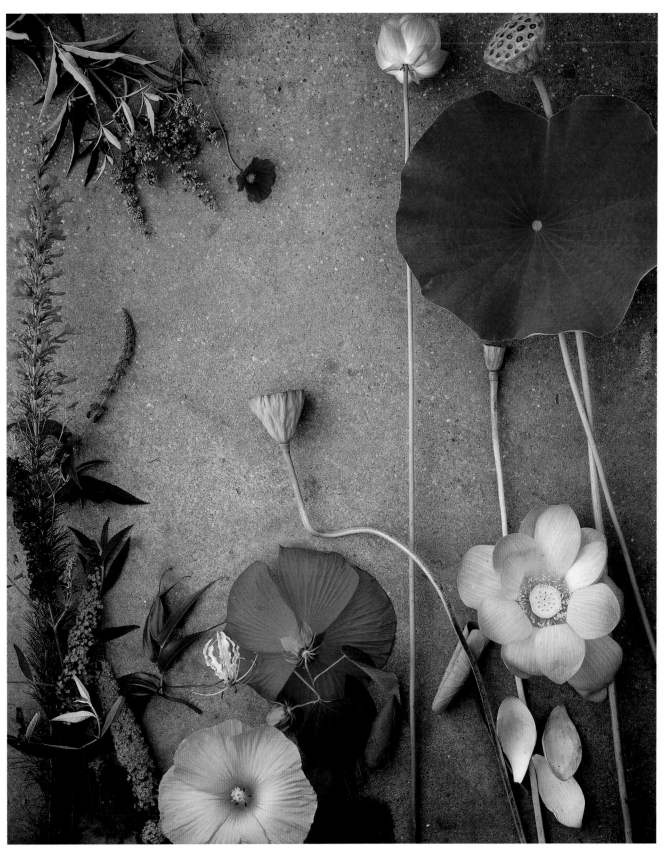

MICHAEL GEIGER: *Summer Lotus*, 1982

MAKING A COLOR PRINT FROM A NEGATIVE
Materials Needed

Once you have assembled the materials needed to make color prints *(see box at right)*, the first step is to make test prints to establish a **standard filter pack.** The color balance of color prints is adjusted by inserting colored filters between the enlarger's beam of light and the paper. Paper manufacturers suggest combinations of filters to produce a print of normal color balance from an average negative or transparency. However, these suggestions are only a starting point for your own tests to determine a standard filter pack for your particular combination of enlarger, film, paper, processing chemicals, and technique. Personal testing is essential because so many variables affect the color balance of prints. Once your standard filter pack has been established, only slight changes in filtration will be needed for most normal printing.

You will need a negative (or a transparency, if you are using reversal materials) that is of normal density and color balance. It should be a simple composition and contain a range of familiar colors, flesh tones, and neutral grays. Do not use a sunset or other scene in which almost any color balance would be acceptable. Your aim is to find a filter pack that will be good as a first trial for most negatives.

Consistency is absolutely vital. The temperature of the developer is critical and must be maintained within the limits suggested by the manufacturer. The same pattern of agitation should be used for all tests and final prints. Even the time between exposure and development must be fairly uniform with some processes.

The following pages show how to produce and evaluate a print from a negative. Pages 234–236 show how to make a print from a positive transparency.

Color Printing: Materials Needed

Color printing papers and processing chemicals. *Two basic types of color printing materials are available, for printing from color negatives or from positive color transparencies. Color prints from color negatives can be made with negative/positive processes such as Fuji Super FA or Kodak Ektacolor papers with Ektacolor RA chemicals. Color prints from positive color transparencies can be made using products such as Ilfochrome Classic materials or Kodak Ektachrome Radiance paper with Ektachrome R-3000 chemicals. Not all processing chemistries can be used with all papers; make sure the paper and chemicals are compatible. See the manufacturer's instructions regarding storage of unexposed paper. Most papers should be stored in a refrigerator at 55° F (13° C) or lower. Remove the package from the refrigerator several hours before opening it to bring the paper to room temperature and prevent moisture from condensing.*

Enlarger. *Any enlarger that uses a tungsten or tungsten-halogen lamp may be used. A fluorescent enlarger lamp is not recommended.*

Filtration. *The color balance of the print is adjusted by placing filters of the subtractive primaries—yellow (Y), magenta (M), and cyan (C)—between the enlarger lamp and the paper. The strength of the filtration is indicated by a density number: the higher the number, the stronger the filter. For example, 20M means a magenta filter 4 times denser than an 05M filter.*

If your enlarger, like the one shown on the opposite page, has a color head with built-in dichroic filters, the strength of each color is adjusted simply by turning knobs or other controls on the enlarger to dial in the desired filtration. Without dial-in filtration, some means must be provided to hold filters in place.

If your enlarger has a drawer for holding filters between the lamp and negative, acetate color printing or CP filters can be used. Filters of the same color can be added to provide a stronger density of a color: 20Y + 20Y gives the same density of yellow as a filter marked 40Y. Any number of filters can be positioned above the negative to create the color balance desired, although the least number that is feasible should be used.

If your enlarger is an older model that does not have a filter drawer, a filter holder can be attached below the lens. In this position, acetate filters cause optical distortions, so the more expensive gelatin color com-

pensating or CC filters must be used. To preserve good optical quality, do not use more than three CC filters below the lens at any one time.

Kodak recommends the following CP or CC filters as a basic kit: one each 2B, 05Y, 10Y, 20Y, 05M, 10M, 20M; two each 40Y and 40R (a red filter equivalent to a 40Y + 40M). Occasionally you may need cyan filtration.

Heat-absorbing glass. *The light sources of many enlargers give off enough heat to damage color negatives and filters unless some of the heat is absorbed. To prevent damage, a piece of heat-absorbing glass should be placed in the enlarger head if it isn't built in. See enlarger manufacturer's instructions.*

Voltage control. *Electric current varies in voltage from time to time, and a change of less than 5 volts will cause a change in the color of the enlarger light—and a visible change in the color of the print being made. So although you can print without it, some type of voltage control is desirable. A voltage stabilizer or regulator automatically maintains a steady output of power if the line voltage fluctuates. A manually adjustable variable transformer is less expensive; you turn a control knob as necessary to maintain uniform voltage. Either type plugs into a wall outlet, then the enlarger plugs into it. Some enlargers have built-in voltage control.*

Analyzers and calculators. *A color analyzer is an electronic device that reads the density and color balance of a negative, compares it to a preprogrammed standard, then recommends exposure and filtration. Good ones are very expensive, and while they make printing easier, you can work without one. Another type of printing aid is a color matrix or subtractive color calculator. Some people find these useful, but others do not. Briefly, you use this device to make a test print in which colors are scrambled to an overall tone. You compare this test to a standard tone to determine exposure and filtration.*

Processing equipment. *A variety of equipment can be used to process color prints (see the box opposite, upper right).*

Miscellaneous. *Most of the other materials needed are also commonly used in black-and-white printing: darkroom timer, accurate thermometer, measuring graduates, and so on.*

1 | color negative printing paper
2 | enlarger with voltage regulator
3 | dichroic color head or filters
4 | timer with sweep-second hand
5 | focusing magnifier
6 | printing-paper easel
7 | color negatives
8 | negative brush
9 | two masking cards for test prints
10 | notebook for record keeping
11 | processing drum
12 | rubber gloves
13 | photographic thermometer
14 | graduates for premeasuring solutions
15 | print-processing chemicals
16 | temperature control and washing tray
17 | squeegee or photographic sponge

Processing Equipment

Equipment to process color prints ranges from entirely manual to completely automatic. A tube-shaped plastic processing drum (item 11, below) is a popular device for color print processing. Each print is processed in small quantities of fresh chemicals, which are discarded after use. This provides economical use of materials as well as consistent processing. Once the drum is loaded and capped, room lights can be turned on so you don't have to work in the dark. Drum processing with manual agitation is shown step-by-step on the following pages.

Mechanized processors come in a variety of styles. At the simplest level is a motorized base for the processing drum. The base provides a consistent agitation of the drum, which is important for color processing.

The unit shown above provides temperature control for the processing solutions and for the processing drum, as well as mechanized agitation of the drum. You add and drain the chemicals yourself.

A completely automated processor does everything for you. You feed in the exposed paper at one end, and a few minutes later a completely processed and dried print comes out at the other end. The unit controls solution temperatures, agitates the print in each solution, and transports the paper from one stage to the next at the correct time.

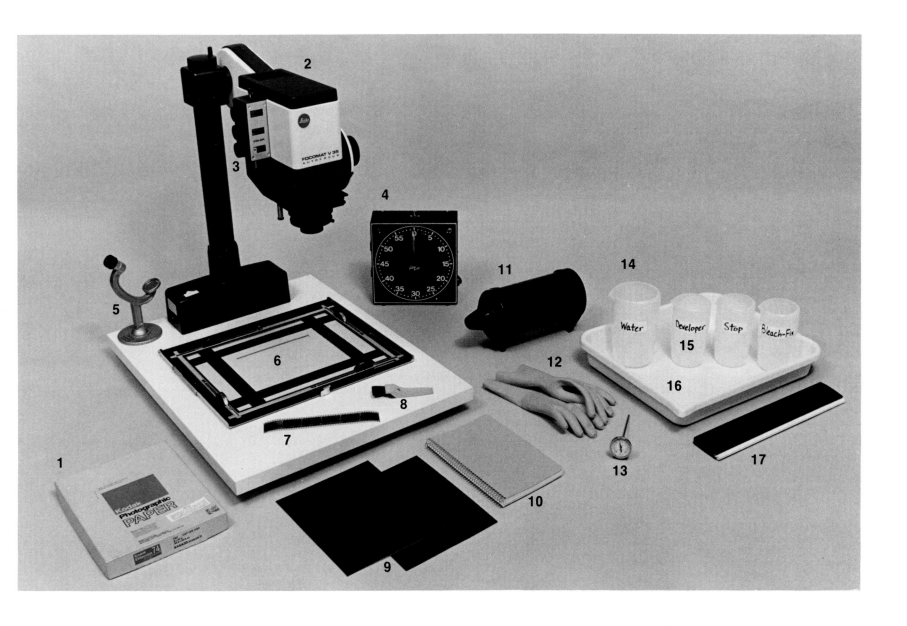

Making a Color Print from a Negative: continued

Exposing a Test Print

The following pages show how to make prints from a color negative using Kodak Ektacolor Ultra print paper processed in Ektacolor RA chemicals. Other papers and developers also work well. Read the manufacturer's current directions carefully, because filtration, safelight recommendations, processing, and so on vary considerably with different materials and may change from time to time.

Kodak recommends handling the paper in total darkness, and you should eliminate stray light from such sources as the enlarger head, timers, or digital displays. If you must have some light, Kodak recommends a $7^{1}/_{2}$-watt bulb with a number 13 amber safelight used at least 4 feet from the paper. If you are using a processing drum, room lights can be turned on once the paper is loaded in the drum with the cap secured.

| 1 | clean the negative |

Clean dust off the negative and carrier. Place negative (dull, emulsion side toward paper) in carrier and insert in enlarger. Set out a clean, dry processing drum and its cap.

| 2 | set up the enlarger |

Insert the heat-absorbing glass, if required. Dial in filtration (or insert CP or CC filters) for the test: 40M (magenta) and 30Y (yellow).

Exposing a Test Print

Five exposures of the same negative are made in the test print shown at right, producing a range of densities from light to dark. See the manufacturer's suggestions for a starting point for filtration. For Ektacolor Ultra paper, Kodak recommends a starting filter pack of 40M + 30Y.

When feasible, it is better to change the aperture while keeping the exposure time the same. This is because extremely long or extremely short exposures could change the color balance and make test results difficult to interpret (the same reciprocity effect that affects film, pages 216–217). In this test each successive strip received one additional full stop of exposure, but the best exposure for a particular negative is often between two of the stops. Exposure times between 5 sec and 30 sec generally do not create noticeable reciprocity effect, so after you get an approximate exposure you can fine-tune by changing the time.

Keep notes of time, aperture, and filtration for each print if you want to save time and materials at your next printing session.

f/4 10 sec

f/5.6 10 sec

f/8 10 sec

f/11 10 sec

f/16 10 sec

3 | adjust the image size

Turn off the room lights. Project the image onto a sheet of paper placed in the easel. Raise or lower the enlarger head until the image is the desired size—here 8 × 10 inches.

4 | focus the image

Looking through a focusing magnifier (if you use one), adjust the focus control of the enlarger until the image is sharp. Focus on the edge of an object since a color negative has no easily visible grain.

5 | set the lens aperture

Stop down the lens to f/16. Set the timer for 10 sec. Turn off the enlarger light. Place a sheet of printing paper on the easel, emulsion side up.

6 | make the first test exposure

Hold a masking card over all but one-fifth of the paper and expose the first test section. Cover the first section with another card. Move the first card to uncover the next one-fifth of the paper.

7 | reset aperture, complete the test

Open the aperture one stop. Reset the timer and expose the next section. Continue moving the cards, opening the aperture one stop and exposing until the last one-fifth of the paper is exposed.

8 | load the paper in the processing drum

Insert the paper in the processing drum with the emulsion (exposed) side curled to the center of the drum. Put the cap on the drum and secure it carefully. Turn on the room lights.

Making a Color Print from a Negative: continued

Processing

With the exposed print stored away from light in the capped drum, prepare the **processing chemicals.** Shown here are Kodak Ektacolor RA chemicals used in a manually agitated processing drum. Mix the chemicals as Kodak's instructions direct, following safety and disposal guidelines carefully. See also Handling Chemicals, page 112.

Contamination will cause trouble, so don't splash one chemical into another or onto the dry side of the darkroom. Be particularly careful not to contaminate the developer with bleach-fix or stop bath. Use a separate container for developer only, and wash mixing and processing equipment carefully after use.

Check the drum manufacturer's recommendations for the volume of solution to be used at each step; it will vary depending on the size of the drum. Make sure to drain the drum completely after each step. In order to empty some drums, you have to tilt them to 180°, then tilt back to the draining position. Before using a new type of drum, practice filling and draining it with water.

Double-check the manufacturer's directions about solution temperatures (particularly for the developer) during processing. With some processes, prints exhibit unpredictable shifts in color and density if the developer varies even slightly from the recommended temperature. If **temperature control** is critical, the best control is obtained from a processing drum that can be agitated while immersed in a constant-temperature water bath. In practice, however, you can deviate somewhat from the exact temperature if you do the same thing every time. If you have difficulty maintaining processing temperatures, "drift-by" temperature control may help. Preheat the solutions slightly more than the normal processing temperature to compensate for any cooling.

Processing Ektacolor Paper in Ektacolor RA Chemicals

	processing step	time	temperature
These times and temperatures are for the type of small processing drum shown in the following illustrations. Procedures for tray processing and larger processors are slightly different; see instructions with the chemicals. The quantity of each solution to use depends on the size of your processing drum; see the drum manufacturer's instructions.	**prewet (water)**	30 sec	*86–96° F (30–36° C)*
	developer	1 min	*94° F ± 0.5° (34.4° C ± 0.3°)*
	stop bath	30 sec	*86–96° F (30–36° C)*
	wash	30 sec	*86–104° F (30–40° C)*
	bleach-fix	1 min	*86–96° F (30–36° C)*
	wash	1 min 30 sec	*86–104° F (30–40° C)*
	dry	as needed	*not above 205° F (96° C)*

1 | **mix solutions, measure quantities, and check temperatures**

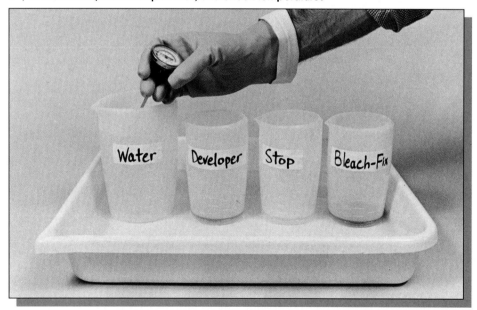

Wearing rubber gloves, mix and measure out the required amounts of solutions. Use the same container each time for a solution to avoid contamination. Bring containers of solutions to the recommended temperature and place them in a water bath at that temperature. Check and keep handy the times for each step.

2 | pour in prewet water

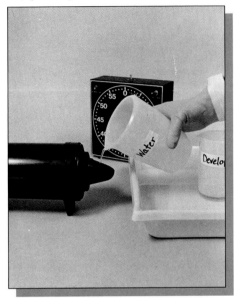

Set timer for prewet time. Pour in prewet water, start timer, and begin agitation. (Prewet warms up the paper and swells the emulsion so chemicals can penetrate easily.)

3 | agitate during prewet

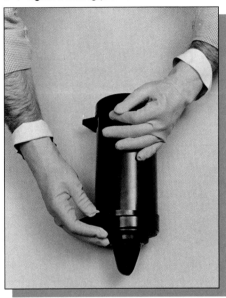

Solutions are agitated across the surface of the paper by rolling or rotating the drum. Use a consistent pattern of agitation to prevent unwanted variations in prints.

4 | drain the prewet water

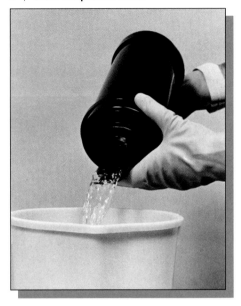

Ten seconds before the end of the prewet period, pour out the prewet. Become familiar with your drum; some drums take slightly longer to drain or need a tilt or shake to drain thoroughly.

5 | development

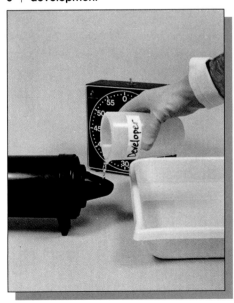

Set timer for development time. Pour in developer, start timer, and agitate as before. Ten seconds before the end of the development period, pour out the developer.

6 | stop bath

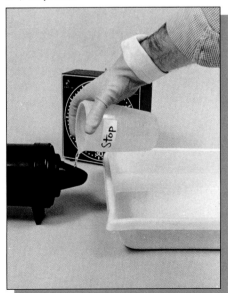

Set timer for stop-bath time. Pour in stop bath, start timer, and agitate. Ten seconds before the end of the period, pour out the stop bath.

7 | wash

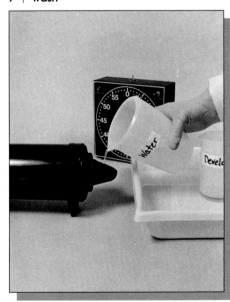

Set timer for wash. Pour in wash water, start timer, and agitate. Ten seconds before the end of the period, pour out wash water.

Making a Color Print from a Negative: continued

8 | bleach-fix

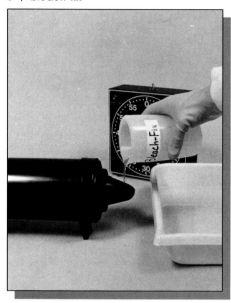

Set timer for bleach-fix time. Pour in bleach-fix, start timer, and agitate. Ten seconds before the end of the period, pour out bleach-fix. The drum can now be opened.

9 | final wash

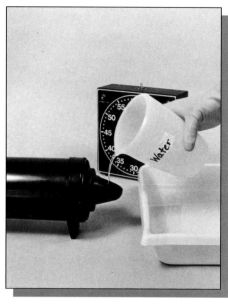

Set timer for 30 seconds. Pour in wash water, set timer, and agitate. Ten seconds before the end of the period, pour out the wash water. Repeat at least two more times.

Troubleshooting Problems: Prints from Color Negatives

If you are not happy with a color print, the problem can often be cured by correcting the exposure or filtration of the print; see Judging Density and Color Balance in a Print Made from a Negative (pages 229–231). Inconsistent or improper processing can also cause trouble; see below. For general difficulties, see Troubleshooting Camera and Lens Problems (page 63), Exposure Problems (page 105), Print Problems (page 163), and Flash Problems (page 272).

**High contrast, cyan stain, and/or high cyan contrast
(pink highlights with cyan shadows)**

Cause: *Developer too concentrated, developer or prewet contaminated with bleach-fix, developer time too long and/or temperature too high.*

**Low contrast (especially magenta-pink highlights with green or blue
shadows)**

Cause: *Developer too dilute, not enough volume of developer, not enough agitation, incorrect developer time and/or temperature.*

Magenta-blue streaks

Cause: *Inadequate stop-bath action (stop bath was exhausted or contaminated, or no stop bath was used)*

Pink streaks or mottled areas

Cause: *Water on print prior to processing due to inadequate drying of drum.*

Light and dark streaks

Cause: *Prewet not used, not enough developer agitation, processor drum not level.*

Bluish blacks

Cause: *Developer too dilute or temperature too low, too short developer time, prewet not fully drained.*

10 | Alternate procedure: tray washing

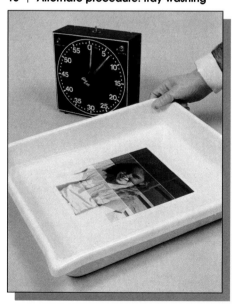

Remove print carefully from drum after bleach-fix; place in a tray of water. Wash by rocking the tray; after 30 seconds dump and refill. Repeat at least two more times.

11 | dry

Sponge or squeegee excess water gently from print and hang or place in dust-free place to dry. Warm air, as from a hair dryer, will hasten drying. Do not use a hot drum dryer.

12 | clean up

Wash all equipment that has come in contact with chemicals. Be particularly careful to wash and dry the processing drum thoroughly so that no trace of bleach-fix remains.

Judging Density in a Print Made from a Negative

1 stop too dark
Give ¹/₂ the previous exposure: close enlarger lens 1 stop or multiply exposure time by 0.5

¹/₂ stop too dark
Give ³/₄ the previous exposure: close enlarger lens ¹/₂ stop or multiply exposure time by 0.75

correct density

¹/₂ stop too light
Give 1¹/₂ times the previous exposure: open enlarger lens ¹/₂ stop or multiply exposure time by 1.5

1 stop too light
Give twice the previous exposure: open enlarger lens 1 stop or multiply exposure time by 2

Judging a color print is similar to judging a black-and-white print in that you have to judge two characteristics separately. In a black-and-white print you judge density first, then contrast. In a color print, you **judge density first** *(shown at left)*, then color balance *(see pages 230–231)*.

The color balance of a test print will probably be off, so try to disregard it and look only at the density, or darkness, of the print. Look for the exposure that produces the best overall density in midtones such as skin or blue sky. Important shadow areas should be dark but with visible detail, textured highlights should be bright but not burned-out white. Some local control with burning and dodging may be needed *(see page 232)*.

The **illumination for judging** a color print affects not only how dark the print looks but also its color balance. Ideally you should evaluate prints using light of the same intensity and color balance under which the print finally will be viewed. Since this is seldom practical, some average viewing conditions have been established. Fluorescent tubes, such as Deluxe Cool White bulbs (made by several manufacturers), are recommended. You can also combine tungsten and fluorescent light for a warmer viewing light, with one 75-watt frosted tungsten bulb used for every two 40-watt Deluxe Cool White fluorescent tubes. Examine prints carefully, but when judging density, don't view a print very close to a very bright light. Average viewing conditions are likely to be less bright, and the final print may then appear too dark.

Making a Color Print from a Negative: continued

Judging Color Balance in a Print Made from a Negative

Almost always, the first print you make from a negative can be improved by some change in the **color balance,** done by changing the filtration of the enlarger light. If your enlarger has a dichroic head, just dial in the filter change. If you are using CP or CC filters, you must replace individual filters in the pack. Decide what color is in excess in the print and how much it is in excess, then change the strength of the appropriate filters accordingly. Ordinarily it is best to evaluate dry prints, since wet prints have a bluish color cast and appear slightly darker than they do after drying.

You can check your print against pictures whose colors are shifted in a known direction, such as the **ringaround test chart** on the opposite page. The chart helps identify basic color shifts, but printing inks seldom exactly match photographic dyes.

A better method for evaluating prints is to look at them through colored **viewing filters** to see which filter improves the color balance. Kodak makes a Color Print Viewing Filter Kit for this purpose.

Find the viewing filter that makes the print look best. Hold the filter a few feet away from the print. Flick the filter in and out of your line of vision as you look at light midtones in the print, such as light grays or flesh tones, rather than dark shadows or bright highlights. Follow the directions with the filters but, in general, change the enlarger filtration half the value of the viewing filter. If you lay the filter on top of the print, the color change increases. If the print looks best this way, change the enlarger filtration the same value as the viewing filter.

To correct the color balance of a print made from a negative, **make the opposite color change in the enlarger filtration from the color change you want in the print.** In other words, if you want to remove a color from a print, add that color to the enlarger filtration. Almost always, you should change only the magenta or yellow filters, either subtracting the viewing filter color that corrects the print or adding the complement (the opposite on the color wheel) of the viewing filter color that corrects (*see chart and color wheel at right*). Kodak's Color Print Viewing Filter Kit also tells you which colors to change.

The cure for a print with too much magenta is to add—not decrease—the magenta in the filter pack; more magenta in the printing light produces a print with less of a magenta cast. A green viewing filter visibly corrects a print that is too magenta; add magenta (the complement of green) to the filter pack.

Similarly, excess blue is corrected by lightening the filter that absorbs blue, the yellow filter; the filter pack will then pass more blue light, so the print (reacting in an opposite direction) will show less blue. When a yellow viewing filter visibly corrects a too-blue print, subtract yellow (the complement of blue) from the filter pack.

Color printing is a skill that is easily learned but that requires both experience and written information from a book or manufacturer's literature. Once you have made a few prints, not only is written information easier to understand but the whole process of printing becomes easier. Help from someone who knows how to print and who can help you judge your prints is invaluable.

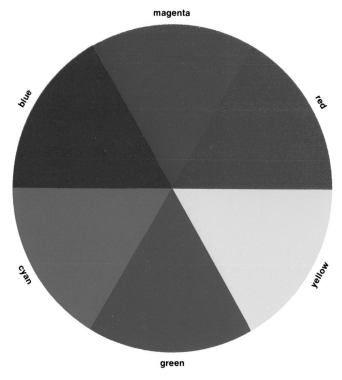

The primary colors of light are shown here arranged in a circle—a color wheel. Each color is composed of equal amounts of adjacent colors (red is composed of equal parts of magenta and yellow). Each color is complementary to the color that is opposite (magenta and green are complementary).

Balancing a Print Made from a Negative

To adjust the color balance of a print made from a negative, change the amount of the subtractive primary colors (magenta, yellow, and cyan) in the enlarger printing light. Usually, changes are made only in magenta and yellow (M and Y).

print is	do this	could also do this
Too magenta	Add M	Subtract C + Y
Too red	Add M + Y	Subtract C
Too yellow	Add Y	Subtract C + M
Too green	Subtract M	Add C + Y
Too cyan	Subtract M + Y	Add C
Too blue	Subtract Y	Add C + M

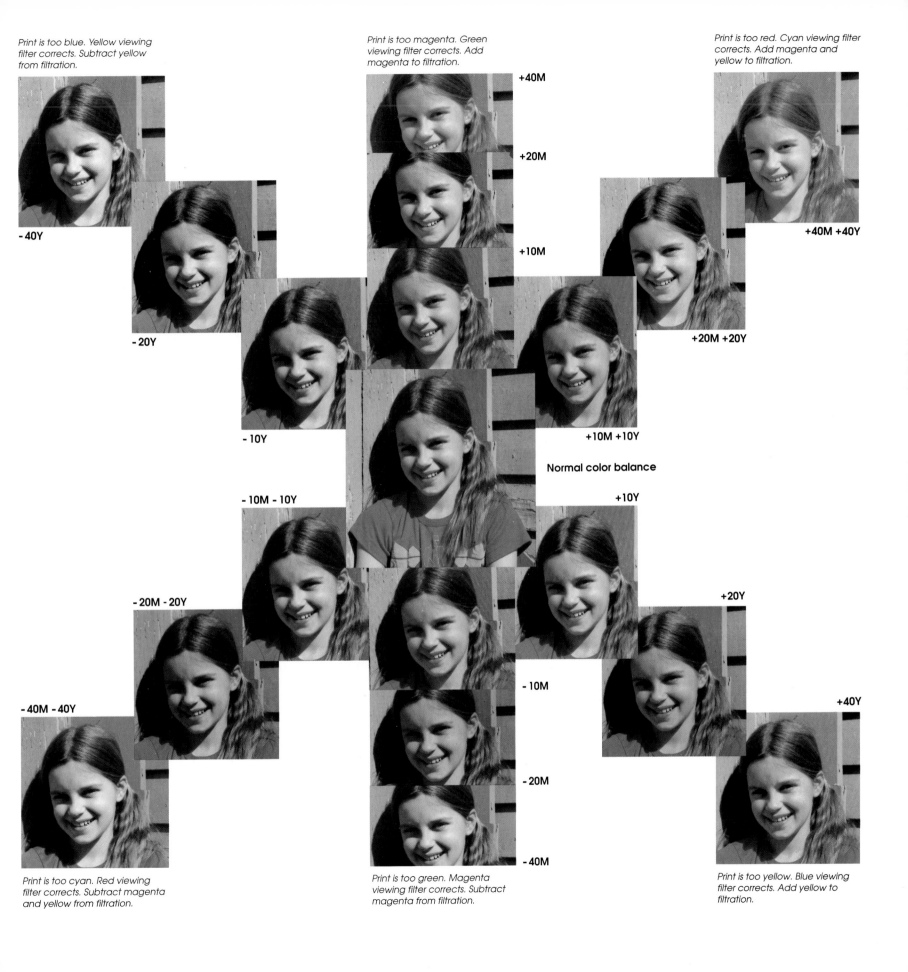

Print is too blue. Yellow viewing filter corrects. Subtract yellow from filtration.

Print is too magenta. Green viewing filter corrects. Add magenta to filtration.

Print is too red. Cyan viewing filter corrects. Add magenta and yellow to filtration.

+40M

+20M

+10M

+40M +40Y

- 40Y

- 20Y

+20M +20Y

- 10Y

+10M +10Y

Normal color balance

- 10M - 10Y

+10Y

- 20M - 20Y

+20Y

- 40M - 40Y

- 10M

- 20M

+40Y

- 40M

Print is too cyan. Red viewing filter corrects. Subtract magenta and yellow from filtration.

Print is too green. Magenta viewing filter corrects. Subtract magenta from filtration.

Print is too yellow. Blue viewing filter corrects. Add yellow to filtration.

Making a Color Print from a Negative: continued
More About Color Balance/Print Finishing

After you change the filtration of a test print, you may then need to make a **final exposure change,** because the filtration affects the strength of the exposing light and thus the density of the print. When feasible, adjust aperture rather than time.

Dichroic filters need minimum exposure adjustment. CP or CC filters require exposure adjustment for changes in both filter density and the number of filters. See the manufacturer's literature or Kodak's Color Darkroom Dataguide, which contains a computing dial that simplifies calculation of new exposures with Kodak materials. As a rough guide, ignore yellow changes, adjust exposure 20 percent for every 10M change, then adjust 10 percent for changes in the number of filters (including yellow).

Do not end up with all three subtractive primaries (Y, M, C) in your filter pack. This condition produces **neutral density**—a reduction in the intensity of the light without any accompanying color correction—and may cause an overlong exposure. To remove neutral density without changing color balance, subtract the lowest filter density from all three colors.

70Y	30M	10C	working pack
10Y	10M	10C	subtract
60Y	20M		new pack

Dodging and burning in a color print is feasible to some extent, as in black-and-white printing, to lighten or darken an area. For example, you may want to darken the sky or lighten a face or shadow area. If you dodge too much, an area will show loss of detail and color (smoky-looking is one description), but some control is possible.

You can also change color balance locally. To improve shadows that are too blue, which is a common problem, keep a blue filter in motion over that area during part of the exposure. Burning in can cause a change in color balance in the part of the print that receives the extra exposure. If a burned-in white or very light area picks up a color cast, use a filter of that color over the hole in the burning-in card to keep the area neutral. Try a CC30 or CC50 filter of the appropriate color.

Like black-and-white prints, color prints may need **spotting** to remove white or light specks caused by dust on the negative. Retouching colors made for photographic prints come in liquid or cake form. Either can be used to spot out small specks. The dry cake dyes are useful for tinting large areas. Black spots on a print are more difficult to correct. One way is to apply white opaquing fluid to the spot, then tint to the desired tone with colored pencils.

For **mounting,** dry-mount tissue is usable, but low temperatures are recommended for RC paper, 180 to 210° F (82 to 99° C). Since the thermostat settings on dry-mount presses are seldom accurate, use the lowest setting that is effective. Preheat the press, the mount board, and the protective cover sheet placed on top of the print, then insert the print for the minimum time that will fuse the dry-mount tissue to both print and mount board.

Color prints fade over time, particularly on exposure to ultraviolet light. Prints will retain their original colors much longer if kept from strong sources of ultraviolet light such as bright daylight or bright fluorescent light, or by using UV-filtering glass or plastic in frames.

ALBERT WATSON: *Fashion Photograph, 1993*

▲ *In fashion photography, attitude—if it isn't* ▶ *everything—is at least a large part of the package. Both in editorial use in magazines and in advertising, it's usually more important to convey how you will feel if you buy these clothes, rather than showing details of the clothing's construction or design. The best fashion photographs use the model as more than just a clothes hanger for the outfit. The personality projected by the model can help get the message across. Above, an illustration for high fashion men's wear; opposite, the opening photograph for a feature article on bathing suits.*

MIKE REINHARDT: *Fashion photograph*, 1993

MAKING A COLOR PRINT FROM A TRANSPARENCY

1 | processing chemicals
2 | cups for chemical solutions
3 | color reversal printing paper
4 | filters or enlarger with dichroic head
5 | manual
6 | processing drum
7 | timer
8 | large waste container
9 | mixing graduate
10 | solution storage bottles
11 | washing tray
12 | rubber gloves
13 | photographic thermometer
14 | stirring rod
also useful: soft rubber squeegee or photographic sponge

Color prints can be made from transparencies (slides) as well as from negatives. You can make a positive print directly from a positive color transparency with materials like Ilford's Ilfochrome Classic paper processed in P-30 chemicals (shown here) or Kodak Ektachrome Radiance paper processed in Ektachrome R-3000 chemicals. Ilfochrome Classic is Ilford's current version of their Cibachrome-A II paper, noted for brilliant, saturated colors, good detail and sharpness, and excellent color dye stability.

Clean the transparency carefully before you place it in the enlarger. Specks of dust on it will appear as black spots on the print. For best results, print from a fully exposed transparency with saturated colors and low to normal contrast. Starting with a contrasty transparency often leads to considerable print dodging or burning in. Reducing excess contrast sometimes requires masking, sandwich-ing the transparency in register with a black-and-white contact negative made on film such as Kodak Pan Masking Film 4570.

Ilford makes several types of print materials. A resin-coated (RC) paper is available in a glossy or slightly stippled pearl finish. The pearl finish is not as likely as the glossy surface to show fingerprints or surface scratches. Also available is a glossy-surface material on a polyester base, which dries to a high-gloss finish. The polyester base provides better color stability and is the preferred choice for archival preservation.

See general instructions for color printing on page 222 and chemical safety guidelines on page 112. Drum processing with manual agitation is shown here. See the box on page 223 for more about other types of processing equipment; however, these materials should not be processed in trays. Be careful when handling any color processing chemicals. Mix chemicals in a very well-ventilated area. Wear rubber gloves to prevent contact of the chemicals with your skin. Safety goggles will protect your eyes. Do not pour P-30 chemicals directly down the drain; the bleach is corrosive and must be mixed with the other solutions to neutralize it for disposal. This is done by draining the spent processing solutions into the same plastic container in the order that they are used. If you then dispose of them down the drain, follow with a generous amount of water. See manufacturer's guidelines.

Make your first print a test to determine exposure and filtration (see manufacturer's suggestions). Unlike printing from a negative, greater exposure makes the print lighter, and heavier filtration adds more of that filter's color to the print *(see page 236)*.

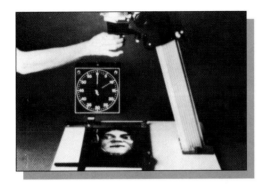

1 | Clean the transparency carefully and place it in the enlarger's film carrier. You may have to remove a 35mm slide from its mount. Expose your first test print. Ilford does not recommend the use of any safelight with Ilfochrome Classic materials.

2 | Curl the exposed print toward the emulsion side and put it into a dry, clean drum. Seal the drum. You can now turn on the room lights.

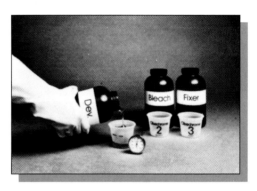

3 | Prepare the solutions for each step: presoak, developer, water rinse, bleach, and fixer. Adjust temperatures and measure out solutions. Note the times for each step. Follow the sequence shown below in steps 4, 5, and 6 for each processing step.

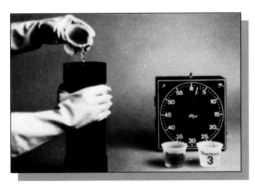

4 | At each processing step, set the timer and pour the solution into the drum. Check the drum manufacturer's instructions; often you start the timer when the drum is laid on its side because solutions do not contact the print until then.

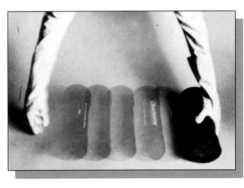

5 | A consistent agitation pattern is important. Roll the drum smoothly back and forth on a level, even surface or use a motorized base.

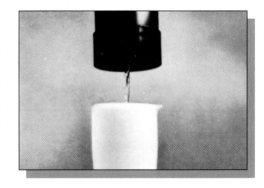

6 | At the end of each processing time, drain the drum into the same large plastic waste container. Full drainage of the drum is important. Do not discard the solutions until the end of the processing.

7 | Fill the drum with water and carefully remove the print. Wash the print in rapidly flowing water. Handle the print carefully; the surface is soft and delicate while wet.

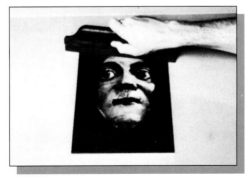

8 | Squeegee the print to prevent water spots but do so gently to avoid damaging the print. Evaluate the print after drying. It will look somewhat red while it is still damp.

9 | Dry the print in a dust-free place. Hang the print or place on an absorbent surface; or for fast drying, use a blow dryer on the warm setting. Do not use a hot drum dryer.

Making a Color Print from a Transparency: continued

Judging a Print Made from a Transparency

Evaluating a reversal print—one made from a transparency or slide—is similar in many ways to evaluating a print made from a negative *(see pages 229–231).* View the print when it is dry in light similar to that under which you will view the finished print. Evaluate and adjust density first, because what looks like a problem in filtration may simply be a print that is too dark or too light. Evaluate color balance by examining the print with viewing filters or by comparing the print against ring-around prints *(right).*

The most important difference between reversal printing and negative/positive printing is in the response to changes in exposure or filtration. **Reversal materials respond the same way that slide film does when you expose it in the camera.** If the print is too dark, increase the exposure (don't decrease it as you would in negative/positive printing). Adjust the color balance by making the same change in the filter pack that you want in the print. Adding a color to the filter pack will increase that color in the print; decreasing a color in the pack will decrease it in the print. For example, if a print is too yellow, remove Y from the filtration *(see chart and prints at right).*

The suggested beginning **filter pack** for a print made from a transparency may have yellow and cyan filtration. (This is different from the beginning pack for a print made from a negative, which has yellow and magenta filtration.) If so, try to adjust the balance by changing only the Y and C filtration to avoid the neutral density caused by having all three primary colors in the same pack *(see page 232).*

One thing is the same in both processes: keep notes—on the print, on the negative envelope, or in a notebook.

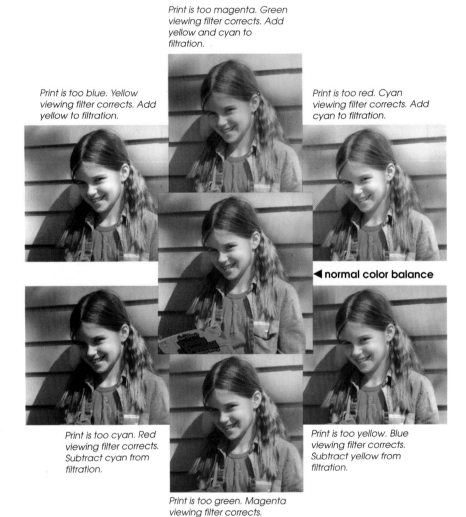

Print is too magenta. Green viewing filter corrects. Add yellow and cyan to filtration.

Print is too blue. Yellow viewing filter corrects. Add yellow to filtration.

Print is too red. Cyan viewing filter corrects. Add cyan to filtration.

◄ **normal color balance**

Print is too cyan. Red viewing filter corrects. Subtract cyan from filtration.

Print is too yellow. Blue viewing filter corrects. Subtract yellow from filtration.

Print is too green. Magenta viewing filter corrects. Subtract yellow and cyan from filtration.

Balancing a Print Made from a Slide

To adjust the color balance of a print made from a positive transparency, change the amount of the subtractive primary (yellow, cyan, and magenta) filtration. Make changes first in Y or C filtration.

print is	do this	could also do this
Too dark	Increase exposure	–
Too light	Decrease exposure	–
Too magenta	Add Y + C	Subtract M
Too red	Add C	Subtract Y + M
Too yellow	Subtract Y	Add C + M
Too green	Subtract Y + C	Add M
Too cyan	Subtract C	Add Y + M
Too blue	Add Y	Subtract C + M

Sculpture by JERRY PEART: *Crossroads, Albuquerque, New Mexico,* 1984

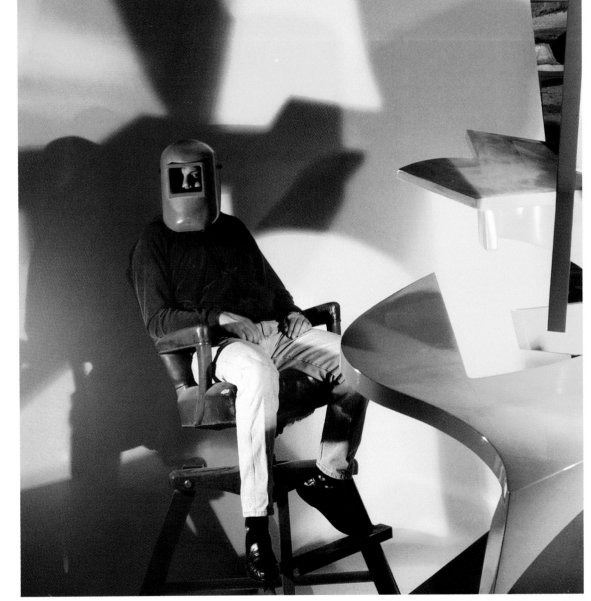

Patty Carroll's photograph of sculptor Jerry Peart is one of series of portraits Carroll made of Chicago artists. "I began this project," she said, "by thinking about issues of portraiture, and realizing that my interest lay in portraying the secret self-portrait everyone has inside themselves. It seemed natural to me to work on fantasy portraits with sitters who themselves have developed very personal, 'fantastic,' elaborate pictorial imagery. . . . Peart cuts metal into shapes like paper and dominates his material like a kid with big toys, but in a serious game."

Carroll photographed Peart in his studio, wearing his welding mask and surrounded by one of his large constructions. She lit the scene with studio lights and colored gels (colored filters placed over the lights).

PATTY CARROLL: *Jerry Peart, Chicago,* 1990

INSTANT COLOR FILM

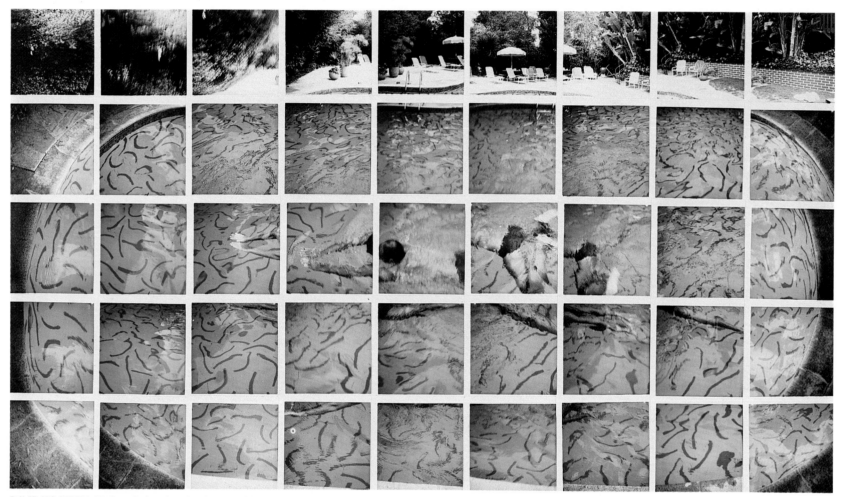

DAVID HOCKNEY: *Nathan Swimming, Los Angeles,* March 11, 1982. Composite Polaroid

Instant color pictures are a favorite with photographers because the processing takes care of itself and within seconds a finished print is ready. Although processing instant color film is very simple for the user, the chemistry on which the film is based is extremely complex. It involves a multilayered negative of light-sensitive silver halides and developer dyes sandwiched with printing paper and an alkaline developing agent when the print is pulled from the camera. Integral films such as Polaroid's Spectra and Time-Zero films are even more complex; the processing takes place within the print itself.

Barbara Bordnick *(photograph opposite)* particularly likes Polaroid for portraits of celebrities. "You're asking these people to perform in the one capacity they're least comfortable in, and that is the role of themselves. They feel very naked." With Polaroid, Bordnick turns the shoot into a more reassuring one for the sitter. "The image comes out right then, my assistant who sees it first exclaims, 'Ohhh!' Then we all go running back and look at it, and the subject hears this whole hullabaloo and it's sort of like telling somebody, 'Look at this fabulous image of you!' "

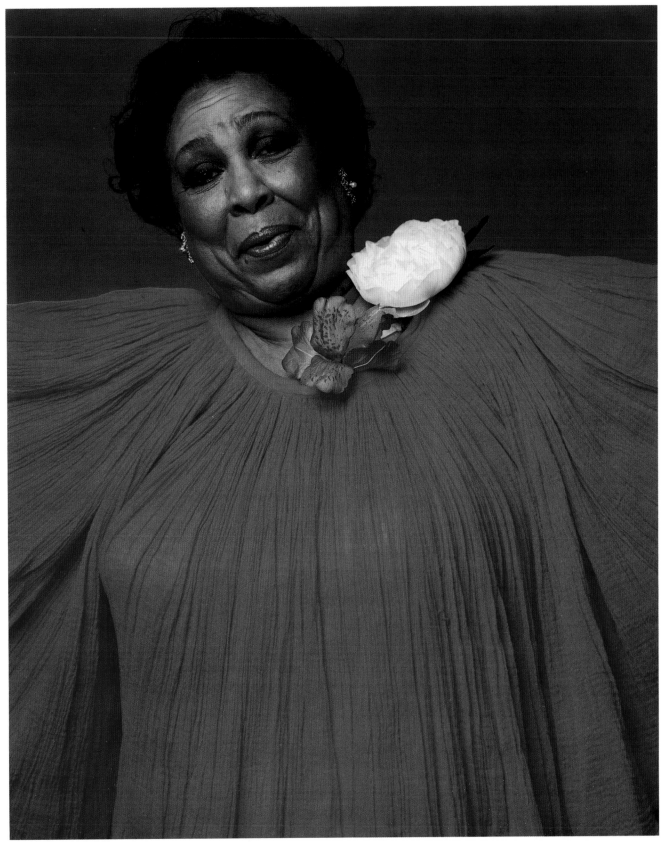

◄ David Hockney's grid of Polaroid photographs has fragmented the space and time of a particular event. "I realized," Hockney said, "that this sort of picture came closer to how we actually see, which is to say, not all-at-once but rather in discrete, separate glimpses which we then build up into our continuous experience of the world."

Barbara Bordnick's portrait of ► Helen Humes conveys a monumentality that matches the reputation of the great jazz singer. Bordnick shot from a relatively low angle that filled most of the picture with the powerful spread of Humes's red dress. She removed all other elements such as hands or background that might have attracted attention, except for the two flowers that help bring the viewer's eye to the singer's face.

BARBARA BORDNICK: *Jazz Singer Helen Humes,* 1977

PHOTOGRAPHER AT WORK: ADVERTISING PHOTOGRAPHY

What makes a good advertising photograph? For Clint Clemens, the answer is simplicity, and he thinks that many photographers lose sight of that. "They complicate it too much," he says. "Too often there isn't a simple statement or any purity of thought or elegance." He believes that to get an advertising message across effectively you have to understand the psychology of your audience: how people perceive themselves and what intangibles the product might supply to them. For example, imparting a feeling of power to the setup for the Harley-Davidson motorcycle at right is as important as showing its design.

Lighting can be dramatic in Clemens's pictures, but it always looks natural. "In nature, there is only one source of light—the sun. Lighting in a photograph should have that single-source feeling, whether it is indoors or outdoors." Clemens likes to give light a direction so that it comes from one area and moves across the picture. A viewer's eye tends to go to the lightest part of a picture first, which means that light, especially when it contrasts with a darker background, can direct attention where the photographer wants it to go.

Clemens always visualizes a photograph before he begins to shoot. He has a clear idea in advance of how the product should be presented, how it should relate to the type in the ad, how the picture will be cropped for the layout, and so on. "You have to be able to see the picture beforehand and be able to describe it to others. You would drive everyone crazy if you didn't have a good idea of what you wanted it to look like." He isn't rigidly tied to his ideas and will take advantage of

something that happens spontaneously, but often the final picture is exactly what he visualized.

Clemens feels that advertising is a very personalized business. He gets to know his clients and lets them know that their job is the most important one he has. More than that, he makes sure that every job *is* his most important one. "You never, never blow a job. You always have to give it your best, and that requires preplanning and constant attention to detail, especially when you are shooting. But don't get so bottled up and rattled that you can't think. You have to be willing to take chances, too."

Recently, instead of being studio based, Clemens has been working mostly on location. He has one assistant who takes care of the equipment, and he hires freelance help on individual shoots. He rents a studio, as needed, or hires a production crew to work at a site. When he used to work mostly in his studio, he often took on apprentices, as many advertising photographers do. He recommends apprenticeship as a good way to learn. His apprentices stayed six weeks, got no pay, worked intensely, and got the kind of experience that is impossible to get in a school or from a book.

Clemens says that if you want to be an advertising photographer, you have to be businesslike: "You have to learn how to deal with people, how to go out and get work, how to present and promote yourself, what to put in a portfolio, and many other things." But the most important attribute is a desire to understand every aspect of photography. "You have to want to learn. That is absolute."

CLINT CLEMENS: *Photograph for Harley-Davidson,* 1992

Clemens knows in advance what he wants and has it built to his exact specifications. He says that spending money for the tools you need is a worthwhile investment. A Harley-Davidson shoot, which called for pictures of a number of different bikes, was as complex as a movie production. Clemens used as the setting for the bikes an old, abandoned factory in a Milwaukee industrial area. A crew of ten created four sets, each with a 60 by 40-foot hand-painted canvas backdrop. Two "detail" people brought the bikes to polished perfection. Manufacturing the four backdrops was itself a production; each had about a thousand hand-set rivets, visible in the photograph as the lines of dots on the canvas.

VITO ALUIA: *Clint Clemens,* 1984

CLINT CLEMENS: *Photograph for Tech HiFi*, 1982

Camera angle is one way to affect a viewer's attitude. To look down on someone is often condescending. To look up can make someone appear impressive or bigger than life. In a photograph for an audio equipment store's catalog, Clemens placed the camera very low, which created an intimacy with the child because the viewer is joining his world rather than looking down on him from the usual adult point of view. "You have to take the viewer's mind," Clemens says, "and put it where you want it."

O. WINSTON LINK: *Hot Shot Eastbound, Iager, West Virginia*, 1956

Y. R. OKAMOTO: *Arnold Newman Photographing President Lyndon B. Johnson*, 1963

▲ When Arnold Newman was asked to make a portrait of President Lyndon B. Johnson in the Oval Office at the White House, Newman covered the windows with cloths to block unwanted light, mounted two view cameras—a 4 × 5 and an 8 × 10—and arranged his lights and reflectors. The lighting setup looks complicated, but its intention is simple—to illuminate the subject in a way that resembles ordinary daytime lighting. This type of lighting looks natural and realistic because it is the kind people see most often. It consists of one main source of light coming from above, usually from the sun, but here from the large umbrella reflector. It also has fill light that lightens shadow areas. In nature, this is light from the entire dome of the sky or from other reflective surfaces; here it comes from the smaller lights.

◄ During the 1950's O. Winston Link made many photographs along the Norfolk and Western Railway. To light this night scene of a steam locomotive thundering past a drive-in movie, Link set up 43 flashbulbs in multibulb reflector heads that he wired together to flash simultaneously. If you look closely along the train embankment at track level you can see a series of round black shapes, the backs of some of the flash heads.

Link was a lifelong train fancier as well as a commercial photographer, and the undertaking was his personal project. "I could only see the headlight of the locomotive in total darkness," Link recalled. "I did not know until the flash was fired that I had captured this prize."

Any kind of lighting has certain basic characteristics. The **direction** of light *(pages 244–245)* and its **degree of diffusion** *(pages 246–247)* are important because they affect the extent and intensity of the shadows that reveal texture and suggest volume. The **color** of light is important when you use color film, because "white" light sources, such as a light bulb, a flash unit, or the sun, can be relatively reddish to relatively bluish in color. Although the eye adapts to color changes so that most light sources appear neutral in color, color film will record even minor color differences and can give a photograph an unwanted reddish or bluish cast. More about the color of light in Chapter 10, Color. The **intensity** or quantity of light has little effect on the lighting but can affect an image in other ways. For example, the dimmer the light, the more you need to use a long shutter speed or open the lens to a wide aperture, with the potential for blurred motion or shallow depth of field.

The type of light source is less important than what the light is doing to the subject. This chapter shows how to understand the effects of lighting on a subject and how to use lighting to get the results you want.

DIRECTION OF LIGHT

Paradoxically, the direction of light is important because of **shadows,** specifically, those that are visible from camera position. Light, except for the most diffuse sources, casts shadows that can emphasize texture and volume or can diminish them. The main source of light—the sun, a bright window in a dark room, a flash unit—illuminates the side of the subject nearest the light and casts shadows on the opposite side.

When looking at the lighting on a scene, you need to take into account not only the direction of the light (and the shadows it casts) but also the position of the camera (will those shadows be visible in the picture?). Snapshooters are sometimes advised to "stand with the light over your shoulder." This creates safe but often uninteresting front lighting in which the entire subject is evenly lit, with few shadows visible because they are all cast behind the subject. Compare front lighting with side or back lighting in which shadows are visible from camera position *(photographs, this page and opposite).*

There is nothing necessarily wrong with front lighting; you may want it for some subjects. Nor does side or back lighting enhance every scene. But before you shoot, take a moment to consider your alternatives. Will moving to another position show the scene in a more interesting light? Can you move the subject relative to the light, or maybe move the light to another position? Outdoors, you have little control over the direction of light, except for waiting for the sun to move across the sky or in some cases by moving the subject. If you set up lights indoors, you have many more options.

RAY McSAVANEY: *Yosemite National Park,* 1983

Back lighting comes toward the camera from behind the subject (or behind some part of the subject). Shadows are cast toward the camera and so are prominent, with the front of the subject in shadow. Back lighting can make translucent objects seem to glow and can create rim lighting, a bright outline around the subject (see the last photo on page 251).

side lighting

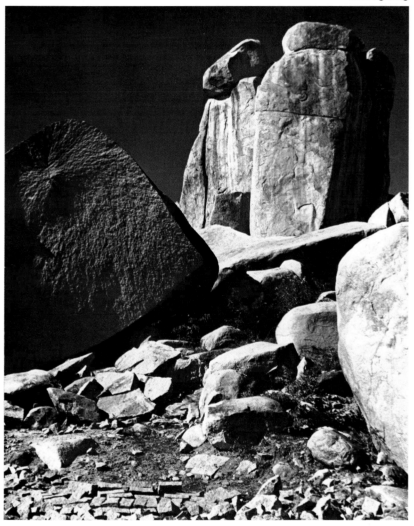

WERNER BISCHOF: *Rocky Landscape*

Side lighting comes toward the side of the subject and camera. Shadows are prominent, cast at the side of the subject, which tends to emphasize texture and volume. Early morning and late afternoon are favorite times for photographers to work outdoors, because the low position of the sun in the sky produces side lighting and back lighting.

front lighting

SERGIO LARRAIN: *Cactus*

Front lighting comes from behind the camera toward the subject. The front of the subject is evenly lit with minimal shadows visible. Surface details are seen clearly, but volume and textures are less pronounced than they would be in side lighting where shadows are more prominent. Flash used on camera is a common source of front lighting.

DEGREE OF DIFFUSION: FROM HARD TO SOFT LIGHT

direct light

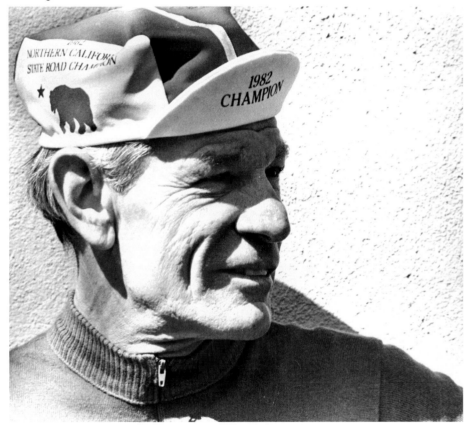

ETTA CLARK: *Bicycle Champion*, 1985

directional-diffused light

FREDRIK D. BODIN: *Young Girl, Norway*, 1975

Next to its direction, the most important characteristic of lighting is its degree of diffusion, which can range from contrasty and hard-edged to soft and evenly diffused. When people refer to the "quality" of light, they usually mean its degree of diffusion.

Direct light creates hard-edged, dark shadows. It is specular: its rays are parallel (or nearly so), striking the subject all from one direction. The smaller the light (relative to the size of the subject) or the farther the light is from the subject, the sharper and darker the shadows will be. The sharpest shadows are created by a point source, a light small enough or far away enough that its physical size is irrelevant.

A spotlight is one source of direct light. Its diameter is small, and it often has a built-in lens to focus the light even more directly. If you think of a performer on-stage in a single spotlight, you can imagine an extreme case of direct light: lit areas very light, shadows hard-edged and black unless there are reflective areas near the subject to bounce fill light into the shadows *(more about fill light on pages 252–253)*.

The sun on a clear day is another source of direct light. Although the sun is large in actual size, it is so far away that it occupies only a small area of the sky and casts sharp, dark shadows. It does not cast direct light when its rays are scattered in many directions by clouds or other atmospheric matter: then its light is directional-diffused or even fully diffused.

Diffused light scatters onto the subject from many directions. It shows little or no directionality. Shadows, if they are present at all, are relatively light. Shadow edges are indistinct, and subjects seem surrounded by light.

diffused light

◀ *Direct light (opposite page, left), with its dark, hard-edged shadows, illuminates subjects that are in the sun on a clear day. Directional-diffused light (opposite page, right) combines qualities of direct and diffused light: shadows are visible, but not as prominent as in direct light. Here, the girl was indoors with the main light coming from a large window to her right, but with other windows bouncing light into the shadows.*

Fully diffused light (this page) provides an even, soft illumination. Here, the light is coming from above, as can be seen from the somewhat brighter foreheads, noses, and cheekbones, but light is also bouncing in from both sides and to some extent from below. An overcast day or a shaded area commonly has diffused light.

DANNY LYON: *Sparky and Cowboy (Gary Rogues)*, 1965

Sources of diffused light are broad compared to the size of the subject—a heavily overcast sky, for example, where the sun's rays are completely scattered and the entire sky becomes the source of light. Fully diffused light indoors would require a very large, diffused light source close to the subject plus reflectors or fill lights to further open the shadows. Tenting *(page 259)* is one way of fully diffusing light.

Directional-diffused light is partially direct with some diffused or scattered rays. It appears to come from a definite direction and creates distinct shadows, but with edges that are softer than those of direct light. The shadow edges change smoothly from light to medium-dark to dark, and the shadows tend to have visible detail.

Sources of directional-diffused light are relatively broad. Indoors, windows or doorways are sources when sunlight is bouncing in from outdoors rather than shining directly into the room. Floodlights used relatively close to the subject are also sources; their light is even more diffused if directed first at a reflector and fused if directed first at a reflector and bounced onto the subject (like the umbrella light on page 243) or if partially scattered by a diffusion screen placed in front of the light. Outdoors, the usually direct light from the sun is broadened on a slightly hazy day, when the sun's rays are partially scattered and the surrounding sky becomes a more important part of the light source. Bright sunlight can also produce directional-diffused light when it shines on a reflective surface such as concrete or sand and then bounces onto a subject that is shaded from direct rays by a tree or building.

LIGHT AS YOU FIND IT—OUTDOORS

directional

PEDRO MEYER: *The Double Mask, Mexico*, 1980

Because direct light outdoors can produce prominent shadows (this page, top), it is important to notice how such light is striking a subject. In diffused light outdoors, such as in the shade of a building, light is soft and revealing (this page, bottom). Outdoors, if the light isn't right, sometimes you can wait for the sun to change position. Sometimes you can move the subject or add fill light. You can't change light outdoors, but you can at least observe it and work with it.

What kind of light will you find when you photograph outdoors? It may be any of the lighting situations shown on the preceding pages, so it is important to stop for a moment to look at the light and see how it affects the photograph.

A clear, sunny day creates bright highlights and dark, hard-edged shadows *(this page, top)*. On a sunny day, take a look at the direction the light is coming from. You might want to move the subject or move around it yourself so the light better reveals the subject's shape or texture as seen by the camera. If you are relatively close to your subject—for example, when making a portrait—you might want to lighten the shadows by adding fill light or by taking the person out of the sun and into the shade where the light is not so contrasty.

On an overcast day, at dusk, or in the shade *(this page, bottom)*, the light will be diffused and soft. This is a revealing light that illuminates all parts of the scene. It can be a beautiful light for portraits, gently modeling the planes of the face.

The light changes as the time of day changes. The sun gets higher and then lower in the sky, affecting the direction in which shadows fall. If the day is sunny, many photographers prefer to work in the early morning or late afternoon; when the sun is close to the horizon, it casts long shadows and rakes across the surface of objects, increasing the sense of texture and volume.

diffused

PENNY WOLIN: *Four Children, Los Angeles*, 1989

LIGHT AS YOU FIND IT—INDOORS

directional

JEB (JOAN E. BIREN): *Darquita and Denyeta, Alexandria, Virginia,* 1979

Shooting toward a bright window indoors will back light a subject so that the side facing the window is much brighter than the side facing the camera (this page, top). Diffused light indoors occurs when light comes from several different directions, such as from windows on more than one side of a room or from numerous light fixtures (this page, bottom).

diffused

NICHOLAS NIXON: *Bebe and Clementine,* 1990

Light indoors can range from contrasty to flat, depending on the source of light. Near a lamp or window, especially if there are not many in the room, the light is directional, with bright areas fading off quickly into shadow *(this page, top).* The contrast between light and dark is often so great that you can keep details in highlights or shadows, but not in both. If, however, there are many light sources, the light can be softly diffused, illuminating all parts of the scene *(this page, bottom).*

When shooting indoors, it is important to meter carefully and expose for the most important parts of the picture. The eye adapts easily to variations in light;

you can glance at a light area, then quickly see detail in a nearby dark area. But there will often be a greater range of contrast indoors than film can record.

Light indoors is often relatively dim. If you want to use the existing light and not add flash or other light to a scene, you may have to use a slow shutter speed and/or a wide aperture. Use a tripod at slow shutter speeds or brace your camera against a table or other object so that camera motion during the exposure does not blur the picture. Focus carefully, because there is very little depth of field if your lens is set to a wide aperture.

THE FILL LIGHT: TO LIGHTEN SHADOWS

When you look at a contrasty scene, your eye automatically adjusts for differences in brightness: as you glance from a bright to a shadowed area, the eye's pupil opens up to admit more light. But photographic film does not make such adjustments and can record only a limited range of tones. If you expose highlights correctly in a contrasty scene, shadows will be very dark; if shadows are properly exposed, highlights will be very light. **Fill light** is one solution if you want to add light to shadow areas to reduce contrast and bring out details that would otherwise be lost. Fill light is useful with most artificial lighting and some scenes in daylight where you are close enough to the subject to effectively lighten shadows. (It is not necessary, of course, to always lighten shadows; dark shadows can be a plus in a photograph. See page 350.)

A **reflector** is a simple, effective, and inexpensive way to add fill light. A reflector bounces the main light into areas where it is needed *(pictures opposite)*. A simple reflector, or **flat,** can be made from a piece of stiff cardboard, 16 × 20 inches or larger, with a soft matte white finish on one side. The other side can be covered with aluminum foil that has first been crumpled and then partially smoothed flat. The white side will give a soft, diffused, even light suitable for lightening shadows in portraits, still lifes, and other subjects. The foil side reflects a more brilliant, harder light.

A floodlight or flash can also be used for fill lighting. A light source used as a fill is generally placed close to the lens so that any secondary shadows will not be visible. The fill is usually not intended to eliminate the shadow altogether, so it is normally of less intensity than the main light. It can have lower output than the main light, be placed farther away from the subject, or have a translucent diffusing screen placed in front of it. See pages 270–271 for how to use a flash for fill with daylight.

A black "reflector" is useful at times. It is a sort of antifill that absorbs light and prevents it from reaching the subject. If you want to darken a shadow, a black cloth or card placed on the opposite side of the subject from the main light will remove fill light by absorbing light from the main light.

You can roughly judge if shadows are so dark that they need fill light by squinting while looking at the scene or viewing the scene through the camera's lens with the aperture stopped down. This makes shadow areas appear darker and thus more noticeable. But the best way is to measure the light with an exposure meter. If important shadow areas, like the shaded side of a face, measure three or more stops darker than midtones, they will be very dark or even black in a print *(see opposite page, left photo)*. Color transparencies need fill light even more than prints do. As little as two stops difference between highlights and shadows can make shadows look very dark.

The difference between the lit side of a subject and the shadow side is sometimes given as a **ratio.** The higher the ratio, the greater the contrast. A 1:1 ratio means the lit side is no lighter than the shadow side—in fact, there are no significant shadows. Doubling the ratio is equivalent to a one-stop change between highlights and shadows. With a 2:1 ratio, the lit side is twice as light as the shadow side (a one-stop difference between meter readings for each side), which will make shadows visible but very light. A 4:1 ratio (with the lit side four times—two stops—lighter than the shadow side) will render shadows darker, but still show texture and detail in them. Portraits are conventionally made at a 3:1 to 4:1 ratio, with the lit side of the face between one and one-half and two stops lighter than the shadowed side. At an 8:1 (lit side three stops lighter than shadows) or higher ratio, some detail is likely to be lost in highlights, shadows, or both.

To measure the lighting ratio, meter the lit side, then the shadow side, and count the number of stops difference between them. With a reflected-light meter, you can either meter directly from the subject or from a standard-gray test card held close to the subject. With an incident-light meter, point the meter first toward the main light from subject position, then toward the fill. If there is too much difference between the lit side and shadows, move the fill light closer to the subject or move the main light farther away.

8:1 ratio—lit side meters 3 stops more than shadow side

3:1 ratio—lit side meters 1¹/₂ stops more than shadow side

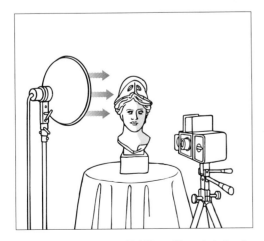

No fill light. *A single floodlight is positioned at about 45° above and to the left of the sculptured head (see drawing above). The side lighting on the statue brings out its rounded contours but leaves one side of the face darkly shadowed.*

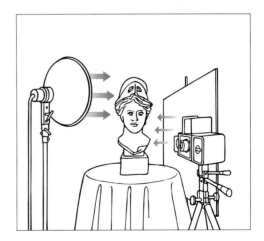

With fill light. *A flat piece of white matte cardboard has been placed to the right of the head, held in a clamp on a stand, and angled so that the light bounces back into the shadow areas on the cheek and chin to add fill light.*

SIMPLE PORTRAIT LIGHTING

open shade

You don't need a complicated lighting arrangement for portraits—or many other subjects. In fact, often the simpler the lighting, the better. Jill Krementz, who has made many portraits of writers (three are shown here), prefers to keep setups as simple as possible. "I think it is very important for the subject to be relaxed, even happy," she says. "For that reason I prefer not to use a tremendous amount of equipment. Lights, tripods, all the paraphernalia of the 'professional' has the effect of turning the session into a stilted portrait sitting."

Outdoors, **open shade** or an **overcast sky** provides a soft, even light *(photograph this page)*. The person is not lit by direct sunlight, but by light reflected from the ground, from clouds, or from nearby surfaces such as a wall. Open shade or overcast light is relatively bluish, so if you are shooting color film, a 1A (skylight) or 81A (light yellow) filter on the camera lens will warm the color of the light by removing excess blue.

Indoors, **window light** is a convenient source of light during the day *(photograph opposite, top)*. Contrast between lit and shaded areas will be very high if direct sunlight falls on the subject, so generally it is best to have the subject lit only by indirect light bouncing into the room. Even so, a single window can be a contrasty source of light, causing those parts of the subject facing away from the window to appear dark.

A **main light plus reflector fill** is the simplest setup if you want to arrange the lighting yourself *(photograph opposite, bottom)*. Bouncing the light into an umbrella reflector, rather than lighting the subject directly, softens the light, makes it easier to control, and may even eliminate the need for fill.

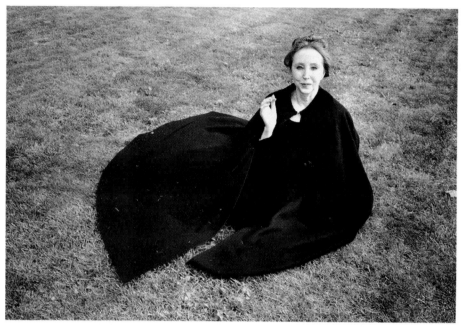

JILL KREMENTZ: *Anaïs Nin, Washington Square Park, New York City,* 1971

In open shade outdoors, a wall, tree, or other object blocks the direct rays of the sun, and the subject is lit only by softer, indirect light. The shade of trees in a city park diffused the light for a portrait of Anaïs Nin.

window light

Keep an eye on the amount of contrast between lit and shaded areas when you are photographing in window light, which can be quite contrasty. Light bouncing off the walls provided some fill light for this picture. A reflector opposite the window can bounce even more fill light onto the side of the subject away from the window. Here, Maya Angelou might be in the act of reciting one of her poems.

JILL KREMENTZ: *Maya Angelou, Wichita, Kansas,* 1975

main light plus fill

A single main light—photoflood or flash— bounced into an umbrella reflector, with reflector on the other side, is a simple lighting setup indoors. The position commonly used for a portrait main light is about 45° to one side and 45° above the subject. Philip Roth, author of Portnoy's Complaint, often writes about situations that are bitterly comic. His expression is suitably bemused.

JILL KREMENTZ: *Philip Roth, New York City,* 1972

MULTIPLE-LIGHT PORTRAIT SETUPS

Conventional **portrait lighting** is realistic but flattering. If you have ever gone to a commercial portrait studio to have your picture made, the photographer may have arranged the lights somewhat as in the diagrams shown here. These lighting setups model most faces in a pleasing manner and can be used to improve some features—for example, using broad lighting to widen a thin face.

A typical studio portrait setup uses a moderately long camera lens so that the subject can be placed at least 6 feet from the camera; this avoids the distortion that would be caused by having the camera too close to the subject. The subject's head is often positioned at a slight angle to the camera—turned just enough to hide one ear. The first photograph shows short or narrow lighting where the main light is on the side of the face away from the camera. This is the most common lighting, used with average oval faces as well as to thin down a too-round face.

The photograph opposite, second from right, shows a broad lighting setup where the side of the face turned toward the camera is illuminated by the main light. This type of lighting tends to widen the features, so it is used mainly with thin or narrow faces. The last setup shows butterfly lighting; the main light is placed high and in front of the face.

Photographers frequently use a softer, more diffused lighting for portraits than that shown here. A typical setup is a diffused main light placed close to the camera (such as a light bounced into an umbrella reflector) plus a fill light or reflector card. Such lighting is soft, attractive, and easy to use. However, when you don't want such even, shadowless light, you can use lights to create a more dramatic effect (*compare the photographs on pages 232 and 233*).

short lighting

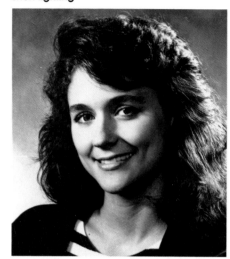

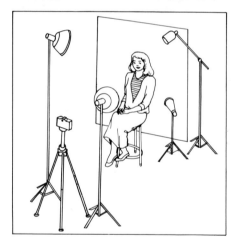

Short lighting *places the main light on the side of the face away from the camera. The next four photographs show the separate effect of each of the four lights in this setup. Photofloods were used here. Flash units can be used instead, but when you are learning lighting, the effects of different light positions are easier to judge with photofloods.*

short lighting: main light only

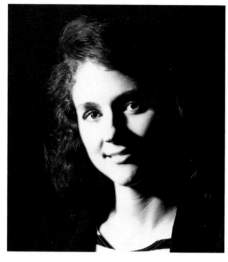

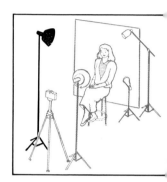

The main light *in a short lighting setup is on the side of the face away from the camera. Here a 500-watt photoflood is placed at a 45° angle at a distance of about 4 feet. The main light is positioned high, with the catchlight, the reflection of the light source in the eyes, at 11 or 1 o'clock.*

short lighting: fill light only

The fill light, *a diffused 500-watt photoflood, is close to the camera lens on the opposite side from the main light. Since it is farther away than the main light, it lightens but does not eliminate the shadows from the main light. Catchlights from the fill are usually spotted out in the final print.*

short lighting: accent light only

The accent or back light *(usually a spotlight) is placed high behind the subject, shining toward the camera but not into the lens. It rakes across the hair to emphasize texture and bring out sheen. Sometimes a second accent light places an edge highlight on hair or clothing.*

short lighting: background light only

The background light *helps separate the subject from the background. Here it is a small photoflood on a short stand placed behind the subject and to one side. It can be placed directly behind the subject if the fixture itself is not visible in the picture.*

broad lighting

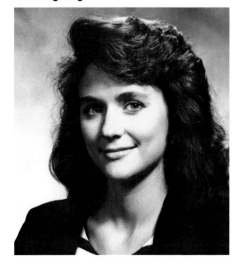

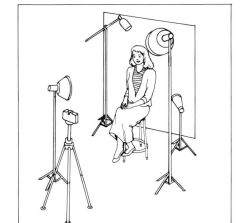

Broad lighting *places the main light on the side of the face toward the camera; again the main light is high so the catchlight is at 11 or 1 o'clock. The main light in this position may make the side of the head, often the ear, too bright. A "barn door" on the light (see page 261) will shade the ear.*

butterfly lighting

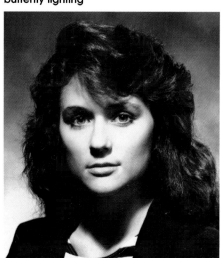

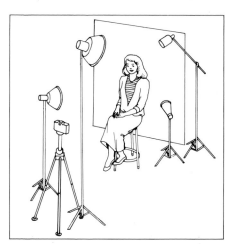

Butterfly lighting *is conventionally used as a glamour lighting. The main light is placed directly in front of the face, positioned high enough to create a symmetrical shadow under the nose but not so high that the upper lip or the eye sockets are excessively shadowed.*

LIGHTING TEXTURED OBJECTS

Lighting for a textured object depends on whether you want to emphasize texture. Every paint stroke shows in the photograph at right because the light is raking across the object at a low angle to the surface, creating shadows that underline every bump and ripple. The same principle can be put to work with any textured object, such as rocks, textured fabrics, or facial wrinkles. Simply aim a source of direct light so it skims across the surface, choose a time of day when the sun is at a low angle in relation to the object, or arrange the object so light strikes it from the desired direction.

Shadows must be seen if the texture is to be prominent, which is why side or back lighting is used when a pronounced texture is desired; the shadows cast will be visible from camera position. A light pointed at an object from the same direction as the lens, called **axis light,** may also produce shadows, but they will be just barely visible from camera position, if at all. Axis light tends to produce the least sense of texture *(see first photograph, page 250, and diagrams at right).* If you want to minimize textures in a portrait because your subject is self-conscious about facial wrinkles, place the main light close to the lens so the subject is in axis light.

side lighting

back lighting

axis lighting

Texture is emphasized in a photograph when light skims across the surface at a low angle and produces shadows that are visible from camera position. For most objects this requires side or back lighting. Axis lighting, which comes from the camera direction, produces the least texture.

SEBASTIAN MILITO: *Doorknob,* 1970

LIGHTING REFLECTIVE OBJECTS

The cornet (left) was so shiny that it reflected images of the camera and lights that the photographer needed to shoot it. To solve the problem, Fil Hunter isolated the horn inside a light tent (see drawing above). The horn and its background are lit evenly and diffusely with two spotlights shining through the thin material of the tent, which itself makes a pleasing and simple pattern of reflections in the horn's shiny surfaces. The camera, looking in through the opening in the tent from the shadows outside, stays out of the picture, as do other potentially distracting reflections.

Photographing objects with glossy surfaces can be like photographing a mirror. Highly polished materials such as metal, ceramic, or plastic can reflect every detail of their surroundings, a distracting trait when the surroundings include such irrelevant items as lights, photographer, and camera. Sometimes reflections work well in a photograph, making interesting patterns or giving information about the surface quality, but often it is necessary to eliminate at least some of them.

Reflections can be controlled. To some extent this can be done by moving the equipment or the object around until reflections are no longer distracting. If the reflections must be reduced still further, a polarizing filter will help if the reflecting surface is not metallic *(see page 86)*. Sometimes polarizing screens are used on the lights as well. You can also use a special dulling spray available in art supply stores. Use it sparingly to avoid giving the surface a flat, lifeless look. Another solution is to **tent** the object, that is, surround it partially or completely with plain surfaces like large sheets of translucent paper that are then lit by large, diffused lights, and whose reflections in the object are photographed *(diagram at left)*. You can also hang strips of paper just outside the picture area to place reflections where you want them. When checking a shiny object for reflections, through-the-lens viewing is best. Even a slight change in position can change the pattern of reflections.

FIL HUNTER: *Cornet,* 1982

LIGHTING TRANSLUCENT OBJECTS

Try lighting translucent or partially transparent objects from behind—glassware, ice, thin fabrics, leaves, and flowers, for example. The light can seem to shine from within, giving the object a depth and luminance that could not be achieved with flat frontal lighting *(see peppers, page 203)*. If you illuminate the background (as in the lighting setup below) instead of shining the light directly on the object, the lighting will be soft and diffused. Glassware is almost always lighted from behind since frontal illumination usually causes distracting reflections.

A row of crystal glasses (right) is softly lighted from the back by two large spotlights whose joined beams bounce off a sheet of seamless white paper, as shown above. The shadow that surrounds the bases of the glassware provides contrast with the brilliance of the reflected light and lends an air of cool elegance to the photograph.

ERICH HARTMANN: *Crystal Glassware*

LIGHTS AND OTHER LIGHTING EQUIPMENT

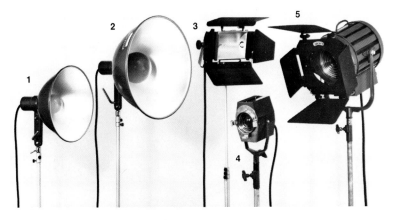

1 | 500-watt photoflood in 12-inch reflector
2 | 1,000-watt photoflood in 16-inch reflector
3 | 1,000-watt quartz floodlight with barn doors
4 | 200-watt spotlight
5 | 750-watt spotlight with barn doors

Types of light

Photofloods *have a tungsten filament, like a household bulb, but produce more light than a conventional bulb of the same wattage. The bulbs put out light of 3200K or 3400K color temperature for use with indoor color films. The bulbs have a relatively short life, and they put out an increasingly reddish light as they age.*

Quartz-halogen bulbs *contain a gas that prolongs the life of their tungsten filament. They (and their lamp housing fixtures) are much more expensive than photofloods, but they last much longer and maintain a constant color temperature over their life. Quartz bulbs are color balanced for indoor color films.*

Flash equipment *ranges from large studio units that power multiple heads to units small enough to clip onto or be built into a camera (see page 264). Flash is used with daylight color films.*

Depending on its housing, any of the above can be a **floodlight,** *which spreads its beam over a wide angle, or a* **spotlight,** *which has a lens in its housing that focuses the light into a concentrated beam. A spotlight often is adjustable so the light can be varied from very narrow to relatively wide.*

Reflectors and light-control devices

Bowl-shaped reflectors *are used with photo lamps to concentrate the light and point it toward the subject. Some bulbs have a metallic coating on the back of the bulb that eliminates the need for a separate reflector.*

A **snoot** *is a tube attached to the front of a lamp housing to narrow its beam. It is used to highlight specific areas.*

A **reflector flat** *is a piece of cardboard or other material used to bounce light into shadow areas (see pages 252–253).*

An **umbrella reflector** *is used on a main light to produce a wide, relatively diffused light. The light source is pointed away from the subject into the umbrella, which then bounces a broad beam of light onto the scene. Umbrella reflectors come in various surfaces such as silvered for maximum reflectivity, soft white for a more diffuse light, and gold to warm skin tones. See the lighting setup with umbrella on page 255, bottom.*

A **flag** *or* **gobo** *is a small panel usually mounted on a stand and positioned so it shades some part of the subject or shields the camera lens from light that could cause flare.*

Barn doors *are a pair (or two pairs, as shown in the photograph at left) of black panels that mount on the front of a light source. They can be folded at various angles in front of the light and like a flag are used to block part of the illumination from the subject or lens.*

Diffusers and filters

A **diffusion screen,** *often a translucent plastic, is placed in front of a light to soften it and make shadows less distinct. The material must be heat resistant if used with tungsten bulbs. The screen may clip onto a reflector or fit into a filter holder.*

A **lightbox** *or* **softbox** *completely encloses one or more lamps and produces a soft, even light. See the very large lightbox shown on page 240.*

A **tent** *is a translucent material that wraps around the subject instead of around the light source. Lights shine on the outside of the tent, which passes through a very diffused and even illumination. See the tent diagrammed on page 259.*

A **filter holder** *on the front of a reflector can accept filters or* **gels** *that change the color of the light, diffusion screens that soften it, or polarizing screens that can remove glare or reflections.*

Supports for lights and other devices

Light stands *hold a lamp, reflector, or other equipment in place. The basic model has three folding legs and a center section that can be raised or lowered.*

A **cross arm** *or* **boom** *attaches to a vertical stand to position a light at a distance from the stand. Some are counterbalanced to compensate for the weight of the light.*

An **umbrella mount** *attaches to a light stand and has a bracket for an umbrella reflector, plus another for the light that shines into the umbrella.*

Background paper *or* **seamless** *is not strictly speaking lighting equipment but is a common accessory in a studio setup. It is a heavy paper that comes in long rolls, 4 feet or wider, in various colors to provide a solid-toned, nonreflective backdrop that can be extended down a wall and across the floor or a table without a visible break. If the paper becomes soiled or wrinkled, fresh paper is unrolled and the old paper cut off. The roll is supported on two upright poles with a cross piece that runs through the hollow inner core of the roll.*

LIGHTING WITH FLASH

Flash units provide a convenient means of increasing the light, indoors or out. **Electronic flash,** sometimes called strobe, has mostly replaced the earlier flashbulb, except with some amateur cameras and for a few specialty uses. The light of an electronic flash unit comes from a tube filled with xenon or other inert gas, which glows brightly for an instant when subjected to a surge of electricity. A unit can be fired many thousands of times before the tube burns out, unlike a flashbulb, which fires only once. In either case, the flash has to be synchronized with the camera's shutter so that it fires when the shutter is fully open. Types of flash equipment and accessories are described on page 264.

Some electronic flash units control exposure automatically by regulating the length of the flash. After the flash is triggered, light striking the subject is reflected back to a light-sensitive cell, or sensor, mounted on the flash unit or in the camera. When enough light for correct exposure has been reflected back to the sensor, it cuts off the flash. The duration of the flash in an automatic unit may vary from as long as $\frac{1}{400}$ second to as short as $\frac{1}{50,000}$ second. See page 265 for how to use automatic flash.

Manually controlled electronic flash units put out a consistently bright flash for a fixed length of time—usually about $\frac{1}{1000}$ second. Exposure is controlled by the photographer adjusting the size of the lens aperture based on the distance from flash to subject; the greater the distance, the weaker the illumination that reaches the subject and the wider the aperture that is needed. See pages 266–267 for how and when to use flash manually.

A camera-mounted flash unit is convenient to carry and use. The light from the flash illuminates whatever is directly in front of the lens. But flash-on-camera pointed directly at the subject (or any single light that is positioned very close to the lens axis) creates a nearly shadowless light; the result is a flatness of modeling and lack of texture that may not be desirable for every subject. There is nothing necessarily wrong with this type of lighting—Weegee was a master of its use *(see photograph, opposite)*—but there are other positions for the flash *(see pages 268–269).*

The burst of light from electronic flash is very brief. Even $\frac{1}{1000}$ second, which is a relatively long flash duration, will show most moving subjects sharply, a great advantage in many situations *(see photograph, this page).* The disadvantage is that the flash is so brief that you can't see how the light affects the subject—for example, where the shadows will fall. Some studio flash units avoid this problem by the addition of a **modeling light,** a small tungsten light positioned close to or even built into the flash unit and used as an aid in positioning the flash. Even without a modeling light, however, you will eventually be able to predict the effects of various flash positions.

News photographers find flash particularly useful. They often have to work fast in an unfamiliar setting to record action while it is happening. Not only does flash stop the motion of a moving subject, but it prevents any blur caused by hand-holding the camera. The light is portable and predictable; unlike existing lighting, which may be too dim or otherwise unsuitable, flash delivers a measured and repeatable quantity of light anywhere the photographer takes it. Studio photographers also like flash because it stops motion, plus it has easily adjustable and consistent output and is cooler than heat-producing tungsten lights.

LOIS GREENFIELD: *Dancer David Parsons,* 1983

Flash stops motion: an understatement for the photograph above. The burst of light from a flash is so brief—usually faster than the fastest shutter speed on a camera—that it shows most moving subjects sharply. When Lois Greenfield photographed dancer David Parsons, she didn't want to photograph a choreographed moment from a particular dance. Instead, she set up an electronic flash and had him "hit shapes" so she could photograph the dancer's movement in the studio as a separate art. More work by Lois Greenfield appears on pages 32–33.

Weegee (Arthur Fellig) specialized in street scenes in New York City—here, a close encounter between denizens of two different worlds. "I am often asked," he wrote, "what kind of Candid Camera I use—there really is no such thing—it's the photographer who must be candid." He always was.

Weegee almost always used direct flash on camera, a harsh, two-dimensional lighting that reveals every detail with a head-on and merciless burst of light—a perfect illumination for his subject matter. This picture also shows that light rapidly gets dimmer as the distance from the light source to the subject increases. This is why the three people in the foreground are adequately exposed while the background is almost black; by the time the light from the flash reached the background, it was too dim to illuminate it.

WEEGEE: *The Critic,* 1943

Lighting with Flash: continued

Flash Equipment

In the early days of flash photography, taking pictures was something of a gamble. Flash powder, an early source of artificial light, was a dangerously explosive mixture that could easily burn or blind the photographer. Not until the 1930s did flash photography become simple and safe, with the mass production of flashbulbs. Today's electronic flash units provide a measured quantity of light in a convenient and easy-to-use form.

An **automatic flash** has a light-sensitive cell and electronic circuitry that determine the duration of the flash needed by measuring the light reflected back from the subject during the exposure. Some units can also be operated manually.

A **dedicated (or designated) flash** is always an automatic flash and is designed to be used with a particular camera. In automatic operation, the flash sets the camera's shutter to the correct speed for flash and activates a signal in the viewfinder when the flash is ready to fire. Do not use a flash unit dedicated for one camera on any other unless the manufacturer says they are compatible. The camera, flash, or both may be damaged.

To **synchronize** flash and shutter so that the flash fires while the shutter is open, an electrical connection is needed between them. Some cameras have a **hot shoe,** a bracket on top of the camera

that both attaches a suitable flash unit and has a built-in electrical connection to the shutter. Other cameras have a synchronization socket (a PC terminal) to which one end of an electrical wire, called a PC cord or **sync cord,** is connected; the other end of the cord attaches to the flash. Consult the manufacturer's instructions for the way to synchronize your flash and camera.

Electronic flash is synchronized to fire when the shutter is fully open because the flash reaches its peak brilliance almost instantly and has a very brief duration. A camera with a leaf shutter (for example, a view camera) can be used with electronic flash at any shutter speed when the camera is set for **X sync.** A camera with a focal-plane shutter (such as a single-lens reflex camera) may have to be used with electronic flash at relatively slow shutter speeds since the shutter on some models is fully open only at $\frac{1}{60}$ sec or slower. Many newer models, however, sync with flash at faster speeds.

Flashbulbs, which used to be quite common, are now seldom used. A flashbulb consumes its filaments in one powerful, brief flash, and then it must be replaced. Today, some flashbulbs are used for special purposes, but electronic flash has largely replaced them.

Electronic Flash

A **built-in flash** *is now part of many 35mm cameras.*

A **hot-shoe flash** *has a mounting foot that slips into the hot-shoe bracket on top of a camera. The hot shoe provides an electrical connection that fires the flash when the camera shutter is released. Some hot-shoe units, like the one shown here, have a head that tilts so the flash can be used on the camera but still provide indirect bounce light.*

A **handle-mount flash** *puts out more light than a typical hot-shoe unit. Its "potato masher" handle serves as a grip and can hold batteries to power the unit.*

Studio flash units *are powerful devices that fire one or more flash heads when triggered either by a cord connection or by a flash slave eye, a sensor that fires a unit when it detects a pulse of light from a primary unit that is synchronized with the camera. A modeling light, a small built-in tungsten light, helps to position the direction of the flash head.*

Using Automatic Flash

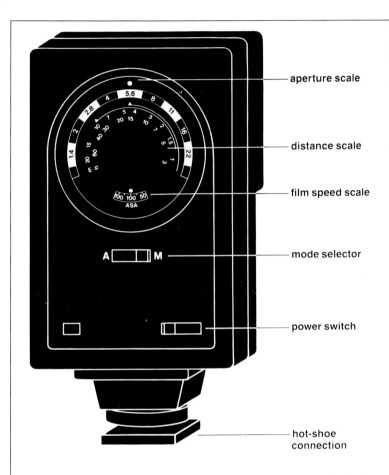

aperture scale

distance scale

film speed scale

mode selector

A [] M

power switch

hot-shoe
connection

Using an automatic flash on a camera is very simple, but models vary in design and operation, so check the manufacturer's instruction book before shooting. The more automatic the flash or camera, the fewer settings you have to adjust for ordinary automatic operation.

1 | *Set the camera shutter-speed to the correct speed for flash operation. Attach the flash to the camera's hot-shoe bracket and turn the flash on, or activate a unit built into the camera.*

2 | *Set the flash mode selector (if there is one) for automatic operation.*

3 | *Set your film speed into the flash calculator dial.*

4 | *On the calculator dial, find the correct lens aperture for flash operation (some flash units offer a choice of apertures). Set the lens aperture accordingly.*

5 | *Focus the camera. The calculator dial will show the range of distances (for example, 3–20 ft) within which the flash will automatically produce a correct exposure for an average subject. Shoot only after the flash signals that it is charged and ready to fire.*

An **automatic flash** controls the exposure for you. You have to do little more than attach the unit and make a few adjustments (not even that much with some models), then shoot *(see the box at left)*. Within the working range of distances, the flash adjusts itself automatically to produce the correct exposure for most subjects. You can spend more time with the subject and less with your equipment because you don't have to reset the lens aperture every time the distance changes from flash to subject.

When doesn't automatic flash work well? Mostly in the same scenes where you have to be careful with any exposure metering. If the subject does not fill enough of the center of the frame and is close to a much lighter background, such as a white wall, the subject may be underexposed and too dark. If the subject is against a much darker background, such as outdoors at night, it may be overexposed and too light. Many flash sensors, like the sensor in an averaging exposure meter, read the brightness of the scene overall and compute a correct overall exposure—but one that may be wrong for just the part of the scene that is of interest to you. See page 272 for troubleshooting flash problems in general and pages 266–267 for how to set flash exposures manually.

TERRY EILER: *Foxhounds at a Field Trial, Carroll County, Virginia,* 1978

Automatic flash works well as long as the main subject fills the central part of the frame. Adjust the exposure or use the flash on manual if the subject is relatively small against a much darker or lighter background.

Lighting with Flash: continued

Basic Flash Techniques

The easiest way to light a scene with flash is with direct flash on camera, a flash unit mounted on the camera and pointed directly at the subject *(shown this page)*. More likely than not, you will get an adequately exposed picture if you just follow the simple instructions that come with the unit. The trouble is that this type of lighting is rather bland; the subject looks two-dimensional with texture and volume flattened out by the shadowless, frontal lighting. The fault lies not with the flash but with its position so close to the camera lens.

You can get more varied and interesting lighting with the flash in other positions, as shown opposite. The goal is the same as with photofloods, to make the lighting resemble natural illumination. Since almost all natural lighting comes from above the subject, good results come from a flash held above the level of the subject or bounced in such a way that the light comes from above. Light that comes from one side is also effective and usually more appealing than light that falls straight on the subject from the direction of the camera.

While the main light should be dominant, natural lighting, whether indoors or outdoors, rarely strikes a subject exclusively from one direction. For example, shadows may be filled in by light bounced off the ground or other surfaces. You can do the same with flash. Bouncing the main light onto the subject from another surface will diffuse some of the light and create softer shadows *(see opposite, center and right)*. A diffusing screen over the flash head has a somewhat similar effect.

The duration of a flash burst is too short to see the effect of different positions while shooting. You have to aim the flash carefully so that the light doesn't create odd shadows or distracting reflections.

CLEM ALBERS: *Japanese Girl on Her Way to a Detention Camp*, 1942

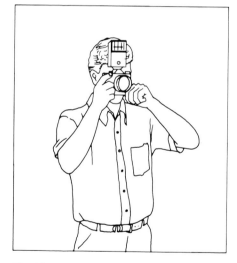

Direct flash on camera. *This is the simplest method, one that lets you move around and shoot quickly. But the light tends to be flat, producing few of the shadows that model the subject to suggest volume and texture.*

◀ *The rather harsh effect of direct flash on camera lends poignance to a photograph of a child sitting on a mountain of luggage. She is one of the Japanese Americans forcibly relocated away from the West Coast during World War II.*

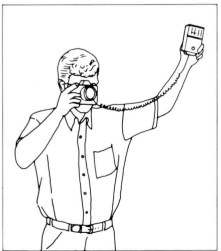

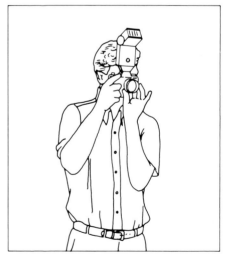

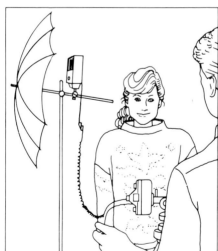

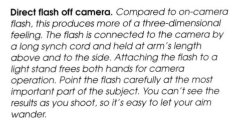

Direct flash off camera. *Compared to on-camera flash, this produces more of a three-dimensional feeling. The flash is connected to the camera by a long synch cord and held at arm's length above and to the side. Attaching the flash to a light stand frees both hands for camera operation. Point the flash carefully at the most important part of the subject. You can't see the results as you shoot, so it's easy to let your aim wander.*

Flash bounced from above. *Bounce light is softer and more natural-looking than direct flash. The flash can be left on the camera if the flash has a head that swivels upward. In a room with a relatively low ceiling, the flash can be pointed upward and bounced off the ceiling (preferably neutral in color if you are using color film). A bounce-flash accessory simplifies bounce use: a card or mini-umbrella clips above the flash head and the light bounces off that.*

Flash bounced from side. *For soft lighting, with good modeling of features, the light can be bounced onto the subject from a reflector or light-colored wall (as neutral as possible for color film). Pages 266–267 show how to set a bounce flash exposure manually. You can use a flash unit in automatic mode if it has a sensor that points at the subject even when the flash head is swiveled up or to one side for bounce lighting.*

Lighting with Flash: continued

Flash Plus Daylight

Flash can be used as a fill light outdoors. A sunny day is a pleasant time to photograph, but direct sunlight does not provide the most flattering light for portraits. Facing someone directly into the sun will light the face overall but often causes the person to squint. Turning someone away from the light can put too much of the face in dark shadow. Flash used as an addition to the basic exposure can open up dark shadows so they show detail *(photographs, this page).* It is better not to overpower the sunlight with the flash, but to add just enough fill so that the shadows are still somewhat darker than the highlights—for portraits, about one or two stops *(see box below).*

Color reversal film, in particular, benefits from using flash for fill light. The final transparency is made directly from the film in the camera, so it is not possible to lighten shadows by dodging them during printing.

In much the same way as it is used to lighten shadows on a partly shaded subject, flash can increase the light on a fully shaded subject that is against a brighter background *(opposite page, left).* Without the flash, the photographer could have gotten a good exposure for the brighter part of the scene or for the shaded part, but not for both. Flash was used to reduce the difference in brightness between the two areas.

Ordinarily, flash outdoors during the day is used simply to lighten shadows so they won't be overly dark. But you can also combine flash with existing light for more unusual results *(see opposite page, right, and page 273).*

sunlit subject without fill

Shadows can be very dark in a sunlit scene, so dark that film will not record details in both the shadows and in brightly lit areas (left, top). For close-ups, such as flowers in nature, or for portraits, fill light will lighten the shadows and preserve detail in them (left, bottom).

Flash is also useful to ▶ lighten a nearby, fully shaded subject if it is against a much lighter background. With the flash you can get a good exposure for both the shaded and the lighter areas (opposite, left).

Flash-Plus-Daylight Exposures

You can use flash outdoors during the day to decrease the contrast between shaded and brightly lit areas. A few automatic units calculate flash-plus-daylight exposures for you, but usually you adjust the flash and camera settings yourself.

1 | *Set both camera and flash to manual-exposure operation. Set your camera shutter speed to the correct speed to synchronize with flash. Focus on your subject.*

2 | *Meter the lighter part of the scene. Set your lens to the f-stop that combines with your shutter synchronization speed to produce a correct exposure for the existing light.*

For a natural-looking fill light, you need to adjust the light from the flash so that it is about one stop less than that on the scene overall. There are several ways to do this depending on the equipment you have.

If a flash has adjustable power settings

After doing steps 1 and 2 above, let's assume that your film speed is ISO 100, your basic exposure is $^1/_{60}$ sec at f/16, and the subject is 6 feet away (the distance can be read on the camera's lens barrel after focusing).

3 | *Set in the film speed (100 in this example) on the flash calculator dial.*

4 | *Line up on the dial the flash-to-subject distance (6 ft) with the camera f-stop (16).*

5 | *Note the power setting that the dial indicates (such as full power, $^1/_2$ power, $^1/_4$ power). This setting will make the shaded area as bright as the lit area, a rather flat-looking light. To get the flash-filled shadows one stop darker than sunlit areas, set the flash to the next lower power setting (for example, from full power to $^1/_2$ power).*

If a flash does not have adjustable power settings

Do steps 1, 2, and 3. Locate the f-stop (from step 2) on the flash calculator dial and find the distance that is opposite it. If you position the flash that distance from the subject, the light from the flash will equal the sunlight. To decrease the intensity of the light, drape one or two layers of white handkerchief over the flash head. Sometimes it's feasible to move the flash farther from the subject to decrease the amount of light reaching it (multiply the original distance by 1.4 for a one-stop difference between lit and shaded areas, multiply by 2 for a two-stop difference).

sunlit subject with flash fill

no flash—exposed for shaded foreground

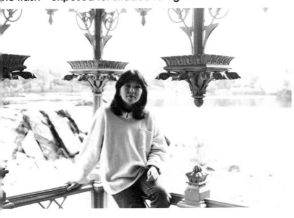

no flash—exposed for sunlit background

**exposed for sunlit background
plus flash to lighten shaded foreground**

RICHARD MISRACH: *Ocotillo,* 1975

Richard Misrach combined two exposures—one with existing light, the other with flash—to create this image of a desert plant in its own pool of light. First he made a 5-second exposure with the light existing at dusk after the sun had gone down but while there was still a glow in the sky. Then he "fried" the plant in the foreground with a flash exposure. If he had exposed just for the sky, the plant would have been only a silhouette against the sky. If he had exposed just with flash, the sky would have been black. The combined exposures record a scene that is visible only with a camera.

Lighting with Flash: continued
What Went Wrong?

Troubleshooting Flash Problems

Until you have used flash often, it is difficult to tell exactly what effect its light will have. Shadows and reflections are nonexistent until the flash goes off, and even then they disappear too fast to be seen. The film records them, though, sometimes with the results shown here. See also Troubleshooting Camera and Lens Problems (page 63), Exposure Problems (page 105), Negative Problems (page 133), and Print Problems (page 163).

Unwanted reflections

Cause: *Shooting at a shiny surface like glass that is parallel to the camera. Light from the flash reflected back into the lens (top photograph).*

Prevention: *When photographing scenes that include reflective shiny objects such as windows, mirrors, paneled walls, or metal surfaces, move the camera and/or the flash to one side so that you shoot or illuminate the scene at an angle to the reflecting surface (see second photograph). Eyeglasses can reflect the light; prevention is the same as for red eye, below.*

Red eye—a person's or animal's eyes appear red in a color picture.

Cause: *Light from the flash reflecting from the blood-rich retina inside the eye.*

Prevention: *Have the subject look away from the camera or move the flash away from the camera.*

Unwanted shadows

Cause: *Flash positioned off camera at an angle that caused shadows you didn't predict (see third photograph).*

Prevention: *Sighting along a line from flash to subject will help predict how shadows will be cast. A small tungsten light positioned close to the flash will also help; large studio flashes have such modeling lights built in for just this purpose.*

Only part of frame exposed

Cause: *Too fast a shutter speed with a camera that has a focal-plane shutter. The flash fired while the shutter was not fully open (bottom photograph).*

Prevention: *Set your shutter to the correct speed for flash synchronization. Most single-lens reflex cameras have focal-plane shutters that synchronize at $^1/_{60}$ sec (a few synchronize as fast as $^1/_{250}$ sec). Check manufacturer's instructions.*

Moving subject partly blurred

Cause: *In addition to the flash-lit image, strong existing light in the scene recorded an image that showed* the subject in motion. The part of the subject lit by the flash is sharp; other parts lit mainly by the existing light are blurred.

Prevention: *Dim the existing light or shoot when the subject isn't moving so much.*

Subject too dark

Cause: *Underexposure—too little light reached the film.*

Prevention: *If this happens once in a while, you may have made a simple error in flash or camera settings or shot before the flash ready light signaled that the unit was fully charged and ready to fire. In manual exposure, increase the exposure about a stop for scenes shot outdoors at night or in a large room like a gymnasium; the relatively dark surroundings absorb light that would otherwise bounce back to add to the exposure.*

If your flash pictures are frequently too dark, your flash is putting out less light than you (or the manufacturer) think it is. If your flash has a calculator dial, decrease the film speed ratings that you set into it. Every time you cut the film speed in half you increase the exposure by one stop. For example, if your film speed is ISO 100 but you set 50 into the calculator dial, your pictures will get one stop more exposure. If you use a guide number to calculate exposure manually, divide the guide number by 1.4 for every stop you want the exposure increased.

Subject too light

Cause: *Overexposure—too much light reached the film.*

Prevention: *Occasional overexposure may be due to an error in flash or camera settings. In manual exposure, close down the aperture about a stop when shooting in small, light-colored rooms to compensate for excess light bouncing back from walls and ceiling. If your flash pictures are usually overexposed, your flash is putting out more light than its nominal rating. Double the film speed or multiply the guide number by 1.4 for every stop you want exposure decreased.*

Part of scene exposed correctly, part too light or too dark

Cause: *Parts of the scene are at different distances from the flash. Parts that are farther away are darker than those that are close because the farther that light travels from the flash, the dimmer it becomes.*

Prevention: *Try to group important parts of the scene at about the same distance from the flash.*

unwanted reflection—shot head-on

no reflection—shot at an angle

unwanted shadows

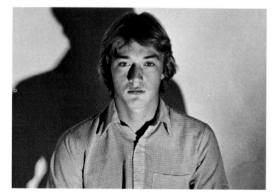

only part of frame exposed

USING LIGHTING

GREGORY HEISLER: *Low Riders, Santa Ana, California, 1979*

Gregory Heisler combined electronic flash and available light to make this glossy portrait of two people and their 1947 Fleetline Chevrolet. The picture was made in dim light at dusk. While the car slowly backed up, Heisler set off two battery-powered flash units, then left the shutter open for 2 sec more. The image is sharp where the car and riders were lit by the flash; the image is streaked and blurred where available light provided the illumination, as on the front fender and in the reflections in the chrome strips.

EADWEARD MUYBRIDGE: *Motion Study*, c. 1885. Digital paint job by MICHAEL KERBOW, 1990

Digital Imaging 12

◄ *High tech from the 19th century meets that of the 20th century. Eadweard Muybridge pioneered the study of motion with his multiple photographs of horses running, humans walking, birds flying—and here, a pig trotting (another Muybridge photo appears on page 381).*

Michael Kerbow appropriated the photograph to demonstrate some of the variations possible with digital imaging. He scanned the Muybridge photograph to convert it to digital form, then sent that to his computer. He digitally added coloring and patterns, and to retain a realistic modeling, allowed the tones of the underlying black-and-white images to show through.

The computers are coming! First, computers made number crunching easier. Then they revolutionized word processing and made themselves useful for graphics and music. Next on the list is photography. Digitizing a photograph (converting it into a numerical form that a computer can manipulate) makes it possible to use computer software to lighten or darken all or part of a picture, change or add colors, remove unwanted parts of an image, seamlessly combine two or more images, and do just about anything that can be done in a conventional wet darkroom—plus some things that can't.

Expensive, high-end digital processors have been employed for many years by publishers, advertisers, and other commercial users to prepare images for publication. Other systems produce prints of very high resolution. But the cost of these machines or even the rental of one for an hour or two is so high that they have been impractical for most individual photographers.

Now, **digital imaging** is within the reach of many more people through the use of personal computers with software like Adobe Photoshop. Digital imaging is increasingly becoming a part of the photographic process, because it speeds up and simplifies many image controls. Newspapers are phasing out their chemical darkrooms and training their staff photographers to use personal computers to select and prepare pictures for publication. Some artists see digital imaging as a useful tool, either to simplify the production of the kinds of photographs they already make or to generate images that are radically different.

This chapter will give you an introduction to digital imaging and show you how photographers of every kind are using it.

PICTURES INTO PIXELS

The pictures that you take with an ordinary camera and film are in **analog** form, that is, on a continuously variable scale, like the volume control on a stereo, which changes in smooth gradations from soft to loud. Similarly, the image on a film negative has a continuous scale of tones, with unbroken gradations from dark to light. To convert this analog image into **digital** form, so the computer can use it, the image is sampled at a series of positions to analyze and record the brightness and color at each point.

Each position at which the image is sampled is recorded as a **pixel** (short for picture element). The pixels that make up the image are arranged in a grid, like the squares on a sheet of graph paper. (You can see the pixels if you enlarge an image enough on your computer; *see illustration, opposite*.) The original analog image is recorded in digital form by assigning each square in the grid a set of numbers to designate its position, brightness, and color. Once the image is digitized, you can use image-editing software to select and change any group of pixels in order to add or change color, to lighten or darken, and so on. The computer does this by changing the numbers for each pixel.

The technical quality of a digital image is determined by the number of pixels and the amount of information each pixel holds. The greater the number of pixels (the **dots per inch**, or dpi) at the time an image is digitized, the greater the amount of detail that is recorded. Also, the more information (the **bit depth** or number of bits) per pixel, the smoother the gradation from one pixel to another, because each pixel will be able to render a greater selection of possible colors and tones. Other factors also affect quality, such as how much the image is enlarged, but in general, the more data in the computer's file for that image, the better the final image.

Unfortunately, you can get too much of a good thing. As the total number of pixels and the amount of information stored for each of them increases, the computer has to process and store more data about the picture. If the file for the image is extremely large, this can cause problems by greatly increasing the time the computer takes to execute each command or by increasing to an unwieldy size the amount of computer storage space needed. Tradeoffs may have to be made between the quality desired and the size of the file that can be conveniently handled by your particular computer.

Bits and Bytes

Computers record information in binary form, using combinations of the digits one (1) and zero (0) to form all other numbers. A bit is the smallest unit of information, consisting of either a one or a zero. A byte is a sequence of bits, usually eight.

```
0   0   1   0   1   0   0   0
⌣
bit
```
byte

The size of an image file is usually described by the number of bytes that it contains.

bit	The smallest unit of digital information
byte	8 bits
kilobyte	1,000 bytes
megabyte	1,000,000 bytes
gigabyte	1,000,000,000 bytes

(The numbers are rounded off. A binary kilobyte, for example, actually contains 1,024 bytes.)

The bit depth or amount of information recorded ▶ in each pixel is as important as the number of pixels (dots) per inch. The greater the number of bits per pixel, the more colors and tones that are available for the image.

bits per pixel	number of colors		
1	2	The image can have only two tones, black or white.	
8	256	The image has available 256 black, white, and gray tones (enough for excellent black-and-white rendition) or 256 colors (enough for a limited color representation).	
24	16,777,216	The image can display more than 16 million colors and produce a digital image that has smooth gradations and full tonality, and is comparable to a conventional color film photograph.	

To put an image into digital form, the image area is first divided into a grid containing many tiny segments called pixels. The location, brightness, and color of each pixel are recorded as a series of numbers that are then saved by the computer for later use. The greater the number of pixels per inch (dots per inch, or dpi), the more detail the image shows. This is something like the connection between ordinary film grain and image detail: the finer the film grain, the greater the detail that the film can record.

File Edit Mode Image Filter Select Window

PHO/Pixels (RGB, 16:1)

192K

To see pixels on your computer's monitor, simply select a part of the image and enlarge it. If you are using Adobe Photoshop, for example:

Open a picture file.

Select the Zoom tool (shown in the tool palette as a magnifying glass) by clicking on it.

Place the magnifying glass on a selected area of the image. Click on the image to see it at various enlargements.

Double-click on the magnifying glass in the tool palette to return the image to the original size.

Each square is a pixel. Notice that each contains a solid tone; the color or brightness may vary from pixel to pixel, but not within a pixel.

DIGITAL IMAGING: AN OVERVIEW

To understand digital imaging, think of the steps you take in conventional photography: exposure, development, and printing. With digital imaging, instead of ordinary exposure and development, you **capture** an image by recording a scene with an electronic camera or, more often, by using a scanner to read the image from a conventional negative, slide, or print into the computer. In either case, the image is **digitized,** that is, recorded in a numerical form that is usable by the computer. You can then direct the computer to electronically **edit** the image, using software commands to change the image either subtly or drastically. The computer can **display** the current version of the image on a screen or print it onto paper or film. The computer can also electronically **store** or **transmit** the image.

There are many advantages to electronic imaging.

For image enhancement: Digitizing an image lets you use image-editing software to make changes you might ordinarily make in a darkroom, such as lightening or darkening selected areas. However, using a computer to make such changes is often faster and easier. It makes it much simpler to combine two or more images or to perform other complex manipulations that are difficult and tedious to do by conventional means.

For publishing: Newspapers and magazines were among the first to use digital imaging because of the ease with which it lets them integrate pictures directly with type in layouts. Older methods of preparing pages for the press are rapidly becoming obsolete.

For storage and retrieval: Because images are stored electronically as digital data, a database can be created within which many images can be stored, indexed, searched for, and quickly retrieved. Image files can be duplicated without loss of quality and so stored indefinitely. Electronic media, like film and prints, eventually deteriorate. But unlike film and prints, electronic files can be copied without loss, so a second- or third-generation file will be identical to the original.

For transmission: You can use ordinary telephone lines to send a digital image around the world, in some cases faster than you can carry a print to the office next door. This is vital to newspapers and anyone else who wants the fastest possible access to an image.

For the environment: Digital imaging minimizes the use of processing chemicals that can cause pollution, which is important now and will be even more so in the future. Toxic materials are produced in the manufacture of electronic equipment, but relatively little is produced by the end user.

Some costs accompany all the advantages of digital imaging. There is a time investment in learning how to use equipment and software skillfully. There is also a financial investment: the better the quality you want, the more money you have to spend on your scanner, printer, and other equipment. However, as with most electronic technologies, prices tend to come down at the same time that performance improves.

Equipment Needed for Digital Imaging

What kind of equipment will you need in order to work with digital imaging on a personal computer? There are two major systems or platforms: one is based on Apple Macintosh computers, the other on IBM computers or their clones. Software and peripheral devices like printers are often designed for a specific system and may not work with others, so be sure before buying anything that it will operate with your system.

You won't need to purchase every part of the system yourself. If you are taking a class, equipment may be made available to you. Computer service bureaus in many towns (often in stores that used to do only photocopying or small printing jobs) give you access to computers, scanners, printers, and other devices. Computer technology changes fast, so it is useful to have someone to help you who is already familiar with computers. More about equipment is on pages 280–281.

For **input,** *you'll need some means of entering the image into the computer in digital form. You can work from negatives, slides, or prints by using a* **scanner.** *Kodak's Photo CD puts your pictures onto a compact disc that can be read into the computer by using a CD drive compatible with Photo CD.*

A **computer** *can manipulate an image, once the image is in digital form. The more powerful the computer, the faster it operates. For black-and-white imaging, popular choices are either a Macintosh computer in the Mac II family or better, or an IBM-type computer capable of running Windows-based software. For color imaging, the more powerful and faster models are preferred.*

With an 8-bit **video display card** *installed in the computer, you can work readily in black and white or in color if 256 colors are enough. You'll need a card with 24 bits to get the 16 million colors required for exacting color control.*

RAM *(random-access memory) holds files temporarily while you are actually working on them. Your computer should have at least 4 megabytes of RAM if you work with black-and-white images, 8 megabytes of RAM if you want to work with color. 20 megabytes is even better because it will speed up the processing.*

Storage *can be a* **hard drive** *built into the computer. Or it can be removable* **external storage,** *for example, a SyQuest cartridge disk drive or an optical disk drive. Removable storage not only stores files outside your computer; it also lets you transport them, such as to a printer at another location.*

A **monitor** *displays the image while you are working on it. A 13-inch or larger high-resolution monitor is preferred. You'll need a color monitor for color work. A* **keyboard** *and* **mouse** *enter your commands into the computer.*

Image-editing software *like Adobe Photoshop or Aldus PhotoStyler contains the editing commands that change the image.*

To **output** *your results into hardcopy, a* **printer** *transfers the image to paper. A* **film recorder** *produces a positive transparency or a negative.*

Capture. *If you start with conventional negatives, slides, or prints, a scanner can convert the images into the digital form that a computer can use.*

Display. *When you want to see your image on more than just the computer's monitor, you can make a print on paper or print the image onto film to make a positive transparency or negative.*

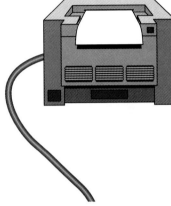

A computer *is the core of a digital imaging system, driving the monitor, printer, or other devices to which it is attached.*

Display. *A computer monitor shows the image that you are working on and also displays various software editing tools and other options.*

Transmission. *You can send an image to a printer, another computer, or other devices, if your computer is cabled to them.*

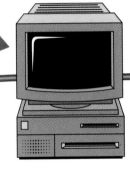

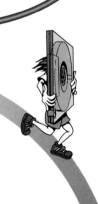

Storage. *A hard drive stores image files within the computer itself.*

Capture. *There are several types of filmless electronic cameras that can be used instead of a conventional camera and film. A digital camera records an image directly in digital form.*

Transmission. *A modem can transmit data, including digitized images, over phone lines to another computer.*

Storage/transmission. *External storage devices, such as a removable cartridge disk drive, let you store more image files than can be stored on your computer's internal hard drive. They can also transport a file, for example to computers and printers at other locations.*

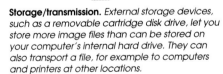

GETTING THE PICTURE:
CAPTURE, STORAGE, DISPLAY, TRANSMISSION

Capture: Putting your picture into the computer. To capture an image, you have to get it into a digital form that a computer can utilize for editing, storage, display, or transmission.

Electronic cameras do not use film. Instead, they use electronic circuitry to capture an image. There are two basic types. **Digital cameras** record an image

digital camera

directly in digital form. **Still video cameras** record an analog (continuous-tone) image onto a small floppy disk, similar to a computer floppy. The image is converted to digital form by a computer accessory called a frame grabber. Analog images can also be captured and converted to digital from video cameras (camcorders), videocassettes, and video disks.

The advantage of filmless electronic cameras is that you don't need to develop film before you can see a picture. Images are usable as soon as you shoot them, something that news photographers value when they are working on a fast-breaking story at a distant location. You can view and edit images immediately, then electronically transmit them to your editor as soon as you can get to a telephone. Some commercial photographers make use of this instant feedback to show an image to the client and get approval on the spot.

However, film is still the most common starting point for digital imaging because it is capable of recording much more information than most electronic cameras. A single 35mm film negative can record the equivalent of about 15 million pixels of information, many times more than the typical electronic camera of comparable size. That makes sharpness, color quality, and tonal range much better when you start with film.

A **hybrid system** combines conventional film technology with electronic imaging. A **scanner** converts a film negative, transparency, or print to a digital image that is then transferred to the computer. With Kodak's Photo CD system, for example, images are scanned onto a compact disc. A compatible CD drive reads the digitized images into the computer.

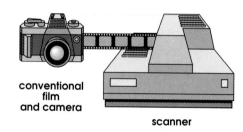

conventional film and camera

scanner

An image can be scanned at different levels of detail or dots per inch. Usually you have to balance factors such as the size of the final print you want to make (the more you enlarge an image, the more dots per inch you'll need for good quality) versus the capability of your computer to handle large image files.

Storage: Keeping an image for later use. A **hard disk** in the computer is useful for storing pictures when you are not working on them—that is, if you have enough storage space on the disk.

Floppy disks, commonly used to store electronic data like word processing files, are useful for relatively small image files, such as for black-and-white images or low-resolution color images. High-resolution image files, however, can occupy so much space that saving one on even high-capacity 1.4-megabyte floppies requires too many disks for practical storage. Compression software helps *(see page 281).*

A removable **cartridge disk drive,** such as a SyQuest or Bernoulli drive, lets you expand your storage, plus take data to another location, for example, to a

removable cartridge disk drive

computer service bureau for printing. With a capacity of 40 megabytes or more, you can store much more on this type of disk than you can on a floppy.

Optical disks are economical for the amount of data they hold. A CD-ROM disc (Compact Disc Read-Only Memory) is like an audio CD: data is written onto it

optical disk

once; thereafter it can be read any number of times, but not rewritten. Rewritable optical devices permit the user to read, write, or erase files. Stock photographers and agencies are increasingly using CD-ROM to publish catalogs of their stock work, and in some cases to supply the work itself to users. Kodak's Photo CD is a type of optical disk.

Digital tape is inexpensive, but mostly used for storage of massive amounts of data that won't need much accessing.

Compression software makes the size of image files more manageable by squeezing them into more compact form, which reduces the amount of space needed for storage and the time needed for transmission. The image is decompressed to its original size for editing or printing. A file can be compressed to 1/100 of its original size or even less, although the more you compress an image, the more likely it is that irregularities, called artifacts, will appear when the image is decompressed.

Display: Showing what you've got. A **monitor** displays the image while you are working on it. A monitor can display different numbers of pixels, depending on the

computer and monitor

size of the monitor, the fineness of its resolution, and the design of the **video display card,** a device inside the computer that controls the monitor. A monitor and video display card combination that displays more pixels (dots per inch) and more information per pixel is better because it is capable of showing more image detail. But even then, if you are working with a large image file, you won't be able to see as much detail on the monitor as you will see in a high-quality printout.

Printers can output to paper. Another type of printer, a **film recorder,** produces a positive transparency or a negative that

printer

you can view or use to print as you would conventional film. Digital imaging is increasingly being used by photographers

to make and control color separations for offset printing.

There are many levels of quality in printers, from electrostatic printers like the ones used for color photocopies to the finest dye sublimation printers that match the look of conventional photographic color prints. Your output can look very much like a silver-based print, or you can produce an image that looks more like the pixel-based electronic medium from which it came.

Size of enlargement will affect image detail, just as in conventional enlarging. You may get pixellation (visible pixels) if a digital image is printed at a size much larger than the one for which it was scanned.

Transmission: Getting it there. There are several ways to transfer a digital image from one device to another, such as from a computer to a printer. You can **cable** one machine to the other. If you can't connect by cable, you can use what is humorously called SneakerNet: save the file in some portable way—for example, on a cartridge disk drive—then walk it to the service bureau or wherever the printer is.

modem

Modems, transmission devices connected to phone lines or a communications satellite, are now regularly used to send news photographs and other photographs that have to get someplace in a hurry. Some computers, especially at large organizations, are connected to **networks,** groups of computers that can share information, including image files.

EDITING A DIGITAL IMAGE

Digital imaging has been called a "darkroom on steroids." Almost any results that you can get in a conventional darkroom, and some that you can't, can now be achieved with the help of a personal computer. Software editing programs display a variety of tools (some are described below) that let you select an area and change its characteristics, such as its size, position, density, contrast, color, or sharpness.

Using conventional darkroom techniques to execute major changes can require making a copy negative or other intermediate stage, which often results in loss of image quality. But with digital

imaging you do not lose quality from one generation to the next, because each generation is merely a set of numbers in the computer's memory. In effect, you start fresh at any stage, so a second-, third-, or fourth-generation image is just as good as a first-generation one.

Furthermore, once you have completed a complex set of manipulations—even dodging and burning in a conventional print can involve several exposures of different times—you don't have to repeat the manipulations every time you want a print. Once the digital description of the final version is saved, every copy you make thereafter will be the same.

Two routes present themselves. You can use digital imaging to perform typical darkroom procedures, like changing contrast or lightening and darkening. For this purpose, you use the computer to reproduce conventional procedures to enhance an image, not to radically change it *(see opposite)*.

Or you can use digital imaging to combine photographs, add color, posterize, draw, and so on. In effect, you are inventing a new image with qualities that are never permanently fixed, because you can always change them. Both routes have their uses; the following pages show more about them.

The commands used to manipulate an image are part of image-editing software like Adobe Photoshop (version 2.5 is shown). They appear on screen as small symbols called icons, displayed in the toolbox (the series of small boxes seen here at the right of the screen). They also appear as word commands, such as Blur, Sharpen, and Stylize, that can be reached from the pull-down menus across the top of the screen.

You use the computer's mouse to move the screen pointer to an icon within the tool palette, then click the mouse to activate the tool. You can adjust the effect of many of the tools. For example, the Brushes Palette (seen here at the bottom of the screen) lets you adjust tool characteristics such as size or paint opacity.

One of the most important commands is called Undo (not shown here). Undo cancels your last command, returning the image to its previous state. This lets you try an effect, then undo it to see how it looked before. You can choose Undo again to reinstate the command.

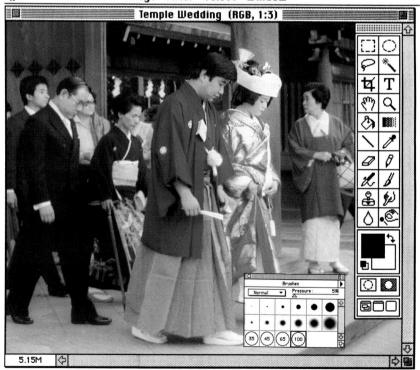

Various editing tools in the toolbox allows you to use the mouse to paint, draw, color, lighten, or darken parts of the image. After selecting a tool, click (or click and drag) the mouse to use the tool at the part of the image that you want to change.

 The Paint Bucket *fills a selected area with a color.*

 The Paintbrush *applies a color to any area it is dragged over.*

 The Pencil *also colors any area it touches, but with a harder edge.*

 The Airbrush *lays down a diffused spray of color.*

 The Rubber Stamp *paints with a copy of some other part of the picture, in effect cloning a part of the image.*

 Dodge/Burn *tools, like dodging and burning tools in a conventional darkroom, lighten or darken part of an image.*

Changes that you might typically make in a wet darkroom, such as lightening or darkening parts of a print or changing contrast, can also be done with digital imaging. The pull-down menus across the top of the screen offer access to many of these commands. For example, the Image menu (shown at right) contains the item Adjust, which offers a set of submenus. Here, Color Balance is being selected.

Changing the brightness or contrast. *Selecting Adjust from the Image menu and then choosing Brightness/Contrast from the submenu brings up a dialog box (shown here below the image) that lets you lighten or darken the image or change the contrast.*

Use the mouse to click on and slide the triangle along the horizontal Brightness line; the results will be somewhat like changing the exposure time during printing. Sliding the Contrast triangle increases or decreases the contrast somewhat like changing the contrast grade of paper during ordinary printing.

The Preview button lets you see the results on screen as you make changes. You can alter selected parts of the image as well as making changes overall (see page 284).

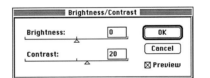

Changing brightness and contrast more exactly. *There are other, more precise, controls of brightness and contrast in the Image/Adjust menu. The Levels dialog box (below) displays the brightness values of the pixels in the image in a graph called a histogram. The slider bars let you adjust the brightness or contrast separately for dark, middle-gray, or light pixels (shadows, mid-tones, or highlights). For example, you can lighten just the midtones without making the highlights overly light and losing detail in them.*

The Curves dialog box also lets you adjust brightness and contrast, but even more precisely, at any point along the image's gray scale.

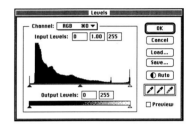

Changing the color balance. *One way to adjust the color balance is to select Adjust from the Image menu and Variations from the submenu. The Variations dialog box (shown at right) displays the current image, plus a ringaround of possible color balance changes.*

The Variations dialog box also lets you view and make changes in contrast or saturation. (Saturation refers to the purity of a color. Saturated red is an intense, brilliant red. A less saturated red is mixed with other colors and is duller and grayer.) You can make changes overall, in selected areas, or separately in dark areas, midtones, or highlights.

More exact changes can be made with the Color Balance and Hue/Saturation commands, also in the Image/Adjust menu.

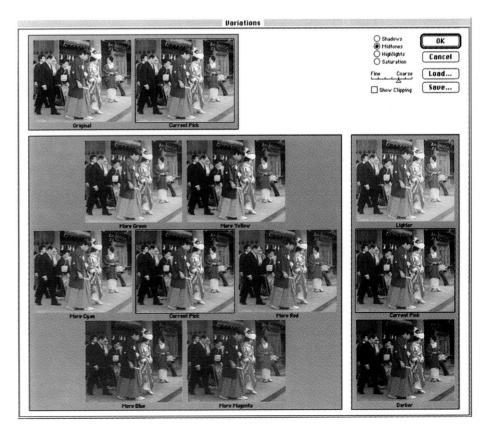

Editing a Digital Image: continued
Changing a Selected Area

Suppose that instead of wanting to change an image overall, you want to change only part of it. Perhaps you want to darken an overly bright sky or lighten someone's shadowed face. You can do this in a conventional darkroom by burning in or dodging. Digital imaging lets you extend those techniques so that you can, for example, lighten just the eye sockets or darken a meandering, irregular shape. You can go even further and completely change the color of an area, sharpen it, blur it, duplicate it, relocate it, or take it out altogether.

The first step is to learn how to use one or more of the editing tools that select an area. You use the tools to select an area of any size, as small as one pixel, and then direct the software to change it.

Selection tools, such as these in Photoshop, let you select portions of the picture for editing. Click on a tool to activate it, then drag the mouse to outline a part of the image. The selected area will be surrounded by a line of moving dashes.

 The Rectangular Marquee *tool captures rectangular areas.*

 The Elliptical Marquee *tool captures rounded areas.*

 The Lasso *lets you draw shapes freehand.*

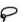 **The Magic Wand** *doesn't select by dragging over areas. Click it at any part of the picture, and it selects all connected areas that have a similar color and brightness.*

 The Pen *tool (in the pull-down menu Window/Show Paths) clicks or drags to select irregular shapes precisely.*

The Magic Wand selects connected areas that are similar in color and brightness to the area that the wand touches. Here, clicking the tool on the body of an apple caused it to select all similar connected tones in the image. The Magic Wand can be customized to select a wider or narrower range of values.

You can also draw the area to be selected. The Lasso tool operates by clicking down and dragging the mouse. The tip of the Lasso onscreen will draw a line following the motion of the mouse. Various methods let you refine any selected area by adding to or subtracting from it.

Once you have selected an area, you can make a mask that lets you alter the selected area or its surroundings in a variety of ways. Quick Mask (part of the toolbox) lets you view both the mask and the rest of the image. Here, the selected area consists of the two apples (but not the label on one of the apples). The rest of the image, including the label, are protected from change. They are displayed on screen with a color overlay.

Retouching. *You can use the Rubber Stamp tool (the rubber stamp icon in the tool box) to retouch defects or areas you want to change by painting over them with another part of the image. The Brushes dialog box lets you choose options such as the size of the area to be changed with each stroke.*

Here a damaged historical photograph is being restored by painting over the scratch showing on the man's coat with a duplicate of the image from another part of his coat. Once you have retouched an image to your satisfaction, you can save it and use it for all future printing. In conventional photography, you would ordinarily have to spot such an area with dyes on each print you made.

Cloning part of an image. *You can make a duplicate of a shape or object and paste it back into the image. Often you'll need to soften the edges of the duplicate object slightly, or it will look too obviously pasted in. Feathering blurs the edges of a selection to make a gradual transition to the new surrounding area. The same technique is useful if you composite a part of one photograph into another (for example, see page 291 top).*

Here a red-hot bolt was selected, feathered, copied, and pasted behind its original. Other changes were made such as darkening the cloned bolt slightly and changing some of its markings.

Editing a Digital Image: continued
Enhancing Reality

STEPHEN JOHNSON: *Wind Generators, Altamont Pass, California*, 1985

REMY POINOT: *Running shoe advertisement, Paris*, 1992

The effects of digital imaging aren't necessarily evident. It can be used to combine objects in a realistic manner, to remove glare, to add a highlight to a model's eyes, and for other enhancements. The image still looks realistic, and in this sense, "reality" is anything that looks like an unaltered photograph made with conventional camera and film.

We are used to the notion that a blurred image shows that the subject moved during the exposure, so digital imaging was used *(opposite page)* to add blur to an otherwise sharp photograph to give the illusion of motion. We are used to size differences between near and far objects, so *(above right)* two photographs were combined to create a scene that utilized those differences. Photographs are commonly spotted to remove small defects; digital imaging can be used for that purpose instead of a brush and spotting dyes *(above left)*.

▲ For an ad for a running shoe, Remy Poinot created a "foot like a mouse can see it, from underneath, very big." For the background, he used a photograph of a group of runners at the Place de la Concorde in Paris. Instead of digging up the street to get a shot of the shoe from mouse level, he made a studio shot of the shoe, with his model standing on a chair. The images were then combined digitally. "It's a picture totally impossible to take in a normal camera," he says, "but it doesn't appear composited."

◄ During prepress work, photographs are prepared for printing. Stephen Johnson was the designer and editor of the book The Great Central Valley: California's Heartland, as well as one of the photographers. He used image-editing software for color correction, to remove dust specks, to correct cropping and alignment, and for other work that is often done by the printer. One advantage of digital imaging in book production is the control it gives photographers over how their work looks. "After a while," Johnson says, "you get tired of what other people do to your photographs."

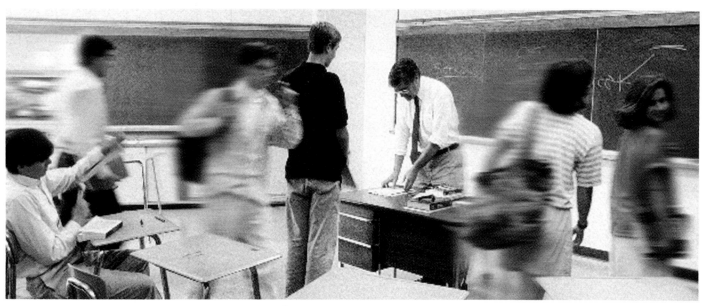

To create a feeling of activity in a photograph for a school brochure, graphic artist Paul Kazmercyk added blur to some of the figures.

GABRIEL AMADEUS COONEY: *Schoolroom.* Digital manipulation by PAUL KAZMERCYK, 1992

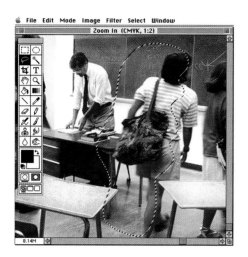

Kazmercyk began by using the Lasso tool (in Adobe Photoshop software) to select the area he wanted to blur.

To avoid a hard edge between the area he was going to modify and its surroundings, he feathered the edges. Choosing Feather from the Select menu brought up a dialog box that let him limit the extent of the feathering to 36 pixels.

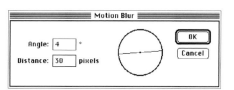

He then selected Blur from the Filter menu and Motion Blur from the submenu. He specified a blur that would look realistic based on the student's position by designating a blurring angle of 4° and a distance of 30 pixels.

The result is a blur that could have occurred if the student had moved during the actual exposure and blurred the original film. Kazmercyk then repeated the procedure on several other figures.

Editing a Digital Image: continued
Going Beyond Reality

If you want to step beyond reality, you can use digital imaging to create an image that obviously didn't come that way straight out of the camera. Many software programs are available that let you add (or remove) colors, textures, and shapes to make an image that merges photography with drawing or painting.

Keith Hampton, a computer graphic artist, often ▶ *uses digital imaging to manipulate photographs. "In the beginning," Hampton says, "computer art was exactly that—art that looked like it was created on a computer." But, he says, "Today's computer art doesn't necessarily look like it's been generated on a computer." You can create a work that looks realistically photographic or one that looks manipulated.*

For this sample of an Elvis album cover, he says, "I wanted to show how a simple photo could be manipulated to get a completely new and interesting look." Starting from a straight photo, he used a scanner to get the image in digital form. He used editing software to filter the image in different ways, then layered the resulting textures to give the look of an aged and tattered poster.

PHOTOGRAPHER UNKNOWN: *Elvis. Illustration by* KEITH HAMPTON, 1990

In the years before digital imaging, photographer Douglas Kirkland often felt that the camera was an incomplete tool, delivering only part of what he saw and imagined. "How frequently I have wanted to make the sky bluer, the grass greener." He feels that computers are the next step for him, making it possible to realize anything he can imagine.

Even though computers give you the ability to do anything at all to a photograph, Kirkland prefers to use that ability carefully. He believes that an overly manipulated image can become weak if it completely loses its connection to straight photography. He added posterized color to his portrait of physicist Stephen Hawking, but otherwise retained the elements in the original photograph.

DOUGLAS KIRKLAND: *Stephen Hawking, 1983. Digital enhancement,* 1993

Mark Jasin often likes to start with a photograph that is relatively simple and uncluttered, then dynamically alter it. For a portrait of poet Kate Cohen, Jasin began by scanning in a black-and-white image. He used drawing software to add colors and textures, creating a vividly graphic image. Several layers were placed "behind" the image to build a background, and layers of semi-transparent colors were added to the skin, hair, and clothing. Over the image he added opaque lines and shapes in bright primary colors as accents.

MARK JASIN: *Kate Cohen*

PHOTOGRAPHER AT WORK: MERGING PHOTOGRAPHY AND ILLUSTRATION

John Lund started working with digital imaging as a way to add interest to his advertising work. He had already been experimenting with manipulations, such as sandwiching transparencies, but when he saw Adobe Photoshop in operation, he realized that image-editing software would be much more flexible to use. Learning how to use the software took a while: "I got an assignment," he recalls, "immediately got into trouble, and needed help quick." Fortunately, a group of computer consultants had just moved into his building, so he had help at hand.

Two years later, he had become one of the first commercial photographers to fully integrate digital imaging into their work. He expanded from doing just photography to being a combination photographer, illustrator, retoucher, and imaging service bureau. "Art directors are only beginning to realize what digital imaging can do," he says. He believes it is inevitable that they will use it more and more.

Lund has added the creation of stock images to his other work. "Traditionally," he says, "stock images were leftovers from another shoot. Then photographers began to shoot specifically for stock use. Now, with digital imaging, you can create stock images of any kind." See the flying $100 bills *(right)*.

"The computer," Lund says, "provides an almost incomprehensible creative potential by removing the barrier between imagination and execution. But it has some pitfalls: with every image, there are so many possibilities that you can spend a lot of time sitting at the computer just trying things out. There comes a point where you have to have the discipline to say, 'Enough.' "

JOHN LUND: *Flight of the Greenbacks,* 1991

John Lund and staff, 1993

▲
John Lund works with his stock agency to create images for sale to advertisers, publishers, and others in need of ready-made imagery. This picture of money flying away has sold so well that the agency asked him to do the same thing with the yen, the pound, and other currencies, so that they can increase sales of it world-wide.

◀ *Lund uses three computers and a staff of three for image editing, plus regular studio assistants. That's not a digitized clone sitting with Lund. It's his twin brother, Bill.*

AL KEUNING: *Buffalo.* JOHN LUND: *Computers.* BRUCE McALLISTER: *Landscape.* JOHN LUND: *Composite image for Hewlett-Packard, 1993.*

Hewlett-Packard wanted an illustration for an advertising campaign featuring their "wide range" of computers. Instead of taking a crew onto the range to make the shot, Lund composited two stock photos—a prairie scene and a separate shot of buffalo. He added an assortment of computers shot in his studio to produce an image that looks as if it was done on location.

JOHN LUND: *Composite image for SuperMac Technology, 1991*

A computer products company wanted Lund to make an image with drama and vivid colors to be used in their corporate and product literature. He began with a trip to the zoo to make some shots of a Rhode Island Red on color film (right, top). Lund shot a sunset sky (right, bottom) from outside his studio door. The two basic photos were scanned to convert them to digital form, then read into the computer. Lund uses Adobe

Photoshop for his image editing. He used the Lasso tool to outline the rooster so he could remove it from its background. He used cloning tools to remove an imperfection in the rooster's "cheek." In the Image/Adjust menu, Hue/Saturation controls changed the ridge around the eye to blue and the iris of the eye to green, and intensified the colors of the comb, wattle, and beak. He gave the rooster a new set

of feathers, by pasting a single feather in various positions on the neck.

The color and contrast of the sky were enhanced, and the rooster was superimposed and blended at the edges. Finally, a color taken from the sky was used to highlight the beak. The completed composite image was printed onto a 4 × 5 color transparency.

USING DIGITAL IMAGING

PETER CAMPUS: *burning,* 1992

ESTHER PARADA: *The Monroe Doctrine: Theme and Variations, Part One,* 1987

▲

Peter Campus uses the camera to record straightforward images of rocks, leaves, branches, and other natural objects. Then he uses the computer to place them against clearly artificial patterned backgrounds. "I was trying to find the spirit of the most humble objects," he says, "without glorifying or romanticising them."

Campus found that the computer gave him "control over every nook and cranny of a picture. You can do almost anything to change the look of a picture, even change the shape of (its) grain. This is not photography. It's something else, although at this point it's still not clear just what."

Esther Parada creates complex digital images that she likens to visual jazz. She thinks of the computer, she says, as something like "an electronic loom strung with a matrix image, into which I can weave other material—in harmony, syncopation, or raucous counterpoint." In the past she had employed various techniques to manipulate images, such as photomechanical halftone and mezzotint screens, or repeated photocopying to produce image degeneration. "The computer," she says, "has enormously facilitated this process of fragmentation, enlargement, and layering of images."

In The Monroe Doctrine, Theme and Variations, Part One, Parada deliberately made the overall image and some of the text difficult or impossible to read at close range. The pixels themselves become dominant up close. "Likewise," she says, "we become absorbed with the day-to-day details or 'current events' of our lives and fail to see—or are discouraged from seeing—the historical pattern of which they are a part."

▶

BARBARA KASTEN: *Over the Guadalupe, San Jose, California,* 1992

Barbara Kasten's photographs have often played with space, shape, and light. She has created large constructions in her studio that she photographed, and she has worked at architectural and natural sites. She freely changes the visual space of these settings by tilting the camera, using intensely colored lights, and sometimes positioning mirrors that reflect other parts of the scene. "I want to change a viewer's perception of the space, and these things do that by disorienting you, especially with an architectural subject, which you expect to be upright and realistic. They reorganize your preconceived idea of what the space should look like."

Digital imaging has literally added a new dimension to her work. For Over the Guadalupe four photographs were montaged on the computer, then painted by computerized jet spray on 25 × 7.5 ft seamless canvas.

Mike Mandel and Larry Sultan ▶ took the idea of pixels to an architectural conclusion. For a tile mosaic at the entrance to a community swimming pool, they started with two photographs of children jumping into the water. They converted the images to six tones: black, white, and four tones of gray. Then these six tones were matched to six shades of one-inch-square ceramic tiles. The tiles were assembled on the building to re-create the images, with each tile the equivalent of a pixel in the digitized images.

MIKE MANDEL and LARRY SULTAN: *deFremery Pool, Oakland, California,* 1993. Ceramic tile photo mosaic

Using Digital Imaging

GERALD BYBEE: *Dalmatian and Cats,* 1990. *Digital retouching by* RAPHAËLE DIGITAL TRANSPARENCIES

To create an ad for a company making contact lenses, whose competitors were alleged to be copycats, Gerald Bybee made hundreds of individual photographs of two dogs and two cats. Two white cats provided the cat talent. Two dalmatians were used to provide enough different shapes of spots.

The work of getting the spots onto the cats and the cats assembled into a realistic grouping was done by a company that specializes in digital retouching. The job was so complex that it took three weeks to fine-tune every detail, including refining the edges of the transferred spots because dog hair is coarser than cat fur.

It was Bybee's suggestion to combine the images digitally. The art director liked that better than the suggestions of other photographers, which included painting spots on cats or drugging them so they could all be photographed at the same time.

DIGITAL IMAGING ENCOUNTERS ETHICS

MICHAEL KIENITZ: *Nicaragua,* 1982

During a survey of 1,600 magazine and newspaper editors, communications professor Shiela Reaves presented the two photographs above. She asked: "This photo was edited to eliminate the person in the background so that he wouldn't be distracting. Do you agree with the computer-editing change?" About half of the magazine editors found the change acceptable, compared to only 10% of the newspaper editors who did.

As it becomes easier and easier to seamlessly alter photographs, will more and more of them be changed, incorporating everything from a little enhancement to all-out fabrication? Will anyone still believe that the camera does not lie? Should anyone ever have believed that?

Few people would object to the transformation of the cats shown in the advertising photograph opposite, even if the cats didn't really look that way and the advertiser didn't explain how the image was made. Advertisers often take considerable leeway with their illustrations. We even expect some exaggeration from them, as long as they don't outright misrepresent their product. But would the dog and cats have been acceptable without explanation as a photo accompanying a news story, for instance, on genetic research?

Now that it is much easier to make extensive changes in a photograph, and much harder—sometimes impossible—to detect them, a host of questions have arisen. Some of them are discussed below; the answers are still being hotly debated.

Photojournalists usually follow fairly strict rules concerning photographic alterations. Generally, they agree that it's acceptable to make changes such as dodging or burning in to lighten or darken parts of an image. However, it's not considered proper at many newspapers to use digital imaging to, say, remove a telephone pole that detracts from an otherwise good shot or, even worse, to insert something that wasn't originally there.

According to John Long, past president of the National Press Photographers Association, "There is a tacit agreement between us and the reader that says this set of conventions within a picture represents reality, and this set doesn't. Using a fill flash or a strobe in a picture has become accepted by society as a valid way of conveying a real picture. But going in with a brush, and taking something out, has not."

As the use of digital imaging increases (which it is sure to do), will photography lose its reputation for accurate representation of reality? For the February 1982 cover of *National Geographic,* digital imaging was used to move a pyramid a little so the photograph would fit the magazine's vertical format better. When some readers objected to this, the change was defended as being merely "retroactive repositioning," no different than if the photographer had simply changed position before taking the shot. Or was it different?

What should we call the image of the dog and cats opposite? Can you refer to it as a photograph, or do you need to add on some qualifiers, like "photo composite" or "computer-generated image"? Certainly the picture didn't come that way straight out of the camera, although as one photographer pointed out, "The notion of what constitutes a camera is broadening."

Working photographers are also concerned about financial matters. How can they protect their rights when images are easily accessible electronically? How can they collect reprint fees for use of their work when images can easily be electronically scanned, altered so as not to be identifiable, and then incorporated in a publication? Is it ever acceptable to appropriate someone else's image and use it without paying for it?

There are more questions than answers on these issues. The discussions will be going on for a long time.

PHOTOGRAPHER AT WORK: A NEWSPAPER PHOTOGRAPHER USES DIGITAL IMAGING

When you walk into the newsroom at the *Sacramento Bee,* the major newspaper in California's capital city, you see a computer terminal on every desk. Some have two or three. Not only do reporters write their stories on computers, but photographers edit their pictures on them, too. The *Bee* commits considerable time and resources to news photography, which is why Lois Bernstein wanted to work there. She has been taking pictures since first grade, and years later when someone suggested photography as a career, it was a revelation: "Do something for your job that you like!"

Bernstein, like most newspaper photographers, gets a variety of assignments. Spot news is something that happens unexpectedly, like an accident or fire. General news is something for which you can plan ahead, like a visit from the president. With either type of news photograph, Bernstein says, "You are not manipulating the event, but you have to see what is around you, what the story is about, and how to show it."

She also is given illustration assignments, which are pictures to accompany articles on food, fashion, health, or similar subjects. For example, for a food article on pearl onions she made a "fashion" picture of the onions strung into a necklace as if they were pearls. When she covers a sports event, she likes reaction pictures even better than general action ones. "I love faces," she says. It is fortunate that she does, because newspaper photographers frequently make portraits. "Often you are doing a story on something after the fact," she says, "like someone who won the lottery and gave all his money away. You have to find some way to make an interesting picture of them." And when

there is nothing else to do, she goes cruising, looking for feature pictures or "enterprise photos," as they are sometimes called—pictures that stand alone and are not hooked to any particular story.

Bernstein has been a photographer for the *Bee* for five years, and during that time she has seen the paper increasingly take advantage of digital imaging and related technologies. Photos are now electronically transmitted by the paper's own photographers in the field, as well as by news services. The *Bee* used to have seven darkroom enlargers. Now there are two; they have been replaced by computers, scanners, modems, and other electronic devices.

Bernstein and other photographers at the *Bee* shoot mostly color negative film, develop it in an automated processor, then scan it into the computer. Although it is possible to make extensive changes using editing software, that is only done for illustration photos, which are credited accordingly. "Guidelines are simple," says Mitch Toll, head of the paper's digital imaging facility. "If it wasn't OK to do in the darkroom, don't do it on the computer. For news stories that means: Don't take things out. Don't put things in."

"But," he says, "do pull as much out of the negative as you can. Digital imaging allows much better precision than you can get in a wet darkroom. You can work with very small areas to dodge, burn, or change the color balance. You can't do that with an enlarger."

Bernstein agrees with Toll's suggestion that photographers should try digital imaging. "Photographers have always had to combine mechanical, technical, and artistic skills," he says. "This is just another kind of enlarger."

LOIS BERNSTEIN: *In the Shadow of the Show,* 1988

Lois Bernstein was working on a story about minor league baseball when she noticed the shadow cast by one of the players in the dugout. She waited until he turned to the side, then waited for an expression she liked. Making an interesting photograph when nothing much is happening is one of a newspaper photographer's basic skills.

JAY MATHER: *Lois Bernstein, Covering a Fire Near Grass Valley, California,* 1988

LOIS BERNSTEIN: *Lost in the War,* 1991

Lance Corporal Thomas A. Jenkins was one of the Marines killed by "friendly fire" during the war with Iraq. Jenkins had come from Coulterville, California, a small town near enough to interest the readers of the Sacramento Bee. Lois Bernstein was sent to get a photograph.

"This was a news story," says Bernstein, "but the news had happened thousands of miles away. And I needed to make a picture in this town to go with the story." The parents wouldn't see anyone from the local media, although they did have a close friend come out to act as a spokesman and had pinned up a picture of their son. Bernstein went back that day several times to the parents' house. "I just didn't feel like I had anything. So near the end of the day I went back to the house again."

This time, the spokesman was talking to a reporter. The shadow of the spokesman, the flag, and the picture all lined up in the late afternoon light. "It told it all," she says. "A kid who was there, but wasn't there. When I shoot a picture like this, I'm proud of it for a long time."

What Bernstein would never do is arrange such a picture or change it digitally. "I never set up a news picture," she says, "even though some other photographers do so all the time. I am known for not doing that—which is good, because it means no one questions the integrity of my pictures."

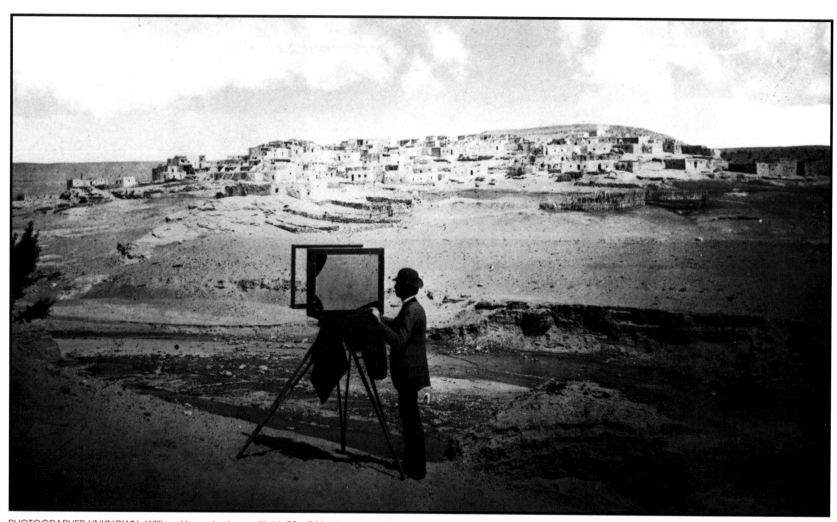

PHOTOGRAPHER UNKNOWN: *William Henry Jackson with his 20 × 24-inch camera photographing Zuni Pueblo near Laguna, New Mexico,* c. 1877

View Camera 13

In today's world of small, hand-held cameras that are fast working and convenient to use, why would a photographer use a bulky, heavy, slow-working **view camera**—a camera that has few or no automatic features, that must almost always be used with a tripod, that shows you an image that is upside down and backward and so dim that you need to put a dark cloth over the camera and your head to see it? The answer is that the view camera does some jobs so well that it is worth the trouble of using it.

A view camera's **movements** give you an extraordinary amount of control over the image. The camera's back (film plane) and front (lens board) can be independently moved in a number of directions: up, down, or sideways, tilted forward or back, swiveled to either side. These movements can change the area of a scene recorded on film, the most sharply focused plane, the depth of field, and the shape of the subject itself.

The **large film size** that can be used is also an advantage. The most common size is 4 × 5 inches; 5 × 7 inches, 8 × 10 inches, and sometimes larger sizes are also used. (Comparable metric sizes range from 9 × 12 cm to 18 × 24 cm and larger.) While modern small-camera films (1 × 1$^{1}/_{2}$ inches is the size of 35mm film) can make excellent enlargements, the greatest image clarity and detail and the least grain are produced by a contact print or a moderate enlargement from a large-size negative.

A few of the most expensive cameras have electronic features such as film-plane metering or even full digital imaging, but most models do not. Nevertheless, a view camera is still the camera of choice when image control is vital, as in architectural or product work. Some photographers use a view camera in all but the fastest-moving situations because they feel that its benefits—maximum image control and detail—more than compensate for any disadvantages.

◄ *In the early days of photography, a practical method of enlarging an image had not yet been devised. So if you wanted a big print, you made a big negative. Opposite: William Henry Jackson's 20 × 24-inch view camera was a standard size used for making scenic views. Jackson had to transport not only the view camera but as many 20 × 24-inch glass plates as he needed to make all the photographs on a trip. (For more about early travel photography, see pages 376–377.)*

View Camera Movements: continued

Shift

controls zeroed

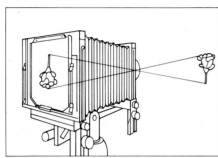

back-shift left or front-shift right

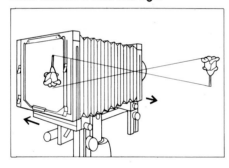

back-shift right or front-shift left

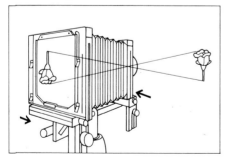

In the diagrams above, the position of the cube on the negative is moved by shifting the camera's front or its back to the side. In the top diagram, the controls are zeroed and the image is in the center of the viewing screen. In the center diagram, the object has been moved to the right side of the viewing screen (left side of the actual photograph) by moving the camera-back to the left or the lens to the right. To move the object to the other side of the picture, move the back to the right or the lens to the left (bottom diagram).

Shift, a sideways movement of either the front or the back of the camera, is the same as rise and fall except the movement takes place from side to side. If you were to lay the camera on its side and raise or drop the back, you would produce the same effect as back-shift.

The reason that rise and fall are the same as shift is that neither changes the angle between the planes of film, lens, and subject. Raise, lower, or shift the back of the camera, and the film is still squarely facing the lens; the only difference is that a different part of the film is now directly behind the lens.

Since shift is simply a sideways version of rise and fall, the results are similar. Back movement to the left moves the subject to the left; back movement to the right moves it to the right. Left or right lens movements have just the opposite results. Image shape does not change with back-shift, but it does change slightly with front-shift.

Again in common with rise and fall, shift of the lens affects the spatial relationship of objects because the lens views them from a different point. The examples at right illustrate these movements, with the reference cube included for comparison.

Remember that the cubes are shown here right side up as they would appear in the final prints. On the ground glass the image is inverted as shown in the diagrams at left.

Shift is a sideways movement. Shift of the front or back changes the position of the image in the frame. Shift of the front also affects the position of foreground and background objects relative to each other. ▶

reference cube

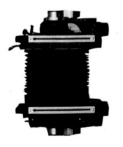

Shift, like rise and fall, has no perceptible effect on the shape of an object. Compare the reference cube with the four cubes to the right of it. While the cubes move back and forth on the film, they continue to look very much the same.

back-shift left **back-shift right** **front-shift left** **front-shift right**

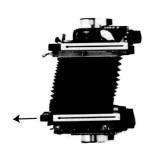

A camera equipped with a back that can move the film from side to side, as well as up and down, can place an object wherever desired on a sheet of film. Here a shift of the camera-back to the left moves the cube to the left on the film.

A rightward movement of the camera-back moves the image to the right. Comparison of this picture with the previous one reveals that there has been no change in the shape of either the cube or the post in front of it. Their spatial relationship has remained unchanged also, despite the movement of the image on the film.

Moving the lens to the left moves the image on the film to the right. It also changes the relationship of post to cube. Since the lens actually moves to the left, it views the two objects from a slightly different position, and so one object appears to have moved slightly with respect to the other. Check the position of the post against the vertical lines on the cube in this picture and the next to confirm this change.

A rightward movement of the lens, as above, (1) moves the image to the left and (2) changes the relationships in space between objects. To summarize: if you want to move the image on the film but otherwise change nothing, raise, lower, or shift the back. If you want to move the image and also change the spatial relationship of objects, raise, lower, or shift the lens.

View Camera Movements: continued

Tilt

controls zeroed

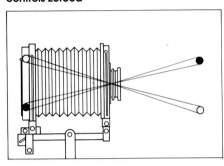

back-tilt of camera-back

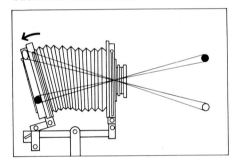

forward-tilt of camera-back

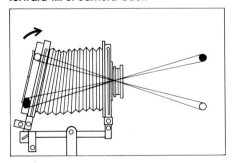

The diagrams above show how the shape of objects can be changed by tilting the camera-back. In the top diagram, two objects of identical size, placed the same distance from the camera, are being photographed. When the camera controls are zeroed, the objects appear the same size on the viewing screen. In the center diagram, the camera-back has been tilted back. Now when the image leaves the lens, it has to travel farther to reach the top of the viewing screen than it does to reach the bottom. As the light rays travel, they spread apart, increasing the size of the object on the top of the viewing screen (the bottom of the actual photograph). To increase the size of an object on the bottom of the viewing screen, tilt the camera-back forward (bottom diagram).

The preceding pages show that rise, fall, and shift have little or no effect on the shape of an object being photographed because they do not change the angular relationship of the planes of film, lens, and object. But what happens with **tilt, an angled forward or backward movement** of either the camera-front or camera-back? That depends on whether you tilt the front or back of the camera.

Tilting the back of the camera changes the shape of the object considerably and changes the focus somewhat. Tilting the front of the camera changes the focus significantly without changing the shape of the object.

To understand why this happens, look again at the reference cube. In that picture the bottom of the film sheet was the same distance from the lens as the top of the film sheet. As a result, light rays coming from the lens to the top and the bottom of the film traveled the same distance, and the top back edge and the bottom front edge of the cube are the same size in the photograph. But change those distances by tilting the camera-back, and the sizes change. The rule is: the farther the image travels inside the camera, the larger it gets. Since images appear upside down on film, tilting the top of the camera-back to the rear will make the bottom of an object bigger in the photograph *(diagrams, left)*.

A tilt of the camera-front does not change distances inside the camera and thus does not affect image size or shape, but it does affect focus by altering the lens's focal plane. Tilting the lens will bring the focal plane more nearly into parallel with one cube face or the other and thereby will improve the focus on that face and worsen it on the other.

Tilt is an angled forward or backward movement. Tilt of the back mostly affects the shape of an object, and so helps to control convergence (the apparent angling of parallel lines toward each other in a photograph). Tilt of the front mostly affects the plane of focus, and so helps to control depth of field.

reference cube

▶

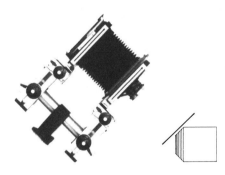

Checking the reference cube again, note that the 45° angle of view has produced an image that falls off in both size and sharpness at an equal rate on both the top and the front faces. As a result the two faces are exactly the same size and shape. Note also that the vertical lines on the front face, which are actually parallel on the cube, do not appear parallel in the photograph, but converge (come closer together) toward the bottom.

back-tilt of the camera-back

forward-tilt of the camera-back

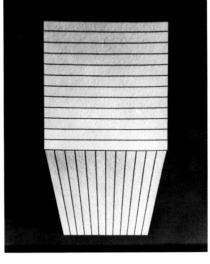

back-tilt of the camera-front

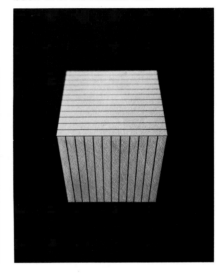

forward-tilt of the camera-front

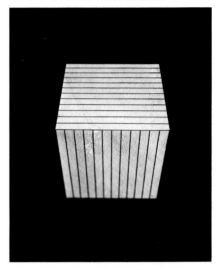

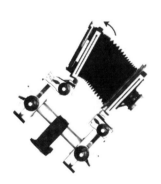

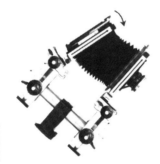

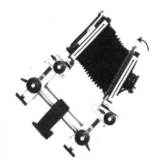

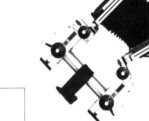

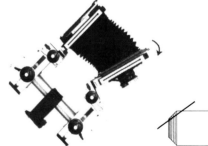

When the back of the camera is tilted so that the top of the film is farther away from the lens than in the reference shot, this movement enlarges the bottom of the cube and tends to square up its front face, bringing its lines more nearly into parallel. At the same time, this tilt has moved the bottom of the film closer to the lens than it was in the reference shot, shrinking the top back edge of the cube so that it converges more than before.

If the back of the camera is tilted the other way, so that the top of the film is forward and the bottom is moved away from the lens, the top of the cube tends to square up and the front bottom converges more. Squaring up one face of the cube results in increasing fuzziness toward the far edge of the squared face. In this case the back edge of the top face is affected. In the picture at left the bottom edge of the front face is affected.

When the lens is tilted, there is no change in the distance from lens to film; thus there is no change in the shape of the cube. However, there is a distinct change in focus. Here the lens has been tipped backward. This brings its focal plane more nearly parallel to the front face of the cube, pulling all of it into sharp focus. The top of the cube, however, is now more blurred than in the reference shot.

If the lens is tilted forward, the top of the cube becomes sharp and the front more blurred. The focus control that lens-tilt gives can be put to good use when combined with back-tilt. Look again at the two back-tilt shots at left; their squared—and blurry—sides could have been made much sharper by tilting the lens to improve their overall focus.

View Camera Movements: continued

Swing

controls zeroed

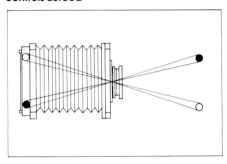

left-swing of camera-back

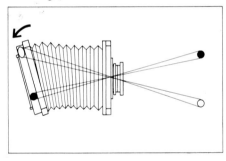

right-swing of camera-back

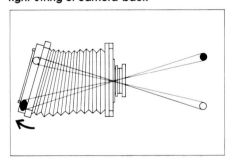

Swinging the camera-back changes the shape of objects by changing the angle between the camera-back and the lens. This top view of a camera shows why. As with back-tilt, if part of an image has to travel farther to reach the camera-back, it will increase in size. In the top diagram, both objects are the same size and the camera's controls are zeroed. In the center diagram, the image on the left side of the viewing screen (the right side of the actual photograph) has been increased in size by swinging the camera-back to the left. To change the size of the image on the right side of the viewing screen, swing the camera-back to the right (bottom diagram).

Swing, an angled left or right movement of either the front or the back of the camera, has different effects depending on whether the front or back is swung.

Swinging the back of the camera, like tilting the back, moves one part of the film closer to the lens while moving another part farther away. This produces changes of shape in the image plus some change in focus *(diagrams, left)*.

Swinging the front of the camera swivels the lens to the left or right and as a result skews the focal plane of the lens to one side or the other. The general effect is to create a sharply defined zone of focus that travels at an angle across an object. A close look at the two right-hand cubes on the opposite page reveals this. There is a narrow diagonal path of sharp focus traveling across the top of each cube and running down one side of the front.

The practical applications of the four camera movements are virtually endless. For example, assume that the reference cube is a house with a large garden in front of it. Raising the back of the camera *(page 303, first picture)* will raise the image on the film and show more of the garden. Or assume that you wish to increase the apparent height of the house. Tilting the back of the camera toward the front *(page 307, second picture)* is one way to produce that effect. The following pages show how swings, tilts, rises, and shifts can be applied in real situations to solve specific photographic problems.

Swing is an angled left or right movement. Swing of the back mostly affects the shape of an object, and so helps to control convergence. Swing of the front mostly affects the plane of focus, and so helps to control depth of field. ▶

reference cube

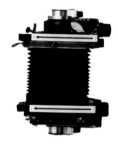

Comparing the reference cube to the pictures at right shows the distortions in shape that can be made by changing the angle of film to lens. Compare the cube with the first two pictures on its right. If you didn't understand the process by which such changes can be made, it would be hard to know that these swing shots—or the two back-tilt shots on the previous page—are all of the same object, taken from the same spot with the same camera and lens.

left-swing of the camera-back

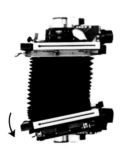

This movement of the camera-back swings the left side of the film away from the lens and the right side closer to it, making the left side of the cube smaller and the right side larger. (Remember, the image is inverted on the ground glass.) This effect is the same as tilt, but sideways instead of up and down.

right-swing of the camera-back

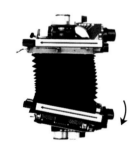

Here the right side of the film is swung away from the lens and the left side closer to it. The results are the opposite of those in the previous picture. In both of them it can be seen that there is a falling off of sharpness on the "enlarged" edges of the cube. This can be corrected by swinging the lens or by closing the aperture a few stops to increase depth of field.

left-swing of the camera-front

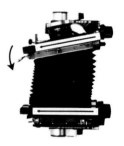

Since it is the lens that is being swung, and not the film, there is no change in the cube's shape. However, the position of the focal plane has been radically altered. In the reference shot it was parallel to the near edge of the cube, and that edge was sharp from one end to the other. Here the focus is skewed. Its plane cuts through the cube, on a course diagonally across the top and down the left side of the cube's face.

right-swing of the camera-front

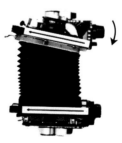

Here is the same phenomenon as in the previous picture, except that the plane of sharp focus cuts the cube along its right side instead of its left. This selectivity of focus, particularly when tilt and swing of the lens are combined, can move the focal plane around very precisely to sharpen certain objects and throw others out of focus. For a good example of this, see page 311.

CONTROLLING THE PLANE OF FOCUS

The photograph above is partly out of focus because the camera-back (line aa') and lens plane (line bb') are parallel to each other but not to the subject plane (line cc').

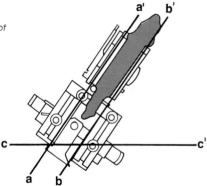

Tilting the front of the camera forward so that the lens plane is more nearly parallel to the subject plane brings the entire page into sharp focus.

Instead of a regular accordion bellows on the camera, the diagrams show a loose bag bellows that is useful when the front and rear camera standards must be brought close together.

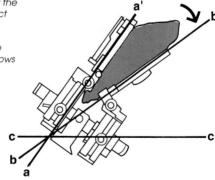

Controlling the plane of focus—the part of a scene that is most sharply focused—is easy with a view camera. Not only can you see on the ground-glass viewing screen exactly where the plane of focus is, but you can adjust its position by tilting or swinging the front of the camera and so the lens.

With a camera that does not have swings and tilts, the lens plane (the front of the camera) is always parallel to the film plane (the back of the camera), and the plane of focus is parallel to both. You increase the depth of field (the area near the plane of focus that will also be sharp) by stopping down the lens aperture.

The disadvantage of using a camera without swings and tilts becomes evident when photographing something that is not parallel to the camera, like the rare book above. You must angle the camera down at the book. If you focus on the part of the book close to the camera, the top of the book is blurred and vice versa. A compromise focus on the middle of the page might not give enough depth of field even if you stopped the lens all the way down.

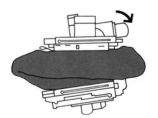

With the camera's back and front in zero position, a close-up shot of some spilled beans requires that the lens be stopped down for both the foreground beans and those in the jar to be perfectly sharp. This also brings the other jars into focus—which the photographer did not want.

A simple swing of the camera-front to the right brings the lens plane parallel to the receding pile of beans—all the way from the right foreground to those in the tipped-over jar. Now the photographer can focus on the beans and open up the lens to its maximum of f/5.6, which throws the other jars out of focus and directs attention to the beans.

A view camera can get around this problem. The plane of the subject that is most nearly parallel to the plane of the lens will be the sharpest in the picture. As shown above, you can increase the sharpness of the book page by tilting the camera-front forward so that the lens is more nearly parallel to the page. If the page is still not completely sharp, stopping down the lens aperture will increase the depth of field so that more of the page will be sharp.

Furthermore, if you adjust a view camera so that the planes of film, lens, and subject all meet at a common point, the subject plane will be completely sharp, even if the plane of the subject is not parallel to the plane of the lens and if the lens is opened to its widest aperture. This phenomenon (named the Scheimpflug rule, after its discoverer) is diagrammed on the opposite page. Fortunately, you don't have to calculate the hypothetical meeting point of the planes (you will be

able to see on the ground glass when the image is sharp), but it does explain why a plane can be sharp even if it is not parallel to the lens.

If you want only part of the picture to be sharp, this too is adjustable with a view camera. By swinging or tilting the camera-front, the plane of focus can be angled across the picture, as in the photographs above of the spilled beans.

CONTROLLING PERSPECTIVE

A view camera is often used in architectural photography for **controlling perspective.** It is almost impossible to photograph a building without distortion unless a view camera is used. You don't *have* to correct the distortion, but a view camera provides the means if you want to do so.

Suppose you wanted to photograph the building at right with just one side or face showing. If you leveled the camera and pointed it straight at the building, you would show only the bottom of the building *(first photograph, right).* Tilting up the camera shows the entire building but introduces a distortion in perspective *(second photograph):* the vertical lines seem to come together or **converge.** This happens because the top of the building is farther away and so appears smaller than the bottom of the building. When you look up at any building, your eyes also see the same converging lines, but the brain compensates for the convergence and it usually passes unnoticed. In a photograph, however, it is immediately noticeable. The view camera cure for the distortion is shown in the third photograph. The camera is adjusted to remain parallel to the building (eliminating the distortion), while still showing the building from bottom to top.

Another problem arises if you want to photograph a building with two sides showing. In the fourth photograph, the vertical lines appear correct but the horizontal lines converge. They make the near top corner of the building seem to jut up unnaturally sharp and high in a so-called **ship's-prow effect.** Swinging the back more nearly parallel to one of the sides (usually the wider one) reduces the horizontal convergence and with it the ship's prow *(last photograph).*

Photographer Philip Trager uses a view camera for his architectural work, such as the photograph on page 318. Here he demonstrates its usefulness. Standing at street level and shooting straight at a building produces too much street and too little building. Sometimes it is possible to move back far enough to show the entire building while keeping the camera level, but this adds even more foreground and usually something gets in the way.

Tilting the whole camera up shows the entire building but distorts its shape. Since the top is farther from the camera than the bottom, it appears smaller; the vertical lines of the building seem to be coming closer together, or converging, near the top. This convergence gives the illusion that the building is falling backward—an effect particularly noticeable when only one side of the building is visible.

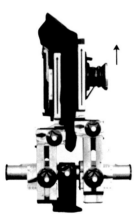

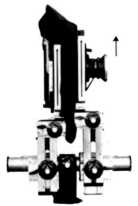

To straighten up the converging vertical lines, keep the camera-back parallel to the face of the building. To keep all parts of the building in focus, make sure the lens is parallel to the camera-back. One way to do this is to level the camera and then use the rising-front or falling-back movements or both. Another solution is to point the camera upward toward the top of the building, then use the tilting movements—first to tilt the back to a vertical position (which squares the shape of the building), then to tilt the lens so it is parallel to the camera-back (which brings the face of the building into focus). You may need to finish by raising the camera-front somewhat.

In this view showing two sides of a building, the camera has been adjusted as in the preceding picture. The vertical lines of the building do not converge, but the horizontal lines of the building's sides do, since they are still at an angle to the camera. This produces an exaggeratedly sharp angle, called the ship's-prow effect, at the top left front corner of the building.

Two more movements are added, as shown in this top view of the camera. The ship's-prow effect is lessened by swinging the camera-back so it is parallel to one side of the building. Here the back is parallel to the wider side. The lens is also swung so it is parallel to the camera-back, which keeps the entire side of the building in focus. It is important to check the edges of the image for vignetting when camera movements are used.

DEALING WITH DISTORTION

Every attempt to project a three-dimensional object onto a two-dimensional surface results in a **distortion** of one kind or another. Yet cleaning up distortion in one part of a photograph will usually produce a different kind of distortion in another part. The book and orange in the two still lifes at right are examples of this. In the first picture, shot from above with all camera adjustments at zero, the book shows two kinds of distortion. Since its bottom is farther away from the camera than the top, the bottom looks smaller. Also the book seems to be leaning slightly to the left. These effects would have been less pronounced if the camera had been farther away from the book—the farther away an object is from a lens, the smaller are the differences in distance from the lens to various parts of the object. It is these differences that cause distortions in scale.

Can distortion be corrected? It can with a view camera, using a combination of tilt, swing, and fall. Back-tilt of the camera-back straightens the book's left edge. A left-swing of the camera-back squares up the face of the book. Since these changes enlarged the image somewhat, back-fall was added to show all of the book.

Is the result a less distorted picture? That depends. The book is certainly squared up nicely, as if it were being looked at head on, but the spine, oddly enough, is still visible. Furthermore, the round orange of the first picture has now become somewhat melon-shaped. All pictures contain distortions; what you must do is manipulate them to suit your own taste.

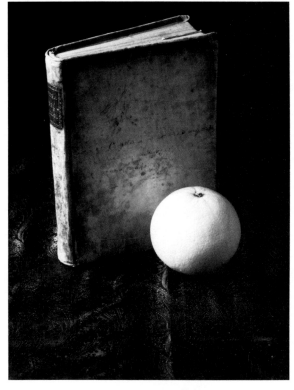

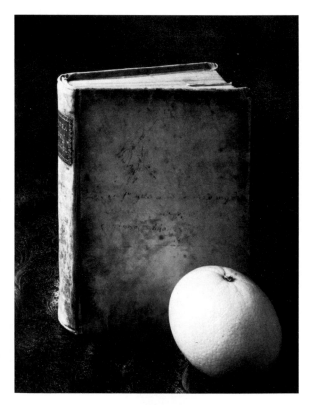

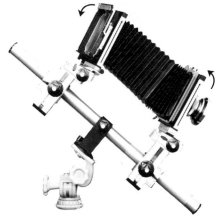

With camera settings at zero, a downward view of a book makes the upper part seem larger than the lower part—just as the top front edge of the cube on page 306 looks larger than the bottom edge. The book also appears to be tipping to the left. The orange, on the other hand, a sphere seen straight on in the center of the picture, appears normal.

The book is straightened by back-tilt and left-swing of the back, but this forces the orange out of shape. These back movements also affected the focus; it was necessary to back-tilt the lens and swing it to the left to bring the lens—and so the plane of focus—into better line with the book's face.

WHAT TO DO FIRST—AND NEXT

Because a view camera is so adjustable, its use requires the photographer to make many decisions. A beginner can easily get an I-don't-know-what-to-do-next feeling. So here are some suggestions.

1) Set up the camera and zero the controls. Set the camera on a sturdy tripod, attach a cable release to the shutter mechanism, point the camera toward the scene, zero the controls, and level the camera (*below left*). Open the shutter for viewing and open the lens aperture to its widest setting. You will almost always need to use a focusing cloth to see the image clearly (*center*).

2) Roughly frame and focus. Adjust the back for a horizontal or vertical format and roughly frame the image on the ground glass. Roughly focus by adjusting the distance between the camera-front and camera-back. The closer you are to the subject, the more you will need to increase the distance between front and back.

3) Make more precise adjustments. To change the shape or perspective of the objects in the scene, tilt or swing the camera-back. You may also want to move the position of the image on the film by adjusting the tripod or using the rising, falling, or shifting movements. Now check the focus *(right)*. If necessary, adjust the plane of focus by tilting or swinging the lens. You can preview the depth of field by stopping down the lens diaphragm.

4) Make final adjustments. When the image is the way you want it, tighten all the controls. Check the corners of the viewing screen for possible vignetting. You may need to decrease some of the camera movements (especially lens movements) to eliminate vignetting.

5) Make an exposure. Close the shutter, adjust the aperture and shutter speed, and cock the shutter. Now insert a loaded film holder until it reaches the stop flange that positions it. Remove the holder's dark slide to uncover the sheet of film facing the lens, make sure the camera is steady, and release the shutter. Replace the dark slide so the all-black side faces out. Your exposure is now complete.

leveling camera

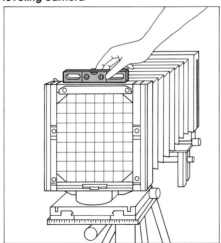

Zero the controls and level the camera before making any other adjustments. Zeroing is important because even a slight tilt or swing of the lens, for example, can distinctly change the focus. A spirit level, like a carpenter uses, levels the camera. Vertical leveling is important if you want the camera to be parallel to a vertical plane such as a building face. Horizontal leveling (above) is vital; without it the picture may seem off balance even if there are no horizontal lines in the scene.

using focusing cloth

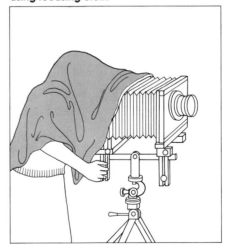

The view camera's ground glass shows a relatively dim image. A focusing cloth that covers the camera-back and your head makes the image much more visible by keeping out stray light. You may not need the cloth if the subject is brightly lit in an otherwise darkened room, but in most cases it is a necessity. Some photographers like a two-layer cloth—black on one side and white on the other—to reflect heat outdoors and to double as a fill-light reflector.

checking focus

A hand-held magnifier, sometimes called a loupe, is useful for checking the focus on the ground glass. Check the depth of field by examining the focus with the lens stopped down. Examine the ground glass carefully for vignetting if camera movements (especially lens movements) are used. If the ground glass has cutaway corners, like the one shown here, you can check for vignetting by looking through one of the corners at the shape of the lens diaphragm. If there is no vignetting, the diaphragm will appear oval and symmetrical.

LOADING AND PROCESSING SHEET FILM

Using **sheet film** is easy once you have practiced the procedures a few times, but do pay attention to some important details. Film is loaded in total darkness into sheet-film holders that accept two sheets of film, one on each side. Each sheet is protected by a light-tight dark slide that is removed after the holder is inserted in the camera for exposure. The film must be loaded with the emulsion side out; film loaded with the backing side out will not produce a usable image. The emulsion side is identified by a **notching code;** when the film is in a vertical position, the notches are in the upper right-hand (or lower left-hand) corner when the emulsion side of the film faces you. After exposure but before you remove the holder from the camera, insert the holder's slide with the all-black side facing out; this is the only way to tell that the film has been exposed and to avoid an unintentional double exposure. Some points on loading film holders are given in the pictures and captions on this page.

Developing sheet film follows the same basic procedure as developing roll film, except three tanks or trays are used—for developer, stop bath, and fixer. Some photographers add a fourth step, a water presoak before development. The film is agitated and transferred from one solution to the next in total darkness; it is not feasible to do this with just one tank as is possible with roll film. Fill tanks with enough solution to more than cover the film in the hanger. Fill trays deep enough for the number of sheets to be developed—one inch is probably a minimum.

Check the instructions carefully for the proper development time. The time will depend on whether you use intermittent agitation in a tank or constant agitation in a tray.

dusting holders

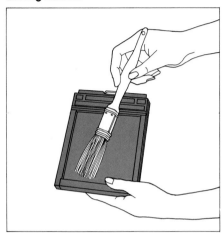

It is a good idea to dust the film holders each time before loading them. This is much less trouble than trying to etch off a dark spot on your print caused by a speck of dust on the unexposed film. A soft, wide paintbrush (used only for this purpose) or a negative dusting brush works well. Dust both sides of the dark slide, under the film guides, and around the bottom flap. Tapping the top of the holder can help dislodge dust inside the slot where the dark slides are inserted.

checking film insertion

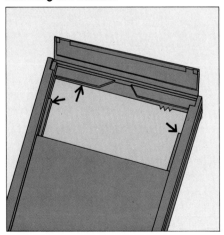

The film is inserted in the bottom (flap) end of the holder underneath narrow metal guides. If you rest your fingers lightly on top of the guides you can feel even in the dark if the film is loading properly. Also make sure that the film is inserted all the way past the raised ridge at the flap end. When the film is in, hold the flap shut with one hand while you push the dark slide in with the other.

checking notching code

Sheet film has a notching code—different for each type of film—so you can identify it and determine the emulsion side. The notches are always located so the emulsion side is facing you when the film is in a vertical position and the notches are in the upper right-hand corner. Load the film with the holder in your left hand and the film in your right with your index finger resting on the notches. (If you are left-handed you may want to load with the holder in your right hand and the film in your left.)

unexposed/exposed film

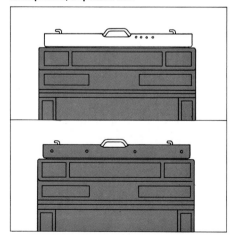

The dark slide has two different sides—one all black, the other with a shiny band at the top—so you can tell if the film in the holder is unexposed or exposed. When you load unexposed film, insert the slide with the shiny side out. After exposure, reinsert the slide with the all-black side facing out. The shiny band also has a series of raised dots or a notch so you can identify it in the dark.

loading hangers

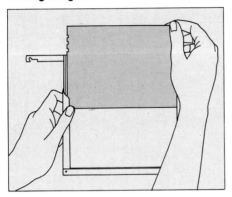

Tank development using film hangers is a convenient way to develop a number of sheets of film at one time. The hanger is loaded in the dark. First spring back its top channel. Then slip the film down into the side channels until it fits into the bottom channel. Spring back the top channel, locking the film in place. Stack loaded hangers upright against the wall until all the film is ready for processing.

tank development

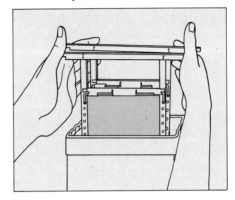

Hold the stack of loaded hangers in both hands with your forefingers under the protruding ends. Don't squeeze too many hangers into the tank; allow at least 1/2 inch of space between hangers. To start development, lower the stack into the developer. Tap the hangers sharply against the top of the tank to dislodge any air bubbles from the film (this is not necessary if the film has been presoaked in water before development). Make sure the hangers are separated.

tank agitation

Agitation for tank development takes place for 6 to 8 sec, once for each minute of development time. Lift the entire stack of hangers completely out of the developer. Tip it almost 90° to one side to drain the developer from the film. Replace it in the developer. Immediately lift the stack again and tilt almost 90° to drain to the opposite side. Replace in solution. Make sure the hangers are separated. Always remove and replace hangers slowly.

tray development

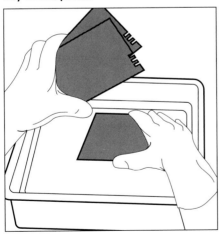

Tray development is easy if you have just a few sheets of film to process. Fan the sheets so that they can be grasped quickly one at a time. Hold the film in one hand. With the other hand take a sheet and completely immerse it, emulsion side up, in the developer. Repeat until all sheets are immersed. (A water presoak before development is useful to prevent the sheets from sticking to each other.)

tray agitation

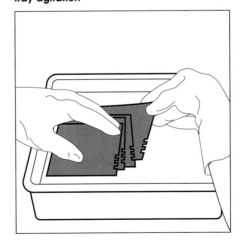

All the film should be emulsion side up toward one corner of the tray. Slip out the bottom sheet of film and place it on top of the pile. Gently push it under the solution. Continue shuffling the pile of film one sheet at a time until the end of the development period. If you are developing only a single sheet of film, agitate by gently rocking the tray back and forth, then side to side. Be careful handling the film; the emulsion softens during development and scratches easily.

washing and drying

A few loose sheets of film at a time can be washed in a tray, but the water flow must be regulated carefully to avoid excessive swirling that could cause scratching. Film in hangers can be washed and then hung up to dry right in the hangers or it can be dried on a line as shown above. Separate the film enough so that the sheets do not accidentally stick together.

USING A VIEW CAMERA

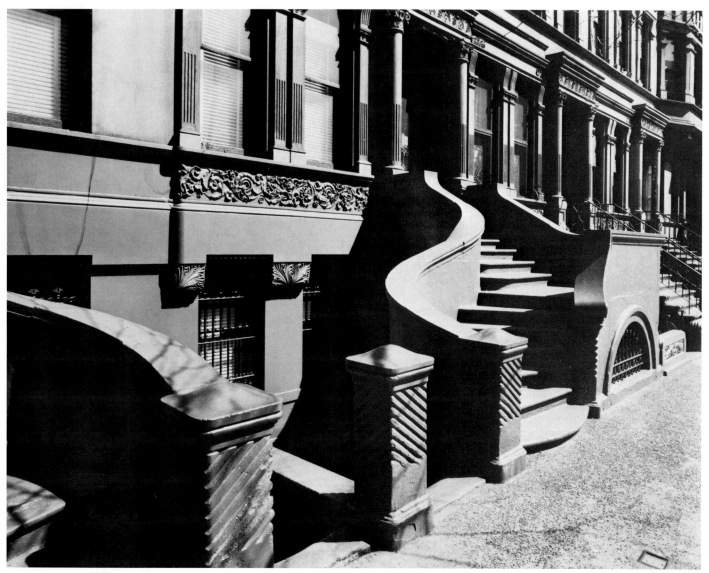

PHILIP TRAGER: *New York*, 1979

Above, a photograph that demonstrates why many photographers like to use a view camera. The front and back of the camera are adjustable, which gives extensive control over the perspective and sharpness of an image. Phil Trager raised the front instead of tilting up the camera, which gave the height he wanted to show but prevented convergence of vertical lines; then he swung the camera-back to the left to avoid excessive convergence of horizontal lines. He swung the camera-front to the left to align the plane of focus with the front of the buildings so that the entire row of buildings was sharp.

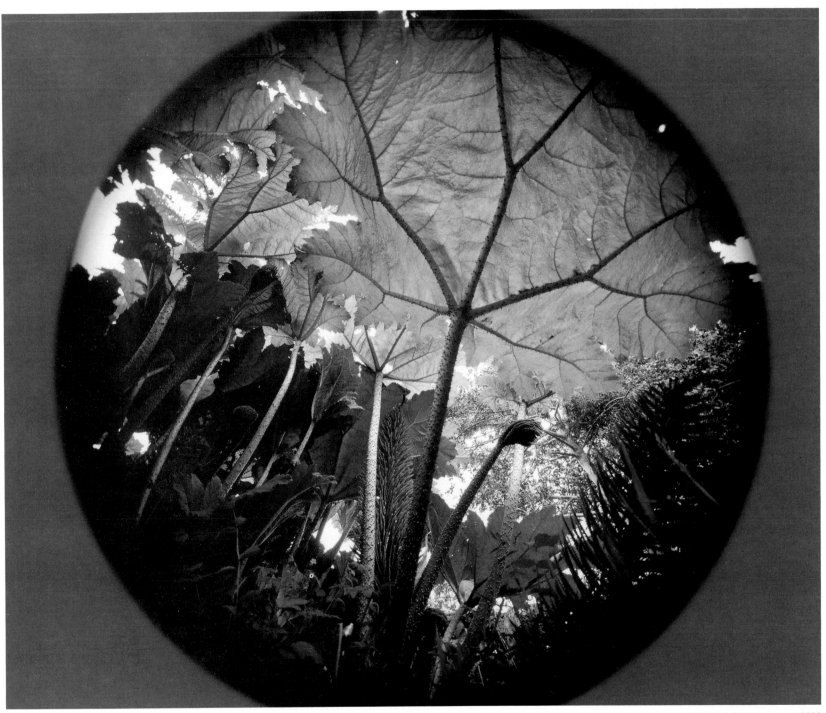

EMMET GOWIN: *Ireland,* 1972

Photographers usually—but not always—want a lens with enough covering power to completely fill the size of the film being used. Emmet Gowin fitted an 8 x 10 view camera with a 90mm lens designed for a 4 x 5 camera. The image formed by the lens would have been big enough to cover 4 x 5-inch film, but the 8 x 10-inch film *showed almost the entire image circle. At first he cropped the image down to a rectangle, but then saw the potential in the image circle itself. "I realized that such a lens contributed to a particular description of space and that the circle itself was already a powerful form."*

ANSEL ADAMS: *Moonrise, Hernandez, New Mexico,* 1941

Zone System 14

Have you ever looked at a scene and known just how you wanted the final print to appear? In the Zone System, this is called **visualization.** Sooner or later every photographer has this experience. Sometimes the image turns out just the way you expected, but as often as not for the beginning photographer, the negative you end up with makes it impossible to produce the print you had in mind. For example, the contrast range of a scene (the difference between its lightest and darkest parts) is often greater than the contrast range of normally processed photographic materials. The result is highlights so light and/or shadows so dark that details in them are completely lost.

The **Zone System** is a method conceived by Ansel Adams *(photograph opposite)* and Fred Archer for controlling the black-and-white photographic process. It applies the principles of **sensitometry** (the measurement of the effects of light on light-sensitive materials) to organize the many decisions that go into exposing, developing, and printing a negative. Briefly, it works this way. You make exposure meter readings of the luminances (the lightness or darkness) of important elements in the scene. You decide what print values (shades of gray) you want these elements to have in the final print. Then you expose and develop the film to produce a negative that can, in fact, produce such a print.

◀ *Ansel Adams remains the acknowledged master of the grand landscape. His great vistas are mythic images that reinforce our romantic ideals of nature. Adams was a superb technician who controlled his medium completely to amplify and bring to life the tonalities in an image. No book reproduction can convey the range of tones in the original print, from the glowing brilliance of the clouds and crosses to the subtle detail in the dark shadows. The photograph is everything that we imagine such a scene might look like in reality, and for many of us it will forever serve as a substitute for the actual experience of being there to see it ourselves.*

Luminances in a scene can be pegged to precise values through the systematic application of an old photographic rule of thumb: **expose for the shadows and develop for the highlights.** Exposure largely controls density and detail in thinner areas of the negative (which produce dark or shadow areas in the print), whereas exposure *plus* development affect negative density and detail in the denser areas (which produce light areas in the print). In effect, development controls contrast in a negative, and you can increase contrast by increasing development or decrease contrast by decreasing development. Pages 326–327 explain this further.

The Zone System allows you to visualize how the tones in any scene will look in a print and to choose either a literal recording or a departure from reality. Even if you continue to use ordinary exposure and development techniques, understanding the Zone System will help you apply them more confidently. This chapter is only a brief introduction to show the usefulness of the Zone System. Other books that tell how to put it into full use are listed in the Bibliography.

THE ZONE SYSTEM SCALES

subject values (luminances)

low meter reading high meter reading

negative-density values

little or no silver dense silver

print values

maximum black silver white paper base

zones

0 I II III IV V VI VII VIII IX X

To control the value (lightness or darkness) of an area, you must first find a way to name and describe how light or how dark the area is. The Zone System has four scales to use for this purpose *(right).*

Subject values. The steps on this scale describe the amount of light reflected or emitted by various objects in a scene. Subject values or luminances can be measured by a reflected-light meter: a low or dark subject value produces a low meter reading; a high or light subject value produces a high meter reading.

Negative-density values. Divisions of this scale describe the amount of silver in various parts of the negative after it has been developed. Clear or thin areas of a negative have little or no silver; dense areas have a great deal of silver. These values can be measured by a densitometer, a device that gauges the amount of light stopped or passed by different portions of the negative.

Print values. These steps describe the amount of silver in various parts of a print. The darkest areas of a print have the most silver, the lightest areas the least. These values can be measured by a reflection densitometer if desired but are ordinarily simply evaluated by eye in terms of how light or dark they appear.

Zones. This scale is crucial because it links the values on the other three scales. It provides descriptions of values to which subject values, negative-density values, and print values can be compared. Each zone is one stop away from the next (it has received either twice or half the negative exposure).

Familiarizing yourself with the divisions of the zone scale *(opposite page)* is particularly important because it gives you a means of visualizing the final print: the zones aid you in examining subject values, in deciding how you want them to appear as print values, and in then planning how to expose and develop a negative that will produce the desired print.

The zone scale on the opposite page has 11 steps and is based on Ansel Adams's description of zones in his book *The Negative.* Some commonly photographed surfaces are listed in the zones where they are often placed if a realistic representation is desired; average light-toned skin in sunlight, for example, appears realistically rendered in Zone VI.

Zone 0 (zero) relates to the deepest black print value that photographic printing paper can produce, resulting from a clear area (a low negative-density value) on the corresponding part of the negative, which in turn was caused by a dark area (a low subject value) in the corresponding part of the scene that was photographed.

Zone X relates to the lightest possible print value—the pure white of the paper base, a dense area of the negative (a high negative-density value) and a light-toned area in the scene (a high subject value).

Zone V corresponds to a middle gray, the tone of a standard-gray test card of 18 percent reflectance. A reflected-light exposure meter measures the lightness or darkness of all the objects in its field of view and then gives an exposure recommendation that would render the average of those tones in Zone V middle gray.

There are more than 11 distinct shades of gray in a print—Zone VII, for example, represents all the slightly different tones between Zones VI and VIII—but the 11 zones provide a convenient means of visualizing and identifying tones in the subject, the negative, and the print.

The Zone System has four scales that describe the lightness or darkness of a given area at the various stages in making a photograph. The divisions of the scales are labeled with roman numerals to avoid confusions with f-stops or other settings.

Subject values *are measured when metering a scene and range from dark shadows to bright highlights. Each value meters one stop from its neighbor. Only 11 subject values are shown here (top scale), but more will be present in a high-contrast scene, such as a brightly sunlit location that also contains deeply shadowed areas. The same location on a foggy or overcast day will contain fewer than 11 values.*

Negative-density values *are those present in the developed negative. Film can record a somewhat greater number of values than the 11 shown here (second scale from top).*

Print values *are those visible in the final print (second scale from bottom). Printing paper limits the usable range of contrast. Black-and-white printing paper can record about 11 steps from maximum black to paper-base white.*

Zones *(bottom scale) tie the other values together. They permit you to plan how light or dark an area in a subject will be in the final print.*

In Ansel Adams's original version of the Zone System, he divided the zone scale into 10 segments (0–IX). When he retested newer film and paper, he revised the zone scale to 11 segments (0–X). The information here is based on the current version of the system.

Zone X. *Five (or more) stops more exposure than Zone V middle gray. Maximum white of the paper base. Whites without texture: glaring white surfaces, light sources.*

Zone IX. *Four stops more exposure than Zone V middle gray. Near white. Slight tonality, but no visible texture: snow in flat sunlight.*

Zone VIII. *Three stops more exposure than Zone V middle gray. Very light gray. High values with delicate texture: very bright cement, textured snow, highlights on light-toned skin, the lightest wood at right.*

Zone VII. *Two stops more exposure than Zone V middle gray. Light gray. High values with full texture and detail: very light surfaces with full sense of texture, sand or snow with acute side lighting.*

Zone VI. *One stop more exposure than Zone V middle gray. Medium-light gray. Lighted side of average light-toned skin in sunlight, light stone or weathered wood, shadows on snow in a scene that includes both shaded and sunlit snow.*

Zone V. *Middle gray. The tone that a reflected-light meter assumes it is reading and for which it gives exposure recommendations. 18 percent reflectance standard-gray test card, clear north sky, dark skin.*

Zone IV. *One stop less exposure than Zone V middle gray. Medium-dark gray. Dark areas with full texture and detail: dark stone, average dark foliage, shadows in landscapes, shadows on skin in sunlit portrait.*

Zone III. *Two stops less exposure than Zone V middle gray. Dark gray. Darkest shadow areas with texture and detail: very dark soil, very dark fabrics with full texture, the dark boards at right.*

Zone II. *Three stops less exposure than Zone V middle gray. Gray-black. Darkest area in which some suggestion of texture will appear in the print.*

Zone I. *Four stops less exposure than Zone V middle gray. A near black with slight tonality but no visible texture.*

Zone 0. *Five (or more) stops less exposure than Zone V middle gray. Maximum black that photographic paper can produce. The opening to a dark interior space, the open windows at right.*

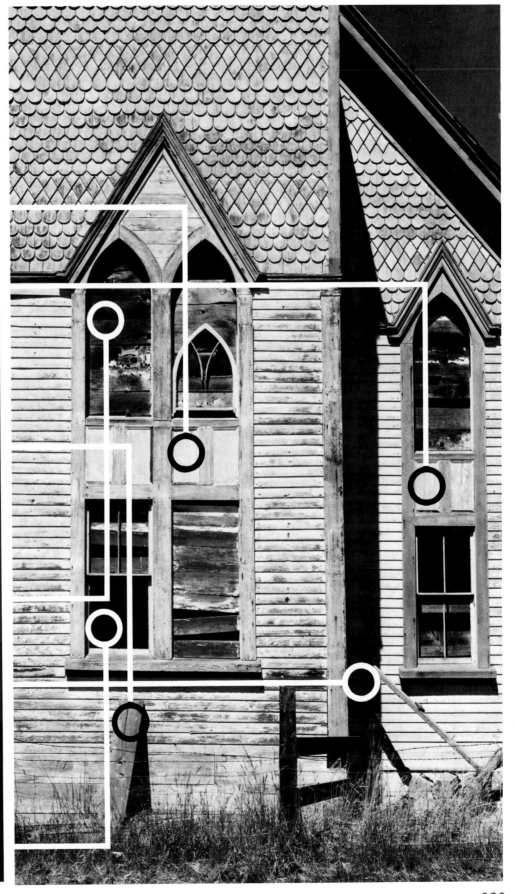

USING THE ZONE SCALE WHILE METERING

When you are standing in front of a subject and visualizing how it might look as a black-and-white print, you have to take into account that ordinary photographic materials given normal exposure, development, and printing cannot record with realistic texture and detail the entire range of luminances (subject tones) in many scenes. For example, a scene in bright sunlight can generally be rendered with texture and detail in either dark shadows or bright highlights but not both. Usually, you have to choose those areas in which you want the most detail in the print and then expose the negative accordingly.

With practice, you can accurately visualize the black-and-white tones in the final print by using the zone scale described on the preceding pages plus a reflected-light exposure meter, either hand-held or built into a camera. (An incident-light meter cannot be used because it measures the light falling on the scene and you will need to measure the luminances of individual areas.)

When you meter different areas, you can determine where each lies on the zone scale for any given exposure. Metering must be done carefully to get consistent results. Try to read areas of more or less uniform tone; the results from an area of mixed light and dark tones will be more difficult to predict. Move in close enough to the subject to make readings of individual areas, but not so close that you cast a shadow on an area as you meter it. A spot meter is useful for reading small areas or those at a distance.

The meter does not know what area is being read or how you want it rendered in the print. It assumes it is reading a uniform middle-gray subject tone (such as a standard-gray test card of 18 percent reflectance) and gives exposure recommendations accordingly. The meter measures the total amount of light that strikes its light-sensitive cell from an area; then, taking into account the film speed, it calculates f-stop and shutter speed combinations that will produce sufficient negative density to reproduce the area as middle gray in a print.

If you choose one of the f-stop and shutter-speed combinations that are recommended by the meter, you will have placed the metered area in Zone V and it will reproduce as middle gray in the print (print Value V). By altering the negative exposure you can **place** any one area in any zone you wish. One stop difference in exposure will produce one zone difference in tone. For example, one stop less than the recommended exposure places a metered area in Zone IV; one stop more places it in Zone VI.

Once one tone is placed in any zone, all other luminances in the scene **fall** in zones relative to the first one depending on whether they are lighter or darker and by how much. Suppose a medium-bright area gives a meter reading of 7 *(see meter and illustration, near right)*. Basing the exposure on this value (by setting 7 opposite the arrow on the meter's calculator dial) places this area in Zone V. Metering other areas shows that an important dark wood area reads two stops lower (5) and falls in Zone III, while a bright wood area reads three stops higher (10) and falls in Zone VIII.

A different exposure could have been chosen, causing all of the zones to shift equally lighter or darker *(illustrations, far right)*. For instance, by giving one stop more exposure you could have lightened the tones of the dark wood, placing them in Zone IV instead of III, but many of the bright values in the lightest wood would then fall in the undetailed white Zone IX. The Zone System allows you to visualize your options in advance.

Each position on an exposure meter gauge measures a luminance (subject value) one stop or one zone from the next position. Suppose that metering a medium-toned area gives a reading of 7. Setting 7 opposite the arrow on the calculator dial places this area in Zone V. A lighter area meters 10, so it falls three zones lighter, in Zone VIII. A dark area meters at 5 and falls in Zone III. The first area metered will appear in the print as middle-gray print Value V, the bright wood as very light gray print Value VIII, and the dark wood as dark-gray print Value III (with standard negative development and printing).

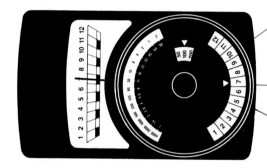

Using Exposure Settings to Count Zones

What do you do if you can't read the difference in subject values (and so, the difference in zones) directly off the meter dial, as you can with the meter above? If you are using a meter built into a camera, the viewfinder often displays the exposure setting—the aperture and shutter-speed combination—for a given reading. You can find the various zones if you count the number of stops between exposure settings for different areas.

Suppose that metering the scene suggests exposures of f/5.6 at $\frac{1}{60}$ sec for one area and f/16 at $\frac{1}{60}$ sec for a lighter area. The area that metered f/16 is three stops (or zones) lighter than the area that metered f/5.6 (f/5.6 to f/8 is one stop; f/8 to f/11, two stops; f/11 to f/16, three stops). Placing the darker area in Zone V will cause the lighter one to fall in zone VIII, three zones higher.

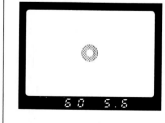

One stop difference in negative exposure creates one zone difference in all areas (if other factors remain the same). The negative exposure for the top print was one stop less than that given to the photograph at left. The negative exposure for the bottom print was one stop more than that for the photograph at left. All the values changed one zone with one stop difference in exposure.

X

IX

VIII

VII

VI

V

IV

III

II

I

0

A FULL-SCALE PRINT

Often (although not always) photographers want to make a **full-scale print** with normal contrast; that is, with a full range of values from black through many shades of gray to white and with considerable texture and detail showing in important areas.

If that is your goal, then the darkest area in which you want some separation in the tonality should be no darker than Zone II; for texture and detail, the area should be no darker than Zone III$^1/_2$, and Zone IV is even better. The lightest area for minimum detail should be no lighter than Zone VIII; for full texture and detail, it should be no lighter than Zone VII. Areas lighter or darker than this will be at the edge of the printing paper's ability to render detail.

Begin by placing the most important shadow area. It is worse to underexpose a negative than to overexpose one because dark values are affected only by exposure, and no darkroom wizardry can add details to an important shadow area if inadequate exposure was given to the film. If you used the Zone System to calculate the exposure for the scene at right, you could place the dark wood boards in the windows in Zone III by metering them, then giving two stops less exposure than the meter calls for (remember that meters calculate exposures for Zone V; *see page 324*). Suppose the boards read 5 on the meter gauge. Placing 5 opposite the arrow on the calculator dial (the Zone V position) would place the boards in Zone V. Since you want the boards in Zone III, place 5 two stops from the calculator arrow toward underexposure, as shown at right.

Then see where the important light areas fall. Light values are affected by both exposure and development. Some small, very light areas might read 10 on the meter dial and fall in Zone VIII, while larger light-toned areas might read 9 and

fall in Zone VII. Is this the way you want the print to look? If so, developing the film normally would produce a negative that, when printed on a normal-contrast grade of paper, would show the dark boards as dark but with good detail, the lightest areas just showing texture, and the larger light-toned areas light but with full detail.

Suppose the scene was more contrasty and the dark boards metered 5, large light-toned areas metered 10, and the lightest boards metered 11. If you placed the dark boards in Zone III, the lightest areas would fall in near-white Zone IX, while much of the scene would fall in very light gray Zone VIII. Giving N − 1 (contracted) development would reduce the lightest areas to Value VIII and other light areas to a fully textured Value VII, while the Value III dark boards would change very little. The contrast would have been decreased by reducing the development time. The negative would print well on a normal-contrast grade of paper with the important areas rendered as you visualized them.

Another way to decrease the contrast would be to plan to use a low-contrast grade of paper during printing. The advantage of analyzing the exposure in Zone System terms is that you know in advance what the range of contrast is in the scene in terms of the print's ability to show detail.

In a photograph that is a portrait, the face is often the first area a viewer notices, so it is important to meter skin tones carefully and see that they will have the desired rendering—either by placing them in the zone where you want them or seeing that they fall there, or by developing them to that value. Normal values for the sunlit side of a face are V for dark skin, VI for medium-light skin, and VII for very light skin. The shaded side of a face in sunlight usually appears normally rendered as Value IV.

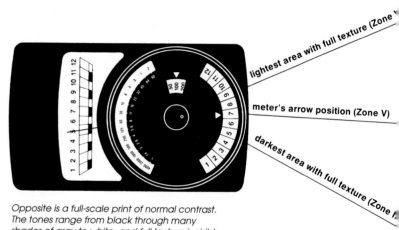

lightest area with full texture (Zone)

meter's arrow position (Zone V)

darkest area with full texture (Zone I)

Opposite is a full-scale print of normal contrast. The tones range from black through many shades of gray to white, and full texture is visible in both the darkest and lightest areas in which texture is important. Some readings that you might have registered for the scenes are shown on the meter above. Dark board areas metered at about 5. They were placed in Zone III (the darkest value that can show full texture) by positioning the meter arrow (which indicates Zone V) two stops higher on the calculator dial. Large light-toned areas metered 9 and fell in Zone VII (light but with full texture). Smaller, even lighter areas metered 10 and fell in Zone VIII (very light gray). A spread of four or five zones between the darkest textured shadow and the lightest textured white will produce a full-scale, rich print on a normal-contrast grade of paper.

PHOTOGRAPHER AT WORK: USING THE ZONE SYSTEM

John Sexton was a photo student when he first encountered the Zone System, attended an Ansel Adams lecture, and then attended one of Adam's workshops. Later, he became one of Adams's darkroom assistants, and now photographs and teaches photography workshops himself.

Sexton sees the Zone System as a communication process. The collaborators are the photographer and the materials. "But," he says, "most people don't listen to what the negative and the paper say to them visually. They don't really look at the results."

"The Zone System is simple," Sexton says, "once you understand that it's all about visualization," thinking ahead to how you want the print to look. There's nothing exotic about that, he says: "Everybody visualizes, from someone with a disc camera to someone with an 8 x 10 view camera. It's the only reason you press the shutter release. And most of us visualize something that is outside of the limitations of the material: if you start thinking, 'I may have to burn in the upper right corner,' you are visualizing. I used to hope a negative 'turned out'; I was really thinking about the print it might make."

"If people understand nothing else," he says, "they should understand that when you point a reflected-light meter at something, you are going to get middle gray. Exposure is the only way you can control shadow density, while exposure and development control the highlights."

He recommends, "If in doubt, don't underexpose. If in doubt, don't overdevelop. Make a negative that gives you options. Your options are limited if you have thin shadows or bulletproof highlights. If you've got shadow detail and highlight detail, there's a lot you can do in the darkroom."

Using Torn Paper Tests for Dodging and Burning

When making a print, John Sexton almost always dodges to lighten some areas and/or burns in to darken other areas. The question is: How much should a print be dodged or burned for best results? He begins by making a test strip to determine his basic print exposure, then makes a straight print without any dodging or burning.

Making a set of test patches. *He examines the print and decides where he might want to dodge or burn. He tears a fresh sheet of printing paper into pieces to go over the areas he wants to see manipulated, fitting together a sort of jigsaw puzzle of the print. On the back of each piece of paper, he writes the planned amount of dodging or burning for that area. Once all the pieces are in place on the printing easel, he gives the exposure that produced a good straight print, dodging the appropriate areas as planned. He then burns in where planned.*

Making a second set of patches. *He sets aside the pieces of paper, then repeats the procedure with another set of torn pieces, doubling every manipulation. For example, if he had planned to dodge an area for 5 seconds, he now dodges that same area for 10 seconds. He gathers all the pieces of paper and develops them.*

Evaluating the patches. *After fixing, he turns on the white lights, puts his straight print on his print viewing area (shown right, bottom) and positions the torn pieces around the print. If he wants to see what the area dodged for 5 seconds looks like, he positions that piece over the print. If it's not light enough, he'll try the piece dodged for 10 seconds. And so on. Once he has assembled a print that begins to feel fairly close to the image he wants, he turns the torn pieces over to find the time for dodging or burning each area, creating a plan for the final print.*

The benefit of this torn-paper procedure is that you can try various combinations of dodging and burning-in, without using sheet after sheet of paper. Lay a manipulated area over the straight print, look at it for a while, then quickly peel it off. You'll know right away which looks better, and much more accurately than if you had simply dodged or burned without testing.

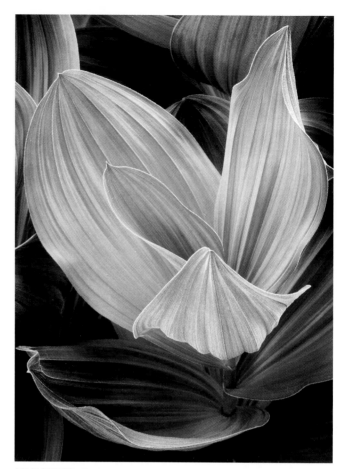

JOHN SEXTON: *Corn Lily, Eastern Sierra Nevada, California,* 1977

Sexton photographed these corn lily leaves on an overcast, rainy day, with light diffused by high clouds and again by heavy forest overhead. He wanted more contrast than the scene provided, so he gave the film an N + 1 expanded development. Later he intensified the negative in selenium toner to expand the contrast a little further, then printed it on a grade 3 paper. More about selenium toning of negatives on page 132.

PATRICK JABLONSKI: *John Sexton in His Darkroom,* 1990

JOHN SEXTON: *Coal Conveyor at Night, Alma, Wisconsin, 1987*

This scene of a coal conveyor at night was extremely contrasty. The lights on the coal conveyor provide the only illumination, and are themselves in the photograph. The 30-minute exposure that was required made the scene even more contrasty due to the reciprocity effect of a very long exposure (explained on page 102). In order to keep detail in both shadows and highlights, Sexton gave ample exposure and greatly reduced development to the negative.

He advises students to use the same tool that is the most important one in his darkroom: the trash can. "That's where most of my prints end up," he says. "Most of the prints I make are for my eyes only. As a photographer, I think you need to be constantly making mistakes: technical mistakes and aesthetic mistakes. As soon as you're no longer making either, you're probably done with that body of work. By risking mistakes, now I can get things on film that ten years ago I wouldn't have known how to handle."

PUTTING IT ALL TOGETHER

The Zone System procedure has four basic steps.

Step 1: Visualize the final print. Decide how you want the print to look, for example, which dark or light areas should show good detail.

Step 2: Meter the most important area in the scene and **place** it in the zone where you want it rendered. Often this is the darkest area in which you want full texture (usually Zone III$^{1}/_{2}$ or IV). It is important to expose shadow areas adequately (that is, to place them in a high enough zone), because there is little that can be done to add shadow density during processing. Placing a value determines your exposure.

Step 3: Meter other areas (especially the lightest area in which you want full texture) to see in which zones they **fall** in relation to the area you have placed.

Step 4: Make development choices. If you want the negative-density values to correspond to the relative luminances of various areas in the scene, develop the negative normally. Change the development time if you want to change the densities of the upper values while leaving the lower values about the same. Increasing the time increases the negative densities of the high values (which will make those areas lighter in the print) and also increases the contrast. Decreasing the development time decreases the negative densities of the high values (they will be darker in the print) and decreases the contrast.

You could also plan to print on a contrast grade of paper higher or lower than normal to control densities and contrast. A change of one printing paper contrast grade causes about a one-zone shift in the high values (when low values are matched in tone).

Testing is the best way to determine normal development time and to establish the changes in development needed to move a value from one zone to another.

The tests, covered in detail in the books listed in the Bibliography, establish five standard elements for the individual photographer: actual film speed, normal development time, expanded development times, contracted development times, and standard printing time. Personal testing is recommended since cameras, meters, films, enlargers, papers, developers, and personal techniques all affect the results.

However, here are some **rough guidelines for expanded and contracted development** that you can use without testing and that will be helpful for approximate control of contrast. First, use the manufacturer's stated film speed rating to calculate the exposure. For normal development, use one of the manufacturer's suggested time and temperature combinations.

For N + 1 expanded development, increase the development time by half. If the recommended development time is 8 minutes for a given combination of film, developer, and temperature, then the high values can be shifted up one zone each by a 12-minute development. For N + 2 expansion, double the time.

For N − 1 contracted development, which will shift the high values downward one zone each, develop for three quarters of the normal time. For N − 2 contraction, develop for half of the normal time.

Compared to other films, Kodak T-Max films require less of a change in development time to produce a comparable change in negative density; change the time about half as much as you do with other films.

Changing the development time is easy with view camera photography, where sheets of film can be processed individually. But it can also be valuable with **roll film** even though a whole roll of exposures is processed at one time. Sometimes a single image or situation is so important that it deserves special development; the other images on the roll will

probably still be printable, possibly on a different grade of paper. Or an entire roll may be shot under one set of conditions and so can be exposed and processed accordingly. Be cautious with increased development of roll film; grain will increase too.

With roll film, Zone System metering and control of negative contrast is often combined with changes in printing-paper contrast. It is essential to give enough exposure to dark areas to produce printable densities in the negative while at the same time attempting to keep bright areas from becoming too dense to be printable. For example, if you are shooting on the street on a generally sunny day and trial metering indicates about one stop too much contrast (that is, with shadows placed in Zone III, the high values in which you want full detail to fall in Zone VIII or IX), contracted development for the entire roll will be useful. Most of the frames shot will print on a normal-contrast grade of paper; those shot under more contrasty conditions will print on a low-contrast grade; those shot in the shade (now low in contrast because of contracted development) will print on a high-contrast grade.

With **color materials,** the Zone System provides a way to place a specific value and check where other values will fall. With color negatives, place the most important shadow value, just as you would with a black-and-white negative; overly bright highlights can usually be burned in later during printing. Correct exposure is vital with color transparencies because the film in the camera is the final viewing product. High values in a transparency lose texture and detail more easily than shadows do, so meter and place the most important light area rather than shadows. If you want a light area to retain texture, place it no higher than Zone VII. Changing development time to control contrast is not recommended for most color materials.

Using the Zone System makes it possible to plan the exposure and development that will produce the tonal range you want in a negative and print. Morley Baer made this photograph for a book on Victorian houses in San Francisco. Baer says that he often has to expand contrast when shooting in the hazy sunlight that is common in San Francisco.

He metered the shadow just under the window cornice, an area that he wanted to be dark but still showing detail, and placed that area in Zone III. Then he metered the lightest area in which he wanted to retain good detail; It fell only in Zone VI, which would have made the scene too flat. To correct this, Baer increased the development time to give the scene a one-zone expansion. Another option that he sometimes takes is to plan to print the scene on a more contrasty grade of paper.

MORLEY BAER: *Window Cornice Detail, San Francisco,* 1966

GARRY WINOGRAND: *Zoo, New York,* 1962

Seeing Photographs 15

SUSAN MEISELAS: *Soldiers Searching Bus Passengers, Northern Highway, El Salvador*, 1980

Susan Meiselas's photographs of the political conditions in Central America have been used in many magazines and newspapers. Her work is often more complex than the straightforward news picture that conveys its story without requiring such effort from the viewer. The photograph above is not one a news photographer would typically make because it does not reveal itself immediately. It is a very powerful image, but, as Meiselas says, "You have to live with it a while before you emotionally connect with it."

◀ *Many of Garry Winogrand's pictures involve unusual confrontations. This one depicts a three-way face-off between humans and animals at the Bronx Zoo, with all participants apparently equally intrigued by the event. Winogrand exploited the camera's ability to collect facts. He said, "Photography is about finding out what can happen in the frame. When you put four edges around some facts, you change those facts. The frame creates a world and photography is about (that) world." When asked why his images were tilted, he replied, "What tilt? There's only a tilt if you believe that the horizon line must be parallel to the horizontal edge. That's arbitrary."*

How do you learn to make better pictures? Once you know the technical basics, where do you go from there? Every time you make an exposure you make choices, either deliberately or accidentally. Do you show the whole scene or just a detail? Do you make everything sharp from foreground to background or have only part of the scene in focus? Do you use a fast shutter speed to freeze motion sharply or a slow shutter speed to blur it? Photography is an exciting and sometimes frustrating medium just because there are so many ways to deal with a subject.

So your first step is to *see* your options, to see the potential photographs in front of your camera. Before you make an exposure, try to visualize the way the scene will look as a print. Looking through the viewfinder helps. The scene is then at least reduced to a smaller size and confined within the edges of the picture format, just as it will be in the print. As you look through the viewfinder, imagine you are looking at a print, but one that you can still change. You can eliminate a distracting background by making it out of focus, by changing your position to a better angle, and so on.

When you look at a photograph—one of your own or someone else's—try to see how the picture communicates its visual content. Photography transforms the passing moment of a three-dimensional event into a frozen instant reduced in size on a flat piece of paper, often in black and white instead of color. The event is abstracted, and even if you were there and can remember how it "really" was, the image in front of you is the tangible remaining object. This concentration on the actual image will help you visualize scenes as photographs when you are shooting.

Edward Weston said, "Good composition is only the strongest way of seeing the subject. It cannot be taught because, like all creative effort, it is a matter of personal growth." But it *can* be learned by looking at photographs, responding to them, asking questions, looking at a scene, trying something, seeing how it looks—and trying again.

335

BASIC CHOICES: CONTENT

Do you want **the whole scene or a detail?** One of the first choices you have to make is how much of a scene to show. Whether the subject is a person, a building, or a tree, beginners often are reluctant to show anything less than the whole thing. If you look at snapshot albums, you will see that people often photograph a subject in its entirety—Grandpa is shown from head to toe even if that makes his head so small that you can't see his face clearly. In many cases, however, it was a particular aspect of the subject that attracted the photographer's attention in the first place, perhaps the expression on the face of the person, the peeling paint on the building, or a bent branch of the tree.

Get closer to your subject. "If your pictures aren't good enough, you aren't close enough," said Robert Capa, a war photographer known for the intensity and immediacy of his images. This simple piece of advice can help most beginning photographers improve their work. Getting closer eliminates distracting objects and simplifies the contents of a picture. It reduces the confusion of busy backgrounds, focuses attention on the main subject, and lets you see expressions on people's faces. *(See photographs, right.)*

What is your photograph about? Instead of shooting right away, stop a moment to decide which part of a scene you really want to show. You might want to take one picture of the whole scene, then try a few details. Let the content determine the size of important objects. Is your picture about the look of an entire neighborhood, about what it's like to walk by a single house in the neighborhood, or about the detail on the gate in front of a house? Sometimes you won't want to move closer, as in photographing a prairie landscape where the spacious expanse of land and sky is important or in making an environmental portrait where the setting reveals something about the person.

Before you bring the camera to your eye, try to visualize what you want the photograph to look like. Then move around a bit as you look through the viewfinder. Examine the edges of the image frame. Do they enclose or cut into the subject the way you want? (More about the frame on pages 338–339 and 352–353.) In time, these decisions come more intuitively, but it can be useful at first to work through them deliberately.

What do you want the subject of your photograph to be? Above, the photographer wanted to show the family members but stood so far back that the picture seems more like one of the back yard. Below, by moving closer, the photograph turned the same scene into an appealing family portrait.

A detail of a scene can tell as much as and sometimes more than an overall shot. Right, part of the life of a working cowboy, a buckaroo, from Paradise Valley, Nevada. Below, the end of a cattle drive to the 96 Ranch's Hartscrabble camp in Paradise Valley.

RICHARD E. AHLBORN: *Boots, Paradise Valley, Nevada, 1978*

CARL FLEISCHHAUER: *Herding Cattle, Paradise Valley, Nevada, 1978*

BASIC CHOICES: FRAMING THE SUBJECT

The **frame** (the edges of a picture) isolates part of a larger scene. Photography is different from other visual arts in the way in which a picture is composed. A painter starts with a blank canvas and places shapes within it. A photographer generally uses the frame of the viewfinder or ground glass to select a portion of the surrounding visual possibilities.

Choices have to be made, consciously or not, about how you crop into a scene and how the edges of the frame relate to the portion of the scene that is shown.

You can leave considerable space between the frame and a particular shape, bring the frame very close so it almost touches the shape, or use the frame to cut into the shape. You can position an edge of an object or a line within an object so that it is parallel to one edge of the frame or position it at an angle to the frame. Such choices are important because the viewer, who can't see the surroundings that were left out of the picture, *will* see how the frame meets the shapes in the print. There is no need to be too analytical about this. Try looking at the edges of the viewfinder image as well as at the center of the picture and then move the frame around until the image you see through the viewfinder seems right to you. You can also cut a small rectangle in an 8 × 10-inch piece of black cardboard and look through the opening at a scene. Such a frame is easier to move around

and see through than a camera and can help you visualize your choices.

Judicious cropping can strengthen a picture, but awkward cropping can be distracting. Ordinarily it is best not to cut off the foot of someone in motion or the hand of someone gesturing, but the deliberate use of such unconventional cropping can be effective. Some pictures depend on the completion of a gesture or motion and are difficult or impossible to crop successfully.

Portrait photographers recommend that you do not crop a person at a joint, such as a wrist or knee, because that part of the body will look unnaturally amputated or will seem to protrude into the picture without connection. It can also seem awkward if the top of a head or an elbow or a toe just touches the edge of the frame. Generally, it is better to crop in slightly or to leave a space.

Should your picture be **horizontal or vertical?** It is common for beginners to hold a 35mm camera horizontally and only seldom to turn it to a vertical position. Unless you have a reason for doing otherwise, hold the camera horizontally for a horizontal subject, vertically for a vertical one. Otherwise, you are likely to create empty space that adds nothing to the picture. A horizontal format shows width side to side *(see page 348)*, while a vertical format shows height or depth near to far *(see page 341)*. Even if your film format is square, you may later want to crop the picture to a rectangular format.

JONAS DOVYDENAS: *Baker*

How does the frame of a photograph (its edges) enclose a subject? How much space, if any, is needed around a subject? You may overlook framing when you are shooting, but it will be immediately evident in the final picture. Above, would you crop anything in this picture, or do you like it as it is?

Sandi Fellman often uses richly textured fabrics and other sensuous, visually complex elements in her work. Here, one of a series of photographs she made on the Japanese art of tattoo. She saw these elaborate tattoos as "an inversion of what I do in my photographs, which is to surround the figure with external decoration." The photographs both fascinate and repel; the viewer may admire the work of the tattoo artist, but flinch at the use of a human canvas. The motif of this tattoo is Kintaro, a hero in Japanese folklore, who is depicted wrestling with a giant carp. Fellman has posed her subject grasping his own sides just as Kintaro grasps the fish. The image is cropped in a way that isolates the tattoo and hands, as if the man is showing you a canvas, which is his back.

SANDI FELLMAN: *Kintaro and Maple Leaves Tattoo,* 1984

BASIC CHOICES: BACKGROUNDS

The **background** is part of the picture. Although some photographs are made to show an overall view or a texture or pattern, and so have no single subject, most photographs have a particular object or group of objects as a center of interest. When we look at a scene we tend to focus our attention on whatever is of interest to us and ignore the rest, but the lens includes everything within its angle of view. What do you do when your subject happens to be in front of a less interesting or even distracting background?

If background objects don't add anything to a picture except visual clutter, do what you can to eliminate them or at least to minimize their importance. Usually it is easiest to change your position so that you see the subject against a simpler background *(see right)*. Sometimes you can move the subject instead.

Even a busy background will call less attention to itself if it is blurred and indistinct rather than sharply focused. Set your lens to a wide aperture if you want to make the background out of focus while keeping the subject sharp. This works best if the background is relatively far away and you are focused on a subject that is relatively close to the camera. (See pages 52–53 for more about controlling the depth of field, the area that is sharp in a photograph.) The viewfinder of a single-lens reflex camera shows you the scene at the lens's widest aperture; if you examine the scene through the viewfinder you will get an idea of what the background will look like at that aperture. Some lenses have a preview button that stops down the lens so you can see depth of field at any aperture.

Use the background when it contributes something. Even though many photographs could be improved by shooting closer to the subject, don't always zero in on a subject or you may cut out a setting that makes a picture come alive. An environmental portrait like the ones on pages 166–167 uses the background to tell you something about the subject. Backgrounds can give scale to a subject, or vice versa. And some backgrounds are what the picture is all about *(see opposite page)*.

What's in the background? In a photograph, objects that are far apart in depth can appear to be close together if they are in the same line of sight. Check the background before you take a picture, or you may end up with a distracting background that was easy to overlook while you were shooting but that will be hard to ignore in a print. Top, a classic example: a person with a tree (or telephone pole or lamp or other unrelated object) growing out of her head. Below, choosing another angle and moving in slightly closer produced a less distracting background.

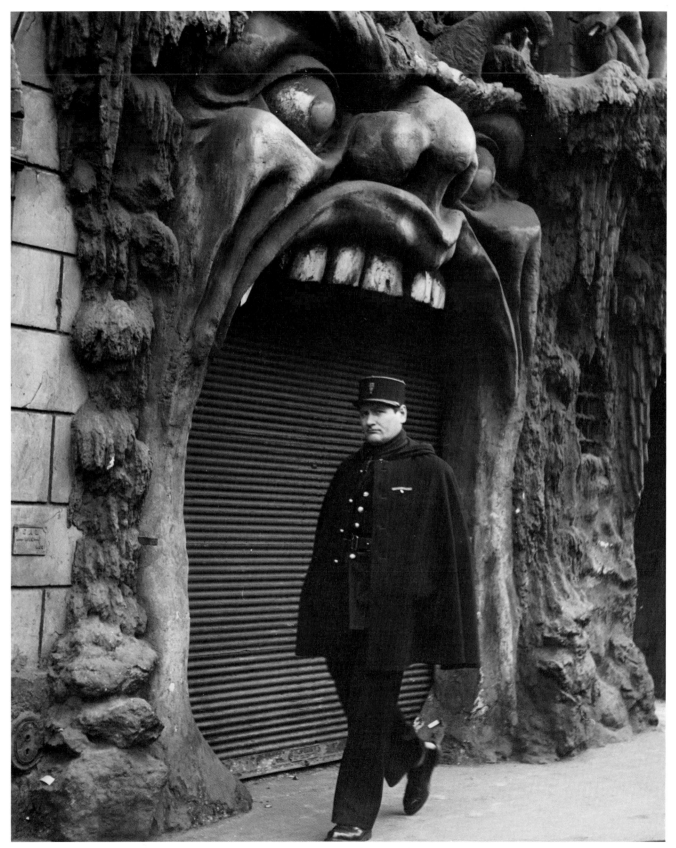

Some backgrounds make it worthwhile to set yourself up and wait until someone walks in front of them. Above, a Paris policeman crosses the entrance to an abandoned night spot, L'Enfer (Hell).

ROBERT DOISNEAU: *Cabaret L'Enfer, Boulevard de Clichy, Paris, 1952*

BASIC DESIGN: SPOT/LINE

What good is design? Most photographs are not constructed but are taken in a pre-existing environment from which the photographer, often working quickly, must select the best views possible. Nevertheless, it is still important for photographers to understand design concepts such as spot, line, shape, pattern, emphasis, and balance because certain elements of design are powerful in their ability to direct a viewer's attention.

Knowing, for example, that a single small object—a spot—against a contrasting background attracts attention will help you predict where attention will go in a photograph. Even if you want to work fast and intuitively rather than with slow precision, some basic knowledge about design will help you fine-tune and speed up your responses to a scene, and it will make you better able to evaluate your own and other people's work.

A single element of design seldom occurs in isolation. Although one can talk about the effect of a spot, for example, other design elements are almost always present, moderating each other's effect. Attention might be drawn by a spot and then attracted away by a pattern of lines elsewhere in the print. The simpler the subject, the more important any single element becomes, but one element rarely totally dominates any composition. The human element may attract the most attention of all; people will search out human presence in a photograph despite every obstacle of insistent design.

Any small shape, not necessarily a round one, can act as a **spot** or **point.** The word *spotlight* is a clue to the effect of a single spot against a neutral or contrasting background: it draws attention to itself and away from the surrounding area. This can be good if the spot itself is the subject or if in some way it adds interest to the subject. But a single spot can also be a distraction. For instance, a small bright object in a dark area can drag attention away from the subject; even a tiny, dark dust speck can attract attention if it is in a blank sky area.

The eye tends to connect two or more spots like a connect-the-numbers drawing. If there are only two spots, the eye continues to shift back and forth between them, sometimes a confusing effect if the eye has no place on which to settle attention. If there are three or more spots, suitably arranged, the brain will make shapes—a triangle, a square, and so on—out of them.

A **line** is a shape that is longer than it is wide. It may be actual or implied, as when the eye connects a series of spots or follows the direction of a person's gaze. Lines give direction by moving the eye across the picture. They help create shapes when the eye completes a shape formed by a series of lines. In a photograph, lines are perceived in relation to the edges of the film format, which are very strong implied lines. This relationship is impossible to ignore, even when the lines are not near the edges of the print.

According to some theories, lines have psychological overtones: horizontal (calm, stability); vertical (stature, strength); diagonal (activity, motion); zigzag (rapid motion); curved (gracefulness, slowness). Horizontal objects, for example, tend to be stable, so we may come to associate horizontality with stability. In a similar way, yellows and reds conventionally have overtones of warmth by way of their associations with fire. However, such associations vary from person to person and are as much dependent on the subject as on any inherent quality in a line.

JOHN SEXTON: *Bleached Branch and Bush, Mono Lake, California,* 1986

The line of the bleached branch in the foreground makes a strong path that is easy for the eye to follow, especially because the light branch contrasts with the darker background. How does your eye move along the thin, interweaving lines of the bush?

RUSSELL LEE: *Hidalgo County, Texas,* 1939

The eye tends to connect two or more spots into a line or shape, and above, the spots formed by the dark hardware against the light cabinets are an insistent element. Russell Lee often used direct flash on camera, especially in his work, as here, for the Farm Security Administration (see page 384). Lee liked direct flash because it rendered details sharply and was easy to use. It also produces minimal shadows and so tends to flatten out the objects in a scene into their graphic elements. The scene above has a harsh, clean brightness that is appealing in its austerity and to which the direct flash contributed.

BASIC DESIGN: SHAPE/PATTERN

A **shape** is any defined area. In life, a shape can be two-dimensional, like a pattern on a wall, which has height and width; or three-dimensional, like a building, which has height, width, and depth. In a photograph, a shape is always two-dimensional, but tonal changes across an object can give the illusion of depth. Notice in the illustration at right how flat the large leaf, with its almost uniform gray tone, looks compared with the light and dark ridges of the smaller leaf. You can flatten out the shape of an object entirely by reducing it to one tone, as in a silhouette. The contour or edge shape of the object then becomes dominant, especially if the object is photographed against a contrasting background *(see page 107)*.

A single object standing alone draws attention to its shape, while two or more objects, such as the leaves at right, invite comparison of their shapes, including the shape of the space between them. The eye tends to complete a strong shape that has been cropped by the edge of the film format; such cropping can draw attention repeatedly to the edge or even out of the picture area. Try cropping just into the left edge of the large leaf to see this effect.

Objects that are close together can be seen as a single shape. Objects of equal importance that are separated can cause the eye to shift back and forth between them, as between two spots. Bringing objects closer together can make them into a single unit, for example, the women on the opposite page. Portrait studio photographers try to enhance the feeling of a family as a group by posing the members close together, often with some physical contact, such as placing one person's hand on another's shoulder. Notice how The Critic *(page 263)* is separated from the society women by space as well as by social standing.

Groupings can be visual as well as actual. Aligning objects one behind the other, intentionally or not, can make a visual grouping that may be easy to overlook when photographing a fast-moving scene but which will be readily apparent in a photograph.

The repetition of spots, lines, or shapes in a **pattern** can add interest and unite the elements in a scene, as do the small, dark squares in the photograph on page 343. A viewer quickly notices variations in a pattern or the contrast between two patterns, in the same way that contrast between colors or between light and dark attracts the eye.

PAUL CAPONIGRO: *Two Leaves, 1963*

What route does your eye follow when it looks at the photograph above? One path might be up the right edge of the larger leaf, up the curved stem, around the smaller leaf to its bright tip, then down again to make the same journey. Take a small scrap of white paper and put it over the bottom tip of the larger leaf. Does your eye follow the same path as before, or does it jump back and forth between what are now two bright spots?

A group of Black Muslim women form a solid band behind one of their leaders. Gordon Parks photographed relatively closer to the woman in front than to the others, which made her appear larger; being closer to her also reduced the depth of field so that when Parks focused on her, only she was sharp. The individual identities of the other women have been submerged by their being out of focus and by the repeated shapes of their headdresses forming a pattern. The picture clearly identifies the leader and makes a visual statement about the solidarity of her followers.

GORDON PARKS: *Muslim Women*, 1962

BASIC DESIGN: EMPHASIS/BALANCE

Emphasis on an element will direct attention to it. If too many parts of a photograph demand equal attention, a viewer won't be sure what to look at first. How do you emphasize some part of a photograph or play down another so that the viewer knows what is important and what isn't?

Contrast attracts attention. The eye quickly notices differences such as sharp versus unsharp, light versus dark, large versus small. If you want to emphasize a subject, try to show it in a setting against which it stands out. Viewers tend to look at the sharpest part of a picture first, so you can call attention to a subject by focusing it sharply while leaving other objects out of focus *(see pages 348–349)*. The contrast of light and dark also adds emphasis; a small object can dominate a much larger background if it is of a contrasting tone or color.

Camera angle can emphasize a subject. If unnecessary clutter draws attention away from your subject, get closer. Shooting closer to an object will make it bigger while eliminating much of the surroundings. Sometimes shooting from a slightly higher or lower angle will remove unnecessary elements from the camera's angle of view.

Use surrounding parts of the scene to reinforce emphasis. Objects that are of secondary interest, such as fences, roads, or edges, can form sight lines directed to the subject *(right, top)*. The point at which two lines (real or implied) intersect attracts notice *(see page 351)*, as does the direction in which people are looking. You may be able to find something in the foreground to frame the main subject and concentrate attention on it

(see opposite page). A dark object may be easier than a light one to use as a frame because lighter areas tend to attract the eye first, but this is not always the case.

People know when a picture is in **balance** even if they can't explain why. A picture that is balanced does not call attention to that fact, but an unbalanced one can feel uncomfortably off center or top-heavy. Visually, dark is heavier than light, large is heavier than small, an object at the edge has more weight than at the center (like a weight on a seesaw), and a picture needs more apparent weight at the bottom to avoid a top-heavy feeling. Except in the simplest cases, however, it is difficult to analyze exactly the weights and tensions that balance a picture, nor do you need to do so. A viewer intuitively weighs complexities of tone, size, position, and other elements, and you can do the same as you look through the viewfinder. Ask yourself if the viewfinder image feels balanced or if something isn't quite right that you would like to change. Move around a bit as you continue to look through the viewfinder. Even a slight change can make a big difference in a scene.

A centered, symmetrical arrangement, the same on one side as it is on the other, will certainly feel balanced and possibly satisfyingly stable, but it also may be boring. Some tension in a picture can be an asset. Perfect balance, total harmony, and exact symmetry make little demand on the viewer and consequently can fail to arouse interest. Try some off-center, asymmetrical arrangements; they risk feeling unbalanced but may succeed in adding impact *(right, bottom)*.

ROY CLARK: *Troublesome Creek, Kentucky,* 1965

A man crosses a footbridge over Troublesome Creek in Kentucky. Lines formed by the sides and planks of the bridge focus attention on the man, as does his placement near the center of the picture. The quiet scene gets added interest from the man's dark form against the lighter boards of the bridge, his foot just raised in midstep, and the house in front of him as his visible destination.

R. O. BRANDENBERGER: *Skier, Idaho,* 1966

An off-center, asymmetrical composition can have a dynamic balance that is absent from a centered, symmetrical one. Take some sheets of white paper and lay them over the bottom and right side of the photo above so that the skier is centered in the frame. The picture is still interesting but lacks the headlong rush that it has when the long slope of the hill is visible.

DENNIS STOCK: *James Dean in Light and Shadow*, 1955

To emphasize your main subject, you can use a foreground object as a frame. A portrait of the actor James Dean, made in the year of his death, uses the dark shadows of a stairwell to frame him in a diamond-shaped patch of light. Dean's image was full of contradictions—tough and sensitive, boyish and manly, polite and wild—and the photograph echoes this in its split between light and dark, face only half visible, head shown both straight on and profiled in the shadow cast on the wall.

MORE CHOICES: USING CONTRASTS OF SHARPNESS

In ordinary life, if your eyes are reasonably good, you seldom have to consider whether things are sharp or not. The human eye, like a camera lens, must refocus for objects at different distances, but the eye scans and refocuses so quickly that you rarely are aware of the process. The sharpness of a photograph or of its various parts, however, is immediately noticeable.

People tend to look at the sharpest part of a photograph before they look at parts that are less sharp. If a photograph is sharp overall, the viewer is more likely to see all parts of it as having equal value *(see below)*. You can emphasize some part of a subject by making it sharper than the rest of the picture *(see page 51)*.

Depth of field affects sharpness from near to far. If you focus on an object and set your lens to a wide aperture, you will decrease the depth of field (the acceptably sharp area) so that the background and foreground are more likely to be unsharp. Or you can use a small aperture to have the picture sharper overall.

Motion can be photographed either sharp or blurred. In life, moving objects appear sharp unless they are moving extremely fast, such as a hummingbird's wings. In a photograph, you can use a fast shutter speed to freeze the motion of a moving object. Or you can use a slow shutter speed to deliberately blur the motion—just enough to indicate movement or so much that the subject's shape is al-

tered *(see opposite page, left)*. Although the sharpest part is usually emphasized because the viewer tends to look there first, occasionally blurred motion attracts attention because it transmits information about how fast and in what manner the subject is moving.

If you change to a faster shutter speed to show motion sharp, you have to open to a larger aperture to keep the exposure the same. Since a larger aperture gives less depth of field, you may have to decide whether the sharpness of a moving object is more important than the sharpness of depth of field. It may be impossible to have both. (To review the relationship between shutter speed and aperture, see pages 20–21.)

U.S. DEPARTMENT OF AGRICULTURE: *Family and Food,* 1981

Pictures that convey data are often sharp overall. The United States Department of Agriculture photographed (left to right) Cynthia, John, Clint, *and Valerie Schnekloth of Eldridge, Iowa, surrounded by the two and a half tons of food an average American family consumes in a year.*

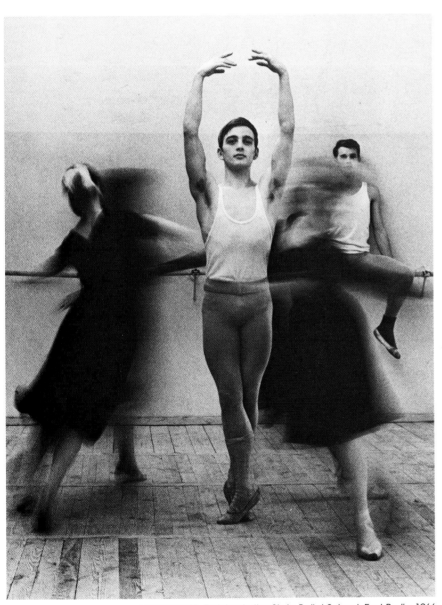

HERBERT LIST: *Training in the State Ballet School, East Berlin*, 1966

In his photograph of dancers, Herbert List used a relatively slow shutter speed. The contrast between the blur of the moving dancers and the sharpness of those that are not moving makes the blurred areas look even more in motion than if all the dancers had been blurred. Photographs such as this give an impression of time and movement that belies the term "still" photograph.

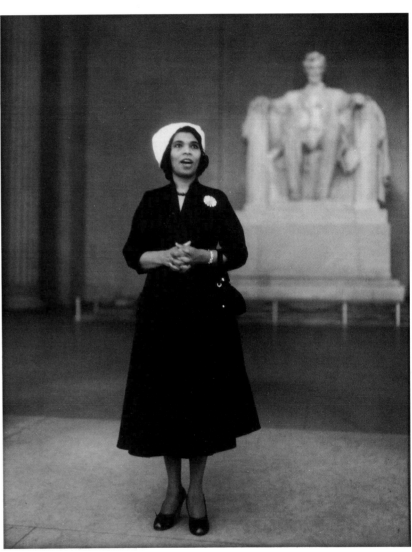

ROBERT S. SCURLOCK: *Marian Anderson, Washington, D.C.*, 1939

An out-of-focus object can still be a strong element in a photograph. In 1939, because she was black, the renowned singer Marian Anderson was barred from giving a concert at the Daughters of the American Revolution's Constitution Hall in Washington, D.C. In response to this, Eleanor Roosevelt helped arrange for Anderson to give a concert from the steps of the Lincoln Memorial. Robert Scurlock focused on Anderson, which made the statue of Lincoln in the background diffused but recognizable, as if listening to Anderson sing.

MORE CHOICES: USING CONTRASTS OF LIGHT AND DARK

Contrast between light and dark draws a viewer's eye. A farmer's hands against a dark background, the outline of a leafless tree against a bright sky, a rim of light on someone's hair, a neon sign on a dark street—light not only illuminates a subject enough to record it on film but by itself can be the subject of a photograph.

Contrast sets off one part of a scene from another. Would you put a black ebony carving against a dark background or a light one? The dark background might make a picture that would be interesting for its somber tones. The light one would make a setting against which the carving would stand out prominently, just as a dark background contrasts with and sets off light tones *(photograph, page 355, left)*. If you squint as you look at a scene, you can often get a better idea of what the tones will look like in a print and whether you should change your angle or move the subject to position it against a better background.

Contrast between two objects may be more apparent in color than in black and white. A red flower against green leaves is distinctly visible to the eye but may merge disappointingly into the foliage in a black-and-white print. The brightness of the flower is very similar to that of the leaves even though the colors are different. *(See information on filters, pages 84–85 and 87.)*

Light along the edge of an object can make its shape stand out. If you chose to work with a dark background for an ebony statue, you could use edge lighting to make sure the statue didn't merge into the shadows behind it. Studio photographers often position a light so that it spills just over the edge of a subject from the back, making a bright outline that is effective against a darker background. Outdoors, the sun can create a similar effect if it illuminates the back or side of an object rather than the front.

Shadows or highlights can be shown as separate shapes. The contrast range of many scenes is too great for photographic materials to record realistically both dark shadows and bright highlights in one picture. This can be a problem, but it also gives you the option of deliberately using detailless shadows or highlights as independent forms.

You can adjust contrast somewhat during film processing and printing. Once film has been processed, the relative lightness or darkness of an area is fixed on the negative, but you can still change tones to some extent during printing by such techniques as changing the contrast grade of the paper or printing filter, burning in (adding exposure to darken part of a print), and dodging (holding back exposure to lighten an area). Contrast control with black-and-white prints is relatively easy; color prints allow less manipulation. Digital imaging offers another way to make changes in light and dark areas *(see pages 282–285)*.

JUDY DATER: *Maggi Wells,* 1970

Film may show shadows as darker than they seemed during shooting. Our eyes make adjustments for differences in light level, but film can record details in only a fixed range of brightnesses. So a photograph may record shapes of light and dark that in life we find easy to overlook. Above, a portrait that is more than just a silhouette of someone's profile against a lighter background. The portrait is expressive and informative, even though—and partly because—the face is hidden.

BILL HEDRICH: *Oakton Community College, Des Plaines, Illinois,* 1981

The photography firm of Hedrich-Blessing has specialized in architectural photography since 1929. The firm is noted for its ability to produce dramatic photographs that are also truthful renditions of a building's features. Here, the image is strongly oriented toward the point where the lines of the building cross with the building's own shadow. Notice how the photographer has placed two people at the crossing point and has positioned the people at right so their shadows line up with the edge of the building.

MORE CHOICES IN FRAMING

Placement of the subject within the frame can strengthen an image. If you look at a scene through a camera's viewfinder as you move the camera around, you will probably see several choices for positioning the subject within the frame of the film format: dead center or off to one side, high or low, at one angle or another. Placement can draw attention to or away from a part of a scene. It can add stability or create momentum and tension. Some situations move too fast to allow any but the most intuitive shooting, but often you will have time to see what the effect will be with the subject in one part of the frame rather than another.

The most effective composition arises naturally from the subject itself. There are traditional formulas for positioning the center of interest *(see box, right)*, but don't try to apply them rigidly. The goal of all the suggestions in this chapter is not to provide a set of rules but to help you become more flexible as you develop your own style. The subject may also have something to say if you try to hear it. Minor White, who was a teacher as well as a photographer, used to tell his students to let the subject generate its own composition.

The **horizon line**—the dividing line between land and sky—is a strong visual element. It can be easy, without much thought, to position the horizon line across the center of a landscape, dividing a scene into halves. Some photographers divide a landscape this way as a stylistic device, but unless handled skillfully, this can divide a picture into two areas of equal and competing interest that won't let the eye settle on either one. One suggestion for placement is to divide the image in thirds horizontally, then position the horizon in either the upper or lower third *(photograph, this page)*. You can also try putting the horizon very near the top or the bottom of the frame.

Stop for a moment to consider what you want to emphasize. A horizon line toward the bottom of the frame emphasizes the sky. A horizon toward the top lets you see more of the land but still includes the strong contrast of sky. Omitting the horizon altogether leaves the eye free to concentrate on details of the land. Even if no horizon line is visible, a photograph can feel misaligned if the camera is tilted to one side. Unless you want to tilt a picture for a purpose, always level the camera from side to side; for a tilt with a purpose, see page 334.

Motion should usually lead into, rather than immediately out of, the image area. Allow enough space in front of a moving subject so it does not seem uncomfortably crowded by the edge of the frame. The amount of space depends on the scene and your own intention. In a photograph, the direction in which a person (or even a statue) looks is an implied movement and requires space because a viewer tends to follow that direction to see what the person is looking at. Although it is usually best to allow adequate space, you can deliberately create tension to add interest to some scenes by framing a subject so that it looks or moves directly out of the picture area.

A subtler tension may be added simply by movement of a subject from right to left. For example, for people whose written language reads from left to right, a subject with strong left-to-right movement may seem slightly more natural or comfortable than a subject with strong right-to-left motion. You can see if you get this effect by looking at the photograph of the skier on page 346 and then looking at it in a mirror to reverse the subject's direction.

Compositional Formulas

In the 19th century, rules of photographic composition were proposed based on techniques used by certain painters of the period. The rule of thirds, for example, was (and still is for some photographers) a popular compositional device. Draw imaginary lines dividing the picture area into thirds horizontally, then vertically. According to this formula, important subject areas should fall on the intersections of the lines or along the lines. A person's face, for example, might be located on the upper left (theoretically the strongest) intersection, a horizon line on either the upper or lower horizontal line, and so on.

Try such formulas out for yourself. Experimenting with them will make you more aware of your options when you look at a scene, but don't expect a compositional cure-all for every picture. Look at photographs that work well, such as the one opposite or on page 43, to see if they fit a particular rule. If they don't, what does make them successful images?

ROBERT BRANSTEAD: *Along the Snake River, Wyoming,* 1971

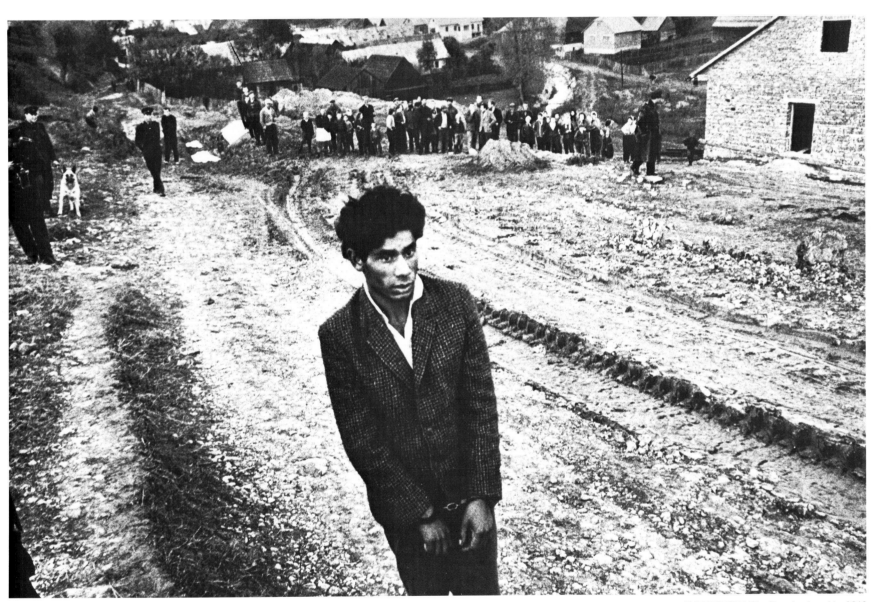

JOSEF KOUDELKA: *Czechoslovakia*, 1963

◄ The conventional placement for a horizon line in a landscape is more or less in the upper (or lower) third of the picture. (The lightness of the grass and trees is due to the use of infrared film. See pages 80–81.)

The most extraordinary photographs merge composition with content on a level that rules do not explain. Above, one of many photographs made by Josef Koudelka showing Gypsies of Eastern Europe. The man, having been found guilty of murder, is on the way to the execution ground.

John Szarkowski wrote about this photograph, "The handcuffs have compressed his silhouette to the shape of a simple wooden coffin. The track of a truck tire in the earth, like a rope from his neck, leads him forward. Within the tilted frame his body falls backward, as in recognition of the terror."

MORE CHOICES: PERSPECTIVE AND POINT OF VIEW

Perspective creates an illusion of three dimensions in a two-dimensional photograph. The relative distance of objects from the lens and from each other is the most direct control of perspective. The brain judges depth in a scene mostly by comparing the size of objects in the background; the bigger the apparent difference in the size of similar objects, the greater the distance between them seems to be. Move some object (or some part of it) very close to the lens, and it will look much bigger and therefore much closer than the rest of the scene. Parallel lines that appear to converge (to meet in the distance) are a strong indicator of depth *(see photograph, page 81)*. The convergence is caused by the nearer part of the scene appearing bigger than the farther part.

Other factors affect perspective to a lesser degree. A sharply focused object may appear closer than out-of-focus ones. Side lighting enhances the impression of volume and depth, while front lighting or a silhouette reduces it. The lower half of a picture appears to be (and generally is) closer than the upper half. Overlapping objects also indicate which is closer. Warm colors (reds and oranges) often appear to come forward, while cool colors (blues and greens) appear to recede. In general, light-toned objects often appear to be closer than dark ones, with an important exception: atmospheric haze makes objects that are farther away lighter in tone than those that are closer, and a viewer recognizes this effect as an indication of distance in a landscape. Another factor is less consciously perceived by many people but still influences their impression of depth: objects appear to rise gradually relative to a viewer's position as they approach the horizon *(see landscape, this page)*.

Photographs of landscapes often fail because the photographer was unable to convey an impression of depth. This is why people have to resort to words when they show you their vacation snapshots: they have to tell you how wonderful the scenery was because their pictures make even the Grand Canyon look flat and boring. To extend the impression of depth, especially in landscapes but also in any scene, try some or all of the following. Position some object in the foreground; if similar objects (or others of a known size) are farther away, the viewer will make the size comparisons that indicate depth. This technique can also add interest to an otherwise bland scene. Position the horizon line in the upper part of the picture. Introduce lines (particularly converging ones), such as a road or a fence, that appear to lead from foreground to background.

An eye-level **point of view** is unobtrusive in a photograph, but shooting from higher or lower than eye level is more noticeable. Photographing an object by looking up at it can give it an imposing air as it looms above the viewer. Vertical lines, as in a building, appear to converge when the camera is tilted up, increasing the feeling of height. Looking straight down on a subject produces the opposite effect: objects are flattened out *(see photographs, opposite)*.

A moderate change in camera angle up or down can give a slight shift to the point of view, making a subject appear somewhat bigger or somewhat smaller without unduly attracting the viewer's attention. When you approach a scene, don't always shoot at eye level or in the first position from which you saw the subject. Look for interesting angles, the best background, or other elements that could add interest.

MARION POST WOLCOTT: *Fields of Shucked Corn, West Virginia,* 1940

One of the standard recommendations for landscape photography is, "Put something in the foreground to give the scene depth." The reason that this device is used so often is that it does give a feeling of depth. Our perception of depth is mostly due to size comparisons between near and far objects, and in the photograph above, it is easy to compare the size of the fence rails in the foreground with those at the end of the field.

It is your handling of whatever you put in the foreground that can rescue a well-used device of this sort from being a cliché. So many photographers have sighted along a fence or randomly included a branch of a tree across the top of a scene that it can be hard to see past the device itself. Here, the device gains interest because the line of the fence also draws the eye from the foreground deeper into the scene, and then down the rows of corn even farther away.

DAVID MOORE: *Sisters of Charity, Washington, D.C.,* 1956

Looking straight down on a subject can appear to flatten space and reduce a subject to its graphic elements. Above, David Moore looked down from an airport mezzanine at a group of nuns. Their white coifs stand out in flowerlike shapes against their black robes.

DOROTHEA LANGE: *Lettuce Cutters, Salinas Valley, California,* 1935

Dorothea Lange, like Marion Post Wolcott, made many photographs for the Farm Security Administration to document the plight caused by the Depression of the 1930s. Lange's photographs often had an almost epic quality. Above, seemingly impassive as statues, members of a gang of migrant laborers bend to a crop of lettuce. Shooting from a low point of view can create an intimacy with a subject as the photograph—and so the viewer—joins the scene instead of impassively observing it from above. See also the Lange photograph on page 385.

SHOWING YOUR WORK TO EDITORS AND OTHERS

LOOKIN
PHOTO

Photographs a
a certain vis
beauty of a
the gritty look
snapshots are
in Paris" is a
snapshot. WI
found in a
what graphic
viewer? You
what the pho
can identify
graph has fo
questions you
look at a pho
ask every qu
can give you
right lists sor
scribe visual e
 1) What t
Sometimes th
an advertisin
news photog
caption or title
tion, but look
caption does
 2) What ca
the **photogra**
ample, is an
tended to c
product? Or i
about the be
people who u
plication that
feel just like t
 3) What e
pher created
done? For e
been used so
of the scene
parts are not'
 4) Do **tech**
the image? F
ement—perh

Suppose you decide to show your work to an editor, agency, potential client, gallery, or museum. What kind of work should you show? Editors, agents, and clients are looking for specific types of work, and you should tailor your portfolio to show them pictures they can use. Gallery and museum people, on the other hand, want to see your personal point of view. All of them give the same advice: Don't pad your portfolio. Putting mediocre pictures in with good ones produces a mediocre portfolio.

Andy Grundberg, Director, The Friends of Photography, San Francisco. For shows at The Friends' Ansel Adams Center for Photography, Grundberg says he is looking for "work that is not safe and conventional, for things that I haven't seen before." Grundberg says that photographers must put their own work in context. "Look at everybody else's work— how it is presented, the quality of it." He recommends that you don't make your portfolio physically difficult to see. Wrapping prints individually, putting a tissue under an overmat, and introducing other protective barriers can be time consuming and frustrating to viewers, especially when they might have 20 other portfolios to look at that day.

Tom Kennedy, Director of Photography, National Geographic Society. This organization publishes several magazines, including their familiar yellow-covered *National Geographic* magazine; *World* magazine, which is for children; and *Traveler.* "What impresses me most," Kennedy says, "is someone who is clearly working from a base of passion and commitment. Someone who understands their subject matter so well that they're able to get those special moments that are rich in content. If they express those moments

with an aesthetic ability to use color to maximum advantage, to see light, to compose—that's what I want."

Bob Lynn, Graphics Director, *The Virginian-Pilot* and *The Ledger-Star,* Norfolk, Virginia. Lynn *(above, right)* is in charge of photography and graphics for all editions of these newspapers. When he opens a portfolio, he hopes he will find surprises, not clichés or even good but standard imagery. "I want someone who can see ordinary events in a different way or who can capture ironies in human behavior that others don't see." He suggests that photographers show only work of which they are especially proud. People often try to prove to him that they can shoot sports, spot news, general features, and every other photojournalism category, and as a result they include lesser pictures. When they do, he wonders if they can tell good work from bad. "If you don't have it, don't show it."

Brigitte Barkley, Foreign Correspondent, *Geo.* *Geo,* a German magazine, publishes illustrated articles about new developments or life styles in countries around the world, new discoveries in the sciences, and adventurous, unusual, or exotic happenings. *Geo* maintains an office in New York, where Barkley's job is to screen material before submitting it to the main office in Hamburg. She wants to see photojournalism, not travel pictures, and she wants a story, not individual photographs. "I want to see how you visually tell a story with a well-defined focus—that you are a photojournalist, not just a picture shooter." Too many photographers say they can do a story but don't show her any examples. "The best find something that interests them and then submit at least the beginning of a good story."

Coni Kaufman, Picture Editor, Delta Air Lines *Sky* Magazine. Magazines like *Sky* are the ones you find on the airplane in the pocket of the seat in front of yours. Kaufman advises that technical considerations like color quality and presentation are important. "I really like color saturation—sharp, true color." She notes that an image is easier to see in large format. If you shoot in 35mm, a 70mm dupe makes the viewing easier and often more likely to be picked simply because it can be seen better.

Mel Scott, Freelance Picture Editor. Formerly an Assistant Picture Editor at *Life* magazine, Scott now works on a variety of picture-editing assignments. "Never," Scott advises, "pad a portfolio. Show your absolute best, not your whole life's work. Don't show one great landscape with ten mediocre ones; the bad ones will only dilute the impact of the great one." He says that photographers should show the kinds of pictures the magazine uses. For example, *Life* now publishes very little news, so there is no point in showing them news pictures. Professionalism is important; editors' days are tightly scheduled, so arrive on time if you are given an appointment.

Scott files a 3 × 5 card for every photographer he sees and then uses that file as a source of names when looking for a photographer. Picture editors often pass names on to each other, so he says not to be discouraged if no work comes right away.

Jennifer B. Coley, Director, Gamma-Liaison. In addition to stock photo sales, this picture agency handles three types of work: corporate and business, entertainment, and news features—each of which tends to attract a different type of photographer. Corporate and business photographs might be used in a company brochure or a business magazine, like *Fortune*. A photographer has to know how to set up single shots, such as a portrait of a company executive or a factory interior. An entertainment photographer also sets up single shots, but with a different awareness of how to deal with the subject. "You don't tell the head of IBM that he's looking great," Coley says, "but you would say that to Jane Fonda." A feature photographer has to be able to tell a story and create a sequence of pictures, not just one good shot. Coley needs to know what a photographer wants to do and then see evidence that he or she can do it. A corporate or entertainment photographer should supply 20 great photos; a feature photographer should show an extended story.

Coley hopes for work that will surprise her, either in subject matter or execution. "I have seen so many photographs that I see mediocrity instantly and pass it by. I see the unique instantly, too." The biggest mistake photographers make, she says, is to wait for other people to tell them what to do. "If you want to do something, go for it. I have seen many photographers improve their work because they have persisted. If you want something enough, you get it."

Evelyne Daitz, Owner and Director, The Witkin Gallery. This long-established New York gallery deals in photography as an art form, with an emphasis on conservative work: "straight" landscapes, still lifes, portraits, and pictures of the human condition. Daitz gets so many requests to look at work that she now looks at portfolios only by photographers who are recommended to her by someone she knows, such as another photographer or curator. Once you get an appointment, however, Daitz, unlike many others, meets with you personally.

Daitz is looking for individual and creative work, not work that is cloned from some other source. She sees many young photographers whose work still shows the influence of their teachers or other photographers. "You must keep working on your own viewpoint. Don't let success or failure influence you. It's your own sense of creativity that is most important." She wants to see "fine" prints, that is, ones with the highest quality printing and presentation. She advises photographers to show their work to as many people as possible; many photographers need outside opinions to help them see their work objectively.

Arthur Ollman, Executive Director, Museum of Photographic Arts, San Diego. Showing your work to a museum (and many galleries) almost always involves a drop-off. You bring or mail your portfolio to the museum, then get it back in a day or two, usually without any personal comment. The experience may feel cold, but, says Ollman, the problem is time. He receives about 40 portfolios a month and looks at all of them. He doesn't have the time to meet with each photographer, nor does he feel it is his job to critique work. He does include a standard thank-you letter when he returns a portfolio; some museums don't do that much.

Ollman looks for a distinctive body of work that focuses on some idea with intensity. He feels many photographers show work without having first employed much self-criticism. Museum and gallery people are thoroughly familiar with the history of photography. "It's not enough to show work that looks like Ansel Adams's. You have to produce your own ideas." He advises photographers to show only their best, and not to get discouraged. "I'm only one person, and if I don't like it, I could be wrong."

PHOTOGRAPHER AT WORK: ILLUSTRATING A CONCEPT

In the seven years that Lois Gervais worked for Atlantic Richfield Company, she photographed everything from oil rigs to executive portraits in every location from Alaska to the company's home base in Los Angeles. Eventually she decided to move out on her own, and she now does corporate, editorial, and advertising work for a variety of clients.

Gervais's specialty is photographic illustration, the creation of photographs that visually interpret or present an idea. Her work is more likely to be about concepts than products; for example, an assignment for a new wine had to be not simply a picture of the wine, but a photograph that conveyed a pleasurable mood. "It is *making* a photograph," she says, "not just taking one of whatever happens to be there." She is responsible for the technical execution of the photograph—how it will be made—and often for its conception—what the picture will show. She frequently works as part of a team that includes an art director and a writer. Sometimes they simply ask her to work from a shooting list or layout; they may ask her for advice on how to technically carry out a photograph; or they may ask her for help with the concept itself. People may have different ideas about what will work, but when it comes to executing a photograph, she is the one who knows how to do it, and in most cases the art director or writer will take her advice.

When Gervais is on the road, she travels with seven cases of equipment: several camera bodies, six lenses, three electronic flash setups including stands and umbrellas, Polaroid gear, meter, film,

and miscellaneous items. One or two assistants help her. At a factory or other location where people are working, an on-site contact is essential; she needs someone who has the authority to ask people to stop work and pose and who understands how various jobs are performed so that the scene looks authentic when photographed.

Gervais says that she tries to get the people she photographs involved in the process so that they feel relaxed and at ease. "Most people are hams when they loosen up, and that can really help me. When I am adjusting my lighting, I make a Polaroid photograph and give that to them. I ask them if there is any way to make it better. I always tell them, 'I am not taking a photograph of you, I am *making* one, and we are going to construct it together.'"

She feels that the fact that she is a woman can help when people are nervous about being photographed. When they have been expecting a male photographer and a 5'2" female arrives instead, she at least has their attention. "People tend to watch what I am doing very closely. I often get comments like, 'It is really interesting to watch you work.' They may be reserved, but they usually don't feel threatened anymore."

Gervais likes going to places that she wouldn't see otherwise, like drilling rigs at sea. Another satisfaction is the essence of photographic illustration itself: solving the problem of how to interpret a concept photographically *(see above right and opposite)*.

LOIS GERVAIS: *Geothermal Energy,* 1977

PETE NEWMAN: *Lois Gervais,* 1983

◀ To illustrate the concept of geothermal energy (energy from the earth), Lois Gervais started with a piece of oiled, black, textured vinyl that resembled a rock surface. In it she mounted the face-plate of a wall outlet with sockets that she had painted red. Underneath she placed a chunk of dry ice in a covered paper cup with a straw coming through the lid, positioning the top of the straw so that it fed into one of the sockets. When she added water to the cup, the dry ice forced a steamy-looking vapor out of the straw. She sprinkled on some water to simulate condensed steam, and lit the whole setup with electronic flash. Gervais credits this shot, which she conceived on her own, as being one of the factors that caused Atlantic Richfield to hire her.

For a brochure promoting one of Atlantic Richfield Company's analytical labs, Lois Gervais combined a long exposure to record the computer screen with a flash exposure for the rest of the scene. First, she composed the picture with the camera on a tripod. She selected the lens aperture she needed to get enough depth of field to have the entire scene sharp—f/16. Then, using Polaroid film, she tested for the exposure time that the screen would need at that aperture—6 min. Finally, she adjusted her flash distance and power so that it would give a correct exposure for the overall scene with the camera lens set to f/16. The combined exposure was made on 35mm transparency film.

LOIS GERVAIS: *Bioengineering Technician*, 1982

PHOTOGRAPHER UNKNOWN: *Daguerreotype of couple holding a daguerreotype*, c. 1850

History of Photography 16

◄ *In the 19th century, photographs of people who were dead or unable to be present were often included in family photographs. It is tempting to try to interpret the relationships among the people shown opposite. The man holds the daguerreotype carefully, his fingers loose and relaxed; he even touches his head to the frame. The woman makes a minimum of contact with the photograph with her right hand and clenches her left hand into a fist. She stares directly into the lens, the corners of her mouth pulled down, unlike the man, who softly gazes into space as if recalling a dear memory. The photograph is revealing, but still unexplained.*

Of all the many inventions of the 19th century—the electric lamp, the safety pin, dynamite, and the automobile are just a few—the invention of photography probably created the most astonishment and delight. Today most people take photographs for granted, but early viewers were awed and amazed by the objective records the camera made: "We distinguish the smallest details; we count the paving-stones; we see the dampness caused by the rain; we read the inscription on a shop sign. . . ."

Photography gradually took over what previously had been one of the main functions of art—the recording of factual visual information, such as the shape of an object, its size, and its relation to other objects. Instead of having a portrait painted, people had "Sun Drawn Miniatures" made. Instead of forming romantic notions of battles and faraway places from paintings, people began to see firsthand visual reports. Photographs recorded what the unaided eye could not see and social miseries that the eye did not *want* to see. And photography began to function as an art in its own right.

This chapter, although extensive, only touches on the rich variety of materials in the history of photography. See the Bibliography for other sources.

DAGUERREOTYPE: "DESIGNS ON SILVER BRIGHT"

LOUIS JACQUES MANDÉ DAGUERRE: *Still Life in the Artist's Studio,* 1837.
Daguerreotype

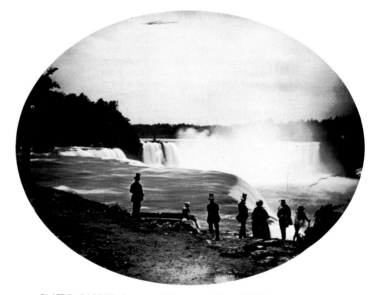

PLATT D. BABBITT: *Group at Niagara Falls,* c. 1855. Daguerreotype

The response to the **daguerreotype** was sensational. After experimenting for many years, both with Niépce and alone, Daguerre was finally satisfied with his daguerreotype process, and it was announced before the French Academy of Sciences on January 7, 1839. A French newspaper rhapsodized: "What fineness in the strokes! What knowledge of chiaroscuro! What delicacy! What exquisite finish! . . . How admirably are the foreshortenings given: this is Nature itself!" A British scientist was more specific: "The perfection and fidelity of the pictures are such that on examining them by microscopic power, details are discovered which are not perceivable to the naked eye in the original objects: a crack in plaster, a withered leaf lying on a projecting cornice, or an accumulation of dust in a hollow moulding of a distant building, are faithfully copied in these wonderful pictures." A daguerreotype viewed close up is still exciting to see. Several are reproduced here, but no printing process conveys the luminous tonal range and detail of an original.

The daguerreotype was made on a highly polished surface of silver that was plated on a copper sheet. It was sensitized by being placed, silver side down, over a container of iodine crystals inside a box. Rising vapor from the iodine reacted with the silver, producing the light-sensitive compound silver iodide. During exposure in the camera, the plate recorded a latent image: a chemical change had taken place, but no evidence of it was visible. To develop the image the plate was placed, silver side down, in another box containing a dish of heated mercury at the bottom. Vapor from the mercury reacted with the exposed areas of the plate. Wherever light had struck the plate, mercury formed a frostlike amalgam, or alloy, with the silver. This amalgam made up the bright areas of the image. Where no light had struck, no amalgam was formed; the unchanged silver iodide was dissolved in sodium thiosulfate fixer, leaving the bare metal plate, which looked black, to form the dark areas of the picture.

Almost immediately after the process was announced, daguerreotype studios were opened to provide "Sun Drawn Miniatures" to a very willing public. By 1853 an estimated 3 million daguerreotypes per year were being produced in the United States alone—mostly portraits but also scenic views.

The daguerreotype was very popular in its time, but it was a technological dead end. There were complaints about the difficulty of viewing, for the image could be seen clearly only from certain angles. The mercury vapor used in the process was highly poisonous and probably shortened the life of more than one daguerreotypist. But the most serious drawback was that each plate was unique; there was no way of producing copies except by rephotographing the original. What was needed was a negative-positive process where any number of positive images could be made from a single negative.

◀ *The earliest known daguerreotype (far left) is by the inventor of the process, Louis Daguerre. The exposure was probably several minutes long—much less than the eight hours required by Niépce's heliograph. The enthusiastic reception of Daguerre's process extended to poetry: "Light is that silent artist / Which without the aid of man / Designs on silver bright / Daguerre's immortal plan." Niagara Falls (near left) was already a world-famous tourist attraction when Platt Babbitt made this daguerreotype about 1855.*

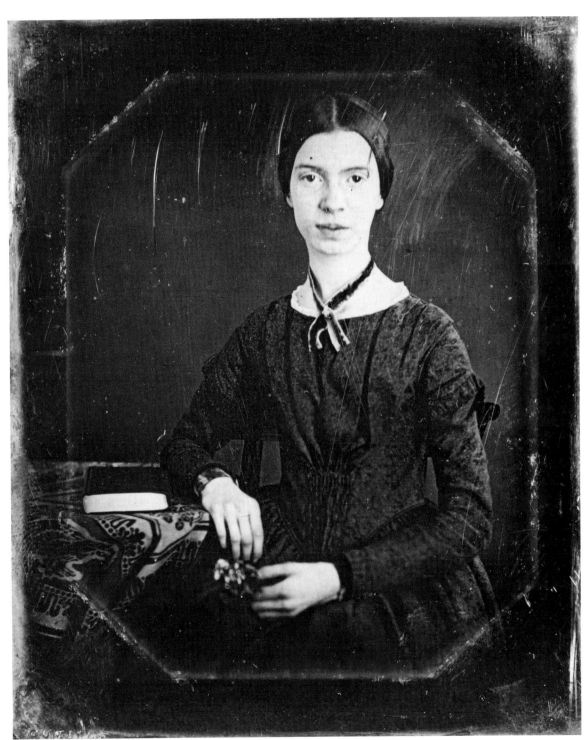

It was in America that the daguerreotype reached the height of its popularity. Millions of Americans, famous (right) and obscure, had their portraits made. Although the exposure time was reduced to less than a minute, it was still long enough to demand a quiet dignity on the part of the subject. This portrait, taken by an itinerant daguerreotypist, is the only known photograph of the 19th-century poet Emily Dickinson. Just like her poems, it seems direct on the surface but elusive on more intimate levels. Dickinson later described herself as "small, like the wren; and my hair is bold, like the chestnut burr; and my eyes, like the sherry in the glass that the guest leaves."

PHOTOGRAPHER UNKNOWN: *Emily Dickinson at Seventeen*, c. 1847. Daguerreotype

CALOTYPE: PICTURES ON PAPER

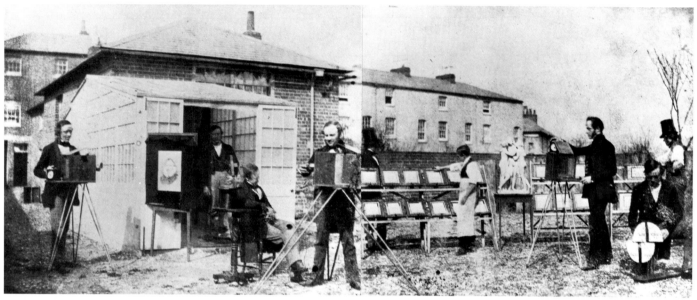

WILLIAM HENRY FOX TALBOT: *Talbot's photographic establishment,* c. 1844. Calotype

On January 25, 1839, less than three weeks after the announcement of Daguerre's process to the French Academy, an English amateur scientist, William Henry Fox Talbot, appeared before the Royal Institution of Great Britain to announce that he too had invented a way to fix the image of the camera obscura. Talbot was a disappointed man when he gave his hastily prepared report; he admitted later that Daguerre's prior announcement "frustrated the hope with which I had pursued, during nearly five years, this long and complicated series of experiments—the hope, namely, of being the first to announce to the world the existence of the New Art—which has since been named Photography."

Talbot's first experiments had been similar to Wedgwood's; he had made negative silhouettes by placing objects on paper sensitized with silver chloride and exposing them to light. Then he experimented with images formed by a camera obscura. The light-sensitive coating used in his early experiments was exposed long enough for the image to become visible during the exposure.

In June 1840 Talbot announced a technique that not only shortened the exposure time considerably but also became the basis of modern photographic chemistry: the sensitized paper was exposed only long enough to produce a latent image, which then was chemically developed. Talbot reported that nothing could be seen on the paper after exposure, but "the picture existed there, although invisible; and by a chemical process . . . it was made to appear in all its perfection." To make the latent negative image visible, Talbot used silver iodide (the light-sensitive element of the daguerreotype) treated with gallo nitrate of silver. He called his invention a **calotype** (after the Greek *kalos,* "beautiful," and *typos,* "impression").

Talbot realized the value of having photographs on paper rather than on metal: his images were easily reproducible. He placed the fully developed paper negative in contact with another sheet of sensitized paper and exposed both to light, a procedure now known as contact printing. The dark areas of the negative blocked the light from the other sheet of paper, while the clear areas allowed light through. The result was a positive image on paper resembling the natural tones of the original scene.

Because of its reproducibility, the calotype had a major advantage over the one-of-a-kind daguerreotype. It never became widely popular, however, primarily because the calotype image seemed inferior to many viewers. The fibers in the paper produced a soft, slightly textured photograph that has been compared to a charcoal drawing. The calotype is beautiful in its own way, but viewers comparing it to a daguerreotype were disappointed in its lack of sharp detail.

Some of the activities at Talbot's establishment in Reading, near London, are shown in this early calotype taken in two parts and pieced together. At left, an assistant copies a painting. In the center, possibly Talbot himself prepares a camera to take a portrait. At right, the technician at the racks makes contact prints and another assistant photographs a statue. At far right, the kneeling man holds a target for the maker of this photograph to focus on.

The prints for the first book to be illustrated with photographs, The Pencil of Nature, were made at Reading. In a "Notice to the Reader," Talbot gave his assurance that "The plates of the present work are impressed by the agency of light alone, without any aid whatever from the artist's pencil. They are the sun pictures themselves, and not, as some persons have imagined, engravings in imitation."

In a brief but productive collaboration between 1843 and 1847, landscape painter David Octavius Hill and photographer Robert Adamson made elegant use of the soft texture characteristic of the calotype's paper negative, basing their compositions on broad masses of light and shade. Their photographs of mid-19th-century Scotland include masterfully composed portraits that almost always display character and naturalness, despite the fact that their subjects were braced to prevent movement during long exposures.

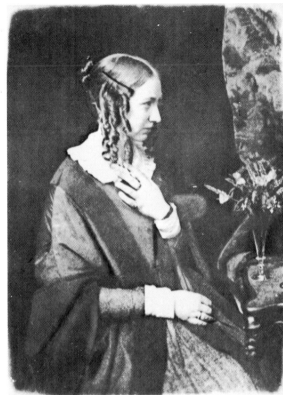

Miss Murray

William Leighton Leitch

Bonaly Tower

John Brown, M.D.

DAVID OCTAVIUS HILL and ROBERT ADAMSON: 1843–1847. Calotypes

COLLODION WET-PLATE: SHARP AND REPRODUCIBLE

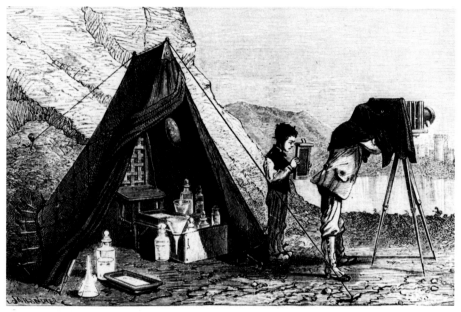

A photographer in the field, c. 1865

The collodion wet-plate process had many advantages, but convenience was not among them. The glass plates on which the emulsion was spread had to be coated, exposed, and developed before the emulsion dried, which required transporting an entire darkroom to wherever the photograph was to be made.

A photographer described a typical load that an amateur might use: "I reached the railway station with a cab-load consisting of the following items: A 9" × 11" brass-bound camera weighing 21 lbs. A water-tight glass bath in a wooden case holding over 90 ozs. of solution (nitrate of silver) and weighing 12 lbs. A plate box with a dozen 9" × 11" plates weighing almost as many pounds. A box 24" × 18" × 12" into which were packed lenses, chemicals, and all the hundred-and-one articles necessary for a hard day's work, and weighing something like 28 lbs. (A tripod) over 5 ft in length. It weighed about 5 lbs. Lastly, there was the tent, that made a most convenient darkroom, about 40" × 40" and 6½ ft high, with ample table accommodation; the whole packed into a leather case and weighed over 40 lbs . . . a load of about 120 lbs."

The **collodion wet-plate** process combined so many advantages that despite having some drawbacks most photographers used it from its introduction in 1851 until the development of the gelatin dry plate about 30 years later. It had the best feature of the daguerreotype—sharpness—and the best of the calotype—reproducibility. And it was more light sensitive than either of them, with exposures as short as five seconds.

For some time, workers had been looking for a substance that would bind a light-sensitive emulsion to a glass plate. Glass was better than paper or metal as a support for emulsion because it was textureless, uniformly transparent, and chemically inert. A cousin of Niépce, Abel Niepce de Saint-Victor, found that egg white could be used, but since his albumen glass plates required very long exposures the search for a better substance continued. Even the slime exuded by snails was tried. One suggested material was the newly invented collodion (nitro-cellulose dissolved in ether and alcohol), which is sticky when wet and dries into a tough, transparent skin. Frederick Scott Archer, an English sculptor who had been making calotypes of his sitters to use as studies, discovered that the collodion was an excellent basis for an emulsion. But the plate had to be exposed and processed while it was still wet.

Coating a plate required skill—nimble fingers, flexible wrists, and practiced timing. A mixture of collodion and potassium iodide was poured onto the middle of the plate. The photographer held the glass by the edges and tilted it back and forth and from side to side until the surface was evenly covered. The excess collodion was poured back into its container. Then the plate was sensitized by being dipped in a bath of silver nitrate. It was exposed for a latent image while still damp, developed in pyrogallic acid or iron sulfate, fixed, washed, and dried. All this had to be done right where the photograph was taken, which meant that to take a picture the photographer had to lug a complete darkroom along *(above)*.

Collodion could be used to form either a negative or a positive image. Coated on glass, it produced a negative from which a positive could be printed onto albumen-coated paper *(opposite, top)*. If the glass was backed with a dark material like black velvet, paper, or paint, the image became positive, an **ambrotype** *(opposite, bottom)*, a kind of imitation daguerreotype. Coated on dark enameled metal, it also formed a positive image—the durable, cheap **tintype** popular in America for portraits to be placed in albums, on campaign buttons, and even on tombs.

By the 1860s the world had millions of photographic images; 25 years earlier there had been none. Photographers were everywhere—taking portraits, photographing scenes of war, exploring distant places and bringing home pictures to prove they had been there.

A popular home entertainment during the 1850s and 1860s was looking at stereographic photographs like the one at right. If two photographs are taken side by side and then viewed through a stereoscope (a device that presents only one photograph to each eye), the impression is of a three-dimensional image. The stereo cards were inexpensive enough for almost everyone to own, and millions were sold. Rather like television today, stereographs brought the world into every home.

"Oh, infinite volumes of poems that I treasure in this small library of glass and pasteboard!" exclaimed Oliver Wendell Holmes of his collection of stereographs. With it, he wrote, "I stroll through Rhenish vineyards, I sit under Roman arches, I walk the streets of once-buried cities, I look into the chasms of Alpine glaciers, and on the rush of wasteful cataracts. I pass, in a moment, from the banks of the Charles to the ford of the Jordan."

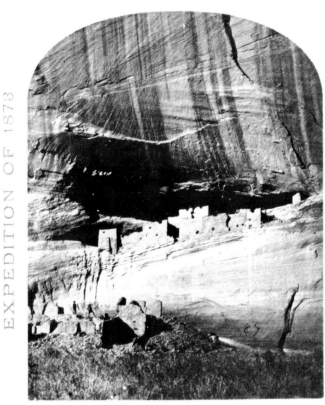

TIMOTHY H. O'SULLIVAN: *Ruins of Canyon de Chelly,* 1875

An ambrotype (right) is a collodion-on-glass negative backed with a dark material such as black cloth or varnish. Half of the plate shown here has not been backed and looks like an ordinary negative. The dark backing behind the other half causes a positive image to appear.

EARLY PORTRAITS

People wanted **portraits.** Even when exposure times were long and having one's portrait meant sitting in bright sunlight for several minutes with eyes watering, trying not to blink or move, people flocked to portrait studios to have their likenesses drawn by "the sacred radiance of the Sun." Images of almost every famous person who had not died before 1839 have come down to us in portraits by photographers such as Nadar and Julia Margaret Cameron *(right)*. Ordinary people were photographed as well—in Plumbe's National Daguerrian Gallery, where hand-tinted "Patent Premium Coloured Likenesses" were made, and in cut-rate shops where double-lens cameras took them "two at a pop." Small portraits called **cartes-de-visite** were immensely popular in the 1860s *(opposite)*. For pioneers moving West in America, the pictures were a link to the family and friends they had left behind. Two books went West with the pioneers—a Bible and a photograph album.

After seeing some daguerreotype portraits, the poet Elizabeth Barrett wrote to a friend in 1843, "several of these wonderful portraits . . . like engravings—only exquisite and delicate beyond the work of graver—have I seen lately—longing to have such a memorial of every Being dear to me in the world. It is not merely the likeness which is precious in such cases—but the association and the sense of nearness involved in the thing . . . the fact of the *very shadow of the person* lying there fixed for ever! . . . I would rather have such a memorial of one I dearly loved, than the noblest artist's work ever produced. I do not say so in respect (or disrespect) to Art, but for Love's sake. Will you understand?—even if you will not agree?" The man on the opening page of this chapter would have understood.

JULIA MARGARET CAMERON: *Sir Henry Taylor,* c. 1865

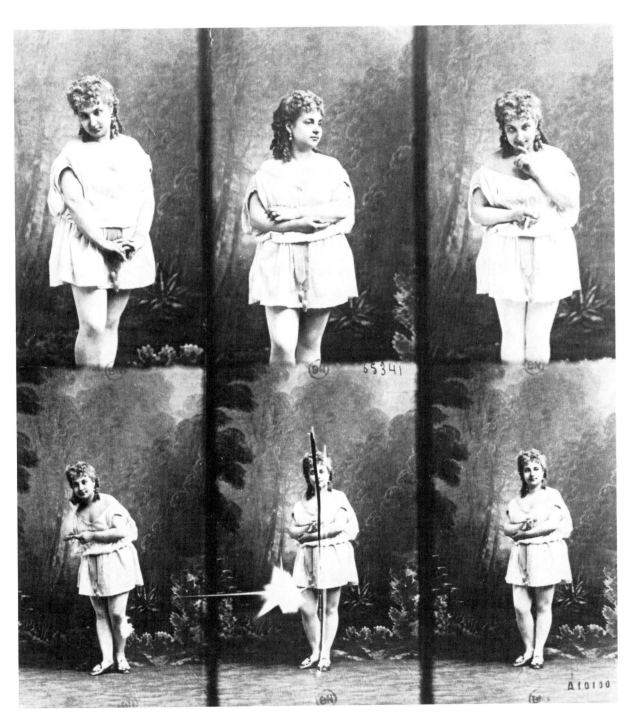

André Adolphe Disdéri, popularizer of the carte-de-visite

Cartes-de-visite were taken with a camera that exposed only one section of the photographic plate at a time. Thus the customer could strike several different poses for the price of one. At left is shown a print before it is cut into separate pictures. People collected cartes-de-visite in albums, inserting pictures of themselves, friends, relatives, and famous people like Queen Victoria. One album cover advised: "Yes, this is my Album, but learn ere you look; / that all are expected to add to my book. / You are welcome to quiz it, the penalty is, / that you add your own Portrait for others to quiz."

André Adolphe Disdéri, who popularized these multiple portraits, is shown above on a carte-de-visite. Carte portraits became a fad when Napoleon III stopped on the way to war to pose for cartes-de-visite at Disdéri's studio.

IMAGES OF WAR

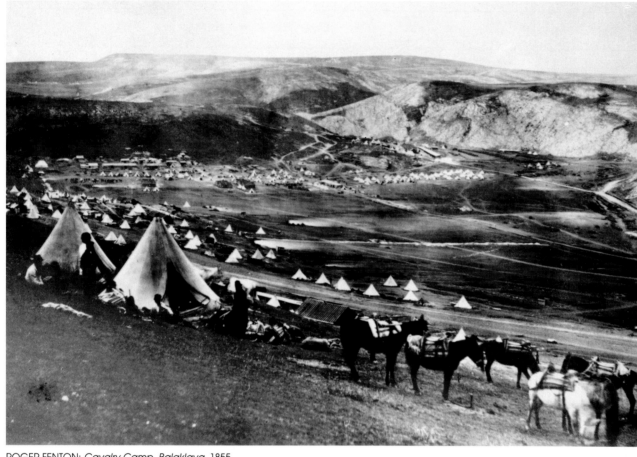

Roger Fenton took many picturesque views of the Crimean War such as the one at left. The Charge of the Light Brigade, a military blunder that needlessly took the lives of hundreds of soldiers, occurred during this war. The famous charge was immortalized in Tennyson's equally famous poem. Like Fenton's views, the poem deals only with the palatable aspects of war:

> Half a league, half a league.
> Half a league onward,
> All in the valley of Death
> Rode the six hundred.
> "Forward, the Light Brigade!
> Charge for the guns!" he said:
> Into the valley of Death
> Rode the six hundred.
>
> When can their glory fade?
> O the wild charge they made!
> All the world wonder'd.
> Honour the charge they made!
> Honour the Light Brigade.
> Noble six hundred!

ROGER FENTON: *Cavalry Camp, Balaklava,* 1855

Photographs of war made such scenes more immediate for those at home. Until the invention of photography, wars often seemed remote and rather exciting. People learned details of war only from delayed news accounts or even later from returning soldiers or from paintings or poems. The British campaigns in the Crimean War of the 1850s were the first to be extensively photographed. It was a disastrous war for Great Britain. The ill-fated Charge of the Light Brigade was only one of the catastrophes; official bungling, disease, starvation, and expo- sure took more British lives than did the enemy. However, Roger Fenton, the offi- cial photographer, generally showed views of the war *(above)* as idealized as Tennyson's poem about the Charge.

Not until the American Civil War did many photographs appear that showed a less romantic side of war *(opposite)*. Mathew B. Brady, a successful portrait photographer, conceived the idea of sending teams to photograph the war. Photographing during a battle was haz- ardous. The collodion process required up to several seconds' exposure and the glass plates had to be processed on the spot, which made the photographer's darkroom-wagon a target for enemy gun- ners. Although Brady had hoped to sell his photographs, they often showed what people wanted only to forget. Brady took only a few, if any, photographs himself, and some of his men (Alexander Gardner and Timothy H. O'Sullivan among them) broke with him and set up their own oper- ation. But it was Brady's idea and per- sonal investment that launched an invalu- able documentation of American history.

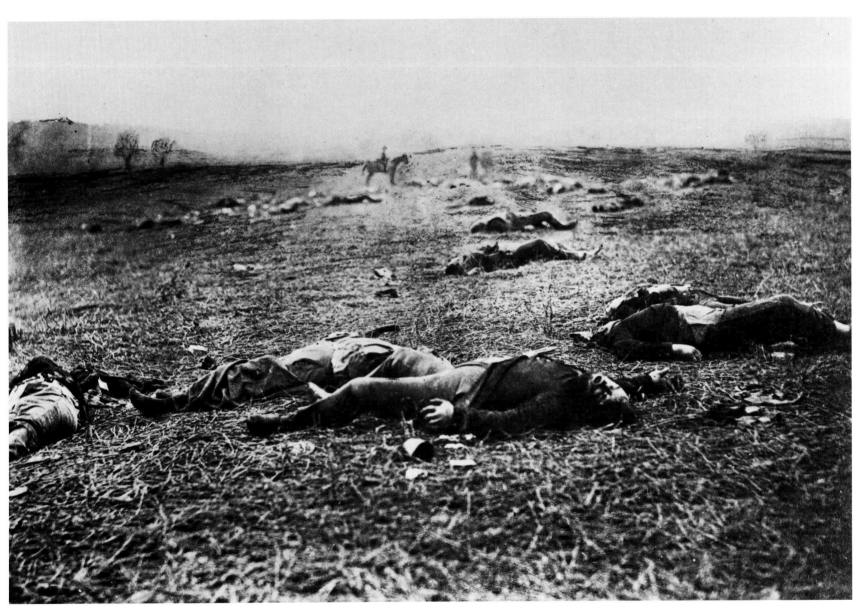

TIMOTHY H. O'SULLIVAN: *A Harvest of Death, Gettysburg,* July 1863

Another view of war was shown by Civil War photographers such as Brady, Gardner, and O'Sullivan (above). Oliver Wendell Holmes had been on the battlefield at Antietam searching for his wounded son and later saw the photographs Brady made there: "Let him who wishes to know what war is look at this series of illustrations. . . .

It was so nearly like visiting the battlefield to look over these views, that all the emotions excited by the actual sight of the stained and sordid scene, strewed with rags and wrecks, came back to us, and we buried them in the recesses of our cabinet as we would have buried the mutilated remains of the dead they too vividly represented."

EARLY TRAVEL PHOTOGRAPHY

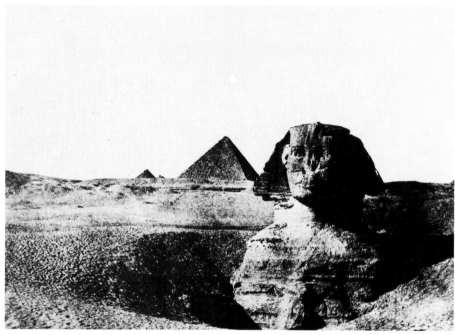

MAXIME Du CAMP: *The Sphinx and Pyramids, Egypt,* 1851

Expeditions to take photographs of faraway places were begun almost as soon as the invention of photography was announced. In addition to all the materials, chemicals, and knowledge needed to coat, expose, and process their photographs in remote places, expeditionary photographers also had to have considerable fortitude.

Timothy H. O'Sullivan, whose darkroom on a boat appears opposite, described an area called the Humboldt Sink: "It was a pretty location to work in, and viewing there was as pleasant work as could be desired; the only drawback was an unlimited number of the most voracious and particularly poisonous mosquitoes that we met with during our entire trip. Add to this . . . frequent attacks of that most enervating of all fevers, known as the 'mountain ail,' and you will see why we did not work up more of that country."

In the mid-19th century, the world seemed full of unexplored wonders. Steamships and railroads were making it possible for more people to travel, but distant lands still seemed exotic and mysterious and people were hungry for photographs of them. There had always been drawings portraying unfamiliar places, but they were an artist's personal vision. The camera seemed an extension of one's own vision; **travel photographs** were accepted as real, faithful images created by a mechanical process.

The Near East was of special interest. Not only was it exotic, but its association with biblical places and ancient cultures made it even more fascinating. Within a few months of the announcement of Daguerre's process in 1839, a photographic team was in Egypt. "We keep daguerreo-

typing away like lions," they reported, "and from Cairo hope to send home an interesting batch." Since there was no way of reproducing the daguerreotypes directly, they had to be traced and reproduced as copperplate engravings. With the invention of the calotype and later the collodion processes, actual pictures from the Near East taken by photographers such as Maxime Du Camp *(above)* and Francis Frith were soon available.

One of the most spectacular regions of all, the western United States, was not much photographed until the late 1860s. Explorers and artists had been in the Rocky Mountain area long before this time, but the tales they told of the region and the sketches they made were often thought to be exaggerations. After the Civil War, when several government ex-

peditions set out to explore and map the West, photographers accompanied them, not always to the delight of the other members of the expeditions. "The camera in its strong box was a heavy load to carry up the rocks," says a description of a Grand Canyon trip in 1871, "but it was nothing to the chemical and plate-holder box, which in turn was featherweight compared to the imitation hand organ which served for a darkroom." Civil War photographers O'Sullivan *(opposite)* and Gardner both went West with government expeditions. William Henry Jackson's photographs of Yellowstone helped convince Congress to set the area aside as a national park, as did the photographs of Yosemite made by Carleton Eugene Watkins.

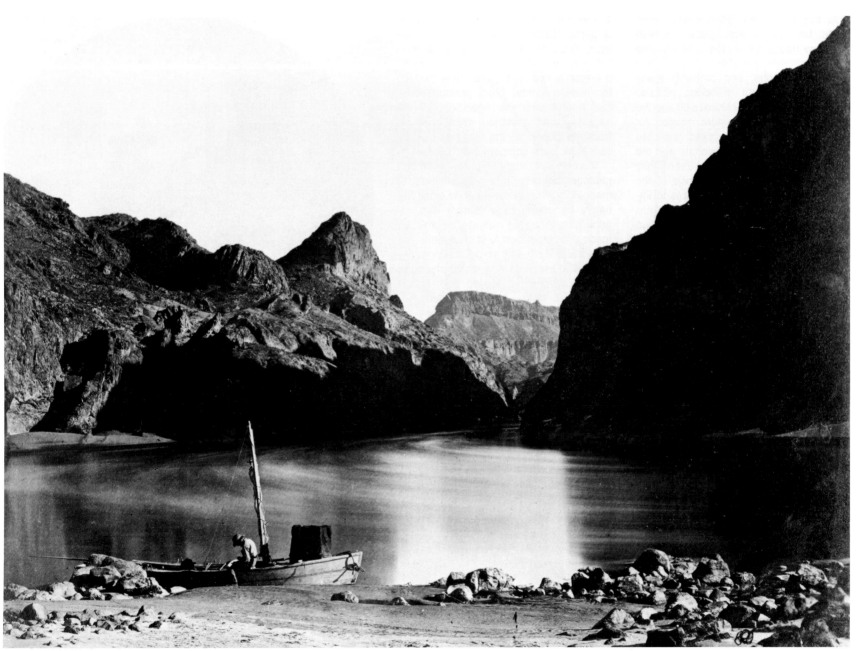

TIMOTHY H. O'SULLIVAN: *Black Canyon, Colorado River,* 1871

TIME AND MOTION IN EARLY PHOTOGRAPHS

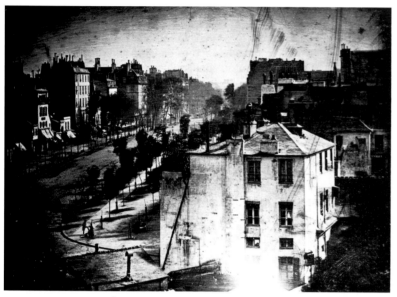

LOUIS JACQUES MANDÉ DAGUERRE: *Boulevard du Temple, Paris,* 1839

EDWARD ANTHONY: *Broadway,* 1859

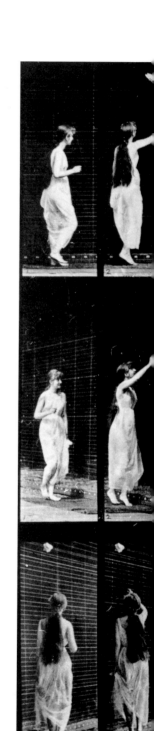

Today, photographers using modern films consider a one-second exposure relatively long. But photographers using earlier processes had to work with much slower emulsions, and an exposure of several seconds was considered quite short. People or objects that moved during the exposure were blurred or, if the exposure was long enough, disappeared completely; busy streets sometimes looked deserted *(above, left)* because most people had not stayed still long enough to register an image.

Stereographic photographs *(half of a pair of images is shown above, right)* were the first to show action as it was taking place, with people in midstride or horses and carts in motion. This was possible because the short-focal-length lens of the stereo camera produced a bright, sharp image at wide apertures and thus could be used with very brief exposure times. "How infinitely superior to those 'cities of the dead' with which we have hitherto been compelled to content ourselves,"

commented one viewer.

These "instantaneous" photographs recorded such a short moment of time that they revealed aspects of motion that the unaided eye was not able to see. Some of the arrested motions were so different from the conventional artistic representations that the photographs looked wrong. A galloping horse, for example, had often been drawn with all four feet off the ground—the front legs extended forward while the hind legs extended back. Eadweard Muybridge was a pioneer in **motion studies.** When his photographs of a galloping horse, published in 1878, showed that all four feet were off the ground only when they were bunched under the horse's belly, some people thought that Muybridge had altered the photographs. Using the new, fast gelatin emulsion and specifically constructed multilens cameras, Muybridge compiled many studies of different animals and humans in action *(right).*

The busy streets of a Parisian boulevard (above, left) appear depopulated because of the long exposure this daguerreotype required. Only a person getting a shoeshine near the corner of the sidewalk stood still long enough to be recorded; all the other people, horses, and carriages had blurred so much that no image of them appeared on the plate. By contrast, the relatively fast collodion process combined with the fast lens of a stereo camera froze the action on another busy street (above, one of a pair of stereo views).

The pictures at right were part of Eadweard ▶ Muybridge's project Animal Locomotion, *which analyzed the movements of humans and many animals. This sequence was made with three cameras, each with 12 lenses and shutters synchronized to work together so that each stage of the movement was recorded simultaneously from three sides.*

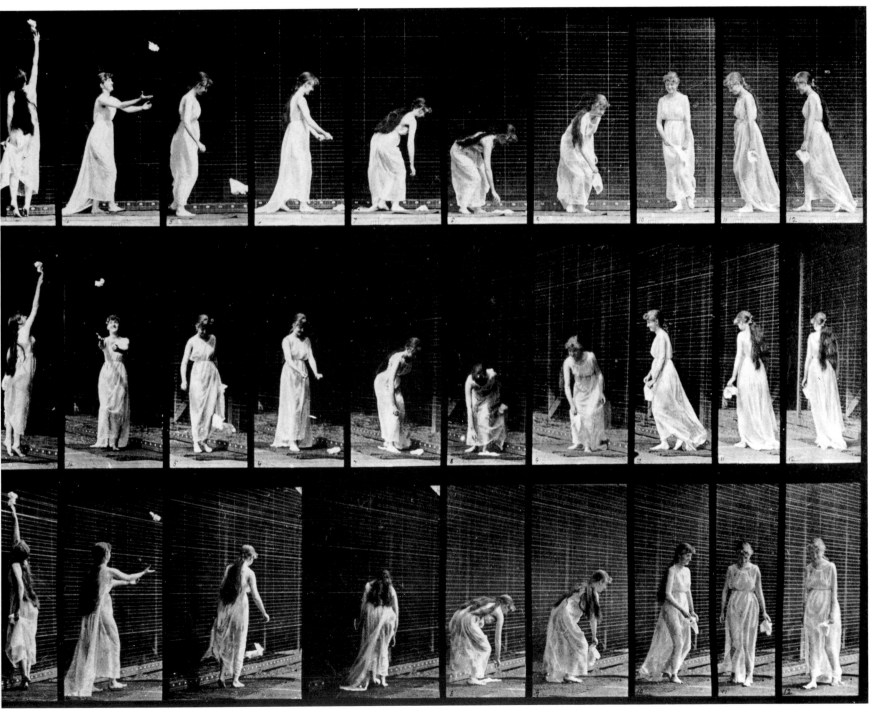

EADWEARD MUYBRIDGE: *Motion Study*, c. 1885

THE PHOTOGRAPH AS DOCUMENT

To early viewers, the most wonderful aspect of photography was its ability to show an immense amount of literal and exact detail. "This is the Daguerreotype! . . . There is not an object . . . which was not in the original [scene]; and it is impossible that one should have been omitted. Think of that!" Faith in the camera as a literal recorder gave rise to a belief, still persisting today, that the camera does not lie; and it provided photographs themselves with the great psychological strength of appearing to tell the truth. (Digital imaging may finally deal the death blow to this belief; see page 295.)

Photographs can be **documents** on many levels. Most snapshots record a particular scene or event simply to help the participants remember it later. A news photograph implies that this is exactly what you would have seen if you had been there yourself. On another level, a photograph can record reality and at the same time communicate the photographer's comment on that reality. Lewis W. Hine said of his work: "I wanted to show the things that had to be corrected. I wanted to show the things that had to be appreciated." His statement describes the use of photography as an instrument of social change and a style that has come to be known as **documentary** *(see pages 384–385).*

Eugène Atget considered his photographs to be documents, but his work, done in the early part of this century, went beyond simple records. A sign on his door read "Documents pour Artistes," and according to a friend, Atget's ambition was "to create a collection of all that which both in Paris and its surroundings was artistic and picturesque. An immense subject." Atget made thousands of photographs of the streets, cafés, shops *(opposite)*, monuments, parks, and people of the Paris he loved. His pictures won him little notice during his lifetime; he barely managed to eke out a living by selling them to artists, architects, and others who wanted visual records of the city. Many photographers can record the external appearance of a place, but Atget did more than that. He conveyed the atmosphere and mood of Paris.

August Sander chose to document a people—the citizens of pre–World War II Germany. His pictures were not meant to reveal personal character but to show the classes making up German society of that period. He photographed laborers *(right)*, soldiers, merchants, provincial families, and other types, all formally posed. The portraits are so utterly factual and unsentimental as to be chilling at times, as the individual all but disappears into class and social role.

AUGUST SANDER: *Laborer,* 1927

August Sander's photographs are documents of social types rather than portraits of individuals. This photograph of a Cologne laborer with a load of bricks was one of hundreds of studies Sander made of the types he saw in pre–World War II Germany. Holding his pose as if standing still for a portrait painter, the subject displays his trade with dignity and without becoming a stereotype. The man has paused between taking up his burden and laying it down, but there is no indication of time or even place. In fact, the background is deliberately absent; Sander eliminated it from the negative.

Eugène Atget artfully revealed the essence of Paris while seeming merely to document its external appearance. Here the shop window display and the dummies merge so that the photograph seems to show a ghostly view of Paris populated only by a group of urbane and smartly dressed mannequins.

EUGÈNE ATGET: *Magasin, avenue des Gobelins,* 1925

PHOTOGRAPHY AND SOCIAL CHANGE

Photography has been called the mirror with a memory; in addition to merely reflecting the world, it can also mirror it with a purpose. Jacob Riis, a Danish-born newspaper reporter of the late 19th century, was one of the first to use photography for **social change.** Riis had been writing about the grinding brutality of life in New York City's slums and began to take pictures to show, as he said, what "no mere description could, the misery and vice that he had noticed in his ten years of experience . . . and suggest the direction in which good might be done."

Lewis W. Hine was a trained sociologist with a passionate social awareness, especially of the abuses of child labor *(right).* This evil was widespread in the early 20th century, and Hine documented it to provide evidence for reformers. With sarcastic fury he wrote of " 'opportunities' for the child and the family to . . . relieve the over-burdened manufacturer, help him pay his rent, supply his equipment, take care of his rush and slack seasons, and help him to keep down his wage scale."

The photographers of the **Farm Security Administration** recorded the Depression of the 1930s, when the nation's entire economic structure was in deep trouble and farm families were in particular need. Assistant Secretary of Agriculture Rexford G. Tugwell realized that the government's program of aid to farmers was expensive and controversial. To prove both the extent of the problem and the effectiveness of the cure, he appointed Roy Stryker to supervise photographic coverage of the program. Stryker recruited a remarkable band of talent, including Dorothea Lange *(see opposite),* Walker Evans, Russell Lee, Marion Post Wolcott, Arthur Rothstein, and Ben Shahn. Their work produced a classic collection of **documentary photographs.**

LEWIS W. HINE: *Victim of a Mill Accident,* c. 1910

Between 1908 and 1921, Lewis Hine made 5,000 pictures for the National Child Labor Committee documenting the abuses of child labor. This one-armed boy, a casualty of a mill accident, posed for Hine in about 1910. "We don't have many accidents," one foreman said at the time. "Once in a while a finger is mashed or a foot, but it doesn't amount to anything."

In showing the plight of "one third of a nation" during the Depression of the 1930s, the documentary photographers of the Farm Security Administration produced a monumental collection of images. Dorothea Lange had a unique ability to photograph people at the moment that their expressions and gestures revealed their lives and feelings.

Lange's captions for her FSA pictures often supplied verbatim what her subject had told her. For the photograph at right, she recorded, "The worst thing we did was when we sold the car, but we had to sell it to eat, and now we can't get away from here. . . . You can't get no relief here until you've lived here a year. This county's a hard county. They won't help bury you here. If you die, you're dead, that's all."

DOROTHEA LANGE: *Woman of the High Plains, Texas Panhandle,* 1938

PHOTOGRAPHY AS ART IN THE 19TH CENTURY

Almost from the moment of its birth, photography began staking out claims in areas that had long been reserved for painting. Portraits, still lifes, landscapes, nudes, and even allegories became photographic subject matter. Some artists bristled at the idea of **photography as an art form.** In 1862 a group of French artists formally protested that photography was a soulless, mechanical process, "never resulting in works which could . . . ever be compared with those works which are the fruits of intelligence and the study of art."

Photographers resented such assertions, but they in turn simply regarded photography as another kind of painting. The oldest known daguerreotype *(page 366),* taken by Daguerre himself in 1837, reveals this clearly. It is a still life self-consciously composed in the style of neoclassical painting.

Many photographers adapted styles of painting to the photographic print. From the 1850s through the 1870s there was a rage for illustrative photographs similar to a storytelling style of painting popular at the time. Julia Margaret Cameron, in addition to producing elegant and powerful portraits *(page 372),* indulged in romantic costume scenes such as illustrations for Tennyson's *The Idylls of the King.* Oscar G. Rejlander pieced together 30 negatives to produce an allegorical pseudo-painting entitled *The Two Ways of Life*—one way led to dissolution and despair, the other to good works and contentment.

At the time, the most famous and commercially the most successful of those intending to elevate photography to an art was Henry Peach Robinson. Robinson turned out many illustrative and allegorical **composite photographs.** These were carefully plotted in advance and combined several negatives to form the final print *(photograph and drawing, right).* Robinson became the leader of a so-called High Art movement in 19th-century

HENRY PEACH ROBINSON: *Fading Away,* 1858

Inspired by romantic literature, the British photographer Henry Peach Robinson perfected a composite photographic technique that allowed him to produce imaginary scenes. Fading Away (above) was staged by posing models separately and piecing together the images. Robinson usually planned such compositions in considerable detail: at right, a half-finished composite for another print shows a cutout photograph of a reclining woman superimposed on a preliminary pencil sketch.

HENRY PEACH ROBINSON: *Preliminary sketch with photograph inserted,* c. 1860

PETER HENRY EMERSON: *Gathering Water Lilies,* 1885

Peter Henry Emerson rejected the methods of the High Art photographers and insisted that photography should not imitate art but should strive for a naturalistic effect that was not artificially contrived. He illustrated his theories with his own photographs of the East Anglian marshes in England.

photography, which advocated beauty and artistic effect no matter how it was obtained. In his *Pictorial Effect in Photography,* Robinson advised: "Any dodge, trick and conjuration of any kind is open to the photographer's use. . . . It is his imperative duty to avoid the mean, the bare and the ugly, and to aim to elevate his subject, to avoid awkward forms and to correct the unpicturesque."

By the 1880s a new movement was coming to the fore. Its leader, Peter Henry Emerson, was the first to campaign against the stand that "art" photographers had taken. He felt that true photographic art was possible only through exploiting the camera's unique ability to capture reality in a direct way *(left).* He scorned the still-popular pictorial school and its practices of composite printing, costumed models, painted backdrops, and sentimental views of daily life.

Emerson laid down his own rules for what he called **naturalistic photography:** simplicity of equipment; no "faking" by means of lighting, posing, costumes, or props; free composition without reliance on classical rules; and no retouching ("the process by which a good, bad or indifferent photograph is converted into a bad drawing or painting"). He also promoted what he believed was a scientific focusing technique that imitated the way the eye perceives a scene: sharply focused on the main subject, but with the foreground and especially the background slightly out of focus.

Although Emerson later became convinced that photography was not an art at all but only "a handmaiden to science and art," his earlier ideas had already influenced a new generation of photographers who no longer felt the need to imitate painting but began to explore photography as an art in its own right.

PICTORIAL PHOTOGRAPHY AND THE PHOTO-SECESSION

Is photography an art? Photographers were still concerned with this question at the turn of the century, and the **pictorialists,** or art photographers, wanted to separate their photographs from those taken for some other purpose—ordinary snapshots, for example. The *American Amateur Photographer* suggested, "If we had in America a dignified 'Photographic Salon,' with a competent jury, in which the only prizes should be the distinction of being admitted to the walls of the 'Salon,' we believe that our art would be greatly advanced. 'Art for art's sake' should be the inspiring word for every camera lover." The pictorial movement was international. Exhibitions and salons where photographs were judged on their aesthetic and artistic merits were organized by the Vienna Camera Club, the Linked Ring Brotherhood in England, the Photo-Club de Paris, the American Photo-Secession, and others.

Many pictorialists believed the artistic merits increased if the photograph looked like some other kind of art—charcoal drawing, mezzotint, or anything other than photography—and they patterned their work quite frankly on painting, especially the work of the French Impressionists, for whom mood and a sense of atmosphere and light were important. The pictorialists favored mist-covered landscapes and soft cityscapes; light was diffused, line was softened, and details were suppressed *(right).*

To achieve these effects, pictorialists often used printing techniques to which handwork was added—for example, gumbichromate printing, where the image was transferred onto a thick, soft, often tinted coating that could easily be altered as the photographer wished. One critic was delighted: "The results no longer have anything in common with what used to be known as photography. For that reason, one could proudly say that these photographers have broken with the tradition of

GERTRUDE KÄSEBIER: *Blessed Art Thou Among Women,* c. 1900

Works by pictorialist photographers at the turn of the century often resembled impressionist paintings, with light and atmosphere more important than sharp details. Gertrude Käsebier created many scenes that depicted the relationships between women and children, including some of their more complex and contradictory aspects.

ALFRED STIEGLITZ: *The Steerage,* 1907

Although Alfred Stieglitz championed pictorialist works that resembled paintings, his own photographs (except for a brief early period) did not include handwork or other alterations of the direct camera image. Above, the patterns made by the people and machinery compelled him to make this photograph. "I saw a picture of shapes and underlying that the feeling I had about life."

the artificial reproduction of nature. They have freed themselves from photography. They have sought the ideal in the works of artists. They have done away with photographic sharpness, the clear and disturbing representation of details, so that they can achieve simple, broad effects." Not everybody agreed. This did not fit at all into Peter Henry Emerson's ideas of naturalistic photography: "If pure photography is not good enough or 'high' enough . . . by all means let him become an artist and leave us alone and not try and foist 'fakes' upon us."

In America, one person, Alfred Stieglitz, was the leader and catalyst for pictorialists, and his influence on photography as an art form is hard to overestimate. For more than 60 years he photographed *(left),* organized shows, and published influential and avant-grade work by photographers and other artists. In his galleries—the Little Galleries of the Photo-Secession (later known simply by its address, 291), the Intimate Gallery, and An American Place—he showed not only what he considered the best photographic works but also, for the first time in the United States, the works of Cézanne, Matisse, Picasso, and other modern artists. In his magazine *Camera Work,* he published photographic criticism and works whose only requirement was that they be worthy of the word *art.* Not only did he eventually force museum curators and art critics to grant photography a place beside the other arts, but by influence, example, and sheer force of personality he twice set the style for American photography: first toward the early pictorial impressionistic ideal and later toward sharply realistic, "straight" photography *(see pages 390–391).*

THE DIRECT AND UNMANIPULATED IMAGE

PAUL STRAND: *White Fence,* 1916

Paul Strand's straight approach to photography as an art form combined an objective view of the world with personal meaning. "Look at the things around you, the immediate world around you. If you are alive it will mean something to you, and if you care enough about photography, and if you know how to use it, you will want to photograph that meaningness."

While pictorialists were making photographs that looked very much like paintings, a few others were seeking to use characteristics unique to the photographic process itself. They wanted to return to the direct and unmanipulated photographs that characterized so much of 19th-century imagery. In 1917 Stieglitz devoted the last issue of his magazine *Camera Work* to Paul Strand, whose photographs he saw as representing a powerful new approach to photography as an art form. Strand believed that "objectivity is of the very essence of photography. . . . The fullest realization of this is accomplished without tricks of process or manipulation, through the use of straight photographic methods."

Stieglitz's own photographs were direct and unmanipulated. He felt that many of them were visual metaphors, accurate representations of objects in front of his camera and at the same time external counterparts or "equivalents" of his inner feelings. Since 1950, Minor White *(pages 69, 81)* carried on and expanded Stieglitz's concept of the equivalent. For White, the goal of the serious photographer was "to get from the tangible to the intangible" so that a straight photograph of real objects functions as a metaphor for the photographer's or the viewer's state of mind.

Straight photography, which dominated photography as an art form from the 1930s to the 1950s, is exemplified by Edward Weston. He used the simplest technique and a bare minimum of equipment: generally, an 8 × 10 view camera with lens stopped down to the smallest aperture for sharpness in all parts of the picture and contact-printed negatives that were seldom cropped. "My way of working—I start with no preconceived idea— discovery excites me to focus—then rediscovery through the lens—final form of presentation seen on ground glass, the finished print previsioned complete in every detail of texture, movement, proportion, *before exposure*—the shutter's release automatically and finally fixes my conception, allowing no after manipulation—the ultimate end, the print, is but a duplication of all that I saw and felt through my camera." Weston's photographs were both objective and personal. "Clouds, torsos, shells, peppers *[opposite],* trees, rocks, smokestacks are but interdependent, interrelated parts of a whole, which is life." Many other photographers, such as Ansel Adams *(page 320),* Paul Caponigro *(pages 108, 344),* and Imogen Cunningham *(page 75)* have used the straight approach.

Edward Weston wrote about this photograph: "It is classic, completely satisfying—a pepper—but more than a pepper: abstract, in that it is completely outside subject matter."

EDWARD WESTON: *Pepper No. 30,* 1930

THE QUEST FOR A NEW VISION

MAN RAY: *Solarization,* 1929

The beginning of the 20th century was a period of great revolution in many areas, including science, technology, mathematics, politics, and also the arts. Movements like Fauvism, Expressionism, Cubism, Dada, and Surrealism were permanently changing the meaning of the word "art." The Futurist art movement proposed "to sweep from the field of art all motifs and subjects that have already been exploited . . . to destroy the cult of the past . . . to despise utterly every form of imitation . . . to extol every form of originality." At the center of radical art, design, and thinking was the Berlin Bauhaus, a school to which the Hungarian artist László Moholy-Nagy came in 1922. He attempted to find new ways of seeing the world and experimented with radical uses of photographic materials in an attempt to replace 19th-century pictorialist conventions with a "new vision" compatible with modern life. Moholy explored many ways of expanding photographic vision, through photograms, photo-montage *(opposite, far right)*, the Sabattier effect (often called solarization), unusual angles *(opposite, near right)*, optical distortions, and multiple exposures. He felt that "properly used, they help to create a more complex and imaginary language of photography."

Another artist exploring new art forms was Man Ray, an American expatriate in Paris. He was drawn to Dada, a philosophy that commented on the absurdities of modern existence by introducing even greater absurdities. "I like contradictions," he said. "We have never obtained the infinite variety and contradictions that exist in nature." Like Moholy, Man Ray used many techniques, including solarizations *(above)* and photograms *(page 190)*.

LÁSZLÓ MOHOLY-NAGY: *From the Radio Tower,* 1928

Photographers such as László Moholy-Nagy and Man Ray used many techniques in their explorations of real, unreal, and abstract imagery. The dark lines along the woman's hand (opposite) as well as other altered tones are due to solarization, exposing the image to light during development (see pages 192–193). In the photograph above, the extreme angle of the camera pointing straight down onto a snow-covered courtyard merged the walkways, trees, and building into a single abstract design. The photomontage (right) combines pieces of several photographs. Moholy defined photomontage as "a tumultuous collision of whimsical detail from which hidden meanings flash," a definition that fits this ambiguous picture.

LÁSZLÓ MOHOLY-NAGY: *Jealousy,* 1927

PHOTOGRAPHY AS ART IN THE 1950s AND BEYOND

A tremendous growth has taken place in the acceptance of photography as an art form, a change that started in the 1950s. Since then, photography has become a part of the college and art school curriculum; art museums have devoted considerable attention to photography; art galleries opened to sell only photographs, while photography entered other galleries that previously had sold only paintings or other traditional arts; and magazines such as *Artforum* and *Art in America* began to regularly publish photographs and essays about the medium.

American work of the 1950s was often described in terms of regional styles. Chicago was identified with the often abstract work of Aaron Siskind *(right)* and Harry Callahan. The West Coast was linked to the so-called straight photographers, such as Ansel Adams *(page 320)* and Minor White *(pages 69 and 81)*. New York was thought of as the center for social documentation, such as by photographers in the politically active Photo League. Meanwhile, tied to no region, Robert Frank, a Swiss, was traveling across the United States photographing his own view of life in the 1950s *(opposite)*.

As an increasing number of colleges and art schools in the 1960s offered photography courses, often in the art departments of the schools, a cross-fertilization of ideas took place between photographers and artists working in traditional art media. Some painters and other artists integrated photographs in their work or sometimes switched to photography altogether. Some photographers combined their images with painting, printmaking, or other media. Older photographic processes were revived, such as cyanotyping *(page 198)* and platinum printing *(page 199)*.

Minor White used to say that in the 1950s photographers functioning as

AARON SISKIND: *Chicago 30,* 1949

artists were so few that they used to clump together for warmth. Since then, photography has developed in many directions *(some are shown on pages 396–399)*, but the long battle over whether photography was an art, a battle that had been waged almost from the invention of the medium, seems finally to have been resolved. The winners were those who said it could be.

Aaron Siskind was active as a documentary photographer during the 1930s, but as he later recalled, "For some reason or other there was in me the desire to see the world clean and fresh and alive, as primitive things are clean and fresh and alive. The so-called documentary picture left me wanting something." His best-known work consists of surfaces abstracted from their normal context (above), such as peeled and chipped paint or posters on walls. The subject of the photograph is the shapes, tonality, and other elements in it, not the particular wall itself.

ROBERT FRANK: *Bar, New York City,* 1955

When Robert Frank's work was published in 1959, it was attacked by critics for its ironic view of America, but it was to exert a great influence on both the subject matter and style of photography as an art form. Like Frank's photographs, the works of Diane Arbus, Lee Friedlander, Garry Winogrand (page 334), and others were personal observations of some of the peculiar and occasionally grotesque aspects of American society. Above, a glimpse inside a New York bar is an unsettling comment on the emptiness of modern society. Jack Kerouac wrote in his introduction to Frank's book, The Americans, "After seeing these pictures you end up finally not knowing any more whether a jukebox is sadder than a coffin."

Photography as Art in the 1950s and Beyond: continued

JOHN PFAHL: *Rancho Seco Nuclear Plant, Sacramento County, California,* 1983

Beautiful landscapes have long been, and still are, a staple of photographic art—witness the perennial popularity of Ansel Adams's grand vistas. But in the 1970s another attitude toward landscapes began to emerge. Photographers such as Robert Adams (no relation to Ansel) and Lewis Baltz dryly recorded the often devastating imprint of humans on the land.

John Pfahl combines these apparent opposites. Above, a luminous sky, a glorious sunset, and a nuclear power plant: the furthest extreme of

technology grafted onto the picturesque. A supporter of nuclear power might like this photograph as much as an antinuclear activist would. "I'm not interested in pushing simple opinions," Pfahl says, "or making propagandistic statements. It seems to me that when more than one message is presented in a work of art, a tension is created that cries out for a resolution. . . . I would hope that most viewers are provoked by the deliberately fostered tension to think more deeply about the complexity of the issues."

Barbara Kruger appropriates existing images, adds on contradictory or ambiguous comments, advertising slogans, or fragments of vaguely familiar popular wisdom, then usually displays the work in giant size (8 × 12 feet or more). Much of her work is social commentary that deals with women's identity and the pressures on it. Kruger points in the direction she wants the viewer to go, but often leaves the exact interpretation to the viewer. Does the gesture here suggest pain or alienation or fear? Does the text imply cynicism or delusion?

Kruger's background was as a magazine graphic designer, and her work is visually engaging as well as confrontational. "I want to make statements that are negative about the culture we're in," Kruger says, but she puts her statements in eye-catching form, "or else people will not look at them."

BARBARA KRUGER: *Untitled (Are We Having Fun Yet?)*, 1987

Photography as Art in the 1950s and Beyond: continued

SANDY SKOGLUND: *Radioactive Cats*, 1980

Sandy Skoglund constructs and then photographs life-size sets in which ordinary domestic scenes are transformed into bizarre or disturbing tableaux. "I like to stay in touch with reality," she says, "and at the same time try and interfere with it, like Magritte does. . . . You could call it making the familiar unfamiliar."

In Radioactive Cats a troop of acid-green cats realistically molded out of plaster prowl around an elderly couple in a colorless kitchen. The result is unsettling and humorous at the same time. "I was thinking of what forms of life might best survive nuclear attack, and cats, with their predatory nature, seemed likely," she says. "It's terrifying to think about the cat, and what it thinks about you."

Serial imagery, sequences, and photo essays release the photographer from the confinement of a single picture. They can show variations of a single photograph or theme, show the same scene from different angles or at different times, bring together different images to make a particular statement, or, as here, tell a story.

Duane Michals tells stories that are seldom literal, but always relevant. "Photography to me is a matter of thinking rather than looking," he says. "It's revelation, not description." His photographs are often accompanied by titling or captions. Notice that you need the title of this story in order to understand it.

DUANE MICHALS: *Death Comes to the Old Lady*, 1969

PHOTOJOURNALISM

Today we take **photojournalism** for granted, and whatever the news event—from a prizefight to a war—we expect to see pictures of it. But news and pictures were not always partners. Drawings and cartoons appeared only occasionally in the drab 18th-century press. The 19th century saw the growth of illustrated newspapers such as the *Illustrated London News* and, in America, *Harper's Weekly* and *Frank Leslie's Illustrated Newspaper*. Because the various tones of gray needed to reproduce a photograph could not be printed simultaneously with ordinary type, photographs had to be converted into drawings and then into woodcuts before they could appear as news pictures. The photograph merely furnished material for the artist.

The perfection in the 1880s of the **halftone** process *(bottom, right)* permitted photographs and type to be printed together, and photographs became an expected addition to news stories. "These are no fancy sketches," the *Illustrated American* promised, "they are the actual life of the place reproduced upon paper." The **photo essay**—a sequence of photographs plus brief textual material *(pages 402–403)*—came of age in the 1930s. It was pioneered by Stefan Lorant in European picture magazines and later in America by a score of publications such as *Life* and *Look*. Today, although the heyday of the picture magazine has passed, due to competition from television, photographs remain a major source of our information about the world.

Early cameras were relatively bulky, and the slowness of available films meant that using a camera indoors required a blinding burst of flash powder. Not until the 1920s did photographers get a small camera able to take pictures easily in dim light. The first of these cameras, the Ermanox, to be followed soon by the Leica, had a lens so fast—f/2—that unobtrusive, candid shooting became practical. Erich Salomon (below) was one of the pioneers of such shooting, with a special talent for dressing in formal clothes and crashing diplomatic gatherings, where his camera let him record those in power while they were preoccupied with other matters, such as at the 1931 meeting (right) of German and Italian statesmen. In tribute to Salomon, the French foreign minister, Aristide Briand, is said to have remarked, "There are just three things necessary for a League of Nations conference: a few foreign secretaries, a table and a Salomon."

ERICH SALOMON: *Visit of German Statesmen to Rome,* 1931

PETER HUNTER: *Erich Salomon,* 1929

The halftone process converts the continuous shades of gray in a photograph (above left) into distinct units of black and white that can be printed with ink on paper (above right).

MURRAY BECKER: *Hindenburg Crash, Lakehurst, New Jersey,* May 6, 1937

The Disaster Photo—one of the staples of news photography: the stunned survivors in the foreground, the crashed plane or burning house or floodwaters in the background. Many news photographs show us the world in standardized ways or patterns, but the best reveal the particulars, the uniqueness of a scene.

The disaster photo at right is a classic of its kind. A black cloud of smoke billows from the big jet crashed in the background. The plane lies in the stubble of a field, looking as out of place and helpless as a beached whale. The picture combines the intensity of the moment with strong graphic composition as the survivors, some grieving, others in shock, move along a path curving to the foreground. One can imagine the photograph as a still from a disaster movie, set up to evoke emotion plus have pictorial appeal.

Above: An equally powerful photograph of the 1937 crash of the dirigible *Hindenburg.* The tiny figures near the aircraft give some idea of its size, 800 feet long. The press had turned out to record what was supposed to be a routine landing, though still enough of a novelty in air travel to be covered. Instead they were witness to an astounding catastrophe as the huge craft burst into flames and exploded.

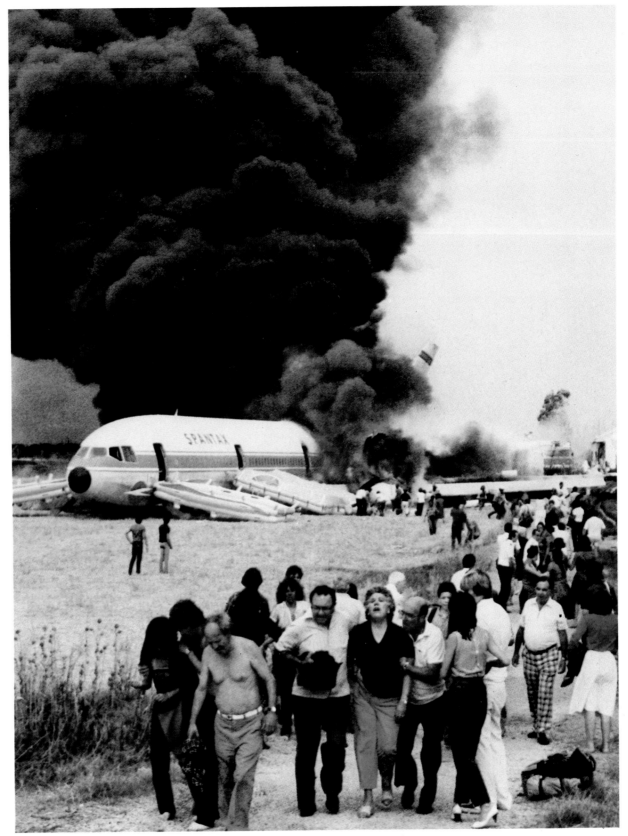

WERNER VOIGHT: *Spantax Crash, Malaga, Spain,* September 13, 1982

Photojournalism: continued

A CHRISTENING

While his godfather holds him over a font, the priest Don Manuel does the head of a month-old Buenaventura Jimenez Moreno after his baptism at village church.

GUARDIA CIVIL

These stern men, enforcers of national law, are Franco's rural police. They patrol countryside, are feared by people in villages, which also have local police.

VILLAGE SCHOOL

Girls are taught in separate classes from the boys. Four rooms and four teachers handle all pupils, as many as 300 in winter, between the ages of 6 and 11.

◀ **FAMILY DINNER**

The Curods eat thick bean and potato soup from common pot on dirt floor of their kitchen. The father, mother and four children all share the one bedroom.

THE THREAD MAKER

A peasant woman moistens the fibers of locally grown flax as she pulls them in a long strand which is spun tight by the spindle (right), then wrapped around it.

126

CONTINUED ON NEXT PAGE 127

W. EUGENE SMITH: From *Spanish Village*, 1951

The photo essay—pictures plus supporting text— was the mainstay of mass-circulation picture magazines such as Life *and* Look. *Above and opposite are four pages from* Spanish Village,

photographed for Life *by W. Eugene Smith, whose picture essays are unsurpassed in their power and photographic beauty.*

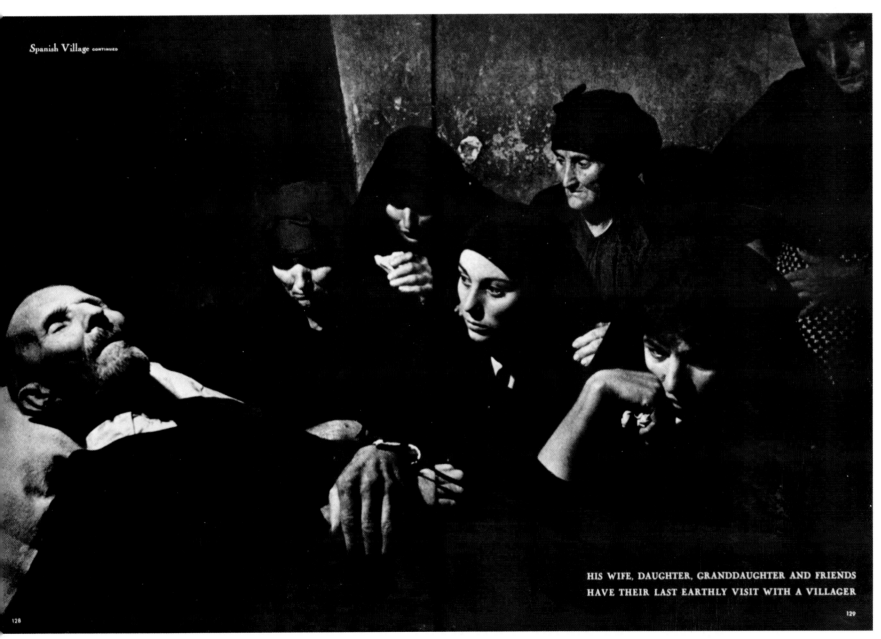

Spanish Village CONTINUED

128

HIS WIFE, DAUGHTER, GRANDDAUGHTER AND FRIENDS
HAVE THEIR LAST EARTHLY VISIT WITH A VILLAGER

129

"I try to do work that affects people," Smith said. "I try to lead them with my photographs so that they can draw their own conclusions." Smith was intensely committed to his work. "I never made any picture, good or bad, without paying for it in emotional turmoil."

HISTORY OF COLOR PHOTOGRAPHY

Daguerre himself knew that only one thing was needed to make his wonderful invention complete—color. "There is nothing else to be desired," he wrote, "but the presentation of these children of light to the astonished eye in the full splendour of their colors." He and Niépce both experimented with various means of recording color without significant success. In 1850 an American minister and daguerreotypist, Levi L. Hill, made some color daguerreotypes, apparently by accident. Unfortunately, he was not able to reproduce the circumstances that had caused his materials to produce colors.

After several other false starts, one of the first successes was demonstrated in 1861 by the British physicist James Clerk Maxwell. To illustrate a lecture on color vision, he devised a way to recreate the colors of a tartan ribbon. He had three negatives of the ribbon made, each through a different color filter—red, green, and blue. Positive black-and-white transparencies were made and projected through filters like those on the camera. When the three images were superimposed, they produced an image of the ribbon in its original colors.

Maxwell had demonstrated additive color mixing, in which colors are produced by adding together varying amounts of light of the three primary colors, red, green, and blue. In 1869, an even more significant theory was made public. Louis Ducos du Hauron and Charles Cros, two Frenchmen working independently of each other, announced almost simultaneously their researches in subtractive color mixing. In subtractive mixing, the basis of present-day color photography, colors are created by combining cyan, magenta, and yellow dyes (the complements of red, green, and blue). The dyes subtract colors from the "white" light that contains all colors. (More about additive and subtractive theory on pages 204–205.) There were many variations of Ducos du Hauron's basic subtractive process in which three separately dyed images were superimposed to form a full-color image. They include his own three-color carbon process *(right, top)*, the carbro process *(opposite)*, and contemporary dye transfer printing.

The first commercially practical color was an additive process. In 1907, two French brothers, Antoine and Louis Lumière, marketed their Autochrome process. A glass plate was covered with tiny grains of potato starch dyed red-orange, green, and violet, in a layer only one starch grain thick. Then, a light-sensitive emulsion was added. Light struck the emulsion after passing through the colored grains. The emulsion behind each grain was exposed only by light from the scene that was the same color as that grain. The result after development was a full-color transparency *(right, bottom)*.

The greatest advance in making color photography practical was perfected by Leopold Mannes and Leopold Godowsky, two musicians and amateur photographic researchers who eventually joined forces with Eastman Kodak research scientists. Their collaboration led to the introduction in 1935 of Kodachrome, a subtractive process in which a single sheet of film is coated with three layers of emulsion, each sensitive to one primary color (red, green, and blue). A single exposure produces a color image *(see page 206)*.

Today it is difficult to imagine photography without color. The amateur market is huge, and the ubiquitous snapshot is always in color. Commercial and publishing markets use color extensively. Even photography as an art form and photojournalism, which have been in black and white for most of their history, now often are in color.

LOUIS DUCOS du HAURON: *View of Angoulême, France,* 1877. Three-color carbon print

ARNOLD GENTHE: *Helen Cooke Wilson in a California Poppy Field,* c. 1908. Autochrome

◀ Louis Ducos du Hauron's three-color carbon process required three separate black-and-white negatives, one for each of the primary colors red, green, and blue. Each image was dyed the color of its primary and then superimposed to form a full-color image.

◀ The Autochrome process was popular at the turn of the century with pictorialists who liked its graininess and subdued colors. The dots of color that composed the image blended at a normal viewing distance into a full range of colors, not unlike the effect that pointillist painters created with individual dots of paint.

The carbro process preceded the ▶ development of Kodachrome and other modern color films. Like Ducos du Hauron's three-color carbon print (opposite, top), carbros required three black-and-white negatives made with three different color filters. A cumbersome "one-shot" camera was used. Light passed through a lens into the camera to an arrangement of mirrors that split the light so that all three negatives were made simultaneously. To make a print, the negatives were converted into three layers of dyed gelatin that were mounted in register on a white backing. Here, two famous movie stars pose for a soft-drink advertisement made by Nickolas Muray, one of the earliest and best of color advertising photographers.

NICKOLAS MURAY: *Fredric March and Claudette Colbert*, 1933. Carbro print

Glossary

aberration An optical defect in a lens causing it to form an image that is not sharp or that is distorted. *See also* astigmatism, barrel distortion, chromatic aberration, coma, field curvature, pincushion distortion, spherical aberration.

acid A substance with a pH below 7. Since an acid neutralizes an alkali, a stop bath is usually an acidic solution that stops the action of the alkaline developer.

additive color A way to produce colors of light by mixing light of the three additive primary colors—red, green, and blue. Varying proportions of the additive primaries can be combined to create light of all other colors, including white, which is a mixture of all wavelengths.

AE *See* automatic exposure.

AF *See* automatic focus.

agitate To move a solution over the surface of film or paper during development so that fresh liquid comes into contact with the surface.

albumen Egg white; used in early photographic emulsions as a coating for glass plates and, more commonly, for printing paper.

alkali A substance with a pH above 7. Developers are usually alkaline solutions.

ambrotype A collodion wet-plate process in which the emulsion was coated on a glass plate. The negative image produced was visible as a positive image when the glass was backed with a dark material.

angle of view The area seen by a lens or viewfinder or read by a light meter.

aperture The size of the lens opening through which light passes. The relative aperture is measured as the focal length of the lens divided by the diameter of the aperture; this is expressed as an f-number: f/8, f/11, and so on.

aperture-priority A mode of automatic exposure in which the photographer selects the aperture and the camera sets the shutter speed that will produce the correct exposure.

archival processing Processing designed to protect a print or negative as much as possible from premature deterioration caused by chemical reactions.

artificial light Light from an electric lamp, a flash bulb, or electronic flash. Often describes lights that the photographer has set up to illuminate a scene.

ASA A film speed rating similar to an ISO rating.

astigmatism A lens aberration or defect that is caused by the inability of a simple lens to focus oblique rays uniformly.

automatic exposure A mode of camera operation in which the camera adjusts the shutter speed, the aperture, or both to produce the correct exposure. Abbreviated AE.

automatic flash An electronic flash unit with a light-sensitive cell and electronic circuitry that measures the light reflected back from the subject and terminates the flash when the exposure is correct.

automatic focus A system by which the camera adjusts its lens to focus on a given area, for example, whatever is at the center of the image. Abbreviated AF.

ambient light *See* available light.

Av Abbreviation of aperture value. Used on some camera information displays as a shortened way to refer to aperture settings (f-stops).

available light The light that already exists where a photograph is to be made, as opposed to light brought in by the photographer. Often implies a relatively dim light. Also called ambient light or existing light.

axis lighting Light pointed at the subject from a position close to the camera's lens.

B *See* bulb.

back lighting Light that comes from behind the subject toward the camera.

barrel distortion A lens aberration or defect that causes straight lines to bow outward, away from the center of the image.

bellows A flexible, light-tight, and usually accordion-folded part of a view camera between the lens board in front and the viewing screen in back. Also used on a smaller camera when the lens must be positioned farther than normal from the film.

bit The smallest unit of information usable by a computer.

bleed mount To mount a print so that there is no border between the edges of the print and the edges of the mounting surface.

blocked up Describes highlight areas that lack normal texture and detail. Due to excess contrast caused by, for example, overexposure or overdevelopment.

blotters Sheets of absorbent paper made expressly for photographic use. Wet prints dry when placed between blotters.

bounce light Light that does not travel directly from its source to the subject but is first reflected off another surface.

bracket To make several exposures, some greater and some less than the exposure that is calculated to be correct. Bracketing allows for error and permits selection of the best exposure after development.

brightness Strictly speaking, a subjective impression of the lightness of an object. The correct term for the measurable quantity of light reflected or produced by an object is *luminance. See also* luminance.

broad lighting Portrait lighting in which the main source of light illuminates the side of the face turned most toward the camera.

built-in meter A reflected-light exposure meter built into a camera so that light readings can be made directly from camera position.

bulb A shutter setting marked *B* at which the shutter remains open as long as the shutter release is held down.

burn in To darken a specific area of a print by giving it additional printing exposure.

butterfly lighting Portrait lighting in which the main source of light is placed high and directly in front of the face.

byte A unit of digital data containing eight bits. *See also* kilobyte, megabyte.

cable release A long coiled wire with a plunger at one end and a socket at the other that attaches to a camera's shutter release. Pressing the plunger releases the shutter without touching (and possibly moving) the camera.

calotype The first successful negative/positive photographic process; it produced an image on paper. Invented by Talbot; also called Talbotype.

camera A picture-taking device usually consisting of a light-tight box, a film holder, a shutter to admit a measured quantity of light, and a lens to focus the image.

camera obscura Latin for "dark chamber": a darkened room with a small opening through which rays of light could enter and form an image of the scene outside. Eventually, a lens was added at the opening to improve the image, and the room shrank to a small, portable box.

carte-de-visite A small portrait, about the size of a visiting card, popular during the 1860s. People often collected them in albums.

cartridge *See* cassette.

cassette A light-tight metal or plastic container that permits a roll of 35mm film to be loaded into a camera in the light. Also called a cartridge.

catchlight A reflection of a light source in a subject's eye.

changing bag A light-tight bag into which a photographer can insert his or her hands to handle film when a darkroom is not available.

characteristic curve A diagram of the response to light of a photographic material, showing how increasing exposure affects silver density during development. Also called the D log E curve, since density is plotted against the logarithm of the exposure.

chromatic aberration A lens defect that bends light rays of different colors at different angles and therefore focuses them on different planes.

chrome A color transparency.

chromogenic film Film in which the final image is composed of dyes rather than silver.

circle of confusion The tiny circle of light formed by a lens as it projects the image of a single point of a subject. The smaller the diameters of all the circles of confusion in an image, the sharper the image will be.

close-up A larger-than-normal image that is formed on a negative by focusing the subject closer than normal to the lens with the use of supplementary lenses, extension tubes, or bellows.

close-up lens *See* supplementary lens.

cold-light enlarger A diffusion enlarger that uses a fluorescent tube instead of a tungsten bulb as the light source.

collodion A transparent, syrupy solution of pyroxylin (a nitrocellulose) dissolved in ether and alcohol; used as the basis for the emulsion in the wet-plate process.

color balance 1. A film's response to the colors of a scene. Color films are balanced for use with specific light sources. 2. The reproduction of colors in a color print, alterable during printing.

color cast A trace of one color in all the colors in an image.

color compensating filters Gelatin filters that can be used to adjust the color balance during picture taking or in color printing. More expensive than acetate color printing filters, they can be used below the enlarger lens if the enlarger has no other place for filters. Abbreviated CC filters.

color printing filters Acetate filters used to adjust the color balance in color printing. They must be used with an enlarger that can hold filters between the enlarger lamp and the negative. Abbreviated CP filters.

color temperature A numerical description of the color of light. It is the temperature in degrees Kelvin (K) to which a perfect black-body radiator (an object that does not reflect any light falling on it) would have to be heated to produce a given color.

color temperature meter A device for estimating the color temperature of a light source. Usually used to determine the filtration needed to match the color balance of the light source with that of standard types of color film.

coma A lens aberration or defect that causes rays that pass obliquely through the lens to be focused at different points on the film plane.

complementary colors 1. Any two colors of light that when combined include all the wavelengths of light and thus produce white light (*see* additive color). 2. Any two dye colors that when combined absorb all wavelengths of light and thus produce black (*see* subtractive color). A colored filter absorbs light of its complementary color and passes light of its own color.

condenser enlarger An enlarger that illuminates the negative with light that has been concentrated

and directed by condenser lenses placed between the light source and the negative.

contact printing The process of placing a negative in contact with sensitized material, usually paper, and then passing light through the negative onto the material. The resulting image is the same size as the negative.

contamination Traces of chemicals that are present where they don't belong, causing loss of chemical activity, staining, or other problems.

continuous tone Describes an image with a smooth gradation of tones from black through gray to white.

contrast The difference in darkness or density between one tone and another.

contrast filter A colored filter used on a camera lens to lighten or darken selected colors in a black-and-white photograph. For example, a green filter used to darken red flowers against green leaves.

contrast grade The contrast that a printing paper produces. Systems of grading contrast are not uniform, but in general grades 0 and 1 have low or soft contrast; grades 2 and 3 have normal or medium contrast; grades 4, 5 and 6 have high or hard contrast.

contrasty Describes a scene, negative, or print with very great differences in brightness between light and dark areas. Opposite: *flat.*

convergence The phenomenon in which lines that are parallel in a subject, such as the vertical lines of a building, appear nonparallel in an image.

cool Refers to bluish colors that by association with common objects (water, ice, and so on) give an impression of coolness.

correction filter A colored filter used on a camera lens to make black-and-white film produce the same relative brightnesses perceived by the human eye. For example, a yellow filter used to darken a blue sky so it does not appear excessively light.

coupled rangefinder *See* rangefinder.

covering power The area of the focal plane over which a lens projects an image that is acceptably sharp and uniformly illuminated.

crop To trim the edges of an image, often to improve the composition. Cropping can be done by moving the camera position while viewing a scene, by adjusting the enlarger or easel during printing, or by trimming the finished print.

curvilinear distortion *See* barrel distortion; pincushion distortion.

cut film *See* sheet film.

daguerreotype The first practical photographic process, invented by Daguerre and described by him in 1839. The process produced a positive image formed by mercury vapor on a metal plate coated with silver iodide.

darkroom A room where photographs are developed and printed, sufficiently dark to handle light-sensitive materials without causing unwanted exposure.

dark slide *See* slide (2).

daylight film Color film that is balanced to produce accurate color renditions when the light source illuminating the photographed scene has a color temperature of about 5500K, such as in midday sunlight or with electronic flash or a blue flashbulb.

dedicated flash An electronic flash unit that when used with certain cameras will automatically set the correct shutter speed for use with flash and will trigger a light in the viewfinder when the flash is charged and ready to fire. Also called designated flash.

dense Describes a negative or an area of a negative in which a large amount of silver has been deposited. A dense negative transmits relatively little light. Opposite: *thin.*

densitometer An instrument that measures the darkness or density of a negative or print.

density The relative amount of silver present in various areas of film or paper after exposure or development; therefore, the darkness of a photographic print or the light-stopping ability of a negative or transparency.

depth of field The area between the nearest and farthest points from the camera that are acceptably sharp in an image.

depth of focus The small range of allowable focusing error that will still produce an acceptably sharp image when a lens is not focused exactly.

designated flash *See* dedicated flash.

developer A chemical solution that changes the invisible, latent image produced during exposure into a visible one.

development 1. The entire process by which exposed film or paper is treated with various chemicals to make an image that is visible and permanent. 2. Specifically, the step in which film or paper is immersed in developer.

diaphragm The mechanism controlling the brightness of light that passes through a lens. An iris diaphragm has overlapping metal leaves whose central opening can be adjusted to a larger or smaller size. *See also* aperture.

dichroic head An enlarger head that contains yellow, magenta, and cyan filters that can be moved in calibrated stages into or out of the light beam to change the color balance of the enlarging light.

diffuse Scattered, not all coming from the same direction. For example, sunlight on a cloudy day.

diffusion enlarger An enlarger that illuminates the negative by scattering light from many angles evenly over the surface of the negative.

digital imaging A method of image editing in which a picture is recorded as digital information that can be read and manipulated by a computer, and subsequently reformed as a visible image.

DIN A numerical rating used in Europe to describe the sensitivity of film to light. The DIN rating increases by 3 as the sensitivity of the film doubles.

diopter An optician's term to describe the power of a lens. In photography, it mainly indicates the magnifying power and focal length of a supplementary close-up lens.

distortion 1. A lens aberration that causes straight lines at the edge of an image to appear curved. 2. The changes in perspective that take place when a lens is used very close to (wide-angle distortion) or very far from (telephoto effect) a subject.

dodge To lighten an area of a print by shading it during part of the printing exposure.

dropout An image with black and white areas only and no intermediate gray tones. Usually made by using high-contrast lith film.

dry down To become very slightly darker and less contrasty, as most photographic printing papers do when they dry after processing.

dry mount To attach a print to another surface, usually cardboard, by placing a sheet of dry-mount tissue between the print and the mounting surface. This sandwich is placed in a heated mounting press to melt an adhesive in the tissue. Pressure-sensitive tissue that does not require heat may also be used.

DX coding A checkered or bar code on some film cassettes. The checkered code can be automatically scanned by a suitably equipped camera for such information as film speed and number of frames. The bar code is read by automatic film processing equipment for film type, processing procedure, and so on.

easel A holder to keep sensitized material, normally paper, flat and in position on the baseboard of an enlarger during projection printing. It usually has adjustable borders to frame the image to various sizes.

EI *See* exposure index.

electromagnetic spectrum The forms of radiant energy arranged by size of wavelength ranging from billionths of a millimeter (gamma rays) to several miles (radio waves). The visible spectrum is the part that the human eye sees as light: wavelengths of 400 to 700 nanometers (billionths of a meter), producing the sensation of the colors violet, blue, green, yellow, and red.

electronic flash A tube containing gas that produces a brief, brilliant flash of light when electrified. Unlike a flashbulb, an electronic flash unit is reusable. Also called a strobe.

emulsion A light-sensitive coating applied to photographic films or papers. It consists of silver halide crystals and other chemicals suspended in gelatin.

enlargement An image, usually a print, that is larger than the negative. Made by projecting an enlarged image of the negative onto sensitized paper.

enlarger An optical instrument ordinarily used to project an image of a negative onto sensitized paper. More accurately called a projection printer because it can project an image that is either larger or smaller than the negative.

etch To remove a small, dark imperfection in a print or negative by scraping away part of the emulsion.

EV *See* exposure value.

existing light *See* available light.

exposure 1. The act of letting light fall on a light-sensitive material. 2. The amount of light reaching the light-sensitive material; specifically, the intensity of light multiplied by the length of time it falls on the material.

exposure index A film speed rating similar to an ISO rating. Abbreviated EI.

exposure meter An instrument that measures the amount of light falling on a subject (incident-light meter) or emitted or reflected by a subject (reflected-light meter), allowing aperture and shutter speed settings to be computed. Commonly called a light meter.

exposure value A system originally intended to simplify exposure calculations by assigning standardized number values to f-stop and shutter speed combinations. More often, used simply as a shorthand way of describing the range of light levels within which equipment operates. For example, a manufacturer may describe a meter as operating from EV −1 to EV 20 (4 sec at f/1.4 to 1/2000 sec at f/22, with ISO 100 film).

extension tubes Metal rings that can be attached between a camera body and lens for close-up work. They extend the lens farther than normal from the film plane so that the lens can focus closer than normal to an object.

factor A number that tells how many times exposure must be increased to compensate for loss of light (for example, due to use of a filter).

Farmer's Reducer A solution of potassium ferricyanide and sodium thiosulfate that is used to decrease the amount of silver in a developed image.

fast Describes 1. a film or paper that is very sensitive to light; 2. a lens that opens to a very wide aperture; 3. a short shutter speed. Opposite: *slow.*

ferrotype To give a glossy printing paper a very high sheen by drying the print with its emulsion pressed against a smooth metal plate, usually the hot metal drum or plate of a heat dryer.

fiber-base paper Formerly the standard type of paper available; now being replaced to a certain extent by resin-coated papers. Printed instructions for washing, drying, and so forth refer to fiber-base papers unless resin-coated papers are specifically mentioned.

field curvature A lens aberration or defect that causes the image to be formed along a curve instead of on a flat plane.

fill light A source of illumination that lightens shadows cast by the main light and thereby reduces the contrast in a photograph.

film The material used in a camera to record a photographic image. Generally it is a light-sensitive

emulsion coated on a flexible acetate or plastic base.

film holder A light-tight container to hold the sheet film used in a view camera.

film plane *See* focal plane.

film speed The relative sensitivity to light of a film. There are several rating systems: ISO (the most common in the United States and Great Britain), DIN (common in Europe), and others. Film speed ratings increase as the sensitivity of the film increases.

filter 1. A piece of colored glass, plastic, or other material that selectively absorbs some of the wavelengths of light passing through it. 2. To use such a filter to modify the wavelengths of light reaching a light-sensitive material.

filter factor *See* factor.

fisheye lens A lens with an extremely wide angle of view (as much as 180°) and considerable barrel distortion (straight lines at the edges of a scene appear to curve around the center of the image).

fixer A chemical solution (sodium thiosulfate or ammonium thiosulfate) that makes a photographic image insensitive to light. It dissolves unexposed silver halide crystals while leaving the developed silver image. Also called hypo.

flare Unwanted light that reflects and scatters inside a lens or camera. When it reaches the film, it causes a loss of contrast in the image.

flash 1. A light source, such as a flashbulb or electronic flash, that emits a very brief, bright burst of light. 2. To blacken an area in a print by exposing it to white light, such as from a penlight flashlight.

flash bar or flash cube A lighting device containing several very small flashbulbs and producing several separate flashes before the unit is discarded.

flashbulb A bulb containing a mass of aluminum wire, oxygen, and an explosive primer. When the primer is electrically fired, it ignites the wire, which emits a brief burst of brilliant light. A flashbulb is used once and then discarded.

flash meter An exposure meter that measures the brightness of flash lighting to determine the correct exposure for a particular setup.

flat 1. A scene, negative, or print with very little difference in brightness between light and dark areas. Opposite: *contrasty.* 2. *See* reflector.

floodlight An electric light designed to produce a broad, relatively diffused beam of light.

f-number A number that equals the focal length of a lens divided by the diameter of the aperture at a given setting. Theoretically, all lenses at the same f-number produce images of equal brightness. Also called f-stop or relative aperture.

focal length The distance from the lens to the focal plane when the lens is focused on infinity. The longer the focal length, the greater the magnification of the image.

focal plane The plane or surface on which a focused lens forms a sharp image. Also called the film plane.

focal-plane shutter A camera mechanism that admits light to expose film by moving a slit or opening in a roller blind just in front of the film (focal) plane.

focal point The point on a focused image where the rays of light intersect after reflecting from a single point on a subject.

focus 1. The position at which rays of light from a lens converge to form a sharp image. 2. To adjust the distance between lens and image to make the image as sharp as possible.

focusing cloth A dark cloth used in focusing a view camera. The cloth fits over the camera back and the photographer's head to keep out light and to make the ground-glass image easier to see.

fog An overall density in the photographic image caused by unintentional exposure to light or unwanted chemical activity.

frame 1. The edges of an image. 2. A single image in a roll of film.

f-stop The common term for the aperture setting of a lens. *See also* f-number.

full-scale Describes a print having a wide range of tonal values from deep, rich black through many shades of gray to brilliant white.

gelatin A substance produced from animal skins and bones, it is the basis for modern photographic emulsions. It holds light-sensitive silver halide crystals in suspension.

glossy Describes a printing paper with a great deal of surface sheen. Opposite: *matte.*

graded-contrast paper A printing paper that produces a single level of contrast. To produce less or more contrast, a change has to be made to another grade of paper. *See also* variable-contrast paper.

graininess In an enlarged image, a speckled or mottled effect caused by oversized clumps of silver in the negative.

gray card A card that reflects a known percentage of the light falling on it. Often has a gray side reflecting 18 percent and a white side reflecting 90 percent of the light. Used to take accurate exposure meter readings (meters base their exposures on a gray tone of 18 percent reflectance) or to provide a known gray tone in color work.

ground glass 1. A piece of glass roughened on one side so that an image focused on it can be seen on the other side. 2. The viewing screen in a reflex or view camera.

guide number A number used to calculate the f-setting (aperture) that correctly exposes a film of a given sensitivity (film speed) when the film is used with a specific flash unit at various distances from flash to subject. To find the f-setting, divide the guide number by the distance.

gum-bichromate process An early photographic process revived by contemporary photographers. The emulsion is a sensitized gum solution containing color pigments. The surface can be altered by hand during the printing process.

halftone An image that can be reproduced on the same printing press with ordinary type. The tones in the photograph are screened to a pattern of dots (close together in dark areas, farther apart in light areas) that give the illusion of continuous tone.

hanger A frame for holding sheet film during processing in a tank.

hard 1. Describes a scene, negative, or print of high contrast. Opposite: *soft* or *low contrast.* 2. Describes a printing paper emulsion of high contrast such as grades 5 and 6.

hardware The processor, monitor, printer, and other physical devices that make up a computer system.

heliography An early photographic process, invented by Niépce, employing a polished pewter plate coated with bitumen of Judea, a substance that hardens on exposure to light.

highlight A very bright area in a scene, print, or transparency; a very dense, dark area in a negative. Also called a high value.

hot shoe A bracket on the top of the camera that attaches a flash unit and provides an electrical connection to synchronize the camera shutter with the firing of the flash.

hyperfocal distance The distance to the nearest plane of the depth of field (the nearest object in focus) when the lens is focused on infinity. Also the distance to the plane of sharpest focus when infinity is at the farthest plane of the depth of field. Focusing on the hyperfocal distance extends the depth of field from half the hyperfocal distance to infinity.

hypo A common name for any fixer; taken from the abbreviation for sodium hyposulfite, the previous name for sodium thiosulfate (the active ingredient in most fixers).

hypo clearing agent or hypo neutralizing agent *See* washing aid.

illuminance The strength of light falling on a given area of a surface. Measurable by an incident-light (illuminance) meter.

illuminance meter *See* incident-light meter.

incandescent light Light emitted when a substance is heated by electricity: for example, the tungsten filament in an ordinary light bulb.

incident-light meter An exposure meter that measures the amount of light incident to (falling on) a subject.

indoor film *See* Type A film; tungsten film.

infinity The farthest position (marked ∞) on the distance scale of a lens. It includes all objects at the infinity distance (about 50 feet) from the lens or farther. When the infinity distance is within the depth of field, all objects at that distance or farther will be sharp.

infrared The band of invisible rays just beyond red, which many people perceive to some extent as heat. Some photographic materials are sensitized to record infrared.

instant film A film such as Polaroid Time-Zero that contains the chemicals needed to develop an image automatically after exposure without the need for darkroom development.

intensification A process increasing the darkness of an already developed image. Used to improve negatives that have too little silver density to make a good print or to increase the density of an existing print.

interchangeable lens A lens that can be removed from the camera and replaced with another lens, usually of a different focal length.

inverse square law A law of physics stating that the intensity of illumination is inversely proportional to the square of the distance between light and subject. This means that if the distance between light and subject is doubled, the light reaching the subject will be only one-quarter of the original.

ISO A numerical rating that describes the sensitivity of a film to light. The ISO rating doubles as the sensitivity of the film doubles.

Kelvin temperature *See* color temperature.

key light *See* main light.

kilobyte A unit of digital data containing 1024 bytes. Used to describe the size of a computer file.

latent image An image formed by the changes to the silver halide grains in photographic emulsion on exposure to light. The image is not visible until chemical development takes place.

latitude The amount of over- or underexposure possible without a significant loss in the quality of an image.

leaf shutter A camera mechanism that admits light to expose film by opening and shutting a circle of overlapping metal leaves.

lens A piece or several pieces of optical glass shaped to focus an image of a subject.

lens shade A shield that fits around a lens to prevent unwanted light from hitting the front of the lens and causing flare. Also called a lens hood.

light meter *See* exposure meter.

light-tight Absolutely dark. Protected by opaque material, overlapping panels, or some other system through which light cannot pass.

line print An image resembling a pen-and-ink drawing, with black lines on a white background (or white lines on a black background). It is made with high-contrast lith film. Also called tone line print.

lith film A type of film made primarily for use in graphic arts and printing. It produces an image with very high contrast.

local reduction *See* reduction (3).

long lens A lens whose focal length is longer than the diagonal measurement of the film with which it is used. The angle of view with such a lens–film size combination is narrower at a given distance than the angle that the human eye sees.

luminance The light reflected or produced by a given area of a subject in a specific direction. Measurable by a reflected-light (luminance) meter.

luminance meter *See* reflected-light meter.

macro lens A lens designed for taking close-up pictures.

macrophotograph *See* photomacrograph.

main light The principal source of light in a photograph, particularly in a studio setup, casting the dominant shadows and defining the texture and volume of the subject. Also called key light.

manual exposure A nonautomatic mode of camera operation in which the photographer sets both the shutter speed and the aperture.

manual flash A nonautomatic mode of flash operation in which the photographer controls the exposure by adjusting the size of the camera aperture.

mat A cardboard rectangle with an opening cut in it that is placed over a print to frame it. Also called an overmat.

mat knife A short knife blade (usually replaceable) set in a large, easy-to-hold handle. Used for cutting cardboard mounts for prints.

matte Describes a printing paper with a relatively dull, nonreflective surface. Opposite: *glossy.*

megabyte A unit of digital data containing 1,048,576 bytes. Used to describe the size of a computer file.

middle gray A standard average gray tone of 18 percent reflectance. *See also* gray card.

midtone An area of medium brightness, neither a very dark shadow nor a very bright highlight. A medium gray tone in a print.

modeling light A small tungsten light built into some flash units. It helps the photographer judge the effect of various light positions because the duration of flash light is too brief to be judged directly.

mottle A mealy gray area of uneven development in a print or negative. Caused by too little agitation or too short a time in the developer.

narrow lighting *See* short lighting.

negative 1. Any image with tones that are the reverse of those in the subject. Opposite: *positive.* 2. The film in the camera during exposure that is subsequently developed to produce a negative image.

negative carrier A frame that holds a negative flat in an enlarger.

negative film Film that produces a negative image on exposure and development.

nonsilver process A printing process that does not depend on the sensitivity of silver to form an image; for example, the cyanotype process, in which the light-sensitive emulsion consists of a mixture of iron salts.

normal lens A lens whose focal length is about the same as the diagonal measurement of the film with which it is used. The angle of view with this lens–film size combination is roughly the same at a given distance as the angle that the human eye sees clearly.

notching code Notches cut in the margin of sheet film so that the type of film and its emulsion side can be identified in the dark.

one-shot developer A developer used once and then discarded.

opaque Describes 1. any substance or surface that will not allow light to pass; 2. a paint used to block out portions of a negative so that they will not allow light to pass during printing.

open up To increase the size of a lens aperture. Opposite: *stop down.*

orthochromatic Film that is sensitive to blue and green but not to red wavelengths of the visible spectrum. Abbreviated ortho.

overdevelop To give more than the normal amount of development.

overexpose To give more than normal exposure to film or paper. The resulting silver density is often too great for best results.

oxidation Loss of chemical activity due to contact with oxygen in the air.

pan 1. To follow the motion of a moving object with the camera. This will cause the object to look sharp and the background blurred. 2. *See* panchromatic.

panchromatic Film that is sensitive to all (or almost all) wavelengths of the visible spectrum. Abbreviated pan.

parallax The difference in point of view that occurs when the lens (or other device) through which the eye views a scene is separate from the lens that exposes the film.

PC connector *See* sync cord.

PC terminal The socket on a camera or flash unit into which a PC connector (sync cord) is inserted.

perspective The apparent size and depth of objects within an image.

photoflood An incandescent lamp that produces a very bright light but has a relatively short life.

photogram An image formed by placing material directly onto a sheet of sensitized film or printing paper and then exposing the sheet to light.

photomacrograph A close-up photograph that is life size or larger. Also called macrophotograph.

photomicrograph A photograph that is taken through a compound microscope.

photomontage A composite image made by cutting out and assembling parts of several photographs.

pincushion distortion A lens aberration or defect that causes straight lines to bow inward toward the center of the image.

pinhole 1. A small clear spot on a negative usually caused by dust on the film during exposure or development or by a small air bubble that keeps developer from the film during development. 2. The tiny opening in a pinhole camera that produces an image.

pixel Short for picture element. The smallest unit of a digital image that can be displayed, changed, or stored.

plane of critical focus The part of a scene that is most sharply focused.

plate In early photographic processes, the sheet of glass or metal on which emulsion was coated.

platinum print A print in which the final image is formed in platinum rather than silver.

polarizing filter A filter that reduces reflections from nonmetallic surfaces such as glass or water by blocking light waves that are vibrating at selected angles to the filter.

positive Any image with tones corresponding to those of the subject. Opposite: *negative.*

posterization An image with a flat, posterlike quality. High-contrast lith film is used to separate the continuous gray tones of a negative into a few distinct shades of gray.

presoak To soak film briefly in water prior to immersing it in developer.

press camera A camera that uses sheet film, like a view camera, but which is equipped with a viewfinder and a hand grip so it can be used without being mounted on a tripod. Once widely used by press photographers, it has been replaced by 35mm cameras.

primary colors Basic colors from which all other colors can be mixed. *See also* subtractive, additive.

print 1. A photographic image, usually a positive one on paper. 2. To produce such an image from a negative by contact or projection printing.

printing frame A holder designed to keep sensitized material, usually paper, in full contact with a negative during contact printing.

programmed automatic A mode of automatic exposure in which the camera sets both the shutter speed and the aperture that will produce the correct exposure.

projection printing The process of projecting an image of a negative onto sensitized material, usually paper. The image may be projected to any size, usually larger than the negative.

projector An optical instrument for forming the enlarged image of a transparency or a motion picture on a screen.

proof A test print made for the purpose of evaluating density, contrast, color balance, subject composition, and the like.

push To expose film at a higher film speed rating than normal, then to compensate in part for the resulting underexposure by giving greater development than normal. This permits shooting at a dimmer light level, a faster shutter speed, or a smaller aperture than would otherwise be possible.

rangefinder 1. A device on a camera that measures the distance from camera to subject and shows when the subject is in focus. 2. A camera equipped with a rangefinder focusing device. Abbreviated RF.

raster streak A dark streak in photographs of television-screen or computer-monitor images, caused by using too fast a shutter speed.

RC paper *See* resin-coated paper.

rear nodal point The point in a lens from which lens focal length (distance from lens to image plane) is measured. Undeviated rays of light cross the lens axis and each other at this point.

reciprocity law The theoretical relationship between length of exposure and intensity of light, stating that an increase in one will be balanced by a decrease in the other. For example, doubling the light intensity should be balanced exactly by halving the exposure time. In fact, the law does not hold true for very long or very short exposures. This reciprocity failure or reciprocity effect causes underexposure unless the exposure is increased. It also causes color shifts in color materials.

reducing agent The active ingredient in a developer. It changes exposed silver halide crystals into dark metallic silver. Also called the developing agent.

reduction 1. A print that is smaller than the size of the negative. 2. The part of development in which exposed silver halide crystals forming an invisible latent image are converted to visible metallic silver. 3. A process that decreases the amount of dark silver in a developed image. Negatives are usually reduced to decrease density. Prints are reduced locally (only in certain parts) to brighten highlights. Opposite: *intensification.*

reel A metal or plastic reel with spiral grooves into which roll film is loaded for development.

reflected-light meter An exposure meter that measures the amount of light reflected or emitted by a subject. Sometimes called a luminance meter.

reflector 1. A reflective surface, such as a piece of white cardboard, that can be positioned to redirect light, especially into shadow areas. Also called a flat. 2. A reflective surface, often bowl-shaped, that is placed behind a lamp to direct more light from the lamp toward the subject.

reflex camera A camera with a built-in mirror that reflects the scene being photographed onto a ground-glass viewing screen. *See also* single-lens reflex; twin-lens reflex.

relative aperture *See* aperture.

replenisher A substance added to some types of developers after use to replace exhausted chemicals so that the developer can be used again.

resin-coated paper Printing paper with a water-resistant coating that absorbs less moisture than uncoated paper, consequently reducing some processing times. Abbreviated RC.

reticulation A crinkling of the gelatin emulsion on film that can be caused by extreme temperature changes during processing.

reversal A process for making a positive image directly from film exposed in the camera; also for

making a negative image directly from a negative or a positive image from a positive transparency.

reversal film Film that produces a positive image (a transparency) on exposure and development.

RF *See* rangefinder.

roll film Film that comes in a roll, protected from light by a length of paper wound around the film. Loosely applies to any film packaged in a roll rather than in flat sheets.

Sabattier effect A partial reversal of tones that occurs when film or paper is reexposed to light during development. Commonly called solarization.

safelight A light used in the darkroom during printing to provide general illumination without giving unwanted exposure.

selective-contrast paper *See* variable-contrast paper.

sharp Describes an image or part of an image that shows crisp, precise texture and detail. Opposite: *blurred or soft*.

sheet film Film that is cut into individual flat pieces. Also called cut film.

short lens A lens whose focal length is shorter than the diagonal measurement of the film with which it is used. The angle of view with this lens–film combination is greater at a given distance than the angle seen by the human eye. Also called a wide-angle or wide-field lens.

short lighting A portrait lighting setup in which the main source of light illuminates the side of the face partially turned away from the camera. Also called narrow lighting.

shutter A mechanism that opens and closes to admit light into a camera for a measured length of time.

shutter-priority A mode of automatic exposure in which the photographer selects the shutter speed and the camera sets the aperture that will produce the correct exposure.

silhouette A scene or photograph in which the background is much more brightly lit than the subject.

silver halide The light-sensitive part of common photographic emulsions; the compounds silver chloride, silver bromide, and silver iodide.

single-lens reflex A camera in which the image formed by the taking lens is reflected by a mirror onto a ground-glass screen for viewing. The mirror swings out of the way just before exposure to let the image reach the film. Abbreviated SLR.

slave An electronic flash unit that fires when it detects a burst of light from another flash unit.

slave eye A sensor that detects light to trigger a slave flash unit.

slide 1. A transparency (often a positive image in color) mounted between glass or in a frame of cardboard or other material so that it may be inserted into a projector. 2. A protective cover that is removed from a sheet film holder when film in the holder is to be exposed. Also called dark slide.

slow Describes 1. a film or paper that is not very sensitive to light; 2. a lens whose widest aperture is relatively small; 3. a long shutter speed. Opposite: *fast*.

SLR *See* single-lens reflex.

sodium thiosulfate The active ingredient in most fixers.

soft 1. Describes an image that is blurred or out of focus. Opposite: *sharp*. 2. Describes a scene, negative, or print of low contrast. Opposite: *hard or high contrast*. 3. Describes a printing paper emulsion of low contrast, such as grade 0 or 1.

software The programs, such as Adobe Photoshop, used to direct a computer to make desired changes in a digital image or other digital file.

solarization A reversal of image tones that occurs when film is massively overexposed. *See also* Sabattier effect.

speed 1. The relative sensitivity to light of film or

paper. 2. The relative ability of a lens to admit more light by opening to a wider aperture.

spherical aberration A lens defect that causes rays that strike at the edges of the lens to be bent more than rays that strike at the center.

spot To remove small imperfections in a print caused by dust specks, small scratches, or the like. Specifically, to paint a dye over small white blemishes.

spotlight An electric light that contains a small, bright lamp, a reflector, and often a lens to concentrate the light. Designed to produce a narrow beam of bright light.

spot meter A reflected-light exposure meter with a very small angle of view, used to measure the brightness of a small portion of a subject.

stereograph A pair of photographs taken side by side and seen separately by each eye in viewing them through a stereoscope. The resulting image looks three-dimensional.

stock solution A concentrated chemical solution that is diluted before use.

stop 1. An aperture setting on a lens. 2. A change in exposure by a factor of two. One stop more exposure doubles the light reaching film or paper. One stop less halves the exposure. Either the aperture or the exposure time can be changed. 3. *See* stop down.

stop bath An acid solution used between the developer and the fixer to stop the action of the developer and to preserve the effectiveness of the fixer. Generally a dilute solution of acetic acid; plain water is sometimes used as a stop bath for film development.

stop down To decrease the size of a lens aperture. Opposite: *open up*.

strobe 1. Abbreviation of stroboscopic. Describes a light source that provides a series of brief pulses of light in rapid succession. 2. Used loosely to refer to any electronic flash.

subtractive color A way to produce colors by mixing dyes that contain varying proportions of the three subtractive primary colors—cyan, magenta, and yellow. Each dye subtracts its color from white light, leaving a balance of colored light. Dyes that absorb all wavelengths of light produce black.

supplementary lens A lens that can be added to a camera lens for close-up work. It magnifies the image and permits focusing closer than normal to an object.

sync cord An electrical cord connecting a flash unit with a camera so that the two can be synchronized. Pronounced "sink."

synchronize To cause a flash unit to fire at the same time as the camera shutter is open.

synchro-sun A way to use flash lighting as fill light in a photograph made in direct sunlight. The flash lightens the shadows, decreasing the contrast in the scene.

T *See* time.

tacking iron A small, electrically heated tool used to melt the adhesive in dry-mount tissue, attaching it partially to the back of the print and to the mounting surface. This keeps the print in place during the mounting procedure.

taking lens The lens on a camera through which light passes to expose the film.

tank A container for developer or other processing chemicals into which film is placed for development.

telephoto effect A change in perspective caused by using a long focal length lens very far from all parts of a scene. Objects appear closer together than they really are.

telephoto lens Loosely, any lens of very long focal length. Specifically, one constructed so that its effective focal length is longer than its actual size. *See also* long lens.

tenting A way to light a highly reflective object. The object is surrounded with large sheets of paper or

translucent material lighted so that the object reflects them and not the lamps, camera, and other items in the studio.

thin Describes a negative or an area of a negative where relatively little silver has been deposited. A thin negative transmits a large amount of light. Opposite: *dense*.

time A shutter setting marked *T* at which the shutter remains open until reclosed by the photographer.

tintype A collodion wet-plate process in which the emulsion was coated onto a dark metal plate. It produced a positive image.

TLR *See* twin-lens reflex.

tone 1. To change the color of a print by immersing it in a chemical solution. 2. The lightness or darkness of a particular area. A highlight is a light tone; a shadow is a dark tone.

transparency An image on a transparent base, such as film or glass, that is viewed by transmitted light. *See* slide (1).

tripod A three-legged support for a camera. Usually the height is adjustable and the top or head is movable.

tungsten film Color film balanced to produce accurate color renditions when the light source that illuminates the scene has a color temperature of about 3200K, as do many tungsten lamps. Sometimes called Type B film. *See also* Type A film.

tungsten light Light such as that from an ordinary light bulb containing a thin tungsten wire that becomes incandescent (emits light) when an electric current is passed along it. Also called incandescent light.

Tv Abbreviation of time value. Used on some camera information displays as a shortened way to refer to shutter speed settings.

twin-lens reflex A camera in which two lenses are mounted above one another. The bottom (taking) lens forms an image on the exposed film. The top (viewing) lens forms an image that reflects upward onto a ground-glass viewing screen. Abbreviated TLR.

Type A film Color film balanced to produce accurate color renditions when the light source that illuminates the scene has a color temperature of about 3400K, as does a photoflood. *See also* tungsten film.

Type B film *See* tungsten film.

ultraviolet The part of the spectrum just beyond violet. Ultraviolet light is invisible to the human eye but strongly affects photographic materials.

underdevelop To give less development than normal.

underexpose To give less than normal exposure to film or paper. The resulting silver density is often less than necessary for best results.

value The relative lightness or darkness of an area. Low values are dark; high values are light.

variable-contrast paper A printing paper in which varying grades of print contrast can be obtained by changing the color of the enlarging light source, as by the use of filters. Also called selective-contrast paper. *See also* graded-contrast paper.

view camera A camera in which the taking lens forms an image directly on a ground-glass viewing screen. A film holder is inserted in front of the viewing screen before exposure. The front and back of the camera can be set at various angles to change focus and perspective.

viewfinder 1. A small window on a camera through which the subject is seen and framed. 2. A camera that has a viewfinder, but not a rangefinder (which shows when the subject is focused).

viewing lens The lens on a camera through which the eye views the subject.

viewing screen In a reflex or view camera, the ground-glass surface on which the image is seen and focused.

vignette To underexpose the edges of an image. Sometimes done intentionally but more often caused accidentally by a lens that forms an image covering the film or paper only partially.

warm Reddish colors that by association with common objects (fire, sun, and so on) give an impression of warmth.

washing aid A chemical solution used between fixing and washing film or paper. It shortens the washing time by converting residues from the fixer into forms more easily dissolved by water. Also called hypo neutralizing (or clearing) agent.

wet-plate process A photographic process in which a glass or metal plate was coated with a collodion mixture, then sensitized with silver nitrate, exposed, and developed while the collodion was still wet. It was popular from the 1850s until the introduction of the gelatin dry plate in the 1880s.

wetting agent A chemical solution used after washing film. By reducing the surface tension of the water remaining on the film, it speeds drying and prevents water spots.

white light A mixture of all wavelengths of the visible spectrum. The human eye sees the mixture as light that is colorless or white.

wide-angle distortion A change in perspective caused by using a wide-angle lens very close to a subject. Objects appear stretched out or farther apart than they really are.

wide-angle lens *See* short lens.

working solution A chemical solution diluted to the correct strength for use.

zone focus To preset the focus of a lens so that some future action will take place within the limits of the depth of field.

Zone System A way to plan negative exposure and development to achieve precise control of the darkness of various areas in a print.

zoom lens A lens adjustable to a range of focal lengths.

Bibliography *Prepared by Peggy Ann Jones*

Technical Information: Basic

This book is a basic introductory text in photography, and you will find that other basic textbooks generally cover the same topics. However, you may want to consult one or more additional beginners' texts because individual texts explain material in individual ways and may emphasize different points. The following books are of about the same level of difficulty as this one.

Davis, Phil. *Photography,* 6th ed. Dubuque, IA: Wm. C. Brown, 1990.

Horenstein, Henry. *Black and White Photography: A Basic Manual,* 2nd ed. Boston: Little, Brown, 1983.

———. *Beyond Basic Photography.* Boston: Little, Brown, 1977.

London, Barbara. *A Short Course in Photography,* 2nd ed. New York: HarperCollins, 1991.

Schaefer, John P. *Basic Techniques of Photography: The Ansel Adams Guide.* Boston: Bulfinch Press, 1992.

Warren, Bruce. *Photography.* Minneapolis–St. Paul: West, 1993.

Technical Information: Advanced or Specialized

A useful listing of information is available from the Eastman Kodak Company (Rochester, NY 14650. Telephone: 1-800-242-2424.) Their *Index to Kodak Information* lists the more than 400 books and pamphlets that they publish for a variety of photographic interests ranging from *Photographing Your Vacation* to *Oblique Aerial Photography.* Kodak publishes many technical data sheets with information on the use of specific products.

Aaland, Mikkel, with Rudolph Burger. *Digital Photography.* New York: Random House, 1992. An introduction to the hardware and software available at the time of publication.

Adams, Ansel. *The New Ansel Adams Photography Series,* with Robert Baker. *The Camera,* 1980; *The Negative,* 1981 (has Zone System details); *The Print,* 1983. Boston: Bulfinch Press. Stresses full technical control of the photographic process as an aid to creative expression.

———. *Examples: The Making of 40 Photographs.* Boston: New York Graphic Society, 1983.

Clerc, L. P. *Photography: Theory and Practice.* Garden City, NY: Amphoto, 1973. A detailed technical reference.

Crawford, Tad. *Legal Guide for the Visual Artist.* New York: Allworth Press, 1989. Ignorance of the law is no defense.

Crawford, William. *The Keepers of Light. A History and Working Guide to Early Photographic Processes.* Dobbs Ferry, NY: Morgan & Morgan, 1979. The history of early photographic media such as the ambrotype, cyanotype, platinum print, gum bichromate print, and others, plus clear directions on how to make these prints yourself.

DeCock, Liliane, ed. *Photo-Lab Index: Lifetime Edition.* Dobbs Ferry, NY: Morgan & Morgan, 1992. A storehouse of information about photographic products, including descriptions of materials and recommended procedures for their use.

Eastman Kodak Co. *Basic Developing, Printing, and Enlarging in Color,* AE-13. Rochester, NY: Eastman Kodak Co., 1992. Useful information on how to make color prints in general using Kodak materials in particular.

———. *Conservation of Photographs,* F-40. Rochester, NY: Eastman Kodak Co., 1985. Detailed information on preserving and restoring all forms of photographs.

———. *Toning Kodak Black-and-White Materials,* G-23. Rochester, NY: Eastman Kodak Co., 1989.

Eaton, George T. *Photographic Chemistry.* Dobbs Ferry, NY: Morgan & Morgan, 1965. Understandable without formal training in chemistry or physics.

Eggleston, Jack. *Sensitometry for Photographers.* Stoneham, MA: Focal Press, 1984. Detailed information for the advanced photographer.

Gassen, Arnold. *Handbook for Contemporary Photography,* 4th ed. Rochester, NY: Light Impressions, 1977. A general, advanced workbook with information on nonsilver processes.

Hirsch, Robert. *Exploring Color Photography,* 2nd ed. Madison, WI: Brown & Benchmark, 1993. Techniques, images, and history of color photography at the college level.

Horenstein, Henry. *The Photographer's Source: A Complete Catalogue.* New York: Simon & Schuster, 1989. An annotated and illustrated guide to equipment, information, materials, services, and accessories.

International Center of Photography. *Encyclopedia of Photography.* New York: Crown, 1984. Alphabetical arrangement of biographical, historical, and technical information.

Keefe, Lawrence E., Jr., and Dennis Inch. *The Life of a Photograph: Archival Processing, Matting, Framing and Storage.* Stoneham, MA: Focal Press, 1984.

Kobre, Kenneth. *Photojournalism: The Professionals' Approach,* 2nd ed. Stoneham, MA: Focal Press, 1991. A comprehensive and readable overview of equipment, techniques, and approaches used by photojournalists.

Larish, John. *Digital Photography: Pictures of Tomorrow.* Torrance, CA: Micro Publishing Press, 1992. An introduction to the hardware and software available at the time of publication.

Picker, Fred. *The Zone VI Workshop: The Fine Print in Black and White Photography.* Garden City, NY: Amphoto, 1974. Introduction to Zone System exposure plus the author's personal printing techniques.

Shaw, Susan, and Monona Rossol. *Overexposure: Health Hazards in Photography,* 2nd ed. New York: Allworth Press, 1991.

Stone, Jim, ed. *Darkroom Dynamics: A Guide to Creative Darkroom Techniques.* Stoneham, MA: Focal Press, 1979. Illustrated instructions on how to expand your imagery with multiple printing, toning, hand coloring, high contrast, and other techniques.

———. *A User's Guide to the View Camera.* New York: HarperCollins, 1987.

Stroebel, Leslie, et al. *Photographic Materials and Processes.* Stoneham, MA: Focal Press, 1986. A comprehensive, advanced text.

Stroebel, Leslie, and Richard D. Zakia. *The Focal Encyclopedia of Photography,* 3rd ed. Stoneham, MA: Focal Press, 1993. New edition of a comprehensive reference covering all aspects of photography.

Todd, Hollis N., and Richard D. Zakia. *Photographic Sensitometry: The Study of Tone Reproduction.* Dobbs Ferry, NY: Morgan & Morgan, 1969. Measuring, analyzing, and applying data on the effects of light on photographic materials.

Wilhelm, Henry. *The Permanence and Care of Color Photographs: Traditional and Digital Color Prints, Color Negatives, Slides, and Motion Pictures.* Grinnell, IA: Preservation Publishing Co., 1993. All you need to know — and more — about photographic care and preservation. Includes information on black-and-white materials.

History, Criticism, Collections

Barrett, Terry. *Criticizing Photographs: An Introduction to Understanding Images.* Mountain View, CA: Mayfield, 1990. A guide to the analysis and interpretation of photographs.

Barrow, Thomas F., et al., eds. *Reading Into Photography: Selected Essays, 1959–1980.* Albuquerque: University of New Mexico Press, 1982.

Berger, John. *About Looking.* New York: Pantheon, 1980.

Browne, Turner, and Elaine Partnow. *Macmillan Biographical Encyclopedia of Photographic Artists and Innovators.* New York: Macmillan, 1983. Several thousand biographies: a *Who's Who* of photography.

Buckland, Gail. *Reality Recorded: Early Documentary Photography.* Boston: New York Graphic Society, 1974.

Coe, Brian. *Cameras, from Daguerreotypes to Instant Pictures.* New York: Crown, 1978. A well-illustrated and complete history of the camera.

Coleman, A. D. *Light Readings: A Photography Critic's Writings 1968–1978.* New York: Oxford University Press, 1979.

Collins, Kathleen, ed. *Shadow and Substance: Essays on the History of Photography.* Bloomfield, MI: Amorphous Institute Press, 1990.

Davenport, Alma. *The History of Photography: An Overview.* Boston: Focal Press, 1991.

Easter, Eric D., et al., eds. *Songs of My People. African Americans: A Self-Portrait.* Introduction by Gordon Parks. Boston: Little, Brown, 1992. Photographs and text from an African American perspective.

Edey, Maitland. *Great Photographic Essays from* Life. Boston: New York Graphic Society, 1978. Twenty-two photographic essays including work by Abbott, Adams, Bourke-White, Cartier-Bresson, and others.

Family of Man, The. New York: The Museum of Modern Art, 1955. Edward Steichen organized this show, which was probably the most publicized and widely seen photographic exhibition ever mounted.

Fralin, Frances. *The Indelible Image: Photographs of War—1846 to the Present.* New York: Harry N. Abrams, 1985. A collection of war photographs from around the world.

Gernsheim, Helmut. *The Origins of Photography.* London: Thames and Hudson, 1982. Early history of the daguerreotype and calotype.

Gernsheim, Helmut, and Alison Gernsheim. *The History of Photography 1685–1914.* New York: McGraw-Hill, 1969. A detailed history "from the camera obscura to the beginning of the modern era." Considerable information on European, particularly British, photography.

Goldberg, Vicki. *Photography in Print: Writings from 1816 to the Present.* New York: Simon & Schuster, 1981.

Green, Jonathan, ed. *Camera Work: A Critical Anthology.* Millerton, NY: Aperture, 1973. Extensive selections from *Camera Work,* "the photographic quarterly published by Alfred Stieglitz, illustrating the evolution of the avant garde in American art and photography from 1903–1917."

———. *American Photography: A Critical History.* New York: Harry N. Abrams, 1984. A survey of American photography since 1945.

Grundberg, Andy. *Crisis of the Real: Writings on Photography, 1974–1989.* New York: Aperture, 1990. Readable and stimulating essays on contemporary issues in photography.

Hill, Paul, and Thomas Cooper. *Dialogue with Photography.* New York: Farrar, Straus and Giroux, 1979. Interviews with 21 major figures in photography, including Beaton, Cartier-Bresson, Cunningham, Doisneau, Kertész, Man Ray, Newhall, W. E. Smith, Strand, and M. White.

Hurley, F. Jack. *Portrait of a Decade: Roy Stryker and the Development of Documentary Photography in the Thirties.* Baton Rouge: Louisiana State University Press, 1972.

Jammes, André, and Eugenia P. Janis. *The Art of French Calotype.* Princeton, NJ: Princeton University Press, 1983. A scholarly work on Second Empire photography, elegantly produced.

Kozloff, Max. *The Privileged Eye: Essays on Photography.* Albuquerque: University of New Mexico Press, 1987.

Life Library of Photography, rev. ed. New York: Time-Life Books, 1981–1983. Seventeen volumes plus yearbooks (1973–1981), all profusely illustrated. The books generally contain historical material and technical information and discuss current trends.

Literature of Photography Series, The. New York: Arno Press, 1973. Sixty-two long out-of-print technical manuals, historical accounts, and aesthetic treatises, including, for example, the 1858 *American Hand Book of the Daguerreotype,* which gives "the most approved and convenient methods for preparing the chemicals and combinations used in the art." Other publishers that have reprinted early photographic books include Morgan & Morgan (Dobbs Ferry, NY) and Dover Publications (New York).

Lyons, Nathan, ed. *Photographers on Photography: A Critical Anthology.* Englewood Cliffs, NJ: Prentice Hall, 1966. Twenty-three well-known photographers (1880s to 1960s) discuss their own work and photography in general.

Maddow, Ben. *Faces: A Narrative History of the Portrait in Photography.* Boston: New York Graphic Society, 1977. Massive and comprehensive.

Mitchell, Margaretta K. *Recollections: Ten Women of Photography.* New York: Viking, 1979. Pictures and recollections by Abbott, Bernhard, Dahl-Wolfe, and others.

Mitchell, William J. *The Reconfigured Eye: Visual Truth in the Post-Photographic Era.* Cambridge, MA: MIT Press, 1992. A critical analysis of digital imaging, including how it has affected what we see and the effects it may have.

Moutoussamy-Ashe, Jeanne. *View Finders: Early Black Women Photographers.* New York: Dodd, Mead, 1986.

Naef, Weston J., and James N. Wood. *Era of Exploration: The Rise of Landscape Photography in the American West, 1860–1885.* New York: The Metropolitan Museum of Art, 1975. Extensive treatment of the subject with emphasis on the photographers Watkins, O'Sullivan, Muybridge, Russell, and Jackson.

Newhall, Beaumont. *The Daguerreotype in America,* 3rd ed. New York: Dover, 1976.

———. *The History of Photography from 1839 to the Present,* rev. ed. New York: Museum of Modern Art, and Boston: New York Graphic Society, 1982. The most widely used basic text on the history of photography.

———. *Latent Image: The Discovery of Photography.* Garden City, NY: Doubleday, 1967. An interesting account of early photographic research and discoveries.

———, ed. *Photography: Essays and Images.* New York: Museum of Modern Art, 1980.

Petruck, Peninah R., ed. *The Camera Viewed: Writings on Twentieth Century Photography.* Vol. 1: *Photography Before World War II.* Vol. 2: *Photography After World War II.* New York: Dutton, 1979. A worthwhile anthology of hard-to-find writing.

Ritchin, Fred. *In Our Own Image: The Coming Revolution in Photography.* New York: Aperture, 1990. The implications of digital imaging, with a particular concern for photojournalism.

Rosenblum, Naomi. *A World History of Photography.* New York: Abbeville Press, 1989.

Rudisill, Richard. *Mirror Image: The Influence of the Daguerreotype on American Society.* Albuquerque: University of New Mexico Press, 1971. Fascinating social history of the cultural, commercial, and social effects of the daguerreotype on mid-19th century America.

Sandweiss, Martha A. *Photography in Nineteenth-Century America.* New York: Harry N. Abrams, 1991. An extensive exploration of the relationship between photography and culture.

Scharf, Aaron. *Art and Photography.* Baltimore: Penguin Books, 1974. The interrelationship of photography and painting.

Sontag, Susan. *On Photography.* New York: Farrar, Straus and Giroux, 1977. The relation of photography to art, reality, and other matters.

Sullivan, Constance. *Women Photographers.* Essay by Eugenia Parry Janis. New York: Harry N. Abrams, 1990. Essays and photographs by women photographers from the 1850s to the present.

Szarkowski, John. *Looking at Photographs.* New York: Museum of Modern Art, 1973. Szarkowski discusses 100 pictures from the museum's collection. An insightful, readable, and highly recommended book.

———. *Mirrors and Windows: American Photography Since 1960.* New York: Museum of Modern Art, 1978.

———. *The Photographer's Eye.* New York: Museum of Modern Art, 1966. Five major concerns of photographers—the subject itself, the detail, the frame, time, and vantage point—with excellent illustrations for each concept.

———. *Photography Until Now.* New York: Museum of Modern Art, 1989. The history of photography organized according to changing photographic technology.

Taft, Robert. *Photography and the American Scene.* New York: Dover Publications, 1964; reprint of 1938 edition. A detailed account of photography's introduction and growth in the United States between 1839 and 1889.

Tucker, Anne. *The Woman's Eye.* New York: Knopf, 1973. Biographies and statements of ten American women photographers and a portfolio of photographs by each. The book explores "the role played by sexual identity both in the creation and the evaluation of photographic art."

———. Trachtenberg, Alan, ed. *Classic Essays on Photography.* New Haven, CT: Leete's Island Books, 1980.

Witkin, Lee, and Barbara London. *The Photograph Collector's Guide.* Boston: New York Graphic Society, 1979. Information of general photographic interest as well as for collectors, such as biographical entries with illustrations for over 200 photographers; lists of over 8000 other photographers, museums, galleries, and so on.

Individual Photographers

The photographers listed below have pictures in this book.

Ansel Adams
———. *Ansel Adams: Images 1923–1974.* Foreword by Wallace Stegner. Boston: New York Graphic Society, 1974.
———. *The American Wilderness.* Andrea Stillman, ed. Boston: Bulfinch Press, 1990.

Bob Adelman
———. *Down Home.* New York: McGraw-Hill, 1972.
———. *The Next America: The Decline and Rise of the United States.* Michael Harrington, ed. New York: Holt, Rinehart and Winston, 1981.

Eve Arnold
———. *In China.* New York: Knopf, 1980.
———. *Unretouched Women.* New York: Knopf, 1976.

Eugène Atget
———. *Atget's Seven Albums.* Text by Molly Nesbit. New Haven, CT: Yale University Press, 1992.
Abbott, Berenice. *The World of Atget.* New York: Horizon Press, 1964.
The Work of Atget. John Szarkowski and Maria Morris Hambourg, eds. New York: Museum of Modern Art, and Boston: New York Graphic Society. Vol. 1: *Old France,* 1981. Vol. 2: *The Art of Old Paris,* 1982. Vol. 3: *The Ancien Régime,* 1983. Vol. 4: *Modern Times,* 1984.

Morley Baer
Olmsted, Roger, and T. H. Watkins. *Here Today: San Francisco's Architectural Heritage.* San Francisco: Chronicle Books, 1968.

JEB (Joan E. Biren)
———. *Eye to Eye: Portraits of Lesbians.* Washington, DC: Glad Hag Books, 1979.

Werner Bischof
———. *Werner Bischof.* Boston: Bulfinch Press, 1990.

Margaret Bourke-White
———. *The Photographs of Margaret Bourke-White.* Sean Callahan, ed. Boston: New York Graphic Society, 1972.
———. *Portrait of Myself.* New York: Simon & Schuster, 1963.
Goldberg, Vicki. *Margaret Bourke-White: A Biography.* Reading, MA: Addison-Wesley, 1987.

Fred Bruemmer
———. *The Arctic World.* San Francisco: Sierra Club Books, 1985.
———. *The Narwhal: Unicorn of the Sea.* Toronto: Key Porter Books, 1993.

Julia Margaret Cameron
Gernsheim, Helmut. *Julia Margaret Cameron: Her Life and Photographic Work.* Millerton, NY: Aperture, 1975.
———. *Victorian Photographs of Famous Men and Fair Women.* Boston: David R. Godine, 1973.

———. *Whisper the Muse: The Overstone Album and Other Photographs.* Santa Monica, CA: J. Paul Getty Museum, 1986.

Paul Caponigro
———. *Landscape.* New York: McGraw-Hill, 1975.
———. *The Wise Silence.* Marianne Fulton, ed. Boston: New York Graphic Society, 1983.
———. *Sunflower.* New York: Filmhaus, 1974.

Patty Carroll
———. *Spirited Visions: Portraits of Chicago Artists.* Urbana: University of Illinois Press, 1991.

Henri Cartier-Bresson
———. *The Decisive Moment.* New York: Simon & Schuster, 1952.
———. *Henri Cartier-Bresson: Photographer.* Essay by Yves Bonnefoy. Boston: Bulfinch Press, 1992.

Clint Clemens
Samuelson, Marnie Crawford. "On Location with Clint Clemens," *Photo District News,* December 1991.

Linda Connor
———. *Solos.* Millerton, NY: Apeiron Workshops, 1979.
———. *Spiral Journey.* Chicago: Museum of Contemporary Art, 1990.

Imogen Cunningham
———. *Ideas Without End: A Life in Photographs.* San Francisco: Chronicle Books, 1993.
———. *Imogen! . . . Photographs 1910–1973.* Introduction by Margery Mann. Seattle: University of Washington Press, 1974.
Dater, Judy. *Imogen Cunningham: A Portrait.* Boston: New York Graphic Society, 1979.

L. J. M. Daguerre
———. *A Historical and Descriptive Account of the Various Processes of the Daguerreotype and the Diorama,* 1839. Reprint with introduction by Beaumont Newhall. New York: Winter House, 1971.
Gernsheim, Helmut, and Alison Gernsheim. *L. J. M. Daguerre: The History of the Diorama and the Daguerreotype.* London: Secker & Warburg, 1956. Bibliography. U.S. edition, New York: Dover, 1968.

Judy Dater
———. *Body and Soul.* Text by Carolyn Coman. Boston: Hill and Co., 1988.
———, and Jack Welpott. *Women and Other Visions.* Dobbs Ferry, NY: Morgan & Morgan, 1975.

Bruce Davidson
———. *Bruce Davidson. Photographs.* Introduction by Henry Geldzahler. New York: Agrinde Publications, 1978.
———. *East 100th Street.* Cambridge, MA: Harvard University Press, 1970.

Robert Doisneau
———. *Three Seconds from Eternity.* Boston: New York Graphic Society, 1979.

Maxime Du Camp
Flaubert in Egypt: A Sensibility on Tour—A Narrative Drawn from Gustave Flaubert's Travel Notes and Letters. Francis Steegmuller, trans. and ed. Boston: Little, Brown, 1972. Includes photographs and extracts from Du Camp's descriptions of the trip.

P. H. Emerson
Newhall, Nancy. *P. H. Emerson: The Fight for Photography as a Fine Art.* Millerton, NY: Aperture, 1975.
Turner, Peter, and Richard Wood. *P. H. Emerson: Photographer of Norfolk.* Boston: Godine, 1975.

Elliott Erwitt
———. *Photographs and Anti-Photographs.* Texts by Sam Holmes and John Szarkowski. Boston: New York Graphic Society, 1972.
———. *To The Dogs.* New York: D.A.P./Scalo, 1992.

Walker Evans
———. *Walker Evans.* New York: Museum of Modern Art, 1971.
———. *Walker Evans. Photographs for the Farm Security Administration 1935–1938.* Introduction by Jerald C. Maddox. New York: Da Capo Press, 1975. An illustrated catalog of photographic prints available from the Farm Security Administration Collection in the Library of Congress.
Agee, James, and Walker Evans. *Let Us Now Praise Famous Men.* Boston: Houghton-Mifflin, 1969.

Andreas Feininger
———. *Andreas Feininger.* Introduction by Ralph Hattersley. Dobbs Ferry, NY: Morgan & Morgan, 1973.
———. *Industrial America: 1940–1960.* New York: Dover, 1982.
———. *In a Grain of Sand: Exploring Design by Nature.* San Francisco: Sierra Club Books, 1986.

Sandi Fellman
———. *The Japanese Tattoo.* Introduction by D. M. Thomas. New York: Abbeville Press, 1986.

Roger Fenton
———. *Roger Fenton: Photographer of the Crimean War. His Photographs and His Letters from the Crimea.* New York: Arno Press, 1973; reprint of 1954 edition.
Hannavy, John. *Roger Fenton of Crimble Hall.* Boston: Godine, 1976.

Carl Fleischhauer
Marshall, Howard, and Richard E. Ahlborn. *Buckaroos in Paradise: Cowboy Life in Northern Nevada.* Lincoln: University of Nebraska Press, 1981. Photographs by Fleischhauer and others.

Robert Frank
———. *Les Américains.* Alain Bosquet, ed. Paris: Delpire, 1958. U.S. edition, *The Americans.* Introduction by Jack Kerouac. New York: Grove, 1959. Rev. eds., Millerton, NY: Aperture, 1969, 1978.
———. *The Lines of My Hand.* New York: Lustrum, 1972. Enlarged Japanese edition, Tokyo: Yugensha, 1972.

Scott Goldsmith
Line, Les. "Silence of the Songbird," *National Geographic,* June 1993.

Emmet Gowin
———. *Photographs.* Philadelphia: Philadelphia Museum of Art, 1990.

Lois Greenfield
———. *Breaking Bounds.* Text by William A. Ewing. San Francisco: Chronicle Books, 1992.

Charles Harbutt
———. *Travelog.* Cambridge, MA: MIT Press, 1974.

Bill Hedrich
———. *Hedrich-Blessing: Architectural Photography, 1930–1981.* Rochester, NY: George Eastman House, 1981.

David O. Hill and Robert Adamson
Bruce, David. *Sun Pictures: The Hill / Adamson Calotypes.* Boston: New York Graphic Society, 1974.
An Early Victorian Album: The Hill / Adamson Collection. Edited and introduced by Colin Ford. Commentary by Roy Strong. London: Cape, 1974. U.S. edition, New York: Knopf, 1976.

Lewis W. Hine
———. *Selected Letters and Photographs of Lewis W. Hine.* Washington, DC: Smithsonian Institution Press, 1992.
Gutman, Judith M. *Lewis W. Hine and the American Social Conscience.* New York: Walker & Co., 1967.
Rosenblum, Walter, Naomi Rosenblum, and Alan Trachtenberg. *America & Lewis Hine: Photographs 1904–1940.* Millerton, NY: Aperture, 1976.

David Hockney
———. *Cameraworks.* New York: Knopf, 1984.
———. *Hockney on Photography.* Conversations with Paul Joyce. New York: Harmony Books, 1988.

Henry Horenstein
———. *Racing Days.* Text by Brendan Boyd. New York: Viking, 1987.

John Isaac
Livingston, Katherine. "Neutral Observer," *American Photographer,* March 1988.

Kenro Izu
Holt, Claire. "The Art of Platinum Printing," *Photo District News,* April 1992.

Mark Jasin
"Painting Digital Portraits," *Step by Step Graphics,* September 1992.

Peggy Ann Jones
"Pinhole Procession," *Minolta Mirror,* 1992.

Yousuf Karsh
———. *Karsh: A Fifty-Year Retrospective.* Boston: New York Graphic Society, 1983.
———. *Karsh: American Legends.* Boston: Little, Brown, 1992.

Gertrude Käsebier
Homer, William Inness. *A Pictorial Heritage: The Photographs of Gertrude Käsebier.* Wilmington: Delaware Art Museum, 1979.

Barbara Kasten
———. *Constructs.* Essay by Estelle Jussim. Boston: Little, Brown/New York Graphic Society/Polaroid, 1985.
———. *Barbara Kasten: 1986–1990.* Los Angeles, Tokyo: Research Art Media, 1990.

Moshe Katvan
"Moshe Katvan in a New Light," *Photo District News,* March 1992.

André Kertész
———. *André Kertész: Sixty Years of Photography 1912–1972.* New York: Grossman, 1972.
———. *A Lifetime of Perception.* New York: Abrams, 1982.

Douglas Kirkland
———. *Icons.* San Francisco: Collins, 1993.
———. *Light Years.* London: Thames and Hudson, 1989.

Joseph Koudelka
———. *Gypsies.* Millerton, NY: Aperture, 1975.

Jill Krementz
———. *The Writer's Image: Literary Portraits.* Boston: Godine, 1980.

Barbara Kruger
———. *Love for Sale: The Words and Pictures of Barbara Kruger.* New York: Abrams, 1990.

Ellen Land-Weber
———. *The Passionate Collector.* New York: Simon & Schuster, 1980.

Dorothea Lange
———. *Photographs of a Lifetime.* Essay by Robert Coles. Millerton, NY: Aperture, 1982.
Meltzer, Milton. *Dorothea Lange: A Photographer's Life.* New York: Farrar, Straus and Giroux, 1978.

Russell Lee
Hurley, F. Jack. *Russell Lee: Photographer.* Dobbs Ferry, NY: Morgan & Morgan, 1978.

William Lesch
———. *Expansions.* Tokyo: Treville Press, 1992.

O. Winston Link
———. *Ghost Trains: Railroad Photographs of the 1950s.* Norfolk, VA: The Chrysler Museum, 1983.

Herbert List
———. *Photographs 1930–1970.* Introduction by Gunter Metken. Munich: Schirmer/Mosel, 1976.

John Lund
"Computer Artist: John Lund," *Computer Artist,* April/May 1993.

Danny Lyon
———. *Conversations with the Dead.* New York: Holt, Rinehart and Winston, 1971.
———. *Pictures from the New World.* Millerton, NY: Aperture, 1981.

Mike Mandel
———. *Making Good Time.* Santa Cruz, CA: Self-published, 1989.

Credits

Cover photo: Ken Kay. Digital manipulation by Paul Agresti.

Title page photo: David Hockney, *You Make the Picture, Zion Canyon, Utah, October 1982*, photographic collage, 52½ × 48¼", © David Hockney.

Chapter 1 **viii:** © William Lesch/Swanstock. **1:** Paul Caponigro. **4:** Fred E. Mang, Jr./National Park Service. **5:** A. L. Weeks/U.S. Department of Agriculture. **7:** Scott Goldsmith; Linda Bartlett; John Senzer; Barbara London.

Chapter 2 **8:** Andreas Feininger/*Life* magazine, © Time Warner. **10:** Pentax Corp.; Minolta Corp. **11:** M. Woodbridge Williams/National Park Service; Barbara London; Fredrik D. Bodin; Jack Sal/Michael Belenky/BL Books, Inc. **12:** Ken Kay; John Upton. **13:** John Upton. **14:** Penny Wolin. **15:** Penny Wolin; Daniel Hall/Shooting Back, Inc. **17:** Ken Kay and Harold Zipkowitz. **18:** Duane Michals; Harold Zipkowitz. **19:** Duane Michals; Harold Zipkowitz. **20:** George Krause. **21:** George Krause. **22:** Ken Kay; Calumet Photographic, Inc. **23:** E. Leitz, Inc.; Ken Kay. **24:** Canon USA, Inc.; Ken Kay. **25:** Mamiya; Ken Kay. **26:** Ken Kay. **27:** Fil Hunter. **28:** Joseph Ciaglia; Jack Sal/Michael Belenky/BL Books, Inc. **29:** Joseph Ciaglia; Jack Sal/Michael Belenky/BL Books, Inc. **30:** Anthony Donna; Jack Sal/Michael Belenky/BL Books, Inc. **31:** Anthony Donna; Jack Sal/Michael Belenky/BL Books, Inc. **32:** © Lois Greenfield. **33:** © Lois Greenfield.

Chapter 3 **34:** André Kertész. **36:** Ansel Adams. **37:** Ansel Adams. **38:** Ansel Adams. **39:** Harold Zipkowitz. **41:** Joseph Ciaglia. **42:** © Bruce Davidson/Magnum. **43:** © Henri Cartier-Bresson/Magnum. **44:** Jack Sal/Michael Belenky/BL Books, Inc. **45:** Walter Iooss, Jr. **46:** William G. Larson. **47:** © 1993 David Muench. **48:** John Neubauer. **49:** Robert Packo. **50:** Margaret Bourke-White/*Life* magazine, © Time Warner. **51:** Mark Kauffman. **52:** Harold Zipkowitz. **53:** Fredrik D. Bodin. **54:** © Elliott Erwitt/Magnum. **55:** U.S. Department of Agriculture. **56:** Jack Sal/Michael Belenky/BL Books, Inc. **57:** Henry Horenstein. **58:** David Arky. **59:** David Arky. **60:** Andreas Feininger/*Life* magazine © Time Inc. **61:** Art Kane. **62:** Frank Siteman/Stock, Boston; Barbara London. **63:** George Constable; Gerald Jacobson; Alan Oransky. **64:** Harold Zipkowitz.

Chapter 4 **66:** Charles Harbutt/Archive. **69:** Courtesy Minor White Archive/© 1982 Trustees of Princeton University. **70:** Arthur Taussig. **71:** Ken Kay. **73:** Joseph Ciaglia. **74:** © 1970 Imogen Cunningham Trust. **76:** Robert Lebeck. **77:** James Drake. **78:** Leonard Soned. **79:** Leonard Soned. **81:** Courtesy Minor White Archive/© 1982 Trustees of Princeton University. **82:** Polaroid Corp.; Alan Ross. **83:** Joe Wrinn. **84:** John Senzer. **85:** Donald Dietz. **86:** Robert Walch. **88:** Urs Moeckli; Jeff Rotman. **89:** Jim Allan/Fred Bruemmer Collection; Fred Bruemmer.

Chapter 5 **90:** Sylvia Plachy. **91:** Ralph Morse/*Life* magazine, © Time Warner. **94:** David F. Warren/U.S. Department of Agriculture; National Park Service. **96:** Walker Evans/courtesy Library of Congress. **97:** Jack Sal/Michael Belenky/BL Books, Inc. **98:** Fredrik D. Bodin. **99:** Flint Born. **100:** Rick Steadry. **101:** John Upton. **103:** Lisl Dennis. **104:** Jack Sal/Michael Belenky/BL Books, Inc. **105:** Flint Born; Arthur Taussig. **106:** Ellen Land-Weber. **107:** John Loengard.

Chapter 6 **108:** Paul Caponigro. **110:** Ken Kay. **113:** Scott Goldsmith. **114:** Ken Kay; Alan Oransky. **115:** Ken Kay. **116:** Jack Sal/Michael Belenky/BL Books, Inc.; Ken Kay; Alan Oransky. **117:** Chauncey Bayes; Ken Kay. **118:** Ken Kay; Chauncey Bayes. **119:** Ken Kay; Chauncey Bayes. **120:** Ken Kay; Alan Oransky. **122:** Eastman Kodak Co., Kodak Research Laboratory, Rochester, New York. **123:** Robert Walch. **124:**

Robert Walch. **125:** David Arky; Sebastian Milito. **127:** Arthur Taussig. **129:** Rick Steadry; Michele McDonald. **130:** Jim Stone. **131:** William Gedney; Sebastian Milito. **132:** Sebastian Milito. **133:** Alan Oransky; Sebastian Milito. **134:** Walter Iooss, Jr.; Dan Jenkins, Jr. **135:** Walter Iooss, Jr.

Chapter 7 **136:** John Isaac. **137:** Arthur Taussig. **138:** Ken Kay. **139:** Ken Kay. **142:** Dmitri Kessel. **144:** Chauncey Bayes; Ken Kay. **145:** Ken Kay. **146:** Chauncey Bayes; Ken Kay. **147:** Ken Kay. **148:** Ken Kay. **150:** Ken Kay. **151:** Ken Kay. **152:** Ken Kay. **153:** Ken Kay. **154:** Jim Stone. **155:** Jim Stone. **157:** Arthur Taussig. **158:** Jules Zalon. **158:** John Loengard. **159:** Jules Zalon; Ken Kay; John Loengard. **160:** Ken Kay; Chauncey Bayes. **161:** John Loengard; Ken Kay. **162:** © Arnold Newman; Rick Steadry. **164:** George A. Tice. **166:** Bob Adelman; Penny Wolin. **167:** © Karsh, Ottawa.

Chapter 8 **168:** Moshe Katvan. **170:** Al Freni; Courtesy Doran Enterprises, Inc.; Alan Oransky. **171:** Rick Steadry. **172:** Ken Kay. **173:** Ken Kay. **174:** Jack Sal/Michael Belenky/BL Books, Inc. **175:** Ken Kay. **176:** Ken Kay. **177:** Ken Kay. **178:** Larry Sultan; Linda Connor. **179:** Mihoko Yamagata.

Chapter 9 **180:** Steve Bronstein. **181:** Steve Bronstein. **183:** Ken Kay. **184:** Ken Kay. **185:** Stephen Brown; Fil Hunter. **186:** Ken Kay. **187:** Ralph Weiss. **190:** Man Ray/© 1993 ARS New York/ADAGP/Man Ray Trust, Paris. **191:** Sebastian Milito; Adam Fuss; Jack Sal. **193:** Arthur Taussig and Carol Linam. **194:** Fred Burrell. **195:** Fred Burrell. **196:** Fred Burrell. **197:** Fred Burrell. **198:** Betty Hahn. **199:** Kenro Izu, 14 × 20" platinum/palladium print. **201:** Peggy Ann Jones.

Chapter 10 **202:** Michael Skott/Stylist: Jeanne Skott. **203:** Kevin Clark. **204:** Sebastian Milito. **205:** Sebastian Milito. **206:** Robert Crandall; Herb Orth. **209:** Sebastian Milito. **210:** Sebastian Milito. **212:** Richard Steinberg. **213:** © David Muench. **214:** Emil Schulthess and Emil Spühler/Black Star. **215:** © 1980 Dick Durrance II. **216:** David Moore/Black Star. **217:** Peter deLory. **218:** Fil Hunter. **219:** © Eve Arnold/Magnum. **220:** Harold Feinstein. **221:** Michael Geiger. **223:** Courtesy Jobo Fototechnic; Donald Dietz. **224:** Donald Dietz. **225:** Donald Dietz. **226:** Donald Dietz. **227:** Donald Dietz. **228:** Donald Dietz. **229:** Donald Dietz. **231:** Donald Dietz. **232:** Albert Watson. **233:** Mike Reinhardt/courtesy *Elle* magazine. **234:** Courtesy Ilford Photo Corp. **235:** Al Freni. **236:** Donald Dietz. **237:** Jerry Peart; Patty Carroll. **238:** © David Hockney, Composite Polaroid, 17¾ × 29⁷⁄₁₆". **239:** Barbara Bordnick. **240:** Clint Clemens; Vito Aluia. **241:** Clint Clemens.

Chapter 11 **242:** O. Winston Link. **243:** Y. R. Okamoto/courtesy Lyndon Baines Johnson Library. **244:** Ray McSavaney. **245:** © Werner Bischof/Magnum. **246:** Etta Clark, from *Growing Old Is Not for Sissies*; Fredrik D. Bodin. **247:** © Danny Lyon/Magnum. **248:** Pedro Meyer; Penny Wolin. **249:** © 1979 JEB (Joan E. Biren); **249:** Nicholas Nixon. **250:** Jack Sal/Michael Belenky/BL Books, Inc. **251:** Jack Sal/Michael Belenky/BL Books, Inc. **253:** Henry Groskinsky. **254:** © 1971 Jill Krementz. **255:** © 1975 Jill Krementz; © 1972 Jill Krementz. **256:** Sebastian Milito. **257:** David Arky. **258:** David Arky. **259:** Fil Hunter. **260:** © Erich Hartmann/Magnum. **261:** Al Freni. **262:** © Lois Greenfield. **263:** Arthur Fellig (Weegee)/© Weegee Collection/Magnum. **264:** Canon USA, Inc.; Courtesy Berkey Marketing Companies; Courtesy Nikon, Inc.

265: Terry Eiler/American Folklife Center. **267:** Jack Sal/Michael Belenky/BL Books, Inc. **268:** David Arky; Clem Albers/National Archives. **269:** David Arky. **270:** Jack Sal/Michael Belenky/BL Books, Inc. **271:** Jack Sal/Michael Belenky/BL Books, Inc.; Richard Misrach/courtesy Fraenkel Gallery, San Francisco/Robert Mann Gallery, New York/Jan Kesner Gallery, Los Angeles. **272:** Elizabeth Hamlin; John Upton; Joseph Ciaglia. **273:** Gregory Heisler.

Chapter 12 **274:** Eadweard Muybridge/Michael Kerbow. **276:** © Richard Frear, National Park Service. **277:** Barbara London/digital manipulation by Stephen Johnson/prints courtesy SuperMac Technology. **282:** Barbara London/digital manipulation by Stephen Johnson/prints courtesy SuperMac Technology. **283:** Barbara London/digital manipulation by Stephen Johnson/prints courtesy SuperMac Technology. **284:** Barbara London/digital manipulation by Stephen Johnson/prints courtesy SuperMac Technology. **285:** Photographer unknown: *John Newton, Oklahoma, c. 1910*/digital manipulation by Stephen Johnson/prints courtesy SuperMac Technology; © 1993 PhotoDisc, Seattle, Washington/digital manipulation by Stephen Johnson/prints courtesy SuperMac Technology. **286:** Stephen Johnson/prints courtesy SuperMac Technology; Remy Poinot. **287:** Photo Gabriel Amadeus Cooney/digital imaging Paul Kazmercyk/courtesy Hotchkiss School/Cheney and Co. **288:** Keith J. Hampton; Douglas Kirkland. **289:** Mark Jasin, represented by Martha Productions. **290:** John Lund; Courtesy John Lund. **291:** John Lund; John Lund/photo composite © 1993 Bruce McAllister and A. Keuning/Panoramic Images, Chicago. **292:** Peter Campus/courtesy Paula Cooper Gallery, New York; Esther Parada. **293:** Barbara Kasten; Mike Mandel and Larry Sultan, San Francisco. **294:** Gerald Bybee/Bybee Studios, San Francisco. **295:** © 1978 Michael Kienitz. **296:** Lois Bernstein/*The Sacramento Bee*; Jay Mather. **297:** Lois Bernstein/*The Sacramento Bee*.

Chapter 13 **298:** Courtesy Robert A. Weinstein. **300:** Arthur Taussig. **302:** Ken Kay. **303:** Ken Kay. **304:** Ken Kay. **305:** Ken Kay. **306:** Ken Kay. **307:** Ken Kay. **308:** Ken Kay. **309:** Ken Kay. **310:** Donald Dietz. **311:** Ken Kay. **312:** Philip Trager; Ken Kay. **313:** Philip Trager; Ken Kay. **314:** Ken Kay. **318:** © Philip Trager 1980. **319:** Emmet Gowin.

Chapter 14 **320:** Ansel Adams/© 1993 Trustees of the Ansel Adams Publishing Rights Trust. All rights reserved. **323:** John Upton. **325:** John Upton. **327:** Rick Steadry. **329:** John Upton. **330:** © 1977 John Sexton. All rights reserved; © 1990 Patrick Jablonski. All rights reserved. **331:** © 1987 John Sexton. All rights reserved. **333:** © Morley Baer.

Chapter 15 **334:** © 1984 Estate of Garry Winogrand/courtesy Fraenkel Gallery, San Francisco, and Estate of Garry Winogrand. **335:** © Susan Meiselas/Magnum. **336:** Linda Bartlett. **337:** Richard E. Ahlborn/American Folklife Center; Carl Fleischhauer/American Folklife Center; Jonas Dovydenas/American Folklife Center. **338:** Jonas Dovydenas/American Folklife Center. **339:** Sandi Fellman. **340:** John Senzer. **341:** Robert Doisneau. **342:** © 1986 John Sexton. All rights reserved. **343:** Russell Lee/courtesy Library of Congress. **344:** Paul Caponigro. **345:** Gordon Parks. **346:** Roy Clark/U.S. Department of Agriculture; R. O. Brandenberger/U.S. Department of Agriculture. **347:** © Dennis Stock/Magnum. **348:** U.S. Department of Agriculture. **349:** Herbert List Estate/Max Scheler, Hamburg; Robert S. Scurlock/Scurlock Studio. **350:** © 1970 Judy Dater. **351:** Bill Hedrich. **352:** Robert Branstead/U.S. Depart-

ment of Agriculture. **353:** © Josef Koudelka/Magnum. **354:** Marion Post Wolcott/courtesy Library of Congress. **355:** David Moore; Dorothea Lange/courtesy Dorothea Lange Collection, Oakland Museum, gift of Paul S. Taylor. **357:** © Sebastião Selgado/Magnum. **358:** Courtesy *Virginian* and *Ledger Star*, Norfolk, Virginia; Robert B. Goodman. **359:** Courtesy Mel Scott; Edmund Yankov; Dave Eliot. **360:** Lois Gervais; Pete Newman. **361:** Lois Gervais/Atlantic Richfield Co.

Chapter 16 362: One-quarter plate daguerreotype, $3\frac{1}{4} \times 4\frac{1}{4}$"/Museum of Modern Art, New York, gift of Virginia Cuthbert Elliott. **365:** Joseph Nicéphore Niépce/Gernsheim Collection, Harry Ransom Humanities Research Center, University of Texas at Austin. **366:** Collections Société Française de Photographie; Platt D. Babbitt/International Museum of Photography at George Eastman House. **367:** Amherst College Library. **368:** Fox Talbot/courtesy Lee Boltin Picture Library. **369:** G. R. Rinhart Collection. **371:** Timothy H. O'Sullivan/courtesy Library of Congress; Joel Snyder/Division of Photographic History, Smithsonian Institution. **372:** Julia Margaret Cameron/courtesy Board of Trustees of Victoria and Albert Museum. **373:** Bibliothèque Nationale/Eddy Van der Veen. **374:** Roger Fenton/Gernsheim Collection, Harry Ransom Humanities Research Center, University of Texas at

Austin. **375:** Timothy H. O'Sullivan/courtesy Library of Congress. **376:** Maxime Du Camp/courtesy Arnold Crane Collection, Chicago, Illinois. **377:** Timothy H. O'Sullivan/courtesy Library of Congress. **378:** International Museum of Photography at George Eastman House. **379:** Fred Church/International Museum of Photography at George Eastman House. **380:** Louis Jacques Mandé Daguerre/Bayerisches Nationalmuseum; Edward Anthony/International Museum of Photography at George Eastman House. **381:** Eadweard Muybridge/International Museum of Photography at George Eastman House. **382:** © Estate of August Sander/courtesy Sander Gallery, New York. **383:** Eugène Atget/gelatin-silver print ($9\frac{1}{16} \times 6\frac{3}{4}$") by Berenice Abbott, 1940/collection Museum of Modern Art, New York, gift of Edward Steichen. **384:** Lewis Hine/International Museum of Photography at George Eastman House. **385:** Dorothea Lange/© City of Oakland, Oakland Museum, California. **386:** Collection Royal Photographic Society; Henry Peach Robinson/Gernsheim Collection, Harry Ransom Humanities Research Center, University of Texas at Austin. **387:** Peter Henry Emerson/Gernsheim Collection, Harry Ransom Humanities Research Center, University of Texas at Austin. **388:** Gertrude Käsebier platinum print on Japanese tissue, $9\frac{3}{8} \times 5\frac{1}{2}$"/Museum of Modern Art, New York, gift of Mrs. Hermine M. Turner. **389:** Alfred

Stieglitz photogravure (artist's proof), $7\frac{3}{4} \times 6\frac{1}{2}$" from *Camera Work*, no. 36, 1911/Museum of Modern Art, New York, gift of the photographer. **390:** Paul Strand gravure, $6\frac{11}{16} \times 8\frac{11}{16}$", from *Camera Work*, nos. 49–50, June 1917/Museum of Modern Art, New York, given anonymously. **391:** Edward Weston/© 1981 Arizona Board of Regents, Center for Creative Photography. **392:** Man Ray/© 1993 ARS New York/ADAGP/Man Ray Trust, Paris. **393:** László Moholy-Nagy/courtesy Hattula Moholy-Nagy and International Museum of Photography at George Eastman House. **394:** Aaron Siskind. **395:** Robert Frank/collection Museum of Fine Art, Houston, Texas. **396:** John Pfahl/courtesy Janet Borden Gallery. **397:** Barbara Kruger/courtesy Mary Boone Gallery, New York. **398:** Sandy Skoglund. **399:** Duane Michals. **400:** © Peter Hunter/Magnum. **400:** Erich Salomon/courtesy Bildarchiv Preussischer Kulturbesitz, Berlin, West Germany. **401:** Murray Becker/Associated Press/Wide World; Werner Voight/SIPA Press. **402:** W. Eugene Smith/*Life* magazine, © Time Warner. **403:** W. Eugene Smith/*Life* magazine, © Time Warner. **404:** Louis Ducos du Hauron/International Museum of Photography at George Eastman House; Arnold Genthe/courtesy Library of Congress. **405:** Nickolas Muray/International Museum of Photography at George Eastman House.

Index

Cut out and assemble these light meter dials to see how film exposure is related to light intensity, film speed, shutter speed, and aperture.

Assembling the dials

1. Cut out the 3 dials and the 2 windows in the dials.

2. Connect the 3 dials by putting a pin first through the center point of the smallest dial, then the medium-size dial, and finally the largest dial. (A pushpin, with a piece of cardboard underneath the largest dial, works best.)

3. Line up the 2 windows so you can read the film speeds through them.

Using the dials

1. To calibrate your meter to your film, you set the arrow ▲ marked ISO to the speed of your film. For a trial, set it to ISO 100.

2. With a real light meter, you point its light-sensitive cell at a subject to get a reading of the brightness of the light. In one type of meter, a needle on a gauge (not shown here) indicates the brightness of the light. Suppose this light measurement reading was 17. Keep the film-speed arrow pointing to 100 while you set the other arrow ▲, which points to the light measurement, to 17.

3. Now you can see, lined up opposite each other, combinations of shutter speed and aperture that will produce a correct exposure for this film speed and this amount of light: 1/250 sec. shutter speed at f/8 aperture, 1/125 sec. at f/11, and so on. All these combinations of shutter speed and aperture let in the same amount of light.

4. Try increasing (or decreasing) the film speed to see how this affects the shutter speed and aperture combinations. For example, keep the light-measurement arrow at 17 while you move the film-speed arrow to 200. Now the combinations show a 1-stop change: 1/250 sec. of f/11, 1/125 sec. at f/16, and so on.

5. If the light gets brighter (or dimmer), how would this affect the shutter speed and aperture combinations? Suppose the light is dimmer, and you only get a light reading of 16. Set the light-measurement arrow to 16, while you keep the film-speed arrow at 200. What are the combinations?

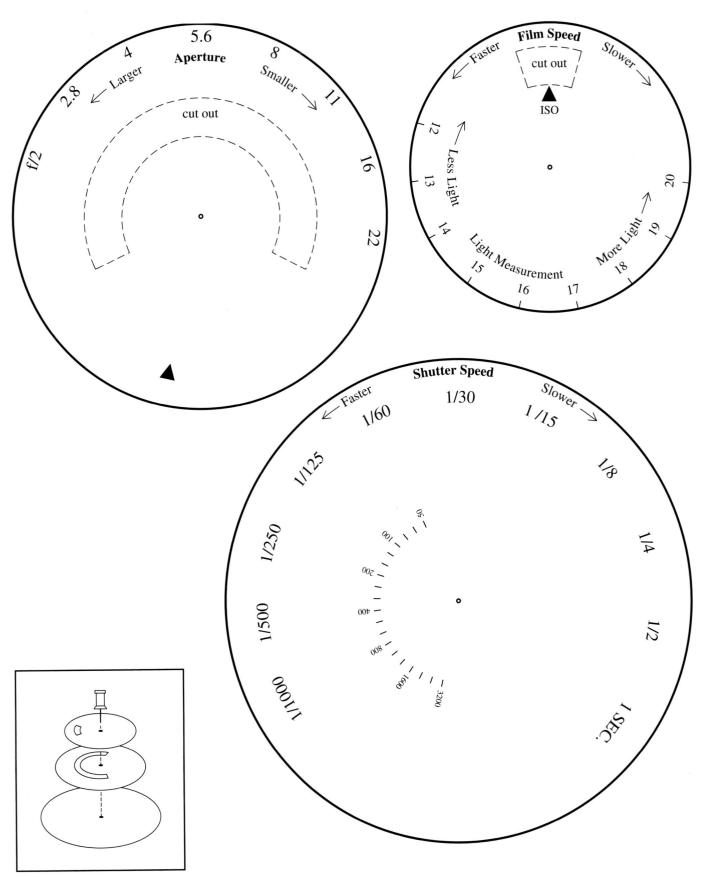